FEDERICO BAROCCI

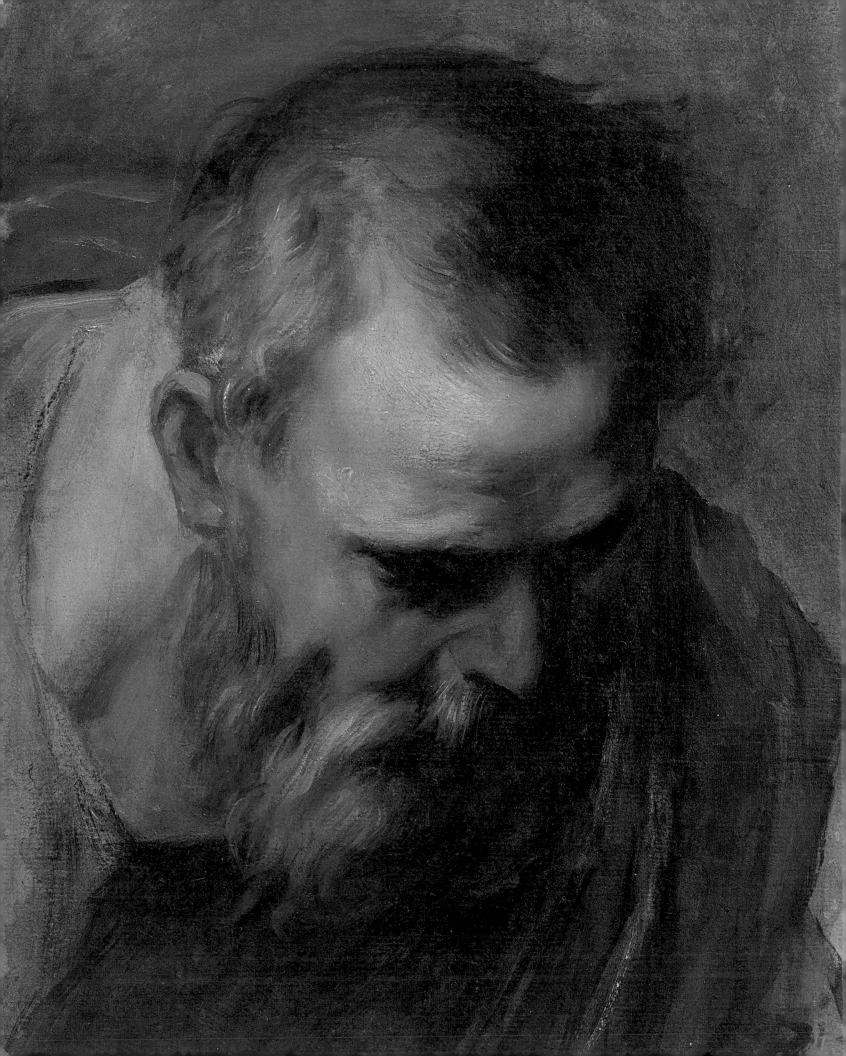

FEDERICO BAROCCI

Renaissance Master of Color and Line

Judith W. Mann and Babette Bohn

With Carol Plazzotta

Saint Louis Art Museum

Yale University Press, New Haven and London

Published in conjunction with "Federico Barocci: Renaissance Master," organized by the Saint Louis Art Museum and The National Gallery, London (where the exhibition was entitled "Barocci: Brilliance and Grace"), in collaboration with the Soprintendenza per il Patrimonio Storico, Artistico ed Etnoantropologico delle Marche–Urbino and the Polo Museale Fiorentino, Gabinetto Disegni e Stampe degli Uffizi, Florence, and with generous support of the Kupferstichkabinett, Staatliche Museen zu Berlin.

The presentation of "Federico Barocci: Renaissance Master" is supported by BMO Private Bank, a part of BMO Financial Group.

The exhibition and symposium in St. Louis is supported in part by Sotheby's.

Financial assistance has been provided by the Missouri Arts Council, a state agency.

This project is supported in part by an award from the National Endowment for the Arts. Additional support has been provided by Emerson.

EMERSON.

Manuscript Editor: Benedicte Gilman
Designer: Rita Jules, Miko McGinty Inc.
Set in Arno and Ideal Sans by Tina Henderson
Printed and bound in Italy by Mondadori

Published by the Saint Louis Art Museum,
1 Fine Arts Drive, St. Louis, Missouri 63110-1380; and
Yale University Press,
302 Temple Street, New Haven, Connecticut 06520
www.yalebooks.com/art

LIBRARY OF CONGRESS CATALOGING-IN-PUBLICATION DATA
Mann, Judith Walker.
Federico Barocci : renaissance master of color and line / Judith W. Mann and Babette Bohn With Carol Plazzotta.
 pages cm
"Published in conjunction with an exhibition at the Saint Louis Art Museum, 21 October 2012 to 20 January 2013; and the National Gallery, London, 27 February to 19 May 2013."
Includes bibliographical references and index.
ISBN 978-0-300-17477-9 (hardcover : alk. paper)—ISBN 978-0-89178-096-0 (pbk. : alk. paper)
1. Barocci, Federigo, 1528–1612—Exhibitions. I. Bohn, Babette, 1950– II. Plazzotta, Carol. III. St. Louis Art Museum. IV. National Gallery (Great Britain) V. Title.
N6923.B286A4 2012
759.5—dc23

2012001538

A catalogue record for this book is available from the British Library.

The paper in this book meets the requirements of ANSI/NISO Z39.48-1992 (Permanence of Paper).

10 9 8 7 6 5 4 3 2 1

Front cover: *Entombment of Christ* (detail), cat. 8
Back cover: *Head of the Virgin Mary for the Annunciation*, cat. 9.6
Frontispiece: *Oil study for the head of Saint Joseph* (detail), cat. 10.10
Pages 70–71: *Last Supper* (detail), cat. 12

Contents

Lenders to the Exhibition

We extend our thanks to all those who have kindly and generously loaned their works to the exhibition.

Alnwick, Collection of the Duke of Northumberland, Alnwick Castle

Amsterdam, Rijksmuseum

Bayonne, Musée Bonnat-Helleu

Berlin, Kupferstichkabinett, Staatliche Museen zu Berlin

Besançon, Musée des Beaux-Arts et d'Archéologie

Budapest, Museum of Fine Arts

Chicago, The Art Institute of Chicago

Chicago, Goldman collection

Cambridge, MA, Harvard Art Museums/Fogg Museum

Cambridge, UK, The Fitzwilliam Museum

Chatsworth, Trustees of the Chatsworth Settlement

Copenhagen, Statens Museum for Kunst

Edinburgh, Scottish National Gallery

Florence, Istituti museale della Soprintendenza Speciale per il Polo Museale Fiorentino, Gabinetto Disegni e Stampe degli Uffizi

Florence, Istituti museale della Soprintendenza Speciale per il Polo Museale Fiorentino, Galleria degli Uffizi

Fossombrone, Pinacoteca Comunale "A. Vernarecci"

London, The British Museum

London, Embassy of Italy

London, The National Gallery

Los Angeles, J. Paul Getty Museum

Madrid, Museo Nacional del Prado

Milan, Veneranda Biblioteca Ambrosiana

New York, Hester Diamond

New York, The Metropolitan Museum of Art

Northampton, MA, Smith College Museum of Art

Oxford, The Ashmolean Museum of Art and Archaeology

Oxford, Christ Church Picture Gallery

Paris, Fondation Custodia, Collection Frits Lugt

Paris, Musée du Louvre, Département des Arts Graphiques

Pesaro, Biblioteca Oliveriana, Antaldi Collection

Rome, Bibliotheca Hertziana, Max Planck Institute for Art History

Rome, Chiesa Nuova FEC–Ministero dell'Interno, Direzione per l'Amministrazione del Fondo Edifici di Culto

Rome, Galleria Borghese

Rome, Santa Maria sopra Minerva FEC–Ministero dell'Interno, Direzione per l'Amministrazione del Fondo Edifici di Culto

Senigallia, Chiesa della Confraternita del Santissimo Sacramento e Croce

Senigallia, Pinacoteca Diocesana

Stockholm, Nationalmuseum

St. Petersburg, The State Hermitage Museum

Stuttgart, Staatsgalerie Stuttgart, Graphische Sammlung

Urbania, Biblioteca e Museo Civico

Urbino, Basilica Metropolitana di Maria Vergine Assunta, Cappella del Santissimo Sacramento

Urbino, Galleria Nazionale delle Marche

Vatican City, Vatican Museums

Vienna, Albertina

Vienna, Gemäldegalerie, Kunsthistorisches Museum

Washington, D.C., National Gallery of Art

Windsor Castle, The Royal Collection

Würzburg, Martin-von-Wagner-Museum der Universität Würzburg

Four private collections

Directors' Forewords

Although Federico Barocci's innovative and highly appealing prints are prized holdings in many American museum collections, his paintings and drawings are much less well represented. Indeed, there is only a single easel painting by Barocci in an American public collection (see cat. 17) and only a handful of drawings. In 2003, when Judith Mann, Curator of European Art to 1800 at the Saint Louis Art Museum, first expressed her wish to devote a major exhibition to the artist's paintings and drawings, it presented a wonderful opportunity to show Barocci's masterpieces of sumptuous color and refined composition in Saint Louis.

The sheer number of Barocci's drawings is daunting, with more than fifteen hundred attributed works in collections throughout Europe and the United States. The decision to focus on the artist's creative process, demonstrating how he utilized various studies in preparing his finished paintings, was based on the recognition that museum visitors have been especially interested in how great works of art are made. Barocci is an artist who left extensive documentation of the stages of his working process and the ideas that informed his pictures. The extant sheets were inspected firsthand in order to make a representative selection of drawings that demonstrated the highest quality and diversity of Barocci's oeuvre. Judith and Consulting Curator Babette Bohn traveled extensively, seeing almost all of Barocci's paintings and visiting more than fifty drawings collections and viewing over eighty-five percent of the attributed sheets. By 2011, they had refined their selection of paintings and drawings to the formal presentation that we are delighted to share in our galleries and in the pages of this catalogue.

Enlisting the National Gallery as a second venue for the exhibition was particularly fortunate. Nicholas Penny's personal enthusiasm for Barocci was a motivating factor in ensuring that the selection would be appreciated in the United Kingdom as well as in the United States. Carol Plazzotta, who shares her director's love of Barocci both as a painter and as a draftsman, followed in Judith's and Babette's footsteps through European print rooms, making many contributions to the final selection, deploying her diplomacy and experience in the negotiation of many loans, and contributing original research on the National Gallery's *Madonna del Gatto* (cat. 7; the only easel painting by Barocci in a British public collection) and its related drawings.

Brent R. Benjamin
Director, Saint Louis Art Museum

The Saint Louis Art Museum and the National Gallery are indebted to many generous and accommodating colleagues who made access to Barocci paintings and drawings possible. We had the early and very gracious support of the office of the Soprintendenza per il Patrimonio Storico, Artistico ed Etnoantropologico delle Marche in Urbino, beginning with an initial conversation with Paolo Dal Poggetto in 2003. His successors Lorenza Mochi Onori, Aldo Cicinelli, Vittoria Garibaldi, and Maria Rosaria Valazzi have all proven instrumental in helping us realize the project. Further, Rosaria together with Agnese Vastano must be thanked for their warmth and generosity during our many visits to Urbino. Equally important to the realization of our project was the enthusiastic and generous collaboration of Marzia Faietti, Director of the Gabinetto Disegni e Stampe degli Uffizi, Florence, the largest single repository of Barocci drawings. We were also extremely fortunate that the other significant Barocci drawing collection—that of the Kupferstichkabinett, Staatliche Museen zu Berlin—is overseen by such a distinguished and helpful colleague as Dr. Heinrich Schulze Altcappenberg, who has likewise been a key supporter of our endeavor.

The National Gallery would like to thank the Joseph F. McCrindle Foundation for an outstandingly generous grant toward the cost of mounting the exhibition in London and funding the position of curatorial assistant Virginia Napoleone.

Brent R. Benjamin
Director, Saint Louis Art Museum

Nicholas Penny
Director, The National Gallery, London

Acknowledgments

All exhibitions are the product of many people, but in the case of an artist as prolific as Federico Barocci, the cliché that "it takes a village" rings especially true. Particular thanks go to Alessandra Giannotti and Claudio Pizzorusso, who were kind and extremely generous colleagues while they, too, worked toward a Barocci exhibition. Thanks are due to Stuart Lingo, whose generosity and collegiality, not to mention innumerable insights, proved instrumental to our task. Thanks also to Jeffrey Fontana for his attentive eye and considered approach to Barocci's work, as well as to Ian Verstegen and John Marciari, who helped us in numerous ways in the course of preparing the exhibition. Suzanne Folds McCullagh deserves our gratitude for her help and thoughtful advice on several occasions. Claire Barry likewise played a pivotal role in helping us to appreciate Barocci's surfaces and technique, and her insights appear throughout this volume. Above all, Maria Rosaria Valazzi and Agnese Vastano were steadfast supporters and wonderful colleagues who made so much of our work possible, more efficient, and considerably more fun.

We want to express our gratitude to the late Harald Olsen, who provided the foundation upon which many scholars have built, and to Andrea Emiliani, whose contributions to Barocci scholarship are legion, and who was kind enough to meet with us and offer his advice. We are also indebted to the late Edmund P. Pillsbury and to Nicholas Turner for their considerable contributions to the ongoing study of Barocci's paintings and drawings. Finally, special thanks go to David Ekserdjian, whose observation in a 1987 review of Emiliani's catalogue raisonné provided the inspiration that helped form this project into an investigation of Barocci's process.

Judith Mann would particularly like to thank Keith Christiansen for his unflagging support and sage advice; Monsignor Alberto Bianco for some marvelous conversations that enlightened me in many unexpected ways; Saverio Ripa de Meana, whose patience and helpfulness set a high standard of collegiality; Pierre Rosenberg for pitching in when he was particularly needed; Giovanna Sapori for her extraordinary generosity and helpful insights; Rossella Vodret for her patient assistance and generosity; Julien Stock for his early assistance in tracking down some elusive names and locations; the marvelous library staff at the National Gallery of Art, Washington, D.C.; Bob Haboldt for his much-needed nudges of my memory; and Adam Williams for bringing the *Circumcision* oil study to my attention. I also had some inspiring conversations at various stages of the project with friends and colleagues that shaped my thinking in sometimes unexpected ways, and for that I would like to thank Luciano Arcangeli, Patrizia Cavazzini, Robert Randolf Coleman, Paul Crenshaw, David Franklin, Marco Grassi, Ian Kennedy, Riccardo Lattuada, Serena Padovani, Shelley Perlove, Wolfgang Prohaska, Francesco Solinas, John Varriano, Louis Waldman, and Phoebe Weil. Mark Weil must be singled out from this list, for he always challenges and inspires me, for which I cannot thank him enough. I am enormously grateful to the director of the Saint Louis Art Museum, Brent Benjamin, for his initial inquiry about what exhibition I would most like to do. His early enthusiasm and continued support for this project have been a gift that few curators are fortunate enough to receive. Babette Bohn deserves a special expression of gratitude. While I can take credit for having had the good sense to ask her to join me in this endeavor, I little realized the enormity of talent that she would bring to the exhibition, not just with her scholarship (which I already knew), but also with her managerial skills, her exacting standards, and her wise advice at every turn. Most of all, I appreciate her friendship and support. I would like also to remember the late Donald Garstang, with whom I had a memorable visit to David Scrase's 2006 Barocci exhibition. Finally, I want to thank my husband, David Konig, who has always provided a shining example of intellectual excellence. His loving support and generosity of spirit inform everything I do.

Babette Bohn would like to thank Judith Mann, who invited my collaboration on this project. It was Judith's vision that launched the exhibition and her persistence in the face of many obstacles that made it possible. In addition, I am deeply grateful for having had the opportunity to work at the Villa I Tatti, the Harvard Center for Italian Renaissance Studies, where I spent a semester as Lila Wallace–Reader's Digest Visiting Professor in 2010. My thanks to everyone at I Tatti, in particular Joseph Connors and Louis Waldman, for their considerable contributions to my work. Elisabetta Cunsolo, Angela Dressen, Scott Palmer, and Michael Rocke were all invaluable to me at the I Tatti library. At I Tatti, I also benefited from interactions with many extraordinary colleagues, including Duncan Bull, Christopher Carlsmith, Serena Ferente, Kate Lowe, Carlo Taviani, and especially Donal Cooper, Francesca Fiorani, and Robert La France, whose research interests overlapped with my own. I was also the beneficiary of several research grants from Texas Christian University; I would like to thank my provost, Nowell Donovan; my dean, Scott Sullivan; and my chair, Ronald Watson, for their unflagging support of my work. I spent many months studying Barocci drawings at the Uffizi, where I was privileged to benefit from the insights of generous

fellow scholars in the *sala di studio,* in particular Miles Chappell, Catherine Monbeig Goguel, and Annamaria Petrioli Tofani. David Ekserdjian generously shared an early draft of his essay on Barocci's *Madonna del Popolo* with me, to my considerable benefit. My good friends Mauro Carboni and Robert Randolf Coleman both provided astute assistance with some perplexing patronage research. Elena Fumagalli and Raffaella Morselli were helpful in countless ways with many obstacles, large and small. John and Michele Spike were unstintingly generous with professional advice and delightful dinners during my stays in Florence. Among my many friends and colleagues in the United States who were helpful, Claire Barry, Jane Burka, Elena Ciletti, Linda Hughes, Shelley Perlove, James Saslow, Mary Vaccaro, and Malcolm Warner deserve special mention. Finally, as always, my greatest debt of thanks goes to my husband, Daniel De Wilde, for his understanding, advice, and love.

Both Babette Bohn and Judith Mann would like to express their gratitude to Carol Plazzotta, our London collaborator in this venture, who has been an extraordinary colleague in every way. An enterprising problem solver, astute critic, energetic traveler, and sensitive viewer, she has contributed in countless ways to both the exhibition and the catalogue.

In return, Carol Plazzotta would like to thank Judith Mann for her initial invitation to collaborate on such an appealing project, giving me the opportunity to resume my beloved Urbinate studies and to pursue my interest in the creative process revealed in preparatory drawings for paintings. Judith and Babette have been a dream team in terms of exhibition collaboration: intelligent, efficient, fiendishly hard working, and by now wonderful friends. My director, Nicholas Penny, had the vision to support the exhibition project in London. Heartfelt thanks are due to my fellow curators of Italian paintings at the National Gallery, Dawson Carr and Luke Syson, as well as to Assistant Curator Jennifer Sliwka, for covering my daily curatorial duties during my absence to work on this project. Virginia Napoleone, McCrindle Curatorial Assistant with special responsibility for this exhibition, arrived too late to assist with the catalogue but has been a key collaborator in the practicalities of mounting the exhibition, compiling the dossier, and investigating feline iconography. In the Exhibitions Department, Miranda Stacey, Elizabeth Johnson, and above all Francesca Sidhu have played a crucial role. Eloise Stewart was our seamlessly efficient registrar. The exhibition was designed with inimitable elegance by Alan Farlie. In addition, I would like to thank Nicholas Penny, David Ekserdjian, Caroline Elam, and Louise Rice for reading my contribution and making many insightful comments. In terms of research in the archives, libraries, and monuments of Urbino, Urbania, and Piobbico, I received invaluable advice and help from Bonita Cleri, Marina Conti, Robert La France, Federico Marcucci, and Feliciano Paoli. Maria Rosaria Valazzi and Agnese Vastano deserve a personal thank you for being such exemplary colleagues, as they were during the National Gallery's Raphael exhibition of 2004.

Viewing more than a thousand drawings and forty paintings required the cooperation and work of many colleagues and collectors. In the course of our travels, we incurred countless debts and were overwhelmed by the generosity and goodwill extended to us as we went about our toils. We want to express our particular gratitude to Marzia Faietti and Giorgio Marini at the Uffizi in Florence and to Heinrich Schulze Altcappenberg and Dagmar Korbacher at the Kupferstichkabinett in Berlin. Several others offered particularly timely and generous contributions to our endeavors, including Joseph Baillio, Jean-Luc Baroni, Raffaella Morselli, Eliot Rowlands, and David Scrase.

For the help we received throughout Europe and the United States, we wish to thank the following: at Alnwick Castle, Lisa Little; in Amsterdam, Taco Dibbits and Marja Stijkel; in Bayonne, Sophie Harent, Aurélia Botella, and Vincent Ducourau; in Besançon, Nicole Baladou, Ghislaine Courtet, Caleb Eckhardt, and Françoise Souliers-François; in Bologna, Pierangelo Bellettini and Carla Bernardini; in Brussels, Joost Vander Auwera; in Budapest, Zoltán Kárpáti; in Cambridge, MA, Marjorie Cohn and Stephan Wolohojian; in Cambridge, UK, David Scrase; in Chantilly, Nicole Garnier; at Chatsworth, Charles Noble; in Chicago, Anne Bent, Jean Goldman, and Suzanne Folds McCullagh; in Copenhagen, Hannah Heilmann, Eva de la Fuente Pedersen, and Miriam Have Watts; in Detroit, Hope Saska; in Edinburgh, Christopher Baker, Valerie Hunter, and Aidan Weston-Lewis; in Florence, Antonio Natali, Lucia Monaci Moran, Massimo Pivetti, and Patrizia Tarchi; in Fossombrone, Laura Picchi, Serena Racche, and Elisabetta Romitti; in Frankfurt, Martin Sonnabend; in Genoa, Piero Boccardo; in Haarlem, Michiel Plomp; in The Hague, Marten Loonstra; in Lille, Cordélia Hattorie; in Los Angeles, Julian Brooks, Lee Hendrix, and Nancy Yocco; in London, Jean-Luc Baroni, Stephanie Buck, Hugo Chapman, Christopher Kingzett, Sarah Murray, Gabriel Naughton, Nicholas Penny, and Cristiana Romalli; in Madrid, Miguel Falomir, Gabriele Finaldi, Almudena Pérez de Tudela Gabaldón, and Manuel Terrón Bermúdez; in Milan, Monsignor Francesco Braschi, Simona Brusa, Matteo Ceriana, Emmanuela Daffra, Monsignor Marco Navoni, Carlo Orsi, and Monsignor Cesare Pasini; in Munich, Cornelia Syre and Kurt Zeitler; in New Haven, Suzanne Boorsch; in New York, Carmen Bambach, Lisa Cane, Caitlin Corrigan, Hester Diamond, George Goldner, and Jon Landau; in Northampton, Aprile Gallant; in Oxford, Colin Harrison, Jacqueline Thalmann, Catherine Whistler, and Jon Whiteley; in Paris, Emmanuelle Brugerolles, Eveline Deneer, Stéphane Loire, and Carel van Tuyll van Serooskerken; in Perugia, Francesca Abbozzo, Dario Cimorelli, Vittoria Garibaldi, Marco Goldin, Francesco Mancini, and Monsignor

Giovanni Tiacci; in Pesaro, Marcello Di Bella; in Piobbico, Elisa Alessandroni and Lino Pagliardini; in Princeton, Laura Giles and Catheryn Goodwin; in Rome, Kristina Herrmann-Fiore, Julian Kliemann, Cardinal Cormac Murphy-O'Connor, Ugo Righini, Stefania Santini, and Claudio Strinati; in Rotterdam, Albert Elen and Sandra Tatsakis; in Senigallia, Alessandro Berluti, Michele Caiazzo, and Bishop Giuseppe Orlandoni; in Stockholm, Martin Olin, Susanne von Plenker-Tind, and Karin Wretstrand; in St. Petersburg, Irina Grigorieva, Tatyana Nerush, and Catherine Phillips; in Strasbourg, Dominique Jacquot; in Stuttgart, Corinna Höper and Hans-Martin Kaulbach; in Turin, Maurizio Fallace; in Urbania, Anita Guerra and Feliciano Paoli; in Urbino, Sara Bartolucci, Gabriele Barucca, Claudia Caldari, Marina Conti, Alessandro Marchi, Benedetta Montevecchi, and Monsignor Davide Tonti; at the Vatican, Isabella di Montezemolo, Arnold Nesselrath, and Paola Spalvieri; in Venice, Annalisa Perissa; in Vienna, Veronika Birke, Barbara Dossi, Sylvia Ferino-Pagden, Margarete Heck, and Susanne Hehenberger; in Washington, D.C., Margaret Morgan Grasselli, Gretchen Hirschauer, and Gregory Jecman; in Weimar, Ernst-Gerhard Güse; at Windsor Castle, Martin Clayton and Lady Jane Roberts; and in Würzburg, Tilman Kossatz.

We also wish to thank the museums that loaned to the show, particularly their directors and board committees, whose willingness to part with their treasures was absolutely vital to our enterprise and is enormously appreciated. Thanks go to Dott.ssa Cristina Acidini (Soprintendente Speciale per il Polo Museale Fiorentino), Dr. László Baán (Museum of Fine Arts, Budapest), Dott. Andrea Bianchini (Biblioteca e Museo Civico, Urbania), Dr. David Bomford (J. Paul Getty Museum, Los Angeles), Dr. Christopher Brown (The Ashmolean Museum of Art and Archaeology, Oxford), Monsignor Franco Buzzi (Veneranda Biblioteca Ambrosiana, Milan), Dr. Thomas Campbell (The Metropolitan Museum of Art, New York), Dott.ssa Antonella Cesarini (Pinacoteca Comunale "A. Vernarecci," Fossombrone), Dr. Michael Clarke (Scottish National Gallery, Edinburgh), Dott.ssa Anna Coliva (Galleria Borghese, Rome), Dott. Marcello Di Bella (Biblioteca Oliveriana, Pesaro), Douglas Druick (The Art Institute of Chicago), Dr. Emmanuel Guigon (Musée des Beaux-Arts et d'Archéologie, Besançon), Dr. Sabine Haag (Kunsthistorisches Museum, Vienna), Dr. Sophie Harent (Musée Bonnat-Helleu, Bayonne), Dr. Matthew Hirst (Chatsworth), Dr. John Leighton (Scottish National Gallery, Edinburgh), Dr. Thomas W. Lentz (Harvard Art Museums/Fogg Museum, Cambridge, MA), Dr. Henri Loyrette (Musée du Louvre, Paris), Dr. Ger Luijten (Fondation Custodia, Paris), Neil MacGregor (The British Museum, London), Jonathan Marsden (The Royal Collection, Windsor Castle), Dott. Antonio Natali (Galleria degli Uffizi, Florence), Dr. Jessica Nicoll (Smith College Museum of Art, Northampton, MA), Dr. Karsten Ohrt (Statens Museum for Kunst, Copenhagen), Dott. Antonio Paolucci (Vatican Museums), Monsignor Pier Domenico Pasquini (Diocesi di Senigallia), Dr. Mikhail Borisovich Piotrovsky (The State Hermitage Museum, St. Petersburg), Dr. Wim Pijbes (Rijksmuseum, Amsterdam), Dr. Timothy Potts (The Fitzwilliam Museum, Cambridge, UK), Dr. Earl Powell III (National Gallery of Art, Washington, D.C.), Dr. Sean Rainbird (Staatsgalerie, Stuttgart), Prof. Dr. Sybille Ebert-Schifferer (Bibliotheca Hertziana, Max Planck Institute for Art History, Rome), Dr. Klaus Albrecht Schröder (Albertina, Vienna), Prof. Solfrid Söderlind (Nationalmuseum, Stockholm), Dr. Jacqueline Thalmann (Christ Church Picture Gallery, Oxford), and Dr. Miguel Zugaza (Museo Nacional del Prado, Madrid). We offer our special thanks to His Excellency the Italian Ambassador to the United Kingdom, Alain Giorgio Maria Economides, and his predecessor, Giancarlo Aragona.

We especially extend our gratitude to the private collectors who have been willing to be without their prized Baroccis so that we could mount our show. We offer our heartfelt thanks to Hester Diamond, Steven and Jean Goldman, Jon Landau, His Grace the Duke of Devonshire, His Grace the Duke of Northumberland, and those collectors who wish to remain anonymous.

At the Saint Louis Art Museum, we wish to thank Jon Cournoyer and Nick Smith, whose enormous creativity always makes our projects better; Philip Atkinson, whose diligence at reworking our design and whose mastery of lighting have greatly benefited the exhibition; Jennifer Stoffel, Abigail Frohne, Whitney Manning, and Bryan Wiebeck for their early attention to the marketing of the show and generally great ideas; Jeanette Fausz, our registrar, who has managed a huge portion of this project, including a very complicated database, with her usual energy and high standards; Linda Thomas for her support, sense of humor, and timely advice throughout, often conveyed via e-mail at late hours; Jeanne Rosen, whose assistance has been instrumental throughout this long project, managing some very complicated travel schedules and budgets, yet maintaining an unflagging cheerfulness in the face of difficult deadlines and a grumpy boss; Ella Rothgangel, Jason Gray, and Rachel Swiston, who negotiated the complicated territory of photo requests with dedication and resourcefulness; Bryan Young and Clare Vasquez for their diligence, wizardry, and unflagging good cheer in obtaining for us the many, many volumes of books that we required; Cathryn Gowan, who, as she scanned image after image, realized perhaps more than anyone else the breadth of Barocci's production; Brigid Flynn and Steve Schenkenberg for their considered handling of our grant proposals; Molly Perse, whose steadfast attention to detail and mastery of many charts and documents prevented more than one serious mistake; Paul Haner for attending to the careful inspection and preparation of our conservation notebook; Ann Burroughs, Bill Appleton, and Sabrena Nelson for their creative insights and hard work on the varied programming and interpretation developed

for this exhibition; Laura Gorman, who has been an exemplary colleague, a much-needed sounding board, and a treasured friend throughout the project; and finally, although he is no longer at the Saint Louis Art Museum, Andrew Walker, who was a pillar of support from the earliest days of this exhibition and contributed to its success in ways too numerable to mention. We also must acknowledge with genuine pleasure and profound gratitude our manuscript editor, Benedicte Gilman, whose extraordinary efforts, kindness, and dedication are very much appreciated. Mary Ann Steiner, former longtime editor at the Saint Louis Art Museum, contributed her wisdom and experience in catalogue publishing at an early stage in the project. We also wish to thank the Saint Louis Art Museum's publishing consultant, Susan F. Rossen, and Patricia Fidler and her colleagues at Yale University Press, including Sarah Henry and Kate Zanzucchi, for their commitment to shaping this book to such a high standard. Linda Truilo and Susan Weidemeyer Davidson proofread the book, Kathleen Friello created the index, and Rita Jules, Miko McGinty Inc., provided the book's elegant design.

Finally, we want to acknowledge the important work that was done by our many museum and university interns, who brought their extraordinary energy and contagious enthusiasm to the project, including Maggie Abbott, Carole Anderson, Kelly Fenton, Marion Grillon, Emily Hanson, Samantha James, Ellen Ladwig, Nicole Leist, Priya Menzies, Andrea Miller, Annette Myers, Emily Olsen, Benjamin Ory, Laura Fenley Patrizi, Sarah Pitt, and Elizabeth Plaster. Among the most important individuals to assist on this exhibition have been our research assistants. Theresa Huntsman and Melissa Benne did some of the formidable work early on in tracking down drawings, collections, and the all-important images. Jessika Miekeley helped us for a short but very productive time. She was succeeded by Erika TenEyck, whose considerable organizational skills brought order and needed clarity to many of our lists and files. Finally, we want to thank Chris Naffziger, who over the past four years has been the heart of the project, performing a wide range of tasks with skill and good cheer while he was shouldering a heavy burden and working for way too many taskmasters.

Judith W. Mann
Babette Bohn
Carol Plazzotta

Notes to Readers and Abbreviations

NOTES TO READERS

In dimensions, height precedes width.

Provenance information is provided only for exhibited paintings.

Unless otherwise indicated, all reproduced works are by Federico Barocci.

Tempera versus distemper: Although many modern sources identify the medium of Barocci's *Stigmatization of Saint Francis* in Fossombrone and *Rest on the Return from Egypt* in Piobbico as *tempera,* we have identified the medium of these two works as *distemper.* Giovanni Pietro Bellori used the word *guazzo,* which can be translated as either pigment in animal glue (distemper) or watercolor in gum arabic (gouache). Based on visual examination of both pictures, we believe that the binding agent for the pigments is animal glue. For the medium Bellori identified as *guazzo* in connection with Barocci's *cartoncini,* we have retained the traditional translation of the term as *gouache.*

ABBREVIATIONS

bib.	bibliography
c.	*carta/-e* (folio/-s, in an Italian manuscript)
ca.	circa
cat.	catalogue number
C.E.	Common Era
chap./chaps.	chapter/-s
cm	centimeters
comp.	compiled by
d.	died
diss.	dissertation
doc./docs.	document/-s
ed./eds.	editor/edited by/editors
edn.	edition
e.g.	for example
esp.	especially
exh. cat.	exhibition catalogue
f./ff.	(and) following (page[-s])
fasc.	fascicule
fig./figs.	figure/-s
fol./fols.	folio/-s
ill./ills.	illustration/-s
in.	inches
intro.	introduction (by)
inv.	inventory number
MS	manuscript
n./nn.	note/-s
no./nos.	number/-s
n.p.	no place (of publication)
p./pp.	page/-s
pl./pls.	plate/-s
r.	ruled
rev.	revised (by)
trans.	translator/translated by/translation

Glossary

bozzetto/-i Rough, preliminary sketch(es) for a work of art

calco Method of transferring a drawing involving the use of a sharp instrument, usually a stylus, to incise the design onto another surface

cangiante Literally, "changing." A method of modeling fabric, where changes in color create highlights and middle tones. For example, orange fabric may have pale yellow highlights and purple shadows

cartoncino/-i Finished drawing(s) for a painting, including all details, in a smaller format than that of the final painting

cartoncino per i colori Smaller finished drawing for a painting with all color details worked out

cartoncino per il chiaroscuro Smaller finished drawing for a painting with light and shadow worked out

cartoon Full-size, finished drawing made in preparation for a painting or fresco that can be transferred directly onto a painting support

counterproof Contact impression (in reverse) taken from a freshly inked print in order to check the appearance of the engraved plate

distemper Ground color suspended in animal glue and applied to panel or canvas

garzone Young male helper or apprentice in an artist's workshop

gouache Opaque color mixed in water with a gum preparation (gum arabic); a painting or drawing made with such color

impasto Paint thickly applied to a canvas or panel

laid down Term describing a drawing that has been affixed to another sheet of paper, board, or fabric so that only one side is viewable

lake Transparent or semitransparent organic pigment made from natural dyes

modello/-i Drawing(s) made to give an idea of a finished composition, often for presentation to a patron

pastel Ground color mixed with a binder, forming a stick; a picture made with pastel

pentimento/-i Revision(s); early ideas in a painting or drawing subsequently revised by an artist. In paintings, these can be seen when the paint covering them becomes transparent with age, or with the aid of infrared reflectography

predella Originally a term describing a step or platform on which an altarpiece rested. It now refers to the small, usually horizontal pictures below the main field of a Renaissance altarpiece

primo pensiero/primi pensieri First sketch(es) or initial idea(s) for a composition

profil perdu Literally, "lost profile." Head seen in three-quarter view from behind so that the profile is lost

red lake *See* lake

ricordo/-i Literally, "memory." Hence, a copy of a drawing or painting made as a record of the original work

sfumato Literally, "fading like smoke." The technique of subtly blending colors and tones in order to define forms without sharp outlines and to obtain delicate gradations from light to shadow

smalt Blue pigment composed of glass colored with cobalt oxide that usually darkens with age

spolvero Also called pouncing. A process whereby the contours of a drawing are pricked with a needle. A dotted outline is created by forcing fine chalk or charcoal dust through these holes onto the painting support

squared/squaring System used to transfer a composition to another surface that can also allow an enlargement or reduction in size. Lines forming a grid are drawn over a composition. The transfer is done by copying the image within each square of the grid, making scale adjustments as necessary

stopping out Technique allowing differentiation in the depths of etched lines by covering part of an etched plate with varnish to prevent the covered lines from being eaten any further by the acid. Lines that have been bitten more deeply by the acid print as darker lines, while shallower grooves appear lighter

stump/stumping Rubbing the pencil or chalk lines of a drawing to achieve shading and color gradations

tempera Colors bound in a medium, usually other than oil, for example, egg yolk (usual in earlier periods), glue size, or gum arabic; hence, a picture painted in tempera

vanishing point The point within a composition's perspective system where the receding parallel lines converge

A Tribute to the Homeland
Barocci and Urbino

ANDREA EMILIANI

Born in 1535 in Urbino, in the heartland of the Montefeltro, Federico Barocci was twenty-five years old when he painted the frescoes of the Casino of Pius IV in the Vatican gardens. A few years later, in 1563, he abandoned the prestigious building site, perhaps on account of illness.

Back in his hometown, where he was probably able to maintain a less stressful work/life balance, Barocci found artistic inspiration in "Christian cheerfulness," a concept shared by a group of ecclesiastics, from Charles Borromeo to Philip Neri, that had formed a so-called low church. Their private adherence to a newfound religiosity, which was gradually translated into Church precepts by the Catholic Reformation, fueled the artist's imagination with engaging human and popular models from both devout and intellectual spheres.

By now, the ducal palace in Urbino (fig. 1) had been deserted, for the center of Della Rovere power had long since been transferred to Pesaro. Barocci nevertheless continued to set his gospel narratives in Urbino in such a way as to give the city a fully religious character. This was its secret identity, yet at the same time plain for all to see, for Urbino features in his oeuvre, from work to work, as if through long autobiographical observation. On the other hand, the evocation of the city is made up of a series of landscapes that frame and accompany the life portrayed within them. With its powerful, harmonious mass, Duke Federico's palace was, and still is, an exemplary model of humanistic form. From the window of his house in the via San Giovanni, Barocci could see its towers and well-proportioned walls, from luminous dawn to melancholic dusk. The palace was transformed from a building into a historical emblem, a tribute to Barocci's homeland. Urbino's political and human drama is tied up in the image of that ancient beauty.

In his daily calvary, the painter succeeded in transfiguring the sites of the city into "stations of the cross," also influenced by an effective, and deeply inspiring, Franciscan Renaissance. However, this personal interpretation of Urbino as a site of suffering was not the result of estrangement, such as El Greco clearly felt in Toledo. On the contrary, Barocci's Urbino represented the painter's complete identification with his city. His days were transformed into a Franciscan "christology," which he lived through daily experience; the local landscapes, which he invested with mournful Passions, were for decades the framework within which he played out his own existential drama, as well as his artistic redemption.

Barocci's solitary working practice was surrounded by grand architectural scenography. In that landscape, his feelings gradually matured to reflect the age in which he lived, an age that represented the twilight of a humanist community in one of the most sublime Italian cities of the Renaissance.

Barocci's house was halfway along a narrow street leading to the Oratorio di San Giovanni and less than a hundred meters from the church of San Francesco, where he was buried in 1612. There he lived, stoically bearing physical suffering, in neighborly community with peasants and scholars, mathematicians and technicians (including his brother Simone, who was a builder of scientific instruments, automatons, and clocks), and also with many cats.

Long before the Della Rovere dukes had established themselves in the Villa Imperiale in Pesaro, the Urbinate cultural tradition had been established and immortalized by Duke Federico I da Montefeltro, who died in 1482. The following year, Raphael was born in a house steps away from the one Barocci would inhabit. Raphael, too, felt an intellectual and emotional bond with Urbino, despite living far away for most of his adult life.

Another example of enduring devotion to the city from a distance was the intellectual courtier and diplomat Baldassare Castiglione, who lived in Rome from 1512 to 1519. His refined humanism eventually inspired the Neo-Platonism of Raphael, who at the time was decorating the Vatican *stanze*. Perhaps somewhat earlier, Castiglione had written *The Courtier,* a treatise conceived as a memoir on the subject of the ideal courtier. Published by Aldo Manuzio in 1528, just before the author's death, it was the literary bestseller of the century.

The architectural landscape of Urbino is thus that of a Celestial Jerusalem. The city appears on the crest of an imaginary Calvary, the towers that greet travelers on the road from Tuscany standing as the public face of the massive structure of the palace behind. Reminders of the rule of the Montefeltro are everywhere,

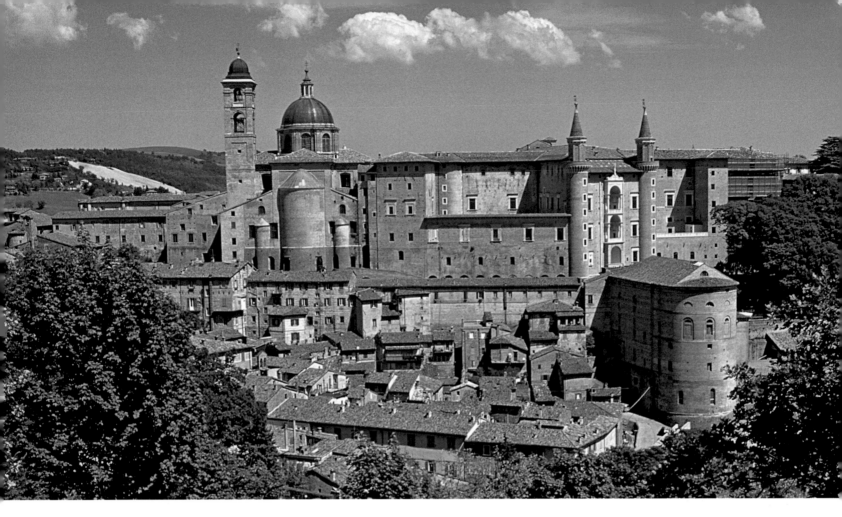

Fig. 1. View of Urbino from the west, showing the dome and tower of the Cathedral on the left and the two-towered facade of the Ducal Palace on the right.

both in the city and in Barocci's works, as in the "joyful" epiphany of his *Annunciation* (cat. 9), originally located in the sanctuary at Loreto.

The entire Urbinate landscape was recruited in Barocci's art to bear witness to the drama of the Passion, especially in the *Crucifixion*s of Urbino (Bonarelli, cat. 2), Genoa (Senarega, fig. 16), and Madrid (Prado, fig. 18). In these paintings, the frontal perspective of the palace recedes, and the towers start to disappear from sight. This view, from Barocci's own window, is a symbol of immense beauty, reflecting the artist's own human condition.

The landscapes of the *Crucifixion*s are, in fact, Urbino seen as a mirage of Calvary. As shadow falls across its towers, light lingers on the silhouette of the mountains before fading away. At night, under the chimney tops of the houses of via Valbona, people light their domestic fires, which send smoke up into the nocturnal mist. The painter's nostalgia induced his prolonged observation of roofs wet with rain.

Other locations in the "city in the form of a palace" (as the historian Bernardino Baldi defined it in 1590), such as the steps up its steep flanks and the main courtyard inside the ducal palace itself, also play host to holy narratives.

The materials an artist uses can become exalted through the employment of an alluring palette. A century later, both Rosalba Carriera and Jean-Antoine Watteau, while guests at the home of the collector and connoisseur Pierre Crozat in Paris, admired the quality of Barocci's draftsmanship. Over his entire life, through his persistent attention to the world in his drawing, Barocci reached perfection in painting.

Barocci's particular sensitivity was perhaps inherited from his ancestor Ambrogio, who was an expert stonecutter from Lombardy. In Barocci's work, both creative spheres—the technical and the artistic—became irrevocably fused in his pursuit of the perfection of beauty, in pursuit of that spiritual vision that Anton Raphael Mengs saw appearing in diaphanous form on the top of a fog-covered mountain. Most of Barocci's unstinting efforts were employed in translating—both in drawing and in color—the deep sense of sweet certainty inherent in reality. Ultimately, all the artistic and mechanical resources available to him enabled him to fine-tune his unique artifice, allowing him to make the intangible concrete. And even beyond his technical and visual achievement, one must acknowledge Barocci's ineffable poetry.*

* Translated from the Italian by Annelise M. Brody.

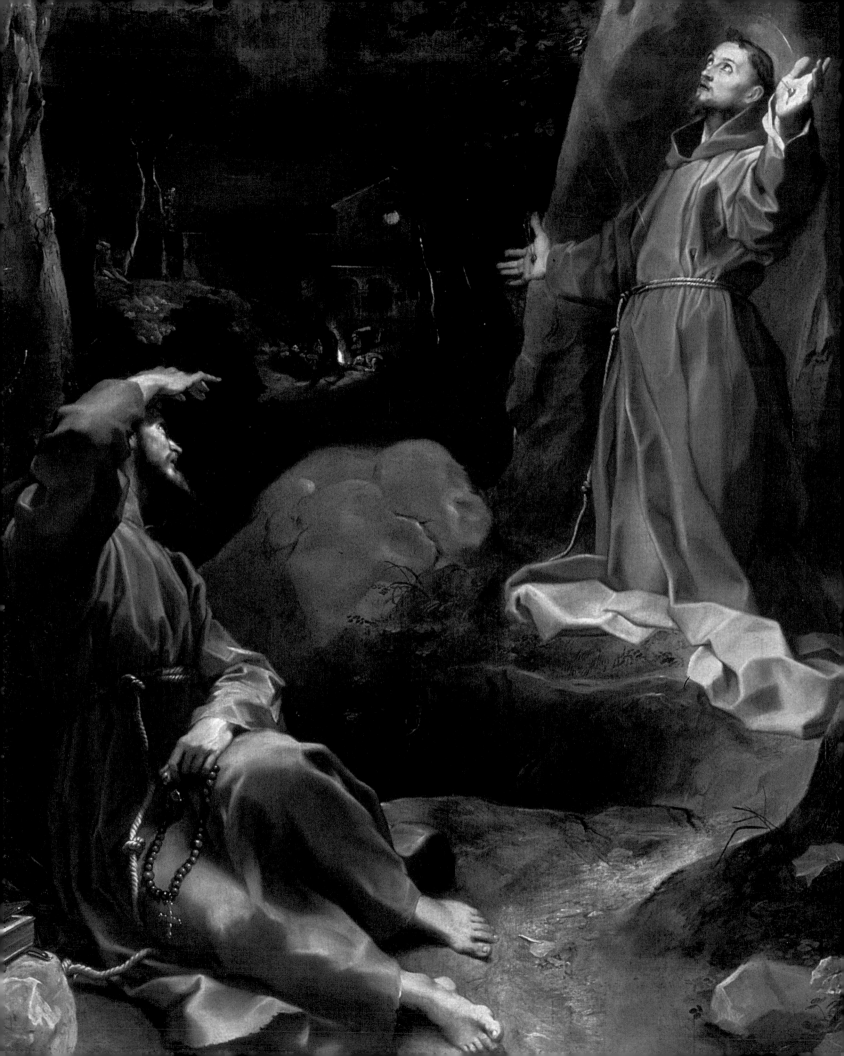

Innovation and Inspiration
An Introduction to Federico Barocci

JUDITH W. MANN

Federico Barocci was an original, distinguishing himself in an age of innovative painters, sculptors, and printmakers. Traditionally, art historians have included Barocci in accounts of late sixteenth-century Italian painting as the influential precursor to the Baroque age, mentioned in such works as Rudolf Wittkower's authoritative survey of Italian art of the seventeenth century.[1] As more attention has turned to Italian art made in the years after Michelangelo, a number of artists, including Barocci, have received greater scrutiny, offering a better understanding of this critical period between Mannerism and the budding Baroque style of the early seventeenth century. During the past five years, the appearance of a revised catalogue raisonné, two significant monographs, and a 2009 exhibition have helped to elucidate Barocci's stylistic origins, his enormous influence, his preparatory process, and the theoretical basis for his art.[2]

It is not the intent of this essay to duplicate what has already been written. Rather, the motivation that prompted the exhibition that occasioned this book—beyond simply a long-cultivated appreciation of the beauty of Barocci's art—was the recognition that Barocci always offered something new. Although he usually trod well-worn ground in the subjects he painted, he rarely kept within the established traditions and usually provided novel pictorial and iconographic insights into the narratives and the portrait subjects he painted. The exhibition was necessarily limited to less than two dozen paintings in order to facilitate in-depth study of the artist's working procedure for each of the selected works. A full appreciation of Barocci's innovation is best achieved by exam-

ining a larger sample of his artistic output. The goal, therefore, is to offer art historians and art lovers alike a good overview of Barocci's approach to narrative painting, tracing his original voice as it emerged over the span of his entire career.

Students of Barocci are fortunate in having a relatively early biography of the painter (published 1672), which, although not accurate in every detail, provides a useful framework for understanding the artist's work. The writer was Giovanni Pietro Bellori, best known as a theorist and adherent of a classically based artistic style, although he was also an antiquarian of exceptional knowledge and a noted numismatist.[3] He included Barocci's life among twelve biographies that he compiled of sixteenth- and seventeenth-century artists and one architect. Bellori's account forms the basis for any discussion of the artist's life. The biography has been translated and is available in three English versions, making it readily accessible to modern readers.[4] Therefore, only a basic framework of relevant biographical information is provided here.

Barocci's birthdate is generally given as 1535, although he may have been born as early as 1533; three independent sources all suggest the earlier date, but it has yet to be confirmed or cited in much of the Barocci literature.[5] He grew up in the northeastern Italian town of Urbino, the son of a watchmaker and gem and relief carver, who, Bellori related, began Federico's artistic training by teaching him how to draw. By the 1530s, Urbino was no longer the court it had been in the fifteenth century under Duke Federico da Montefeltro (1422–1482). He built the ducal palace in Urbino (designed by Luciano Laurana, it was one of the glories of

fifteenth-century architecture) and filled it with paintings and furnishings nearly unrivaled elsewhere in Italy. The roster of worthies in the arts and sciences either in residence at the court or visiting there indicates that it was one of the most flourishing cultural centers of its day. Such was the prestige of the Montefeltro court that it was the setting for Baldassare Castiglione's *The Courtier* (published 1528), a treatise on the proper comportment of a Renaissance citizen/warrior.

Federico's son Guidubaldo had no heir, so in 1504 he adopted his nephew Francesco Maria I della Rovere, the grandfather of Barocci's friend and patron Francesco Maria II. By the time the Della Rovere assumed control of the duchy, their interest had turned from Urbino to the coastal town of Pesaro. There they amassed a considerable art collection, particularly rich in examples of Titian's work.

Barocci undoubtedly came under the influence of a number of painters during his early years. He would unquestionably have had exposure to the work of Raphael, for some of the master's works could be seen in Urbino and nearby Pesaro. Bellori specified that both Francesco Menzocchi of Forlì and Battista Franco of Venice exerted influence on him as well. At a young age, Barocci was probably voracious in his artistic appetites, and it is likely that he studied everything and anything available to him.

Based on the information Bellori provided, it seems that Barocci moved to Pesaro in the 1540s and presumably lived there until he turned twenty. Bellori stated that when Battista Franco left Urbino, Barocci moved to Pesaro to live with his uncle (actually a cousin), the architect Bartolomeo Genga, who was involved in some of the renovation and expansion work on the various Della Rovere palaces in that coastal city.[6] It is reasonable to assume that it was during this time, when he was in his late teens, that Barocci had prolonged firsthand experience of the ducal collections, having already primed himself by copying figures with Franco, making drawings after available prints, and studying antique casts.[7] In Pesaro he would have had perhaps his first extensive experience with Titian's canvases, including the famous *Venus of Urbino,* as well as sixteen others.[8] As John Shearman pointed out years ago, we have to assume that Barocci looked at and remembered everything, and that he most likely responded with equal enthusiasm to other artists contained within the collection, such as Piero della Francesca, Pedro Berruguete, and Justus of Ghent.

It may have been at this time that Barocci painted one of his earliest pictures, the *Portrait of Antonio Galli* (fig. 2). The work has been attributed both to Titian and to Barocci. However, because the rooster clock finial identifies the sitter (*galli* means roosters in Italian), and because Bellori stated specifically that Barocci painted a portrait of Galli, many writers have accepted Barocci's authorship of the picture. It rightly belongs within his oeuvre.[9]

The painting is a firm testament to his early study of Titian and his adaptation of the latter's pictorial formats and style. Barocci placed Galli facing a table, rather than fully before it, giving the sitter a less aggressive stance than that typically found in Titian's portraits. Also characteristic of Barocci is Galli's sensitive gesture rather than the more forceful masculine hand position Titian often favored. Galli appears to have been either reading or in prayer; with his left hand he marks the pages of a book, presumably planning to resume his study once the portrait session is completed. We know that Barocci created at least one replica of Titian's work; such a painting is listed in the Della Rovere collection when, after the death of Francesco Maria II in 1631, everything was shipped to Florence, including "a Madonna, the child and two angels, copied by Barocci after an original by Titian."[10] Titian's influence on Barocci proved profound throughout his working life. He turned to the older artist's models to prepare individual paintings, occasionally adopting Titian's brushier paint application and resonant, rich coloration.

Bellori stated that at the age of twenty, Barocci made the first of two visits to Rome. Scholars have debated whether Bellori's account is correct, for there is documentary evidence to support only one Roman trip, between 1560 and 1563, when Barocci participated in a papal commission.[11] The earlier trip would have dated to the mid-1550s if Bellori was correct about Federico's age. This date makes sense, especially in light of a Roman trip made by another artist who had worked in Urbino in the early 1550s, Taddeo Zuccaro, who traveled to Rome in April 1553, as did Duke Guidubaldo himself. It is worth considering that Barocci may have traveled with them.[12] The fact that Bellori mentioned Taddeo in a famous anecdote that the biographer ascribed to Barocci's first Roman residence lends credence to his account.[13] If Barocci's birth date of 1533 proves correct, the dates line up and support the earlier Roman trip, which, as Andrea Emiliani suggested, was probably dedicated to study.

Barocci's earliest surviving religious painting, done after he returned from Rome, gives little hint of the artist he would ultimately become.[14] Completed in 1556, the *Saint Cecilia with Saints* (fig. 42) appears to be little more than a variation on Raphael's famous painting. It currently adorns an altar in Urbino cathedral, but Peter Gillgren recently argued that it was designed as an organ decoration, an explanation that satisfactorily accounts for its relatively small size and the absence of choral music, which was integral to Raphael's conception. Barocci probably used Marcantonio Raimondi's well-known print (fig. 43).[15] The picture reads almost as a demonstration piece for the painter, aware of his artistic forebear Raphael, as well as the format of the famous print. It is by far the most conservative of all Barocci's paintings, a combination of his immaturity as an artist and maybe a stipulation by the patron that the picture adhere closely to the recommended

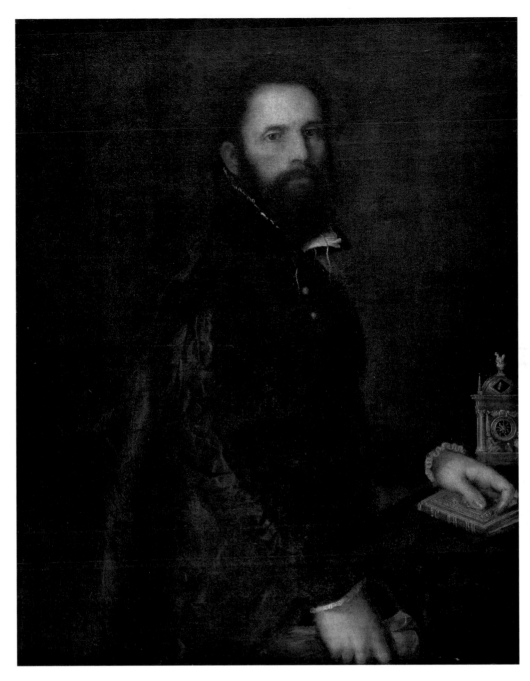

Fig. 2. *Portrait of Antonio Galli*, 1552–53? Oil on canvas, 108 x 84 cm.
Statens Museum for Kunst, Copenhagen, inv. KMSsp 138

model. However, details such as the transparent drapery worn by Saint Catherine (on the right) and the unusual position of Saint John the Evangelist's eagle attribute (shown standing on a closed gospel book) suggest that we are looking at the work of an original thinker.

The first marker of Barocci as a major painter and artistic talent is his *Martyrdom of Saint Sebastian,* still in situ above an altar on the south wall of Urbino cathedral (fig. 3). The contract was signed on 9 November 1557 for an altarpiece for the Chapel of Saint Sebastian. The picture commemorates the torture of the early Christian martyr, who maintained his faith in spite of opposition by the Roman emperor Diocletian, shown at the left side of the painting. In general Barocci followed fifteenth-century models that emphasized the athletic prowess of the bowmen and the focus on the martyred saint's body. Barocci also incorporated references to paintings by Sebastiano del Piombo, Titian, and Girolamo Genga, suggesting that he relied heavily on available models to formulate his ideas.[16] In spite of its Mannerist crowding, studied poses, and distortion of form (the seated emperor at left), Barocci's *Martyrdom of Saint Sebastian* demonstrates his

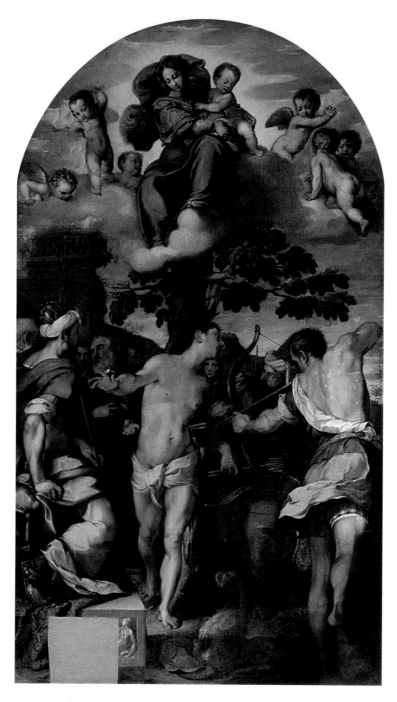

Fig. 3. *Martyrdom of Saint Sebastian*, 1557–58. Oil on canvas,
405 x 225 cm. Cathedral, Urbino

early gifts as a colorist, his penchant for rich fabrics, and his attempt
to establish relationships with viewers through invigorated poses
and charming details such as the dog in the foreground who looks
intently at his master.[17] Although Barocci seems not to have stud-
ied animal anatomy (his animals are often generic and sometimes
inaccurate), he clearly observed animal behavior. The dog tamps
down the discarded drapery to prepare his bed, yet fidelity causes
him to look up at Sebastian, a suitable analogy to the suffering saint,
who, in demonstration of his faith, turns his head toward Christ.

Based on evidence on the versos of some Barocci drawings
that establish his presence in Florence before 1560, Jeffrey Fontana
posited that Barocci may have traveled to other Italian cities.[18] A
phrase from an oration delivered at Barocci's funeral by his friend
and fellow resident of Urbino Vittorio Venturelli claimed that the
artist had "seen the most famous cities of Italy."[19] Those who study
Barocci have suspected that he visited such places as Parma, Bolo-
gna, Sansepolcro, and Venice.[20] Certainly, as his career unfolded,
his art increasingly demonstrated a broad foundation, based on
the paintings and prints of his predecessors and contemporaries,
testifying to the depth of Barocci's visual knowledge.

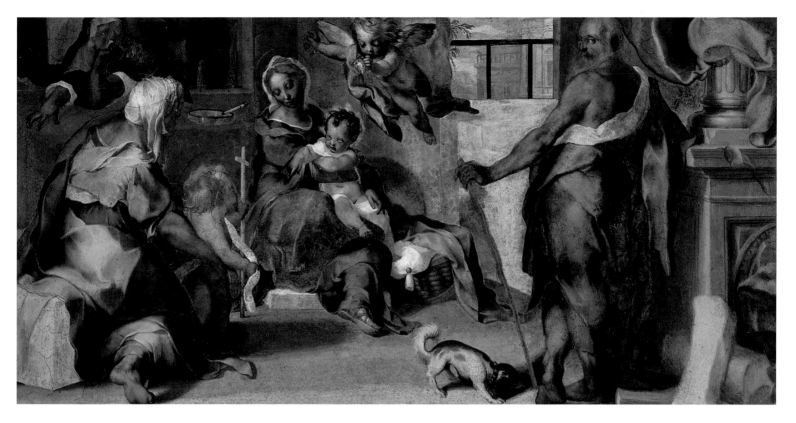

Fig. 4. *Holy Family with Elizabeth, Zaccharias, and Saint John the Baptist (Visitation)*, 1561–63.
Fresco, 198 x 317 cm (with frame). Casino of Pius IV, Vatican City

Barocci's second trip to Rome, securely dated by Bellori to 1560, yielded an early masterpiece. Barocci was chosen to be part of a team to decorate two rooms in the Casino of Pius IV, Pirro Ligorio's garden pavilion west of the Belvedere courtyard at the Vatican Palace.[21] Documents verify payments to Barocci from 1561 to 1563.[22] It was this activity that brought him to the attention of Giorgio Vasari.[23] Barocci played a large role in this program devoted to allegorical figures and scenes from the Life of Christ. His finest work was a fresco, the *Holy Family with Elizabeth, Zaccharias, and Saint John the Baptist* (fig. 4), which forms the axial image of the larger room.

Based on Giulio Romano's *Madonna of the Cat* (Museo Nazionale di Capodimonte, Naples), the painting depicts a visit of Saint John the Baptist and his parents to the Holy Family. It demonstrates Barocci's developing abilities as a colorist (the beautiful *cangiante* colors in the Virgin's and Elizabeth's drapery) and his mastery of fresco, evidenced in the nuanced light and shadow that play across the faces of the Virgin and the airborne angel. To achieve cohesion, Barocci created a diagonal flow from Elizabeth and Saint John, through Mary, the Christ Child, and the hovering angel.[24] The artist relied on some compositional methods of

Mannerism (Zaccharias as a repoussoir figure with his back to the viewer, and the abrupt transitions of spatial recession), but several passages attest also to his effective incorporation of the particulars of everyday life. For example, he captured the realistic movements of the Infant Christ resisting the encircling arms of his mother. Further, he combined those observed details with sophisticated references to the inevitable death implied through the Incarnation. The wriggling child pushes his left foot against the linen of his cradle, a traditional reference to the sleep of death, while he strains to embrace his cousin John, living testament to Christ's eventual sacrifice. The shallow dipper on the table behind John and Elizabeth draws attention to John's future role in Jesus's Baptism.

One can best appreciate Barocci's evocation of the intimacy of domestic life in the casino when it is compared to another painting that must have been undertaken during the artist's second Roman sojourn, *Madonna and Child with Saints John the Baptist and Francis* (fig. 5). Barocci was feeling his way as an artist, no doubt absorbing everything he could in the papal city and experimenting with the models before him, as was the case with this altarpiece, which pays homage to both Raphael and Parmigianino.[25]

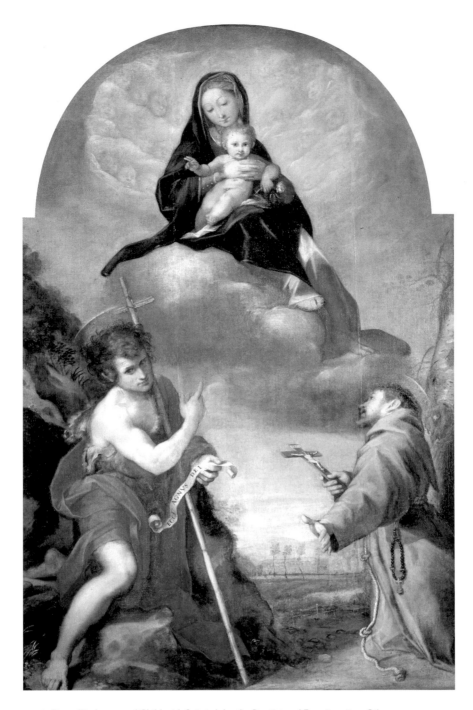

Fig. 5. *Madonna and Child with Saints John the Baptist and Francis*, 1560s. Oil on canvas, 250 x 163 cm. Pinacoteca Nazionale di Brera, Milan, inv. 6104

It relies heavily on Raphael's *Madonna di Foligno,* a painting the artist could easily have consulted, for it was in Santa Maria in Aracoeli on the Capitoline Hill; it makes sense to see Barocci developing his composition with its famous inspiration before him.[26] In fact, the painting as well as the finished study (cat. 11.1) should be considered meditations on Raphael's painting. Although Barocci kept within the hierarchical format of the Renaissance altarpiece, he attempted to introduce a more updated sense of space by bringing Saint John forward toward the viewer and using Saint Francis's extended left arm to establish an expanded fore-

ground. Barocci emphasized John's gesture by lining it up directly with the Christ Child. Although this is not a variation on a Raphael model in the same way that the *Santa Cecilia* had been, Barocci must have intended his inspiration to be clear, for he repeated so many of the details of Raphael's work—the pose of the Virgin, the cross held by Saint Francis, the way Francis's rope belt lies on the ground, and the demeanor of Saint John.[27] Barocci may well have prepared the drawing while he was still in Rome, with his models available to him, and then painted the altarpiece several years later in Urbino.[28]

Many new vistas were opened for Barocci when he was in Rome, both in the 1550s and in the 1560s. One must imagine that he filled sheet after sheet with sketches inspired by antiquities, altarpieces, and sculptures that he was able to see in the Imperial City.[29] There are many extant drawings that, at first glance, appear to be copies after the antique, but because they have not yet been matched with any specific models, they should probably be seen as general musings that were generated by the experience of the originals. One sheet in the Biblioteca e Museo Civico in Urbania has rightly been understood as a copy after Michelangelo's *Last Judgment*; Fontana and others have associated a drawing in the Uffizi with Raphael's *Disputa*.[30] Several examples of Roman models emerge in Barocci's work of the 1590s and early seventeenth century, lending further credence to the idea that he made copies after important artworks that served him as a source book, a common practice and one to be expected of a draftsman as obsessive as Barocci. Of course, many of these drawings have been lost, and it is only possible to surmise the store of images that the artist took back with him to Urbino when in 1563 or 1564 he departed Rome, never to return.

The reason Barocci left Rome, according to Bellori, was the onset of a lifelong illness.[31] Drawing on the sixteenth-century writer Raffaello Borghini's account in his 1584 art treatise *Il Riposo,* Bellori related an "unhappy accident that befell" Barocci.[32] Invited by fellow painters to a picnic, he was poisoned by a salad, allegedly the work of rivals jealous of his success. Bellori raised some doubts about the story, prefacing his account of Barocci's ensuing illness with the qualifying phrase, "Whatever the truth of the matter." The artist sought treatment, assisted by Cardinal Giulio della Rovere, but to no avail. The suffering artist returned to Urbino.

Scholars have offered different theories as to the nature of Barocci's illness, wondering if it was in truth the result of intentional sabotage. Luciano Arcangeli suggested that the stress of competition in Rome among a group of talented and extremely competitive young painters may have been Barocci's undoing, especially given his shyness, and may have triggered some sort of emotional breakdown.[33] Nicholas Turner hypothesized that it could have been food poisoning; others found evidence of an ulcer in Bellori's description of the long-term effects on Barocci's health.[34] Most recently, Suzanne McCullagh suggested that Barocci may have suffered from the ingestion of lead from lead-white paint, diagnosing his illness as "piombism," and further arguing that his use of pastels may have been a concerted effort to avoid lead-based pigments as he struggled to regain his health.[35]

All these theories remain plausible possibilities. Evidence uncovered in preparation for this exhibition, however, shows that Barocci had access to Michelangelo's drawings, and may therefore have been the subject of jealous rivalry on the part of other young artists who aspired to the privilege of sharing the master's ideas.[36]

This lends credence to the supposition that Barocci's health may indeed have been sabotaged by his comrades. There are other famous instances of artistic sabotage, including Benvenuto Cellini's description of his own poisoning, with symptoms very similar to Barocci's.[37] Interestingly, during the sixteenth century, fresh greens were losing some of their earlier stigma as a food associated with the lower classes.[38] A treatise on salad and greens as food had been written by a botanist from the Marches in 1565, and it is likely that Barocci was used to eating these greens, which, in some locales may have been held to be unhealthy, partly because they were associated with various types of gastrointestinal distress. Although a green salad may seem an implausible means of poisoning, the person who administered the agent—if indeed Barocci was intentionally injured—may have assumed that any resulting ill effects would have been associated with the expected effects of eating greens.

Whatever the cause, the results were severe and debilitating. Bellori wrote that Barocci took a four-year hiatus from painting, for he was physically unable to wield a brush; absent documents to the contrary, it is difficult to challenge his assertion. The artist never recovered completely, and Bellori's account, as well as letters from Duke Francesco Maria II to potential patrons later in the artist's career, attests to the severe restraints of a life-long condition that limited the time he could spend at the easel and did not allow him to eat without being sick or to enjoy a full night's sleep.[39] His work time was allegedly limited to two hours a day, although that may have been a minimum standard required for training his assistants. In 1608, Annibale Carracci signed a contract with some apprentices, indicating that he would maintain his workshop for at least two hours per day. The specification that Barocci worked two hours a day comes suspiciously close to this standard.[40]

Barocci's illness seems to have inspired his first real demonstration of artistic inventiveness—a small picture painted around 1565 for the Capuchin church at Croicchia (fig. 6), the *Madonna of Saint John*. The canvas shows a young Saint John the Evangelist, tentatively kneeling, holding his hands together in prayer, before a vision of the Virgin and her infant son. The setting is a temporary shelter in the countryside, defined by rustic natural elements and a red drape stretched overhead. John, accompanied by the eagle who since the early Middle Ages had been used to symbolize the visionary nature of his writing, prays beside a silver chalice from which a serpent has just slithered away, barely visible beside the saint's left knee. The sensibility is Correggio's, while the brushwork and color recall the work of Titian, but the image is all Barocci. The Virgin is vulnerable and beautiful; the child is engaging and charming; and Saint John is shown neither in his typical demeanor as an emotional respondent to Christ's suffering nor as the visionary writer whose Gospel is peppered with apocalyptic imagery. He is simply a young man who, in fervent prayer,

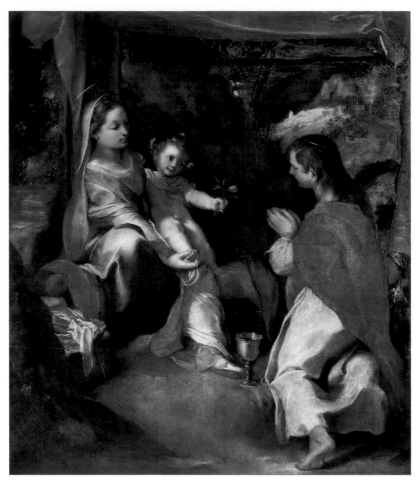

Fig. 6. *Madonna of Saint John*, ca. 1565. Oil on canvas, 151 x 115 cm.
Galleria Nazionale delle Marche, Urbino, inv. 1990 D 88

responds to a vision of the Virgin and Child. Scholars agree this is the painting Borghini described as Barocci's *ex voto* (gift of thanks) to the Virgin for his recovery from the worst stages of his illness.[41] John's symbol—the golden chalice—alludes to the saint's survival after being poisoned, which demonstrated the power of his God to nonbelievers. The cup's presence cements the identification of the painting as the artist's gift of gratitude for recovering from his own encounter with poison.[42]

The following three years established Barocci as an artist capable of executing important commissions, all illustrating his rapidly developing visual vocabulary and iconographic singularity. However, in designing his next several altarpieces, all compelling and beautiful, he never lost sight of the earlier models that inspired his compositions. His first was the *Crucifixion*, 1566–67 (cat. 2), painted for the personal chapel of an intimate of the Della Rovere, Pietro Bonarelli. Barocci's sources—Titian's Ancona *Crucifixion* (fig. 44) and Piero della Francesca's panel in Borgo Sansepolcro—remain evident in this early altarpiece, although he nonetheless managed to focus on a new moment within the narrative, the dramatic point at which Christ dies and his observers react.

Barocci's debt to Correggio's *Madonna of Saint Jerome* (*Il Giorno/The Day*) is apparent in his next major church picture, the *Madonna of Saint Simon,* ca. 1567, painted for San Francesco in Urbino (fig. 7). Barocci used it as a starting point to create an unusual example of an altarpiece with donors.[43] He borrowed Correggio's prominent red drape, a cloth of honor denoting Mary as a heavenly queen, and was inspired by the large book that the earlier artist had provided Saint Jerome. For Correggio, the volume referred to the saint's Latin translation of the Hebrew Bible. For Barocci it became a diminutive book of hours, the focal point of the picture that signals the theme of personal piety. The unidentified donors (at lower right) reinforce the painting's devotional function. The man, whose head echoes the angle of the Virgin's, points toward her, while his companion (shown in pure profile) holds her hands together to pray. They form the end of a compositional diagonal that includes the prayerbook and begins with the putto holding the crown of roses in reference to the rosary, another aid to prayer.[44]

Even Barocci's tour de force of color and lyrical compositional rhythms, the *Deposition,* 1568–69 (cat. 3), never completely broke

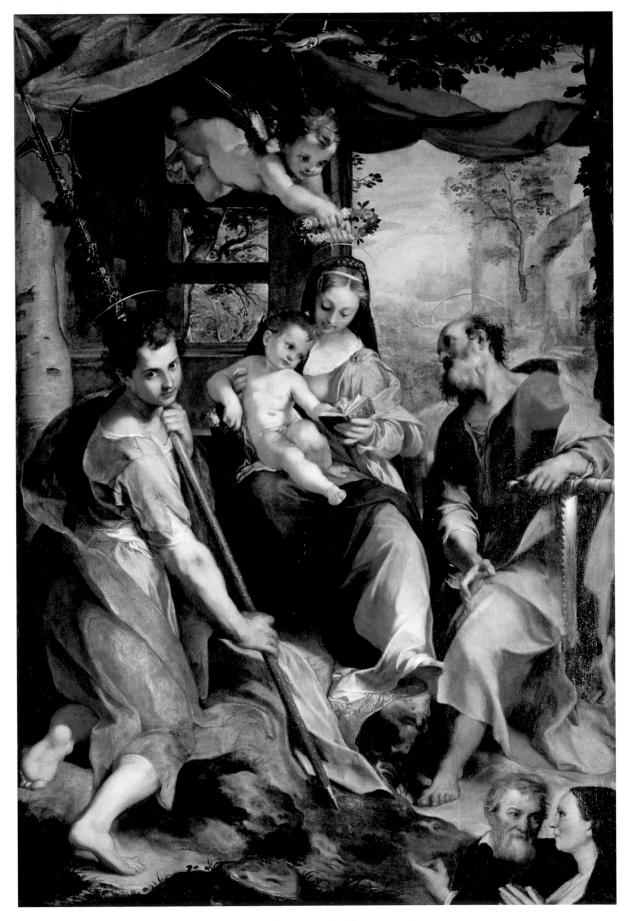

Fig. 7. *Madonna of Saint Simon*, ca. 1567. Oil on canvas, 283 x 190 cm.
Galleria Nazionale delle Marche, Urbino, inv. 1990 D 84

free of its initial inspiration. Daniele da Volterra's earlier *Entombment* (Santa Trinità dei Monti, Rome) remained evident even as Barocci imprinted his own genius for suggesting the play of light and shadow as well as his improved arrangement of the three women who tend to the swooning Virgin. Nonetheless, the Perugia picture brought wider recognition and ushered in a period of unmatched creativity in Barocci's career, with additional iconographic inventions shaping a new visual discourse on some of the vital theological issues of his day.

The first major public picture of the 1570s was Barocci's completely original visualization of a miraculous experience of Saint Francis of Assisi, *Il Perdono,* a work that occupied the artist for at least five years, between 1571 and 1576. The complicated subject is outlined in Bohn's catalogue entry (cat. 5) and need not be reiterated here. Suffice it to say that Barocci's task was to give potent visual form to the saint's vision of Christ. The artist developed a two-level composition in which the heavenly beings (the Virgin Mary, Christ, and Saint Nicholas of Bari) are rendered with greater physicality and more saturated color than in previous works, imbuing the altarpiece with a powerful evocation of the immediacy of the divine realm. The lower register of the picture relies on muted middle tones that serve to focus attention more directly on the vision above, with the saint as a visual link. There was no established format for presenting the subject, for it was rarely represented in contemporary imagery; therefore Barocci did not necessarily have to break free of a constraining tradition. He did indeed respond to Raphael's *Transfiguration* and *Sistine Madonna,* as Bohn points out, although the relationship to these models is far more subtle than has been seen heretofore. The pose of the afflicted boy in the *Transfiguration* offered a possible pose for Saint Francis, and the tripartite grouping of Raphael's Virgin and Saints Sixtus and Barbara is indeed reflected in Barocci's heavenly trio. However, the full conception, where lighting, shadow, and masterful coloration work together to bring to life the compelling appearance of divine visitors, has few rivals in terms of efficacy in the oeuvres of the artist's contemporaries. Barocci evoked the palpable sensation of physicality based on a model available to him in Urbino: Christ's protruding feet in Titian's *Resurrection* (Galleria Nazionale delle Marche, Urbino). Most forward-looking, however, is Christ's right hand, which seems nearly to break free of the canvas, echoed in Saint Francis's gesturing left hand, which reaches forward while his right hand penetrates back toward the open chapel. Barocci developed imagery that created an unforgettable physical experience for those who approached his altarpiece; this is still evident to the contemporary church visitor. His solution was innovative and bold, representing the first in a string of altarpieces and devotional pictures that influenced his contemporaries and the subsequent generation of early Baroque painters.

It was during the 1570s that Barocci completed an acknowledged masterpiece, the *Madonna del Popolo* (fig. 8), commissioned by the Fraternita di Santa Maria della Misericordia in Arezzo in 1575.[45] The second major commission for a church outside Urbino, this project came to Barocci after Giorgio Vasari, the original artist, died in 1574. The negotiations and communications between the artist and the confraternity rectors were strained from the start, when Barocci responded to the initial request for a Madonna della Misericordia, a traditional image of the succoring and protective Virgin, saying that he did not find the subject one that would make a beautiful painting.[46]

Having rejected the confraternity's idea, Barocci developed new iconography in a tour de force of color, composition, and figure drawing. He combined a multifaceted presentation of Mary's role as spiritual overseer and mediator between humankind and Christ with an effective evocation of the good works and pious devotion of the confraternity members. Various individuals engage in prayer and charitable acts below, while the airborne Virgin Mary commends them to Jesus's care. With her right hand, the Virgin points downward, toward a congregation of believers who have assembled in a space defined by the wingspan of the Holy Spirit. This area is cut off from the rest of the composition by paler coloration and an arch of angel heads just below Mary's hand and is intended perhaps to represent the piety of previous confraternity members. The cupped gesture of Mary's left hand connotes the protection that she provides for her followers; Barocci underscored her benevolent care by allowing the shadow of her mantle to fall over them, as Marcia Hall recently noted.[47] Barocci's painting is populated with a range of individuals, spanning infancy to old age, poverty to wealth, actively engaged to passively observant. The blind hurdy-gurdy player at lower right is one of Barocci's most successful creations; his powerful and muscular left arm, which steadies his music box, is set off against the less aggressive right arm of the kneeling mother on the left, who gently guides her young children to the heavenly vision above. She points with her other arm to the miraculous vision, in contrast to the hurdy-gurdy player, whose blindness precludes a full appreciation of the heavenly scene.

The altarpiece is the sole extant picture Barocci executed on panel, constructing the surface by joining planks horizontally, in the Venetian manner. The picture retains its extraordinary coloration, three primary colors for the heavenly figures, and a panoply of dappling and changing hues that disperses the viewer's gaze throughout the lower register. Ironically, the members of the confraternity complained about the condition of the painting, for cracks began to appear as early as ten days after it was installed, and given the arduous process they had gone through as a result of Barocci's notoriously slow execution, they were very unhappy about it, even committing a few unkind barbs to paper in order to register their dismay.[48]

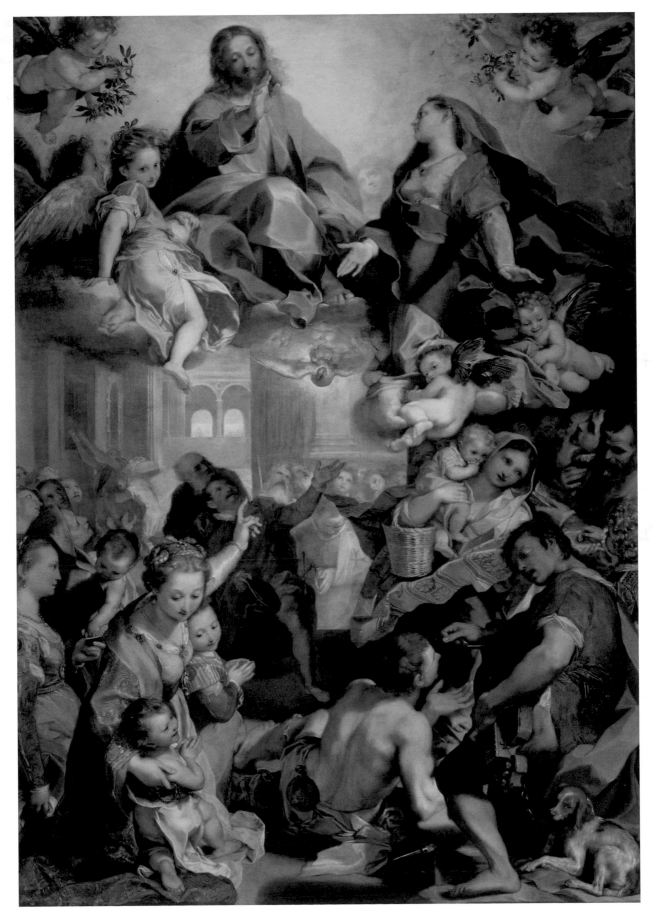

Fig. 8. *Madonna del Popolo*, 1575–79. Oil on panel, 359 x 252 cm. Signed and dated bottom right:
"FEDERICVS BAROTIVS/VRBINAS MDLXXIX." Galleria degli Uffizi, Florence, inv. 1890 no. 751

It is hard to overstate the innovative quality of Barocci's solution for this altarpiece, which has been discussed extensively by Stuart Lingo in terms of Barocci's balance of tradition with innovation.[49] It was the second time the artist had approached the theme of the protective Virgin. He first undertook the subject of the Misericordia in his smaller altarpiece painted for the convent of San Francesco in Urbino, where he developed the definitive representation for perhaps the most difficult of all Christian theologies to portray, the Immaculate Conception of the Virgin (cat. 6)—the idea that Mary, in her own conception, was not tainted by Original Sin, a doctrine with a complicated history and argumentation.[50] In illustrating this concept, Barocci was heir to a visual tradition that included an airborne Virgin atop a crescent moon, encircled by symbolic illustrations of her virtues (enclosed garden, heavenly star, Lebanon cedar), overt symbolism intended to present a remote idea. Barocci created a streamlined vision of a radiant, timeless being that combines an iconic heavenly presence with an active earthbound corporeality that places her outside both realms. She stands between light and dark, male and female, and among young and old. Her deceptively simple pose with arms extended into space and the contrapposto position of her torso convey perfect balance yet suggest movement, providing a brilliant solution to this difficult concept. So successful was this image that it became the model for the illustration of the doctrine for the succeeding centuries, a testament to the painter's inventive pictorial powers.

Barocci created some of his most appealing small devotional pictures during the 1570s—several versions of the *Rest on the Return from Egypt,* the first two in 1571–73 (cat. 4), and a domestic scene of the Holy Family with Saint John the Baptist, the *Madonna del Gatto,* in 1575–76 (cat. 7). They are discussed in their respective catalogue entries, but it is useful to point out here that they represent Barocci's first known work for private patrons, for evidence suggests that at least one version each of the *Rest on the Return* and the *Madonna del Gatto* was intended for an intimate domestic location.[51] These were compositions that enjoyed further impact through printed copies, although the artist's achievement goes far beyond their success as devotional aids and the overt charm of adorable children and engaging animals. One wonders if the reduced format allowed Barocci to explore complicated compositional problems on a more focused and smaller scale.[52] The two paintings under discussion both consist of angled groupings that penetrate back into space. Further, Barocci reused the concept of the active figure reaching back into space from the *Rest on the Return* in his much later *Nativity* (cat. 15), where Joseph was turned to face the back left. Given the vague description in Bellori as to how many of these pictures were made, one can surmise that Barocci made several for clients who were ready and willing to own them.

Although Barocci continued to produce a few small paintings for private devotion later in his career, there is no similar time when evidence tells us that he produced a comparable group of popular domestic compositions. It may be a question of his developing relationship, and friendship, with Duke Francesco Maria II della Rovere, who assumed control of the duchy in 1574; but the duke did not commission works from Barocci until the 1580s, when he began to play an increasing role in the painter's professional life.[53] There were direct commissions, such as the *Annunciation* altarpiece for the Della Rovere chapel in Loreto in 1582 (cat. 9), but Francesco Maria also funded a number of church commissions, navigated Barocci's relationships with patrons, and ordered works that he sent as diplomatic gifts to heads of state, such as Emperor Rudolf II in Prague (r. 1576–1612) and King Philip II in Spain (r. 1556–98).[54] It is hard to know whether the duke's support prohibited Barocci from taking other commissions or saved him from having to solicit additional work from private patrons.

Barocci's explorations from the 1560s through the early 1580s led him to greater efficacy in reaching his audience, something Lingo has discussed in depth. One way that he managed to engage onlookers was the marked energy of his interpretations, presenting emotional and exuberant protagonists. His *Deposition, Madonna del Popolo,* and *Entombment* altarpieces all display elements of the former, perhaps cresting in his depiction of the powerful, if somewhat awkward, rendering of the *Martyrdom of Saint Vitalis* (fig. 9), created for the high altar of the church of San Vitale, Ravenna, between the signed contract of 1580 and delivery of the painting in 1583.[55] The narrative of the early Christian saint's life is short, telling us only that he went to Ravenna and observed the trial of a doctor named Ursicinus.[56] When the doctor was condemned to decapitation, Vitalis offered him words of encouragement, for which he himself was punished. The judge ordered a ditch dug, directing that once water was reached, Vitalis was to be thrown in and buried alive. The site of his martyrdom was a well in Ravenna, over which the sixth-century Byzantine church was built. The composition was understandably tricky, given that its main protagonist needed to be positioned partially underground. In fact, the artist was encouraged to make it more complicated. When Barocci presented the initial finished drawing (fig. 39) to the monks of the order, they found it to be too thinly populated and requested he add figures.[57] In the finished painting, Barocci eliminated the architectural backdrop that had given the earlier study some order, producing one of his most confusing compositions. The resulting melee reflects, in part, the charge of more figures, but Barocci's decision to include a falling martyr, two figures heaving stones, a gesturing judge (at upper right), and a youth wielding a shovel reflects the greater physicality of the pictures from this phase of his career. These works also express intensity of feeling, exemplified by the zealous prayer of the citizens of

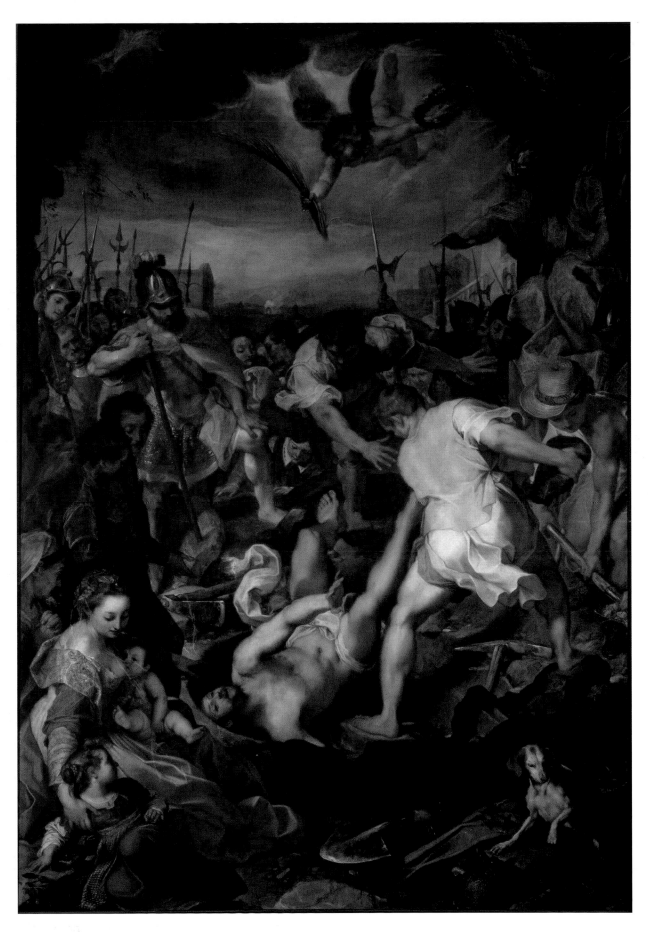

Fig. 9. *Martyrdom of Saint Vitalis*, 1580–83. Oil on canvas, 392 x 269 cm. Signed and dated bottom right:
"FEDERICVS BAROCIVS/VRBINAS P.A.D. MDLXXXIII." Pinacoteca Nazionale di Brera, Milan, inv. 401

Fig. 10. Luca Ciamberlano after Barocci, *Noli me tangere,* 1609.
Engraving, 39.6 x 27 cm. The British Museum, London, inv. V,8.178

lurches forward while Christ pulls back, forming an almost balletic interchange between them. The preparatory drawings convey Mary's focused, nearly passionate resolve to embrace her Savior. They also capture the tension in the muscles of Christ's body as he shrinks back. These figures belong among the lively and bustling compositions of the 1570s rather than the monumental and grander (if more staid) poses and arrangements that characterize the artist's later production.

At the end of the 1570s, Barocci undertook the picture that became one of his most successful, the Senigallia *Entombment* (cat. 8). The altarpiece sheds light on Barocci's inventive solution to compositional problems as well as the forthright assertion of the body of Christ as the central object of the Eucharist. It serves as a fitting culmination to this decade of emotive figures who engage the viewer with the passion of their belief. The Virgin begins to yield to her grief, her companion's sorrow is enhanced by the rippling edges of the white shroud, John's swirling drapery suggests emotional turmoil, and the Magdalen's inclined head and clasped hands are powerful signifiers of feeling. The picture also amply demonstrates Barocci's sophisticated coloration, with a palette that has been contained within a narrow range (save for the Virgin's cobalt drapery), achieving a golden tonality that evokes the encroaching dusk and Christ's burial. The painting is a masterpiece; its popularity attests to its emotional and aesthetic power. The zeal with which it was copied testifies not simply to the beauty of its palette and the energy of its composition: It was simply one of the most straightforward encapsulations of the central purpose of the altar—the visualization of the body that will be ritually consumed by the faithful. Barocci's solution, suggesting that the body will be brought forward toward the communicant, established a strong connection between the represented narrative and the actual experience of the liturgy.

Perhaps having exhausted the possibilities of a more energetic mode, between 1580 and 1590, Barocci produced works of monumental grandeur using simplified compositions focusing on two main protagonists. Obviously this compositional choice was determined in part by the subjects he was required to portray, but the works of the 1580s use this format with noteworthy regularity. The earliest of these is his *Calling of Saint Andrew,* signed and dated 1583 (fig. 11), painted for the oratory of the Confraternita di Sant'Andrea in Pesaro. The commission was instigated by Lucrezia d'Este, the estranged wife of Francesco Maria II, who maintained a household in her native Ferrara. For the altarpiece, Barocci modified the story of the calling of the first apostles, Peter and his brother Andrew. As told in the Gospel of Luke, after working hard but catching no fish, the brothers successfully landed a huge haul. Peter fell to his knees before Jesus, saying "Leave me, Lord; I am a sinful man."[60] Barocci assigned that role to Andrew to accommodate the dedication of the confraternity. The story

Arezzo who gather to witness the divine vision in the *Madonna del Popolo,* or the onlookers who intently observe the killing of Saint Vitalis.

Perhaps the best illustration of Barocci's developing vocabulary of energy and emotion during this phase of his career is his *Noli me tangere.* The almost completely ruined painting is in the collection of the duke of Allendale, but the engraving by Luca Ciamberlano (fig. 10) appears to be a faithful reproduction.[58] Bellori mentioned the picture in passing, giving little indication of its dating. Scholars have traditionally placed it in the 1590s, after a signed and dated (1590) painting of a related subject, *Christ Appearing to Mary Magdalen* (fig. 12). Often the two are conflated as a single exercise, as Emiliani did in his catalogue raisonné.[59] This makes little sense, for they are recorded in Bellori as two different commissions for separate patrons. More to the point, they represent different phases in Barocci's developing aesthetic. The Allendale *Noli me tangere* illustrates Mary reaching out to Jesus when she encounters him after the Resurrection, to which he replies, "Don't touch me" (John 20:14–17). Having recognized him, Mary

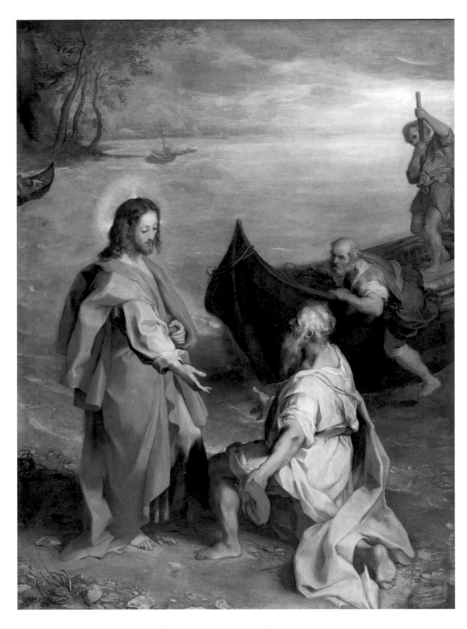

Fig. 11. *Calling of Saint Andrew*, 1580–83. Oil on canvas, 315 x 235 cm.
Musées Royaux des Beaux-Arts, Brussels, inv. 254

ends with several apostles bringing their boats back to the shore as a signal that they will follow Christ.[61] Eschewing a more popular tradition for a complex and multifigured arrangement, Barocci boiled the narrative down to a simple scene of a kneeling figure expressing his devotion to the Savior, relegating Peter to a subsidiary position in the background. Through the judicious use of primary colors, Barocci created a simple but magisterial scene where the red of Christ's garment, the yellow drapery worn by Andrew, and Peter's blue tunic define the three anchor points of the composition. Each apostle is tied coloristically to Christ—Andrew through the red cap in his left hand, Peter through his red sash.

While painting the *Calling of Saint Andrew,* Barocci was simultaneously at work on another Della Rovere commission, the

Annunciation altarpiece (cat. 9) for the ducal chapel in the cathedral of Loreto.[62] Both paintings rely on the same basic format, typical for the *Annunciation* but unusual in the case of the *Calling*. In each, however, Barocci did not sacrifice the careful reading and iconographical creativity that underlie his best work. In the *Annunciation,* he produced an unusual representation by having Gabriel gaze up at Mary, a visual shorthand to convey her queenly status in spite of her simple garment and humble pose. His inclusion of the sleeping cat also provided more innovation than may be immediately apparent. As Bohn points out in the entry, contemporary images of the scene differed from Barocci's version; others tended to emphasize the intrusion of the heavenly into the earthly realm. Barocci devised more subtle means for

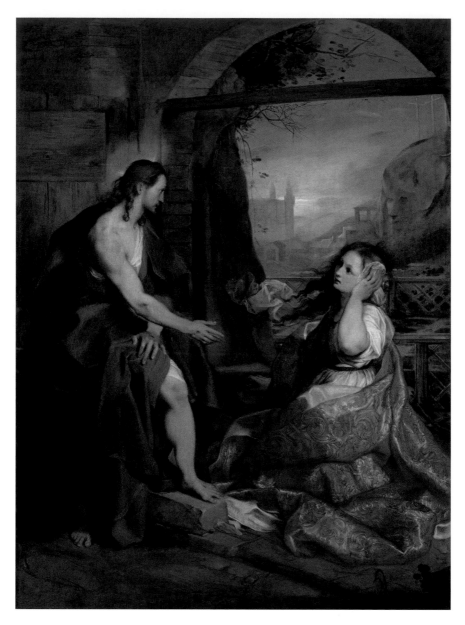

Fig. 12. *Christ Appearing to Mary Magdalen*, 1590. Oil on canvas,
122 x 91 cm. Galleria degli Uffizi, Florence, inv. 1890 no. 798

implying the miraculous, including his rare use of a halo and the slumbering cat. A popular proverb, dating to the fifteenth or sixteenth century, held that "the cat sees through shut lids," meaning it is ever vigilant and aware.[63] Here, the cat sleeps soundly, registering no reaction, an indication that we are witnessing a miraculous rather than a quotidian event. Placed at the lower-left corner of the canvas, it is also an attractive draw into the composition.

The third of the simpler but monumental compositions of the 1580s is the *Visitation* for the Chiesa Nuova (cat. 10), which is among Barocci's most noted pictures, and his first Roman commission since his departure in the 1560s. Although the painting includes five figures and a donkey, the main focal point is the embrace of the two holy women, Saint Elizabeth and the Virgin

Mary. The altarpiece is carefully structured and engagingly beautiful, but the artist eschewed the emotion of his earlier pictures, an approach that would have been appropriate had he focused on the warm friendship between the two cousins. Instead, the scene implies ritual, marked by a ceremonial tone that has been enhanced, as Lingo noted, by the reference to the Eucharist that is inherent in the sack of bread and wine that Joseph places at the lower left.[64] The archway and stairway setting enhance the idea of ceremony.

Another picture that fits within this monumental group is perhaps the least appreciated. Partly due to its darkened varnish and compromised condition, the *Christ Appearing to Mary Magdalen* in the Alte Pinakothek, Munich, is too often dismissed as a repeat of the primary figure and basic composition of the

Calling of Saint Andrew.[65] The picture is nearly illegible in its current condition, but can still be appreciated in the smaller autograph copy in the Uffizi (fig. 12).[66] Much more than a reprise of the Brussels altarpiece, it stands as one of the most thoughtful renderings of biblical narrative that Barocci produced. The scene comes from a passage in John 10:11–17, which describes the weeping Mary Magdalen who visits Christ's empty tomb. Finding no trace of him, she encounters two angels. Asked why she is weeping, she replies, "They have taken my Lord away and I don't know where they have put him." As she says this, she sees Jesus, who also asks why she is crying. Mistaking him for a gardener, she asks him where Jesus has been taken. When he utters her name, "Mary," she recognizes him and calls him "Master." He then tells her not to cling to him but spread the word of his resurrection.

It is the moment when Mary recognizes Jesus that Barocci captured. With her left hand, she wipes her eyes; in one of Barocci's most beautiful gestures, her hand becomes a signifier, not just of her tears, but of revelation and seeing.[67] In preparatory studies for Mary's arm, Barocci experimented with having the hand more obviously embrace the ear to indicate Mary's recognition of Jesus by his spoken words.[68] With her other hand, Mary automatically reaches toward the ointment jar, an understated reference to the touching of Christ's body, alluding both to her intention to anoint as well as to his subsequent statement that she must not touch him.[69] The narrative frame that Barocci selected is both poignant and profound, its composition elegant and refined. The torque in Mary's torso as she turns in her kneeling position (based on antique sculptures of the Crouching Venus) conveys her early failure to really see who is before her. The artist was attentive to the dynamics of space. Mary's hand goes out, Christ's reaches forward. She kneels and twists while he steps up and toward her. By focusing on the early part of the narrative, Barocci introduced the possibility of impending drama, for we know what will ensue once full recognition occurs. The artist incorporated an important contemporary notion of the Magdalen as the sinner who is welcomed back into the Church. Christ's foot, placed firmly on a raised stone within the entrance to the tomb, underscores the founding of his Church and his charge to Mary to disseminate news of his resurrection. At the same time, as he moves toward her, he reminds us that the Church reaches out to those who renounce their sinful past.

One last element that denotes Barocci's thoughtful rendition is the silhouetting of Christ's head with several rays of illumination; they echo the sunlight that infuses the morning sky behind the ducal palace and indicate that Christ, like the sun, has now risen. It also reminds the devout viewer that Mary's charge will be to spread that news as the light permeates the surrounding sky. A drawing (fig. 13) made in conjunction with this painting demonstrates other creative ways in which Barocci developed his com-

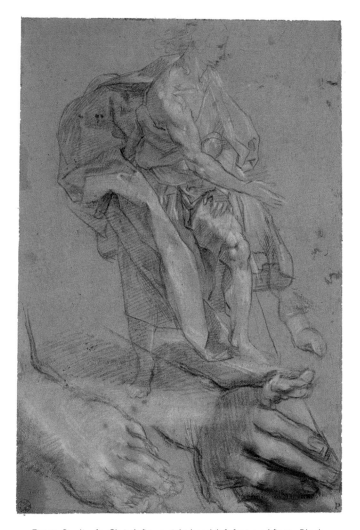

Fig. 13. *Studies for Christ's figure, right hand, left foot, and finger.* Black, white, and red chalk on blue paper, 40.5 x 26.6 cm. Kupferstichkabinett, Staatliche Museen zu Berlin, inv. KdZ 7706 (4160)

positions. The study represents Christ's hand and fingers from the point of view of the Magdalen, suggesting that Barocci either conceptualized his narratives as if they were acted out in real space, or explored an arrangement in which the viewer and the Magdalen were afforded the same frontal view of Christ's gesturing hand. Either way, Barocci's thinking established a bold relationship between the viewer and the subject as part of his continual quest for an engaging visual language.

A final monumental altarpiece from the 1580s is the *Circumcision* (fig. 14), painted for the oratory of the Compagnia del Nome di Gesù in Pesaro. It is signed and dated 1590, although the commission was initially made in 1581.[70] As Christ's first shed blood is stanched by the officiating priest's assistant, an acolyte gestures toward the foreskin that floats in the bowl on the table, lined up with the trussed lamb so that its symbolic association with Christ's eventual sacrifice is made clear. With its incorporation of ethereal angels and somber palette, the painting serves as a harbinger of Barocci's later works, although its poor condition makes it look

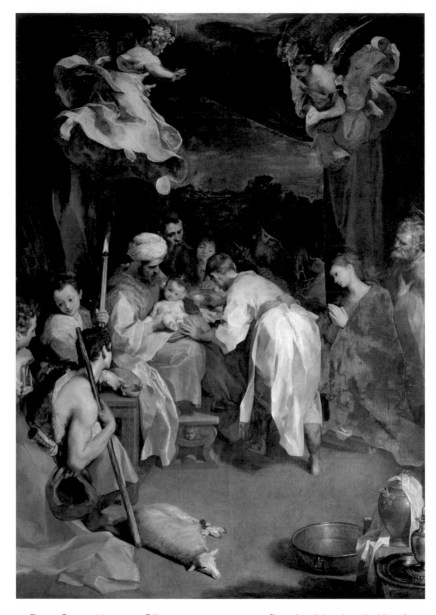

Fig. 14. *Circumcision*, 1590. Oil on canvas, 374 x 252 cm. Signed and dated on the Virgin's hassock: "FED. BAR. VRB. PINX. MDLXXXX." Musée du Louvre, Paris, M.I. 315

darker than it originally was. It also displays the diagonal compositional focus that the artist used more and more in the remaining decades of his life, and it is perhaps the last painting in which the primary trio of colors—red, blue, and yellow—forms the dominant foci within the picture. Barocci imbued the scene with the sanctity of ritual, moving the seated priest back into the space. He anchored the left corner with the symbolic lamb and the right corner with a ewer and patten in reference to the Eucharistic meal, appropriate since both body and blood are associated with the Circumcision. Like other works from this period, the resulting canvas is majestic and grand, although, as Emiliani and others have pointed out, its naturalistic still life and attendant shepherds pay homage to recent developments in naturalistic painting.[71] Barocci eschewed the typical temple setting for the event, substituting a

domestic ambience, making his successful rendering of a formalized ritual even more remarkable as he managed to combine the ceremonial with the intimate.

The 1580s may have brought renewed interest on Barocci's part in the work of Titian and Jacopo Tintoretto, as he was considered for a commission in Venice. Sabine Eiche noted that, in a letter of 1 May 1583, written from the archbishop to Duke Francesco Maria II, there is a reference to Barocci, who at the time was in Ravenna supervising the installation of his altarpiece for San Vitale. According to the letter, he was also under consideration for a commission in Venice, most likely for San Giorgio Maggiore.[72] He may, therefore, in preparation for a possible Venetian commission, have visited Venice and studied the altarpieces around the city. This hypothesis is supported by his conversance with exam-

ples of both painters' work, which appears throughout the following decade. Barocci's renewed acquaintance with Tintoretto may be one of the factors that led to his increasingly dark palettes of the 1590s, as well as his frequent explorations of that artist's iconography and approaches to compositional problems.[73]

The greater energy of the 1570s that evolved into more monumental compositions in the 1580s may suggest the trajectory of an increasingly infirm artist who began to yield to the constraints of his illness. This idea, although perhaps not directly articulated, has informed a good bit of our understanding of Barocci's so-called late work, which is usually designated as beginning in the last decade of the sixteenth century. The period was, in fact, one of remarkable energy. This is borne out to some degree in the numbers of his narrative pictures. Emiliani's catalogue lists eleven paintings in the 1550s, twelve in the 1560s, nineteen in the 1570s, only eleven in the 1580s, and over twenty paintings in the 1590s.[74] In this decade, Barocci completed his second major commission for the Chiesa Nuova in Rome (the *Presentation of the Virgin*, fig. 15), his largest picture (a *Crucifixion* for the Genoa cathedral, fig. 16), his *Last Supper* (cat. 12) with the second-highest number of figures in any of his paintings, and the introduction of a new subject into his oeuvre—the nocturne. Emiliani's catalogue raisonné includes five pictures from the 1590s that have been identified as full or partial productions by Barocci's assistants; no narratives have been so identified for earlier decades. However, while one way of interpreting the increase of studio involvement is to posit an older and sicker Barocci, it also suggests a very intellectually active and engaged artist. He may simply have accepted more work, knowing he could rely on his studio assistants when necessary, personally producing the commissions that were of greatest interest or deepest meaning to him, in greater numbers than ever before.

During the early 1590s, Barocci also produced one of the two principal pictures that established his reputation as a "proto-Baroque" artist, the *Madonna of the Rosary* (cat. 11). His depiction of the kneeling Saint Dominic's vision of the Virgin reflects a very rare tradition in which Mary is shown completely airborne, as Marilyn Lavin argued some time ago.[75] The artist inverted conventional Renaissance models for the portrayal of a praying saint, where a larger group of earthbound figures provided a visual base. Building on his earlier *Il Perdono*, he developed a composition where the invasion of the divine realm is not anchored in the structural support of earthly beings. The resulting painting, compelling and dynamic, looks ahead to the next century.

It is interesting to observe that in the late 1550s Barocci made his sole classical subject, *Aeneas Fleeing Troy* (cat. 16), painted for the Hapsburg ruler Rudolf II in Prague, whose tastes ran to the erotic, and for whom therefore a secular subject was chosen.[76] Known only through a copy that Barocci created ten years after the original, this painting also looks toward the darker palette of the later pictures. Although it is not known what role Barocci may have played in determining the exact subject, it is noteworthy that he avoided the more widely followed approach to the theme that focused on the heroic Aeneas, who rescues his family from the flames of Troy. Perhaps inspired by Girolamo Genga's painting of the same subject, Barocci gave equal attention to the figure of Aeneas's wife, Creusa, who only rarely appears in representations of this narrative. In fact, in one of the most poignant of the artist's surviving drawings (cat. 16.4), Barocci included a wedding band, as Bohn noted in the entry, something he edited out in the extant version of the painting. One must imagine the lifelong bachelor Barocci, who was even sometimes forced to eschew the pleasantries of company due to his illness, meditating on the marital relationship between Aeneas and his wife. Barocci also showed himself to be conversant with the text of the *Aeneid,* for the last stanzas of Book 2 are given over to Aeneas's long and painful lament over the loss of Creusa, who is separated from her family and perishes.[77]

A major masterwork of the 1590s is the *Presentation of the Virgin in the Temple* (fig. 15), commissioned in 1590 by Angelo Cesi, bishop of Todi, who had assumed responsibility for the Chiesa Nuova in 1586.[78] The painting took more than ten years to complete, and the duke had to help prod the painter to finish. Barocci evoked the exceptional nature of the young Virgin, who at age three entered temple service. In the painting, she is being received by the high priest, his robes held open in welcome. The young Virgin, dressed in the same colors as her adult counterpart in the *Visitation* (cat. 10) on a different altar in the same church, crosses her hands over her chest and lowers her head in obedience and humility while her proud parents look on approvingly. Although the story, from the thirteenth-century compendium of saints' lives called the *Golden Legend,* specifies that there were fifteen steps up to the temple, few artists included the entire number.[79] Barocci painted only seven, enough to evoke the sense of an impressive child, just taken from her mother's breast (as stated in the text), who mounted the steps completely unaided, a mark of her exceptional nature. The empty staircase at the center of the picture reinforces her singularity. Barocci incorporated traditional references to a later episode, when Christ was entered into temple membership (the two doves) and when the Virgin was ritually purified as required by Jewish law, giving a dove and a ram as part of her temple offering.[80] In that way, Barocci underscored Mary's purity, further enumerating her virtues. The doves are but one of several examples of paired elements (the acolytes' candlesticks, the framing columns, the two shepherds) that imbue the picture with rhythmic patterns to establish its liturgical character. Barocci again blended the quotidian with the ceremonial to create an appealing image that captures the essential message of Mary's exceptionality.

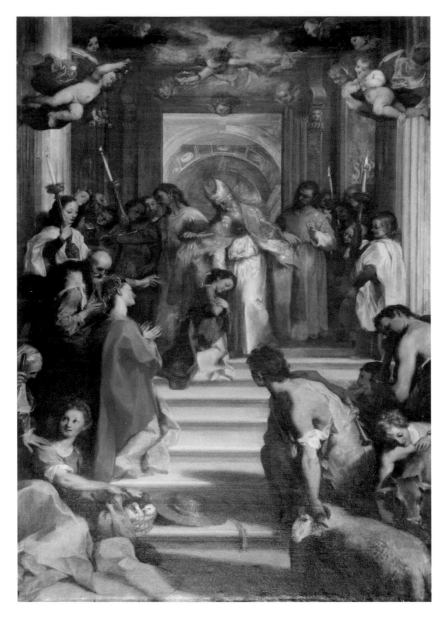

Fig. 15. *Presentation of the Virgin in the Temple*, 1593–1603. Oil on canvas, 383 x 247 cm.
Church of Santa Maria in Vallicella (Chiesa Nuova), Rome

As already noted, Barocci created his first nocturnal scenes in the 1590s. The *Stigmatization of Saint Francis* (cat. 13), *Nativity* (cat. 15), and *Saint Jerome in Penitence* (Galleria Borghese, Rome) may reflect his response to a growing preference for nighttime imagery that would climax in the paintings of Caravaggio.[81] The iconography of the *Stigmatization* worked best with a darkened sky against which the seraphic apparition was most easily discerned. The popularity of the thirteenth-century Saint Bridget of Sweden's vision of the Nativity, where heavenly light bathed the Christ Child, made an evening depiction more suitable for that subject as well, although both paintings demonstrate the artist's continued resourcefulness as he approached familiar subjects.[82] His use of a darkened setting for Jerome's act of penitent contemplation, however, may have been a more deliberate choice, for it

appears to be based in neither textual nor long-standing visual tradition. Here the interior cavern, illuminated by a single candle, enhances the drama and creates a more palpable image, where the physical details of the stone and the crucifix receive greater tactile definition. This painting does not appear in any of the contemporary sources; it probably exemplifies a type of image that the artist made several times—the single saint in the act of devotion (see cat. 17). A drawing in the Uffizi shows several pen and wash trials for a Saint Jerome, seated in a study, dressed in his cardinal's robe, and adoring a crucifix, suggesting that Barocci explored representing him as the scholarly saint before he produced this image of the penitent hermit.[83]

Barocci's undiminished resourcefulness and continually expanding repertoire are apparent in his largest altarpiece, a

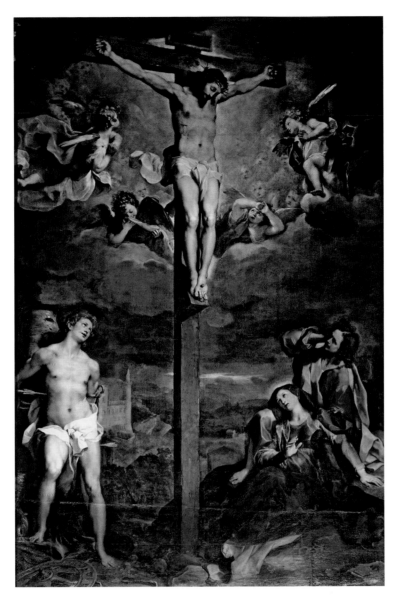

Fig. 16. *Crucifixion with Mourners and Saint Sebastian,* ca. 1590–96. Oil on canvas, 500 x 318.5 cm. Signed and dated bottom right: "FEDERICVS BAROCCIVS; VRB. F. MDLXXXXVI." Senarega Chapel, Cathedral, Genoa

creative rethinking of a straightforward theme, the *Crucifixion* (fig. 16), completed for the Genoese doge Matteo Senarega. The first negotiations began through the assistance of a Genoese nobleman (Ettore Spinola) on Senarega's behalf; in 1587 he approached the artist through Duke Francesco Maria II.[84] By 1590, Barocci wrote to accept the commission. During that same year, Senarega came to Urbino on a pilgrimage to the Santa Casa of Loreto and personally made the arrangements with the artist. They agreed on a very large sum (one thousand *scudi*), which probably reflected both Barocci's stature and the enormous size of the commissioned work, almost sixteen and a half feet high.[85] In 1596 the picture was finished and installed in the chapel dedicated to Saint Sebastian in Genoa cathedral, inscribed with the artist's name and the date, and delivered by Barocci's pupil Antonio Viviani.[86]

On first look, the painting appears to be a traditional handling of its subject. The beautiful and muscular Christ hangs from the tall central cross, which is barely contained within the height of the picture. To his right, Saint Sebastian, tied to a tree and wounded with several arrows, casts his eyes upward to Jesus. Beneath him lie the shield and armor that identify his military profession.[87] On the right side of the cross, Mary reclines on the ground, supported by Saint John the Evangelist. John's disheveled hair suggests agitation, and he holds his hand to his ear, partly as a sign of distress, and partly to allude to Christ's charge to him to care for Mary ("This is your mother"), as recorded in the Gospel of John.[88] Mary appears faint; her pale color and sunken pose suggest imminent collapse. Her right hand reaches out toward the viewer, and the palm is illuminated to give it greater prominence and three-dimensionality. If

one assumes that the light comes from the heavenly aura behind Christ, it is clear that Mary's palm is lit from a different source—the interior illumination within the chapel—thus tying her directly to the approaching visitor in a daring penetration of the picture plane.

Mary's outbound gesture makes it clear that the picture focuses on her. Sebastian's body is inclined toward her, and the cross is rotated in her direction; it also faces the viewer entering the chapel. Christ himself is angled toward Mary, and other details indicate that the altarpiece is intended as a meditation on Mary's sorrow at the physical torments of her son. This focus on wounds is appropriate in the case of Sebastian, to whom the chapel is dedicated and who, in retribution for his adherence to Christ's teachings, was first tortured with arrows before he was clubbed to death, thus achieving martyrdom.

In depicting Christ, Barocci used a pose very different from that in his first *Crucifixion* (cat. 2). In the earlier painting, the cross faces the viewer while Christ's upper and lower torso are angled in different directions, one toward Mary and the other toward John. In this way, Barocci united the three figures. Here, he inclined Christ's head downward, repeating the tilt of his mother's head, although in the opposite direction. It is the position of Christ's feet that has particular importance for Mary. Barocci chose an extremely rare placement, with the left foot covering the right, a position derived from the *Revelations of Saint Bridget of Sweden,* a source that was translated into Italian in 1556.[89] The fourteenth-century saint had a number of visions of the Virgin Mary, who appeared and spoke to her. During one episode, purported to have occurred in the 1340s, Mary described Christ's Crucifixion, emphasizing in lurid detail the physical torments meted out to her son and recounting the placement of his feet: "They crucified his right foot with the left on top of it."[90] In fact, Mary's pose conforms to another vision of the Crucifixion, which Bridget herself experienced: "And as I, filled with sorrow, gazed at their cruelty, I then saw his most mournful Mother lying on the earth, as if trembling and half-dead. She was being consoled by John and by those others, her sisters, who were then standing not far from the cross on its right side."[91]

Barocci simplified the scene and eliminated any figures other than Saint John, as he had done in his earlier depiction. In his three Crucifixions, and the one in his small devotional picture *Saint Francis in Prayer* (cat. 17), Barocci omitted the bleeding wound on Christ's side; he included it here in order to emphasize his wounds as a source of Mary's suffering.

The depiction of Mary at the Crucifixion was aimed at establishing her "full participation" in the most important representation of Christ's physical sacrifice. Increasingly, sixteenth-century depictions of the Crucifixion, and more often the Deposition from the Cross, showed her in the process of fainting.[92] Theolo-gians had argued that to show Mary in such a state negated her special state of grace, and therefore few artists chose to show her in a full faint, as Barocci had done in his earlier *Deposition.*[93] However, the popularity of writings such as those of Bridget, as well as the ideas advocated by theologians, such as Ignatius Loyola, urging the faithful to conjure up the physical experience of biblical events, encouraged the visualization of the suffering and wounding of Christ. By focusing on Mary's torment as she gazes upon her dead son, Barocci created a powerful meditation on the wounds of Christ, where Mary serves as the mediator for the chapel visitor.

The position of Christ's feet, an apparently minor detail, may seem to be an arrangement that was chosen for compositional reasons rather than to focus on Mary's response to Christ's suffering. However, the rarity of the position within the enormous number of Crucifixion images demonstrates that few artists deviated from the preferred right-over-left position. The year after the Genoa altarpiece was completed, Barocci was commissioned to paint another Crucifixion for the Oratorio della Morte in Urbino (fig. 17). Bellori pointed out that some of the painting was done by Barocci's students (he claimed the figures at the base of the cross were by Alessandro Vitali), and it appears that perhaps the figure of Christ was as well. Nonetheless, the altarpiece was created using the drawings developed by Barocci for the Genoa painting. However, the position of Christ's feet was not copied. Rather, the painting used the ubiquitous format for the Crucifixion, with the right foot laid over the left. The painting overall has the sense of a pastiche of reused elements rather than a newly invented meaning. Mary and John were repeated, although on the opposite side from the Genoa painting, and the kneeling Mary Magdalen has been adopted from the Senigallia *Entombment.* Therefore, it all suggests that Barocci was not very involved even in the design of the composition, but it is noteworthy that the position of Christ's feet was not copied, for it did not have resonance for the Oratorio altarpiece.

Barocci painted the Crucifixion one more time during the first years of the seventeenth century, offering another completely new interpretation. *Christ Expiring on the Cross* (fig. 18), today in the Prado, was commissioned by Francesco Maria II della Rovere, who made the final payment to Barocci on 28 August 1604.[94] Barocci's earliest version of the narrative (cat. 2) portrays a Christ who seems just to have died (having not yet received the lance wound of the Roman soldier who tested to see if he was dead). Barocci's Genoa painting depicts a lifeless Jesus, with his eyes closed and his head drooping. This last time, the artist painted a still-living Christ, eyes heavenward and mouth opened, adapting the head from a drawing he had developed some years earlier for the blessing Christ at the Last Supper (cat. 12.2). Very likely, Barocci selected the moment recorded in all four Gospels, when, after the sky turns dark and the sun is covered, Christ cries out.

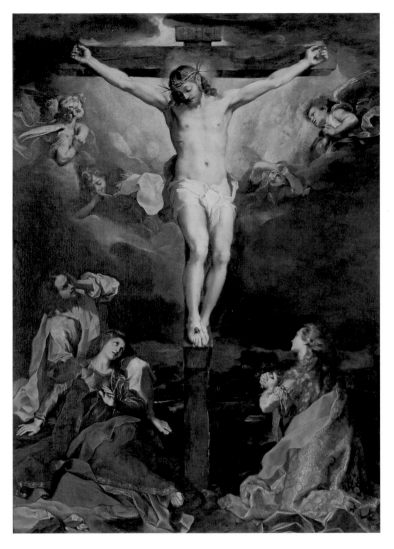

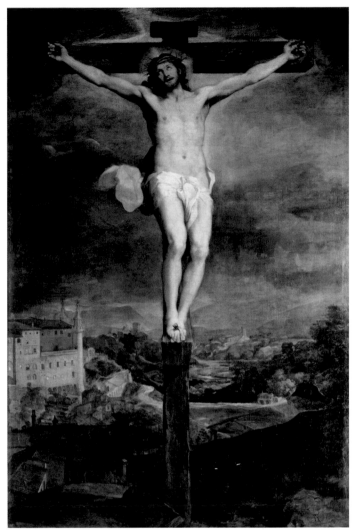

Fig. 17. *Crucifixion*, ca. 1597–1604. Oil on canvas, 360 x 297 cm.
Oratorio della Morte, Urbino

Fig. 18. *Christ Expiring on the Cross*, 1600–1604. Oil on canvas, 374 x 246 cm.
Museo Nacional del Prado, Madrid, inv. P07092

Luke's account is the simplest and accords well with Barocci's image: "It was now about the sixth hour, and the sun's light failed, so that darkness came over the whole land until the ninth hour. The veil of the Sanctuary was torn right down the middle. Jesus cried out in a loud voice, saying, 'Father, into your hands I commit my spirit!' With these words he breathed his last."[95]

Barocci painted a muscular figure, animated and speaking; the fissure in the sky (rather than the auras that accompanied each of the previous versions) recalls the Gospel reference to the rending of the temple veil. The wood support itself appears to divide the sky, while clouds waft in front of the crossbar. As Christ is about to expire, the viewer is afforded a breathtaking view of the ducal palace in Urbino and the landscape looking toward the southern approach to the town.

Seldom addressed in the literature on this painting is its daring presentation of Christ's cross. Barocci eliminated any of the attending figures included in his other *Crucifixion*s; in so doing,

he was able to bring the front of the cross nearly contiguous with the picture plane. Thus, he created a painting that initiates the general trend of the early seventeenth century for the depiction of an isolated Christ, without attendants or the accompanying two thieves from the Bible text.[96] More importantly, Barocci evoked near-vertigo, giving the viewer the sensation of looking out over a vast distance from an elevated position in front of the cross, eliciting a visceral response to the experience of Christ's impending death. The inclusion of a very detailed Urbinate landscape forming the backdrop of Christ's demise (the most expansive view of Urbino in any of Barocci's paintings) was undoubtedly done for the benefit of the duke, who by 1604 had been living in Pesaro and Casteldurante and visiting Urbino only occasionally.[97] The manner in which Barocci presented this familiar scene shows how he continually rethought established tradition and injected new experiences and new readings into the accepted standards. What at first seems a simple presentation of

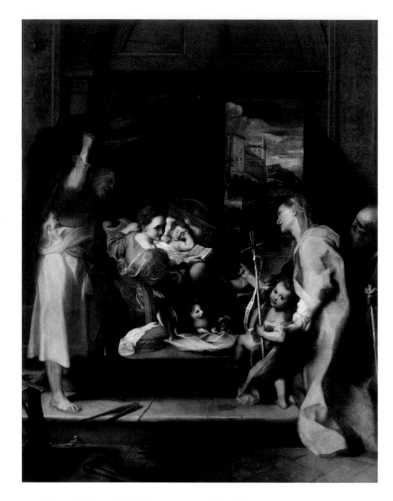

Fig. 19. *Madonna della Gatta*, ca. 1595–1600. Oil on canvas, 233 x 179 cm. Galleria degli Uffizi, Florence, inv. 1890 no. 5375

cross and banner announcing the coming of the Savior, over the stone threshold and into the room. The Christ Child's fist, which he has used to rub his eyes, and Elizabeth's manipulation of an eager toddler up the steps capture the movements of real children and testify to Barocci's observational skills. John points unself-consciously toward his cousin, sharpening the focus of the painting. Zaccharias peers into the building from the right. An open doorway at the rear affords a view of the ramparts of Urbino, with the walls and turret of the ducal palace as seen when one approaches the town from the north. Thus the artist alluded to the papal visit through the view of local topography, blending the political with the devotional in this charmingly intimate picture.[100]

Barocci created a new version of the Visitation, inverting Mary's travel to see her cousin Elizabeth into a seemingly unplanned visit by Saint John's family to the home of Mary and Joseph, a creative variation of his early fresco in the papal Casino of Pius IV in Rome (fig. 4). This image of charming domesticity enhances the sense of shared intimacy through Joseph's role as the mediator who permits a view into their private space. Barocci worked in all the requisite symbolism. Joseph, a vigorous and commanding figure, in keeping with sixteenth-century devotion to the saint that stressed his role as protector and provider for the Holy Family, has been interrupted in the midst of his carpentry.[101] His role is underscored through references to his work, with the calipers, ax, hammer, and curled wood shaving directly below his foot. Barocci chose tools that resemble the pincers and hammer from the Crucifixion that he arrayed to such powerful effect in his *Entombment* altarpiece of the late 1570s. Appealing still-life elements that draw the viewer's attention, they can also be associated with the Crucifixion. It is not accidental that they point toward the sleeping Child, lying beneath an arched headboard decorated with an angel's head reminiscent of sarcophagus imagery, thereby alluding to death. However, the real subject is Mary, made manifest by the mother cat, awakened as she nurses her young, drawing attention to the Virgin's central role as the nurturing vessel for the Savior. Mary's recumbent pose also refers to her later response to Christ's Passion, her swoon when she reclines at the foot of the cross.

As Barocci entered the final decade of his career, his production declined considerably, and three of the major pictures he undertook remained unfinished at his death. He had always been notoriously slow; because documentation on many pictures is incomplete, it is unclear exactly how long he worked on these late canvases. In any case, the germination period of his work from the 1590s and into the early seventeenth century often spanned years. Sometimes he deliberated for decades on given themes. It has already been noted that he created three distinct versions of the Crucifixion: They should not necessarily be considered three discrete projects, but rather nuanced meditations on a central theme. The Prado *Christ Expiring on the Cross*, for example, although

the crucified Christ soon becomes an intense emotional and thereby devotional experience.

Barocci's innovations continued in small-scale works as well. The *Madonna della Gatta* (fig. 19) demonstrates his creative approach to subject matter and willingness to invent new iconographies. Heavily damaged by fire in the late eighteenth century, the picture is often omitted from discussions of Barocci's oeuvre. Although its legibility has been considerably improved through a restoration undertaken nearly ten years ago, so much original surface was lost that it can no longer be taken as fully representative of the artist's hand. It is, however, fully representative of his thinking.[98] The picture was probably made for Pope Clement VIII's visit to Pesaro and Ferrara in 1598 and was most likely begun around 1596. Its visitation theme may have been related to the official arrival of the pontiff.[99]

Saint Joseph stands to the left of a wooden doorway, having pulled aside the curtain to reveal the Virgin, seated on a low chair and rocking the sleeping Christ Child while she reads from a prayer book. She turns to greet her visitors, her cousin Saint Elizabeth who helps the young Saint John the Baptist, carrying his reed

completed in 1604, was the culmination of thoughts about the representation of Christ's death that had started in the 1560s. The exhibition illustrates that point in a drawing (cat. 2.6) for the Virgin in the early Bonarelli *Crucifixion* (cat. 2) onto which the artist sketched the head of an angel, which he used later in the Senarega altarpiece in 1596 (fig. 16).[102] The *Last Supper* (cat. 12), begun in 1590, must be seen together with the *Institution of the Eucharist,* 1602–7 (cat. 18); they reveal a continued meditation spanning twenty years on the role of humility and penance in preparing for the Sacrament of the Eucharist. During the last phase of Barocci's working life, he continued to develop ideas that had engaged him earlier in his career, such as the *Lamentation* (fig. 21) and the *Assumption of the Virgin* (fig. 22), and he also tackled new subjects not undertaken before.

Christ Taking Leave of His Mother (fig. 20) demonstrates the difficulties in approaching these late pictures, for one must distinguish between evidence of Barocci's creative input and the actual execution of the painted surface. The interpretation is definitely that of Barocci. However, he probably painted the picture with considerable assistance from his workshop. It was listed in the inventory of Barocci's studio at his death; its patron and intended location are not known.[103] The subject comes from Pseudo-Bonaventure's *Meditations on the Life of Christ,* written in the fourteenth century and one of the most influential texts on Christ's life.[104] Mary Magdalen left the Last Supper to tell the Virgin the news of her son's pending death, and Christ followed, spending some moments in intimate conversation with his mother. Although rare in Italian art, both Correggio and Lorenzo Lotto had painted the episode.[105] Barocci followed the text by depicting Christ visiting his mother before he was crucified, while northern artists sometimes portrayed Jesus coming to see her after his resurrection. Barocci combined the two types by alluding to the Resurrection with a standing Christ, centered in the picture, wearing pale garments, raising his hand in blessing, with a tripartite aura suggestive of the risen Savior. The Virgin has sunk to the ground, cared for by an attendant. Mary Magdalen kneels at the right side of the composition; she is described in the text as sitting at the feet of mother and son. The Magdalen assumes a pose associated with her attempt to touch Christ when she encounters him after the Resurrection. Saint Francis, who observes from the side, is also shown without wounds, an unusual presentation for Barocci who, on other occasions, depicted not only the wounds that Francis received on Mount La Verna at the stigmatization, but also the nails that inflicted them.

This is the fourth time Barocci included the swooning Virgin, a subject that must have had specific resonance for him. Although the Madonna has not lost consciousness, she has fallen to her knees and is lovingly attended by a figure who embraces her shoulders (Saint John the Evangelist or one of the Marys?). By repeating the

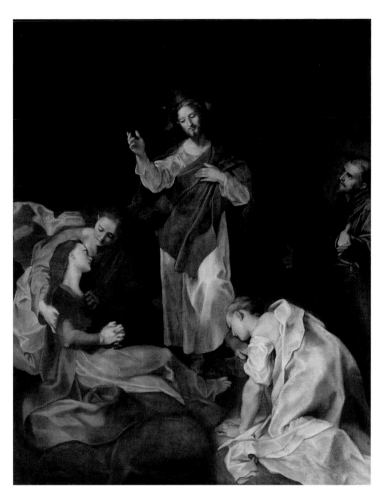

Fig. 20. *Christ Taking Leave of His Mother,* ca. 1604–12. Oil on canvas, 219 x 191 cm. Musée Condé, Chantilly, inv. PE 57

green of her mantle in the drapery across Christ's shoulder, Barocci tied the two figures together, enhancing our understanding of the cause for her swoon. Although her distress is not inspired by his physical suffering, her knowledge of his coming sacrifice causes her to lament his loss and clasp her hands in grief.

The picture's unfinished state precludes a full appraisal of it; missing background details may have refined the narrative further. Nonetheless, this late, unfinished painting indicates that during the last decade of his career, Barocci continued to embrace unusual subjects, giving them his own narrative spin. The rendering of the figures, however, lacks Barocci's facility in handling paint, and the touch is hard and somewhat ponderous. The color combinations, as Keith Christiansen observed, are uncharacteristic, and no similar coloration can be found elsewhere in the artist's oeuvre.[106]

Barocci's *Lamentation* demonstrates his late narrative gifts, although it, too, was partly executed by his assistants (fig. 21). This commanding altarpiece was undertaken for the chapel of San Giovanni Buono in Milan cathedral.[107] Discussions for a commission from Barocci had begun as early as 1592, and it came through in 1597, but the painting was never completed. The picture

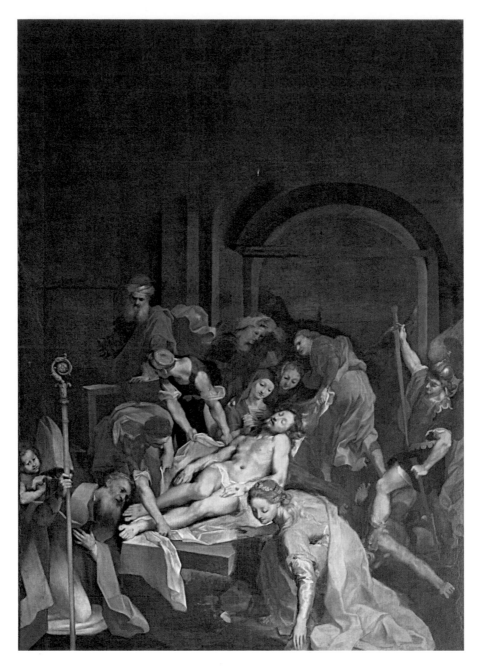

Fig. 21. *Lamentation*, 1600–1612. Oil on canvas, 410 x 288 cm.
Biblioteca Comunale dell'Archiginnasio, Bologna, inv. P 673

builds on Barocci's earlier *Entombment* (cat. 8). The attendants in the earlier picture carry Christ toward the waiting tomb slab; in the *Lamentation*, they lay him out on the burial shroud atop the slab. Whereas Mary Magdalen's role as an anointer of his body in the earlier altarpiece is merely implied by the container of ointment at the lower left, here she stoops down to open her jar as she prepares to perform this task. The *Entombment* altarpiece, in fact, returned to Barocci's studio in late 1606 or early 1607 for repair, so it may well have inspired his imagery in the *Lamentation*.[108] Some drawings for Christ's body relate to both paintings, further testimony to the similarity of the themes.[109] At least one commen-

tator has seen in Mary Magdalen's pose an uninspired adaptation of Saint John the Evangelist in Barocci's earlier *Institution of the Eucharist* (cat. 18), but in fact it is a mark of the artist's inventiveness in reusing poses and figures developed for another context, drawing additional meaning from them in their new settings.[110]

The Bologna painting, however, is not a repetition of earlier themes and figures. The recumbent dead body forms the calm anchor of a scene filled with activity and gesture, both focusing the attention of the devout observer and reaffirming the notion of Christ as the central mystery of faith. One of the patron saints, Saint John the Good, is in the left foreground, kneeling

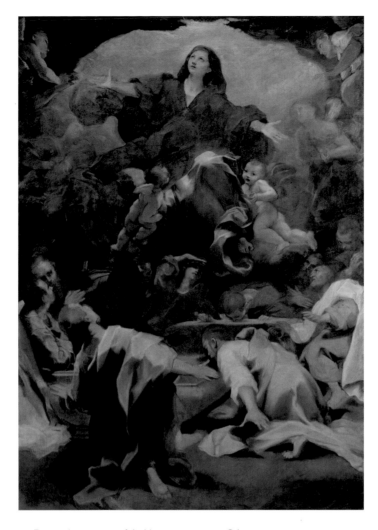

Fig. 22. *Assumption of the Virgin*, ca. 1603–12. Oil on canvas, 259 x 190 cm.
Galleria Nazionale delle Marche, Urbino, inv. 1990 D 83

before the stone slab, underscoring its relationship to an altar. Joseph of Arimathea, gesturing at the back left toward the open chamber, oversees the flurry of activity as the body is lowered onto the slab and the shroud is prepared for wrapping. One attendant turns as if to discuss with Joseph the procedure underway. At the right, Saint Michael sheaths his sword, having vanquished the devil. Although his figure is not well integrated into the larger scene, his appearance not only refers to the secondary chapel dedication to Saint Michael but also contextualizes Christ's sacrifice as a means of vanquishing sin and ensuring redemption. With the Virgin's placement close to Christ at the painting's calm center, a quiet interaction between mother and son augments the reflective tone of the picture. Barocci enhanced the poignancy of the scene by adapting a format where the figures fill only half of the available canvas height.[111] Although at times the execution displays the same hardness and stasis seen in *Christ Taking Leave of His Mother*, arguing therefore for the extensive participation by assistants, the intellect guiding the endeavor was clearly Barocci's.

The workshop intervention in the previous pictures becomes especially evident when contrasted with the other late picture that was in Barocci's workshop at his death in 1612, the *Assumption of the Virgin* (fig. 22).[112] He had worked with this subject at least since the *Madonna of the Rosary*, commissioned in 1588 (cat. 11). The related drawings for that altarpiece indicate that he simultaneously developed imagery for the Virgin being assumed into heaven.[113] Although it has no scriptural source, the idea of Mary's bodily assumption into heaven following her death addressed central issues about the Virgin's very nature and was closely aligned with the idea of her exemption from the constraints of Original Sin.[114] Such works as Titian's altarpiece in the Church of the Frari in Venice had established the iconography for this supernatural event, in which Mary's body is carried by angels into a light-filled heaven, where she rejoins her son and reigns as queen. Barocci developed poses that suggest both physical and emotional reactions to the observation of a divine event and underscore the sense of the miraculous through color and

31 Bellori 1672 (1976), 184; Bellori 1672 (2000), 178.

32 Borghini 1584 (2007), 138–39.

33 Arcangeli 1988, 405, where he described the poisoning incident as sending Barocci back to Urbino, where he "closed himself off in a hypochondriacal isolation." His further elaboration on this point was communicated to me in a private conversation in June 2003.

34 Turner 2000, 30, n. 28. Those suggesting an ulcer include Pillsbury, in Pillsbury and Richards 1978, 15, n. 14, citing the opinion of Jørgen Kringelbach, who believed that Barocci suffered from a chronic gastric ulcer, based on comparing the description given by Bellori with a condition described in Matthew Ballie, *The Morbid Anatomy of Some of the Most Important Parts of the Human Body* (London, 1793), 87. Pillsbury cited Graham Smith, "Two Drawings by Federico Barocci," *Bulletin of the Detroit Institute of Arts* 52 (1973), 91, n. 16, as the source.

35 McCullagh 1991, 59.

36 See cat. 2 for a discussion of how one of Barocci's preparatory studies for his *Crucifixion* demonstrates his knowledge of one of Michelangelo's late Crucifixion drawings.

37 Cellini ca. 1560 (1971), Book 2, part 104, 576–77; Cellini 1973, 392–94.

38 The information on salad eating was taken from a fascinating essay: Laura Giannetti, "Italian Renaissance Food-Fashioning, or, The Triumph of Greens," *California Italian Studies Journal* 1.2 (2010), accessed 15 November 2011, http://escholarship.org/uc/item/1n97s00d. I thank John Varriano for bringing it to my attention.

39 Bellori 1672 (1976), 199; Bellori 1672 (2000), 186, provided details of Barocci's disorder, including his inability to sleep, near-constant discomfort, and recurrent vomiting. On the notion that the duke may have used Barocci's slow speed and illness as a means of discouraging rival courts from monopolizing too much of the artist's time, see Lingo 2007, 193.

40 On 14 July 1608, Annibale signed an agreement with his students Giovanni Antonio Solari, Antonio Carracci, and Sisto Badalocchio to work in the workshop at least "2 hours every day." See Daniele Benati and Eugenio Riccomini, *Annibale Carracci,* exh. cat., Museo Civico Archeologico (Milan, 2006), 478.

41 Borghini 1584 (1967), 1, 569.

42 This detail about John's life is told in the *Golden Legend.* See Jacobus de Voragine 1993, 1, 53.

43 For the Correggio painting, see Ekserdjian 1997, 193–204. Turner 2000, 41, also associated Barocci's painting with that of Correggio. E 2008, 1, 74, no. 20.1, relates the gouache head study for Saint Simon in the Doria Pamphilj (inv. 247) to Correggio. A compositional sketch now in the Louvre, inv. 2849 (E 2008, 1, 179–80, no. 20.5, illustrated), supports the idea that Correggio's painting was a model, reflected in the architectural elements in the background as well as the draped cloth of honor.

44 On the rosary, see cat. 11.

45 The painting has been well discussed in the literature; see E 2008, 1, 310–49, no. 38; Lingo 2008, 48–61, 196–201; Nicoletta Lepri and Antonio Palesati, "La consegna della *Madonna del Popolo* del Federico Barocci alla confraternita di Santa Maria della Misericordia," *Bolletino d'informazione. Brigata aretina amici dei monumenti* 35 (2001), 46–52; Gianotti 1999.

46 Gualandi 1844, 137.

47 Hall 2011, 206.

48 See Lingo 2008, 60, 250, n. 58. For the documents, see Gualandi 1844, 176–82.

49 Lingo 2008, 48–60, analyzed the painting within the tradition of the Madonna della Misericordia and demonstrated that Barocci wedded it to the more modern idea of a dramatic-vision altarpiece. David Ekserdjian, in an essay that I was permitted to read prior to its publication, argued that this altarpiece does not build on the idea of the Madonna della Misericordia, but upon the "Double Intercession" type of altarpiece. He noted that Barocci had painted a tondo of God the Father above the altarpiece, so the *Madonna del Popolo* therefore included essential elements of the "Double Intercession" type, a hierarchy from the people through the Virgin (who typically offers her breast to her son), to Christ and the Holy Spirit, and on to God the Father. For Ekserdjian's

ideas on the *Madonna del Popolo,* see his entry in Suzanne Folds McCullagh, with the assistance of Kate Tierney Powell, *Capturing the Sublime: Italian Drawings of the Renaissance and Baroque,* exh. cat., Art Institute of Chicago (New Haven, 2012), 88–90, no. 40.

50 See cat. 6 for a discussion of the doctrine and related bib. David Ekserdjian (unpublished essay) argued that the Misericordia drawing (Uffizi inv. 11446 F., cat. 6.1) was done not for the *Immaculate Conception,* but for the *Madonna del Popolo.* I agree with Bohn's assignment of the drawing to the former picture and also that many drawings were not necessarily discrete meditations on any single picture, but that Barocci often revisited and developed ideas from one painting to another.

51 See cat. 4, n. 39, for a description of the *Rest on the Return from Egypt* covered with a green curtain in Lucrezia d'Este's apartment. See also cat. 7, where Plazzotta discusses the *Madonna del Gatto* as a work intended for the personal apartment of Laura Cappello, Duchess of Brancaleone.

52 I want to acknowledge and thank Babette Bohn, who shared her thoughts about this very issue in her response to an earlier version of this essay.

53 On the relationship between Barocci and the duke, see Olsen 2002; Lingo 2007, 187–88, argued that Francesco Maria II inherited an impoverished duchy and was forced to instill austerity measures, leaving no funds for commissioning paintings until the following decade.

54 On this subject, see Lingo 2007, 189–90.

55 The contract was signed on 20 June 1580, and the painting was completed by late April 1583.

56 As told in the *Golden Legend,* Jacobus de Voragine 1993, 1, 249–50.

57 Olsen 1962, 172.

58 See Madsen 1959, who illustrated what survives of this picture. The surface at present consists of only two narrow strips of paint; almost all the rest is bare canvas.

59 E 2008, 2, 71–87, no. 47.

60 Luke 5:1–11; text from *The New Jerusalem Bible.*

61 Matthew 4:18–20; Mark 1:16–18; Luke 5:1–11, *The New Jerusalem Bible.*

62 Olsen 2002, 202–4, noted that when Barocci was commissioned in 1583 to paint a portrait of the duke to send to the Medici grand duke, he had to suspend work on two commissions then underway, the *Calling of Saint Andrew* and the *Annunciation.*

63 I must thank and acknowledge Riccardo Lattuada, who shared this observation with me years ago in conversations about Barocci. On the proverb, see Katharine M. Rogers, *The Cat and the Human Imagination: Feline Images from Bast to Garfield* (Ann Arbor, 1998), 22.

64 Lingo 2008, 168.

65 Turner 2000, 92, who described the painting as a "short-cut."

66 Olsen 1962, 183, accepted the Uffizi version as autograph; Turner 2000, 92, identified it as a "bozzetto for the colours."

67 Lisot 2009, 166–71, discussed this painting as Christ offering himself to Mary, an invitation to partake of the Eucharist.

68 E.g., a drawing in the Louvre (inv. 2886) represents her fingertips cupped over the ear. For an illustration, see E 2008, 2, 79, no. 47/A.16.

69 This was used by Titian to good effect: the Magdalen grasps the jar as a substitute for Christ's body in his *Noli me tangere* of ca. 1514. See Penny, in David Jaffé, ed., *Titian,* exh. cat., National Gallery (London, 2003), 86–87, no. 7.

70 E 2008, 2, 89, who cited the recent work by Grazia Calegari on the church and the confraternity, having discovered several documents of the 1580s.

71 Ibid., 89.

72 Eiche 1982.

73 See cats. 8, 12, and 17.

74 These numbers take into account those compositions for which multiple versions were made. Therefore, the *Rest on the Return* counts as four paintings; the *Calling of Saint Andrew* as two; and *Aeneas Fleeing Troy* as two. The 1590s also include three self-portraits, not all of which are accepted as autograph. Even if they were, they represent much easier commissions to complete. In fact, nine of the paintings in the 1590s were portraits.

75 Lavin 1965, 542.

76 See cat. 16 for the history of the commission, paid by Duke Francesco Maria II.

77 See Virgil, *The Aeneid,* trans. Patric Dickinson (New York, 1961), 50, esp. 2.711–16. I want to thank Maggie Abbott, who provided essential research for this painting and brought the Genga version to my attention.

78 Olsen 1962, 190–92; and E 2008, 2, 249–67, no. 72, both give relevant documentation, although none exists for the commission. For the most recent bib., see Gillgren 2011, 262, no. 39.

79 Jacobus de Voragine 1993, 1, 152.

80 Luke 2:22–24, *The New Jerusalem Bible:* "And when the day came for them to be purified in keeping with the Law of Moses, they took him up to Jerusalem to present him to the Lord . . . and also to offer in sacrifice, in accordance with what is prescribed in the Law of the Lord, a pair of turtledoves or two young pigeons." The Jewish tradition for the purification of women can be found in Leviticus 12:6: "When the period of her purification is over . . . she will bring the priest at the entrance to the Tent of Meeting a lamb one year old for a burnt offering, and a young pigeon or turtledove as a sacrifice for sin."

81 On the *Saint Jerome,* see E 2008, 2, 169, no. 58.

82 On Saint Bridget's vision of the newborn Christ and its impact on Nativity imagery, see cat. 15.

83 Uffizi inv. 11486 F. verso includes three images related to a seated saint in an interior setting adoring a crucifix. The same sheet contains several pen and ink and wash drawings exploring a Nativity set in a barn interior, suggesting that these images were developed together during the mid-1590s.

84 Presumably, Spinola's connection with one of the ship commanders at Lepanto (also Ettore Spinola), who was killed in that battle, may have been the reason he approached Francesco Maria, for the duke, too, was a veteran of the battle.

85 Spear and Sohm 2010, 85–88, included a table of Roman altarpiece prices between 1590 and 1700. Although they did not include comparable information for Genoa, one can still understand that Barocci was very well paid, as Spear noted in his chapter on Rome, 56.

86 For a fuller discussion of the commission, see E 2008, 2, 172, no. 59. Bellori included a famously profuse letter from Senarega praising Barocci, long assumed to be partly Bellori's embellishment as a means of reinforcing his high opinion of Barocci's style. Discovery of the actual letter in the Senarega archives shows that it was, indeed, the opinion of the doge. See Michael Bury, "The Senerega Chapel in San Lorenzo, Genoa: New Documents about Barocci and Francavilla," *Mitteilungen des Kunsthistorischen Institutes in Florenz* 31.2–3 (1987), 355–56.

87 Recounted in the *Golden Legend.* See Jacobus de Voragine 1993, 1, 97.

88 John 19:27, *The New Jerusalem Bible.*

89 Harris 1990, 3–4.

90 *The Revelations of St. Birgitta of Sweden* 2008, 169, 1:23. See cat. 17 for a discussion of Barocci's use of one rather than two nails for the feet of Christ. Lisot 2009 also noted the influence of Saint Bridget's writings on this painting, although her analysis is based on the analogies to Bridget's text as a means of effectively inspiring meditation on Christ, rather than to the emphasis on wounds.

91 Harris 1990, 189, Book 7, 13–14.

92 Hamburgh 1981, 45.

93 See Bohn's discussion of this issue in relation to the *Deposition,* cat. 3.

94 For the commission and payment, see E 2008, 2, 273–78; Gillgren 2011, 262–63, no. 40.

95 Luke 23:44–46, *The New Jerusalem Bible.*

96 Mâle 1932, 276.

97 It is not Barocci's widest landscape. That distinction goes to a late picture (dated 1610) the *Saint Catherine of Siena,* painted for the sanctuary dedicated to Saint Margaret in Cortona and mentioned by Bellori 1672 (1976), 198; Bellori 1672 (2000), 180. The painting, still in situ, rarely figures in the Barocci literature. Pillsbury, in Pillsbury and Richards 1978, 20, n. 46, noted that the picture was, at that time, untraceable. Emiliani did not include it in his 2008 catalogue. The saint appears on a terrace with a balustrade behind her, beyond which is a vast but unidentifiable landscape—not Urbino. Due to an unfortunate approach to restoration undertaken in the 1980s, it is difficult to ascertain whether the painting is autograph. On the restoration, see Andrea Rothe, *Personal Viewpoints,* ed. Mark Leonard (Los Angeles, 2003), 19.

98 Di Pietro 1913, 168, noted the blackened surface of the picture; Olsen 1962, 188, described the painting as being in a "complete state of ruin." E 2008, 2, 138, noted that it did not appear in the 1975 exhibition due to its compromised condition. Restored in 2003, the picture was the subject of a publication and exhibition. See Natali 2003, esp. 47–61.

99 Ibid., 35–36.

100 Ibid., 35–38. Natali advanced the idea that the theme may relate to an event in the duke's own family: he had a son born to him when he was of advanced age, which would date the picture to around 1605.

101 On contemporary devotion to Joseph, see cat. 4.

102 That same drawing was very likely used by the members of his workshop for the *Crucifixion* in the Oratorio della Morte in 1597.

103 Calzini 1913b, 75. Christiansen 2005a, 727, suggested that the picture was undertaken as an altarpiece for Barocci's funerary chapel.

104 Isa Ragusa, ed., *Meditations on the Life of Christ: An Illustrated Manuscript of the Fourteenth Century,* trans. Rosalie Green (Princeton, 1962), LXXII, 308–9.

105 For the Correggio painting, see Ekserdjian 1997, 43–45; for the Lotto, see David Alan Brown, Peter Humfrey, and Mauro Lucco, *Lorenzo Lotto: Rediscovered Master of the Renaissance,* exh. cat., National Gallery of Art (Washington, D.C., 1997), 121–24, no. 17.

106 Christiansen 2005a, 727–28.

107 E 2008, 2, 312–27, no. 83.

108 Lingo 2008, 113–19, discussed the relationship of the two pictures in the more general context of Barocci's rethinking of the role of the altarpiece as a conveyer of a story versus an icon for worship.

109 Albertina inv. 546, e.g., seems close to a number of the drawings listed by Emiliani for the *Lamentation* (E 2008, 2, 83.16, e.g.). Birke and Kertész 1992–97, 1, 300; and Schmarsow 1909, 3, 32 (identifying it as no. 641) associated it with the Senigallia *Entombment.*

110 Turner 2000, 133; and E 2008, 2, 314, no. 83, noted that the relationship between the Magdalen and Christ in this picture is one of the artist's most beautiful.

111 The device is remarkably similar to the late work of Caravaggio, in which the darkened void above his figures lends pathos to the depicted events, such as the Valletta *Beheading of Saint John the Baptist* or the *Burial of Saint Lucy* in Syracuse, although surely there is no direct influence between them. For those paintings, see Catherine Puglisi, *Caravaggio* (London, 1998), 297–308 and 317–19.

112 E 2008, 2, 328–41, no. 84; Olsen 1962, 212, no. 66; and Gillgren 2011, 267, no. 50.

113 A drawing in the Uffizi, inv. 11552 F., suggests that Barocci's ideas for the *Assumption* and the *Madonna of the Rosary* were connected. The *primo pensiero* for the *Assumption* shows Mary cloudborne, high above the apostles. In the center, directly beneath her, Saint Thomas holds her girdle. This relates Barocci's ideas on the Assumption to the narrative he considered using in lieu of the *Madonna of the Rosary.* See cat. 11. For the drawing, see E 2008, 2, 332, no. 84.2, illustrated.

114 On the close relationship between these two doctrines, see P. Gabriele Maria Roschini, *L'assunzione e immacolata concezione: Assunta perche immacolata* (Rome, 1950).

115 Arcangeli 1988, 406–8; Caldari 2009, 337, no. 68; and Scrase 2006, 208, no. 76, use this very term.

116 Sangiorgi 1989, 186. It is the entry for 1 October 1612, on fol. 83r.

117 Christiansen 2005a, 727.

118 Spear, in Spear and Sohm 2010, esp. 56 and 85–88.

119 Gillgren 2011, 16.

120 Rudolf and Margot Wittkower, *Born under Saturn: The Character and Conduct of Artists: A Documented History from Antiquity to the French Revolution* (New York, 1963), esp. 79–81.

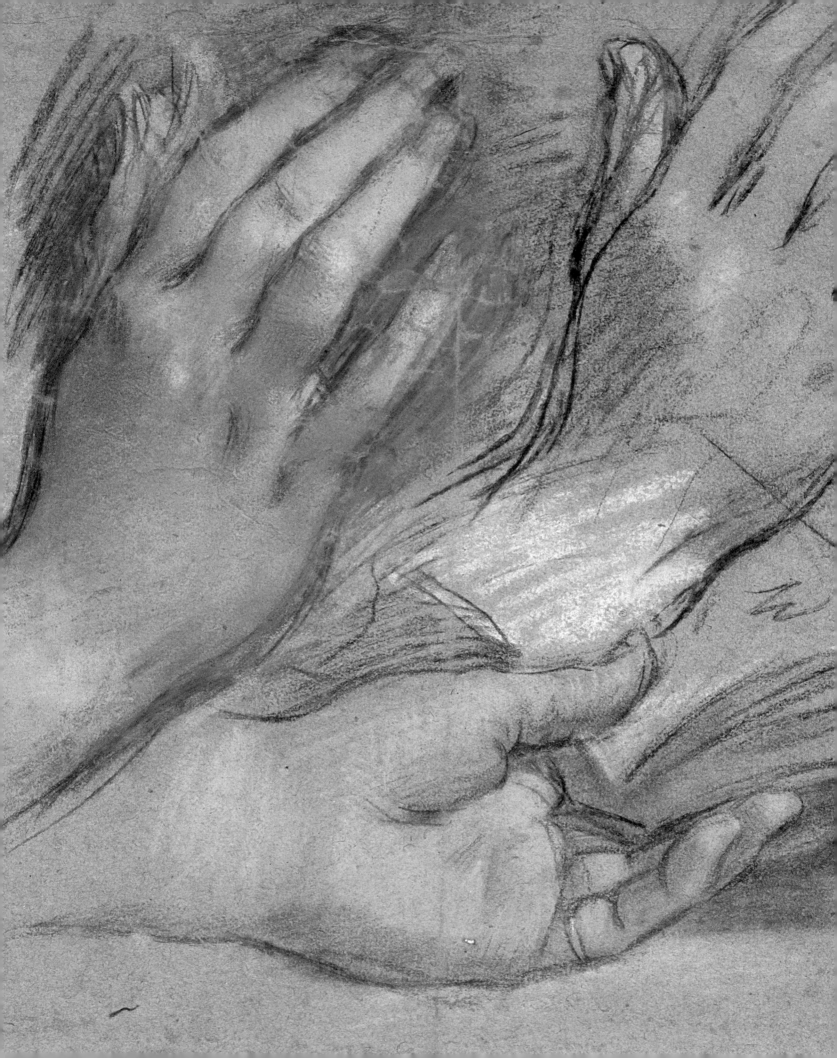

Drawing as Artistic Invention
Federico Barocci and the Art of Design

BABETTE BOHN

Introduction

Federico Barocci's oeuvre of some fifteen hundred extant drawings distinguishes him as one of the most prolific and original draftsmen in the history of Italian art. We have more preparatory drawings for paintings by Barocci than by any other Italian Renaissance artist, thanks to the long preliminary procedures he developed. This huge oeuvre has provided a wealth of information for scholars about his draftsmanship and preparatory processes, but it has also posed problems, given the difficulty of mastering such a large corpus and the practical obstacles to visiting all of the eighty or more collections with Barocci drawings.[1]

This rich corpus means that we know a great deal about Barocci's draftsmanship and preparatory procedures, much more than about most early modern artists. His drawings elucidate a lengthy creative process for paintings, employing both traditional and untraditional drawing types and media; paradoxically, he was both methodical and inventive.[2] Many of Barocci's preliminary studies employ pastel, colored chalks, oil paint, or gouache, and he incorporated color into pictorial preparation to a greater degree than any earlier Italian artist. Another innovation, as John Marciari and Jan Verstegen demonstrated, was his unprecedented reliance on several types of drawings that were the same size as the paintings they prepared.[3] Barocci was also perhaps the artist of his generation most dedicated to life drawing, at least for male figures, a practice that contributed to the naturalism of his paintings. His lengthy design procedures, however, sometimes led him away from his initial life studies, tempering naturalism and promoting idealization.

The seemingly paradoxical coexistence of Barocci's meticulous design procedures with his remarkable inventiveness constitutes one of the many ways in which he resembles Leonardo da Vinci. Like Leonardo, Barocci was constantly reinventing himself, sometimes appearing more engaged with the creative process than with its end result in painting. Many aspects of his approach to the figure, draperies, landscape, light and dark, and color seem analogous to Leonardo's views and practices. Although it is unlikely that Barocci had the opportunity to see many of Leonardo's works, he probably had access to a manuscript version of Leonardo's *Trattato della pittura* (*Treatise on Painting*).

Barocci's drawings pose particular challenges to scholars, for in addition to being numerous and geographically scattered, they are technically diverse. Furthermore, his proclivity for repeatedly drawing a figure or anatomical detail—as many as ten times[4]—necessarily raises questions of connoisseurship. I have rejected many attributions to the artist, some specifically in this catalogue; this accounts for my lower estimate of fifteen hundred extant drawings, as opposed to the two thousand generally suggested by modern scholars.[5] Other artists admired Barocci's achievements, and his works were often copied, sometimes in drawings of very high quality.[6] Nevertheless, it is undeniable that the artist himself often redrew the same motif repeatedly, to an extent that is unthinkable for any other Italian artist. One of the goals of this essay is to come to terms with the reasons behind this remarkable repetitiveness and to reconcile it with the seemingly incongruous fact of Barocci's extraordinary inventiveness.

Opposite: *Study for the Virgin's hands* (detail), cat. 9.5

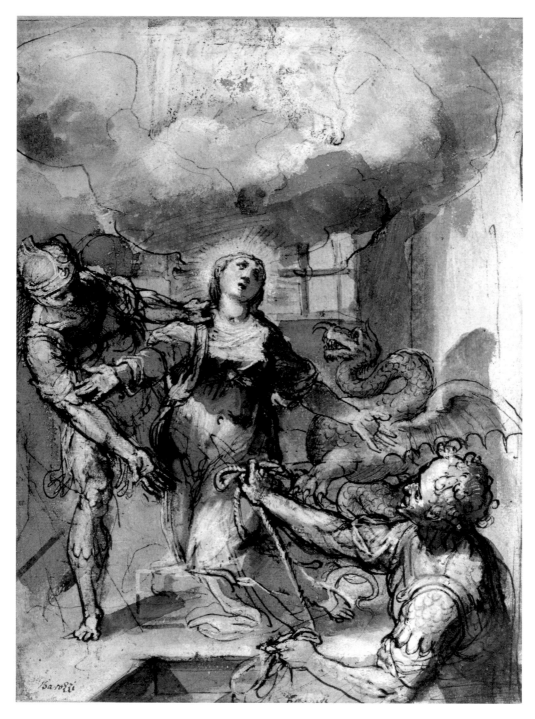

Fig. 25. *Martyrdom of Saint Margaret*, ca. 1555. Pen and brown ink with brown wash heightened with white, 28.3 x 12.3 cm. Victoria and Albert Museum, London, inv. D.1084-1900

not altogether convincing poses, proportions are not naturalistic, and much attention has gone into creating the dramatic lighting evoked by the wash and white heightening. The slightly later *Saint Cecilia* demonstrates an increased command of techniques and figures; the wash and white heightening describe more detail, resulting in forms that are vividly enunciated in light and shadow, although the figures are still elongated and were not drawn from life. The same qualities characterize the few known drawings for Barocci's

Martyrdom of Saint Sebastian of 1557–58. Although some figures in the painting (fig. 3) are more naturalistic, no extant drawings for this work are life studies (see, e.g., fig. 26).[15] Barocci's skills had progressed by 1557, but he had not yet established his mature practices or mastered figurative naturalism. Although his command of drawing media is already evident, resulting in luminous and volumetric figures, his lengthy preparation and commitment to life drawing cannot be confirmed in his practice for another decade.[16]

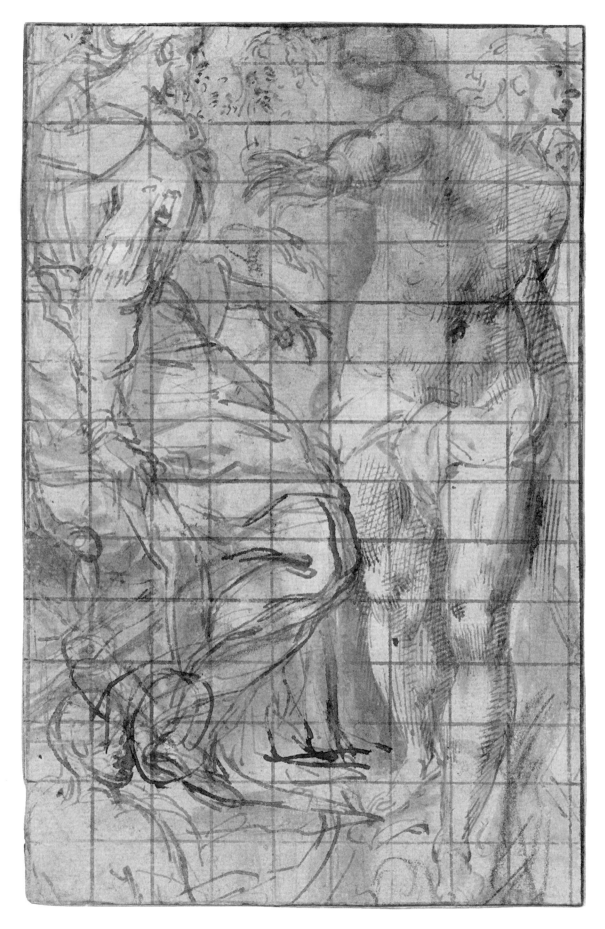

Fig. 26. *Study for the Martyrdom of Saint Sebastian,* 1557–58. Pen and brown ink over black and some red chalk, squared in brown ink, 20 x 13 cm. The Fitzwilliam Museum, Cambridge, inv. PD.1-2006 recto

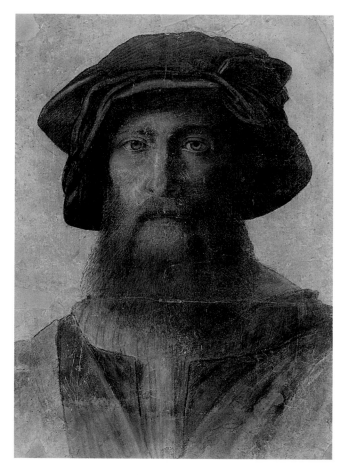

Fig. 27. Attributed to Timoteo Viti, *Portrait of a man (self-portrait?)*,
ca. 1544–66. Black chalk, pastel, and watercolor, 50.8 x 37 cm.
The British Museum, London, inv. 1860,0616.95

employ pastels extensively and in a variety of colors. Bellori claimed that Barocci learned this technique from *pastelli* by Correggio.[51] Alternatively, Barocci might have encountered examples by Raphael or Timoteo Viti, another predecessor in Urbino. One pastel ascribed to Viti (fig. 27) was in the Antaldi collection in Urbino, where it was presumably known to Barocci. But although the use of pastel in this beautiful sheet may have influenced Barocci, the carefully detailed technique is quite different from his freer handling.[52] Indeed, there are no real precedents for Barocci's singular use of pastels; as Marilyn Lavin and Charles Dempsey observed, pastels provided a means of imparting tonal unity to his drawings that parallels the harmonious coloring in his paintings.[53] McCullagh hypothesized that Barocci's attraction to pastels, beginning shortly after his health problems developed, may have been motivated by medical necessity, if he was suffering from lead poisoning caused by exposure to toxic oil paints.[54]

Modern writers often do not differentiate between colored chalks deriving from natural minerals, and pastels from artificial sources. It is impossible to distinguish between the two without chemical analysis, and even chemical testing can be inconclusive. Several sixteenth-century writers confirmed the use of *pastelli*, including Benvenuto Cellini, Antonio Francesco Doni, and Giovanni Paolo Lomazzo.[55] Burns argued that the *pastelli* used by Italian artists such as Barocci were fabricated drawing sticks, made from either natural or artificial sources, and that the term signifies the method of their fabrication, rather than materials.[56] Because it is impossible to do chemical analyses of Barocci's drawings, I will use the term "pastel," with the understanding that we cannot conclusively identify the materials in Barocci's fabricated sticks.

Second Trip to Rome and Early Maturity as a Draftsman, up to 1570

According to Bellori, after a few years in Urbino, Barocci returned to Rome in 1560.[57] His principal accomplishments there—frescoes in the Casino of Pius IV and the Vatican Belvedere—were painted in 1561–63, ending when Barocci returned to Urbino, ill and convinced that he had been poisoned by a jealous rival.[58] This essay focuses on Barocci's drawings for oil paintings, so comments about his preparation for these frescoes will be brief. But it is noteworthy that few studies for these works were made from life. A drawing of legs and feet that arguably prepared a putto,[59] a study of Zaccharias's left arm for the *Holy Family*,[60] and a sheet depicting Moses for *Moses and the Serpent* may be life studies.[61] But this is a small group, in the context of the thirty-three drawings that Emiliani connected to these frescoes. Most are compositions, studies for the framework, or full-figure drawings that seem too generalized to be life studies.

landscape drawings; only thirty-three survive.[48] Most numerous among all types of drawings, however, were pastels. The inventory differentiated between heads in pastel that were highly finished (one hundred), less finished (eighty), and even sketchier (ninety); and the undifferentiated eight hundred miscellaneous drawings included another hundred pastels.[49]

These two early sources—Bellori and the inventory—are not foolproof, but they are critical for understanding Barocci's preparatory procedures. They elucidate his long creative process for paintings, the remarkable variety of design instruments he used, the importance of drawing from life, and his reliance on the innovative media of oil and pastel.

Although most of Barocci's drawings were executed in black chalk or charcoal with white chalk or white heightening on blue paper, he was one of the first Italian artists to experiment extensively with pastels, beginning in the 1560s.[50] Pastels (*pastelli*) were created by mixing colored pigments with a binding agent, forming a paste that was rolled into sticks, which could be used as drawing instruments after they dried. Although some accounts trace the inception of pastels to the fifteenth century, Barocci and his Venetian contemporary Jacopo Bassano were the first Italians to

This pattern among Barocci's surviving preparatory drawings began to change after his return to Urbino. The naturalistic figures in the *Madonna of Saint John*, ca. 1565 (fig. 6),[62] suggest some reliance on life studies, although only two are known, for the Virgin's head and for the Christ Child.[63]

The first painting for which we have numerous drawings made from life is the *Crucifixion*, 1566–67 (cat. 2). This does not mean that Barocci did not make such drawings earlier, but this is the first painting for which a sizeable group confirms this practice. The twenty-seven extant studies include drawings from life for all three of the principal figures. Although the Virgin's body is less naturalistic than the bodies of the two men, it was in this work that Barocci first evinced his remarkable skills in portraying naturalistic figures whose affect is created by expressive gestures and poses, all based on life drawing. Perhaps his most naturalistic figure studies to date are three drawings from male nude models for the Virgin (cats. 2.3–2.5). Several drawings for Christ also betray an inception in life drawing. The final resolution of this believably human figure (cat. 2.1) shows how crucial this transformation of Barocci's drawing process was for his style and iconography. Christ's naturalism is critical in conveying the actuality of his sacrifice in dying on the cross for humanity's sake.

The *Crucifixion* marks a turning point in Barocci's development. From this point on, his increasing commitment to drawing the human figure from life is evident in a growing corpus of preparatory studies for paintings. Although few surviving drawings document this practice for the *Madonna of Saint Simon* (ca. 1567; fig. 7),[64] the convincing figures confirm that such drawings once existed. Today, however, only two studies for the Virgin's left hand testify to such procedures.[65]

With his *Deposition* of 1568–69 for the cathedral of Perugia (cat. 3), Barocci's extensive preparatory practices developed significantly. The fifty-six surviving studies for this altarpiece—more than twice the number known for any earlier work—document the creation of complex, believable poses for the twelve figures through drawing from life. This process enabled Barocci to create a range of poses, actions, and gestures that recall Leonardo's injunction: "The painter takes pleasure in the abundance and variety of the elements of narrative paintings and avoids the repetition of any part that occurs in it, so that novelty and abundance may attract and delight the eye of the observer."[66]

To portray his actors in varied poses, Barocci employed compositional studies, individual figure drawings, and studies of specific details such as heads, hands, feet, legs, and drapery. All these drawing types exist in greater numbers than for any earlier painting. A dozen compositional studies hint at the many changes in Barocci's development of this complex work. Cat. 3.1 shows an early design, before he had devised his arrangement for either the group of women or the men lowering Christ from the cross;

cat. 3.2 documents the end of his design process, when all these particulars had been resolved. The latter is the earliest surviving *cartoncino per il chiaroscuro*. Large, carefully finished, and painstakingly detailed, the *cartoncino* corresponds precisely to the altarpiece, and it was probably employed as a presentation drawing to the still relatively unknown artist's patrons.

Most surviving drawings for the *Deposition* study individual figures or anatomical particulars, executed in Barocci's favorite media of black and white chalk on blue paper. The naturalistic Christ provides a case in point. One head, six leg studies, and two drawings for the torso or full figure (including cat. 3.3) confirm Barocci's attention to drawing from life. The result is a figure of breathtaking naturalism, with a more complex pose compared to earlier works, and a careful calibration of the strong light that focuses attention on Jesus. He hangs, gracefully and asymmetrically, from the cross, his carefully conceived position providing nuanced linkages to each portion of the composition.

Another protagonist whose design is recorded in many drawings is the young woman at right, supporting the fainting Virgin. The half-dozen drawings for her include several full-figure and two head studies. Barocci began with the Virgin and her companion in reverse, using male models.[67] The next full-figure studies are reversed, clothed, and in more or less the final position (e.g., cat. 3.6); they show how Barocci evolved away from the naturalism of his initial life study to the idealization of his final conception. Cat. 3.7, for the head of the woman supporting the Virgin, records Barocci's final resolution. The cartoon fragment for this head has also survived (cat. 3.8); it was incised for transfer and used first for the *Deposition* and then in several subsequent works: for a mother in the *Immaculate Conception* (ca. 1574–75; cat. 6); for Creusa in *Aeneas Fleeing Troy* (1598; cat. 16); and, with revisions, for the Magdalen in the *Lamentation* (1600–12; fig. 21).[68] This is the first time Barocci recycled a figure in subsequent paintings, a practice that depended for its success upon his skill in altering these passages to make them suitable for different characters. Despite reutilizing the same template, the affect of each figure varies, registering, respectively, grief, maternal affection, and fear.

This procedure depends on Barocci's transfer of his designs, using incision (visible on the cartoon) to transmit an image to a painting.[69] Although this was the first instance of this practice, it was not the last. One later example is a drawing (cat. 9.1 verso) for the angel in the *Annunciation* (1582–84), reused for both the woman holding chickens in the *Visitation* (1583–86; cat. 10) and Saint Anne in the *Madonna della Gatta* (ca. 1595–1600; fig. 19). These examples testify to the importance of Barocci's retention of drawings for reuse in the studio and to his skills in transforming models for different contexts.

The *Deposition* marked Barocci's establishment of some fundamental procedures. Henceforth, he relied on numerous drawings

to design paintings, including compositional drawings and figure studies, many from life. He initiated his reliance on the transfer of designs from one painting to another; and he implemented the first in a long series of design reversals with the Virgin and her companion. For the *Deposition,* Barocci relied principally on drawings in black and white chalk on blue paper, as he did for the remainder of his career. Nevertheless, this was the first painting for which pastel was a prominent tool in his preparatory studies (e.g., cats. 3.7 and 3.11).[70] The *Deposition* was the first work for which Barocci used a *cartoncino,* which soon became a crucial part of his design procedure. Finally, from this time on, life drawing became integral to his creative process—although this practice was variable with different subjects.

Life Drawing

> The practices maintained by Barocci in his painting . . . required much effort and dedication. When working, he always referred to nature, not allowing himself to put in the tiniest detail without first checking it in the real world.[71]

As Edmund Pillsbury first observed, Bellori's generalization is somewhat oversimplified.[72] Although Barocci employed male models frequently after 1565, he also copied art works and transferred earlier designs to new paintings. Moreover, for certain subjects, including women, landscapes, and animals, his reliance on drawing from life was inconsistent.[73]

Beginning in the mid-1560s, Barocci increasingly drew men from life. As already mentioned, according to Bellori, he asked his youthful assistants to assume the poses of the figures, checking to see whether they felt any discomfort, and modifying the poses accordingly. The consequence of this process was a significant increase in figurative naturalism. Both the verisimilitude of painted figures and the existing drawings confirm Barocci's reliance on this method for the *Crucifixion* and *Deposition.*

But although his oeuvre includes some beautiful and dramatically effective female figures, Barocci's women do not share the anatomical naturalism and specificity of his men. Although drawing men from life was central to his process, there is no evidence that Barocci ever drew from living female models. Relying on male models or artistic prototypes for female figures was not unique to Barocci, but some of his methods are unusual. His means of distinguishing gender may be related to his character, patrons, geographical isolation in Urbino, methods for repetition, and approach to life drawing.

Before considering Barocci's approach to the female figure, we should briefly discuss the Italian practices that preceded him. In central Italy, although drawing from life was standard practice,

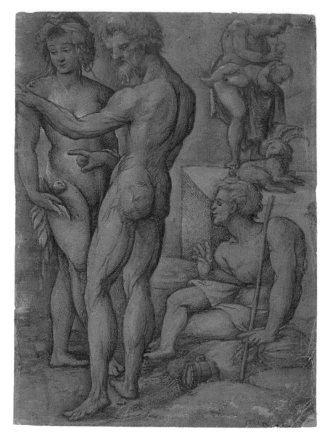

Fig. 28. Amico Aspertini, *Drawing of nudes,* ca. 1530–40. Black and red chalk and pen and brown ink with colored wash heightened with white, 21.9 x 15.9 cm. The British Museum, London, Aspertini album (London II), folio 1 recto

there are many more drawings of male nudes than female nudes. Sixteenth-century writers such as Giorgio Vasari and Giovanni Battista Armenini emphasized the importance of drawing both genders from life, though not uncritically: Nature is a source of beauty, Armenini remarked, only when corrected by a competent artist.[74] But despite literary endorsements of drawing both genders from life, there were discrepancies between theory and practice.

The question of how often Italian artists employed living female nudes as models is disputed among modern critics, but the visual evidence of surviving drawings suggests that some painters did draw nude women from life. The procedures employed for the earliest Italian sketches of female nudes—by fifteenth-century artists such as Pisanello—are debatable.[75] Reliance on female models was never universal. Seventeenth-century documents from the Florentine Accademia del Disegno record no female models, confirming that many Florentines consulted artistic rather than living models for female figures. Many relied on contemporary works. A drawing by Francesco Salviati, for example, copies a nude woman from one popular source—Michelangelo's *Last Judgment.*[76]

Numerous artists looked to antique models for female nudes. A drawing by Amico Aspertini (fig. 28) illustrates this practice.[77]

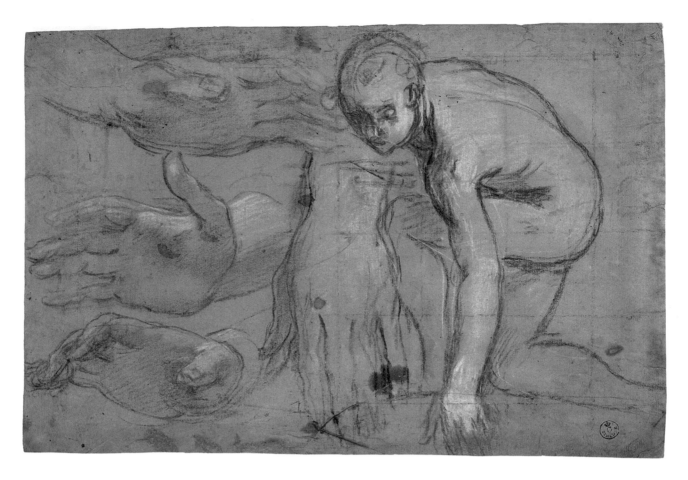

Fig. 29. *Study for Mary Magdalen in the Lamentation,* ca. 1600–1612. Charcoal and white chalk, squared in charcoal, 28 x 42.4 cm.
Gabinetto Disegni e Stampe degli Uffizi, Florence, inv. 11638 F. recto

Using artistic rather than living models was partially driven by social proprieties, as was Aspertini's discrete placement of the woman at left so that her body is partially concealed by her male companion. Moral concerns must sometimes have diminished the use of nude female models, who were frequently prostitutes. A letter of 1522 from Titian noted the convenient availability of Venetian whores as nude models.[78] The sexual license of female models was confirmed also by Benvenuto Cellini, who used the beautiful Caterina both as a model and for sex, paying her thirty *scudi* a day to pose in the nude.[79] Cost also discouraged this practice. In 1541, Lorenzo Lotto reported that female models charged ten *scudi;* a century later, Artemisia Gentileschi complained of high fees for nude female models.[80] Such accounts confirm that some Italian draftsmen drew nude women from life. And a few sixteenth-century Italian drawings—by Domenico Tintoretto, for example—appear to be based on female models, judging from their naturalistic female nudes.[81]

Artists such as Parmigianino and Michelangelo employed an alternative method: using male models for female figures. Michelangelo's drawing for the Libyan Sibyl (Metropolitan Museum of Art, New York), for example, is manifestly based on a male model. The muscular body is unequivocally male; even the frescoed figure on the Sistine ceiling retains this masculine sensibility.

Barocci used male models for female figures throughout his life, and sometimes the drawings employing this procedure are fairly traditional. One early example is a study for the Virgin in the *Madonna del Gatto* (cat. 7.2). The pose corresponds to the woman in the painting, but the drawing portrays a youthful male nude. He continued this practice to the end of his life, as seen in a study for Mary Magdalen in his late *Lamentation* (fig. 29).[82] Mary's pose is identical to that of the nude male model. In both these drawings, Barocci evidently used a young male assistant, who would have been readily and inexpensively available. Moreover, although the nursing Virgin in the *Madonna del Gatto* has necessarily acquired female breasts, no aspect of the Magdalen's body, which is seen in rear view and covered with ample draperies, betrays her gender. Barocci frequently employed poses and draperies that obfuscate the form of female bodies.

Whereas the two latter drawings employ a procedure used by many artists, some of Barocci's drawings are less conventional. In a sheet of studies for a mother in the *Madonna del Popolo* (fig. 30), the transposition from male to female is explicitly rendered.[83] Barocci began with a nude man, probably sketched from life, then

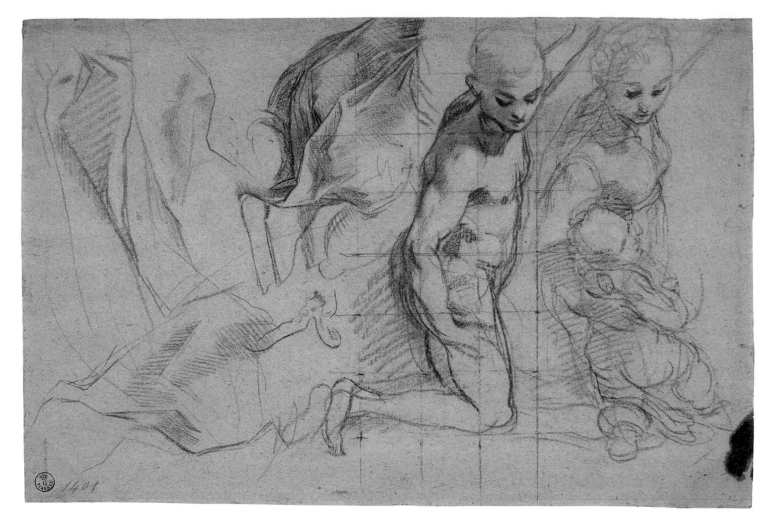

Fig. 30. *Sheet of studies for a mother in the Madonna del Popolo,* ca. 1575–79. Red and black chalk with stump, partially squared in black chalk, on faded blue paper, 21.5 x 32.1 cm. Gabinetto Disegni e Stampe degli Uffizi, Florence, inv. 1401 F. recto

redrew the figure at right, adding the feminizing elements of coiffure, female breasts covered by feminine clothing, and child.

An intriguing sheet in Berlin (cat. 2.5) is even more explicit in its transformation of gender. In this sequence of three studies for the Virgin in his early *Crucifixion,* Barocci first drew a male nude from life. His close attention to anatomy even includes the male genitals, obviously not a pertinent detail for the Virgin, but betraying her genesis in a male model. The next two studies, at center and left, add drapery that largely conceals the body. The glimpse of protuberant breasts, in the last study at left, was eliminated in the painting, where arms and drapery obscure this feminizing detail. This is the earliest example of Barocci's inclusion of male genitals in a study for a woman, a practice that is unprecedented in Italian art.

In a study for the Virgin in the *Annunciation* (cat. 9.3 recto), Barocci first drew a male nude, with genitals, in the center. The man's buttocks provided a guideline for more generous, feminine hips in the second study, at left. Now endowed with female genitals, hips, and breasts, the figure is both fleshier and more frontal.

The two heads on this sheet illustrate Barocci's proclivity for developing even female heads from male models. This partially explains the resemblance between many women in his works, as exemplified by the similarities between these studies and two unrelated works, a drawing in Modena and a painting in the Uffizi.[84]

None of Barocci's drawings of female nudes was clearly based on a female model. A drawing for the *Rest on the Return from Egypt* (cat. 4.4) is among his most naturalistic female nudes, but the woman's disproportionately small shoulders preclude her inception in a living female model. A two-sided sheet in the Rijksmuseum (fig. 31) prepared a mother and child in the *Madonna del Popolo.* Notwithstanding a relatively convincing female body, her genesis in a male model is betrayed by the muscular legs and left arm on the recto.[85]

A study for the Virgin in the *Immaculate Conception* demonstrates that Barocci sometimes employed artistic models for female figures. Cat. 6.5 was probably based on either an antique sculpture or a classicizing Renaissance work. Although Armenini allegedly saw numerous plaster casts after the antique in Urbino, early

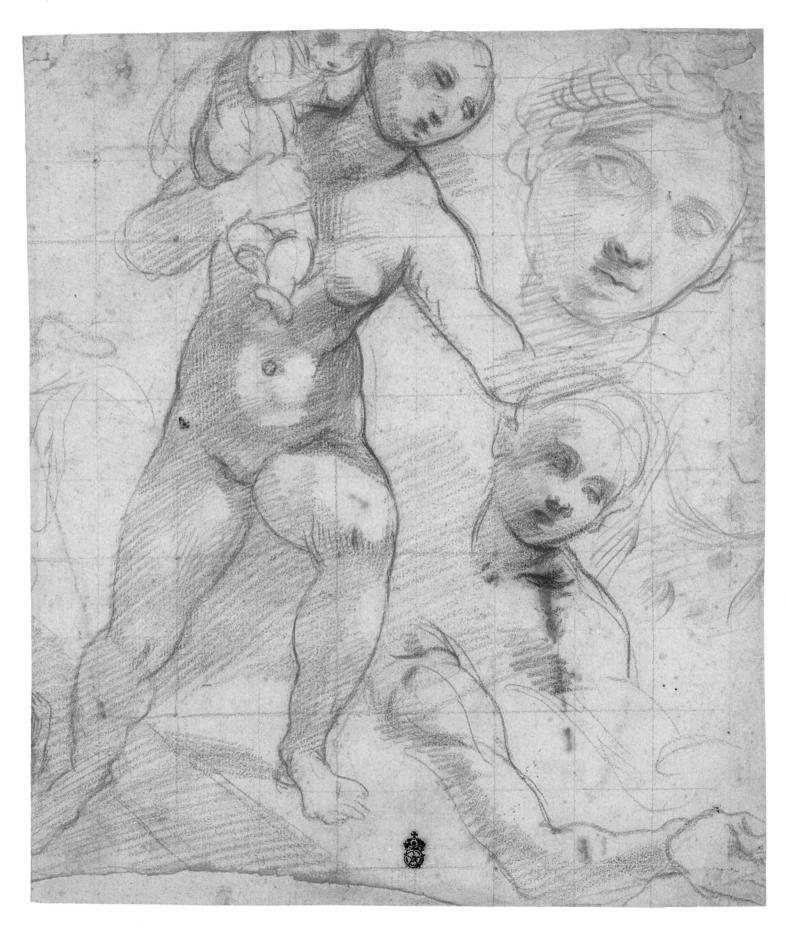

Fig. 31. *Studies for a mother in the Madonna del Popolo,* ca. 1575–79. Red chalk, 27 x 22.9 cm.
Rijksmuseum, Amsterdam, inv. RP-T-1981-31 recto

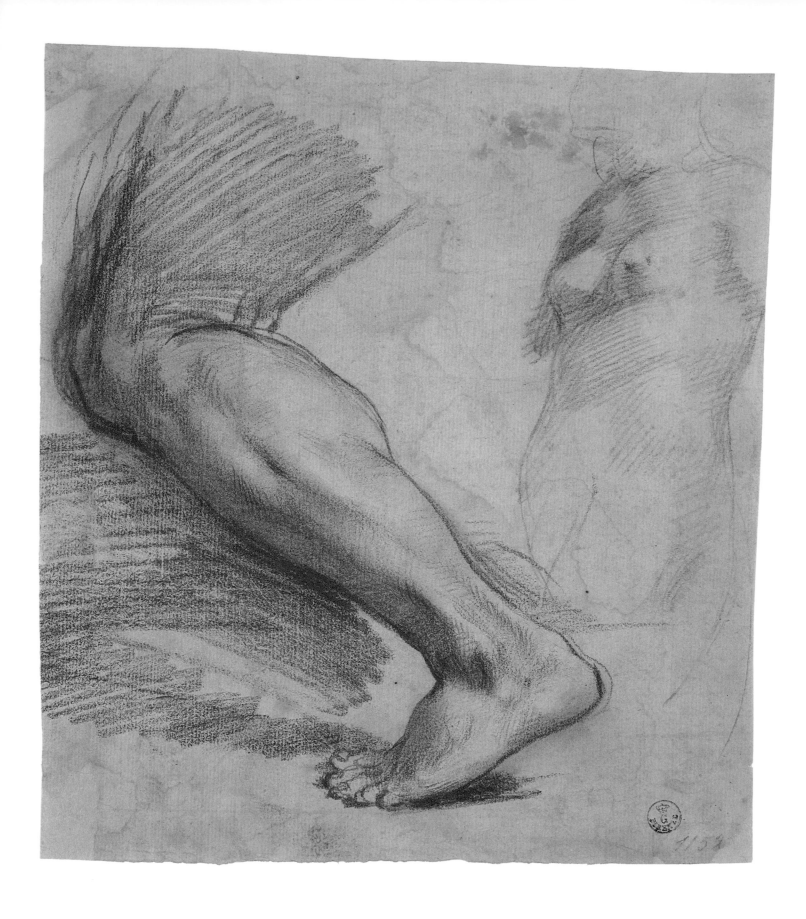

Fig. 32. *Study of a female torso after the antique and a leg for Saint John in the Madonna of Saint Simon*, ca. 1567.
Red and black chalk, 20.8 x 18.3 cm. Gabinetto Disegni e Stampe degli Uffizi, Florence, inv. 11521 F.

inventories of the ducal collections include few antiquities, and no specific antique female nudes from the ducal collections are identifiable today.[86] Claudio Pizzorusso argued that Barocci's responses to antiquity were often filtered through Renaissance intermediaries,[87] and his model may have been a Raphael drawing, perhaps one of the eighty he owned, some of which depicted women. Several Raphael drawings offer analogous approaches to the female figure.[88]

Bellori noted that during his apprenticeship with Franco, Barocci drew from plaster casts and reliefs; Fontana discussed a few drawings testifying to this activity.[89] All portray male models, apart from one caryatid drawing in Berlin, which—as Fontana observed—was probably based on a print or drawing after the antique. An unpublished drawing in the Uffizi (fig. 32) is among the few surviving sheets that may show Barocci drawing directly from an antique sculpture or cast of a nude female figure. This torso must date from about 1567; it is on the same sheet as a study for the *Madonna of Saint Simon*.[90]

Barocci's avoidance of nude female models is hardly surprising. The artist was strongly religious and, according to Bellori, never painted or drew anything that was less than proper.[91] It seems unlikely that he would have hired prostitutes as nude models, particularly working in conservative Urbino under the devout duke.

A few hypotheses about Barocci's portrayals of women seem warranted. Although he often drew men from life, there is no evidence that he used nude female models, instead consulting either male models or other artworks. The religious inclinations of both the artist and his principal patron, the duke, surely promoted an avoidance of nude female models. Although scholarship on Renaissance drawings has not considered the impact of morality on artistic practices, such views must often have diminished reliance on nude female models. Drawing from life, for most Italian artists, meant drawing men. Barocci's anomalously explicit betrayal of his sources by depicting male genitals exemplifies his idiosyncratic practices, perhaps promoted by his geographical isolation in Urbino.

Landscape studies are another category of drawings that contradicts traditional assumptions that Barocci invariably drew from life. His thirty-three extant landscape drawings seem to have been made neither in preparation for specific paintings nor, in many cases, directly from nature. Although his paintings sometimes revisited motifs in these drawings,[92] his landscape studies seem to constitute the single category of his drawings that were not made to prepare pictures. Perhaps this freedom from an ulterior purpose encouraged experimentation, to a degree that was not typical for Italian landscape drawings. Although most of the 170 landscape drawings cited in the inventory of his studio are now lost, the description testifies to their diversity: "Landscapes colored in colored gouache, watercolors . . . other landscapes drawn in light and dark, in watercolor, with lapis, all studied from life."[93]

Unlike his painted sceneries, Barocci's drawn landscapes are quite varied, in subject and technique. A few sketches in black chalk, sometimes combined with red chalk or pastel (fig. 82), are quick exercises, probably made directly from nature, given their naturalistic and casual, uncomposed character and their reliance on dry media that were easily transportable to the outdoors. Although the example illustrated in fig. 82 portrays a full scene, sometimes such drawings depict a specific motif.[94]

Barocci's most interesting landscape drawings add colored gouache, watercolor, or pastels to these traditional media. These works, including eight studies of trees, are all spontaneous, colorful, and vividly naturalistic, despite a limited amount of detail, suggesting the possibility that they were drawn from nature. Although the inventory of Barocci's studio indicates that all his landscape drawings were created from life, this sweeping generalization is not entirely sustainable. We do not know whether sixteenth-century Italian artists used gouache outdoors. Although the naturalism of some examples (such as cats. 14.1–14.3) hints at such an inception, we cannot be certain whether these works were created outside, directly from nature, or in the studio.

Four landscape drawings demonstrate Barocci's diversity in this genre. One (cat. 14.1), depicting two slender, foliated trees, illustrates a remarkable sense of light and atmosphere, achieved principally with the brush. Another tree study (cat. 14.2) is daringly economical, employing only black chalk with minimal white heightening to evoke a sense of the illuminated foliage. After making preliminary indications in black chalk, Barocci created his vividly naturalistic *Riverbank with trees* (cat. 14.3) entirely with the brush, using several colors of wash and gouache. The fourth example (cat. 14.4) illustrates another type of landscape drawing, a large, finished sheet, clearly composed in the studio rather than drawn from nature, which must have been intended from the outset for sale to a collector.

The varied subjects and media in Barocci's landscape studies are unusual for Italian drawings by this date. Apart from some of Leonardo's landscape drawings, most Italian landscape draftsmen produced full compositions in a single medium, such as pen and ink or red chalk. Most surviving sixteenth-century landscape drawings depict relatively panoramic scenes and are highly finished. Only a few sheets by Titian and Parmigianino adopt a more specific compositional scope and more casual finish. Flemish drawings by Bruegel and the Master of the Errera Sketchbook (figs. 79, 81) provide more pertinent prototypes, in their handling of media, for Barocci's innovations in landscape draftsmanship.[95]

Although the three dozen extant landscape drawings by Barocci constitute only a fraction of his original production, they testify to his originality and diversity as a landscape draftsman. Freed from the functional constraints of painting design that shaped every other type of drawing he created, Barocci's landscapes include some of his most original works on paper.

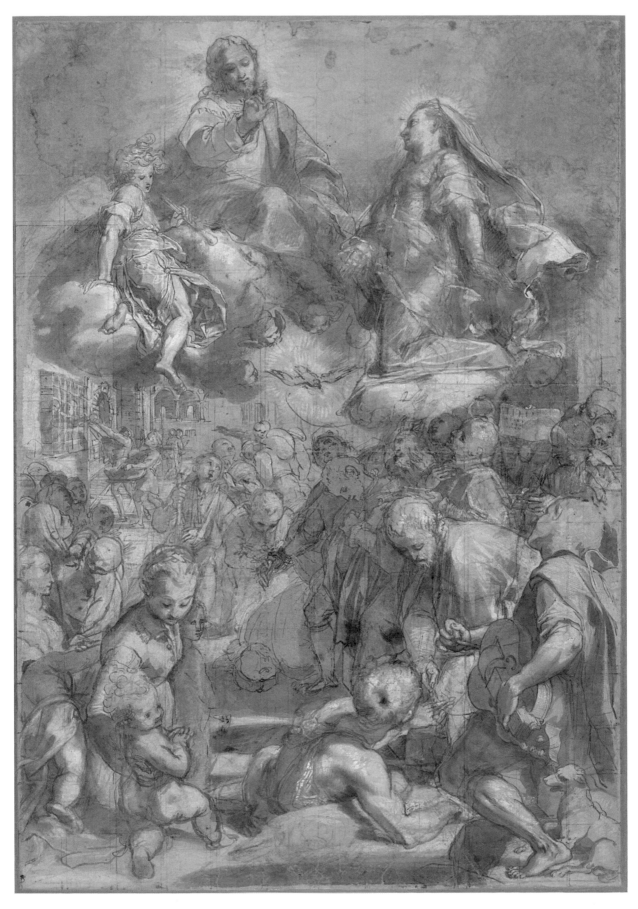

Fig. 33. *Cartoncino per il chiaroscuro for the Madonna del Popolo,* ca. 1575–79. Black and red chalk and pen and brown ink with brown wash heightened with white, lightly squared in black chalk, with a correction pasted to the original sheet in the lower-right corner. Private collection, United States

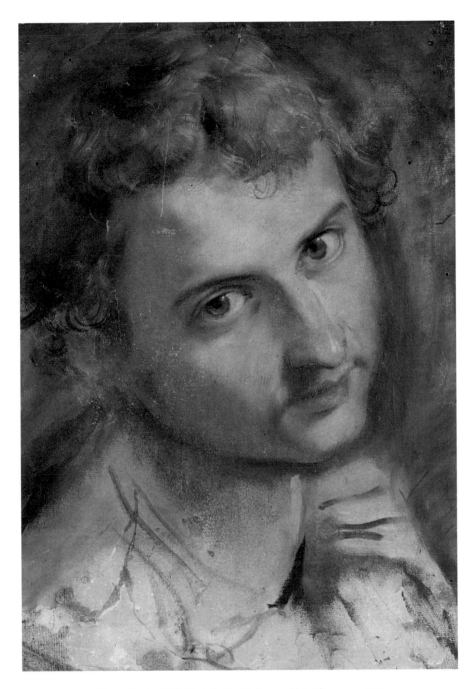

Fig. 34. *Study of Saint Jude for the Madonna of Saint Simon*, ca. 1567.
Tempera over red chalk on paper, laid down on canvas, 38.5 x 25 cm.
Galleria Doria Pamphilj, Rome, inv. F.C. 247

to use heads in oil on paper as preparatory studies for paintings.[107] Although a few contemporaries, such as Annibale Carracci, produced similar heads, these were independent exercises, not preparatory studies for paintings.[108] Barocci's heads are full-scale and close to those in the final paintings but do not conform exactly, confirming their preparatory function. Neither paintings nor drawings in any conventional sense, as John Shearman remarked, these works "illustrate . . . the indivisibility of the drawing process from that of painting."[109] This characterization is warranted by both the

unconventional use of oil paintings as studies for other oil paintings and by the technique. In at least three instances, the inception of these heads was in chalk.[110] In these cases, Barocci began making a drawing that, in the course of creation, became a painting.

Barocci's first painted head for another painting is in tempera (over red chalk) rather than oil: the Saint Jude for the *Madonna of Saint Simon* (fig. 34).[111] Although it is more finished than later oils, the freedom of handling in the hair, hand, and neck anticipate later works. Barocci's next painted head was the oil on paper pasted

onto the canvas of *Il Perdono* of about 1576, which perhaps gave him the idea of utilizing such works in his preparatory procedures.[112] A few years later, he produced four oils for the *Entombment,* immediately followed by three for the *Visitation.* These two altarpieces are Barocci's only works for which so many heads in oil are known. During the following decade, he created one head for *Christ Appearing to Mary Magdalen* in the late 1580s,[113] two recently discovered heads for the *Circumcision* of 1590 (fig. 14), a Saint Francis for the *Stigmatization* (cat. 13.7), and a Saint Sebastian for the Genoa *Crucifixion.*[114] The last two heads, from the mid-1590s, demonstrate diminished freedom of handling compared to earlier examples. This greater finish also characterizes Barocci's latest heads in oil, for the *Beata Michelina* of about 1606.[115] Although further heads in oil may still come to light, it is striking that extant examples are connected with only nine paintings. Barocci usually employed studies in chalk and pastel for heads, and it is not clear why he created these unusual studies in oil for a small minority of his pictures.[116]

For the *Entombment,* Barocci produced four heads in oil on paper, the same number as heads in chalk and pastel known for this picture. The pastels are quite diverse. Whereas the head of the Virgin seems rather preliminary and freely drawn, the two heads of Joseph of Arimathea (cat. 8.7) and Nicodemus (cat. 8.8) are more advanced and colored, with full iterations of facial features and lighting. The heads in oil are more finished and were clearly made later, as is particularly clear from a comparison of the studies for Nicodemus in pastel (cat. 8.8) and oil (cat. 8.9). A fascinating instance is provided by the two oils for Saint John. The Washington example (cat. 8.10), the more freely executed of the two, was clearly made first; the more detailed and finished head in a private collection (cat. 8.11) must have followed.

The three heads in oil for the *Visitation* also include two studies for the same figure—Saint Joseph.[117] The more freely painted head in London (cat. 10.11) surely preceded the more elaborated one in New York (cat. 10.10). Replication of the same subject, of course, is hardly unusual for Barocci. In light of his proclivity for repeating the same subject in all types of preliminary studies, such repetition is not surprising.

As was often true of his finished heads in pastel, Barocci's heads in oil on paper are generally the same size as the paintings they prepared. For this reason, they have sometimes been termed auxiliary cartoons. Like Barocci's large pastel heads, and unlike Raphael's auxiliary cartoons, however, these were not incised for transfer to the final painting, as Barocci's conventional cartoons were. Several writers have suggested that he may have made these full-scale heads after he began painting the larger pictures, a hypothesis that is consistent with their scale and close correspondence to the paintings.[118] He may also have intended to sell these handsome works to private collectors.

Contrary to the traditional notion that Barocci invariably followed the same orderly, methodical procedures, his occasional utilization of head studies in oil on paper provides an example of some inconsistency in his practices. This issue also arises with Barocci's compositional studies, and it is to that category that we will now turn.

Compositional Studies, from *primi pensieri* to *cartoncini*

EARLY COMPOSITIONAL STUDIES

For all Italian draftsmen, the initial rough sketches for compositions—termed *primi pensieri* (first thoughts)—have the lowest survival rate of any type of preparatory studies. Such unfinished drawings generally had little appeal to early collectors and were of limited utility in the studio compared to more finished drawings.[119] But when they do survive, they can be useful in revealing an artist's conceptual starting point. Of course, given their sketchiness and often limited relationship to the final composition, sometimes their attributions or connections to the paintings are disputed.

Barocci's oeuvre to 1586 is relatively well represented in this category. *Primi pensieri* are known for eight of his seventeen major works from these years, sometimes more than one for a single picture. Although occasionally, as with a sketch for the *Deposition* (fig. 48), these drawings depict only the rudiments of an inchoate design, sometimes they record a more fully conceived composition. For the *Deposition,* five other compositional sketches elucidate Barocci's early ideas. One two-sided drawing (cat. 3.1), for example, shows that Barocci planned from the outset to include Saint Bernardino and a fainting Virgin (although she was initially accompanied by only two women, not three); but his crucial asymmetrical arrangement of Christ and of the figures around the cross had not yet been conceived.

Some early sketches for paintings demonstrate that Barocci did not always begin with a clear notion of his iconography. A *primo pensiero* for the *Madonna del Gatto,* for example, shows that although he began with the notion of placing both the Christ Child and Saint John on the Virgin's lap, he had not yet devised the charming central action, in which John holds up a bird, attracting a cat's attention.[120] This activity provides a key element of the iconography; the goldfinch symbolizes the Passion of Christ, transforming the infancy narrative into a proleptic expression of his future.

The *Deposition* and *Visitation* are Barocci's two paintings for which the greatest number of early compositional studies survive. Seven drawings for the latter show how he experimented with this design, varying all five figures, as well as the setting.[121] Barocci's continued revisions to the *Visitation* are evident even in his cartoon (fig. 70); depictions of Saint Zaccharias and the woman holding

Fig. 35. Benozzo Gozzoli, *Presentation drawing for Totila's Assault on Perugia*, ca. 1461. Metalpoint and pen and brown ink heightened with white, with stylus incisions, on purple prepared paper, 31.6 x 42 cm. Gabinetto Disegni e Stampe degli Uffizi, Florence, inv. 333 E.

chickens differ from the painting. In such cases, when so many compositional studies survive, we have fascinating evidence of the artist's permutations throughout the design process. Unfortunately, such evidence is lacking for other major paintings from these years, such as the *Crucifixion* (cat. 2), *Madonna del Popolo, Martyrdom of Saint Vitalis,* and *Calling of Saint Andrew,* so Barocci's early conceptions for these pictures remain unknown.

CARTONCINI PER IL CHIAROSCURO

In about 1568, Barocci invented a new type of finished compositional drawing, which Bellori termed a *cartoncino.* He noted that these were made in either oil or gouache, immediately before the cartoon.[122] These specifications regarding timing and medium are crucial in differentiating between *cartoncini* and more conventional compositional studies. Some of Barocci's *cartoncini* are the most detailed and finished of all his drawings, much more fully elaborated than the cartoons. As noted above, Bellori explained that the artist produced a *cartoncino* in light and dark (*chiaroscuro*),

followed by a full-scale cartoon, the same size as the painting, and then by another small cartoon for the colors. Modern scholarship on Barocci has largely accepted this account, distinguishing between the *cartoncino per il chiaroscuro* (small cartoon for the light and dark) and the *cartoncino per i colori* (small cartoon for the colors). But the biographer's account must be approached with some caution. As discussed below, it seems unlikely that Barocci used color studies of full compositions to design paintings.

Barocci's thirteen extant *cartoncini per il chiaroscuro* prepared less than half of the paintings he produced during 1568–1612.[123] All are related to large pictures, principally altarpieces; if Barocci made *cartoncini* for smaller works, none is extant. An examination of these works, including a comparison of their style and function to finished compositional studies produced before Barocci, will elucidate the originality of Barocci's *cartoncini* and their role in his creative process.

A spectacular study for the *Deposition* (1568–69; cat. 3.2) is Barocci's earliest extant *cartoncino* and may be the most highly

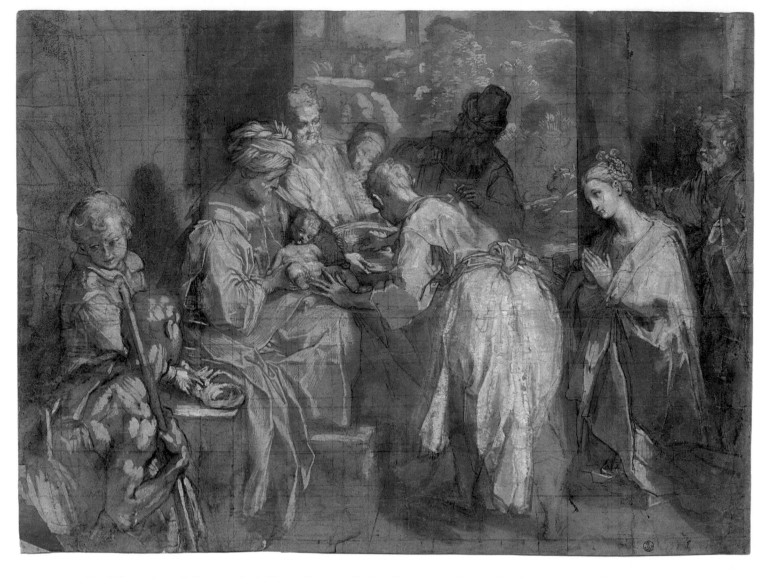

Fig. 36. *Cartoncino per il chiaroscuro for the Circumcision,* 1590. Black chalk and pen and brown ink with brown wash heightened with white, squared in black chalk, on brown paper, laid down, 43.5 x 58.5 cm. Gabinetto Disegni e Stampe degli Uffizi, Florence, inv. 818 E.

finished small cartoon he ever produced.[124] This drawing on ocher-colored paper, which corresponds precisely to the painting (fig. 47 and cat. 3), is truly a *cartoncino per il chiaroscuro,* studying the play of light and dark perhaps more than any subsequent work by Barocci. The artist employed a tiny brush to create fine striations in white heightening throughout the sheet, expressing the dramatic play of light across every form in the composition.

Barocci probably used this work both as a preparatory study and as a presentation drawing, to obtain his patron's approval for the design. Although no artist before Barocci had made *cartoncini per il chiaroscuro,* finished presentation drawings were common in Italian workshop practice from at least the fifteenth century. It makes sense that the inception of Barocci's innovative drawing type was rooted in a traditional category of drawing that would have been familiar to any Italian painter. The consistently careful

finish of the Uffizi drawing, which would soon be modified in later *cartoncini,* seems closely linked to earlier Italian presentation drawings.

During the fifteenth and sixteenth centuries, presentation drawings, or *modelli,* were sometimes required by patrons who wished to approve the design before the artist began painting. In 1485, for example, the Florentine patron Giovanni Tornabuoni stipulated in his contract with Domenico Ghirlandaio that he would need to approve compositional drawings before Ghirlandaio painted his frescoes in Santa Maria Novella.[125] Sometimes presentation drawings were submitted to the patron to secure the commission in the first place, a probable inception for Benozzo Gozzoli's study for *Totila's Assault on Perugia* of about 1461 (fig. 35).[126] Because such *modelli* were intended to provide the patron with a clear idea of the design, they were generally detailed and

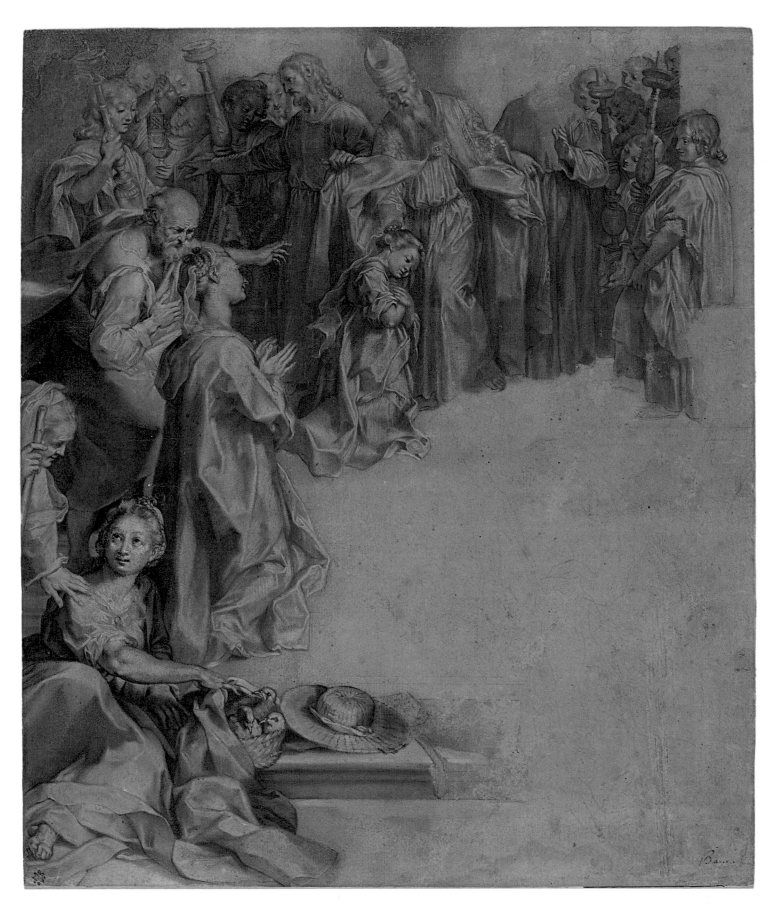

Fig. 37. *Cartoncino per il chiaroscuro for the Presentation of the Virgin in the Temple,* 1593–1603. Black chalk with
brown wash heightened with white and gray body color with some touches of pink, 39.6 x 33.8 cm.
National Gallery of Art, Washington, D.C., Woodner Collection, Gift of Andrea Woodner, inv. 2006.11.4

finished, as in Gozzoli's drawing. Such drawings provide a clear precedent for Barocci's *Deposition cartoncino*, which is closer to these antecedents than his later *cartoncini*.

Barocci's second extant *cartoncino*, made a half-dozen years later for *Il Perdono* (cat. 5.7), is also quite finished but decidedly less monochromatic than the *Deposition* drawing. Here Barocci introduced red chalk, in combination with other media, to add color. Once again, the drawing corresponds precisely to the painting it prepared. As in the *Deposition* and other *cartoncini*, Barocci employed squaring but kept it to a minimum to avoid the disfiguring effects of this functional component on his beautiful drawing. This practice may also have facilitated the drawing's likely use as a work that could be presented effectively to the patron to secure approval for the design of an artist who was then still early in his career.

With his *cartoncino* for the *Madonna del Popolo* (fig. 33),[127] Barocci introduced significant new features. Less finished than the two earlier *cartoncini* and more characterized by the dynamic energy of a creation still in process, this study is further from the final painting, with many variations, particularly in the right foreground, where figures were revised; one late addition was even pasted atop the sheet. These discrepancies from the painting indicate that this drawing was made earlier in the process, suggesting that Barocci's procedures with *cartoncini* were more varied than Bellori implied. The reason for this change was probably circumstantial: Barocci's patrons were dissatisfied with this design and requested more figures.[128] This *cartoncino* employs some red chalk, as in the *cartoncino* for *Il Perdono*, but to a more limited degree. A notable difference from the two earlier examples is the varied finish, very detailed on most foreground figures but freer in the middle ground. As in both earlier *cartoncini*, however, Barocci's ambitious work stages an impressive display of lighting effects, conveying a sense of drama, texture, and luminosity that is new to Italian drawings.

Beginning with the key small cartoon for the *Madonna del Popolo*, Barocci's *cartoncini* demonstrate a growing variety in medium, finish, relationship to the final painting, and scale. Two examples, for the *Circumcision* (fig. 36)[129] and *Presentation of the Virgin in the Temple* (fig. 37),[130] examine only a partial composition. In the *Circumcision*, Barocci left out three figures, the sheep, and the still life in the foreground, confirming that he sometimes continued revising compositions after completion of the small cartoon. The *Presentation cartoncino* includes only the figures in the left and central portions, lacking the entire upper register and lower-right sections. This drawing was never completed: One head at right has not yet been indicated, and a portion of one figure's drapery is also unfinished.

Barocci's remarkable *Entombment cartoncino* in the Getty (cat. 8.14) shows how he continued to use certain traditional techniques, probably learned from Raphael's example. In this detailed but unfinished study, Barocci drew on a sheet of slightly oiled paper, after mechanically transferring black, traced outlines, taken from another draft (Art Institute of Chicago). These traced lines are evident in the unfinished parts of the Magdalen, at right. Barocci's transfer technique, also employed by Raphael, involved smudging the verso of a drawing with charcoal or chalk before tracing the design with a stylus.[131]

Three drawings, for the *Entombment* (in Amsterdam; cat. 8.13), *Last Supper* (fig. 73), and *Lamentation* (fig. 38),[132] all employ an unprecedentedly large scale, somewhere between small and full-scale cartoon. Sometimes wrongly termed a cartoon, the Rijksmuseum *Entombment* is about half the size of the altarpiece.[133] This makes it larger in proportion to the related painting than the two others. All three are close in size, but the *Last Supper* is one-third the size of the related painting, and the *Lamentation* is one-quarter the size of the altarpiece it prepared. Although the *Last Supper* is a *cartoncino*, the media Barocci employed for both the Rijksmuseum *Entombment* and *Lamentation* (black chalk, charcoal, and white chalk) differ from those he used in other *cartoncini*. If we accept Bellori's definition of a *cartoncino* as employing gouache or oil, these two works do not qualify. Given their unusually large size, their reliance on the same media Barocci used for cartoons, and their diminished concern with lighting compared to true *cartoncini*, these two works should instead be considered reduced cartoons.[134]

A recent discovery by Bonita Cleri suggests another purpose that was sometimes served by these drawings: They provided models for prints. A documented agreement in 1590 between Barocci and the Flemish merchant Giovanni Paoletti records that Barocci gave Paoletti his *cartone preparatorio* (preparatory cartoon) for the *Entombment* so that Paoletti could have Giovanni Stradano make an engraving.[135] Three years later, Barocci complained that his drawing had never been returned to him; his remarks, considered below, provide a valuable record of the artist's views on his *cartoncini*. This employment of the *Entombment cartoncino* as a model for an engraving parallels Agostino Carracci's use of the *Aeneas cartoncino* for another engraving five years later (cat. 16.6).

Because they were made immediately before the cartoon, most *cartoncini* correspond closely to the paintings, as exemplified by the *Madonna of the Rosary* (cat. 11.7). Apart from instances in which the patron made subsequent demands, such as for the *Madonna del Popolo* and *Institution of the Eucharist*, significant differences between drawing and painting may suggest that some drawings are best understood as compositional studies from an earlier stage of design, rather than as *cartoncini*. A finished drawing for the *Martyrdom of Saint Vitalis* (fig. 39) offers an example.[136] Virtually every figure, as well as the landscape setting, was subsequently revised, and many figures were added. This extensive

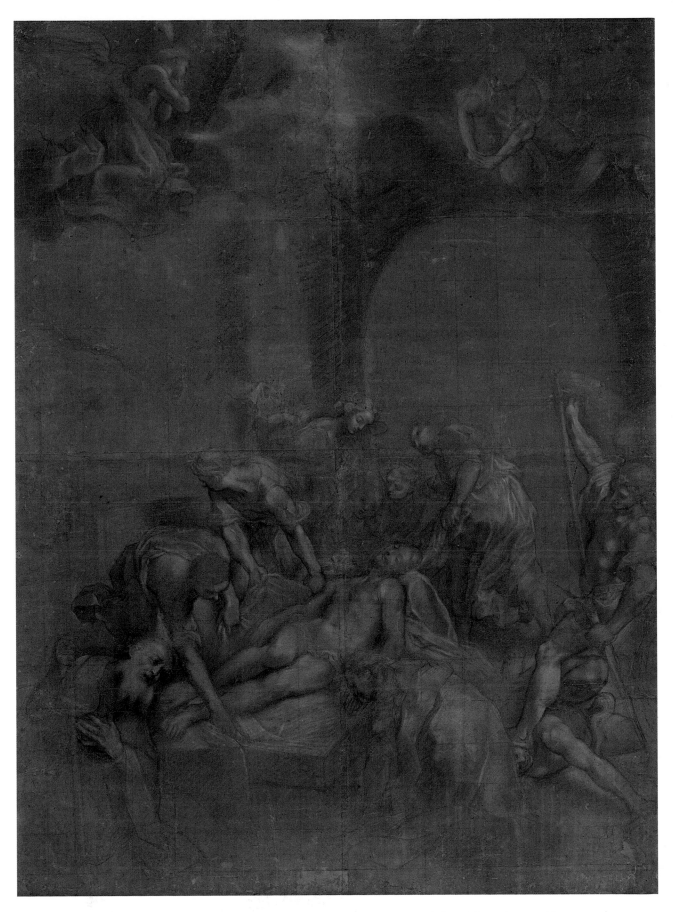

Fig. 38. *Reduced cartoon for the Lamentation,* 1600–1612. Black and white chalk and charcoal, squared for transfer in black chalk, on several pieces of brown prepared paper glued together, laid down on linen, 105 x 77 cm. Rijksmuseum, Amsterdam, inv. RP-T-1977-138

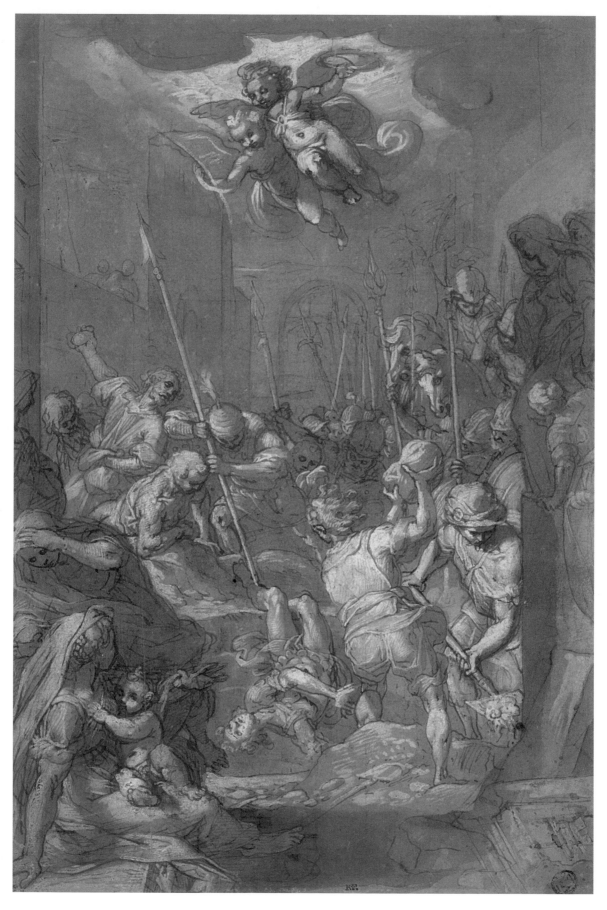

Fig. 39. *Compositional study for the Martyrdom of Saint Vitalis,* ca. 1580–83. Black chalk and pen and black ink
with brown wash heightened with white, partially squared in black chalk, on a brown prepared sheet, 33.8 x 22.6 cm.
Musée du Louvre, Département des Arts Graphiques, Paris, inv. 2858

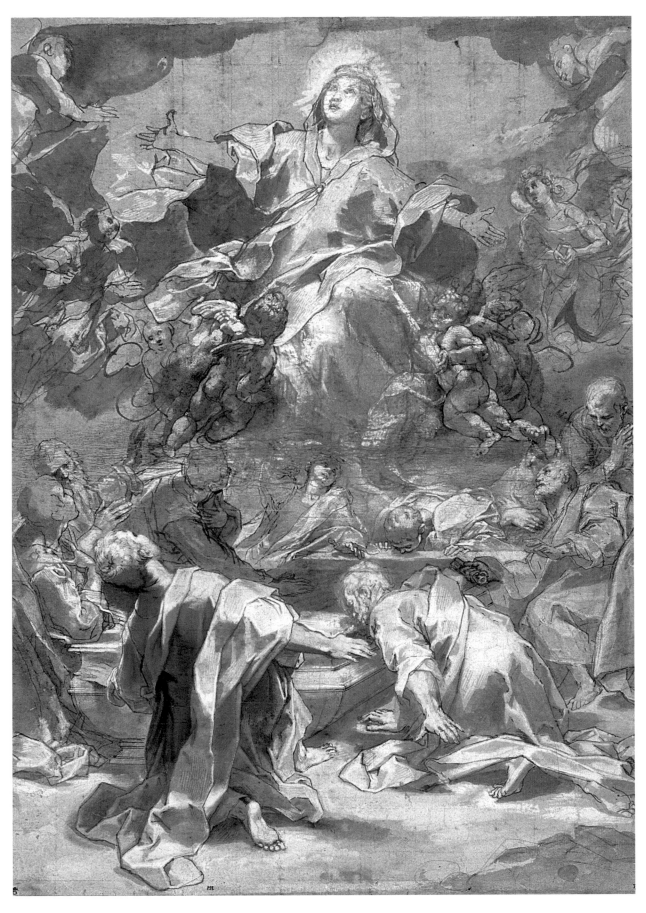

Fig. 40. *Cartoncino per il chiaroscuro for the Assumption*, ca. 1605–12. Black chalk and pen and brown ink with
brown and gray wash heightened with white, squared in black chalk, on gray paper, 52.2 x 36.7 cm.
Trustees of the Chatsworth Settlement, Chatsworth House, Derbyshire, cat. 122, inv. 364

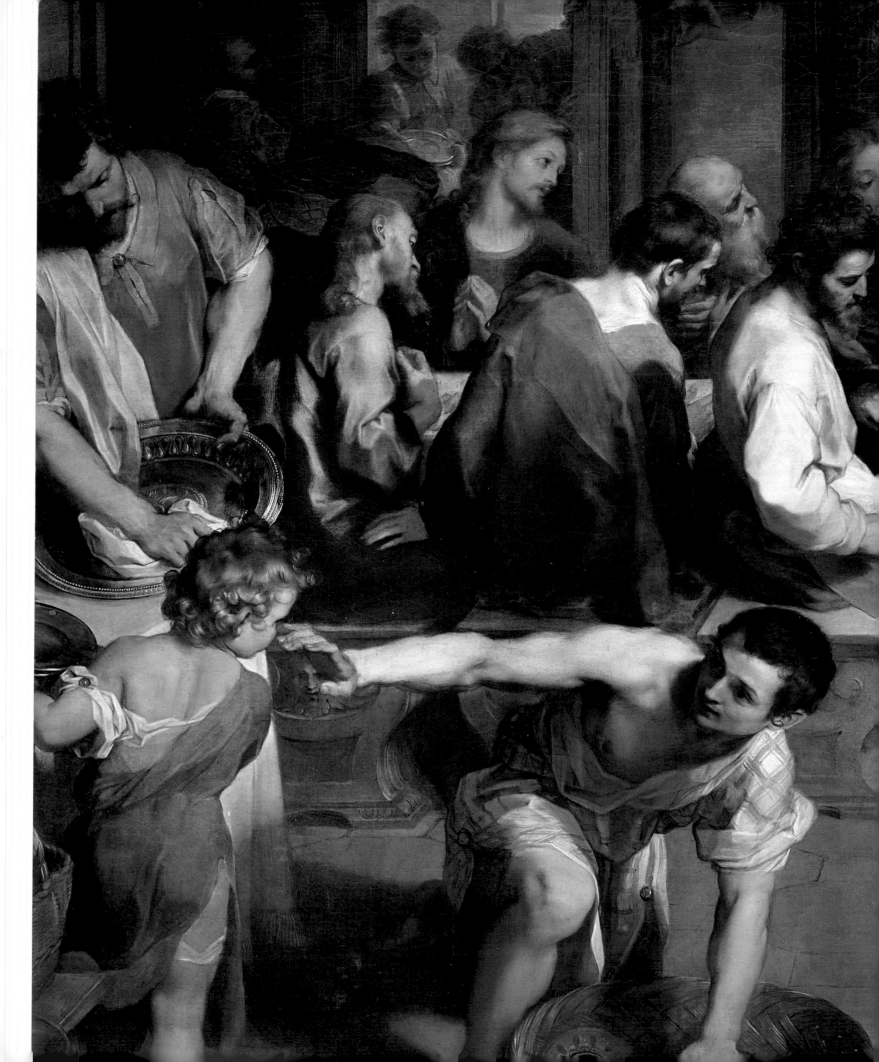

CAT. 1. *Saint Cecilia with Saints Mary Magdalen, John the Evangelist, Paul, and Catherine,* ca. 1556. Pen and brown ink with brown wash heightened with white over black and some red chalk, laid down, 12½ x 9 1/16 in. (31.8 x 23 cm). Inscribed in brown ink lower right: "10/Z"; in pencil lower right, an illegible inscription; in pencil on the verso: "von einem Schüler Santis."
Staatsgalerie Stuttgart/Graphische Sammlung, inv. 1338

Saint Cecilia with Saints Mary Magdalen, John the Evangelist, Paul, and Catherine

Barocci's finished compositional drawing of Saint Cecilia with four other saints is a preparatory study for his earliest surviving painting, of about 1556. This drawing demonstrates many revealing aspects of the artist's early drawing style and design methods: the influences of Raphael, Barocci's Venetian teacher Giovanni Battista Franco (ca. 1510–1561), and other Mannerist artists; Barocci's firm grounding in traditional drawing media and preparatory procedures for paintings; his less naturalistic beginnings in comparison to his mature works; and his lack of reliance on drawing the human figure from life, in contrast to his later commitment to this practice. The Stuttgart drawing, in short, reveals a Barocci who is not yet the artist he became, before his extensive preparatory procedures and naturalistic style had developed. Nevertheless, the sheet reveals the young artist's remarkable technical skill as a draftsman even at this early date.

The drawing was a preparatory study for Barocci's painting *Saint Cecilia with Saints Mary Magdalen, John the Evangelist, Paul, and Catherine* in the cathedral of Urbino (fig. 42), to which it corresponds closely. Both painting and drawing portray Saint Cecilia, the patron saint of music, holding a musical instrument and surrounded by others as she listens, rapt, to the celestial music of the angels above, whose heavenly offerings outstrip the earthly alternatives below. Saint Cecilia is accompanied by four other saints, each of whom is clearly identified by his or her traditional symbol: at the left, Mary Magdalen, who holds the jar of ointment with which she anointed Christ's body; then Saint John the Evangelist, identifiable by the eagle standing before him; at right, Saint Paul, holding the sword with which he was beheaded; and last, Saint Catherine, who stands on the wheel upon which this early Christian martyr was tortured. In the painting, four angels in the heavens provide the celestial music to which Saint Cecilia responds; in the drawing, there are only two angels.

Barocci's painting *Saint Cecilia with Saints* was evidently produced for the cathedral of

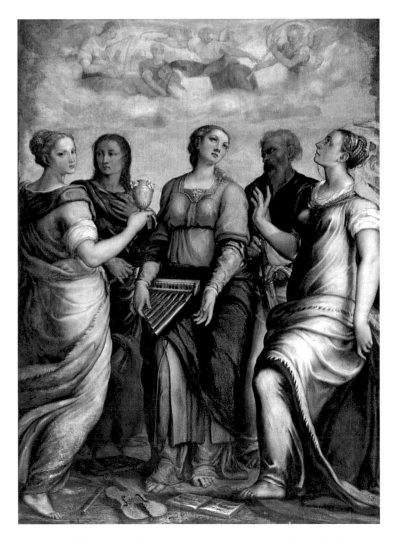

Fig. 42. *Saint Cecilia with Saints Mary Magdalen, John the Evangelist, Paul, and Catherine*, ca. 1556. Oil on canvas, 200 x 145 cm. Cathedral, Urbino

Urbino, where it was first recorded by Raffaello Borghini in 1584. Peter Gillgren recently suggested, based on evidence from a manuscript of 1717, that the painting originally decorated the cathedral organ, but it was moved to a side chapel after the cathedral's destruction and rebuilding during the eighteenth century.[1] Bellori, Barocci's principal biographer, noted that the artist made his first, short trip to Rome after reaching the age of twenty (i.e., in ca. 1555).[2] Giovanni Pietro Bellori included the *Saint Cecilia* among the three early works painted

after Barocci's return to Urbino. The first, *Saint Margaret,* was executed for the Confraternita del Corpus Domini of Urbino. Although this painting is lost today, a document records the confraternity's final payment to Barocci on 1 January 1556; a drawing in the Victoria and Albert Museum (fig. 25) was probably a preliminary study for this work.[3] Next, the biographer recorded, "Also among his first works, but in the Cathedral, are the *Martyrdom of Saint Sebastian* and *Saint Cecilia with Three Other Saints*."[4] Documents also record the commission for

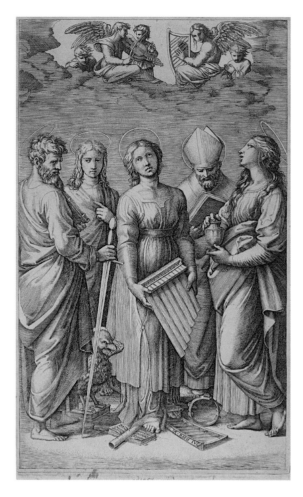

Fig. 43. Marcantonio Raimondi after Raphael, *Saint Cecilia with Saints*, ca. 1516–18. Engraving. The British Museum, London, inv. 1868,0822.34

the *Saint Sebastian* in 1557. Although no surviving document confirms the commission for Barocci's *Saint Cecilia,* its handling clearly indicates a less mature artist than the painter who produced the *Saint Sebastian.* Thus most modern writers have reasonably dated the *Saint Cecilia* to about 1556.[5]

Bellori observed that Barocci's painting was "imitated from Raphael,"[6] and modern scholars have noted that the composition derives from Raphael's painting *Saint Cecilia with Saints* of about 1516 (then in the church of San Giovanni in Monte, Bologna, and now in the Pinacoteca Nazionale, Bologna).[7] As most writers have acknowledged, however, Barocci's immediate model was probably Marcantonio Raimondi's reproductive engraving after Raphael's design (fig. 43), which exhibits several differences from Raphael's picture that correspond to Barocci's composition.[8] As in the engraving, in both Barocci's drawing and paint-

ing, the female figure at the far right (Saint Catherine in Barocci's works, Mary Magdalen in the print) is depicted in profile, looking up toward the angels. This pose was revised in Raphael's painting, in which Mary Magdalen looks out at the viewer. The frontal position of Saint John, who gazes directly at the viewer, and the arrangement of the musical angels above are further corresponding details in Barocci's two works and Raimondi's print that differ from Raphael's painting. Thus Barocci's immediate model evidently was the engraving. Engravings provided a more easily accessible means of transmitting compositions during this period, of course, and the young artist was presumably encouraged to study such prints— a conventional feature of artistic training in early modern Italy—during his training with Franco during the late 1540s.

As several writers have observed, however, although Barocci's composition is based on the

Raphael–Marcantonio models, his figure style is less naturalistic than these two sources, suggesting an influence from other artistic sources. Mannerist artists who employed similarly elongated figures, with limited anatomical detail, evidently impacted Barocci's approach. Nicholas Turner and Andrea Emiliani have both proposed the probable role in this regard of Francesco Menzocchi da Forlì (1502–1574), who was one of the leading painters in the Marches. Turner argued that Menzocchi's influence on Barocci's drawing in Stuttgart is evident in both figure style and technique, as shown by a high degree of finish, heavy reliance on white heightening, and sparing use of wash.[9]

Given its polished execution and close adherence to the painting, Barocci's drawing was probably a final compositional design for the *Saint Cecilia with Saints.* Although all five saints are similar in both works, Mary Magdalen's gaze was raised and her clothing revised in the painting; Cecilia's arms were revised to correspond more closely to the engraving; John's gaze was adjusted; and Paul's head was slightly turned, from a three-quarter to an almost-profile view. Additionally, the arrangement of four angels was worked out in greater detail in the painting. Otherwise, all particulars correspond closely.

The drawing demonstrates what a gifted draftsman Barocci was, even at the age of about twenty or twenty-one. His delicate pen lines are confident and applied without revisions, and his generous applications of white heightening create a luminous effect, indicating a clear sense of a naturalistic light source from the right. The figures, modeled in wash and white heightening, convey a convincing sense of weight, although their elongated proportions and minimal anatomical details limit their naturalism. All these features are consistent with the Mannerist draftsmanship that was common throughout the Italian peninsula during the mid-sixteenth century. This style may reflect the influence of Francesco Menzocchi, as noted above; it also shows some affinities with the draftsmanship of Franco, with whom the young artist worked probably during the later 1540s, while Franco was painting a fresco for the cathedral of Urbino (1544–46). Although most of Franco's drawings during these years are less reliant on white heightening, a number from the 1540s are similar to Barocci's *Saint*

Cecilia in that they are finished compositions without pentimenti that employ a combination of pen, ink, and wash to describe their elongated figures (fig. 23).[10]

For most artists of this period, relatively few preparatory drawings for their earliest works survive, in comparison with their later production, and Barocci is no exception. The Stuttgart sheet illustrates one reason for this situation: Its style is dissimilar to Barocci's mature, and hence recognizable, draftsmanship. For this reason, it was catalogued among the anonymous Italian drawings at Stuttgart, until Christel Thiem recognized it as Barocci's work in 1966.[11] Since Thiem's discovery, Barocci's authorship of the drawing has never been questioned; indeed, it has been used to silence earlier doubts about Barocci's authorship of the painting.[12] Scholars have connected several other drawings with the altarpiece, providing more questionable possibilities in terms of either Barocci's authorship or a convincing relationship to the painting. Harald Olsen tentatively connected three drawings with the picture, but none of these was accepted by Edmund Pillsbury and Louise Richards. In 1985, Emiliani ignored the Louvre sheet Olsen had suggested and registered his skepticism about the two drawings in the Uffizi that Olsen had adduced. In 2008, however, Emiliani included all three drawings among the preparatory studies for the altarpiece and added three drawings, at Windsor, the British Museum, and in a private collection.

Of the three drawings originally proposed by Olsen—all head studies—none is conclusively connected to a figure in the painting. In my view, only one drawing in the Uffizi may possibly record an early idea for one of the figures.[13] Of the three other drawings proposed later, only one may arguably be a preparatory study for the altarpiece: the head study at Windsor, which David Scrase connected with the head of Saint Catherine.[14] This drawing, however, is so damaged that it is difficult to judge conclusively whether it is an original study by Barocci for the painting or a copy by another artist. In other words, although two other drawings may be preparatory studies for the *Saint Cecilia*, the Stuttgart sheet is the only entirely convincing, autograph study for Barocci's earliest surviving picture. Although we should assume that other drawings were

made for the painting that have been lost, only this drawing provides firm visual evidence of the artist's preparatory procedures at this early stage of his career.

The Stuttgart drawing provides the basis for several conclusions. First, it seems improbable that Barocci made figure studies from life for this painting—based both on the absence of such studies today and on the evidence of the unnaturalistic figures themselves.[15] Barocci evidently changed his procedure very soon after painting the *Saint Cecilia*, for even the *Martyrdom of Saint Sebastian* of 1557 shows signs of some reliance on life drawing, as evidenced by its more naturalistic figures.[16] Second, the drawing confirms the early impact on Barocci of his famous predecessor Raphael, although it also demonstrates that this influence did not always come directly from Raphael's own works and was sometimes tempered by other, more recent artistic sources. The drawing further shows that the young Barocci produced drawings that in several respects are typical of Mannerist preparatory studies in both function and style: finished, detailed, and entirely lacking in pentimenti; conventional compositional studies that conform to the sorts of drawings that his contemporaries were making late in their design processes for their paintings; and employing the traditional media for such sheets: pen, ink, wash, and white heightening. Although the Stuttgart drawing reveals the early competence of the gifted young Barocci, it demonstrates nothing of the technical experimentation and dedicated naturalism that soon developed as the hallmarks of his extraordinary draftsmanship.

Babette Bohn

NOTES

1 Gillgren 2011, 81.
2 Barocci's undocumented date of birth is generally given as ca. 1535 by modern writers, but this date is based on some contradictory evidence from the early sources. On this issue, see Sangiorgi 1982, 57–58; and Lingo 2008, 255, n. 39.
3 The drawing, inv. D.1084-1900, is inscribed both "Barozzi" and "Canuti." The correctness of the old attribution to Barocci was recognized independently by both Aidan Weston-Lewis (private communication noted by Scrase) and Forlani Tempesti 1996, 62 and 69. See also Scrase 2006, 74–75, no. 12.
4 Bellori 1672 (1976), 183; Bellori 1672 (2000), 177.
5 Gillgren, however, suggested ca. 1554 (2011, 239, no. 1).

6 Bellori 1672 (1976), 183; Bellori 1672 (2000), 177.
7 The documents for Raphael's commission are no longer extant, and the painting has been variously dated between 1514 and 1518. See, most recently, Francesca Valli's catalogue entry on this picture, in which she dated it to 1518, in Jadranka Bentini et al., eds., *La Pinacoteca nazionale di Bologna: Catalogo generale. 2. Da Raffaello ai Carracci* (Venice, 2010), 418–27, no. 283. On the iconography of Raphael's painting, see Roger Jones and Nicholas Penny, *Raphael* (New Haven, 1983), 146.
8 A drawing in the Petit Palais, Paris inv. Dutuit 980, which corresponds to the engraved composition, has been ascribed to both Perino del Vaga and Gianfrancesco Penni. Barocci substituted Saint Paul for Saint Augustine.
9 Turner 2000, 10–11. E 2008, 1, 101, no. 2.1, also noted the influence of Parmigianino on the young Barocci. Fontana 1997b, 55–56, had previously argued that Parmigianino's works provided the pivotal influence on Barocci's figure style in this early work. See also Scrase 2006, 62–63, no. 6.
10 See, e.g., Lauder 2009, no. 30 (Louvre inv. RF 1069), which also uses white heightening.
11 Thiem's discovery was published by Olsen 1969, 49–54, who demonstrated its connection to the *Saint Cecilia* painting.
12 Ibid.
13 Inv. 821 E. bis, in red chalk, E 2008, 1, 102, no. 2.3. The two other drawings of heads proposed by Olsen are: Uffizi inv. 821 E., E 2008, 1, 102, no. 2.2; and Louvre inv. 2875, E 2008, 1, 102, no. 2.4.
14 Inv. 5425, Scrase 2006, 76–77, no. 13; and E 2008, 1, no. 103, 2.6. The two other drawings whose role as preparatory studies for the painting is not accepted here are: British Museum inv. 1946,0713.20, Scrase 2006, 78–79, no. 14, E 2008, 1, 102, no. 2.5; and private collection, DeGrazia 1984, 286–88, no. 95 (where the drawing is published as Barocci's work but not connected to this painting), E 2008, 1, 103, no. 2.7.
15 Pillsbury and Richards 1978, 28, argued that Barocci began to employ detailed studies from life only in the next decade, while preparing the Casino decorations in Rome.
16 If Barocci made drawings from life for the *Martyrdom of Saint Sebastian*, however, those studies have not survived. See E 2008, 1, 110–14, no. 7.

Bibliography: Borghini 1584 (2007), 271; Bellori 1672 (1976), 183; Bellori 1672 (2000), 177; Olsen 1969, 49–54; Pillsbury 1976, 57; Thiem 1977, 200–201, no. 373; Pillsbury and Richards 1978, 28–29, no. 1; Smith 1978, 333; Emiliani 1985, 1, 5; Fontana 1997b, 54–56; Turner 2000, 10–11, n. 6, and 15–17; Scrase 2006, 76, under no. 13; E 2008, 1, 101, no. 2.1; Lingo 2008, 211–13; Gillgren 2011, 76–81, and 239, no. 1.

Crucifixion with the Virgin and Saint John the Evangelist

Barocci's *Crucifixion with the Virgin and Saint John the Evangelist* is his earliest altarpiece to break away completely from a Mannerist conception, demonstrating the artist's true powers of original interpretation and creative response to earlier masters. A straightforward depiction of the veneration of the crucified Christ, the picture illustrates Barocci's ability to offer fresh insights into a well-established iconography even with a very simple composition that offered limited options. Coupling an old-fashioned format with energized figures, dynamic lighting, and dramatic spatial recession, Barocci navigated between the archaic and the innovative, developing a picture that slowly reveals its novelties.[1] The twenty-seven extant drawings associated with this picture document Barocci's efforts, even his struggles, to design suitable poses that realized his ambitions. His sketches record his use of studio models to investigate the placement and postures of his figures, envisioning them fully in the round as he sought to understand how they would work within his finished composition.[2]

Giovanni Pietro Bellori provided what little information we have about the origins of this painting. It was commissioned by Pietro Bonarelli della Rovere for his chapel in the Church of the Crocifisso Miracoloso in Urbino. On 4 September 1559, Bonarelli had been given the title of count along with its ensuing privileges by Duke Guidubaldo II della Rovere, whom Bonarelli served as minister until the duke's death in 1574. Andrea Emiliani posited that the patronage for this altarpiece coincided with a high point in Bonarelli's career, for after Duke Guidubaldo died, Bonarelli was not on good terms with the next duke, Francesco Maria II della Rovere.[3] The church is no longer standing, and we cannot reconstruct the picture's original context. All we know is that there was an altarpiece across the aisle by Taddeo Zuccaro (*Dead Christ with Angels*), a painting that, like Barocci's *Crucifixion*, is now in the Galleria Nazionale delle Marche in Urbino.

The painting that Barocci provided for his patron offers a simplified composition for religious devotion. In the center, the dead body of Christ hangs on the cross, his head inclined down to the viewer's left, and his right foot crossed over his left. He wears the crown of thorns fashioned for him in mockery of the declaration that he was the king of the Jews; the four letters (INRI) posted at the top of the cross represent the first initials of the Latin words for Jesus, Nazareth, king, and Jews.[4] The Virgin Mary and John the Evangelist flank the sides of the cross. Mary folds her hands in prayer, while John's expansive gesture suggests physical movement, poses that Gary Walters sensitively described as "responsive grief."[5] The cross stands on the edge of a steep slope that affords a view both urban and pastoral. Emiliani identified the view (with a circular temple, a fortress, and a winding road) as one the artist himself would have seen outside his studio window.[6] Two airborne putti hover on either side of Jesus, holding wide cups beneath Christ's wounds, although no blood issues forth.[7] Behind, in a central clash of deep blue, white, and blazing yellow, light explodes in the middle of the sky. Three apostles climb a path at the far left, two with long gray beards and a third with dark hair. Two assume gestures of prayer, while the leader holds his hand with the palm turned outward in an attitude of surprise or wonder.

The biblical descriptions of Christ's Crucifixion on a hill outside Jerusalem offer varying degrees of detail. All four Gospels tell how Jesus was led to Mount Golgotha and crucified between two thieves. Soldiers divided his clothing among themselves, posted the title claimed for him on top of the cross, offered him a sponge soaked in vinegar to drink, and witnessed his last cry to God as he died. John's Gospel (19:32–34), the most detailed, provides the famous account of a Roman soldier who, when he came to break Christ's legs to hasten death, suspected that Jesus was already dead and pierced his side to be sure. All four Gospels note that a group of soldiers accompanied Jesus to the site of his death and describe various spectators who reproached him. They offer little detail on the number of observers and identify only a handful of them, including several Marys (the Magdalen among them), a Roman soldier, a woman named Salome, and a passerby, Simon of Cyrene.

The form artists chose to translate the events at Golgotha into visual imagery varied over time. The simple composition that Barocci selected continued a tradition, first developed in Byzantine art as early as the eighth century, in which only Mary and Saint John the Evangelist stand as witnesses to Christ's suffering.[8] Some writers have suggested that the choice of these particular players had its origin in the Gospel of John, where Jesus tells Mary, "Woman, behold thy son," and then says to John, "Behold thy mother," thus assuring Mary the comforts of familial care (John 19:26–27). Beginning in the thirteenth century, artists favored a more historical approach for the scene, with architectural and topographical specifics. Triggered in part by greater knowledge of the Holy Land resulting from the Crusades, these paintings included groups of soldiers, general bystanders, and sometimes all of the apostles. By the late sixteenth century, theologians argued for more austere presentations, suggesting that for such imagery truly to move pious viewers to pray, the number of figures should be reduced.[9] By the early seventeenth century, images of a solitary figure of the crucified Christ prevailed, a type that Barocci painted late in his career: the majestic *Expiring Christ* of 1600–1604, now in the Prado (fig. 18).

During the sixteenth century, many artists favored a limited presentation in keeping with the conservative religious climate after the Council of Trent, although they typically included at least four figures. Mary Magdalen was often depicted, due in part to her increasing popularity and to the fact that both Mark and John identify her as one of the spectators. Other artists included specific saints, perhaps a local saint or one related to the patron, as Titian did when he included the patron saint of the church for his celebrated *Crucifixion with the Virgin Mary, Saint Dominic, and Saint John*, painted in 1558 for the Church of San Domenico in Ancona (fig. 44). Barocci simplified further by depicting only three main figures, and he even eliminated the skull that was traditionally placed at the

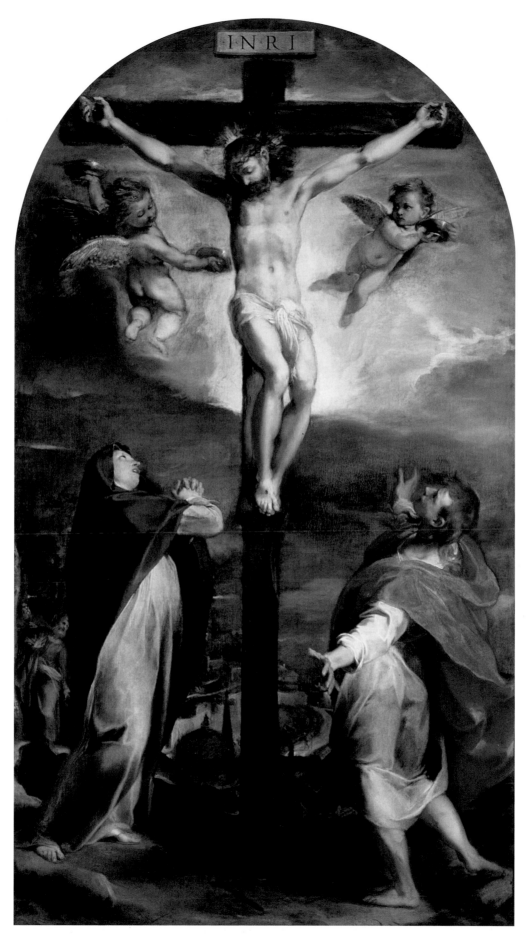

CAT. 2. *Crucifixion with the Virgin and Saint John the Evangelist*, 1566–67. Oil on canvas, 113⅜ x 63⅜ in. (288 x 161 cm). Galleria Nazionale delle Marche, Urbino, inv. 1990 D 85

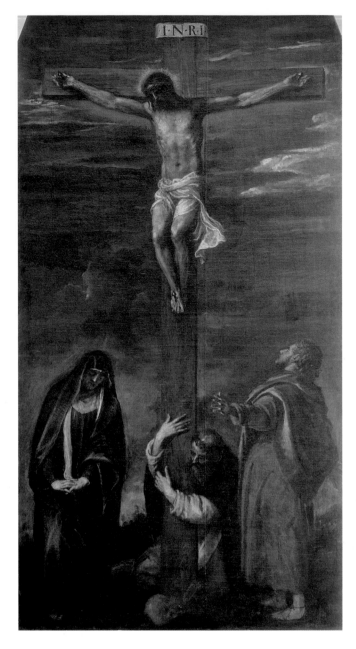

Fig. 44. Titian, *Crucifixion with the Virgin Mary, Saint Dominic, and Saint John,* 1558. Oil on canvas, 375 x 197 cm. Church of San Domenico, Ancona

populated backgrounds.[13] These deep landscapes spreading out to a distant horizon intensified the immediacy of the small group that was placed close to the viewer, and Barocci continued and even maximized such a combination of deep space and figures placed close to the picture plane. By extending the cross to the edges of the upper, curved section of the painting, he more or less defined the picture surface as coinciding with the front of the cross, with Christ in front.[14] Saint John's extended left arm gains impact as it appears to protrude from his space into ours. Barocci recognized the power of this type of gesture, for he used it again, although with refinements and modifications, for the swooning Virgin Mary in his later *Crucifixion with Mourners and Saint Sebastian* in Genoa cathedral (fig. 16).[15]

Titian's influence may go beyond composition and gesture. A number of commentators have pointed out how Barocci seems to have emulated Titian's brushy style, dynamic color juxtapositions, and specific color choices.[16] The handling of the head and beard of Christ as well as the bursting light in the sky can be likened to the manner in which the older Venetian master used the medium. The compromised state of Barocci's painting must be acknowledged and dictates a certain amount of restraint in overly emphasizing Barocci's incorporation of an explicitly Titianlike style. Nonetheless, it does make sense that he would have turned to Venetian style for a member of the Della Rovere court. The dukes collected Titian's work. During the 1550s, when Barocci worked under the guidance of his cousin Bartolomeo Genga in Pesaro, he had access to the ducal art collection, where, according to Bellori, he had the opportunity to study Titian's paintings.[17]

Never one to doggedly follow even well-established traditions, Barocci introduced a number of new and innovative elements into his picture that confirm his careful attention to the texts he illustrated as well as his recognition that he needed to make imagery that would appeal to the contemporary viewer. The cup-bearing angels are among the most interesting innovations of this painting. A holdover from gold-ground devotional images from the thirteenth and fourteenth centuries and not usually part of the standard sixteenth-century iconography, Barocci's airborne angels nonetheless had precedents.[18] Raphael used flying

base of the cross—a reference to Adam's burial at the same site where Christ died.[10]

Several writers have acknowledged Barocci's debt to Titian's Ancona *Crucifixion,* a painting that may well have served as Barocci's starting point.[11] The Ancona picture, with its kneeling Dominic, whose poignant embrace of the wooden shaft gives an almost tactile palpability to the act of mourning, speaks a quiet yet powerfully emotive language. Barocci probably knew Titian's painting, for the coastal city of Ancona lies within fifty miles of Urbino. The Ancona

picture's general tonality, the open pose of Saint John, and the more restricted posture of the Virgin seem to have been in Barocci's mind as he worked out his own depiction of the scene. In fact, given that Bonarelli was from Ancona, he may even have suggested Titian's painting as a model, and for that reason the artist may have intended his source to be evident.[12]

Barocci may have found inspiration also in other Venetian examples beyond Titian; Giovanni Bellini and Carlo Crivelli both created spare renderings with open and sparsely

angels in his *Crucifixion,* created in the first years of the sixteenth century for the church of San Domenico in Città di Castello, a town within 130 miles of Urbino.[19] Raphael incorporated the angels to underscore the Eucharistic associations of Christ's death and arranged them symmetrically on either side of the cross, with streaming ribbons that reinforce their symbolic role. Undoubtedly, Barocci intended a similar association, although he apparently omitted a key element, for no blood pours into the cups; indeed, there is none in the altarpiece at all. Although the picture is not in pristine condition, we can probably rule out the wearing off or unintentional removal of red glazes that originally represented the blood, for an engraved copy of the altarpiece by Gijlsbert van Veen indicates no spouting or dripping blood either.[20] Although an inscription on the print's lower border refers to Christ's blood—"But if we live in light, as he is in light, we have a share in another's life, and the blood of Jesus, his Son, cleanses us from all sin"—Van Veen dutifully copied Barocci's bloodless painting.[21] In the late sixteenth century, when the centrality of the ritual wine/blood in the Mass had just been reiterated by the Council of Trent, and newly invented formats for presenting the blood of Christ offered numerous vehicles for meditating on the meaning of his blood and body, it was highly unusual for an artist to omit such a seemingly essential component.[22] The inscription beneath Van Veen's print suggests that even without actual bleeding, contemporary viewers were primed to read Crucifixion imagery in terms of the shedding of Christ's blood, and we can therefore speculate that the cup-bearing angels accomplished the necessary allusion.

Barocci's omission of the blood may be due in part to his desire to de-emphasize Christ's physical suffering as well as his determination to modernize as he sought a composition that combined the clarity of a simple devotional image with the vigor and dynamism of a dramatic event. He energized the putti by arranging one to face forward toward the viewer while posing the other to move backward into the space behind the cross. The cup-bearing putto, a decidedly archaic form, was used to increase the sense of spatial continuity, injecting new life into an old-fashioned motif.

Barocci's treatment of space and the relationship among his players is much more complicated than appears at first viewing. A review of countless images of the Crucifixion demonstrates that few artists varied the axis between the top and bottom of Christ's body. Most placed Christ's lower body frontally on the cross with his head facing forward. Sometimes painters inclined his head toward the viewer's left, and sometimes they positioned the figure so that the head and lower body together would face one side or the other. Barocci, however, inclined Christ's head toward the Virgin Mary and his lower body toward John, thus nicely indicating the connections between each of the mourners and Christ. In this way, the painter also gracefully knitted the three together into a seamless whole, reinforcing the X-shaped composition, for the putti echo the gestures and hand placements of their diagonally opposed earthbound companions. At the same time, Barocci chose poses for both the Virgin and Saint John that fill the space of the painting's foreground. John's open gesture challenges the fictive picture plane toward the viewer and extends back behind the body of Christ. Mary, assuming a closed posture, thrusts her head and hands toward the background while extending her lower right leg to the foreground. Together they provide a rhythmic, circular movement at the base of the cross.

Perhaps most unusual in the artist's rendering of the end of Christ's life is the spectacle of light and shadow that forms the backdrop for the cross. Although several artists before Barocci had alluded to the unnatural change in light that accompanied Christ's expiration, they did so either by placing the scene in relative darkness or by depicting a sweeping edge of night that divided the background into light and dark.[23] Barocci created a dynamic burst of yellow and white light, described by more than one modern commentator as suggestive of a cataclysmic event.[24] Such a show was intended to suggest the moment of Christ's death, described in Luke's Gospel in dramatic terms.[25] Mary and John respond to this event, as do the background apostles who gesture and pray as they arrive at the scene. Christ's closed eyes and lowered head tell us he is dead, but because he has no wound on his right side, we know that his death must be recent (the Roman soldier plunged the spear into his chest only after he had died).[26] In fact, the left putto's vessel, held toward Christ despite the absence of a side wound, makes it clear that the cup is symbolic.

In this way, Barocci could focus his painting on an event that triggered emotion and reaction. As he would soon do in his depiction of the three Marys and their concern for the Virgin in his masterful *Deposition* altarpiece (cat. 3), Barocci here turned to human emotion as a means of drawing his viewers into his subject. It is evident that his interpretation was inspired by Titian's Ancona *Crucifixion,* as already noted, and also by a small panel by Piero della Francesca that was part of the Misericordia polyptych in Borgo Sansepolcro (1445). Roughly thirty miles from Urbino, it was a likely place for him to have visited, especially to see paintings by an artist who had worked for the Montefeltro dukes, the forebears of the Della Rovere, in Urbino.[27] In both these models, Barocci found a suitable demeanor for John the Evangelist, whose religious intensity is suggested by his fervent gaze, open stance, and animated drapery. Leaning, he plants his weight on his left leg, lifting his right foot slightly off the ground, a pose closely resembling that of his counterpart in Piero's small picture.

The sequence of drawings Barocci generated suggests that he arrived at the solution for John before he finalized the poses for the Virgin Mary and Christ. The only surviving full compositional study is a drawing in the Uffizi (fig. 45). It includes a pose for John that comes very close to the one in the finished painting. Certainly it is not possible to determine how many earlier drawings may have been made for the *Crucifixion*, and there are no surviving *primi pensieri*. All that can be said for certain is that, by the time Barocci executed this sheet, he had determined the open and animated position that he sought for Saint John, but he was still some distance from the final poses for the other two protagonists.[28]

One extremely important aspect of the drawing concerns the position in which Barocci portrayed Christ. It is the only drawing of Christ's entire figure (among the four surviving examples) where his left foot crosses over his right. This seemingly inconsequential detail may be significant on two counts. Among the thousands of Crucifixion paintings created between the thirteenth and the late sixteenth centuries, the vast majority show Christ with his right leg placed over his left. There is, in fact,

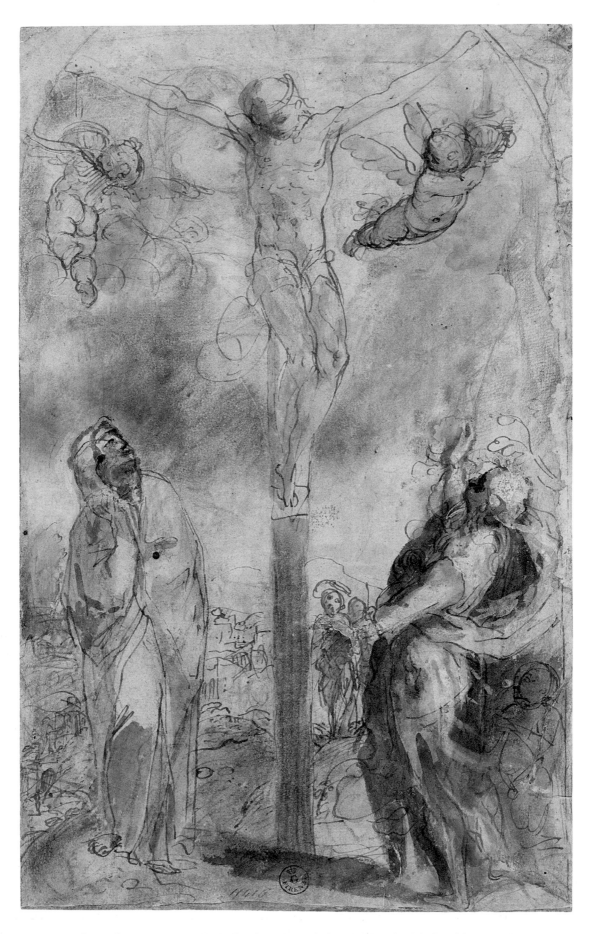

Fig. 45. *Compositional study for the Crucifixion.* Pen and ink and black and red chalk with brown wash heightened with white, 37.2 x 23.1 cm. Gabinetto Disegni e Stampe degli Uffizi, Florence, inv. 11416 F.

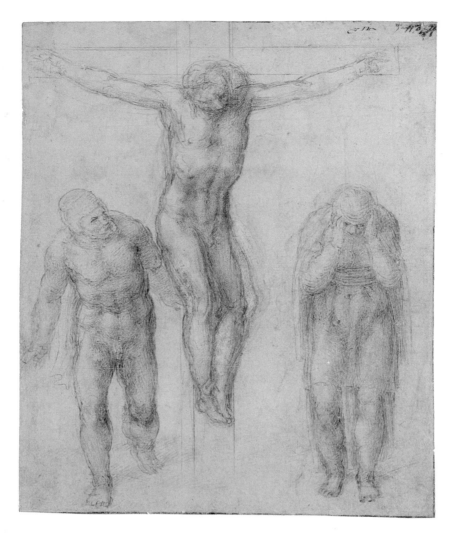

Fig. 46. Michelangelo, *Crucifixion with Two Mourners*, ca. 1555/64. Black chalk
heightened with lead white (discolored), 27.8 x 23.4 cm. The Ashmolean
Museum of Art and Archaeology, Oxford, inv. WA1846.89 recto

a textual source for the position Barocci drew in his sketch. The revelations of Saint Bridget of Sweden (1303–1373), a widely read account of events from Christ's life, included several visions in which the Virgin spoke to Bridget. In one of them, Mary described Christ's Crucifixion, detailing how he was placed upon the cross with his left foot covering the right, and that two nails were used.[29] Michelangelo used this position in one of his late Crucifixion drawings (fig. 46), where the angled left foot of Jesus is placed with its heel intersecting the ankle of the right foot, a pose remarkably similar to the position of the left foot in Barocci's drawing (fig. 45). Stuart Lingo suggested that Barocci may have had access to the older master's drawings in Rome during the early 1660s, and it may have been this favorit-

ism that incited the jealousy of Barocci's rivals in Rome and prompted their purported poisoning of him.[30] This compositional study for the Crucifixion may be the first piece of firm evidence that Barocci was granted this most privileged opportunity to avail himself of Michelangelo's designs. In beginning the process to set the poses and positions for the Crucifixion, Barocci may have remembered this unusual arrangement for Christ's legs from Michelangelo's sketch. He abandoned the motif in his subsequent designs as he worked out the torque in Christ's torso before settling on a prominent right leg (with the right foot on top) to emphasize more effectively the angling of the lower body toward John.[31]

As Barocci developed his composition further, the body of Christ drew most of his atten-

tion, evidenced by the ten surviving studies that relate to the figure. Interestingly, however, the single element that commanded his greatest interest was the proper left arm. Five sheets contain eight separate trials for this limb. Barocci recorded his ideas for the right arm in only two.[32] He devoted three sketches to the whole figure: an early pen and ink study in the Fitzwilliam Museum, Cambridge; a sensitive and quite beautiful chalk rendering in Würzburg; and the commanding drawing in Cambridge (cat. 2.1).[33] The Würzburg Christ has a somewhat more robust physique, an aspect that the artist toned down in the later Fitzwilliam study, opting for a more emaciated figure that elicits the viewer's compassion. This Fitzwilliam study also documents how Barocci lessened the torque in Christ's body, creating a

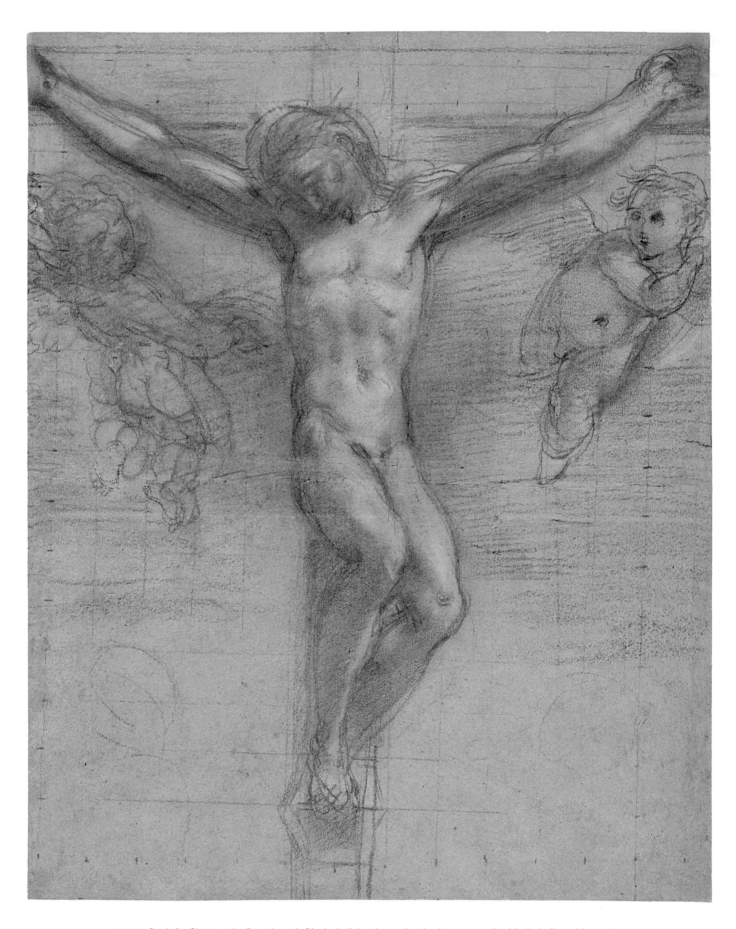

CAT. 2.1. *Study for Christ on the Cross* (recto). Black chalk heightened with white, squared in black chalk, on blue paper. [Verso: Studies for Christ on the Cross and for figure standing on a ladder. Black and red chalk heightened with white], 20¼ x 16⅛ in. (51.5 x 41 cm). Lent by the Syndics of The Fitzwilliam Museum, Cambridge, inv. 1978

more centralized figure whose upper torso lies closer to the wood of the cross. Barocci's sensitive application of black and white chalk creates a well-modeled figure in which light and shadow play across the thighs and chest. He omitted the loincloth on both sheets, although it appears in the early pen and ink study in the Fitzwilliam mentioned above, where he seems to have explored further the suggestion of a fluttering strip drawn to the left of the cross that he introduced in the early full compositional study. He was undoubtedly aware of the tradition for an undulating loincloth that was still popular in the early sixteenth century, but he seems to have abandoned it, most likely after recognizing that its effect of dramatic enhancement would have been lost against the powerful lightburst behind it.[34] Revisions on the Cambridge sheet reveal that Barocci lowered Christ's head, positioning it more in profile, and placed the hips parallel to the supporting beam of the cross to place greater emphasis on the different directions of the two halves of the body. Sketches on the verso of this sheet record Barocci's experimentations with three different models for Christ, of three different ages, further demonstrating how carefully he developed this figure.[35]

Barocci also revised the poses and placement of the cup-bearing putti, playing down the lateral symmetry of the picture and developing a more complex pose for the one on the left. In a partial sheet, now in a London private collection, he further refined their poses and shadows, working with a cursorily outlined body for Christ, his focus clearly being the finished appearance of these small angels.[36]

Other than the full compositional study, only two separate drawings remain for Saint John. Traditionally, artists portrayed him as intensely emotional, responding with grief at the Last Supper and effusively mourning on Golgotha. Barocci recognized in both Titian's and Piero della Francesca's renditions the necessary elements for an appropriately dramatic pose, which he used in the early compositional study (fig. 45). Here, Barocci placed John nearly in profile, his back arched with his left arm extended before him and out to his left side, while his right arm reaches up toward the cross. The artist used billowing drapery to increase Saint John's emotional energy. He refined the pose in a second study where he

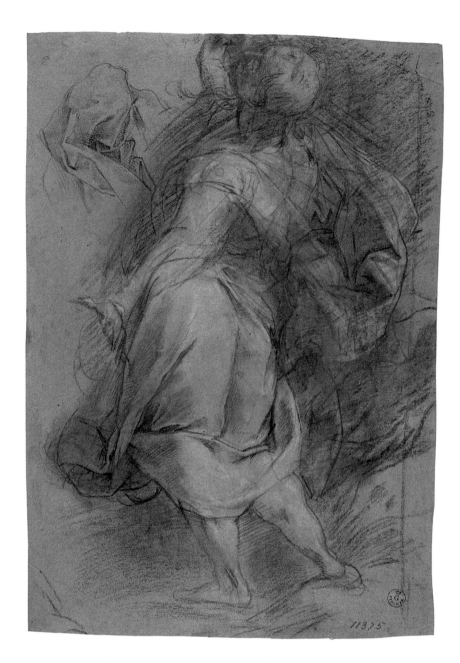

CAT. 2.2. *Study for Saint John the Evangelist* (recto). Black chalk heightened with white on blue paper. [Verso: Study for the Virgin Mary. Black chalk heightened with white], 15¹⁵⁄₁₆ x 10¾ in. (40.5 x 27.3 cm). Gabinetto Disegni e Stampe degli Uffizi, Florence, inv. 11375 F.

rotated the entire figure clockwise so that more of John's back could be seen.[37] The arching drape remained essentially unchanged, although when the figure was rotated, the proper right arm moved farther to the left in the drawing. Barocci sketched a second arm closer to Saint John's head to correct this shift.

The third sketch (cat. 2.2) shows how Barocci emphasized the vigor and intensity of John's response through looser and expanded drapery, defined as much by light and deep shadow as by its vigorous shape. Barocci drew

the position of the saint's head and neck quickly, at first farther back toward the right, and then reinforced the final position with darker, more decisive chalk strokes. He drew the left hip before he sketched in the left arm and broadened the portion of John's back so that he becomes a visual stepping stone into the picture—as John addresses the expiring Savior, so can the viewer. By turning up the hem of John's garment and introducing zigzagging lines for the cloak, the artist maximized the emotional power. He made slight

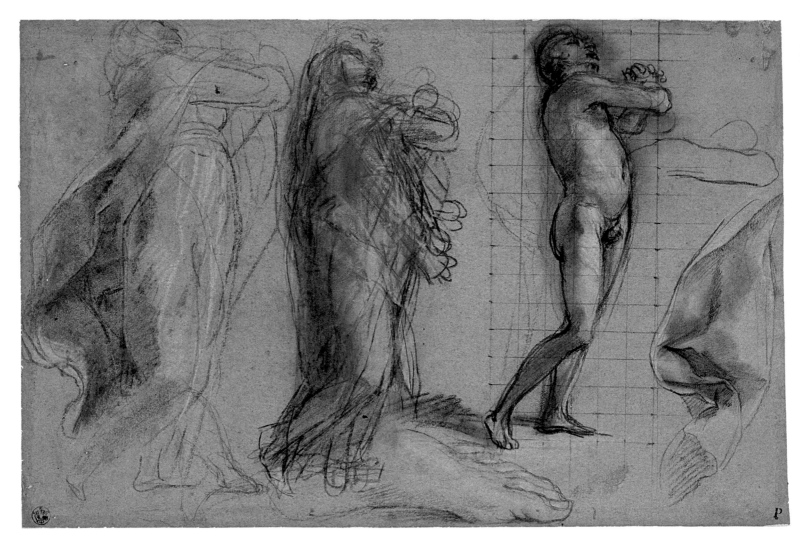

CAT. 2.5. *Studies for the Virgin Mary and drapery.* Black and white chalk on blue paper, laid down, 11¹/₁₆ x 16¹³/₁₆ in. (28.1 x 42.7 cm). Kupferstichkabinett, Staatliche Museen zu Berlin, inv. KdZ 27466 (4176)

Mary's figure was further refined in a later sheet (cat. 2.6) where Barocci worked out her hands and the fall of light, using the more contained contour that he employed in the painting. This last drawing suggests that Barocci revisited the drawings he made for the Bonarelli *Crucifixion* when he produced a later version of the theme, the enormous canvas that graces the cathedral in Genoa (fig. 16). This later painting, *Crucifixion with Mourners and Saint Sebastian,* produced between 1590 and 1596, expands the angelic host considerably beyond the two small putti Barocci included in his early altarpiece. In the later Genoa picture, he included adolescent angels hovering on clouds behind the cross as well as a group of angelic faces that materialize among the clouds. In the lower-right quadrant of cat. 2.6 is an

angel's head, a study for the small putto immediately to the right of Christ's feet in the Genoa painting. Whereas Barocci ultimately adopted a very different interpretation in Genoa—the swooning Virgin supported by John—he seems to have reviewed the drawings for his first version of the subject as he prepared the later design. (For a fuller analysis of this painting, see Mann essay, pp. 21–22.) Such revisiting of earlier design conceptions was a regular and expected part of Barocci's working procedure. Seldom, however, are we afforded such a direct glimpse into the ideas he considered when he prepared a second version of a subject he had painted years earlier.

In devising a suitable pose for the Virgin, Barocci examined at least five different solutions. In all of them, he sought a more impos-

ing, solid figure, a suitable foil for the drama that informs John's demeanor. In fact, Barocci allowed the viewer to see the two figures from slightly different vantage points, as we clearly look up at the Virgin Mary, thus enhancing her monumentality, while our position relative to Saint John is a bit higher as we look down on his left shoulder. Mary gains in stoic reserve, while John becomes even more emotive.

The simplicity of Barocci's *Crucifixion* belies its sophistication. Upon close examination, it reveals itself to be filled with innovations. Barocci's strategy was to elicit viewer involvement while negotiating the sometimes difficult terrain of the late sixteenth-century strictures against flamboyant and sensuous presentation. It is this constant balancing of opposites that gives this painting its punch. Barocci

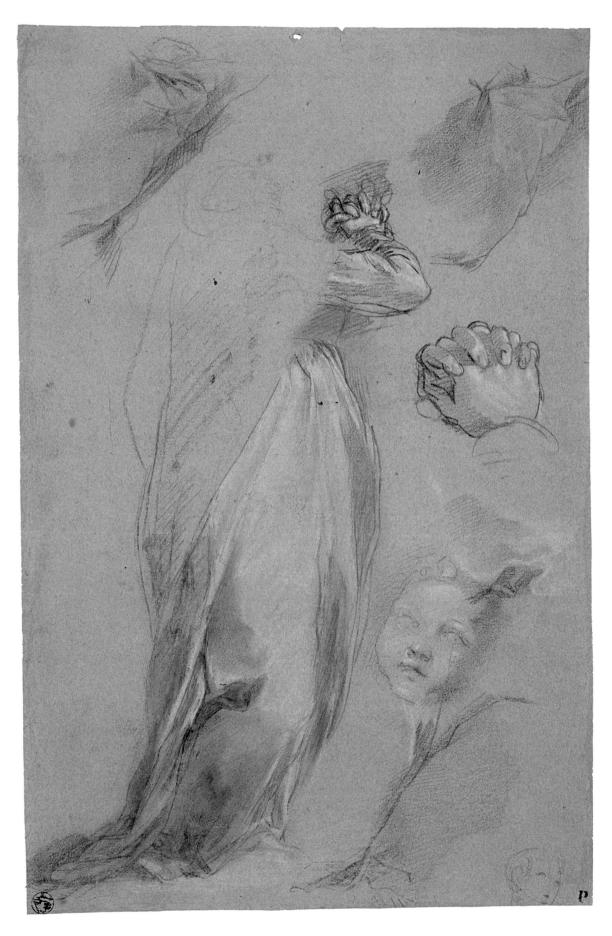

CAT. 2.6. *Studies for the Virgin Mary's torso, drapery, and hands; study for putto head for the Genoa Crucifixion.* Black and white chalk on blue-green paper, 16¼ x 10⁵⁄₁₆ in. (41.3 x 26.2 cm). Kupferstichkabinett, Staatliche Museen zu Berlin, inv. KdZ 20266 (4327)

Deposition

Federico Barocci's *Deposition* for the Chapel of San Bernardino in the cathedral of Perugia (fig. 47) was the artist's first masterpiece, representing a turning point in his career and in Italian religious painting. A seventeenth-century guidebook to Perugia praises the picture as one of the most beautiful and valuable paintings in the city, admirable particularly for its great design, many handsome figures, and exceptional coloring.[1] Barocci's first major altarpiece for a city outside his native Urbino, the picture is the first painting by him for which a large group of preparatory drawings is known—fifty-six sheets of various types.[2] The *Deposition* introduces several innovations: Barocci's extensive preparatory procedures; his singular approach to the female figure; experimentation with color; and an approach to religious subjects that combined tradition with innovation, shaped by the zeitgeist of the Catholic Reformation. Moreover, his designs for this altarpiece provided templates that were reutilized in future works, illustrating the artist's creation of a repertoire of figures that were repeated in different narrative contexts.

The altarpiece depicts a narrative with two principal components: the lowering of Christ's body from the cross by five men; and the grief of four women, including the fainting Virgin Mary. At the top of the arched painting, Nicodemus (at left) and Joseph of Arimathea (at right) stand on ladders and lean over the cross, while a young man at left, seen from the rear, holds fast to Christ, and Saint John the Evangelist (in red) waits to receive the body. At the right, another anonymous man descends a ladder, carrying a crown of thorns and a pair of pincers (used to remove the nails). Nearby, Saint Bernardino, to whom the chapel is dedicated, stands looking up reverently at his Savior. In the foreground, the Virgin has fainted; she is supported by a lovely young woman in yellow. Two other young women, one of whom must be Mary Magdalen, rush forward to attend to the Virgin. These two events are linked by a diagonal formed primarily by Christ's body, which bisects the arched, vertical canvas from upper left to lower right, creating a composition of great visual power that is singularly effective within Perugia's cathedral.

Today the capital of Umbria, Perugia was part of the Papal States during the early modern period. The imposing Cathedral of San Lorenzo, which flanks the main square of the city and faces the Fontana Maggiore and the Palazzo dei Priori, was largely designed about 1300, though it continued to be expanded and refined until its consecration in 1569.

Barocci's painting was commissioned by the Nobile Collegio della Mercanzia, the merchants' guild of Perugia and one of the city's two major guilds, which obtained the Chapel of San Bernardino in 1515. Although the chapel's decoration had been entrusted to Agostino di Duccio in 1474, his project was never completed, and on 8 November 1559, the guild initiated a new decorative program, commissioning the architect and sculptor Lodovico Scalza of Orvieto to design the altar. Payments from 1567 confirm that the sculptor Vincenzo Danti also contributed thirteen works to Scalza's project.[3] Early sources indicate that on 22 November 1567, Captain Raniero Consoli, a representative of the guild, met with Barocci in Urbino and evidently accompanied him back to Perugia. The contract between Barocci and the guild was signed in 1568, and the painting was completed and installed in the chapel on 24 December 1569, an exceptionally fast execution for a painter who soon became notorious for his slowness in fulfilling commissions. Barocci received 325 *scudi* for the large altarpiece.[4] The painting was set into a marble facade designed by Scalza and decorated with sculptures by Danti. It remained for over two hundred years as part of this ensemble, until Scalza's altar screen was demolished during the eighteenth century, when the French took Barocci's painting to Paris. In the course of its travels to and from France, the painting was damaged, but it was recently restored and may now be appreciated in its full coloristic splendor as one of Barocci's most breathtaking achievements.[5]

The chapel is dedicated to Saint Bernardino of Siena (1380–1444), a Franciscan monk who became one of the most famous preachers of the fifteenth century. Canonized in 1450, a scant six years after his death, Bernardino

was a member of the Observant Franciscans, the strictest and most ascetic branch of the order, which took absolute poverty as a central feature of its practice. His preaching was known for its emotional engagement with his audience and for his employment of a tablet with the monogram YHS (referring to Jesus's name), which he himself had designed for use during his sermons. Barocci's saint may be holding this device (or a book), but the lettering is not visible. Bernardino became vicar general of the Observants (1438–42), but he refused the three bishoprics of Siena, Ferrara, and Urbino in order to remain an active preacher.

Fra Bernardino visited and preached in Perugia on several occasions, and his strict moral exhortations influenced the laws of the city. His first and longest stay in Perugia was from September to November 1425; Perugia's sweeping penal reforms were approved on 4 November 1425, immediately after Bernardino's preaching mission there. These regulations outlawed many sinful activities, including sodomy, blasphemy, gaming, sacrilege, and various alleged abuses in female monasteries. The Bernardino-inspired laws against sodomy—a favorite target of his acrimonious moral exhortations—were long and detailed, specifying punishments for various scenarios, ranging from fines for minor infractions to being burned at the stake for serious offenses.[6]

Although there were doubtless many factors in the selection of the subject and the design of Barocci's altarpiece, the choice of a narrative focusing on the body of Christ, who is accompanied by other saints, may have been influenced by Fra Bernardino's views. The preacher advised his audiences, "Go to a high altar when you enter a church, and adore it, rather than stand before painted images. First give due reverence to the body of Christ, then show your devotion to the other figures which represent to you other devout saints."[7] Barocci's altarpiece, with the centralized body of Christ surrounded by other saints, seems a perfect vehicle for this approach to devotion.

Although the Descent from the Cross was described by all four of the Evangelists, the

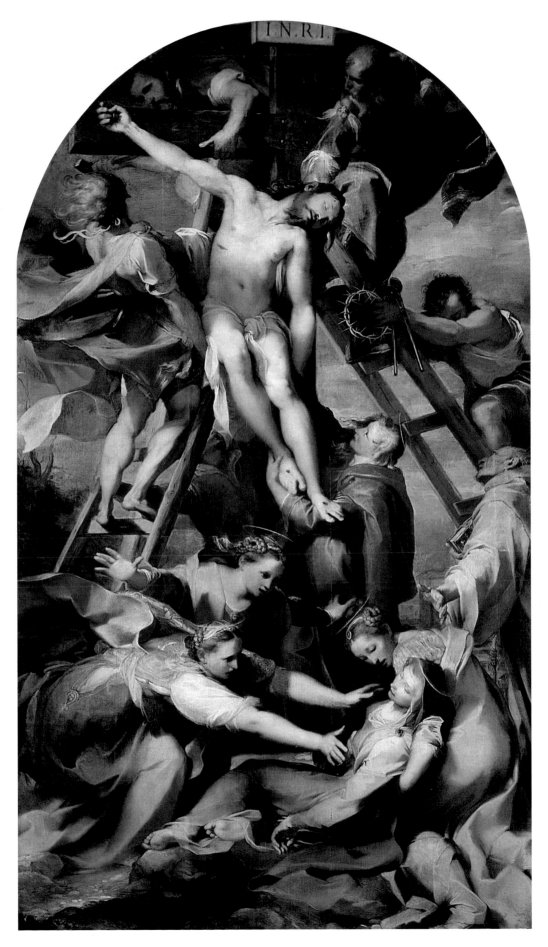

Fig. 47. *Deposition*, 1568–69. Oil on canvas, 412 x 232 cm. Chapel of San Bernardino,
Cathedral of San Lorenzo, Perugia

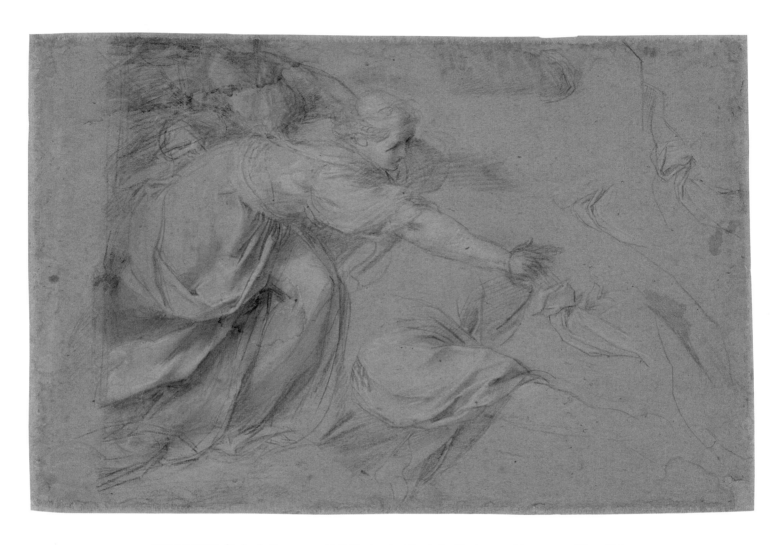

CAT. 3.4 VERSO. *Studies for the woman at left.* Black and white chalk with stump on blue paper, 10¹¹⁄₁₆ x 16⅛ in. (27.2 x 41 cm), slightly irregular. Bibliotheca Hertziana, Max Planck Institute for Art History, Rome, inv. 10092

Compared to Christ in Daniele da Volterra's *Deposition,* Barocci's Jesus is more centralized and more illuminated, enhancing the painting's dramatic focus. He is also more idealized, in a pose that seems implausibly graceful for a dead man. Notwithstanding his commitment to drawing from life, Barocci compromised strict naturalism here by idealizing his figures and their actions. This idealization applies also to the men supporting Christ's body in poses that seem designed with an eye more for beauty, elegance, and variety than for believable functionality in terms of bearing the real weight of a body.

Perhaps it is no surprise that we have as many preparatory studies for the youth seen from the rear on the left ladder as we do for Christ. An example of Barocci's capacity for graceful complexity, this beautiful figure—with his turned head, twisting torso, actively differentiated arms and legs, and billowing, colorful draperies—elicited Bellori's particular admiration. The youth is one of Barocci's most lyrical creations. He moves dynamically through space while bearing most of Christ's weight; his windswept hair and fluttering draperies convey a sense of weightlessness that belies the physicality of his efforts. Although the drapery and head studies that Barocci must have made have not survived, seven drawings document the

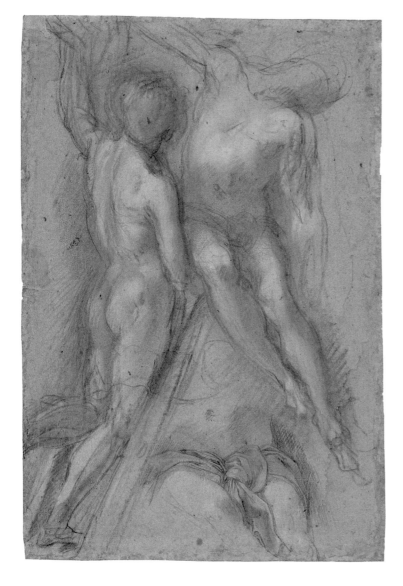

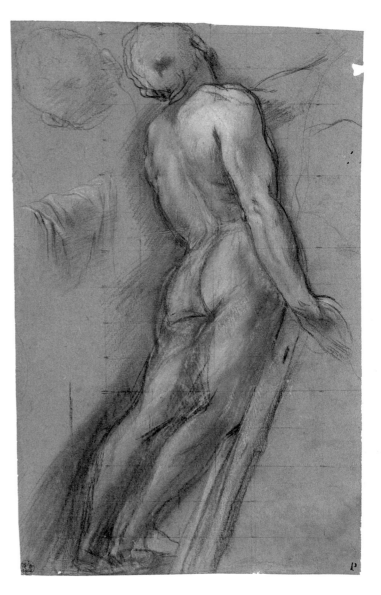

CAT. 3.4 RECTO. *Nude studies for the man on a ladder and Christ.*
Black and white chalk on blue paper, 16⅛ x 10¹¹⁄₁₆ in. (41 x 27.2 cm),
slightly irregular. Bibliotheca Hertziana, Max Planck Institute for
Art History, Rome, inv. 10092

CAT. 3.5. *Nude study for the man on a ladder.* Black and white chalk with
stump, incised, squared in black chalk, on blue paper, 15⁹⁄₁₆ x 9⁷⁄₁₆ in.
(39.5 x 24 cm). Kupferstichkabinett, Staatliche Museen zu Berlin,
inv. KdZ 20462 (3747)

careful preparation of this man. Three nude studies from life for the full figure illustrate the subtle modifications Barocci devised to achieve his lyrical effects. The earliest, a wonderful drawing from the Hertziana (cat. 3.4 recto), portrays the youth in a pose that is more upright than the position finally employed in the painting, supporting a Christ who has already received his final form. Barocci introduced the torsion of the back and turn of the head in a sheet in the National Gallery of Art.[20] These key changes were retained in a more detailed study in Berlin (cat. 3.5), in which only the position of the legs remains to be modified. The taut, straining pose, with the straight right arm contrasting with the arched back, bent with effort, and the head turned away from the viewer were all resolved in this luminous sheet. Barocci differentiated the legs further in two additional drawings in Berlin,[21] whereas he examined the full figure in a quick sketch in Cambridge, and the clothed upper body in a drawing in Urbania.[22]

The youth on the ladder typifies several characteristic aspects of Barocci's figure style: relying on complex poses, expressive gestures, and dynamic draperies to convey narrative action and emotion, the face is invisible to the viewer and thus does not contribute to the emotional content of the ensemble. The seven

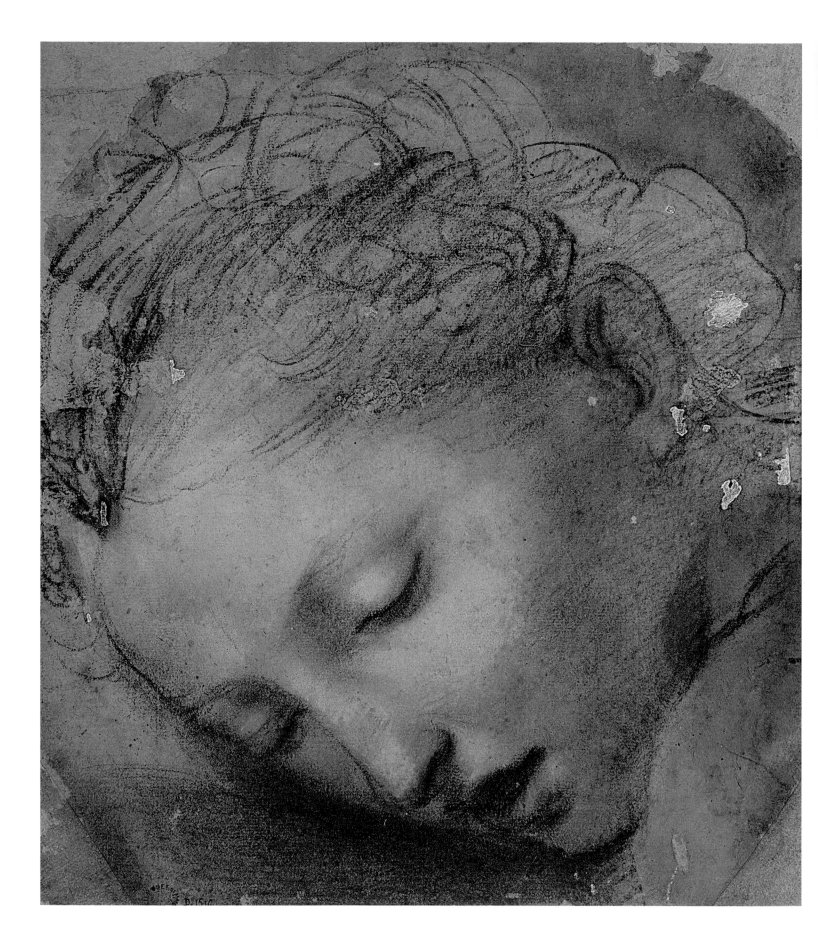

CAT. 3.7. *Study for the head of the woman supporting the Virgin.* Red, black, and white chalk and peach pastel on blue-gray paper, laid down, 12½ x 11⅛ in. (31.7 x 28.2 cm). Musée des Beaux-Arts et d'Archéologie, Besançon, inv. D. 1516

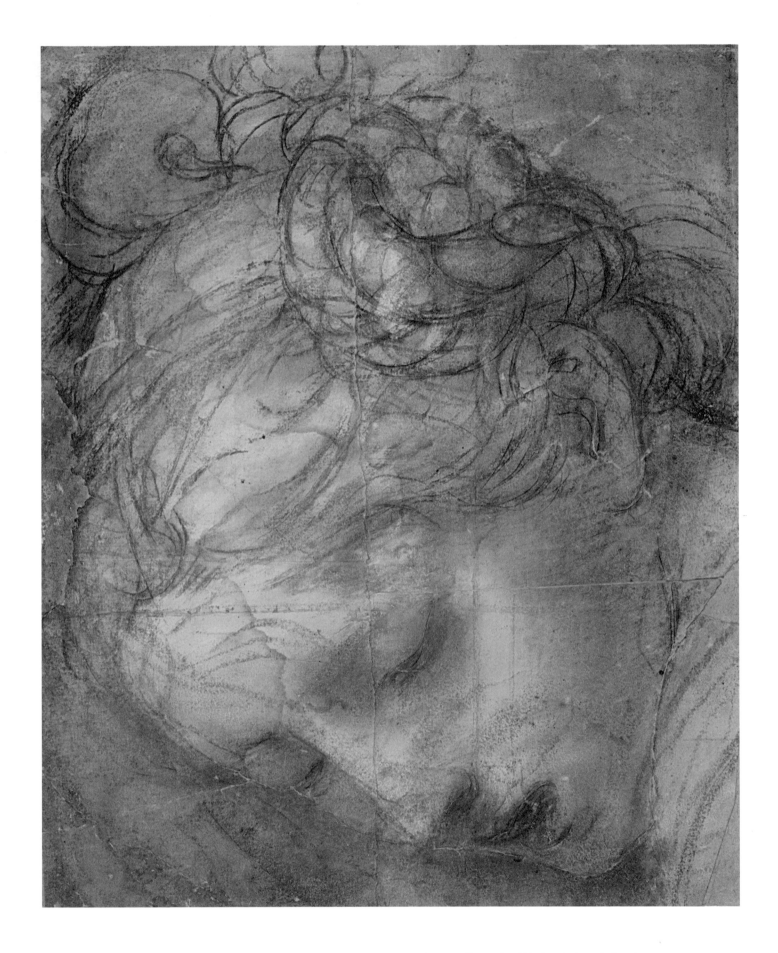

CAT. 3.8. *Cartoon fragment for the head of the woman supporting the Virgin.* Charcoal and black and white chalk with traces of red chalk, incised, 11¹³⁄₁₆ x 9½ in. (30 x 24.2 cm). Albertina, Vienna, inv. 2287

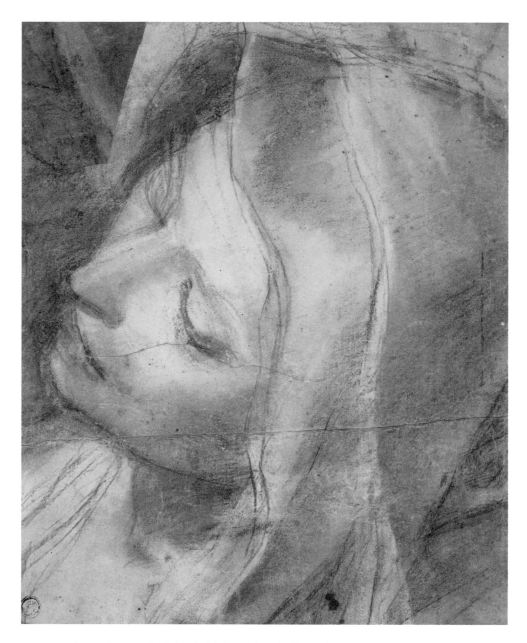

CAT. 3.9. *Cartoon fragment for the head of the Virgin* (recto). Charcoal and black and white chalk with stump, incised. [Verso: Fragment of a composition with a column. Black chalk], 11⅝ x 9⁷⁄₁₆ in. (29.5 x 23.9 cm). The Art Institute of Chicago, The Leonora Hall Gurley Memorial Collection, inv. 1922.5406

Albertina sheet probably record the transfer of this design not only to the *Deposition* but also to these later paintings.

A second cartoon fragment for the head of the Virgin has also survived (cat. 3.9). This beautiful sheet is particularly remarkable for its close study of the play of light and shadow. Barocci's cartoons are singular for their careful attention to lighting, expressed particularly through stumping, to create subtle areas of shadow across the surface. Such pictorial handling is unusual in a cartoon, in which only the contours were incised for transfer to the painting.

The surviving drawings for the nine other figures in the *Deposition* are more uneven in recording Barocci's design process. There are four drawings for Joseph of Arimathea and Nicodemus, but only two cursory head studies for Saint John, one for the head of a man standing below and behind the cross,[26] and one quick sketch for the man descending the ladder with the crown of thorns and pincers.[27] An early idea for Saint Bernardino was included on the verso of the Edinburgh sketch (cat. 3.1), but only one more detailed and advanced drawing for him is known. This drawing, principally a

study from life of a nude in the saint's final pose, also includes sketches of the right hand and the draped figure at left (cat. 3.10).

A greater number of drawings relate to the two remaining female figures at the left of the composition whose dynamic poses evidently required extensive preparation. Full of movement and close to the viewer, these two women are the most emotionally expressive figures in the painting. An early study (cat. 3.1 verso) demonstrates that Barocci began with a less dynamic portrayal that is closer to Volterra's painting, with only one of these women, who is

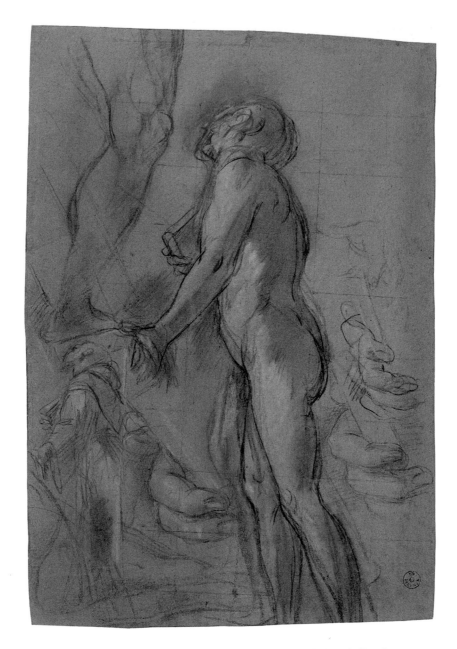

CAT. 3.10. *Studies for Saint Bernardino* (recto). Black and white chalk with charcoal and stump, squared in black chalk, on blue paper. [Verso: Sketch for Joseph of Arimathea. Black chalk], 16¾ x 11¹⁄₁₆ in. (42.5 x 28.1 cm). Gabinetto Disegni e Stampe degli Uffizi, Florence, inv. 11383 F.

stationary and leaning over the prostrate body of the Virgin. All the other preparatory studies for these two figures, however, show Barocci examining them in essentially their final positions. A drawing of both women in the Musée Condé, Chantilly, examines particulars such as drapery and the extended arms of the woman at the rear.[28] A drapery study and a colored drawing of her head are the only two other known designs for this woman.[29]

The forward figure (probably the Magdalen), however, which seems to have given Barocci some trouble, was prepared in many other drawings. Although only one dedicated drapery study is extant,[30] Barocci examined the arms and hands in no less than four drawings,[31] in addition to a fifth rendering of the full figure in which the right arm and sleeve were redrawn (cat. 3.4 verso). Despite these efforts, her arms seem somewhat disproportionate. This raises questions about whether these drawings were made from life, although one might otherwise assume that drawings like the two arm studies in Berlin had such an inception. Probably the latest is a beautiful study in Berlin for both hands.[32] Barocci's expressive hands, often fore-

shortened, moving, and variously positioned, were key components of his highly affective repertoire of gesture. This woman's hands, one with fingers outspread and the other curving gracefully around the Virgin's shoulder, were later reused, with modifications, for Creusa in *Aeneas Fleeing Troy* (cat. 16).

Barocci's *Deposition* is his first painting for which multiple head studies are known for some figures, and the greatest number are connected with the Magdalen. Three drawings in Turin (fig. 50),[33] Munich,[34] and Vienna (cat. 3.11) examine this head. The Turin example,

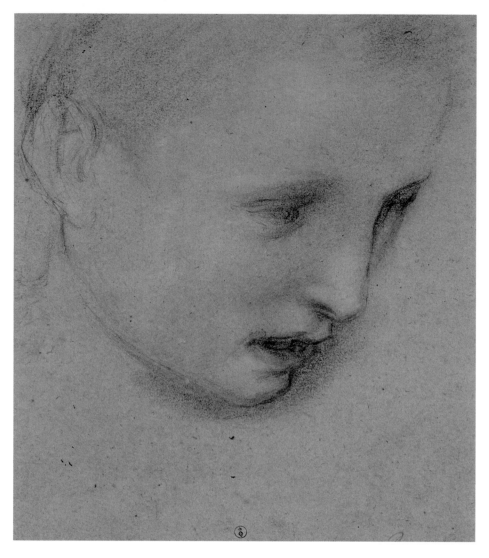

Fig. 50. *Study of a woman's head*, ca. 1568. Black and red chalk with traces of white chalk and peach and ocher-yellow pastel on blue paper, laid down, 24.7 x 21.5 cm.
Biblioteca Reale, Turin, inv. 15848

at this stage that he elaborated all the specifics for his final conception.

The *Deposition* marked a turning point in Barocci's creative process. It was here that he first established many critical aspects of his methods for picture preparation: the reliance on numerous drawings of various types; the use of multiple head studies for each figure, including studies in chalk and pastel; the employment of male models for female figures; and the use of a *cartoncino per il chiaroscuro*. Although Barocci's later works developed new stylistic features that were different from some aspects of the *Deposition,* many critical features of his preparatory apparatus were established in this pivotal masterpiece of his early career.

Babette Bohn

NOTES
1 Crispolti 1648 (1974), 64.
2 This number counts each two-sided drawing as two studies. E 2008, 1, 191–217, no. 22, also catalogued fifty-six (his no. 22.40 includes both the recto and verso of a drawing in Manchester). Emiliani overlooked three drawings discussed here: Cambridge 1978 verso; Cambridge PD.117-1961 verso (here fig. 48); and the drawing in the National Gallery, Washington, D.C., inv. 2007.111.46 verso. I reject three of his suggestions. One is not by Barocci: Metropolitan Museum of Art, Lehman collection, inv. 1975.1.269, E 2008, 1, 211, no. 22.34. Two (Louvre inv. 2851, E 2008, 1, 194, no. 22.3, and Urbino inv. 1659, E 2008, 1, 198, no. 22.12) are not convincingly connected to the *Deposition*.
3 Santi 1972, 112. A drawing in the Collegio della Mercanzia, Perugia, records the altar design with Danti's thirteen sculptures; the ensemble was dismantled during the late eighteenth century (ibid., fig. 1).
4 The documentation for the commission is found in the Archivio del nobile Collegio della Mercanzia, Perugia, *libro verde;* cited by Olsen 1962, no. 21, and subsequent authors.
5 On the restoration, see Abbozzo and Castellano 2010.
6 Mormando 1999, 156–57; Pacetti 1940.
7 Quoted by Richard Trexler, *Public Life in Renaissance Florence* (New York, 1980), 55.
8 Réau 1955–59, 2.2, 513.
9 Matthew 27:57–61, Mark 15:42–47, Luke 23:50–56, John 19:38–42.
10 Réau 1955–59, 2.2, 514–15.
11 On the dating of this work, see Hirst 1967, 499–501, illustrated 503, fig. 10.
12 Hamburgh 1981, 45–75, noted the popularity of the swooning Virgin, particularly in Franciscan settings during the sixteenth century.
13 Bellori 1672 (1976), 185–86; the English trans. is from Bellori 1672 (2000), 178.

probably the first in the series, shows that Barocci's female heads sometimes had their inception in male figures. The more elaborated and now recognizably female head in Munich, in chalk and pastel, illustrates the metamorphosis in gender that transpired with the addition of hair and fleshier cheeks. The beautiful head from the Albertina (cat. 3.11), possibly retouched by a later hand, shows the head with the details of expression, coiffure, and coloring all finalized.

After completing all his creative decisions, Barocci produced a finished compositional study for the *Deposition*—what Bellori called a *cartoncino per il chiaroscuro* (small cartoon for light and shadow). The splendid example from the Uffizi (cat. 3.2) is one of the most beautiful and best-preserved examples of this type of drawing in Barocci's oeuvre; he probably employed this large sheet as a presentation drawing, to obtain final approval from the patron for his design. This highly finished drawing on ocher-colored paper relies extensively on white heightening to express the dramatic play of light that has such a critical role in Barocci's painting, employing a tiny brush to create fine striations in white.[35] This is the earliest surviving example of Barocci's *cartoncini*—literally, "small cartoons"—that would have marked the penultimate stage of his design process, just before making the full-scale cartoons used for direct transfer to the painted surface. Barocci's *cartoncini* are more detailed than the full-scale cartoons, though, and it was typically

14 Another drawing ascribed to Barocci in the Uffizi (inv. 11360 F. verso), with sketches for both a *Deposition* and an *Entombment,* is not autograph.

15 Fitzwilliam Museum inv. PD.117-1961 verso, Scrase 2006, 92–93, no. 21.

16 Urbino inv. 1658 recto and verso; Berlin inv. KdZ 20463 (3737); Uffizi inv. 11312 F. recto and verso; and Uffizi inv. 11595 F. verso, E 2008, 1, 216, nos. 22.41, 22.42, illustrated, 22.43, and 195–97, nos. 22.4, 22.7, 22.9, all illustrated.

17 Berlin inv. KdZ 20457 (4273), KdZ 20459 (4274), KdZ 20461 (4275), and KdZ 20468 (4406) all study the left leg, whereas inv. KdZ 20283 (4391) and KdZ 20458 (4278) examine the right. Inv. KdZ 20468 (4406) also includes a study of the full figure. All were catalogued by E 2008, 1, 210, no. 31, 216–17, nos. 22.47–22.49 (only 22.47 is illustrated), and 217, nos. 22.51–22.52.

18 Urbino inv. 1657; E 2008, 1, 216, no. 22.45.

19 The second study for the full figure is Berlin inv. KdZ 20468 (4406), E 2008, 1, 210, no. 22.31. A drawing of Christ (formerly in the Dreyer collection, London, and now in the Lehman Collection, Metropolitan Museum of Art, New York, inv. 1975.1.269), was published as Barocci's study for Christ in the *Deposition* by Olsen 1962, 153; Pillsbury 1978, 49, no. 21; and E 2008 (1, 211, no. 22.34), but Anna Forlani Tempesti (1987, no. 102) convincingly attributed the drawing to Alessandro Casolani.

20 Inv. 2007.111.46 recto, E 2008, 1, 211, no. 22.33.

21 Inv. KdZ 20464 (4286) and inv. KdZ 20465 (4270), E 2008, 1, 216, no. 22.44, and 211, 22.35, both illustrated.

22 Fitzwilliam Museum inv. 1978 verso, Scrase 2006, 90–91, no. 20, illustrated; and Urbania inv. II 92.642 recto, E 2008, 1, 212, no. 22.36, illustrated.

23 Inv. 1652, E 2008, 1, 195–97, no. 22.5, illustrated.

24 Inv. 11341 F. recto, E 2008, 1, 195–97, no. 22.6, illustrated.

25 Musée des Beaux-Arts, Lille, inv. W. 4502, catalogued by Emiliani when it was in the van Regteren Altena collection (2008, 1, 196–97, no. 22.8).

26 Whitworth Museum, Manchester, inv. D.18.1933 recto, E 2008, 1, 213–14, no. 22.40, illustrated.

27 Berlin inv. KdZ 20463 (3737), E 2008, 1, 216, no. 22.43.

28 Inv. OE-161, E 2008, 1, 201, no. 22.17, illustrated.

29 Uffizi inv. 11595 F. recto and inv. 11635 F. recto, E 2008, 1, 202, no. 22.18 and 257, 33.22, both illustrated.

30 Uffizi inv. 11341 F. verso, E 2008, 1, 217, no. 22.54.

31 Two arm studies are in Berlin: inv. KdZ 20449 (4234) and inv. KdZ 20470 (4365). Two drawings of the hands are in the Uffizi (inv. 11648 F.) and Berlin (inv. KdZ 20456 [4205]). All four are in E 2008, 1, 207–8, nos. 22.25–22.28, with all but the last illustrated.

32 Inv. KdZ 20456 (4205), E 2008, 1, 207, no. 22.25, illustrated.

33 Biblioteca Reale, Turin, inv. 15848, E 2008, 1, 204, no. 22.21, illustrated.

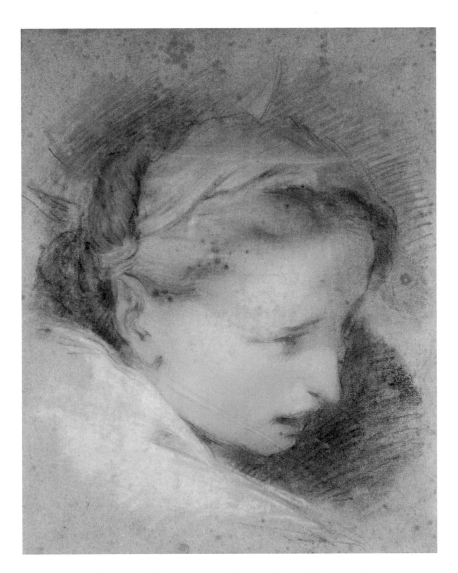

CAT. 3.11. *Study for the head of a woman.* Black, red, and white chalk with peach and ocher pastel on blue paper, laid down, 15 x 11⅞ in. (38.1 x 30.1 cm). Albertina, Vienna, inv. 554

34 Staatliche Graphische Sammlung, Munich, inv. 1952.35, E 2008, 1, 206, no. 22.24, illustrated; known to me only from photographs.

35 Catherine Monbeig-Goguel hypothesized that some of the white heightening might have been added by a later hand, as she has observed in many Louvre drawings (oral communication). Close examination of the drawing, however, confirms that the white heightening is all original.

Provenance: The work is still in its original location, the cathedral of San Lorenzo, Perugia. In 1797, it was taken to Paris by French troops; it was restored to the cathedral in 1815

Bibliography: Borghini 1584 (2007), 569; Crispolti 1648 (1974), 64; Scannelli 1657 (1989), 197; Bellori 1672 (1976), 185–87; Bellori 1672 (2000), 178–79; Baldinucci 1681–1728 (1975), 3, 243, and 399; Dennistoun 1909, 3, 371; Schmarsow 1909, 9; Schmarsow 1909 (2010), 43–49; Schmarsow 1910, 8–9; Schmarsow 1911, 7, 25, 31; Di Pietro 1913, 16–28; Schmarsow 1914, 6–7, 30–31, 44; Olsen 1962, no. 21; Andrews 1968, 1, 12; Emiliani 1975, 78–81, no. 50; Pillsbury 1976, 56; Shearman 1976, 50, 51, 53; Pillsbury and Richards 1978, 47–50, nos. 19–22; Emiliani 1985, 1, 60–75; Birke and Kertész 1992–97, 1, 304, and 2, 1196; McCullagh and Giles 1997, 15–17, no. 15; McCullagh 2000, 173–74; Turner 2000, 44–47; Scolaro 2005, 52; Scrase 2006, 96–101, nos. 23–25; E 2008, 1, 191–217, no. 22; Marciari and Verstegen 2008, 318, n. 45; Mancini 2009, 267–68, no. 1; Mancini 2010, 11–12 and 32–33, no. 2; Abbozzo and Castellano 2010; Gillgren 2011, 106–9 and 244–45, no. 10; Scrase 2011, 28–29, no. 31, and 31–32, no. 33.

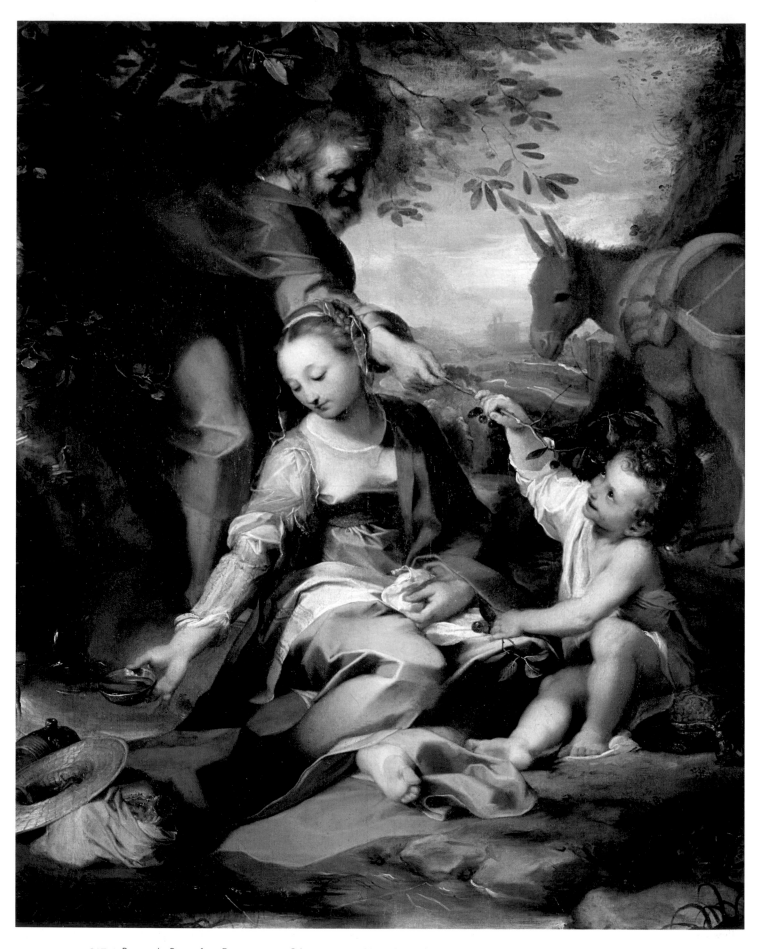

CAT. 4. *Rest on the Return from Egypt*, 1570–73. Oil on canvas, 52⅜ x 43⁵⁄₁₆ in. (133 x 110 cm). Vatican Museums, Vatican City, inv. 40377

Rest on the Return from Egypt

One of Barocci's most charming devotional pictures, the *Rest on the Return from Egypt* testifies to the artist's extraordinary skills as a colorist as well as his ability to weave three figures together into a sophisticated yet endearing composition. The picture is first and foremost a devotional image of the Virgin Mary. She is the solid anchor of the composition, accounting for more than one-fifth of the canvas. Barocci based his composition on the more widely known imagery associated with the Holy Family's flight into Egypt, which included a stop for rest and fortification. By the late sixteenth century, images of the Rest on the Flight had become popular as part of the growing cult of devotion to Saint Joseph, Mary's husband and the Christ Child's guardian.[1] Barocci incorporated the ideas behind the devotion to Joseph by presenting him as an active figure who stands, literally, at the top of the picture, by implication heading the family. Barocci made several versions of this subject. Each differs in small details from the others, indicating that the artist fine-tuned the image every time he painted it in order to address the slightly different function that each picture served. In revising his composition, he drew on a range of sources, and he probably created many more drawings than the twenty-six that still survive. The drawings demonstrate how carefully he developed the three-person composition, focusing much of his attention on the Christ Child, while at the same time devising compelling poses for both Mary and Joseph.

The painting depicts a simple scene. In a shady spot, the Virgin sits on the ground, dipping a silver bowl into a stream at the left side of the picture. Behind her, Joseph reaches up into the overhanging cherry tree for fruits that he hands to Jesus, who is seated on a cushion on the lower right. A small still life composed of a wine jug, an upturned straw hat, and an open sack of bread occupies the lower-left corner of the canvas. A donkey wearing a wooden saddle stands behind the family group, turning his head toward Joseph. A distant landscape, punctuated with the suggestion of buildings along the horizon, is illuminated by a sunlit blue and yellow sky.

Fig. 51. Antonio Capellan after Barocci, *Rest on the Return from Egypt*, 1772.
Etching and engraving, 31.4 x 25.4 cm. The British Museum,
London, inv. 1856,0510.221

Barocci made at least three versions of this subject and perhaps four; the Vatican's painting was most likely the second version. Any discussion of this painting must begin with a summation of these other commissions. The first of the three pictures was created for Guidubaldo della Rovere, duke of Urbino, who presented it to his daughter-in-law Lucrezia d'Este, in honor of her marriage to his son Francesco Maria II on 2 January 1571; the picture must therefore have been made in 1570.[2] The painting was listed in a 1592 inventory of the Este collection, and when Lucrezia died in 1598, Cardinal Pietro Aldobrandini inherited it. The canvas remained in the Aldobrandini collection until at least 1787; by the early nineteenth century, it was in England; there is no record of it after 1876. Although

currently untraceable, the painting is known through Antonio Capellan's 1772 etching/engraving, made as part of a published record of celebrated paintings in the city of Rome (fig. 51).[3] Giovanni Pietro Bellori reported that because the picture was so admired, Barocci painted "some others of it," a decidedly vague description that heretofore has been understood to refer to the Vatican picture, but in truth probably encompasses at least two versions—the Vatican painting and another known only through a chiaroscuro woodcut that was in the artist's studio at his death.[4] Edmund Pillsbury identified the woodcut as a copy after the Este picture, but it deviates from the Capellan print on two key points—the hat is top up, and the child holds an apple or some other round fruit.[5]

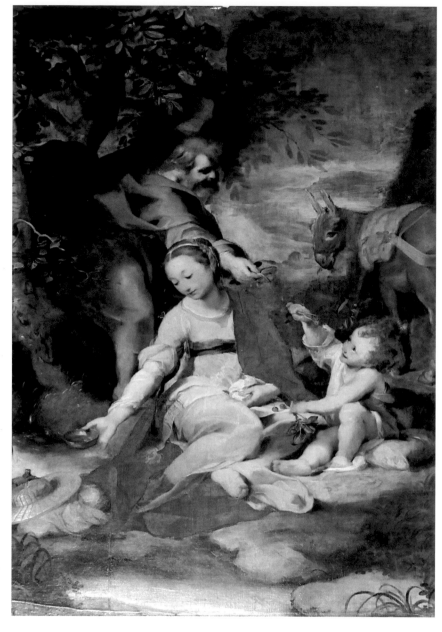

Fig. 52. *Rest on the Return from Egypt*, 1575–76. Distemper and oil on canvas, 190 x 125 cm. Church of Santo Stefano, Piobbico

Anastagi read architecture, dabbled in mathematics, and was an avid art collector whose many travels involved visits to the studios of artists and artisans in Genoa, Venice, Naples, Milan, and, most often, Rome. He was keenly devout, with a special reverence for the Virgin Mary, which prompted his commission for the *Rest on the Return*.

In spite of Bellori's sequence, most scholars have identified the Brancaleoni version as having been painted prior to the Vatican picture. However, before Guidubaldo's death in 1574 there were frictions between Guidubaldo and the Brancaleoni that had begun to be resolved in 1575.[11] Although Barocci was not yet a true court painter for the duke, it is nonetheless highly unlikely that the artist would have undertaken a commission for his patron's enemy prior to the resolution of their difficulties. Therefore, the Brancaleoni version should probably be dated no earlier than 1575, when Cornelis Cort made an engraving that shares some elements with Barocci's Brancaleoni composition (the bridled donkey and the cherries in Mary's lap) and may be based on some intermediary stage of that composition. The print's date is consistent with that proposed for the Brancaleoni picture.

Variations between these three versions confirm the logic of this sequence. The Este picture, as recorded in Capellan's print, included a kneeling Christ Child and the Virgin's straw hat shown upside down. Both the Vatican and Brancaleoni paintings were changed to incorporate a seated rather than kneeling child. However, the Vatican version continues the position of the straw hat from the Este picture, suggesting a sequence in which Barocci introduced the change in the child's pose in the Anastagi painting, followed by the Brancaleoni version in which the artist continued to refine by flipping the hat over. The Este and Anastagi pictures shared the same smaller and squarer format, confirmed in the Capellan print. In the Brancaleoni picture, Barocci needed to enlarge the canvas into a vertical composition for its use in a church interior. The proposed fourth version, based on the chiaroscuro print, is difficult to place within the series. It combines the child's pose in the Este version with the hat position of the later Brancaleoni picture and introduces a larger round fruit in the child's hand, suggesting that Barocci

The fact that it was in Barocci's workshop may indicate that it faithfully records an as-yet-undiscovered version of the subject. Bellori also stated that a painting of larger dimensions and in distemper rather than oil (fig. 52) was commissioned by Count Antonio II Brancaleoni.[6] It was sent to a parish church, Santo Stefano in Finocchieto, which was destroyed by an earthquake in 1781. The canvas currently hangs in the newer, relocated church of Santo Stefano in the center of Piobbico.[7]

The Vatican picture was ordered by Barocci's friend Simonetto Anastagi of Perugia.

Bellori noted that after spending three years in Perugia working on the *Deposition* altarpiece, the painter sent the picture to Anastagi as a token of friendship.[8] However, Anastagi's accounts reveal that he himself commissioned the painting and made the final payment in January 1573.[9] We know that the work was delivered to Perugia on 3 October 1573, according to a letter Barocci sent with it.[10] Anastagi was a cultivated man and a member of the Accademia del Disegno in Perugia, an institution founded in 1573 and modeled after the one that had recently been established in Florence.

changed and recombined elements as he continued to work with this popular composition.

The subject is identified in all the early sources. Anastagi called it a painting of "the most Glorious Virgin when she had returned from Egypt." Raffaello Borghini in 1584 used the same title, and Bellori described it as "the Virgin resting from her journey from Egypt."[12] Although this episode has no detailed textual tradition, it was based on Matthew's statement that the Holy Family journeyed back to Palestine from Egypt, where they had fled to avoid King Herod's decree that all young male children be massacred.

The subject has often been identified erroneously as a Rest on the Flight into Egypt. All the examples conform to the details of that far more commonly depicted story, and Barocci was obviously following its well-established iconography. The narrative comes not from the Bible, but from one of a number of noncanonical stories that filled in details of the lives of Jesus and his mother and enjoyed widespread popularity throughout the Middle Ages and the Renaissance. Known as the Pseudo-Matthew, it was originally written in the fifth century and grew to become the most widely read of the apocrypha by the later medieval period. Whereas Matthew 2:14–15 states simply that Joseph "got up and, taking the child and his mother with him, left that night for Egypt, where he stayed until Herod was dead," the Pseudo-Matthew embellished the story with a variety of miracles and adventures that inspired an array of painted illustrations. The relevant portion comes from chapter 20, which describes the early days of the family's flight from Palestine:

And it came to pass on the third day of their journey, while they were walking, that the blessed Mary was fatigued by the excessive heat of the sun in the desert; and seeing a palm tree, she said to Joseph: Let me rest a little under the shade of this tree. Joseph therefore made haste, and led her to the palm, and made her come down from her beast. And as the blessed Mary was sitting there, she looked up to the foliage of the palm, and saw it full of fruit, and said to Joseph: I wish it were possible to get some of the fruit of this palm. And Joseph said to her: I wonder that thou sayest this, when

thou seest how high the palm tree is; and that thou thinkest of eating of its fruit. I am thinking more of the want of water, because the skins are now empty, and we have none wherewith to refresh ourselves and our cattle. Then the child Jesus, with a joyful countenance, reposing in the bosom of His mother, said to the palm: O tree, bend thy branches, and refresh my mother with thy fruit. And immediately at these words the palm bent its top down to the very feet of the blessed Mary; and they gathered from it fruit, with which they were all refreshed. And after they had gathered all its fruit, it remained bent down, waiting the order to rise from Him who had commanded it to stoop. Then Jesus said to it: Raise thyself, O palm tree, and be strong, and be the companion of my trees, which are in the paradise of my Father; and open from thy roots a vein of water which has been hid in the earth, and let the waters flow, so that we may be satisfied from thee. And it rose up immediately, and at its root there began to come forth a spring of water exceedingly clear and cool and sparkling.[13]

The key elements that formed the core of fifteenth- and sixteenth-century depictions of the story included the Holy Family (Mary, Christ, and Joseph), a donkey, a tree with fruit, and a spring of water. The palm tree in the text was by no means the most frequently illustrated, and Barocci kept well within the pictorial norms for the subject by selecting a deciduous tree that offered the required fruit as well as sheltering branches. By 1570, the iconography for the Rest on the Flight into Egypt was well established, and Barocci followed tradition in placing Mary on the ground beneath the tree and depicting Joseph as an active participant. The artist deviated from the standard arrangements by putting the Christ Child on the ground rather than on Mary's or Joseph's lap, and by including cherries as the designated fruit.[14] Barocci's only change to make his picture read more like the Holy Family's return from exile was to increase the age of the child. Jesus had been an infant when he first fled from Herod, and he was three or four years old when he returned.[15]

Barocci's portrayal of Joseph shows that he was attuned to the saint's growing popularity.[16] Although the earliest devotion to Saint Joseph began in the twelfth century, the cult gained recognition in the fifteenth century and grew swiftly during the sixteenth, resulting in more painted images and the saint's greater prominence and larger role in a number of narrative scenes. He was revered as the protector of the Holy Family. A favored title that was used for him in prayers was *nutritor Domini* (nurturer, or provider, for the Lord). He was also protector of the Church; as he took care of Mary, he took care of the Church, for Mary was symbolically understood as a representation of Ecclesia (the Church).[17] Every time Barocci had occasion to depict Saint Joseph, he portrayed a vigorous and engaged leader, never a mere figurehead who rested passively at the periphery. The Joseph who provides for his family in the *Rest on the Return from Egypt* encapsulates authority and vigor through his diagonal reach and the forward thrust of his right leg. In the London *Madonna del Gatto* (cat. 7), Joseph thrusts himself assertively into the room; his advancing arm suggests a protective stance. The conception of Joseph as caretaker also guided Barocci's portrayal in the *Visitation* (cat. 10), where the saint's strength is evident as he handles the heavy sacks from the journey.[18] Over twenty years after the *Rest on the Return*, when Barocci designed his devotional picture of the Nativity (cat. 15), he turned to the same vigorous pose used here; several studies suggest that he tested the position by sketching his studio assistants.[19]

Barocci's rendering of the *Rest on the Return from Egypt* is among the most lyrical and poetic that any artist created.[20] The Virgin sits serenely at the center of the painting, her overall contour conforming roughly to a triangle, while her drapery describes a gentle S-curve of pale pink flanked by rich blue fabric. Joseph steps toward the lower-right corner as he proffers a branch to the Christ Child, establishing a strong diagonal toward the lower right. Joseph's fluttering red cape reinforces the diagonal, while his left hand, reaching back into the tree above his head, creates another line directed toward the upper right. The work consists, therefore, of a series of cascading counterdiagonals, sweeping from one side to the other, suggesting the rhythmic movement of a pendulum.

Fig. 53. *Study for the Rest on the Flight into Egypt.* Pen and brown ink with brown wash, 16.6 x 11.6 cm. Gabinetto Disegni e Stampe degli Uffizi, Florence, inv. 11469 F. recto

The Anastagi painting marks a high point in Barocci's development as a colorist, although he himself seems to have found the color inadequate, as he explained to his friend in the previously mentioned letter that he sent along with the painting. Barocci wrote that he knew the picture would be unsatisfactory to his friend, apologizing most profusely for Joseph's red drapery, which he found *macchiato* (uneven), suggesting that the problem lay in the varnish.[21] In spite of the shortcomings Barocci perceived in Joseph's drapery, however, the painting demonstrates a sophisticated handling of color. Barocci varied the palette among the three figures, using rich, unmuted vermilion and yellow for Joseph's clothing, while the Virgin's dress is in paler tones, with more lead white. Her blue drapery has an intense hue, but the parts that receive the greatest amount of light have been mixed with white. Therefore, her overall tonality is much paler and thus similar to the Christ Child's garment, which shows little color save for an edging of gold that ties him visually to his mother, whose neckline and lining (visible at the hem) are also painted gold.

By graduating the intensity of color from saturated to more diffused, Barocci built a progression from the darker shadow of the upper left, to the greatest illumination around the child in the lower-right corner of the painting, an aesthetic as well as metaphorical success.

Color also became a means for further stabilizing Barocci's pyramidal composition. The yellow of Joseph's sleeve, immediately above Mary's head, underscores the apex of her triangle; the straw hat at the left and the tasseled pillow on the right form its other two points. Blues establish a cadence from lower left to upper right, counter to the main sweep of the primary compositional elements that have a diagonal focus from upper left to lower right. Green is used sparingly to define a meadow in the middle ground behind Mary's left elbow as well as the girdle around her waist. This detail may be more than an attempt to repeat a background color, for it reflects the artist's own dedication to Mary. In the fifteenth and sixteenth centuries, an extremely popular Marian relic was the Virgin's belt, or girdle, which she passed down to Saint Thomas upon her

assumption into heaven.[22] The long belt, a beautiful pea green, was kept in a chapel dedicated to the Madonna della Cintola (Madonna of the Holy Girdle), the pride of Prato cathedral, near Florence. It enjoyed enormous popularity as a pilgrimage site after the girdle was moved there in the late fourteenth century.[23] It is not known if Barocci traveled there, but given his own piety and the relic's fame, he may well have stopped there during his trips to Rome.

Barocci's source for this composition has traditionally been assumed to be Correggio's famous altarpiece the *Madonna della Scodella* (1525–30), which hung in the church of San Sepolcro in Parma during the sixteenth century (now in the Galleria Nazionale, Parma).[24] The picture shares several elements with Barocci's canvas: the strongly diagonal composition, the dipping bowl held by the Virgin, the standing Saint Joseph reaching fruit from the tree, and the child's role as a unifying element. However, this view has been increasingly modified, most recently by both Jeffrey Fontana and Stuart Lingo, who have noted that Barocci responded to other sources as well as to Correggio, particularly Raphael.[25] In examining the drawings, however (see below), the tie to Correggio is apparent, pointing to the earlier altarpiece as Barocci's starting place.

In taking on a composition of three figures, Barocci understood that he was tackling a formal challenge that earlier Renaissance masters had also addressed—namely, the problem of working three figures together in an engaging grouping that preserves clarity and avoids rigidity. Lingo pointed out that Barocci may have deemed it necessary to demonstrate a mastery of Central Italian models and complex poses in order to impress Lucrezia d'Este, the intended recipient of the first picture.[26] Michelangelo's *Doni Tondo,* Leonardo's *Madonna and Saint Anne,* and a number of Raphael's Holy Families stand as variations on this simplest of themes. It is tempting to see, as Lingo did, the imprint of Michelangelo's seated Virgin from the *Doni Tondo* in Barocci's final solution. What Barocci achieved, which perhaps none of the other artists did, was to incorporate compositional flow and rhythmic movement, taking his picture beyond the stasis of the High Renaissance into the promised energy of the Baroque. The drawings document some of the stages in his thinking as he worked out these solutions.

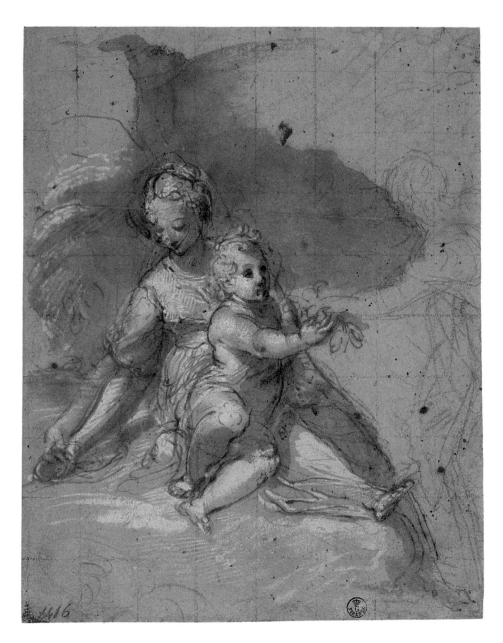

CAT. 4.1. *Compositional study* (recto). Black chalk and pen and brown ink with brown wash heightened with white, squared in black chalk, on blue (now turned buff-colored) paper. [Verso: Sketch of the Virgin and Christ Child in reverse. Brush and brown wash], 9¹³⁄₁₆ x 7¹¹⁄₁₆ in. (24.9 x 19.5 cm). Gabinetto Disegni e Stampe degli Uffizi, Florence, inv. 1416 E.

Barocci's initial attempts at the subject appear in several small pen, ink, and wash studies, a format that is consistent with other *primi pensieri* we have from his hand. These sketches all show the Virgin still riding the donkey as the group prepares to rest, and they all appear to represent the Rest on the Flight rather than the Rest on the Return, for the Virgin cradles a young infant. In the most developed of them (fig. 53), Joseph appears at the lower right, stooping to put down his burdens before helping Mary dismount.[27] An unidentified third fig-ure observes from the background, and Mary holds the Infant Christ. The subject is treated with Barocci's customary innovation and will-ingness to try out new formats. Speculation as to his reasons for abandoning these initial ideas suggests that none of them allowed the desired focus on Mary. He may also have found that using an older child permitted him to work with three similarly sized figures, yielding a more graceful composition.

The earliest design for a three-figured group that focuses on the seated Virgin includes the Christ Child on his mother's left and shows the belated addition of a standing Joseph at the right margin (cat. 4.1). The composition is sig-nificant in that it suggests that at a very early stage Barocci was already responding to Cor-reggio's picture, for the position of the Virgin's right arm repeats that of Correggio's Madonna.[28] In fact, it may well have been the Parmese art-ist's picture that induced Barocci to abandon the Rest on the Flight theme and turn to the more obscure subject. At the same time, the Uffizi drawing demonstrates that Correggio's

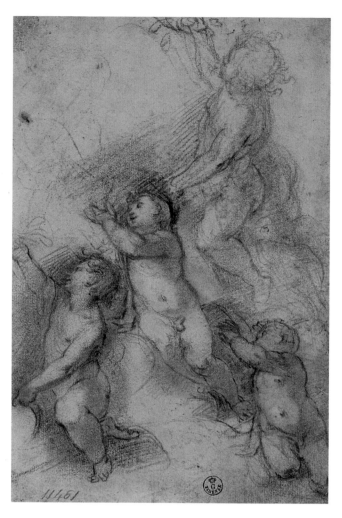

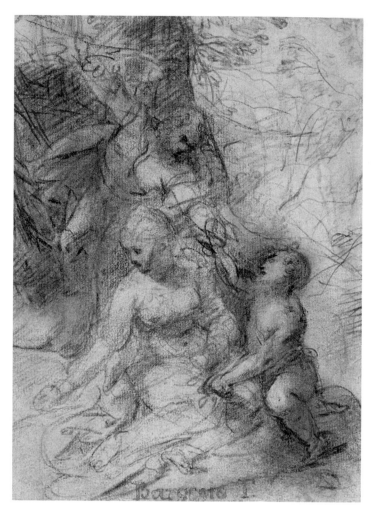

CAT. 4.2. *Studies for the Christ Child* (recto). Black and red chalk. [Verso: Figure study. Black chalk], 8⅜ x 5⁹⁄₁₆ in. (21.3 x 14.1 cm). Gabinetto Disegni e Stampe degli Uffizi, Florence, inv. 11461 F.

CAT. 4.3. *Compositional study.* Black and red chalk and pen and brown ink (?), laid down, 7⅜ x 5½ in. (18.8 x 13.9 cm). Inscribed in pen and grayish-black ink lower center: "Baroccio F." Goldman collection

altarpiece may not have been Barocci's only early inspiration, for he began with a more centrally placed Madonna and did not initially incorporate the pose or location that the older artist had used for Joseph. Although, as noted above, the Rest on the Flight grew in popularity because of the cult of Saint Joseph, the scene itself was one that typically focused on the Virgin, and that is precisely how Barocci began. After delineating the figures in ink and wash, Barocci bathed them in light by adding white heightening along Mary's torso and right leg, and on the side of Christ's body and legs as well. Barocci may have gone back to a series of studies he had done in Rome in the 1560s that explore poses for the ceiling of the Casino for Pius IV to identify a position for the body of Christ. These earlier trials depict a seated young boy with different axes for the upper and lower torsos.[29]

Two of the remaining twenty-two drawings suggest that Barocci continued to work on the composition as presented in the early Uffizi drawing. A sheet of hand studies in the Kupferstichkabinett in Berlin includes three sketches for the left hand of the child, assuming a gesture very similar to that of his right hand in the finished composition.[30] Each of the three sketches depicts a hand resting on a horizontal surface while grasping white drapery. The uppermost hand in the series holds a thin stick, suggestive of the cherry branch. Such a position would be possible only if the child were seated to the Virgin's left, as he appears in the initial compositional study. One must conclude that these drawings show how the artist further developed this early format (with the Christ Child on the left), exploring possible placements for Christ's left hand on his moth-

er's lap, before deciding that the child would work better to the right of Mary. Additional evidence to support this supposition can be found in another Uffizi drawing, a sheet on which Barocci drew disparate sketches, including one of a man's left leg positioned as if striding in from the right.[31] It appears to be a more advanced idea based on the very lightly sketched figure of Joseph at the right edge of the early study in the Uffizi (cat. 4.1), proving that the artist continued to explore this arrangement.

Of the remaining twenty drawings associated with the *Rest on the Return*, only two document how Barocci developed elements for the lost Este painting (the first version) and the possible fourth version (cats. 4.2 and 4.3). Three additional sheets were used to revise the figure of the child for the Vatican and Branca-

leoni versions from a kneeling to a seated position. The additional fifteen sketches document Barocci's preparatory work on other passages of the composition that he must have used for all the versions.[32]

On the verso of the early compositional study in the Uffizi (cat. 4.1), Barocci traced the figures of Mary and Jesus in reverse, yielding a semikneeling pose for the child that had considerable torque to the body, an idea he developed further in a subsequent series of sketches (cat. 4.2). This sheet records four attempts to develop the kneeling posture for the child that he used in the first painted version of the *Rest*.[33] The artist created the sketch after deciding to place the figure on the right side of the composition. Two sketches (center and lower right) depict a seated male child, legs together, reaching across his face with his elevated left arm, refinements of the pose on the verso of the early compositional study. In the two other drawings on the sheet, Barocci raised the right arm and lowered the left in front of the body. At the top, he drew a slightly older boy; of the four sketches on the sheet, this is the one he worked up the least, an indication that he did not find it suitable for his painting.[34] The pose in the lower left of the sheet, however, was the one he decided to use, and he transferred it, in slightly smaller scale, to a full compositional study now in the Goldman collection in Chicago (cat. 4.3).[35]

The Goldman drawing registers many elements that Barocci maintained for the final version of the *Rest on the Return from Egypt*, as seen in the Capellan print (fig. 51). The child kneels, his right hand reaching toward Joseph, his left on his mother's lap. Barocci's reliance on Correggio's altarpiece is evident in the standing pose of Joseph, clearly taken from the Parmese painting. Barocci continued Correggio's diagonal, although in the opposing direction, rotating the group so that it reaches back into the fictive space and the figures progress from under the left-hand tree out toward the near right foreground. This created a counterdirectional movement through the leftward gazes of the two foreground figures. Barocci also established his lighting when he laid in the essentials of this preliminary composition. Joseph is partly in shadow, while the Virgin and child receive fuller illumination. Barocci's mixture of red and black chalk enlivens the figures and

shows he was already thinking about greater illumination in the head and shoulders of the Virgin and the entire figure of the child. Joseph's dynamic pose and the force of his gaze as he inclines his head toward Christ establish him as a source of energy within the picture.

Barocci's choice of a kneeling child for his initial version imbued it with a slightly different iconography from the later examples. In changing to a seated child, he added a pillow for Jesus to sit on. Undeniably, the change reaped aesthetic benefits, for the diagonal formed by Joseph's right arm falls at a gentler angle, and the slight rise formed by Christ's head at the end of that line is less abrupt. However, the addition of the pillow adds an overt reference to Christ's future sacrifice, for the pillow had come to be associated, particularly in and around Venice, with death and tomb imagery.[36] In this context, the upturned hat beside the bread and wine may also take on Eucharistic meaning, as Lingo suggested.[37]

Depictions of the Holy Family including Saint Joseph were popularly used in domestic settings and made suitable gifts for marriage and birth, as they stressed the family; indeed, Joseph was the patron saint of fathers.[38] Lucrezia d'Este's 1592 inventory describes the painting as hanging in her bedroom, protected by a green curtain, confirming such a domestic role.[39] It makes sense that in a painting intended as a wedding gift, Barocci did not utilize symbols that alluded to Christ's ultimate sacrifice, but when commissioned by Anastagi, a very devout man, the artist introduced an element that underscores the rich themes associated with that sacrifice. After all, Herod's edict for the extermination of all male children was a foretelling of Christ's subsequent execution, and like any scene from Christ's infancy, it carries inherent references to Christ's sacrificial death, required for human salvation. Although the poor condition of the Brancaleoni painting does not allow an assessment of the cushion, the Vatican painting features a pillow covered in dense brocade with a gold tassel, recalling liturgical vestments rather than the more rustic trappings of an outdoor picnic.

No single sheet shows the lyricism Barocci achieved in his *Rest on the Return* better than the large figure study for Mary (cat. 4.4), among his most naturalistic treatments of the female nude.[40] His initial compositional trial (cat. 4.1)

portrays the Virgin with her right leg straight in front of her; the faint suggestion of a second leg farther to the right may simply be an adjustment. The position of her left leg in that sheet is unclear. The pose is awkward, and Barocci likely abandoned it early in the design process, turning to a more graceful placement. Although he did not change the upper portion of the torso significantly from his first compositional study, he bent Mary's knees and relocated the child away from her lap. The precise position of the lower legs is not indicated. However, the three trials for the Virgin's left foot suggest he had already worked out her final pose where she bends her knees and brings her left foot forward. The absence of any suggestion of a placement for the child suggests that this sheet preceded the Goldman study. Ultimately, Barocci posed all of his figures so that their heads follow their extended arms, and the several corrections in the profile of the Virgin's face document the artist's work to achieve that end.[41] He seems to have determined his light source, having bathed the shoulder, breasts, and stomach of his nude in white. In a later pen and ink study for the Virgin, he finalized her position and indicated a preliminary costume; another sheet in red and black chalk records his refinement of her drapery.[42]

As he had done in the *Crucifixion* (cat. 2), Barocci developed a dynamic pose for his male protagonist, set off against a serenely posed female. Completed prior to the Goldman study, the sole surviving sheet devoted to Joseph inverts the pose from Correggio's Parma altarpiece (cat. 4.5). Barocci raised and straightened the right arm while he extended the saint's left to achieve greater energy. Positioning the left leg as the anchoring support, he raised the right foot and experimented with several different positions. He left almost no contour unchanged, working the lower torso and the thighs especially heavily. He lowered the left arm and adjusted the right accordingly, and he defined the musculature of Joseph's shoulders, developing an athletic and vigorous body in spite of the saint's relatively advanced age. Joseph's body may have begun with observations based on a living model. The short torso and elongated legs, however, suggest that by the time Barocci executed the drawing, he had already deviated from his initial observations. His greater concern was the play of light on the

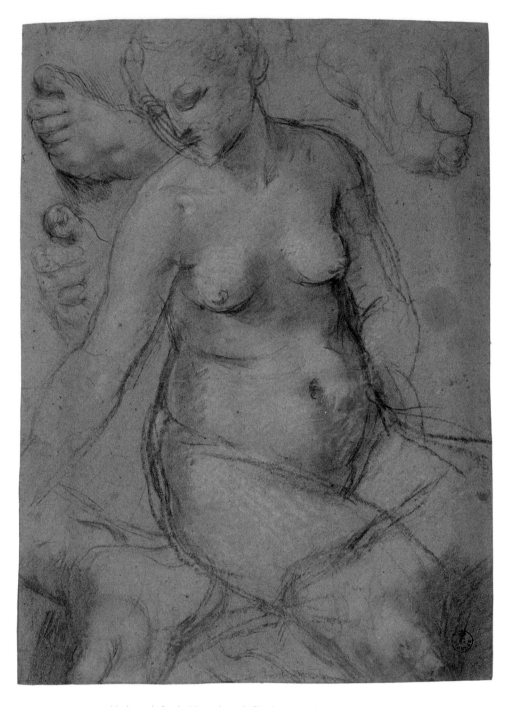

CAT. 4.4. *Nude study for the Virgin* (recto). Black, red, and white chalk on blue paper.
[Verso: Nude study of a youth seated atop an arch. Black chalk], 15⅜ x 10¹⁵⁄₁₆ in. (39 x 27.8 cm).
Gabinetto Disegni e Stampe degli Uffizi, Florence, inv. 11284 F.

upper torso, indicated through white heightening applied to the upper chest and arms, calling to mind Bellori's account that Barocci used clay and wax figures to study the composition and lighting.[43]

Barocci included one additional participant in the *Rest on the Return:* the donkey in the background. Several studies for donkeys have been associated with this painting, and although not all of them appear to be auto-graph, five relate to the creature standing behind the Holy Family.[44] Included here are two separate studies for different parts of the donkey: a sketch for the head and another for the body, an approach the artist often used for rendering animals (cats. 4.6 and 4.7). While commentators often note that such charming depictions attest to the artist's naturalist sensibility, Barocci's animals were rarely drawn from life. Typically, he drew only the relevant parts that he needed for the composition at hand.[45] He tended to repeat standard forms (as is true of the various donkey studies) that are often rather cursory and lacking in detail.[46] A related drawing of an ass in Amsterdam records a head and neck emerging from behind a hill or barrier. The existence of several other sketches of a head with no body suggests that Barocci may originally have intended a more limited representation of the beast, perhaps just its head.[47]

The study for the body was created over an earlier one of a donkey grazing; the Amsterdam sheet depicts the animal as seen from behind, eating. The donkey brings charm to the picture, presumably one reason for its prominence within the composition.[48]

The creation of the *Rest on the Return from Egypt,* which followed Barocci's first major success with the *Deposition* altarpiece, came at a pivotal point in his career. He painted each of the three documented versions for an important collector or patron. The first composition was a commission from the duke of Urbino, and the subsequent modified copies were made for collectors in Perugia and Piobbico. Barocci provided a lyrical yet complex picture, focused on the seated Virgin, who is flanked by a dynamic Joseph and an artfully arranged child who forms a secondary focal point. An examination of the drawings suggests that the elements of the picture that appear most graceful were those parts on which Barocci focused the major part of his effort. By relying on the well-established iconography of a closely aligned subject, the Rest on the Flight into Egypt, he was able to portray the subject, one most likely requested by the duke of Urbino, and create an intimate picture perfectly suited for private devotion. It may have been the need to include an older child, no longer contained within his mother's lap, that necessitated his exploration of so many different poses. Barocci finally settled on an initial solution that perfectly suited the original function of the painting as a nuptial gift, with its emphasis on the cohesion of the family group. In creating further copies—the Vatican and Brancaleoni examples—he revised the position and placement of the Christ Child, and in doing so, succeeded in creating a picture of extraordinary beauty as well as nuanced meaning.

Judith W. Mann

NOTES

1 See Schwartz 1975, an excellent introduction to the relationship of this subject and Saint Joseph.
2 The most detailed record of the picture's provenance is in Olsen 1962, 154.
3 The set was published by Gavin Hamilton in 1773, issued under the title *Schola Italica Picturae sive Selectae Quaedam Summorum e Schola Italica Pictorum Tabulae Aere Incisae Cura et Impensis Gavini Hamilton Pictoris,* for which a variety of dif-

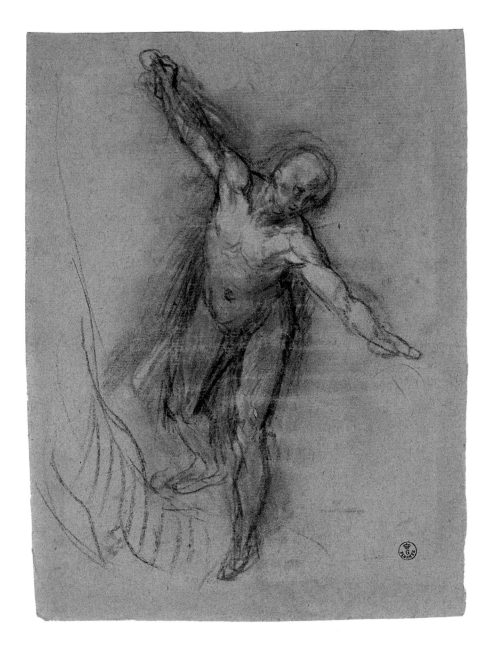

CAT. 4.5. *Nude study for Saint Joseph.* Charcoal and red chalk and stump heightened with white, on blue paper, 10¹¹⁄₁₆ x 7⁷⁄₈ in. (27.2 x 20 cm). Gabinetto Disegni e Stampe degli Uffizi, Florence, inv. 11505 F.

ferent artists participated. Given its purpose of providing replicas, it seems that the Capellan print can be taken as an accurate rendering of this lost picture. On the prints, see Ian Jenkins and Kim Sloan, *Vases and Volcanoes: Sir William Hamilton and His Collection* (London, 1996), cat. 173.
4 Bellori 1672 (1976), 202; Bellori 1672 (2000), 188; Calzini 1913b, 82. On the woodcut, see Pillsbury, in Pillsbury and Richards 1978, 108–9, no. 80.
5 In fact, Pillsbury suggested that a pen and ink and chalk drawing in Würzburg, inv. 7192, may have served as the preparatory sketch for the woodcut. However, the position of the hat in the drawing (upside down) suggests it may instead be related to Capellan's print.

6 There are two other known printed copies. One, by Raffaello Schiaminossi, is a signed and dated etching of 1612. It is reproduced in Olsen 1962, pl. 122b. Pillsbury, in Pillsbury and Richards 1978, 109, stated that Barocci "allowed" Schiaminossi to copy his composition, although no other evidence exists to support this contention. The Schiaminossi print introduces a change not found in any other extant copy: some palm fronds seen above the back of the donkey. Rather than taking this as evidence of yet another version by Barocci, perhaps it reflects a revision made by Schiaminossi, who, thinking the subject was supposed to be a Rest on the Flight, added the palm trees mentioned in the story. Finally, E 2008, 2, 409, 115.4, rather inexplicably reproduces a chiaroscuro

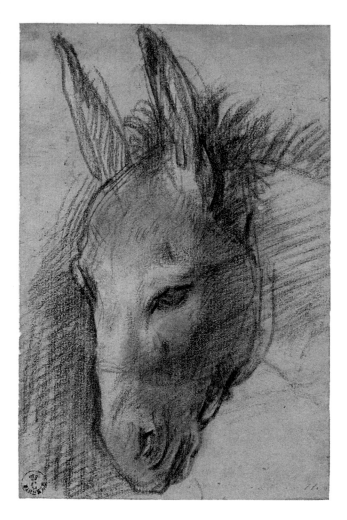

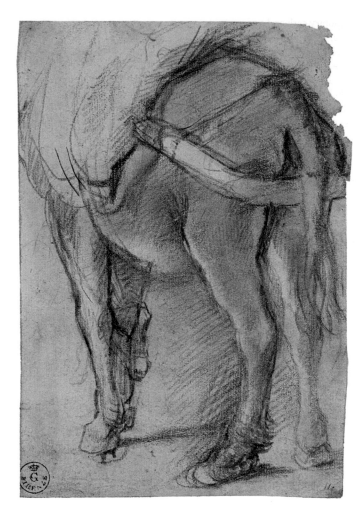

CAT. 4.6. *Study for a donkey's head.* Black and red chalk heightened with white, 6⅛ x 4 in. (15.5 x 10.2 cm). Gabinetto Disegni e Stampe degli Uffizi, Florence, inv. 928 Orn.

CAT. 4.7. *Study for a donkey.* Black and red chalk heightened with white, laid down, 7⅜ x 5⅟₁₆ in. (18.8 x 12.8 cm). Gabinetto Disegni e Stampe degli Uffizi, Florence, inv. 926 Orn.

woodcut (similar to the one discussed in the text except that it is printed in the same orientation as the paintings), yet Emiliani identified it as by Cornelis Cort, which it surely is not. Whether this is merely a misprinting of another copy of the woodcut, or it represents yet another version is not known at this time.

7 On the church, see Tarducci 1897 (2003), 288–91.

8 Bellori 1672 (1976) 186; Bellori 1672 (2000), 179. Bellori mentioned the painting twice. In his first reference, he called it a *Nativity,* which a number of writers have considered to be a mistake. However, Anastagi's letters indicate that the patron asked Barocci for a Nativity sometime after the completion of the present picture, probably during the 1580s or 1590s. Bellori must have been aware of this second request and confused the two commissions in his narrative. See Giovanna Sapori 1983, 80.

9 Ibid., 80, quoting the passage from Anastagi's account book.

10 The letter, dated 2 October 1573, is in the collection of the Raccolta Piacastelli di Forlì and was transcribed by Giovanna Sapori 1983, 80.

11 I owe an enormous debt of gratitude to Carol Plazzotta, whose own research into the Brancaleoni and their history enabled her to set me straight, as my own first reading of the visual record led me to support the previous sequence. See Tarducci 1897 (2003), 129. For more information on the Brancaleoni, see cat. 7.

12 Borghini 1584 (1967), 1, 569. Turner 2000, 53–54, identified it as *Rest on the Flight.* Turner's translation of Bellori's text also follows that understanding. In Bellori 2005, 170, Wohl likewise translated it as "resting on the flight into Egypt." Others who similarly adopted that title are Schmarsow 1909 (2010), 50; Olsen 1962, 154; E 2008, 1, 224, 226; and Ortenzi 2009, 389, who also proposed *Madonna delle ciliegie* as an alternate title. Fontana 1997b, 109; Verstegen 2002, 49; and Lingo 2008, 225, reinstated the title used in the sixteenth- and seventeenth-century sources. See Lingo 2008, 226–28, and 273–74, n. 4, where he argued the case for the corrected original title and summarized the scholarship, noting that Ekserdjian 1997, 222–25, was the first to clarify this iconography as it relates to Correggio's *Madonna della Scodella.*

13 Gospel of the Pseudo-Matthew, chap. 20, trans. in *The Ante-Nicene Fathers,* ed. A. Roberts and J. Donaldson, 7, 377 (Grand Rapids, MI, 1951), as cited by Schwartz 1975, 5.

14 Several authors associated the cherries with a visual reference to Christ's later Crucifixion wounds. See, e.g., Gillgren 2010, 125.

15 On the issue of the child's age, see Ekserdjian 1997, 223–24.

16 See Wilson 2001, esp. part 1, 3–20. For a fuller history of the cult of Saint Joseph, see Francis L. Filas, S. J., *The Man Nearest to Jesus: Nature and Historic Development of the Devotion to St. Joseph* (Milwaukee, 1944.)

17 Wilson 2001, 22.

18 In fact, one of the *primi pensieri* for the *Rest on the Return,* Uffizi inv. 11469 F. (fig. 53), may even have been the starting point for the figure of Joseph in the *Visitation,* for it is very similar to the depiction of the saint on the far right side of the preparatory compositional study from the Lugt Collection (inv. 5483, cat. 10.2 recto).

19 Florence inv. 11555 F. verso has two figures in the pose of Joseph in the *Nativity,* one clothed in

contemporary garb and a second shown nude; see E 2008, 1, 26.18, 234. Although Emiliani considers the seated figure in that drawing a study for the Virgin in the *Rest on the Return*, I have not been able to establish any relationship based on my understanding of the evolution of that figure.

20 See Lingo 2008, 225–42, who used the picture as a test case for a larger discussion of Barocci's pictorial strategies. Lingo's astute observations and extended analysis in terms of contemporary musical theory underscore Barocci's high aesthetic achievement.

21 Giovanna Sapori 1983, 80, where the text is transcribed.

22 The Assumption refers to the moment after Mary's death, when she was carried, body and soul, to heaven. The term *Assumption* denotes a different event from Christ's Ascension, when he rose, unaided, into the heavenly realm.

23 On the girdle and its veneration, see Renzo Fantappié, "Storia e 'storie' della cintola," 41–59, and Claudio Cernetelli, "La pieve e la cintola: Le trasformazioni legate alla reliquia," 78, both in *La sacra cintola nel duomo di Prato* (Prato, 1995).

24 Olsen 1962, 60; Turner 2000, 53; E 2008, 1, 224; Turner and Goldman 2009, 133; Ortenzi 2009, 389; Lanzi 1809, 352. For the Correggio painting, see Ekserdjian 1997, 219–33, ill. 218.

25 Fontana 1997b, 110–13, argued for a painting from Raphael's studio as the primary compositional model. For a summation of the scholarship, see Lingo 2008, 274, n. 5. Arguing in support of Correggio as the model are Schmarsow 1909 (2010), 53, who suggested the three paintings should be considered original variations on Correggio's composition, and Lanzi 1809, 352, who identified Correggio's altarpiece as the clear model.

26 Lingo 2008, 229.

27 Uffizi inv. 18322 F., an unpublished sheet, is an earlier version of the drawing reproduced here, in which Barocci sketched the donkey and the Virgin very quickly and also experimented with two positions for Joseph on the lower right. The other sheet, Uffizi inv. 11471 F., E 2008, 2, 399, 111.13, conforms more closely to the Flight into Egypt with Joseph leading the donkey. Barocci tried two different placements for Joseph, at the left and then again to the right of the donkey's head.

28 Lingo 2008, 230, also identified this addition as a response to Correggio. A sheet in the Uffizi (inv. 11596 F.) includes two studies for the Virgin's right hand holding the dipper; both of them show her thumb protruding over the edge of the rim in a more vertical alignment and come much closer to the position of the Virgin's hand in Correggio's painting than to the hand position in any of Barocci's three versions. See E 2008, 1, 230, 26.8, although he did not publish an image of it.

29 A study for a nude youth seated atop an arch appears on the verso of a study for the Virgin, Uffizi inv. 11284 F. verso (see cat. 4.4), E 2008, 1, 234, 26.21.

30 Berlin inv. KdZ 20526 (4451) recto, E 2008, 1, 232, no. 26.10.

31 Uffizi inv. 11591 F., E 2008, 1, 230, no. 26.7.

32 E 2008, 1, 228–39, lists twenty-seven drawings associated with the painting. Among that group are eight that I would eliminate. Three, 26.5, 26.24, and 26.28, do not appear to be by Barocci's hand. The rest are simply not related to this picture. I would add to his list, in addition to cats. 4.1 and 4.2, Uffizi inv. 1416 E. verso, Uffizi inv. 11377 F. verso (an association first made by Bohn), and Biblioteca Oliveriana, Pesaro, inv. 647 verso.

33 E 2008, 1, 183, no. 20.21, first published this sheet, but included it as part of the preparatory work for the *Madonna of Saint Simon*.

34 Given that his subject was the Rest on the Return from Egypt, it is striking that he did not choose to use the older child in his finished composition, which demonstrates how dependent he remained on iconography more suitable to the Rest on the Flight.

35 This sheet, a relatively recent discovery, was purchased at auction in 1999. The change in scale is interesting, for one would expect the final study for the Christ Child from the Uffizi sheet to have been transferred directly to the compositional study. On Barocci's various scales for his drawings and the standards that he used, see Marciari and Verstegen 2008.

36 Rona Goffen, "A 'Madonna' by Lorenzo Lotto," *Museum of Fine Arts Bulletin* 76 (1978), 37, explained the overt imagery in Lotto's painting where the pillow is coupled with a small coffin. Goffen explored the theme further, including precedents in ancient imagery and the larger context of the sleeping child as an allusion to Christ's ultimate death, in Goffen, "Icon and Vision: Giovanni Bellini's Half-Length Madonnas," *Art Bulletin* 57 (1975), 503.

37 Lingo 2008, 239.

38 On Saint Joseph as a patron of the family and images of Saint Joseph as images intended for domestic use, see Chorpenning, "Icon of Family and Religious Life: The Historical Development of the Holy Family Devotion," in *The Holy Family as a Prototype of the Civilization of Love: Images from the Viceregal Americas,* ed. Joseph F. Chorpenning and Barbara von Barghahn (Philadelphia, 1996), esp. 4–17. Gillgren 2011, 126, likewise found the subject suitable, noting that it is an "image of family union: the purity of the bride, the generosity of the husband and a hope for children." He suggested that placing it over an altar could allow the painting to take on Eucharistic connotations.

39 Again, I must thank Carol Plazzotta for sharing this information with me. In the inventory, fol. 14.132 includes the following: "Una Madonna con Nro Sigre et Santo Gioseppo di mano del Barozzo cornisati di legno dorati con Una coltrina di tenda verde et al pinto nella camera dove dorme S.A." (A Madonna with our Lord and Saint Joseph by the hand of Barocci framed with gilded wood with a hanging green curtain is among the pictures in the room where Her Highness sleeps.)

40 See Bohn essay here, 42–47.

41 I owe this observation to Babette Bohn, who shared her written notes on Barocci's Uffizi drawings with me.

42 For the pen and ink study (Scottish National Gallery, Edinburgh, inv. D 821), see E 2008, 1, 229, no. 26.4; for the chalk drawing (Biblioteca Oliveriana, Pesaro, inv. 647 verso), see Forlani Tempesti and Calegari 2001.

43 Bellori 1672 (1976), 205; Bellori 1672 (2000), 190.

44 In addition to the two exhibited donkey studies: Uffizi inv. 924 Orn., E 2008, 1, 239, no. 26.27; Uffizi inv. 925 Orn., E 2008, 1, 236, no. 26.23; and Amsterdam inv. RP-T-1981-29 recto, E 2008, 1, 234, 26.22.

45 Turner 2000, 54, expressed a somewhat different view by remarking on the naturalism of Barocci's animal studies, noting that if we did not know them to be by Barocci, their realism might lead us to believe they were nineteenth-century works.

46 When one studies the various animal drawings attributed to Barocci, not only are many of the attributions incorrect (based on the expectation that a naturalistic animal study from the sixteenth century must be by Barocci), but they are seldom completely anatomically accurate. On this issue, see cat. 13.

47 Rijksmuseum, Amsterdam, inv. RP-T-1981-29 recto, Lingo 2008, 233, fig. 190.

48 This ties into Lingo's notion about the inclusion of everyday implements and animals as aspects of charming the viewer, one component of the "Allure" of his 2008 title. For a similar view, see Turner 2000, 54. Gillgren 2011, 125, however, interpreted the donkey as a symbol of the endurance of faith.

49 Recorded by Friedrich Wilhelm Basilius von Ramdohr, *Malerei und Bildhauerei in Rom* 1 (Leipzig, 1787).

Provenance: Commissioned by Simonetto Anastagi (d. 1602), delivered 5 October 1573; 1602 bequest to Jesuits of Perugia, placed in sacristy of their church; in 1773, at the suppression of the order, transferred to the Quirinal Palace, Rome[49]; 1790 moved to the Pinacoteca Vaticana; Vatican Museums, Vatican City

Bibliography: Borghini 1584 (1967), 1, 569; Bellori 1672 (1976), 203; Morelli 1683, 98ff.; Lanzi 1809, 351–52; Lanzi 1822, 127; *Catalogo risassuntivo della raccolta* 1890, 182; Bombe 1909; Schmarsow 1909, 10, 28, 33; Schmarsow 1909 (2010), 50–53; Bombe 1912; Krommes 1912, 58, 112, 113; Poggi 1912–13, 54; Di Pietro 1913, 13, 18, 173, fig. 28; Olsen 1955, 112, 117, n. 156; Olsen 1962, 154–56; Emiliani 1975, 86, nos. 53, 57; Schwartz 1975, 153; Dal Poggetto and Zampetti 1981, 516, no. 161; Giovanna Sapori 1983, 78–80; Emiliani 1985, 1, 78–85; Petrioli Tofani 1986–87, vol. 2, 588–89; Fontana 1997b, 254–57; Turner 2000, 53–54; Wilson 2001, 232; Verstegen 2002, 49, 200; E 2008, 1, 224–39, nos. 26, 26.1; Lingo 2008, 225–42; Ortenzi 2009, 388–89; Turner and Goldman 2009, 132–33, no. 50; Gillgren 2011, 122–26.

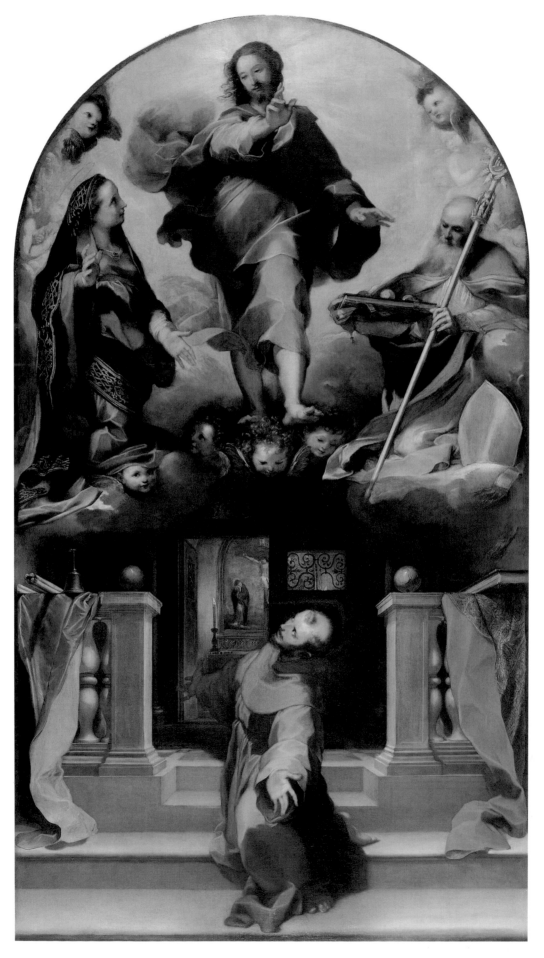

Fig. 54. *Il Perdono Altarpiece*, 1571–76. Oil on canvas, 427 x 236 cm. Church of San Francesco, Urbino

Il Perdono

Barocci's altarpiece *Il Perdono* (the high altar-piece for the church of San Francesco in Urbino, 1571–76; fig. 54) represents an original interpretation of an unusual Franciscan subject and demonstrates the artist's timely capacity to prioritize theological content over conventional narrative. The painting exemplifies Barocci's emphasis on the visionary and doctrinal in many of his altarpieces and reveals a characteristic combination of formal debts to earlier artistic prototypes with iconographic originality. *Il Perdono* also provided the model for the first of Barocci's two large-format prints, which occupy a special place in the artist's oeuvre.

In light of the work's iconographic originality, it seems particularly surprising that there are fewer extant preparatory studies for this painting than for almost any other major altarpiece in Barocci's career—twenty-nine, about half the number known for his *Deposition* (cat. 3) of a half-decade earlier.

New archival research suggests that a small painting (cat. 5) related to *Il Perdono,* hitherto considered preparatory for the altarpiece in San Francesco, must have been made later and was probably a somewhat revised *ricordo* (record) of the completed design rather than a preliminary study for the altarpiece. The painting depicts Saint Francis, arms extended and gaze directed upward, half-kneeling on the steps leading up to a small chapel. A version of Barocci's altarpiece representing the *Crucifixion* is partially visible through the open left door of the chapel. At the top of the painting, a vision of the resurrected Christ appears in the center, directly above Francis and three cherub heads. He is flanked by the Virgin Mary on the left and Saint Clare on the right. Clare does not appear in the altarpiece, as we shall discuss.

Barocci's huge painting was his most important public commission after completing the *Deposition* in 1569. San Francesco was a Conventual Franciscan church (one of the three divisions of the Franciscan order, along with the Capuchins and the Observant Franciscans); the Conventuals had become particularly numerous during the sixteenth century, with more than a thousand convents.[1] The site

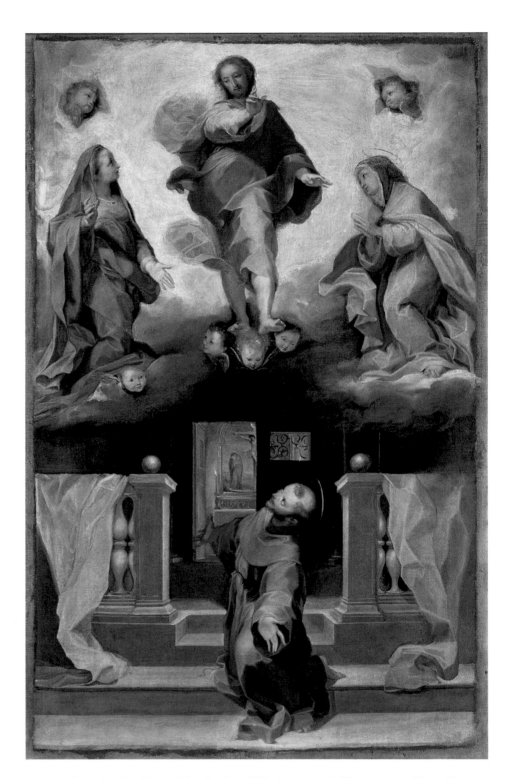

CAT. 5. Barocci and workshop, *Reduced variant of Il Perdono,* ca. 1576. Oil on canvas, 43⁵⁄₁₆ x 27¹⁵⁄₁₆ in. (110 x 71 cm). Galleria Nazionale delle Marche, Urbino, inv. 1990 D 78

Fig. 55. *Early compositional sketch for Il Perdono*, ca. 1571–76. Black chalk, 15.1 x 13.2 cm. Gabinetto Disegni e Stampe degli Uffizi, Florence, inv. 11504 F. recto

el's early two-tiered compositions, such as the (destroyed) *Nicholas of Tolentino* altarpiece for Città di Castello. Christ and Saint Francis are positioned one above the other, creating an almost rigidly hierarchical main axis down the center of the painting. This forceful verticality is offset, however, by the assertively recessional thrust of several gestures: Christ's extended right hand and left foot; the Virgin's right hand, which pushes into the viewer's space; and above all, Francis's extremely foreshortened, extended arms, which connect the viewer with the painted altarpiece in the background. This carefully constructed balance between fictive and real space, between verticality and depth, linking the four principal figures across the considerable expanse of the large canvas, is critical in unifying the action in the picture. This compositional synthesis is further reinforced by the color scheme, which simultaneously separates the lower section—largely colored in grays and browns—from the golden-hued realm above, while also unifying the two sectors with complementary touches of green and red. Finally, Barocci's dramatic focus and cohesion is furthered by his economical approach to his subject, with elimination of all but the essential figures.

Bellori spoke admiringly of the artist's reliance on natural light in his painting, an element that furthers visual unification and naturalism, modeling forms with convincing three-dimensionality and imbuing the miraculous with a sense of believability. He remarked that even the figure of Christ is illuminated by the natural light of day, but because the event took place at night, it is not daylight but miraculous lighting that infuses the scene. Although Barocci relied principally on a naturalistic light source from the left, he also manipulated the lighting for dramatic effect, juxtaposing the brilliantly illuminated figure of Saint Francis against the dark background wall of the church. This darkened section also provides a clear separation between the luminous heavenly realm and the earthly space of the church interior.

As other writers have observed, Barocci responded to influential models by both Titian and Raphael in this painting. Compositionally, Raphael's *Transfiguration* and *Sistine Madonna* provided prototypes for the vertical composition, balanced between the lower, earthly sector and the upper, celestial realm. Christ's

Nicholas, like the Virgin at left, is splendidly attired. His red, blue, lavender, and gold robes provide an effective coloristic balance to the Virgin's red, green, and gold costume. In the altarpiece, the concentration of varied, bright colors in the upper register helps to distinguish this celestial realm from the earthly sector below, inhabited only by Saint Francis, in his simple, brown robes. This use of color to contrast the celestial and terrestrial sectors is crucial to the design of the altarpiece, and the absence of this feature in a late preparatory design would be very surprising indeed.

Whereas Barocci's iconography in *Il Perdono* is unprecedented, his style in the painting combines retardataire elements with subtle originality. He employed a conservative composition and some traditional poses, with

assertively recessional features, a luminous color scheme, and his signature use of expressive hands and restrained facial expressions. A close reading of the painting suggests that Barocci had by now moved away from his early Mannerism, but he continued to respond selectively to aspects of Titian's and Raphael's styles of painting.

Although the issue is overlooked by modern scholars, *Il Perdono* is one of several Barocci altarpieces that, according to Filippo Di Pietro, Luigi Serra, and Egidio Ricotti, were first painted in tempera before being repainted in oil.[27] The veracity of this account cannot be resolved without technical analysis, however.

Barocci's centralized composition in *Il Perdono* has similarities with many of his other visionary subjects and is reminiscent of Rapha-

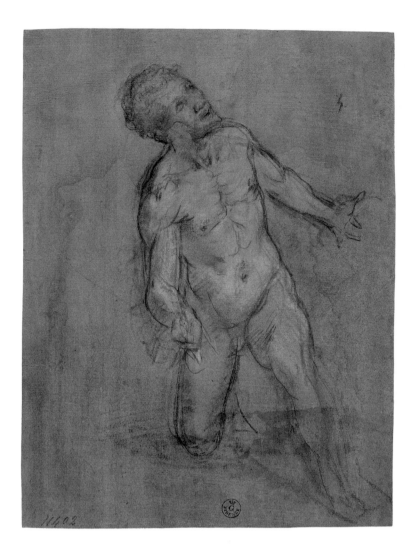

Fig. 56. *Nude study for Saint Francis*, ca. 1571–76.
Black chalk heightened with white, 33 x 24.2 cm. Gabinetto Disegni
e Stampe degli Uffizi, Florence, inv. 11402 F. recto

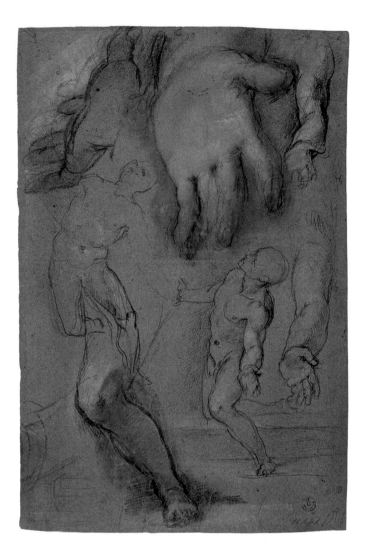

CAT. 5.1. *Studies for Saint Francis.* Black chalk and charcoal heightened
with white on blue paper, 16⅝ x 11⅛ in. (42.3 x 28.2 cm).
Gabinetto Disegni e Stampe degli Uffizi, Florence, inv. 11441 F.

graceful and balanced pose also reflects the influence of such Raphaelesque models, but the principal source was Titian's Christ in his painting of the *Resurrection*, then as now in the Galleria Nazionale delle Marche, Urbino. Lingo perceptively analyzed how the retrospective qualities of Barocci's work are offset by a new dynamism in *Il Perdono.*[28]

Although only twenty-nine preparatory studies can be convincingly associated with *Il Perdono,*[29] this group is the earliest in Barocci's oeuvre to include every type of preliminary study, conventional and unconventional, that he employed in the course of his career. *Il Perdono* thus seems to have been a turning point for Barocci, in terms of both its iconographic originality and its synthesis of traditional and original preparatory procedures. Although

some preliminary drawings for the painting have surely been lost (for instance, only two drawings for the small angels are known), the surviving sheets highlight Barocci's reliance on varied types of compositional and figure studies. The drawings illustrate his close attention to key details (even when such particulars were loosely inspired by earlier prototypes); his paramount concerns with spatial illusionism, compositional unity, and dramatic effect; his attention to light; and his reliance on strongly differentiated poses and expressive gestures to convey essential themes.

Two compositional studies and two figure studies from very different stages of the design process document Barocci's extensive revisions to his overall conception. A rough, early compositional study in the Uffizi (fig. 55)[30] shows

that the artist began with a much less symmetrical and centralized composition, placing Saint Francis on the lower left rather than in the center below Christ. Barocci quickly rejected this diagonal composition, repositioning Francis in the center, rotating the saint from his second idea of a frontal pose to the more daringly foreshortened position. Saint Francis is presented frontally, looking up, in two drawings from life that have not previously been connected with this painting (fig. 56 and a sheet in Berlin[31]) and in a quick sketch on another sheet (cat. 5.1). Typically for Barocci, who often rotated his figures spatially in the course of his creative process, he revised Saint Francis to his final position, in profile, on the same sheet. The progression in these three drawings was critical to Barocci's design for the saint. After beginning

with a frontal, half-kneeling position (fig. 56), he revised the upper body, now twisting to the left, in one of the sketches on cat. 5.1 to essentially the final pose on the same sheet. This complex sheet of studies also includes sketches for both hands, the left arm, and the left leg. All seven additional drawings for Saint Francis portray him in this final position, looking up to the left, with arms outstretched and foreshortened.

The latest of Barocci's two known compositional studies for *Il Perdono* is the *cartoncino per il chiaroscuro,* a large, highly finished drawing (cat. 5.7).[32] This magnificent work illustrates the staggering quantity of detail the artist included in his *cartoncini,* in which every particular of the composition is established. His *cartoncini* are much more finished and detailed than his full-scale cartoons, confirming that although he relied on the traditional mechanical transfer process from full-scale cartoons for the broad outlines of his compositions, he prepared many details in the *cartoncini* that were not transferred in this way to the canvas. This combined reliance on mechanical transfer and freehand design allowed him to continue modifying his designs to the very last moment. It seems that this attachment to the continual reinvention of design, this relentless process of creation, was an integral part of painting for Barocci, who postponed the act of painting to a degree that may be unprecedented in Italian art.

This ongoing commitment to continual design and redesign is also confirmed by yet another unusual practice in *Il Perdono*. While painting the picture, the artist was evidently dissatisfied with the head of Saint Francis; according to Andrea Lazzari, Barocci was unhappy with its effect and changed it several times.[33] These problems arose despite the head's complete resolution in a splendid study from life (cat. 5.2), whose full-sized scale and exact correspondence to the painted head (apart from the hair) suggest its function as a sort of auxiliary cartoon, as David Scrase suggested.[34] This term may be applied to Barocci's head only with one significant qualification, however. In contrast to Raphael's auxiliary cartoons for his *Transfiguration*—a group of finished drawings of apostles' heads that were pounced for transfer—Barocci's head was not mechanically transferred, for there is no evidence of either pouncing or incision on the

Edinburgh drawing. The remarkable beauty of Barocci's vibrant study even attracted the great collector Pierre-Jean Mariette, who once owned this sheet.[35] Notwithstanding what would have appeared to be its full preliminary preparation in this drawing, Barocci had trouble painting the head—so much so, evidently, that he repainted it, in oil on paper, and pasted this sheet atop the canvas of the altarpiece.[36] This unusual approach to revising Saint Francis's head is difficult to understand in technical terms: Why did he not simply scrape away the paint on the canvas and repaint the head? We do not know whether this unconventional method of revision simply reflects Barocci's preference for working on paper in the studio, or whether there was some other reason. Moreover, today, when one examines the surface of the picture, the head looks sunken to a noticeably lower level than the rest of the painting, raising questions about what befell the canvas underneath before the head on paper was superimposed. Whatever the explanation, these events may have given Barocci the idea of painting heads in oil on paper in preparation for some of his later canvases, beginning a few years later, with the Senigallia *Entombment* (cat. 8).[37] As I discuss in my essay on Barocci's drawings, he was one of the first Italian artists to employ heads in oil on paper to prepare his paintings.

However, in his preparation for heads in *Il Perdono,* the artist relied principally on drawings in chalk and pastel. These include a drawing for Saint Nicholas's head; two head studies connected to the Virgin;[38] and two studies for the heads of the cherubim. One beautiful and well-preserved example is a vividly colored and animated drawing for the head of the small angel at the upper right (cat. 5.6). In this chalk and pastel study, the plump child gazes lovingly toward Christ.[39]

The surviving preparatory studies for *Il Perdono* also testify to a singular emphasis on the design of hands and feet. Eleven drawings—more than a third of the extant sheets for the picture—examine these anatomical particulars. The extremities of Christ (three drawings) and Saint Francis (four drawings) particularly absorbed Barocci's attention, resulting in carefully foreshortened and subtly diversified portrayals. Saint Francis's hands, examined in three drawings, including a wonderful example from the Uffizi (cat. 5.1),[40]

provide a critical formal and iconographic function, simultaneously creating a sense of spatial recession and expressing the saint's ecstatic spiritual condition as he receives the indulgence from Christ. The dynamic study from Berlin for Christ's feet (cat. 5.5) illustrates Barocci's inventiveness, even when his figure is inspired by an earlier prototype. Although the raised foot and moving stance are clearly based on Titian's *Resurrection,* Barocci revisited the pose, placing Christ's feet over the head of a curly-haired angel to express the miraculous weightlessness of the Savior in his divine, resurrected form. Although Christ's corporeality is paradoxically evinced by the modeling of solid forms in light and shadow, he stands upon nothing and even raises one foot to emphasize this condition. This sense of Christ's weightlessness, floating in the golden celestial realm above the saint, is further reinforced by his swirling draperies and hair, whose tendrils flutter gracefully beside his right cheek. None of the other figures is clothed in such lively draperies, and none of them shares the dynamic stance of Barocci's Christ, whose feet directly challenge the picture plane, moving forcefully into the viewer's space.

An examination of Barocci's studies for Christ illustrates how his meticulous design process was constantly shaped by iconographic concerns. Even in his *primo pensiero* for the composition (fig. 55),[41] the central notion of Christ's weightlessness, expressing his resurrected and divine state, is clearly expressed. After increasing Christ's centrality and scale, Barocci continued to refine this idea, even though his conception is based on a prototype by Titian. A vibrant study for the full figure (cat. 5.3) shows that before turning to Titian as a model, Barocci first conceived a pose with both arms outstretched, a solution inspired by Raphael's Christ in the *Transfiguration,* which conveyed drama and lightness but failed to convey Christ's granting of the indulgence to Saint Francis. This problem was corrected in the next full study for the Redeemer: a drawing (cat. 5.4) that essentially adopts the final pose, with Christ's right hand extended in blessing and his left lowered and slightly extended into space. Here Barocci also conceived much of his final solution for the drapery, although one passage at the lower right was eliminated, creating a less symmetrical arrangement. After resolving

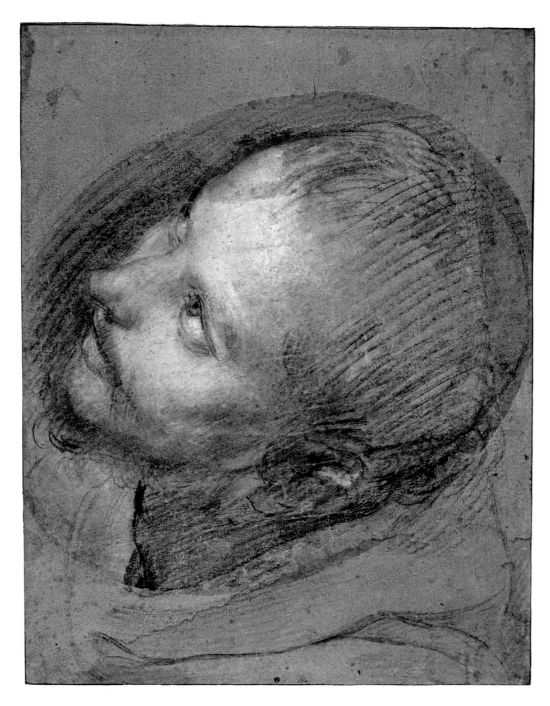

CAT. 5.2. *Study for the head of Saint Francis.* Black, red, and white chalk and pink pastel,
13⁹⁄₁₆ x 10⁹⁄₁₆ in. (34.5 x 26.8 cm). Scottish National Gallery, Edinburgh, inv. D 2250

the pose, Barocci moved in for a closer look at particulars, studying the hands and feet in three drawings in Berlin, including cat. 5.5,[42] and the drapery and legs in a sheet in the Biblioteca Oliveriana, Pesaro.[43] These particulars, too, were designed to enhance the sense of Christ's dynamic pose, expressing his divinely resurrected condition. His right hand is raised effortlessly, the fingers delicately elevated in blessing, while the left extends gracefully into space,

encircled by billowing draperies. The feet are surrounded by light as he steps forward, ostensibly supported by the three cherubim below but not quite resting on them, again conveying the absence of real weight. Barocci's conception of Christ's pose is thus central to the iconography of this figure.

After employing the engraver Cornelis Cort to reproduce some of his earlier painted compositions in prints, Barocci turned for the

first time in *Il Perdono* to the practice of printing his own composition (cat. 5.8). As Michael Bury suggested, the artist probably had access to printmaking equipment in his brother Simone's workshop of mathematical instruments, and he may first have experimented with the smaller prints of the *Virgin and Child in the Clouds* (cat. 11.2) and the *Stigmatization of Saint Francis* (cat. 13.2).[44] The importance of the *Perdono* picture, both as a key altarpiece and as a

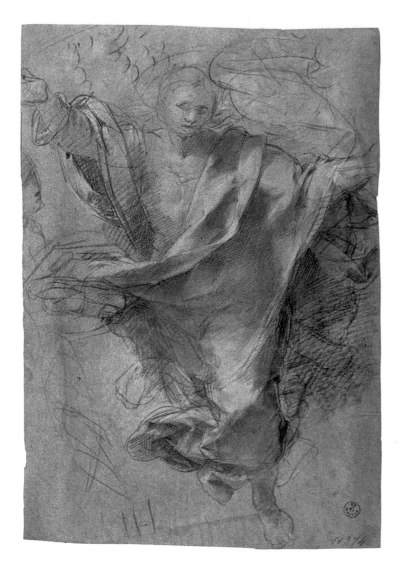

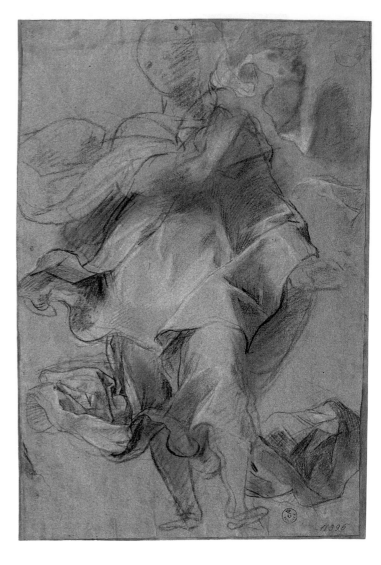

record of the new dissemination of this Franciscan indulgence, may have stimulated Barocci to negotiate an exceptional copyright privilege with the Vatican, ensuring his exclusive rights, not only to this composition, but also to the entire subject of the *Perdono* indulgence. The papal copyright for the print explains that the purpose of granting Barocci this privilege was to stimulate devotion in the faithful.[45] However, the ten-year protection was not enforced: Francesco Villamena reproduced Barocci's composition in an engraving dated 1588, only seven years after the publication of Barocci's own print in 1581.[46]

Barocci's print, which is faithful to the painting in almost every particular, apart from a few details such as the metal grate on the window of the choir, makes the arcane content of the indulgence explicit in an explanatory inscription at the lower left. Lavin suggested that the author of these lines was Magister Prospero Urbani of Urbino (1533–1609), who taught in the theological school of the monastery.[47]

The print, like the painting, illustrates both the artist's formal sensitivity to light and texture and his commitment to an ongoing process of revision in artistic creation. As in the small print of the *Stigmatization of Saint Francis* (cat. 13.2), Barocci employed the stopping-out technique, etching the plate conventionally by immersion in an acid bath, then covering portions of the plate with a varnish, reinforcing the lines in the uncovered portions with the etching needle, and reimmersing the plate in the acid to render the twice-etched portions darker. Afterward, Barocci also engraved portions of the plate to darken selected areas further. This process resulted in a remarkable range of tone, which is further enhanced by the great variety of Barocci's line work, in both the modeling lines and the contours. This variety of touch is particularly evident in the excellent, rich impression from the British Museum illustrated here. Some contours are left open; in other areas (principally selected draperies), the edges of forms are expressed with short lines of hatching, rather than being enclosed with a simple contour line. To create a sense of otherworldly

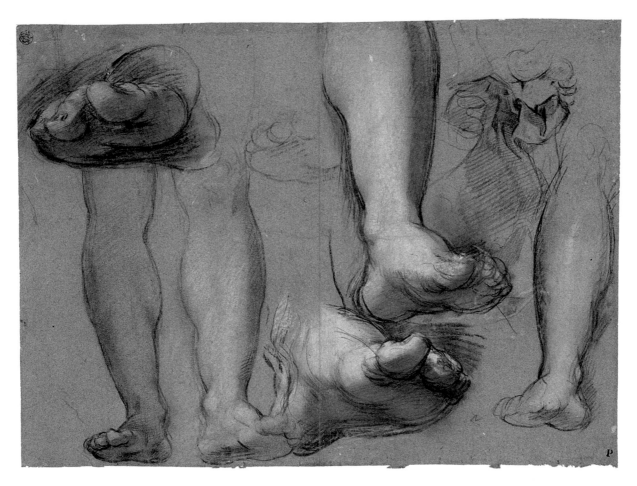

CAT. 5.5. *Studies of Christ's legs and feet.* Black and white chalk with traces of red chalk and stump on blue paper, 12¹¹⁄₁₆ x 17¹⁄₁₆ in. (32.2 x 43.3 cm). Kupferstichkabinett, Staatliche Museen zu Berlin, inv. KdZ 20221 (4279)

weightlessness in the angels, for example, Barocci's cherubim are almost completely lacking in conventional contour lines. The diversified strokes for interior modeling are especially varied on the figure of Christ, whose draperies are portrayed with lines of varied direction, length, and patterns.

Barocci's work on the drawings, painting, and print of *Il Perdono* between 1571 and 1581 is in several respects a turning point in his artistic development. His innovative undertaking for the Conventual Franciscans constitutes his most original interpretation of a Franciscan subject and his most inventive religious iconography to date, a quality that was to prove of signal importance in his future interpretations of religious subjects. His remarkable synthesis of traditional and untraditional iconography, his employment of obscure earlier Franciscan writings and well-known earlier Italian paintings, and his focus on doctrinal and visionary

content rather than conventional narrative all establish key features of his mature artistry. The lengthy preparatory process for this work included for the first time all the innovative types of preparatory instruments employed in Barocci's creative deliberations for paintings: head studies in chalk and pastel; a head in oil on paper; and a *cartoncino per il chiaroscuro*. This arsenal of preliminary tools, here expanded to include some that are unusual or unprecedented in Italian art, confirms Barocci's indefatigable commitment to the design process. Moreover, his etching of *Il Perdono* in 1581 was his first monumental print, his first reproduction of his own painted composition, and his only print to receive papal copyright privilege. Although he made only one other monumental print after a painting, the *Annunciation,* his use of stopping out and his sensitivity to light and texture made these works two of the most influential Italian prints of the period.

The reassessment proposed here of the small painting from Urbino provides critical evidence for understanding Barocci's procedures. Previously considered a preparatory study for the altarpiece, the picture formerly supplied the only example in Barocci's oeuvre of a so-called *cartoncino per i colori* with significant differences from the final painting, alleged confirmation of its role in the still-developing design process. Thus the picture provided critical evidence to support Bellori's claims for the artist's reliance on such instruments in his preliminary procedures. In the absence of such proof, we must seriously reconsider whether Barocci actually employed these *bozzetti* in color to prepare his paintings, a question that is addressed in my essay on Barocci's drawings.

Babette Bohn

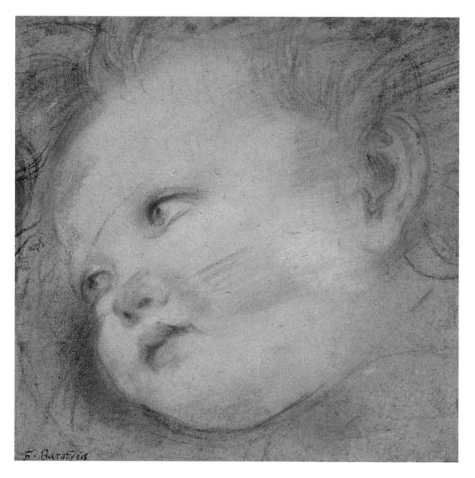

CAT. 5.6. *Cherub's head.* Red, black, and white chalk and pink and ocher pastel on blue paper, laid down, 7¼ x 7¼ in. (18.4 x 18.4 cm). Inscribed in brown ink lower left: "F. Baratius." Christ Church Picture Gallery, Oxford, inv. 1172

NOTES

1 On the Conventual Franciscans during this period, see Parisicani 1984, 19–104.

2 Ricotti 1954, 5–15. The *frati minori,* later called the Conventual Franciscans, are documented in Urbino even earlier, in 1254. For a transcription of this document, see Ligi 1972, 9–10.

3 Cooper 2000, 56–58; Mazzei 2002–3, 13–14.

4 Ricotti 1954, 52. Barocci's will was published by Luigi Renzetti in *Studi e notizie su Federico Barocci* 1913, 1–12. On Barocci and the Franciscans, see esp. Lingo 1998 and cat. 13.

5 The document of 11 October 1571 establishing a mutual commitment between the patron and the monastery, conserved in the Libro delle Notizie del Convento di S. Francesco, noted that the painting was commissioned by Nicolò di Ventura, "il Fattore." Both Lavin and Emiliani interpreted this reference to mean that he was the *fattore,* or financial manager, of the monastery, which would explain his large donation to that institution. Nicolò di Ventura died 5 September 1574 (MS published 1735 by Father Camillo Antonio Mariani and discussed in Lavin 2006, 20). Lavin plausibly concluded that Barocci began designing the work in late 1571.

Because there is no documentation of his residence near the church until 1575, however, it is unlikely that he began painting before this later date. For further discussion of this document, see n. 21.

6 Scatassa 1901, 129.

7 This letter to the rectors of the confraternity in Arezzo, which had recently commissioned the *Madonna del Popolo,* specified that the artist had just completed a project in Urbino (presumably *Il Perdono*) and would now be able to work unencumbered on this next commission (letter published by Gualandi 1844, 137).

8 This idea was first suggested by Carol Plazzotta, to whom I am grateful for these and other useful suggestions on this essay.

9 Inv. 11416 F. Olsen 1962, 149, no. 15; Lingo 2008, 82, who also emphasized the stylistic archaism in Barocci's reliance on this earlier design.

10 Sensi 2002b, 23–25.

11 Lavin 2006, 15–18; Lingo 2008, 64.

12 Lavin 2006, 13–14; Sensi 2002b, 99–105; illustrated in Cooper 2009, 291, fig. 236.

13 For illustrations of Spinelli's fresco, see Cooper 2009, 288, fig. 234, and 290, fig. 235. On Sassetta's altarpiece for Borgo San Sepolcro, composed of

sixty images, which were subsequently dispersed, see Israëls 2009, including Cooper 2009. The scene of Saint Francis receiving the indulgence from the pope (now National Gallery, London) is illustrated in Israëls 2009, 2, 498, fig. 15.1. For replicas after Ilario Zacchi's altarpiece and other representations of the subject, see Sensi 2002b, 121–37.

14 Borghini 1584 (2007), 568.

15 Francesco Bartoli (1312–1365) worked on his *Tractatus* until his death in 1365. See Sensi 2002b, 75–77 and 95.

16 Cooper 2009, 285–96.

17 Although I have been unable to find specific records of these treatises in Urbino, both the monastery and the duke owned substantial libraries that are likely to have included them. Part of the ducal library is recorded in an inventory now in the Biblioteca Civica, Urbania, but a search of those documents failed to turn up these treatises. For other inventories of the ducal collections, which were mostly assimilated into the Vatican collection after the death of Francesco Maria II, see Biganti 2005. On the library of Francesco Maria II, see Boutcher 2002 and Oradei 2002.

18 This is in contrast to another painting of this subject that was stylistically influenced by Barocci's picture: Francesco Vanni's *Il Perdono* altarpiece for the Conventual church of San Francesco in Pisa, probably datable to the 1590s. See Lingo 1998, 342–44.

19 Lingo 2008, 72.

20 See George Ferguson, *Signs and Symbols in Christian Art* (London, 1962), 135–36.

21 I am grateful to Padre Francesco and Dott.ssa Anna Falcioni for allowing me to work in the archive of San Francesco; to Dr. Carlo Taviani for assisting with logistics; and to the archivist Dr. Giambattista Fania for help with the transcription. Drs. Falcioni and Fania plan to publish full transcriptions of the archival materials in San Francesco. They explained to me that the entire archive was moved to Ancona in 1810, during the Napoleonic invasions, and that in 1816 some material was restored to Urbino, but most of the early documentation was lost. The following transcription largely accords with Lavin's transcription of the same document (2006, 35–38), but differs in a few particulars: "Li ditti frati di San Francesco di Urbino promettano et co[n]cedano a Nicolo di Ventura del [detto il?] fattore da Urbino lo altare maggiore di dicta chiesa, et detto Nicolo prometto dotarla di tanti beni olivati al valor de scudi quattrocento ovvero 400 scudi in dinari da reinvestirsi in tanti beni stabili olivati et de piu [in piu] scudi cento cinquanta per la fattura di una [repeated] tavola da ponersi in detto altare da farsi per mano di Federico Baroccio in onore di nostro signore Jesu Cristo, di la vergine sua madre e di San Francesco e di San Nicolo con questo che detti frati siano tenuti farla fare ben insieme [repeated] con tutti li ornamenti e finimenti di oro fine alla sua perfectione et bisognando spendere piu che detti frati siano tenuti del loro proprio oltra li detti 150 scudi, et hora a detto

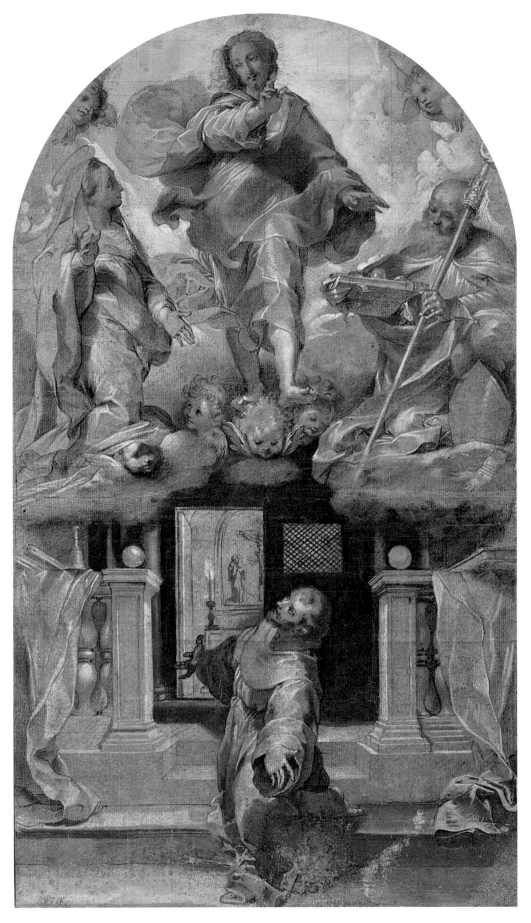

CAT. 5.7. *Cartoncino per il chiaroscuro.* Black and red chalk and pen and brown ink with brown wash, heightened with white, squared in black chalk, with an arched top, laid down, 21 x 11¾ in. (53.3 x 29.8 cm). The State Hermitage Museum, St. Petersburg, inv. OR-14714

Immaculate Conception

The *Immaculate Conception* altarpiece for the Conventual Franciscan church of San Francesco in Urbino was the smallest of Barocci's three works for the church and his only commission from the Confraternity of the Immaculate Conception (Compagnia della Concezione). Datable to about 1574–75, the painting was produced at a significant moment in the long theological battle over the doctrine of the Immaculate Conception, a fact that may explain in some measure Barocci's major changes to the iconography of the painting. The eighteen extant preparatory studies that are here connected to the altarpiece, including seven new suggestions, illustrate the artist's deliberations over a subject that had been as popular in religious art as it was theologically controversial within the Catholic Church.

The small altarpiece centers on the Virgin Mary. She fills most of the picture's vertical axis and is the most brilliantly colored figure in the painting, with a rich ultramarine-blue mantle, a *cangiante* lining in pale blue and pink (probably red lake), and a red dress (probably vermilion).[1] Her complex and space-penetrating pose is reminiscent of Barocci's Christ in *Il Perdono* (cat. 5).[2] Both of these visionary appearances are made by figures who are emphatically real in terms of weight and spatial definition. Mary stands in a contrapposto pose with her weight resting on her right leg, her body twisted slightly to the right, and her head turned back subtly to the left. Although her body is almost entirely concealed by abundant draperies, her carefully foreshortened hands—meticulously shaded to express both palpable volume and a junction between the celestial light above and terrestrial shadow below—hint at her unique synthesis of normal humanity and extraordinary purity. She stands in the clouds on a crescent moon, surrounded by cherubim, both arms extended amid billowing draperies, as she looks down benevolently toward the half-length figures who fill both lower corners of the picture. Bellori identified the men and women below as members of the confraternity that commissioned the work. All look up in adoration at the Virgin, except the mother who looks down at her daughter. Mary's gaze is lowered toward the deserving confraternity members below, but her acceptance of them is expressed most forcefully by her extended arms, which imply her benevolent protection of the faithful.

The painting has suffered from condition problems that date back to Barocci's lifetime. Giovanni Pietro Bellori reported that the picture was originally painted in gouache, but when its condition deteriorated, Barocci repainted it in oils during his last years.[3] Although the presence of gouache has never been verified by modern analysis, the painting has suffered, and it was restored and relined in 1973.[4] Before this intervention, Harald Olsen had dismissed the picture as workshop, but Andrea Emiliani argued that the painting is entirely autograph, a judgment that has been accepted by most subsequent writers.[5]

The chapel for which the altarpiece was commissioned was the second one in Urbino to be dedicated to the Immaculate Conception. The first, in the cathedral, was begun in 1516, in gratitude for the city's recent liberation from the plague. The cathedral chapel, like its counterpart in San Francesco, had Franciscan associations, for the dedication was suggested by the Franciscan preacher Padre Giovanni da Fano.[6] The Immaculate Conception had long been associated with the Franciscan order.

The *Immaculate Conception* was one of many commissions Barocci received from confraternities during his career. Bellori reported that the artist's first painting after his return to Urbino from his first trip to Rome, probably in the mid-1550s, was a *Martyrdom of Saint Margaret* for the Confraternita del Corpus Domini in Urbino.[7] Barocci himself joined this confraternity in 1573, following the example of other prominent Urbinate artists, including Giovanni Santi, Raphael, and Timoteo Viti, who were all members.[8] Subsequent commissions from confraternities included: the *Madonna del Popolo*, painted about 1575–79 for the Fraternita di Santa Maria della Misericordia in Arezzo; the *Entombment* of 1579–82 for the Compagnia del Santissimo Sacramento e Croce in Senigallia (cat. 8); and the *Madonna of the Rosary,* completed in 1593 for the Confraternita dell'Assunto e del Rosario (cat. 11).

Although little is known today about the Confraternity of the Immaculate Conception —most of the church's early records have been lost—Olsen reported that the picture was recorded in the archives of San Francesco, without a date.[9] Most modern authors, including Olsen, Emiliani, Nicholas Turner, and Stuart Lingo, have dated the picture to about 1575, but an exchange of letters in late 1574 between Barocci and the confraternity in Arezzo that commissioned the *Madonna del Popolo* suggests that he had then already begun his preliminary preparations for the *Immaculate Conception.* When the rectors of the Arezzo confraternity first wrote to Barocci on 30 October 1574, asking him to paint a panel with "the mystery of the *misericordia* or another mystery and *historia* of the Blessed Virgin," Barocci responded quickly and decisively on 5 November.[10] His letter firmly rejected the *misericordia* as a subject that did not provide much possibility for a beautiful painting. His comments imply some prior experience with this subject, and the most likely explanation is that he had previously explored and rejected this iconography in a drawing for the *Immaculate Conception,* as discussed below.

Barocci's painting shows the Virgin Immaculate looking down toward the confraternity members, who are divided by gender, with the men at Mary's right and the women at her left, including the youngest worshiper, a small girl who looks up at the Virgin and raises her hands in prayer. Her mother, the only confraternity member not looking at the Virgin, is the first of several reutilizations of a female figure first conceived for the *Deposition* (cat. 3), in which she leans over and supports the fainting Virgin. As Giovanna Casagrande demonstrated, although confraternity memberships in the Italian peninsula were predominantly male, female membership increased during the early modern period. In Urbino, for example, women were increasingly admitted to the Confraternita del Corpus Domini. Although their activities were limited, women often joined confraternities with Marian dedications, a practice illustrated in Barocci's picture.[11]

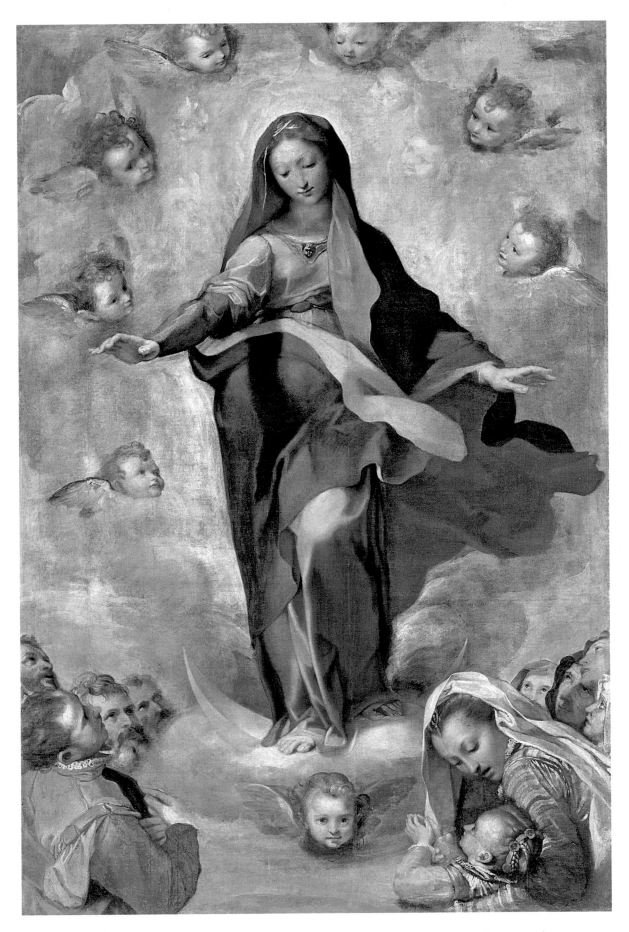

CAT. 6. *Immaculate Conception*, ca. 1574–75. Oil (over gouache?) on canvas, 87⅜ x 59¹⁄₁₆ in. (222 x 150 cm).
Galleria Nazionale delle Marche, Urbino, inv. 1990 D 86

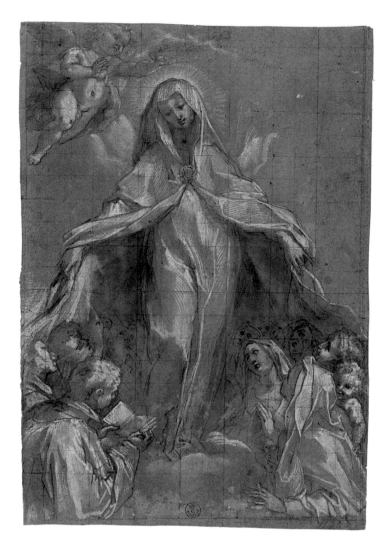

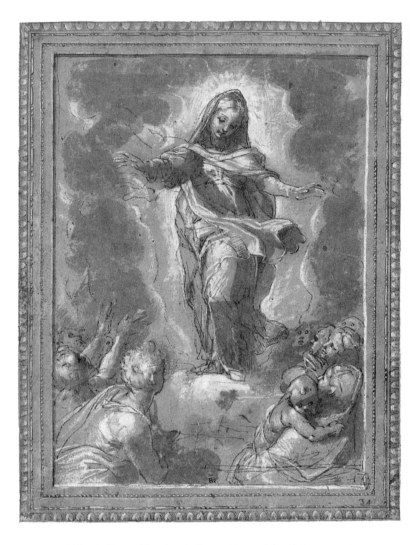

CAT. 6.1. *Compositional study for the Madonna della Misericordia* (recto). Pen and brown ink with brown wash heightened with white, squared in black chalk, on blue-green paper. [Verso: Drapery study. Black chalk], 10¾ x 7⅜ in. (27.3 x 18.8 cm). Inscribed in black chalk on verso: "Baroccio." Gabinetto Disegni e Stampe degli Uffizi, Florence, inv. 11446 F.

CAT. 6.2. *Compositional study.* Pen and brown ink with brown wash heightened with white, 8 1/16 x 5⅞ in. (20.5 x 15 cm). Inscribed on mat: "Olim Eq della Penna Pers & deinde D. Crozat." Musée du Louvre, Département des Arts Graphiques, Paris, inv. 2855

In addition to the three compositional studies, there are six head studies for various figures, one sketch for a subsidiary figure, and eight drawings of various types for Mary. Among the head studies, perhaps the loveliest is a vividly colored drawing for the head of the cherub below the Virgin's feet (cat. 6.4). Previously ascribed to Barocci but mistakenly connected with another painting,[36] this head of a child depicts the only figure in the painting to make direct eye contact with the viewer. The chubby, childish face, full eyes, and blond hair make both the drawing and the painted head very engaging, and it is no surprise that this study was copied in another drawing by a close Barocci follower in the Rijksmuseum (fig. 57). Although the copy is competently drawn and

essentially faithful to Barocci's original, a comparison of the two drawings elucidates his singular skills, which were difficult to emulate. Apart from the freely drawn details of curling hair that animate the original but are absent from the copy, the Amsterdam sheet corresponds closely to Barocci's drawing in most respects.[37] Unlike Barocci's head, however, which was outlined partially in red and partially in black, a characteristic method for him, the contours of the Amsterdam head were rendered entirely in black chalk. Perhaps most significantly, in the copy the pastels were applied evenly and meticulously, in contrast to Barocci's freer and more selective applications of color. The freedom and liveliness of Barocci's head were lost in the faithful but mechanical copy.

Other head studies employ varied techniques. A drawing for the cherub's head at upper right was prepared in red chalk and stump, whereas a study for the little girl below was made with colored chalks and pastels.[38] A drawing in the Uffizi (fig. 58) features two female heads, one in red and one in black chalk.[39] Both heads appear to have been based on sculptures, confirming that the artist sometimes employed artistic rather than living models. Barocci made the drawing in black chalk first and then reversed the head in the red chalk rendering to design one of the female *confratelli.* Another drawing in the Uffizi probably prepared the head of one of the men.[40]

The Virgin is the focus of Barocci's painting, so it is no surprise that almost half of the

surviving preparatory studies for the painting are connected with her design. These eight drawings are evenly divided between full-figure, drapery, and anatomical detail studies. The last group includes one unpublished sheet: a small sketch for the Virgin's right hand in Berlin.[41] A remarkable sheet of studies in the Uffizi includes several renderings of the Virgin's right foot, sketches for the left arm and both hands of the little girl, and studies for two cherubim heads at the upper right of the painting.[42] Drawings like this, with studies for four different figures, are typical of Barocci's practice but make him unusual among his Italian contemporaries. Of the three drapery studies connected with the Virgin,[43] none records the artist's final solution, and all testify to the many permutations in his conception.

Among the full-figure studies for Mary, the most spectacular and revealing portrays a female nude, with the head redrawn at right (cat. 6.5). The idealized proportions of her body and the emphatically volumetric character of her depiction suggest that Barocci was working from a sculptural model, probably an antique or modern sculpture in the ducal collection.[44] Barocci rarely, if ever, made drawings from living female models, usually relying on male models for his female figures and sometimes consulting sculptural prototypes, as he seems to have done here. His avoidance of living female models for his painted women accounts for their more limited naturalism, compared to his male figures, who were generally based on living models of the same gender.[45]

A sheet in Paris that has been widely accepted as a second autograph study for the figure (fig. 59) does depict the same pose as in the Uffizi drawing, but it is stylistically too far from the Uffizi study to sustain the attribution to Barocci.[46] The Paris drawing's thick lines and coarse shading, applied both over and around the body, and the very mannered pen sketch are quite unlike Barocci's other drawings. Above all, the more naturalistic rendering of the female body—with its convincingly weighty rendering of breasts, hips, and abdomen—contrasts sharply with Barocci's idealized female figure in the sheet in Florence. The Paris drawing exemplifies one of the central difficulties in studying Barocci's drawings. The artist's beautiful and numerous sheets were widely circulated, admired, and imitated, often

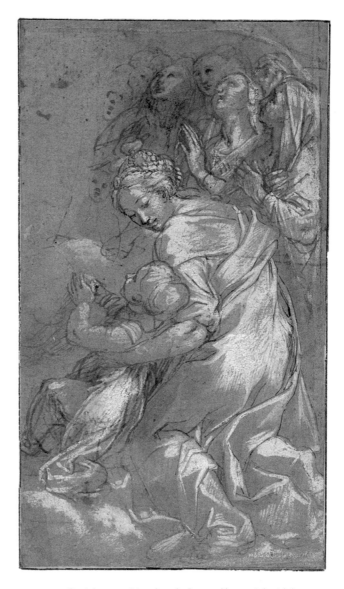

CAT. 6.3. *Partial compositional study.* Pen and brown ink with brown wash heightened with white over black chalk on blue paper, laid down, 9³⁄₁₆ x 5⅛ in. (23.3 x 13 cm). Albertina, Vienna, inv. 548

by gifted draftsmen who created skilled copies after Barocci's originals. In contrast to the Amsterdam copy after Barocci's head of a child in Stockholm, however, the Paris sheet is a freer replica of Barocci's original, and it was probably made by a Florentine artist working from the Uffizi drawing. This Florentine inception is underscored by the traditional attribution of the sheet to Jacopo da Pontormo. Although this attribution is not convincing either, it points in the right direction, and the drawing was probably made after Barocci's design, by an artist such as Jacopo da Empoli, who was influenced also by Pontormo.[47]

Barocci's *Immaculate Conception* synthesizes old-fashioned iconographic features with more modern devotional simplicity.[48] The complex genesis of his painting, developed in eighteen extant preparatory drawings, evolved from the traditional Madonna della Misericordia theme to an updated devotional work, in which the confraternity members provide models for the faithful in their devotion to the Virgin. Standing in the clouds and towering over the *confratelli,* Mary appears as the Apocalyptic Woman, creating a visionary altarpiece reminiscent of such earlier works as Raphael's *Sistine Madonna.*[49] But in addition to her miraculous nature, Barocci's Virgin inculcates qualities of human compassion. The artist's path from the Misericordia iconography in the Uffizi study to the dynamic Louvre drawing to

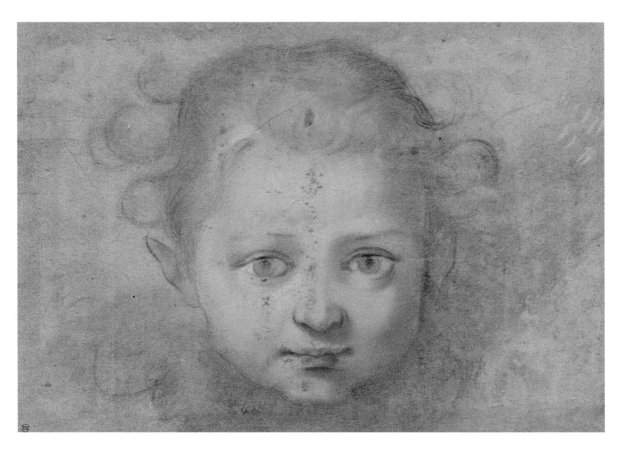

CAT. 6.4. *Head of a cherub*. Black, red, and white chalk and peach and yellow pastel on blue paper, laid down, 8¼ x 11¾ in. (21 x 29.8 cm). Nationalmuseum, Stockholm, inv. NM 408/1863, cat. I, 427

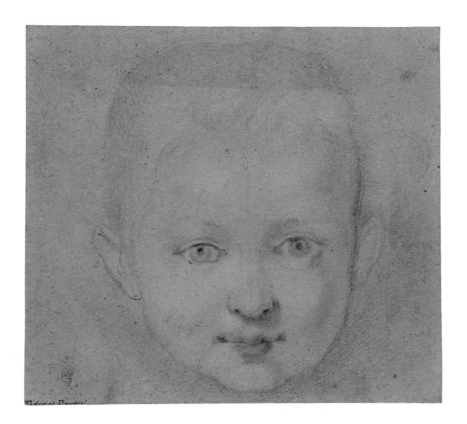

Fig. 57. Workshop of Barocci, *Copy of a cherub head for the Immaculate Conception*, after 1575. Black and red chalk and pink and yellow pastel, 19.3 x 21.4 cm. Inscribed in brown ink lower left: "Federico Barocci." Rijksmuseum, Amsterdam, inv. RP-T-1981-30 recto

the solemn quietude of his final solution resulted in a graceful balance between the miraculous and the human. The emotional accessibility of the figures, whose humanity is signaled particularly by the mother and child, conveys the idea that Mary's intervention in human salvation is offered both to the confraternity members in the painting and, by extension, to the viewer-worshiper before the altarpiece.

Babette Bohn

NOTES

1 These pigment identifications were made by conservator Claire Barry, who also observed that the plain-weave canvas has two vertical seams, one running to the right of the Virgin's head and proper left knee and the other to the left of her right hand.

2 As Turner 2000, 66, also noted.

3 Bellori 1672 (1976), 198; Bellori 1672 (2000), 186.

4 See Torriti and Bizzotto Abdalla 1973, 414, no. 102. Early allegations (by Bellori and others) regarding several instances of repainting by the artist have largely been dismissed or ignored by modern writers, but these claims have never been tested with modern scientific analysis.

5 Olsen 1962, 161–62, no. 30; Emiliani 1975, nos. 82–86. Emiliani's views were accepted by Lingo (2008, 39), but Turner attributed the execution of the secondary figures to assistants (2000, 66–67).

6 Ligi 1956, 16.

7 This painting, for which Barocci received final payment in 1556, is now lost, but a version of the composition is recorded in a drawing (Victoria and Albert Museum, London, inv. D.1084-1900, fig. 25), as recognized independently by Anna Forlani Tempesti 1996, 62 and 69), and Aidan Weston-Lewis (cited in Scrase 2006, 74–75, no. 12). See also E 2008, 1, 97–98, no. 1.

8 On this confraternity, see Moranti 1990.

9 Olsen 1962, no. 30. My search through the church archives failed to turn up the document Olsen mentioned.

10 The correspondence between Barocci and his patrons in Arezzo was published by Gualandi 1844; these two letters are transcribed on pages 1, 135, and 137–38.

11 Casagrande 2000; Moranti 1990, 35–36.

12 Levi D'Ancona 1957, 4.

13 Ibid., 10–13.

14 Mayberry 1991, 209.

15 Ibid., 221.

16 Weissman 1982, 220–21.

17 Lisimberti and Todisco 2000, 38–39.

18 This altarpiece of ca. 1516–18 (now Pinacoteca Nazionale di Brera, Milan) is discussed by Galizzi Kroegel 2004.

19 On this painting (now National Gallery, London), see Lightbown 2004, 489–500, who speculated that this work, too, was painted for a confraternity.

20 Levi D'Ancona 1957, 24–25. Although there are

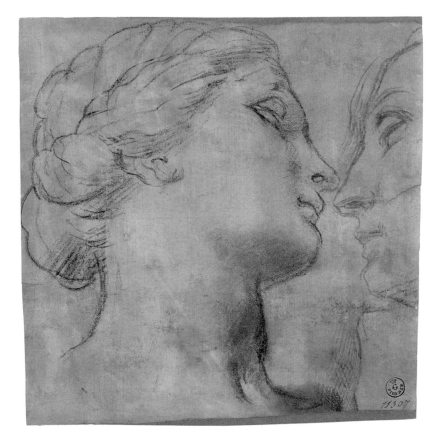

Fig. 58. *Study of two female heads*, ca. 1574–75. Black and red chalk, 25.8 x 24.8 cm. Gabinetto Disegni e Stampe degli Uffizi, Florence, inv. 11307 F. recto

earlier representations of the Apocalyptic Woman, dating back to the ninth century, these are not connected to the Virgin Immaculate. See Morello, Francia, and Fusco 2005, 114, no. 1.

21 Santi di Tito's painting (chapel of the Conception, San Gerolamo al Velloso, Volterra, after 1578–before 1585) includes Adam and Eve, Saints Nicola of Tolentino and Barbara, and other figures. Vasari's *Immaculate Conception* (Uffizi, after 1541) includes Adam and Eve, David, and eight other figures. An example by the Sienese painter Rutilio Manetti (San Niccolò degli Alienati, Siena, 1629) portrays the Immacolata above David and Isaiah. All three paintings were catalogued and illustrated in Morello, Francia, and Fusco 2005, 164–65, no. 28; 168–69, no. 39; and 182–83, no. 36.

22 Ibid., 162–63, no. 27.

23 Ibid., 218–19, no. 59.

24 Ibid., 176–77, no. 33.

25 Schiferl 1989, 12.

26 Lingo 2008, 33.

27 A drawn copy after the Uffizi drawing is in the Albertina (inv. 544; Birke and Kertész 1992–97, 1, 298–99, no. 544). Lingo first published cat. 6.1 as a study for the *Immaculate Conception* (2001, 217–18), but he later debated between connecting it to this painting or to the *Madonna del Popolo* (2008, 39–40).

28 Levi D'Ancona 1957, 17 and 33.

29 This was also a popular subject for sculpture during the fifteenth century in the Marches, as seen

in an example by an anonymous Marchesan sculptor in polychrome wood in the same museum.

30 David Ekserdjian observed (private communication)—both because the light comes from the left in this drawing, as it does in the *Madonna del Popolo,* and because the Arezzo confraternity was dedicated to the Misericordia—that cat. 6.1 was made for that work rather than for the *Immaculate Conception,* an idea that was considered inconclusively by Lingo (2008, 39–40). This is one of several drawings that may have pertinence for both commissions (see, e.g., the discussion of Uffizi inv. 11377 F. recto in n. 33, below), but given Barocci's rejection of this subject in his initial correspondence with the patrons for the *Madonna del Popolo,* I believe that he made the drawing to prepare the earlier picture, as Dempsey also argued (2010, 255). Ekserdjian also suggested that the frame in cat. 6.2 was drawn by Barocci. I am grateful to Dr. Ekserdjian for generously sharing his observations with me in advance of their publication, and also to Carol Plazzotta for her many insightful comments on these and other issues in this entry.

31 Previously ascribed to Paolo Farinati, this drawing was published by Birke and Kertész 1992–97, 1, 301, no. 548, as Barocci's drawing for the Perugia *Deposition.*

32 E 2008, 1, 300–309, nos. 37.1–37.18. Although Emiliani generally catalogued rectos and versos of the same drawing separately, his no. 37.18 included

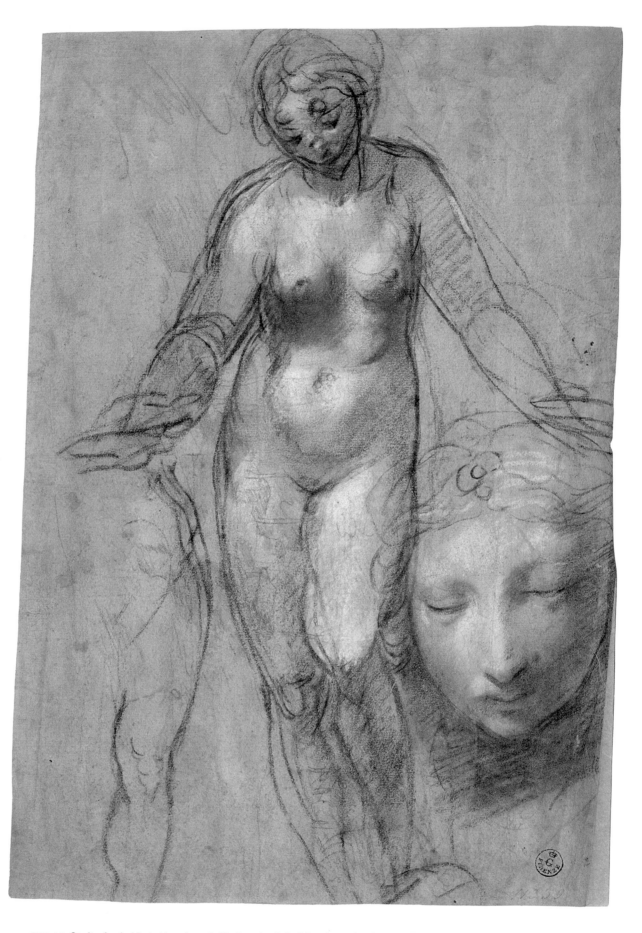

CAT. 6.5. *Studies for the Virgin Mary* (recto). Black and red chalk heightened with white. [Verso: Sketches of figures in a landscape, by a later hand. Black chalk], 14¹⁵⁄₁₆ x 10 in. (38 x 25.4 cm). Gabinetto Disegni e Stampe degli Uffizi, Florence, inv. 11339 F.

both the recto and verso of a drawing in the Biblioteca Oliveriana in Pesaro (inv. 234). Thus I have characterized Emiliani's catalogue as listing nineteen studies for the painting.

33 These three studies include: Uffizi inv. 11668 F. verso (E 2008, 1, 306, no. 37.11, illustrated), which probably prepared a discarded idea for a figure in the *Madonna del Popolo;* and Biblioteca Oliveriana, Pesaro, inv. 234 recto and verso (E 2008, 1, 309–11, no. 37.18, illustrated), which prepared three figures in the *Madonna del Popolo*—the hands of the two children at lower left (recto) and the leg and drapery of the hurdy-gurdy player, studied in reverse (verso). A fourth drawing, Uffizi inv. 11377 F. recto (E 2008, 1, 306, no. 37.12, illustrated), has been retained here among Barocci's studies for the *Immaculate Conception,* but it may alternatively have been made for the *Madonna del Popolo.* The verso features a design for the hand of Saint Joseph in the Vatican *Rest on the Return from Egypt.*

34 The drawings connected by Emiliani with this painting, whose authorship by Barocci seems unlikely, include: École de Beaux-Arts, Paris, inv. 2388 (2008, 1, 300, no. 37.1, discussed below); Uffizi inv. 11339 F. verso (2008, 1, 309, no. 37.17), which appears to be much later; Uffizi inv. 11567 F. (2008, 1, 308–9, no. 37.15, illustrated), inv. 11568 F. (2008, 1, 309, no. 37.16), inv. 11361 F. recto (2008, 1, 305, no. 37.9, illustrated), and inv. 11361 F. verso (2008, 1, 305, no. 37.10), which all seem to be by Barocci school artists. Olsen 1962, 228, n. 77, suggested an attribution to Antonio Viviani, a Barocci follower, for the last two drawings.

35 Christ Church, Oxford, inv. 0223, Scrase 2006, 180–81, no. 64.

36 This drawing, characterized by Olsen as a copy after Barocci (1962, 291), was rightly restored to autograph status by Emiliani, who mistakenly connected it with *Il Perdono* (2008, 1, 282, no. 24.25).

37 The measurements are not close enough to suggest that the copy was traced from the original. The copy measures 19.3 x 21.4 cm, whereas the original measures 21 x 29.8 cm.

38 The first drawing, Uffizi inv. 1570 Orn., has not previously been connected with the *Immaculate Conception.* The rough sketch on the verso, in red and black chalk, prepared one of the male figures at lower left. The second drawing, in Christ Church, Oxford, inv. 0223 (Byam Shaw 1976, no. 327), was published by several authors, including most recently Scrase 2006, 180–81, no. 64.

39 Inv. 11307 F. This drawing was published by Pizzorusso 2009, 57 and 59, in his excellent essay on Barocci and sculpture. Correctly recognizing the drawing's inception in a sculptural model, Pizzorusso associated it with a much later painting, the *Christ Taking Leave of His Mother* in Chantilly (fig. 20).

40 Uffizi inv. 11438 F. recto, in red and black chalk with peach and white pastel on blue paper, E 2008, 1, 308–9, no. 37.14, illustrated.

41 Inv. KdZ 20249 (4259).

42 Inv. 11668 F. recto, E 2008, 1, 308, no. 37.13, illustrated.

43 Uffizi inv. 11601 F. recto, E 2008, 1, no, 37.8;

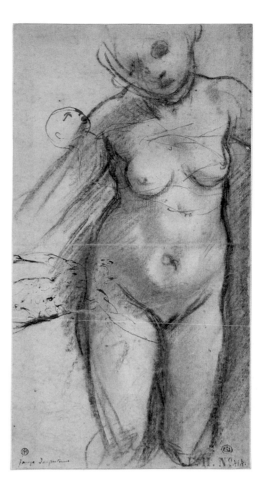

Fig. 59. Florentine artist, *Copy after a drawing by Barocci for the Virgin in the Immaculate Conception,* after 1575. Black chalk and stump over another drawing of two figures in pen and brown ink, 25.5 x 13.8 cm. École Nationale Supérieure des Beaux-Arts, Paris, inv. 2388 recto

Uffizi inv. 11446 F. verso, E 2008, 1, no. 37.7; and Uffizi inv. 11307 F. verso, unpublished.

44 On Barocci's early drawings after sculptural models, see Fontana 1997b, 36–47. On Barocci's relationship to sculpture, see Pizzorusso 2009, 54–65.

45 See the longer discussion of this issue in my essay here.

46 École des Beaux-Arts, Paris, inv. 2388 recto. This drawing of a nude figure is in black chalk and stump, over another drawing of two figures in pen and brown ink; inscribed lower left in brown ink: "Jacopo da Pontormo." The verso has a rough sketch in black chalk for a figure kneeling in right profile, and is also inscribed in a modern hand, in black ink: "ecole florentine. / jacopo Carucci detta da Pontormo / né a Florence en 1493 mort en 1558." The recto was connected with the *Immaculate Conception* by Olsen (1962, 162, no. 30) and Emiliani (1975, no. 83, and E 2008, 1, 300, no. 37.1).

47 A more finished, final preparatory study for the clothed Virgin is in the Uffizi (inv. 11410 F. recto, E 2008, 1, 302, no. 37.3, illustrated). A second drawing in the Vincent Price collection in Los Angeles, known to me only from a black and white photo (and therefore difficult to judge conclusively), was published by Pillsbury and Richards 1978, 53–54, no. 29, illustrated; and E 2008, 1, 302, no. 37.4. An early copy after Barocci's Virgin, based either on Uffizi inv. 11410 F. or on the painting itself, is in the

Albertina (inv. 543, catalogued by Birke and Kertész 1993–97, 1, 298, no. 543, as a copy after Barocci).

48 On Barocci's ongoing balancing act between archaism and modern style, see Lingo 2008, 33–61.

49 As noted by Lingo 2008, 46.

Provenance: Chapel of the Immaculate Conception, church of San Francesco, Urbino; Galleria Nazionale delle Marche, Urbino

Bibliography: Bellori 1672 (1976), 198; Baldinucci 1681–1728 (1974–75), 3, 341; Dolci 1775 (1933), 302; Lazzari 1801, 107–8; Schmarsow 1909, 14; Schmarsow 1909 (2010), 78–80; Schmarsow 1911, 7, 11; Krommes 1912, 110; Di Pietro 1913, 93–97; Schmarsow 1914, 26, 31, 32, 42; Serra 1930, 115; Olsen 1962, no. 30; Bertelà 1975, 43–46, nos. 33–37; Emiliani 1975, 103–6, nos. 82–86; Byam Shaw 1976, 109–10, nos. 327 and 331; Pillsbury 1976, 59, 61–62; Shearman 1976, 52; Pillsbury and Richards 1978, 53–54, no. 29; Emiliani 1985, 1, 122–27; Zampetti 1990, 111; Birke and Kertész 1992–97, 1, 301; Fontana 1997b, 42, n. 90, and 140, n. 84; Bjurström and Magnusson 1998, no. 427; Turner 2000, 66–67; Lingo 2001, 215–21; Morello, Francia, and Fusco 2005, 216–17, no. 58; E 2008, 1, 298–310, no. 37; Lingo 2008, 14–15, 33, 39–48, 63, and 105; Faietti 2009, 80; Pizzorusso 2009, 57; Sangalli 2009, 157; Dempsey 2010; Gillgren 2011, 168–72 and 247–48, no. 16.

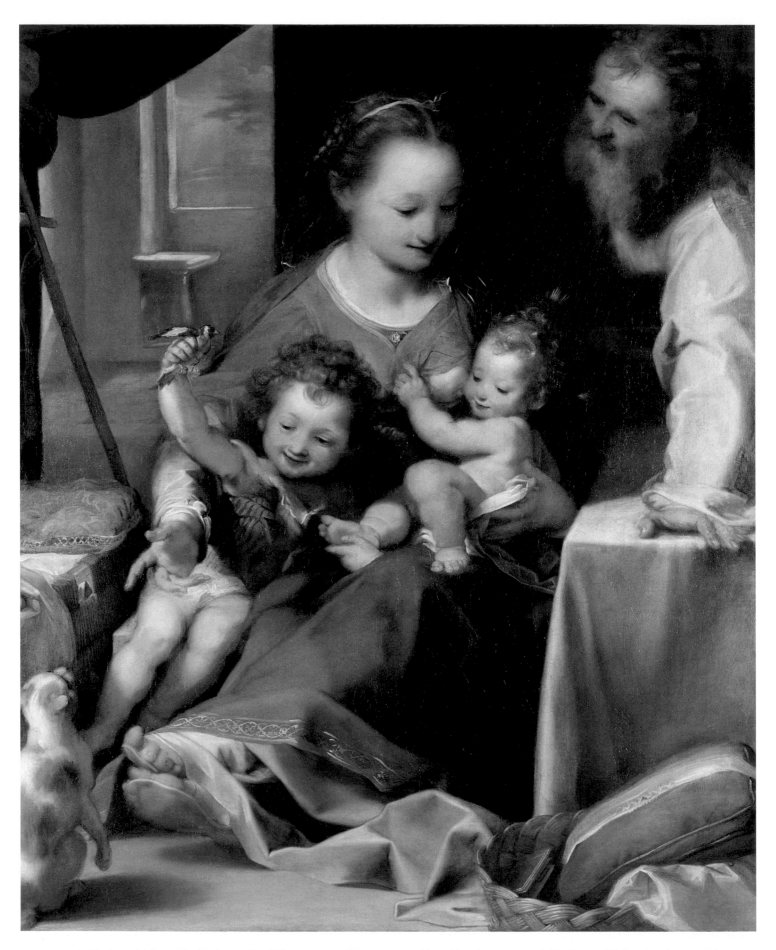

CAT. 7. *La Madonna del Gatto* (*The Madonna of the Cat*), ca. 1575–76. Oil on canvas, 44⅜ x 36½ in. (112.7 x 92.7 cm). The National Gallery, London, inv. NG29

La Madonna del Gatto (The Madonna of the Cat)

The *Madonna del Gatto,* the only easel painting by Barocci in a British public collection, was among the first pictures to enter the National Gallery after its foundation in 1824. Comparable in scale and mood to the *Rest on the Return from Egypt* (cat. 4), the *Madonna del Gatto* is among the most delightful and engaging of all Barocci's devotional pictures. It shows the Holy Family in an atmosphere of cozy domesticity, watching in amusement as the Infant Baptist teases the household cat that gives the painting its name. Giovanni Pietro Bellori referred to the picture as a *scherzo* (a playful piece), aptly emphasizing its light-hearted spirit.[1] Indeed, in the animated warmth of the gathering, it is easy to lose sight of the picture's more serious devotional message—the anticipation of Christ's future sacrifice. Instead, the close-up view, the familiar domestic environment, and the protagonists' cheerful expressions combine to create an atmosphere of relaxed intimacy that has direct appeal. The four figures are gracefully arranged in a subtle diagonal rising from the cat in the bottom-left corner, their limbs creating a complex interplay of movement forward and backward in space. The delicate sfumato blush that caresses their faces, limbs, fingers, and toes epitomizes Sir Joshua Reynolds's observation (quoting Plutarch) that Barocci's figures look "as if they fed upon roses," a quality, along with a perceived irreverence in the subject, not universally favored after the painting's acquisition by the National Gallery.[2] The painting thus emerged from almost complete scholarly obscurity only in the 1960s, with research published by Harald Olsen and Cecil Gould, reinforced by its loan to the pioneering monographic show held in Bologna in 1975.

The scene is set in the bedchamber of a Renaissance palace. Through a doorway in the background, from which a green curtain is drawn back, an open window reveals a twilit sky, the glow of the setting sun reflected on the elegant stone window seat and the left-hand wall. Seated on a low stool, with her legs stretched out and feet comfortably crossed, the Virgin breastfeeds the Christ Child. She has recently lifted him from his wicker cot, for the bedcover is turned back and a silk pillow trimmed with gold bears the imprint of his head. Her wicker workbasket in the foreground contains a narrow white cloth stretched over an embroidery cushion, a larger cloth, and a small book with a gold-embossed leather binding, its pages falling open to reveal an engraved frontispiece. The young mother cradles her baby to her breast while embracing Saint John, perched on the stool alongside her. Steadying himself against the Virgin's knee and instinctively clutching his cousin's chubby foot, he playfully holds up an alarmed goldfinch, prompting the cat to sit up on its haunches and lift its nose in the bird's direction. Christ pauses from suckling to watch as directed by his mother's gesturing hand. Supporting himself on a low table, Saint Joseph leans over Mary's shoulder to enjoy the scene.

Bellori noted that Barocci painted the picture for Antonio Brancaleoni (ca. 1532/33–1598), who was count of Piobbico, a small stronghold straddling a strategic mountain pass about twenty miles west of Urbino; he also mentioned that Brancaleoni commissioned a version in distemper of the *Rest on the Return from Egypt* (see cat. 4 and fig. 52) for his parish church.[3] Bellori's reliability in respect to the latter is unproblematic, since the painting remains in situ in Santo Stefano in Piobbico.[4] Hitherto, however, there was no other information to support his association of the *Madonna del Gatto* with Brancaleoni.[5] A newly discovered document recording the picture's presence in the Perugian palace of Brancaleoni's granddaughter in 1671 confirms that Bellori was correct about the National Gallery picture.[6] We shall see that the painting's date, coinciding with the creation of splendid new apartments in Brancaleoni's palace, as well as its subject and appearance, offer much further corroboration of the count's patronage.

Despite his commission of two such beautiful works from the artist in the mid-1570s, the interesting figure of Count Antonio II Brancaleoni has received little attention in the Barocci literature.[7] His birthdate is unknown, but he was probably born around 1532/33.[8] Like his forebears, he took up arms from a young age and was a talented horseman, fighting in many wars, including the Battle of Lepanto in 1571.[9] In 1552, he married Laura Cappello, daughter of the exiled Venetian poet and diplomat Bernardo Cappello (1498–1565).[10] The young Laura had been lady-in-waiting to Vittoria Farnese (1521–1602), duchess of Urbino, who was instrumental in her match with Count Antonio, and who contributed a substantial sum to her dowry.[11] Between 1555 and about 1569, Laura bore Antonio fourteen children, of whom eight sons and a daughter survived into adulthood.[12] As the eldest son of Count Monaldo di Roberto Brancaleoni, Antonio inherited the lordship of Piobbico in 1556, when his father was murdered by the rival Ubaldini clan of nearby Apecchio.[13] Antonio himself was involved in a number of murderous incidents in the defense of his family and territory, for which Duke Guidubaldo of Urbino reprimanded him, but penalties of exile and confiscation of property were always quickly rescinded, indicating a degree of favor at the Della Rovere court.[14]

Barocci's picture must have been made for Brancaleoni's palace, which dominates the medieval village of Piobbico from the top of a small hill. In the 1470s, his great-grandfather, Guido di Antonio I Brancaleoni (1437–1484), had transformed it from a modest family residence into a worthy seignorial seat on the model of the Urbinate palace of his employer and ally, Duke Federico da Montefeltro.[15] Count Antonio, the patron of this picture, undertook the next significant campaign to extend and decorate the palace in the mid-1570s.[16] It is exactly to this period, in which he was actively re-establishing favor with the Della Rovere in Urbino (see below), that Barocci's two paintings can be dated. The purpose of Brancaleoni's palace extension was to provide himself and his consort with an elegant apartment on the *piano nobile* (main floor), the finest rooms in the palace to this day. The new suite consisted of a central *salone,* or reception room, flanked by the count and countess's separate bedchambers, decorated with exemplary scenes from Greek and Roman history, respectively, each provided with a private chapel.[17] The rooms were embellished with stucco ceiling moldings and reliefs

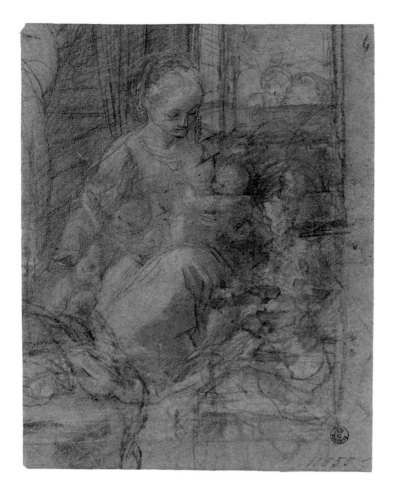

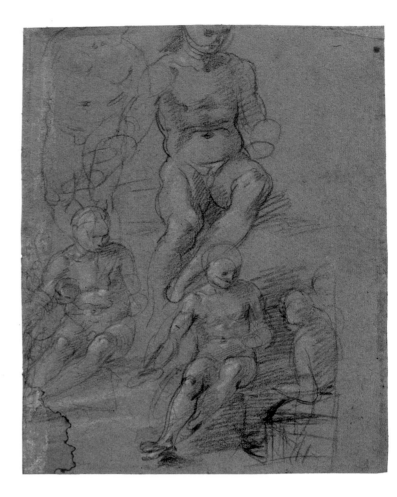

Fig. 62. *Compositional study.* Black, white, and red chalk on blue paper, 21.3 x 16.9 cm. Gabinetto Disegni e Stampe degli Uffizi, Florence, inv. 11555 F. recto

Fig. 63. *Nude figure studies.* Red and black chalk heightened with white on blue paper, 24.7 x 19.5 cm. Kupferstichkabinett, Staatliche Museen zu Berlin, inv. KdZ 20526 (4451) verso

felt any discomfort; and, by slightly turning them here and there, they would find their most comfortable attitude. In this way, he experimented in finding the most natural and least affected movements of the figure, and he would make his sketches from these."[58] Exactly such a process is evident in Barocci's studies for the Virgin. Having established her contrapposto pose, with the upper body facing right and the lower body turned to the left, he proceeded to explore the position of her legs, first having them slightly apart, then crossed right over left (fig. 63), finally settling on a left-over-right pose, as in cat. 7.2. In this elegant drawing, Barocci made effective use of the yellow paper as a midtone for the hatched shadows and white chalk highlights. He did not bother to develop the left forearm, knowing that it would be concealed by the baby. But pentimenti in the figure's right hand (pointing at a black chalk squiggle that must stand for the cat) and in the

feet reveal that he still remained uncertain of these elements (areas that he continued to modify even when he came to paint the picture).[59] After settling on the Virgin's quite complex, but pictorially pleasing pose, he then proceeded to study the fall of the drapery over her outstretched legs; at least three such studies survive.[60] In each of these, the arrangement of the drapery is slightly different as Barocci adjusted it to his satisfaction.

Several chalk studies for the two children survive. A sheet in the Uffizi contains studies of the Baptist's head and left arm and right armpit, along with passages of drapery.[61] Another sheet in the Uffizi contains a quick black chalk sketch for the raised right arm, the bird denoted cursorily with only a few rapid loops.[62] In a beautiful drawing in three chalks in Berlin, Barocci studied this arm again in more detail, also sketching the Baptist's right hand, holding a more detailed animal now recogniz-

able as a bird.[63] At least one study for his legs survives.[64]

Barocci worked extremely hard to achieve the beautiful, tender expressions of the four protagonists in the picture. He probably prepared individual studies in colored chalks for all the heads, but only those for the Virgin and Christ Child are extant.[65] There are at least three studies for the head of the Virgin.[66] Among the most ethereal of all Barocci's head studies is a sheet from Windsor (cat. 7.3), which appears at once sublimely idealized and remarkably lifelike.[67] It is conceivable that the head was a life study of a young *garzone*.[68] From this, Barocci made an intermediate study that focuses more on the variations in the pink and white skin tones of the face and, given the redrawn eyes, the specific angle and placement of the head as well.[69] He must have made this study with the other one at hand, for they are identical in scale and fractionally larger than

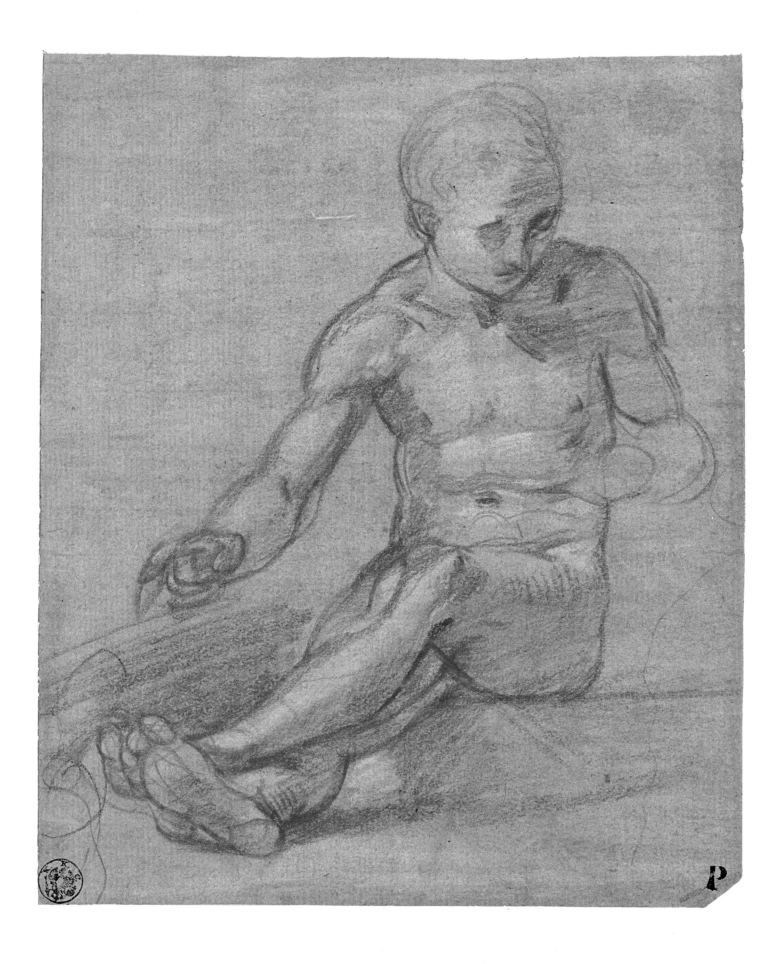

CAT. 7.2. *Study for the Virgin.* Red and white chalk with some black chalk on yellow paper, 7⁹⁄₁₆ x 6¼ in. (19.2 x 15.9 cm).
Kupferstichkabinett, Staatliche Museen zu Berlin, inv. KdZ 20140 (4156)

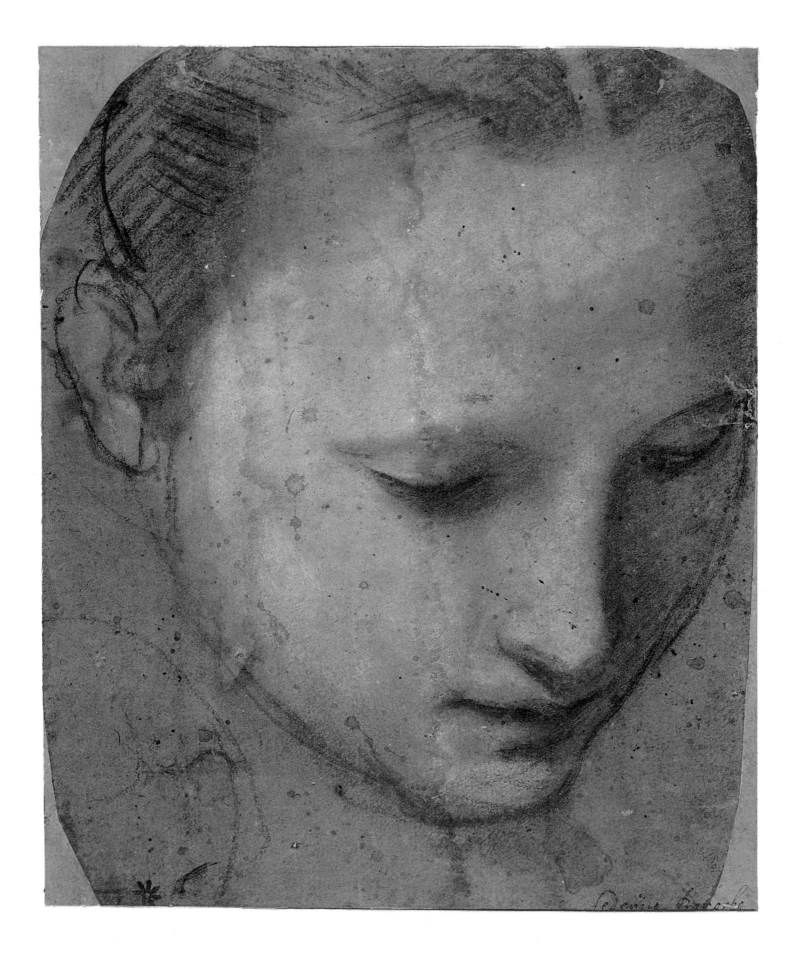

CAT. 7.3. *Study for the Virgin's head.* Black, red, and white chalk on faded blue paper, 8¾ x 7¼ in. (22.2 x 18.4 cm).
The Royal Collection, Windsor Castle, inv. 5230

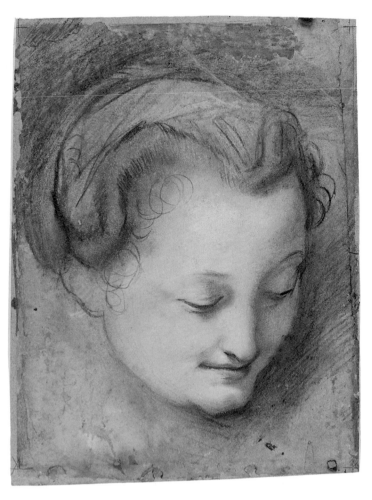

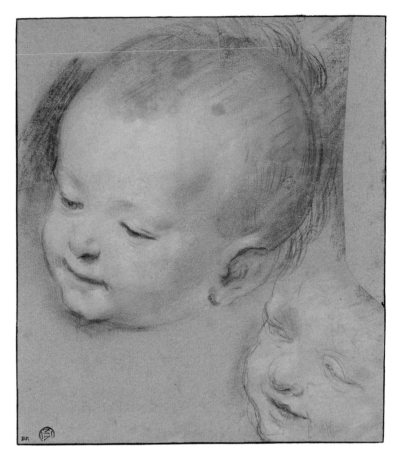

CAT. 7.4. *Study for the Virgin's head.* Black, red, and white chalk and pink, ocher, and brown pastel with stump on blue paper, reinforced with blue paper, and laid down on board, 13¹⁵⁄₁₆ x 9⅝ in. (35.4 x 24.4 cm). Smith College Museum of Art, Northampton, MA, inv. 1960:99

CAT. 7.5. *Studies for Christ's head.* Black, red, and white chalk on blue paper, 10⁹⁄₁₆ x 9¹⁄₁₆ in. (26.8 x 23 cm). Musée du Louvre, Département des Arts Graphiques, Paris, inv. 2869

the Virgin's head in the painting. In this second drawing, Barocci expanded the far cheek according to the slight pentimento in cat. 7.3 and continued to define the square chin and to explore the exact relation of the tip of the nose to the corner of the mouth, thus slightly altering the angle of the head's rotation. A final, much more finished and individualized study in chalk and pastel is in the Smith College Museum of Art (cat. 7.4).[70] Interestingly, this is the only study that is the same size as the head in the painting. In contrast to the Windsor drawing, this one gives the appearance of having been made from life (the plumpness beneath the jaw and the square dimpled chin might suggest a slightly mature life model), but it was almost certainly developed from the previous studies without reference to a model; its verisimilitude derives from the degree of detail (curls added to the

hairline) and subtle gradation of color (as many as six different colored chalks were used). This is the only drawing in which the subject is truly smiling, as in the finished work. Although Barocci maintained the expression of the Smith study in the painting, he reverted to a face more akin to the Uffizi study, softening the overemphasized jaw and chin.

The Louvre has a very beautiful sheet containing two studies for the head of the child, probably made from life (cat. 7.5).[71] The subsidiary study shows the model chuckling with his mouth and eyes open, an expression relevant for the Baptist, while the main study shows him looking down and smiling pacifically, as Christ does in the painting. Like the Windsor and Uffizi head studies for the Virgin, this one is slightly larger than the finished painting, suggesting that, in contrast to his

altarpiece commissions, Barocci did not feel the need to use scale drawings as auxiliary cartoons when he was working on small-scale domestic commissions.[72]

Barocci probably made further detail studies that have not survived. Nicholas Penny, for example, suggested that he might have made a drawing of the Urbinate architecture in the background, and perhaps a still-life sketch of the workbasket in the foreground.[73] However, there is only a single extant still-life sketch for the instruments of the Passion in the *Entombment,* and the earliest architectural studies that survive are much later. Penny also suggested that Barocci made—or at least used—studies of a cat, though none survives in the alert pose of the feline here.[74]

Barocci paid minute attention to one more feature: the Virgin's hand pointing to the cat,

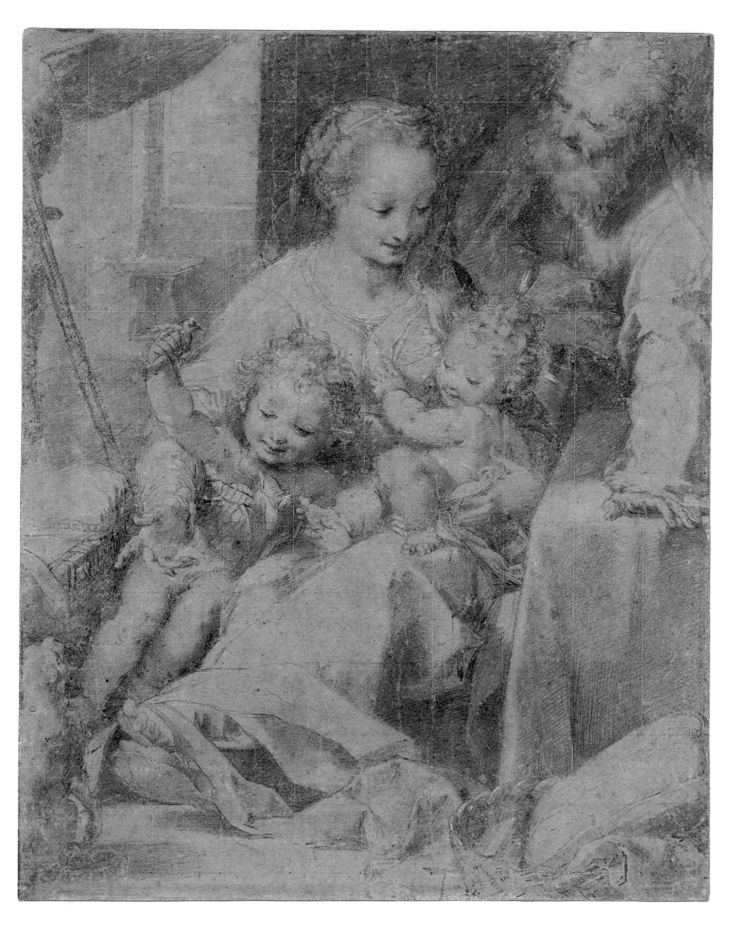

CAT. 7.6. *Compositional study for Cornelis Cort's Madonna del Gatto print* (recto). Black and red chalk, heightened with white, some outlines incised, squared by incision. [Verso: Three studies for the Virgin's right hand. Red chalk], 12¹⁄₁₆ x 9⁷⁄₁₆ in. (30.6 x 23.9 cm). The British Museum, London, inv. 1994,0514.55

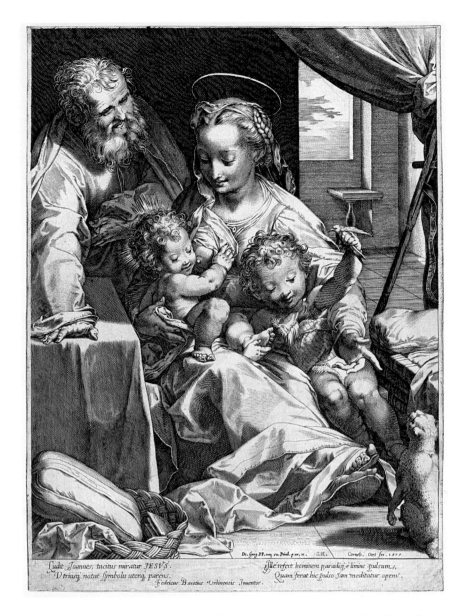

CAT. 7.7. Cornelis Cort after Barocci, *La Madonna del Gatto, State II*, 1577. Engraving, 13³⁄₁₆ x 9¹¹⁄₁₆ in. (33.4 x 24.5 cm).
Inscribed at bottom: "Di. Greg. PP.xiij ex Privil.p. an. X. Corneli. Cort fec. 1577." Inscribed in lower margin:
"Ludit Joannes, tacitus miratur JESVS. / Utriusq notat symbolj uterq parens, / Ille refert hominem paradisj e limine pulsum, /
Quam ferat hic pulso jam meditatur opem. / Fedricus Barotius Urbinensis Inventor." The British Museum, London, inv. V,8.159

for which there are studies on four sheets.[75] The gesture began life as a pointing index finger with the other fingers closed. He made several detail drawings at this stage but in subsequent studies began to unfurl the other fingers, ending up painting the hand with the palm open. In a drawing in the Uffizi, with six different studies for the hand similar to the final position, Barocci narrowed his focus even more to perfect the position of the thumb. The large number of studies for the Virgin's hand (at least eleven on four sheets) underscores the importance of her gesture for the picture's interpretation.

Only one drawing remains to be discussed: a subtle *ricordo* in the British Museum (cat. 7.6), drawn on the back of a sheet of two red chalk sketches for the Virgin's pointing finger. Barocci made the *ricordo* as a model for Cort (1533–1578).[76] It was long thought to be a copy, but, despite its abraded condition, its quality is such that scholars now rightly consider it autograph.[77] Barocci had probably made a similar model drawing for Cort after a version of the *Rest on the Return from Egypt*, from which the printmaker produced a beautiful engraving in the same orientation as the picture, dated 1575 (see cat. 4). Cort engraved the *Madonna del*

Gatto (this time in reverse) in 1577, providing a *terminus ante quem* for the painting's completion (cat. 7.7). These are the only two paintings by Barocci that Cort engraved, their association being curtailed by his death in 1578. It is not known how or even whether the two came into direct contact. Cort was active in Venice (1565–66 and probably 1571–72), where he stayed in Titian's house and produced a dozen engravings after his paintings. Otherwise, from 1567 until his death, Cort lived mainly in Rome, where he worked with—among others— Barocci's friends the Zuccaro brothers and Girolamo Muziano. Although Cort may have

traveled through Urbino, it is more likely that Barocci sent this drawing, and perhaps a comparable one for the *Rest,* to Cort in Rome, where the two engravings were published. Despite being such a fine printmaker, Cort is known to have relied on others to provide him with drawings of the paintings he engraved—he was allegedly incapable of copying from the originals himself—and Barocci's drawing falls exactly into this category.[78] It has been suggested that because Count Brancaleoni owned both these *scherzi* by Barocci, he may have played some part in having them engraved.[79] However, if the engraving of the *Rest* was in fact not made after the Piobbico picture (fig. 52), but after an earlier version, as argued by Mann in cat. 4, then the prints could have been made at the suggestion of Duke Francesco Maria—a keen collector of prints—as records of Barocci's charming designs that had left Urbino.[80] Cort's engravings are the first prints made after Barocci's pictures; their success, as well perhaps as their limitations, may have inspired Barocci to try his own hand at printmaking, which he did with great originality in four examples, all probably datable to 1581–84 (cats. 5.8, 9.8–9.9, 11.2, and 13.2).

Carol Plazzotta

NOTES

1 Bellori used the term *scherzo* for diverting vignettes in two other paintings by Barocci: the girl feeding cherries to the jay in the *Martyrdom of Saint Vitalis,* and the cat suckling her newborn kittens in the *Madonna della Gatta* (Bellori 1672 [1976], 190 and 204; on the term, see Baldinucci 1681–1728 [1846], 3, 408–9, and Colantuono 2002, 252–54).
2 Reynolds 1798, 3, 178.
3 Bellori 1672 (1976), 203: "And because the invention [of the *Rest on the Return*] was popular, he made several other versions, one of which he painted in gouache, with life-size figures, which was sent by Count Antonio Brancaleoni to the *pieve* of his castle at Piobbico. For this gentleman he painted another *scherzo,* the Virgin seated in a room with the Child to her breast, to whom she points out a Cat, about to spring at a Swallow tied by a string and held aloft by the Infant Saint John; behind them, Saint Joseph, supporting himself with his hand on a little table, leans forward to watch" (author's trans.). Bellori's account errs in misdescribing the bird as a swallow and as being tethered, a more conventional motif (see, e.g., Spanzotti's Madonna mentioned in n. 30 below).
4 Originally destined for Santo Stefano in Finocchieto, of which Count Antonio was patron, the altarpiece was transferred to a newly built church after the old church was destroyed by an earthquake in 1781 (Tarducci 1897 [2003], 288–91).
5 No inventories of the palace contents survive before 1729, when the Brancaleoni branch descended from Count Antonio was extinguished (see Bischi 1983, passim).
6 Documents held at the Fondation Custodia, Paris, 1990-A.25 to 1990-A.32, which will be published in more detail in my forthcoming catalogue of the sixteenth-century Tuscan and Roman paintings in the National Gallery, London.
7 The principal sources are: a contemporary manuscript account (1582) of the Brancaleoni family by Costanzo Felici, a doctor and botanist who resided at the Brancaleoni court at Piobbico (published by Bischi 1982, esp. 71); Felici's account was the basis of Sansovino's genealogy (1582, 1, 347v–348r); further information was gleaned from family papers by the local historian Don Antonio Tarducci 1897 (2003), 123–42.
8 I have calculated his birthdate from family trees recording the marriage in 1531 of his parents, Monaldo di Roberto and Pantasilea di Tancredi da Sorbello, and his own marriage in 1552 to Laura Cappello (Biblioteca Universitaria di Urbino [henceforth BUU], Fondo Antico, busta 112, fasc. 3; and Pietro Paolo Torelli, Brancaleoni papers, BUU, Fondo Antico, MS vol. Univ. 157, 2, pl. II). In 1549, Antonio committed a murder, for which he was exiled for three years (Tarducci 1897 [2003], 123 and docs. XV–XVII); I am assuming that he would have been sixteen or seventeen at the time of the crime.
9 Felici, in Bischi 1982, 72; Sansovino 1582, 1, 347v.
10 F. Fasulo and C. Mutini, entry on Bernardo Cappello in *Dizionario biografico degli italiani* 18 (1975), 765–67.
11 Torelli, Brancaleoni papers, BUU, MS vol. Univ. 157, 47.
12 Felici, in Bischi 1982, 72, who noted that Laura had died young, in 1582.
13 Tarducci 1897 (2003), 116–22.
14 Ibid., 123–42.
15 Fini 2011, 52ff., esp. 70.
16 Felici, in Bischi 1982, 71 (repeated in Sansovino 1582, 1, 347v).
17 Fini 2011, 70–79.
18 For Brandani at Piobbico, see Luisa Fontebuoni, "Gli stucchi di Federico Brandani e il loro restauro," in *Atti* 1985, 237–83; for Damiani, see entry by B. Teodori, in *Dizionario biografico degli italiani* 32 (1982), 328–31; for the attribution to Picchi of the frescoes in the *camera greca,* see Arcangeli 1990, 108–16; and on Picchi in general, see Massimo Moretti, in Ambrosini Massari and Cellini 2005, 198–219, esp. 202–3.
19 Emiliani 1985, 1, 96, fig. 162b; Turner 2000, 55–58, 140–43; E 2008, 1, 248.
20 Tarducci 1987 (2003), 238, n. 2.
21 For affectionate letters from the duchess, see ibid., 124–28; for the coat of arms, see Fini 2011, 70.
22 Payments to Damiani are recorded by Tarducci 1897 (2003), 240; for the date, see Bischi 1982, 35 and 50–51.
23 Bischi 1982, 35 and 50–51.
24 Felici, in Bischi 1982, 72, referred to her as a "putta di bellissimo ingegno" (a highly intelligent little girl).
25 Documents referred to in n. 6.
26 Ibid; Gould 1975, 11–12.
27 Foucart-Walter and Rosenberg 1987, esp. 66–67; Zuffi 2007.
28 Natali 2003, 55–65.
29 Museo di Capodimonte, Naples, inv. Q140, Spinosa 1994–95, 2, 121–22.
30 There are only rare precedents for this subject in devotional works on a domestic scale, one example being Giovanni Martino Spanzotti's *Virgin and Child* in the Philadelphia Museum of Art, ca. 1475; Sweeny 1966, no. 242 (as studio of Cosimo Tura).
31 Friedmann 1946, 9, who also noted (p. 1) that the bird's colorful plumage made it a favorite household pet, especially with children, explaining its presence (often tethered) in many child portraits.
32 Pillsbury and Richards 1978, 107, no. 77; Bury 2001, 21–22, no. 5.
33 Sansovino 1582, 1, 345v, discussed the various coats of arms of the different branches of the Brancaleoni family; engravings of these were first published in Henninges 1598, 4.2, 1408–9; reproduced in Bischi 1982, 33; and Fini 2011, 50.
34 Most of these have not been adequately photographed, but see, e.g., Bischi 1983, figs. 2, 13, 28, 30, 34; Fini 2011, 85.
35 Tarducci 1897 (2003), 128–29.
36 Ibid., 129.
37 Ibid., 129–39.
38 Gualandi 1844, 152 (2 June 1576): "I have done everything to remain in a peaceful state of mind, so that I can attend only to this [the *Madonna del Popolo*], and even though many commissions have fallen into my hands, I have refused everything in order to attend only to this" (author's trans.).
39 The most comprehensive discussion of the preparatory drawings for this composition is Penny's account, in Dunkerton, Foister, and Penny 1999, 183–92.
40 Olsen 1962, 157–59; E 2008, 1, 248–63, no. 33.
41 Five drawings from Olsen's list that Emiliani also accepted are rejected here: Rijksmuseum, inv. RP-T-1955-64, E 2008, 1, 260, no. 33.32 (for the Christ Child, but in fact for another recently discovered picture to be published by Nicholas Turner); Uffizi inv. 11475 F., E 2008, 1, 254, no. 33.14, illustrated, and Louvre inv. 2866, E 2008, 1, 254, no. 33.17 (for the Virgin's head, but both at a different angle); Uffizi inv. 11532 F., E 2008, 1, 259, no. 33.31 (for the Christ Child, but pose unrelated); Louvre inv. 2900, E 2008, 1, 259, no. 30.30, as attributed (studies for the Christ Child, here classified as copies). Four further studies added by Emiliani to Olsen's list are rejected: Arnold-Lévie collection, Munich, E 2008, 1, 250, no. 33.1; Musée des Beaux-

Arts, Dijon, inv. 1750, E 2008, 1, 263, no. 33.39, illustrated (for the Virgin's head, but the angle and lighting are incompatible); Biblioteca Ambrosiana, Milan, Codice Resta, E 2008, 1, 263, no. 33.40; Kunsthalle, Bremen, inv. 53.261, E 2008, 1, 263, no. 33.41. The following four drawings that Emiliani added to Olsen's list are accepted: Berlin inv. KdZ 20526 (4451) verso, E 2008, 1, no. 33.13, illustrated (here fig. 63); British Museum, recto and verso (cat. 7.6); Christie's, London, 13 October 1969, E 2008, 1, 251, no. 33.5, illustrated. One drawing not included by either Olsen or Emiliani is: Uffizi inv. 11555 F. verso, E 2008, 1, 234, 26.18, illustrated. Two more are in the Staatliche Galerie Dessau. Two others that may be workshop copies are the study of a cat's hind leg mentioned in n. 74, and a study for the Baptist's legs in Ambrosiana, Milan, inv. F. 268 inf. n. 20.

42 I thank Babette Bohn for this observation.

43 Uffizi inv. 1412 E. recto, E 2008, 1, 250, no. 33.3, illustrated.

44 Uffizi inv. 11542 F., E 2008, 1, 251, no. 33.6.

45 Christie's, London, 13 October 1969, E 2008, 1, 251, no. 33.5, illustrated.

46 Uffizi inv. 11463 F. recto, E 2008, 1, 251, no. 33.8, illustrated; Uffizi inv. 11453 F. recto, E 2008, 1, 252, no. 33.9; and Uffizi inv. 1419 E. recto, E 2008, 1, 251 no. 33.7, illustrated. By piecing together the fragments of a cityscape of Florence on their versos, Jeffrey Fontana (1997a) was the first to realize that these once formed part of a single sheet. He argued that the style of the drawings on both recto and verso were earlier in date than the *Madonna del Gatto* and linked the cityscape to a putative trip to Florence that Barocci is said to have made in the 1550s, removing the recto drawings from the group of preparatory drawings. Because there are so many links between the Virgin and Child sketches and the other preparatory drawings for the *Madonna del Gatto,* it is preferable to assume that Barocci took up an old sheet, conceivably dismembering it himself. This chronology better explains the presence of an acknowledged (even by Fontana) red-chalk sketch of the Baptist in the *Madonna del Gatto* on the verso of Uffizi inv. 11564 F.

47 Uffizi inv. 11564 F. recto, E 2008, 1, 251, no. 33.4; the verso, E 2008, 1, 262, 33.38, has a quick sketch of the Baptist in red chalk that contains the seeds of his final pose, but with his legs reversed.

48 Uffizi inv. 11477 F. recto (cat. 7.1), E 2008, 1, 250, no. 33.2.

49 Urbino inv. 1674 verso, E 2008, 1, 258, no. 33.23, illustrated, though wrongly captioned as 33.4. We can tell these two studies were made at this moment, for they are the last time the Virgin appears with her legs to the right rather than to the left, as in the painting.

50 E 2008, 1, 122–41, esp. 137.

51 See Lingo 2008, 229–30.

52 Berlin inv. KdZ 20526 (4451) verso, E 2008, 1, 254, no. 33.13, illustrated.

53 Uffizi inv. 11555 F. recto, E 2008, 1, 252, 33.10, illustrated.

54 Uffizi inv. 11555 F. verso, E 2008, 1, 234, no. 26.18, illustrated; Berlin inv. KdZ 20526 (4451) verso, E 2008, 1, 254, no. 33.13, illustrated (here fig. 63); and Berlin inv. KdZ 20519 (4413), E 2008, 1, 258, no. 33.25, illustrated. Barocci may have adapted the figure of Joseph in this pose from a life drawing in Pesaro, inv. 647 recto, E 2008, 1, 281, no. 34.24, illustrated, which closely relates to Berlin inv. KdZ 20519. However, the Pesaro drawing is in reverse, and thus lit from the opposite side and therefore cannot conclusively be said to be for this composition.

55 Bellori (see n. 3) was clearly struck by this feature, describing Joseph's pose accurately and succinctly.

56 Urbino inv. 1675 verso and recto, E 2008, 1, 260–62, nos. 33.35–33.36, illustrated.

57 In sequence: Urbino inv. 1674 verso, E 2008, 1, 258, 33.23 illustrated, but wrongly captioned 33.24; Uffizi inv. 11555 F. verso, E 2008, 1, 234, no. 26.18, illustrated; Berlin inv. KdZ 20526 (4451) verso, E 2008, 1, 254, no. 33.13, illustrated (here fig. 63); Urbino inv. 1674 recto, E 2008, 1, 258, no. 33.24; and Berlin inv. KdZ 20140 (4156), E 2008, 1, 254, no. 33.12, illustrated.

58 Bellori 1672 (1976), 205; Bellori 1672 (2000), 190.

59 Gould 1975, 11.

60 In sequence: Urbino inv. 1674 recto, E 2008, 1, 258, no. 33.24; Berlin inv. KdZ 20525 (3777), E 2008, 1, 257, no. 33.19; and Berlin inv. KdZ 20524 (4399), E 2008, 1, 257, no. 33.20, illustrated.

61 Uffizi inv. 11519 F., E 2008, 1, 260, no. 33.34, illustrated.

62 Uffizi inv. 11593 F., E 2008, 1, 259, no. 33.27, illustrated.

63 Berlin inv. KdZ 20518 (4244), E 2008, 1, 259, no. 33.28.

64 Urbino inv. 1682, E 2008, 1, 260, no. 33.33. A red-chalk drawing in the Ambrosiana, Milan, inv. F. 268 inf. n. 20, is probably a copy after Barocci. I am grateful to Judith Mann and Babette Bohn for their comments on this drawing.

65 The study for the head of Saint Joseph, E 2008, 1, 250, no. 33.1, is not accepted here.

66 Several more have been accepted in the literature in the past (see n. 41), but, because Barocci established the angle of the Virgin's head early in the design process, they are excluded here.

67 E 2008, 1, 254, 33.15, illustrated.

68 For this plausible suggestion, I am grateful to Babette Bohn, who points to similar practice among drawings for the *Deposition* (cat. 3).

69 Uffizi inv. 9319 S., E 2008, 1, 254, no. 33.16, illustrated.

70 E 2008, 1, 255–56, no. 33.18; see Sievers 2000.

71 E 2008, 1, 259–60, no. 33.29, illustrated.

72 Marciari and Verstegen 2008.

73 Dunkerton, Foister, and Penny 1999, 189.

74 A number of cat studies by Barocci survive, some for the *Annunciation* (see, e.g., cat. 9.2). The tabby model in several of these seems to be the same as the cat in the *Madonna del Gatto* (see Penny, in Dunkerton, Foister, and Penny 1999, 189–92)—perhaps Barocci's own. On Barocci's fondness for cats, see Foucart-Walter and Rosenberg 1987, 11 and 66. Gary Walters published a very rough black-chalk drawing of the hind leg and paw of a cat, perhaps attributable to Barocci (Berlin inv. KdZ 20153 [4345]; Walters 1978, fig. 81). It resembles the hind leg of the cat in the painting, but at a slightly different angle and in reverse.

75 Cat. 7.6 verso, Turner 1999, 1, 219, no. 343; Uffizi inv. 11583 F., E 2008, 1, 257, no. 33.21; Uffizi inv. 11593 F. recto, E 2008, 1, 259, no. 33.27, illustrated; and Uffizi inv. 11635 F. verso, E 2008, 1, 257, no. 33.22, illustrated.

76 E 2008, 1, 252–53, no. 33.11; Nicholas Penny and John Gere jointly suggested that Barocci made the drawing for Cort to engrave (note in the National Gallery dossier, dated 1991).

77 Dunkerton, Foister, and Penny 1999, 187; Turner 1999, 219–20, no. 343; Bury 2001, 22, cat. 6.

78 Bury 2001, 13, quoted a letter sent to Giulio Clovio in 1570, in which the humanist, poet, and artist Dominicus Lampsonius observed, "God has not given [Cort] the gift of knowing how to copy from the originals so as to produce works of the fine quality required."

79 Bury 2001, 21–22, cat. 5.

80 Gronau 1936, 261–62; Bury 2001, 45, 96, 213, 219–20.

Provenance: Painted for Count Antonio II Brancaleoni, Piobbico; by descent to Angela Ansidei degli Oddi, Perugia; by descent upon her death in 1671 to her daughter Maria Francesca degli Oddi Arrigucci; by 1784, Count Giulio Cesarei, Perugia; 1805, offered in Italy to the Scottish dealer James Irvine and bought through William Buchanan in March of that year by the Rev. William Holwell Carr; 1831, bequeathed by Holwell Carr to the National Gallery, London

Bibliography: Bellori 1672 (2000), 193; Baldinucci 1681–1728 (1846), 3, 408–9; Orsini 1784, 242–43; Lazzari 1800, 28; Ottley 1832, 57–58; Landseer 1834, 175–82; Smith 1860, 40; Jameson 1864, xlviii and 72; Cook 1888, 2, 328–39; Schmarsow 1909 (2010), 54–55; Holmes 1923, 124–25; Gronau 1936, 261–62; Bierens de Haan 1948, 64–65, no. 44; Popham and Wilde 1949, 190, no. 95; Olsen 1955, 123–25; Olsen 1962, 61–62 and 157–59, no. 26; Gould 1975, 11–12; Bertelà 1975, no. 13 and 40–41 under no. 29; Emiliani 1975, 91–93, nos. 63–68; Walters 1978, 81–84, fig. 81; Pillsbury and Richards 1978, 52–53, no. 28, and 107, no. 77; Emiliani 1985, 1, 93–103; Heise and Ziesche 1986, 65; Halasa 1993, 91–92, fig. 12; Griswold and Wolk-Simon 1994, 55, under no. 21; Fontana 1997a; Dunkerton, Foister, and Penny 1999, 183–92; Emiliani, in Borea and Gasparri 2000, 2, 262; Turner 2000, 56–58 and 140–43; Sievers 2000; Bury 2001, 45, 96, 213, 219–20, nos. 5–6; Py and Viatte 2001, 85, no. 227; Mahon, Pulini, and Sgarbi 2003, 106; Scrase 2006, 106–13, nos. 28–31; Ekserdjian 2007, 146–47; E 2008, 1, 248–63, no. 33; Lingo 2008, 158 and 169; Marciari and Verstegen 2008, 294–96, 314; Ortenzi 2009, 386–87, no. 112; Gillgren 2011, 246–47, no. 14.

Entombment of Christ

Barocci's *Entombment,* the high altarpiece for the Chiesa della Croce in Senigallia, represents one of the outstanding achievements of the artist's career. Among his most popular paintings, it displays his mastery of color and composition and represents one of his most effective visualizations of scripture. Barocci adapted a subject usually presented in a horizontal format into a vertical composition suitable for an altarpiece. The unusually diverse group of drawings for this painting raises many questions fundamental to our consideration of the artist regarding influences from earlier art, his proclivity for repetitions and reversals, and the question of whether he used *cartoncini per i colori* in designing paintings.

The altarpiece was commissioned by the Confraternita del Santissimo Sacramento e della Croce for their church in the seaside town of Senigallia, thirty miles east of Urbino. This confraternity was probably founded in about 1498, but there are no records of the membership before 1515. The confraternity's first seat was in the church of Santa Maria Maddalena; indeed, early documents refer to confraternity members as *gli padre di Santa Maria Maddalena* (the fathers of Saint Mary Magdalen).[1] About 1520, the company built the church of Santa Maria dello Sportone, outside Senigallia's city walls, retaining ownership of their chapel and sacristy in Santa Maria Maddalena until 1591. By 14 August 1564, however, finding the location inconvenient, they moved to an oratory near the cathedral, the site of the present church. In 1575, they began building a new church on this site.[2]

On 3 February 1578, the confraternity assigned to Mastro Filippo, master of intaglio, the decoration of the high altar, with a design focusing on their cross-and-chalice insignia framed in wood. On 1 June of that year, however, they rejected his work and resolved to commission an altarpiece from Barocci.[3] The artist first set his fee at six hundred *scudi,* a sum far beyond the confraternity's means. After some negotiations, the price was reduced to three hundred *scudi,* payable in three installments. The altarpiece was ordered on 2 July

1579, probably allowing Barocci two years for completion.[4] He received the first of several extensions in June 1581 and finished the altarpiece by May 1582, when it was carried to the church on the shoulders of sixteen men.[5] Barocci furnished drawings for the ornamentation surrounding the picture and recommended a framemaker. In a letter of 9 January 1582, he specified his preference for a gilded frame and asserted the importance of lighting, explaining, "because if pictures don't have light, they never show what they are."[6] Barocci personally supervised the installation of the altarpiece; its placement was evidently important to him.

The painting suffered from its own success. Many artists copied it, using oiled paper held against its surface to obtain tracings. Bellori recounted one careless copyist who "ruined the paint."[7] Further atrocities wrought by mice gnawing and urinating on the back of the picture had been manifest already by late 1587. In a letter of 23 January 1588, Barocci agreed to repair the work, proposing a personal visit to assess damages when he traveled to Loreto.[8] In 1607–8, Barocci took the painting back into his workshop and completely repainted it, using his original drawings. A letter of 2 June 1607 expressed Barocci's distress about the extent of the damage, which was also reflected by his high fee for the restoration—a hundred and fifty *scudi,* half the amount he had received for painting it in the first place.[9] While Barocci restored the painting, the church was expanded to provide a more suitable space for the altarpiece. On 20 April 1608, Barocci wrote to inform the confraternity that the restoration was complete, and on 4 May the painting was returned to the newly refurbished church.[10]

It is unclear what relationship, if any, exists between the ensemble of gilded architrave, Corinthian columns, and flanking angels currently surrounding the picture and the frame that the artist envisioned. Although Harald Olsen speculated that Barocci collaborated with Giovanni Matteo Pozzi, the framemaker he had recommended, the confraternity assigned the task to one "Mastro Pasqualino." Confraternity documents confirm that Barocci

supplied drawings for the design of the frame, which was executed between January and June of 1581,[11] although no extant drawings record Barocci's contribution.[12]

Barocci's *Entombment* focuses on the body of Christ carried by Saint John the Evangelist on the left and Nicodemus on the right. Joseph of Arimathea, wearing a turban and dressed in beautiful *cangiante* fabric, helps support Christ's shoulders. In the background on the left, the Virgin, wearing a brilliant blue cape, is comforted by a female companion, while a third woman gives vent to her grief by burying her head in a strip of fluttering white cloth. A fence and gate separate the foreground from the distant landscape, which includes the illuminated facade of the ducal palace in Urbino. Beyond, atop a hill, the three crosses appear, silhouetted against a sunset sky. At the right side and closest to the viewer, Mary Magdalen kneels in prayer. Beside her, at the opening of the rock-cut tomb, a worker wipes the inside of the sarcophagus in preparation for its coming occupant. On the ground to the left lies the stone that will close the chamber. Upon it are arrayed several implements related to Christ's Crucifixion: the three nails that secured his body to the cross; the hammer that pounded the nails; pincers that aided in removing them; the Crown of Thorns; and a vessel for ointment topped by a linen cloth. In the entry to the cave, above the worker's back, Barocci inscribed his name, his city, and the year 1582.

Matthew, Mark, Luke, and John all describe the transmission of Christ's body from Golgotha to the tomb. Barocci followed John's Gospel:

> Joseph of Arimathea, being a disciple of Jesus, but secretly for fear of the Jews, asked of Pilate that he might take away Jesus's body. Pilate gave him permission. He came therefore and took away his body. Nicodemus, who at first came to Jesus by night, also came bringing a mixture of myrrh and aloes, about a hundred pounds. So they took Jesus's body, and bound it in linen cloths with the spices, as the custom of the Jews is to bury. Now

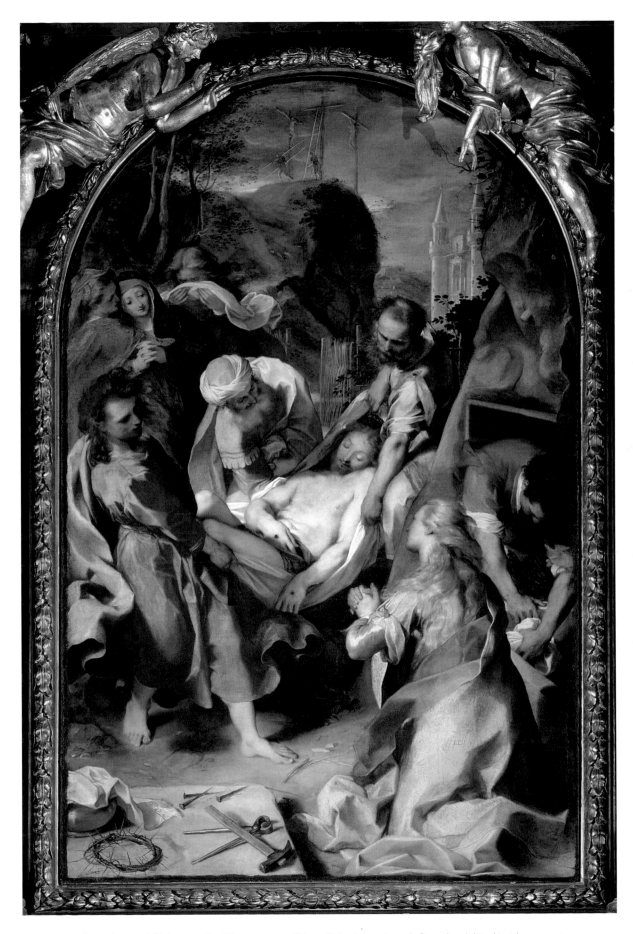

CAT. 8. *Entombment of Christ*, 1579–82. Oil on canvas, 116⅛ x 73⅝ in. (295 x 187 cm). Signed and dated inside cave entrance: "ꜰᴇᴅᴇʀɪᴄᴠꜱ ʙᴀʀᴏᴄɪᴠꜱ / ᴠʀʙɪɴᴀꜱ ꜰ. ᴍᴅʟxxxɪɪ." Chiesa della Croce, Senigallia

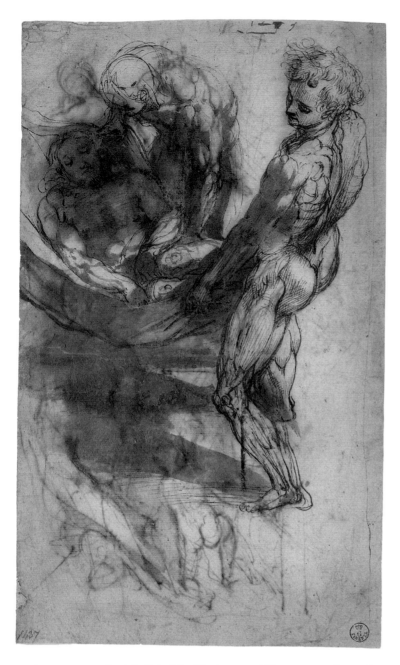

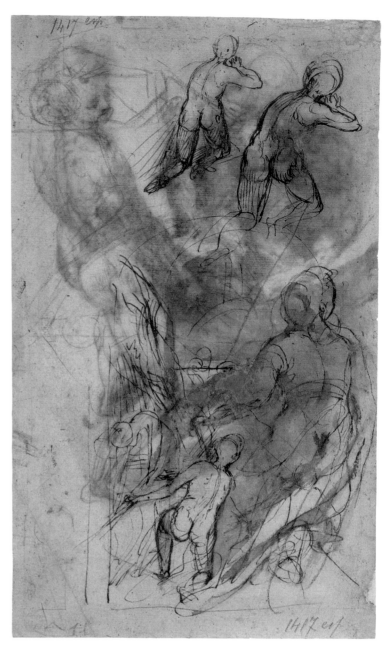

CAT. 8.4 RECTO. *Study for Saint John, Nicodemus, and Christ in reverse.* Pen and brown ink with brown wash and one stroke of black chalk, 10¾ x 6⁵⁄₁₆ in. (27.3 x 16.1 cm). Gabinetto Disegni e Stampe degli Uffizi, Florence, inv. 1417 E.

CAT. 8.4 VERSO. *Studies for the Magdalen in reverse.* Pen and brown ink with brown wash and some black chalk, 10¾ x 6⁵⁄₁₆ in. (27.3 x 16.1 cm). Gabinetto Disegni e Stampe degli Uffizi, Florence, inv. 1417 E.

Although two quick studies have survived for the men carrying ladders in the background, below the three crosses,[67] there are few drawings for either the mourner to the right of the Virgin (only one sketch) or Joseph of Arimathea (only two), suggesting that other drawings originally existed for these details. The most important extant drawing for Joseph is a handsome head study (cat. 8.7). Probably drawn from life late in Barocci's process, this study in chalk and pastel shows a range of finish characteristic of his head studies in these media.

Whereas he drew the moustache, nose, cheeks, and eyes in some detail, the upper head (covered by a turban in the painting) and beard are more sketchily indicated. The color is unevenly applied and is concentrated principally in the same area as the light: on a narrow portion of the face between the turban and beard.

A second naturalistic head study in chalk and pastel prepared the head of Nicodemus (cat. 8.8). This wonderful drawing was made late in Barocci's design, for it conforms closely to the painting, but it is nevertheless characterized by a marked freedom of execution. Contours are loosely indicated, and the shading and coloring were applied with a sense of forceful spontaneity that dynamically expresses Barocci's creative energy. There are significant pentimenti, particularly along the forehead and cheek, and the hair is indicated quite cursorily. The drawing seems focused above all on the portrayal of expression and facial physiognomy, although the artist also attended to the naturalistic light and shadow.

Also related to Nicodemus's head is a spec-

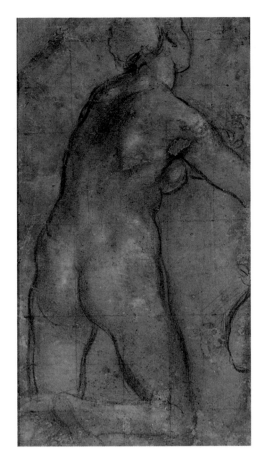

Fig. 66. *Nude study for Mary Magdalen in reverse*, ca. 1579–82. Black and white chalk, squared in black chalk, on faded blue paper, 25.2 x 14.2 cm. Galleria Nazionale delle Marche, Urbino, inv. 1655

tacular oil painting that succeeded the chalk and pastel drawing (cat. 8.9). This is one of four such heads, in oil on paper, that Barocci made for the principal figures in the *Entombment*. This full-scale head is, remarkably, painted with extraordinary freedom—remarkably in the sense that it is nevertheless detailed and corresponds precisely to the painting. Nicodemus's wispy, windblown hair, the bright patch of illumination on his forehead and rosy nose, and his deeply shadowed eyes all conform to the altarpiece. These head studies in oil, which were in all likelihood produced while the painting was already underway, demonstrate how fully and sensitively Barocci thought through every element of these key passages, enabling him to try out his lighting and color in full scale and in oil before committing these areas to the canvas.

This synthesis of free handling, sensitivity to light and color, and precise correspondence to the final painting also characterize heads in

oil on paper for Saint John (cat. 8.10) and Mary Magdalen (cat. 8.12). In both, Barocci employed incision to transfer his design to paper, presumably from earlier drawings. The study for John is a wonderful, painterly work, with a virtuoso treatment of the long, billowing locks of hair and the rich movement of light and shadow across the face. The luminous oil sketch for Mary Magdalen, the largest of these studies, which includes her upper arms and back, displays Barocci's remarkable freedom of handling and ability to blend colors and express the play of light and shadow over form. Her hair includes hints of pale blue, golden yellow, and deep brown, demonstrating his mastery of color for things other than rich fabrics and evening skies. The study includes the edge of the cavern, placed farther away from Mary's profile than in the painting. This detail shows that the artist's uncertainty over Mary's placement persisted very late in the design process.

Compared to these three oil sketches, the handsome head of Saint John in a private collection (cat. 8.11) is somewhat more tightly executed, particularly in the face and hair. Although portions of the hair and costume retain the virtuoso freedom of the other heads, the more measured execution of face and hair suggests it succeeded the head in Washington. This is one of only two known examples, both recent discoveries, in which Barocci made two oil sketches for a single head; the question of "why" naturally arises. Did he produce a second oil sketch because these works were saleable? Was the repetition dictated principally by design considerations? Because repetition is an integral part of Barocci's creative process, it would be a mistake to assume that replication precludes a role in design. Although the creative decisions for John's head were fully formulated in the Washington study, we may never know whether this second oil sketch was made as a replica, for sale to a private collector, or as a later preparatory refinement in the design of the painting.[68]

The eight head studies for the *Entombment* are the most extensive and diverse group of such works to have survived for any of Barocci's paintings. They include one fairly rough, preliminary drawing, principally in black and white chalk; a more finished study in black, red, and yellow chalk[69]; two vividly colored sheets in chalk and pastel; and four oil sketches.[70] This

large and technically diverse group was produced after the composition was reversed and confirms that Barocci finalized such details very late in his procedure. The remarkable diversity of technique and the careful study of each head (in two instances, in two separate drawings) testify to his careful attention to such particulars. Typically large in scale and characterized by a balance between freedom of execution and close attention to light, color, and expression, these works are among Barocci's most brilliant and original accomplishments.

The fascinating and complex group of more finished compositional instruments has elicited disagreement among scholars concerning either their authorship or their respective roles in Barocci's design. The largest drawing in this group is a study on brown paper from the Rijksmuseum (cat. 8.13). It has been suggested that this drawing may be the "cartoon in chiaroscuro on white paper portraying a Christ carried to the Tomb, with his mother and other figures like those in the print, but the heads all in pastels" listed among the contents of the artist's studio.[71] Although this identification is possible, the Rijksmuseum drawing is on light brown paper, not white. Sometimes wrongly termed a full-scale cartoon,[72] it is approximately half the size of the altarpiece, making it a reduced cartoon.[73] While it has sometimes been argued that this drawing was made later than the *cartoncino* in the Getty (cat. 8.14), the penultimate arrangement employed in the Amsterdam drawing—with a wider space and a larger rocky bluff that extends left, beyond the Magdalen's hands—precludes such an order of creation. The final design, with Mary Magdalen's hands extending beyond the rocky cliff, was devised subsequently, and the two compositional drawings that employ this solution must have been made after the Amsterdam drawing.[74]

These two later drawings are a sheet in the Art Institute of Chicago and the *cartoncino* from the Getty (cat. 8.14).[75] The figures' measurements in these two works correlate precisely, and Barocci presumably transferred his design directly from the Chicago sheet to the Getty *cartoncino* using

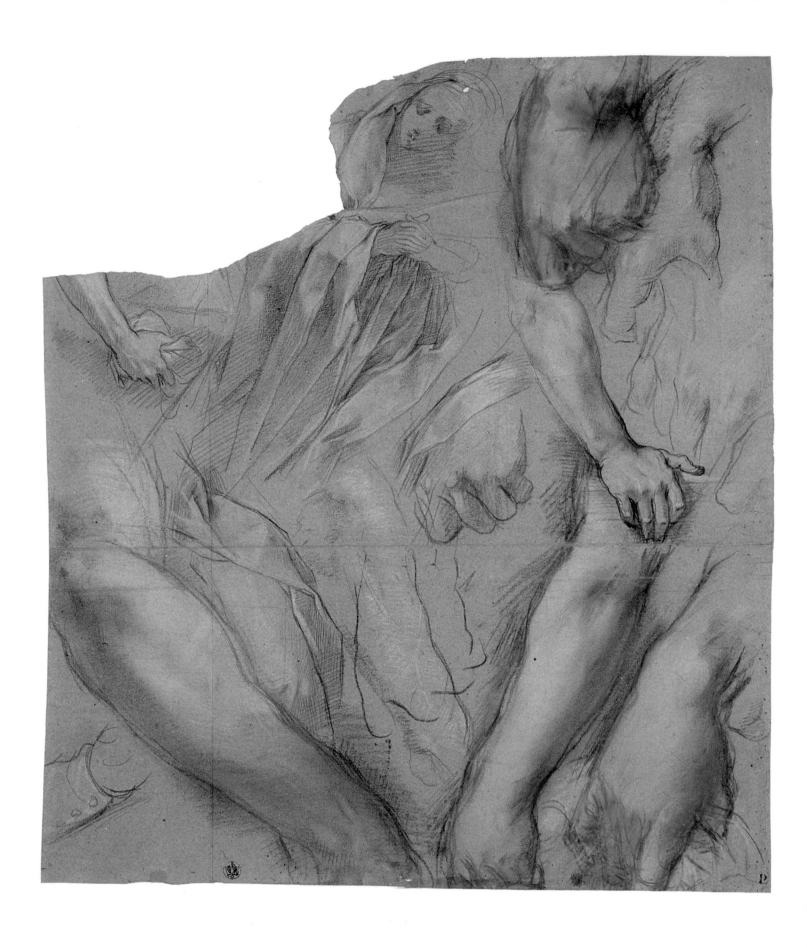

CAT. 8.5. *Studies for the Virgin and hands of Nicodemus, Saint John, and the tomb cleaner.* Black and white chalk with red and pink pastel on blue paper, 18½ x 16⅛ in. (47 x 41 cm) [irregular]. Kupferstichkabinett, Staatliche Museen zu Berlin, inv. KdZ 20361 (4267)

incision.[76] The completed portions of the Getty drawing are beautifully elaborated, with the background fully portrayed for the first time, including the trees, crosses, and ducal palace. The only missing details are the foreground still life and the details of the Magdalen, who was never completed. The unfinished portions of this figure reveal passages where the underlying design, transferred from another sheet, is still visible. It is apparent that Barocci began with the contours before adding interior details, a process that was never finalized for the saint. Also unusual is his choice of media. Instead of employing the lead-based white gouache traditionally used in Italian drawings, he relied on white oil paint after first oiling his paper, a process that has resulted in some brittleness, causing the lower-right corner to break. Aside from the study for the Magdalen, this is the most finished of all Barocci's drawings for the *Entombment;* all details of lighting, drapery, facial expression, and setting have been fully determined.

Previous authors have suggested that, after completion of all these preparatory studies in various media on paper, Barocci painted two *cartoncini per i colori,* one in a private collection (cat. 8.15), the other in Urbino (cat. 8.16). Several writers have plausibly suggested that the Urbino picture derives from the Amsterdam reduced cartoon, for their measurements correspond fairly closely. The Urbino painting may also be the picture described in the inventory of Barocci's studio as an unfinished copy.[77] Olsen considered it a copy. It was first ascribed to Barocci in 1955, and his authorship was subsequently accepted by Emiliani (in 1975, 1985, and 2008), Pillsbury (1978), Turner (2000), Lingo (2008), Marciari and Verstegen (2008), and Gillgren (2011). Notwithstanding this modern critical consensus, we are convinced that the Urbino picture is a copy after Barocci, rather than an autograph work. Such a conclusion is supported above all by the style and technique of the painting. Its atypically broad applications of paint, angular rendering of John's head, and complete absence of incision or red underdrawing are unlike Barocci's technique. Although the work was probably made by an artist in his workshop, based on the Amsterdam reduced cartoon, it cannot be by Barocci's hand, and the judgments of the inventory and Olsen must be sustained here. Given

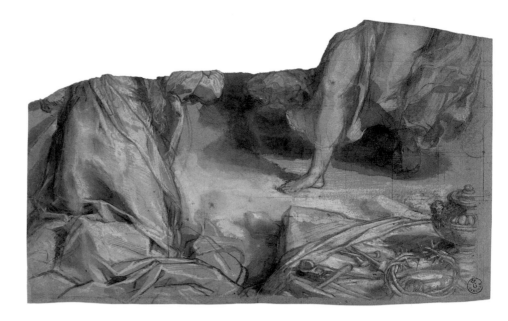

CAT. 8.6. *Still life and partial figures in reverse (fragment of a composition) (recto).* Pen and brown ink with brown wash heightened with white over black chalk, squared with black chalk, on blue paper. [Verso: Study for an arm and a figure in the Calling of Saint Andrew. Black, red, and white chalk with pink pastel, squared in black and red chalk], 10½ x 14¹¹⁄₁₆ in. (26.6 x 37.3 cm). Gabinetto Disegni e Stampe degli Uffizi, Florence, inv. 11326 F.

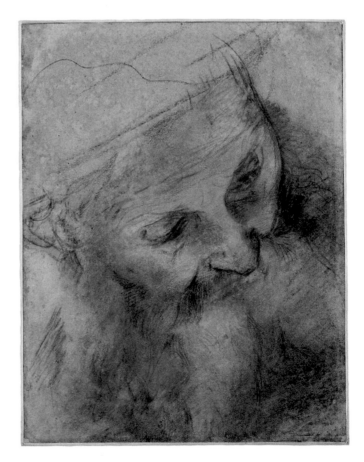

CAT. 8.7. *Head study for Joseph of Arimathea.* Black and red chalk and ocher pastel with stump, heightened with white on faded blue-green paper, 12⅜ x 9⅝ in. (31.5 x 24.4 cm). Fondation Custodia, Collection Frits Lugt, Paris, inv. 5681

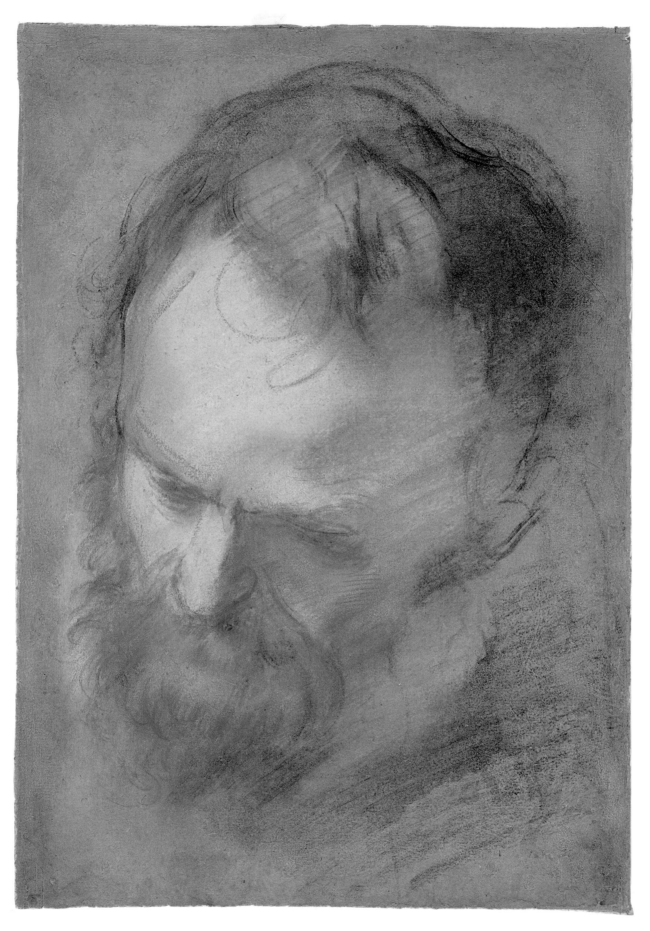

CAT. 8.8. *Head study for Nicodemus.* Black, red, and white chalk and red and ocher pastel with stump on gray paper, 14¹⁵⁄₁₆ x 10³⁄₈ in. (38 x 26.3 cm). National Gallery of Art, Washington, D.C., Woodner Collection 1991, inv. 1991.182.16

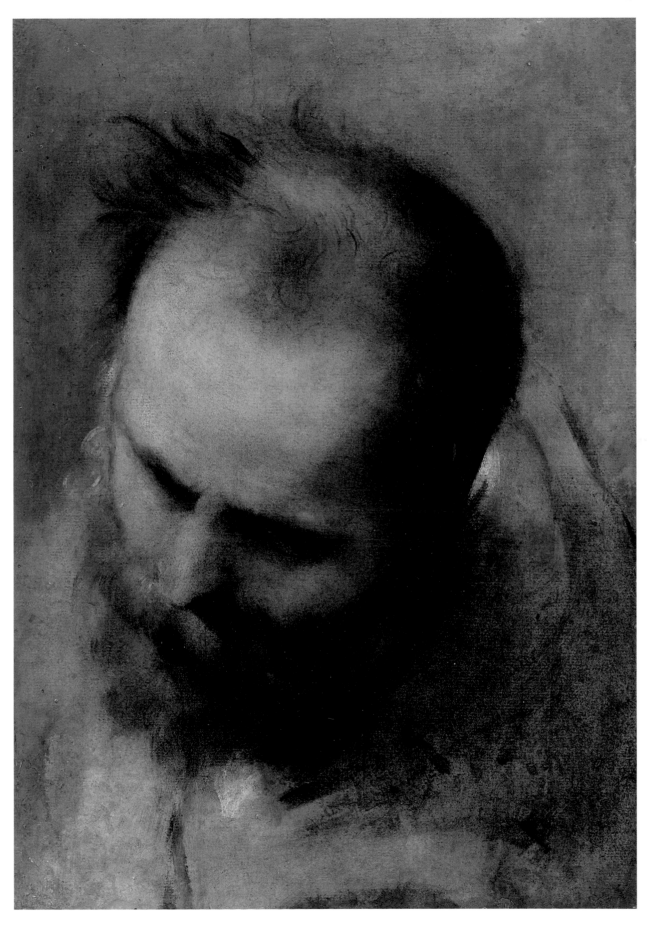

CAT. 8.9. *Head study for Nicodemus.* Oil on paper, laid down on canvas, 15¼ x 10¾ in. (38.7 x 27.3 cm).
The Metropolitan Museum of Art, New York, Harry G. Sperling Fund, 1976, inv. 1976.87.1

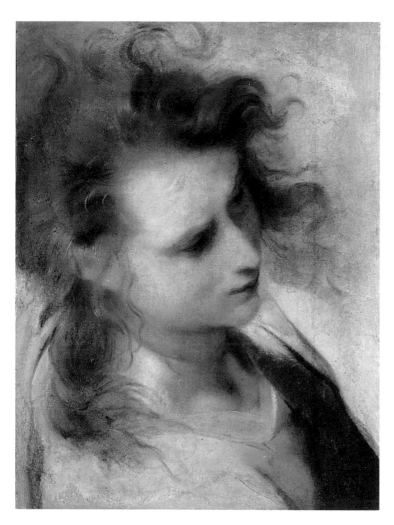

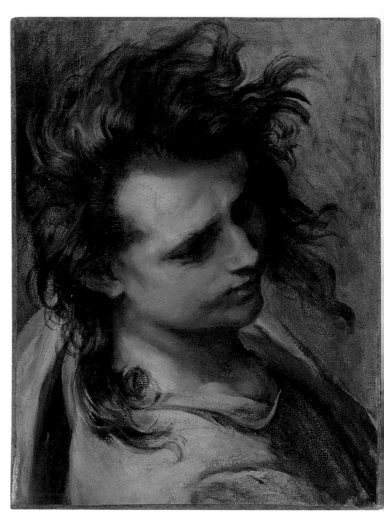

CAT. 8.10. *Head study for Saint John the Evangelist.* Oil on paper lined with linen, 16⅝ x 12⁹⁄₁₆ in. (42.2 x 31.9 cm). National Gallery of Art, Washington, D.C., Ailsa Mellon Bruce Fund 1979, inv. 1979.11.1

CAT. 8.11. *Head study for Saint John the Evangelist.* Oil over traces of black chalk on paper, laid down on canvas, 15½ x 11¾ in. (39.4 x 29.9 cm). Private collection

the great popularity of Barocci's *Entombment*—which, as noted above, resulted in damage to the picture and the need for the artist to repaint it—many painted copies must have been produced at an early date. Even in Senigallia, the confraternity received Barocci's permission to have the painting copied in 1589.[78]

In contrast to the Urbino canvas, there can be no doubt about Barocci's authorship of the private-collection painting (cat. 8.15). Beautifully executed, of consistently high quality, filled with the incision marks that are so characteristic of the artist, and featuring some of his typical red underdrawing (e.g., in the hands of Mary Magdalen), this *Entombment* is the most complex and best preserved of all the artist's small pictures. The work was originally painted in an arched format; the corners were filled in later to achieve the present rectilinear shape, as

is apparent in the small color changes in the upper corners. In most respects, it corresponds closely to the altarpiece; the most significant discrepancies include color changes to the robes of the Virgin and her companion and the generous use of lead white throughout, contributing to a somewhat pale tonality. In many areas, the private-collection picture is better preserved than the long-suffering altarpiece, and areas that have darkened in the latter—such as the striped pants of the tomb cleaner and portions of the draperies—are decidedly more legible in the smaller work.

The question arises as to when and why Barocci produced the smaller picture. One possibility, if we accept Bellori's account, is that this is a *cartoncino per i colori,* which would mean that it was made after the Getty *cartoncino per il chiaroscuro* and the (lost) full-scale

cartoon. But in the absence of further evidence, one must question whether Barocci did indeed produce such *cartoncini per i colori,* and exactly what function they served in the creative process. If we believe that Barocci finalized his color decisions in these smaller paintings, the discrepancies in the coloration of the clothing of the Virgin and her companion are perplexing.

Alternatively, Barocci may have painted the private-collection picture after completing the altarpiece, as a *ricordo* of a popular composition. If this was the case, as we suspect, it seems likely that this masterpiece of Barocci's small canvases was made not simply as a workshop record, but on commission, for sale to an illustrious patron. Although the work's early provenance is unrecorded, such an inception would explain its remarkably detailed and masterful execution, which in our view is

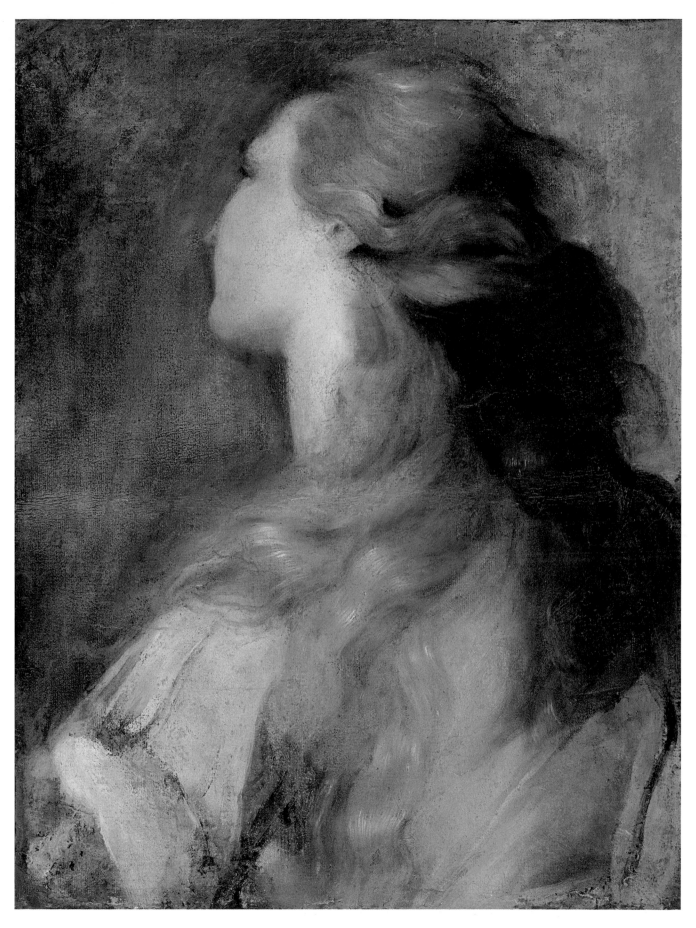

CAT. 8.12. *Head study for Mary Magdalen.* Oil on paper, laid down on canvas, 22¹³⁄₁₆ x 16¹⁵⁄₁₆ in. (58 x 43 cm).
Musée Bonnat-Helleu, Bayonne, inv. RF 1997.3

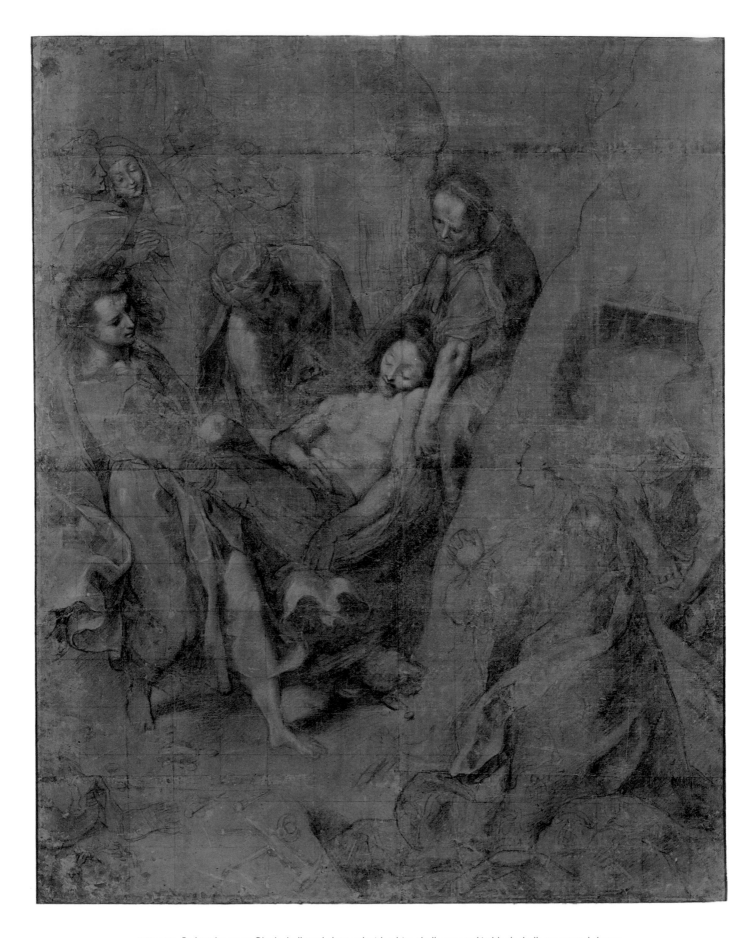

CAT. 8.13. *Reduced cartoon.* Black chalk and charcoal with white chalk, squared in black chalk, on several sheets of brown prepared paper glued together, laid down on linen, 44½ x 36⁹⁄₁₆ in. (113 x 90.4 cm). Rijksmuseum, Amsterdam, inv. RP-T-1977-137

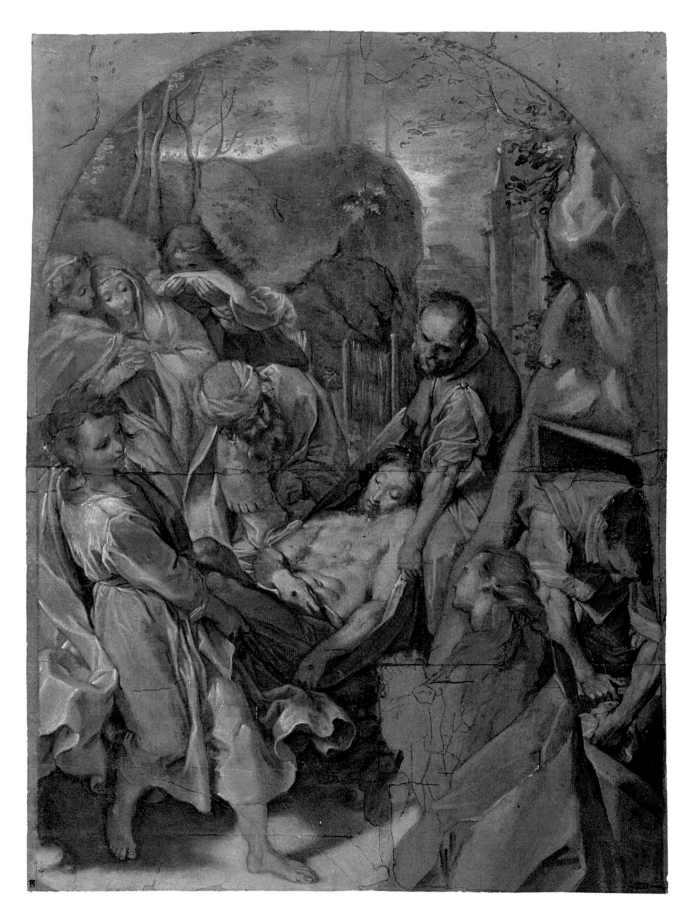

CAT. 8.14. *Cartoncino per il chiaroscuro.* Black chalk and oil on oiled paper, incised and
laid down, made up at the bottom and on the left, 18¾ x 14 in. (47.7 x 35.6 cm).
J. Paul Getty Museum, Los Angeles, inv. 85.GG.26

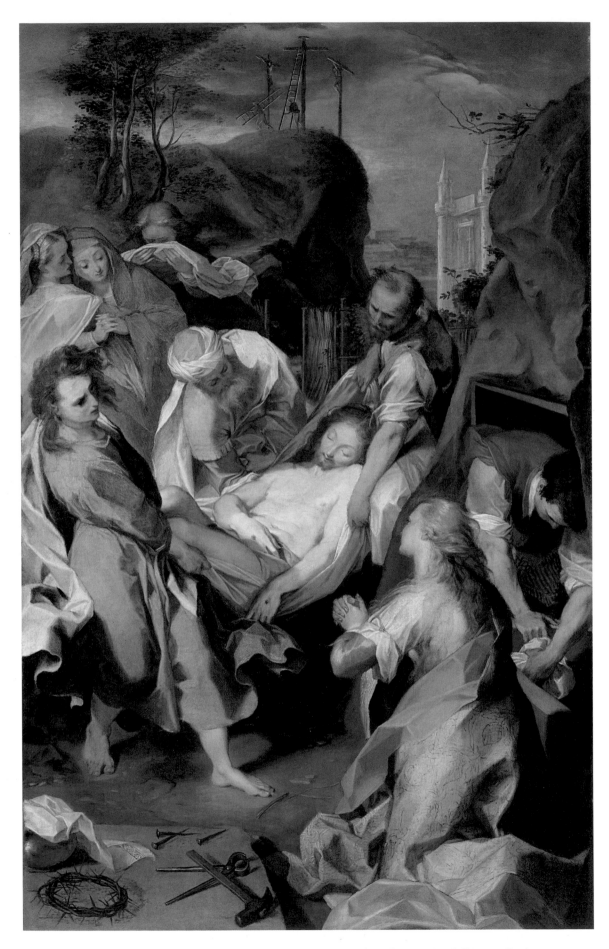

CAT. 8.15. *Entombment in reduced format.* Oil on canvas, 35⁵⁄₁₆ x 22¾ in. (89.7 x 57.8 cm). Private collection

unmatched by any of the other surviving contenders for so-called *cartoncini per i colori*. One detail, however, may supply evidence to the contrary: the use of smalt for the painting of the Virgin's blue robe. Because smalt, a far cheaper alternative to lapis lazuli, alters in tone over time, it seems less probable that it would have been used in a *ricordo* if the artist had intended it for sale.

If the private-collection picture was made in preparation for the altarpiece rather than after the conclusion of the design process, it may be the only plausible candidate for such a role.[79] It certainly seems unlikely that so elaborately finished a picture would have been made as a presentation piece for a provincial confraternity. Although we think it improbable that Barocci made these small paintings as part of his design process, the surviving evidence makes it impossible to form a secure conclusion for this one picture.

In addition to the workshop copy in the Galleria delle Marche, the *Entombment* inspired many drawn, painted, and printed copies.[80] Barocci himself supplied a drawing for one reproductive engraving. A document dated 9 July 1590, published by Bonita Cleri, records an agreement between Barocci and a Flemish merchant, Giovanni Paoletti. The notary recorded that Barocci gave Paoletti his preparatory cartoon (*cartone preparatorio*) for the *Entombment* so that Paoletti could have the engraver Giovanni Stradano make an engraving (*intaglio in rame*).[81]

Stradano's print was either never completed or is lost, but two other reproductive engravings, by Philippe Thomassin (1585–90) and Aegidius Sadeler (ca. 1595–97), were made soon afterward, and a third, by Raffaele Guidi reworking Sadeler's plate, was produced in 1774.[82] Of these prints, the one by Sadeler (fig. 67), a gifted reproductive engraver who moved to Verona from Munich in 1595, is most faithful to Barocci's original.[83] Unlike Thomassin's engraving, Sadeler's print reproduces the full composition in the same direction with the arched top and all the details of the altarpiece.[84] Sadeler dedicated his engraving to Federico Borromeo, archbishop of Milan, so the print must date after Borromeo's ascension to that position in 1595. The verses in the lower margin were composed by Flaminio Valerini, a poet from Verona, supporting D. A. Limouze's suggestion that Sadeler's print was produced there.[85]

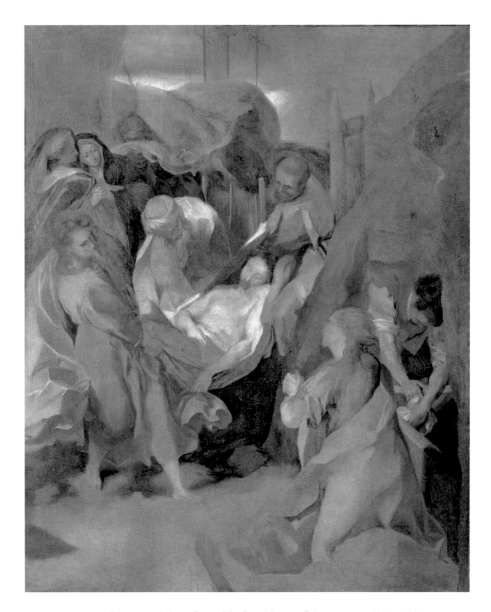

CAT. 8.16. Barocci workshop, *Copy of the Entombment*. Oil on canvas, 48 1/16 x 36 1/4 in. (122 x 92 cm). Galleria Nazionale delle Marche, Urbino, inv. 1990 DE 187

Like other reproductive engravers of his day, Sadeler presumably created his print from a detailed drawing of the composition. Olsen published a drawing (cat. 8.17) as Sadeler's study for his engraving,[86] but Dorothy Limouze rejected this attribution.[87] The measurements of print and drawing are close, but not identical; they correlate in every detail, apart from a few minor adjustments to the foliage and pose of the man carrying a ladder in the background. Whether or not Sadeler created this sheet, it must have been made for a serious collector who wanted a faithful replica of Barocci's picture, and it may well have been made with the idea of producing a print. The drawing is of the highest quality and must be the best among the

many copies of this composition, a claim supported by its illustrious provenance, in the collections of Pierre Crozat, Jean-Pierre Mariette, and Everhard Jabach. It is quite beautiful and sensitive, apart from the applications of white heightening (perhaps added later?), which lack the subtlety and finesse that are otherwise evident in the drawing.

When Barocci began painting the *Entombment,* he had just completed the *Madonna del Popolo.* That masterpiece may well have prompted the Senigallia confraternity's consideration of him for their commission. Expectations were undoubtedly high, and his creation did not disappoint; it even occasioned a rebuilding program for the church to provide a

Annunciation

The *Annunciation* was a key commission from Barocci's most important patron, Duke Francesco Maria II della Rovere. One of the artist's most influential works, created during his full maturity, in 1582–84, the painting showcases several characteristic features of his artistry: his brilliance as a colorist, his links to his native city, and his combination of traditional and original iconography.[1] Moreover, the surviving preliminary drawings for the picture illustrate some fundamental aspects of Barocci's preparatory procedures: his experimentation with pastels for varied types of drawings, his reliance on male models for female figures, his proclivity for repetition, and his close attention to poses and gestures in repeated studies of the full figure or details. All these features are particularly evident in the studies for the Virgin Mary, for whom the artist made more (surviving) drawings than for any other figure during his career. Barocci's decision to reproduce the *Annunciation* in a large-format print suggests his own satisfaction with this composition and represents a decision, unusual for him, to repeat the printed reproduction of a painted composition, a course he had first pursued with *Il Perdono* some years earlier. The last of Barocci's four prints, the *Annunciation* was also his most successful combination of the three printmaking techniques of etching, engraving, and drypoint, and it contributed to the widespread influence and popularity of the composition.

The *Annunciation* portrays the angel Gabriel's visit to the Virgin Mary to announce that she will give birth to the Son of God, despite her virginity. The archangel kneels at right, gesturing in salutation toward the Virgin and holding his traditional stalk of white lilies. As he speaks, the dove of the Holy Spirit, in a blaze of light, descends from above. Mary kneels on a prie-dieu, her eyes lowered and her left hand still holding the book she was reading; she raises her right hand in response to Gabriel's words. Meanwhile, a cat sleeps peacefully in the left foreground. Through an open window in the background, a landscape that includes the ducal palace of Urbino is visible; the rosy sky

and hazy lighting suggest that these events are taking place at dawn.

The *Annunciation* was created for the duke of Urbino's chapel in the right transept of the basilica of the Madonna di Loreto.[2] Barocci's initial payment of a hundred and fifty *scudi* was listed in Duke Francesco Maria II's account book in 1582, followed by a payment of fifty *scudi* in 1583, and a final payment of a hundred and fifty more in 1584.[3] This chronology is confirmed by a letter of 8 October 1583 from the duke to Simone Fortuna, in which the duke reported that Barocci was working on the picture.[4] A letter from the artist dated 7 October 1583 addressed his concerns about the lighting in the chapel.[5]

The basilica of the Madonna di Loreto, located southeast of Urbino in the Marches, has been a popular pilgrimage site for the cult of the Virgin Mary since the early fourteenth century. The cult derived from the claim that the Virgin's house (the Santa Casa) had been miraculously transported from Nazareth to Loreto.[6] According to legend, the Santa Casa has been in or near its present location since 1295, and pilgrims came to visit it from the late Middle Ages on.[7] The sanctuary, begun in 1469, was built over the house and attracted numerous pilgrims. Today, one can still visit the Santa Casa, which occupies a central position within the basilica.

During the mid-sixteenth century, in response to the requirements of the Counter-Reformation, the apse chapels of the basilica were modified and new chapels were added along the sides of the nave. Duke Francesco Maria's chapel was part of this later expansion. The architect is not documented, but the design is ascribed to Lattanzio Ventura, about 1572.[8] Federico Brandani was evidently the Urbinate sculptor who provided the rich sculptural reliefs.[9] The chapel walls were decorated also with frescoes by Federico Zuccaro (1582–83), whom Barocci had known earlier in Rome. Zuccaro's frescoes include the *Marriage of the Virgin*, the *Dormition of the Virgin*, the *Visitation*, the *Assumption*, and, in the vault, the *Coronation of the Virgin*, in addition to depictions of allegorical figures.[10]

During the transportation of Barocci's painting to Paris by Napoleonic troops in 1797 and its return to Italy in 1820, it suffered considerably, resulting in the ruined lower portion of the canvas and a large damaged area in the angel's gold drapery.[11] Thanks in part to two successful restoration campaigns, in 1923 and 1993–94, the painting is, however, still vividly colored and legible.

The Annunciation was a popular subject in Christian art, dating back to early Christianity; it appeared in catacomb frescoes during the third century C.E. The narrative provided the theologically crucial account of Christ's human and divine parentage. Artistic representations drew both from the sole Gospel account (Luke 1:26–38) and from apocryphal narratives that supplemented the information provided by Luke. In Luke's Gospel, God sent the angel Gabriel to visit the Virgin in Nazareth, while she was engaged to Joseph. The angel greeted her and told her that she would conceive and bear a great son whom she would name Jesus, who would reign over the house of Jacob forever. When Mary asked how this was possible, for she was a virgin, the angel explained that the Holy Spirit would come upon her, and the power of God would overshadow her, so her son would be called the Son of God. Mary accepted this charge, saying: "Here am I, the servant of the Lord; let it be with me according to your word" (Luke 1:38). Apocryphal accounts supplemented this story with details of the time (25 March, at noon or at sunrise), place (Mary's bedroom, the temple, or an enclosed garden), and other particulars. The frequent setting of the Annunciation in the Virgin's bedroom, the probable location of Barocci's scene, connects the event to the Santa Casa, Mary's home, which was believed to have been transported to Loreto.

Artistic portrayals of the Annunciation evolved considerably over the centuries. During the Middle Ages, it was typically interpreted as an intimate, quiet scene. Beginning in the sixteenth century, particularly after the Council of Trent (1545–63), the presence of celestial elements was often expanded, with the heavens

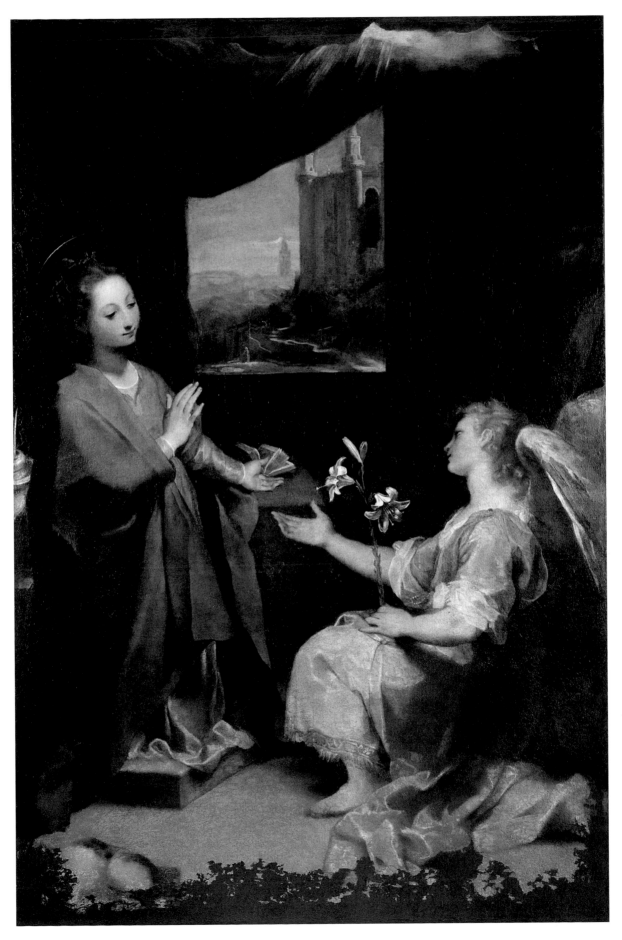

CAT. 9. *Annunciation*, 1582–84. Oil on canvas, 97⅝ × 66¹⁵⁄₁₆ in. (248 × 170 cm). Vatican Museums, Vatican City, inv. 40376

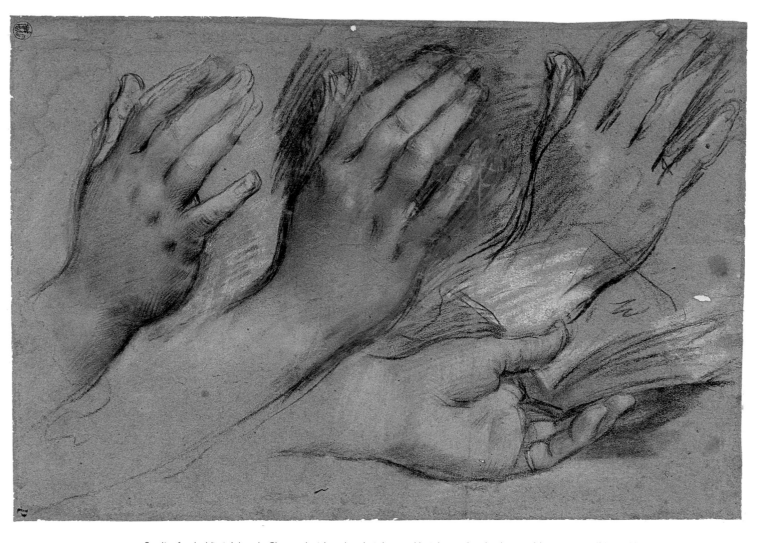

CAT. 9.5. *Studies for the Virgin's hands.* Charcoal with red and pink pastel heightened with white on blue paper, 10¹³/₁₆ x 15½ in. (27.4 x 39.4 cm). Kupferstichkabinett, Staatliche Museen zu Berlin, inv. KdZ 20453 (4190)

slightly different arrangement of the drapery.[31] Perhaps Barocci was just not concerned with the head in the sheet in fig. 69, which was probably made late in his process, after his basic drapery arrangement had been resolved.

Seven additional drawings focus on specific features of the Virgin. Three beautiful studies in the Uffizi, all in Barocci's signature media of black chalk heightened with white on blue paper, examine her drapery arrangement. Cat. 9.4 is a superb example of the artist's skill in modeling powerfully volumetric forms, using the blue of the paper as a middle tone and moving from strong darks to a somewhat lighter, hatched area, to the highlights in white, creating what may appear to a modern eye, at first glance, as an abstract geometric composition.[32]

Barocci also examined the Virgin's hands in three separate drawings, one of which is featured here (cat. 9.5). In this fascinating sheet, three studies examine the Virgin's raised right hand, and one portrays the left hand holding a book. The sequence of three right-hand studies includes a progression that is typical for the artist. Beginning with the rough sketch in charcoal at right, once the position was essentially established, Barocci spent more time on the two more finished and colored versions at center and left, both breathtaking examples of his capacity for detailed realism: they are anatomically precise, sensitively colored, and carefully modeled in light and shadow.[33]

A final detail study is one of his most beautiful and well-preserved pastel drawings: the head of the Virgin in Windsor Castle (cat. 9.6). The head corresponds precisely to that of her painted counterpart, even to the fall of light and some shadow on the right cheek. Thanks to its excellent condition, this drawing is instructive in revealing Barocci's technique. He began with rough, thick lines of black chalk around the head, employing broader, more tonal applications of black chalk for the hair, which is also adorned with orange-peach pastel to indicate a hair ribbon. The face is treated quite differently: almost completely shaded and modeled in tone, apart from black lines for the eyebrows and red and black lines for the eyes, nose, and mouth. The flesh tones are modeled in pink, red, white, and some orange-peach pastel, illustrating the artist's subtlety in employing nuances of color to create forms. The facial features stand out as the more finished part of the sheet, in contrast to the more gestural outer contours, hair, and hair ribbon. The overall effect illustrates Barocci's remarkable mastery of tonal gradations and subtle coloring. But despite its naturalistic features, the head seems too idealized to have been based on a real female model.

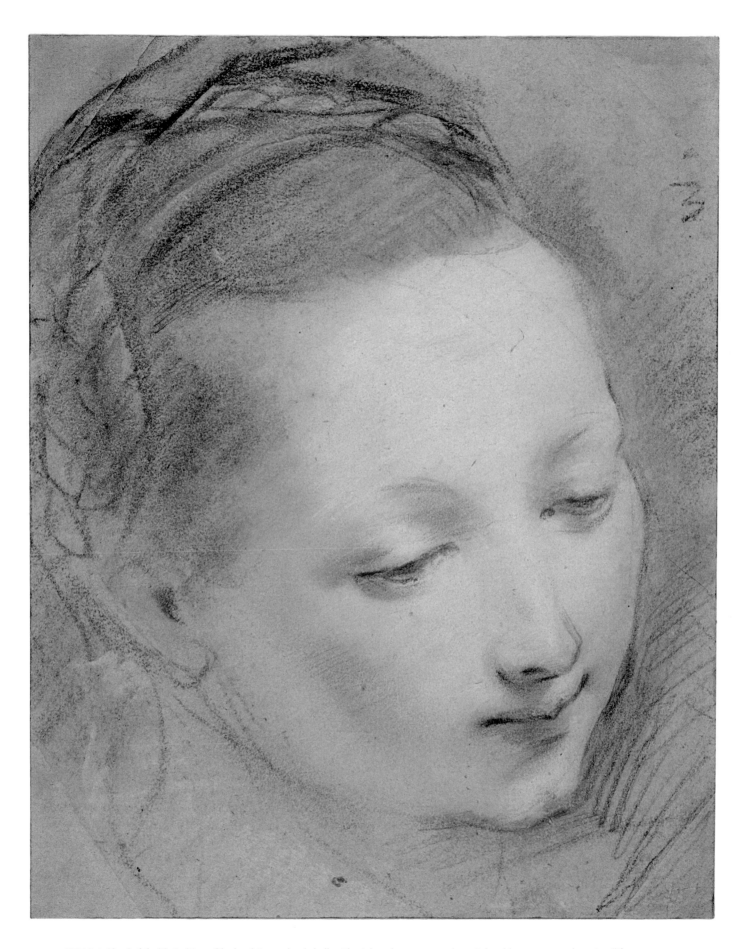

CAT. 9.6. *Head of the Virgin Mary.* Black, white, and red chalk with pink and orange-peach pastel on blue paper, made up in all four corners, laid down, 11¾ x 9¹⁄₁₆ in. (29.9 x 23 cm). The Royal Collection, Windsor Castle, inv. 5231

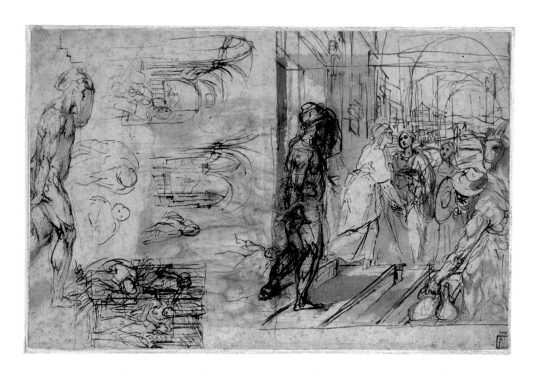

CAT. 10.2 RECTO. *Compositional studies.* Pen and brown ink with brown wash over traces of black chalk, 8¹¹⁄₁₆ x 12¹³⁄₁₆ in. (22 x 32.6 cm). Fondation Custodia, Collection Frits Lugt, Paris, inv. 5483

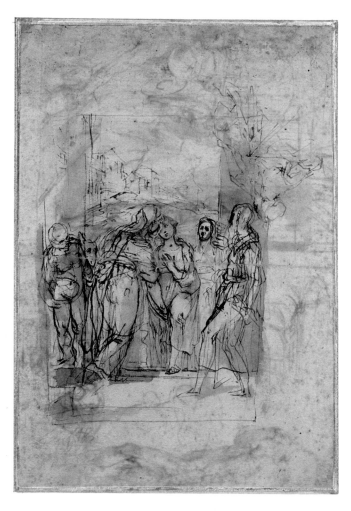

CAT. 10.2 VERSO. *Compositional studies.* Pen and brown ink with brown wash, 12¹³⁄₁₆ x 8¹¹⁄₁₆ in. (32.6 x 22 cm). Fondation Custodia, Collection Frits Lugt, Paris, inv. 5483

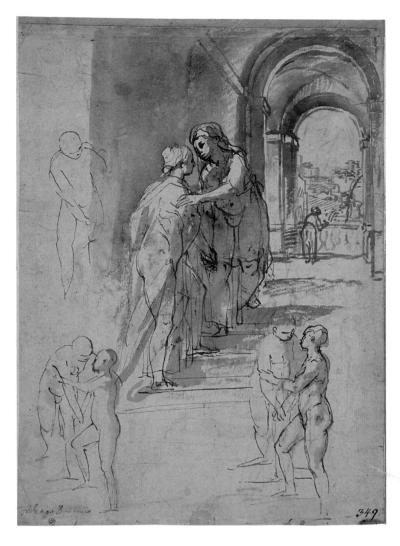

CAT. 10.3 RECTO. *Compositional studies of the Virgin and Saint Elizabeth.*
Pen and brown ink with brown wash, 11³⁄₁₆ x 8¹⁄₁₆ in. (28.4 x 20.4 cm).
Inscribed in brown ink lower left: "Federigo Barroccio."
Nationalmuseum, Stockholm, inv. NM 412/1863

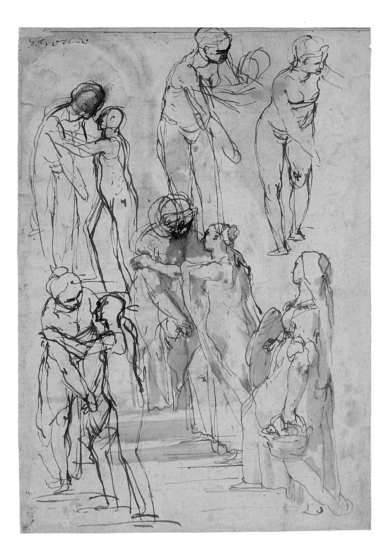

CAT. 10.3 VERSO. *Compositional studies of the Virgin and Saint Elizabeth.*
Pen and brown ink with brown wash, 11³⁄₁₆ x 8¹⁄₁₆ in. (28.4 x 20.4 cm).
Inscribed in black ink top left: "Baroche." Nationalmuseum,
Stockholm, inv. NM 413/1863

rendering of Zaccharias writing on the tablet, as pictured on the Copenhagen sheet. On the recto of the Lugt drawing, Barocci first devised the archway that became a critical element of his design in framing Saint Elizabeth. Moreover, although the positions of Zaccharias and Joseph were subsequently reversed, here he introduced something like Joseph's final pose, leaning forward away from the donkey to unload some of their possessions. Such reversals are quite typical of Barocci's creative process, and for this painting, he flipped both Joseph and the two central figures of Mary and Elizabeth, as we shall see in the next compositional drawing.

Several critical decisions were formulated in the splendid two-sided sheet in Stockholm (cat. 10.3). The archway, with its view into the distant landscape, is more articulated on the recto, although shifted over to the right rather than enhancing compositional focus behind the two embracing women. Perhaps most significantly, it was here that Barocci finally resolved the positions of Elizabeth and Mary, with Elizabeth reaching down from a higher step toward her cousin, who is pictured in profile. Beginning with Elizabeth on the right, in the principal study on the recto, Barocci began experimenting with a reversal, first in two quick sketches on the recto, then, turning the sheet over, sketching the pair three times in the reversed position and redrawing Elizabeth twice. On the verso, he also made an early study for the woman holding chickens, depicted in a pose that is surprisingly close to that in the painting.

The more finished compositional study from Edinburgh (cat. 10.4), made late in the design process, portrays all five figures in their final poses, with the architecture likewise in its final form. Although a few details are missing, such as the view of the ducal palace through the archway and the still-life elements in the left foreground, Barocci seems to have used this drawing as a template for his final design, squaring the sheet for transfer to a larger scale, presumably for the cartoon. With lavish applications of wash and white heightening, Barocci also turned his attention in this drawing to the lighting, always a consideration of paramount importance for him.

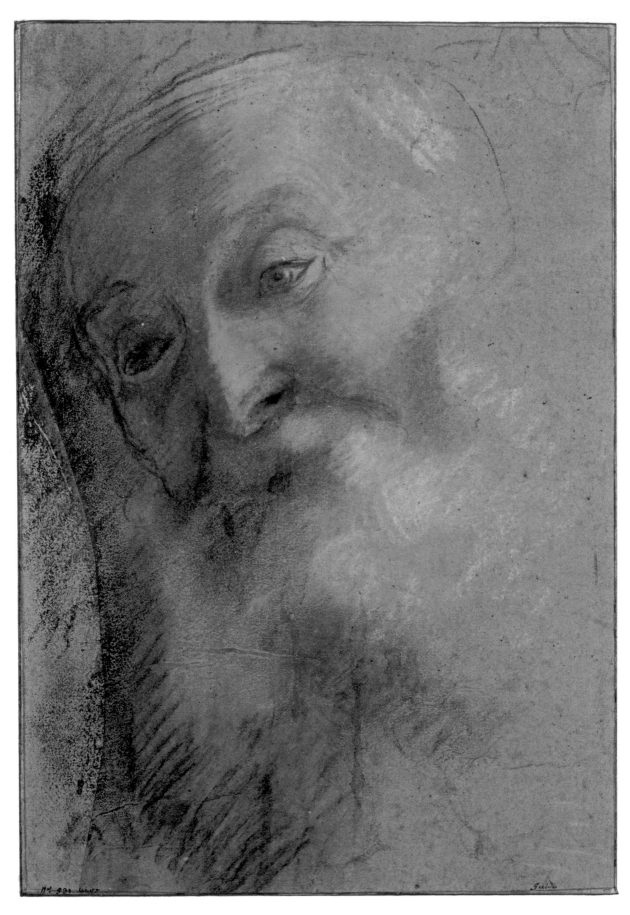

CAT. 10.8. *Study for the head of Saint Zaccharias.* Black, red, and white chalk
with peach and ocher pastel on blue-green paper, laid down, 13¹¹⁄₁₆ x 9¼ in. (34.8 x 23.5 cm).
Inscription, in brown ink lower right: "Guido." Albertina, Vienna, inv. 556

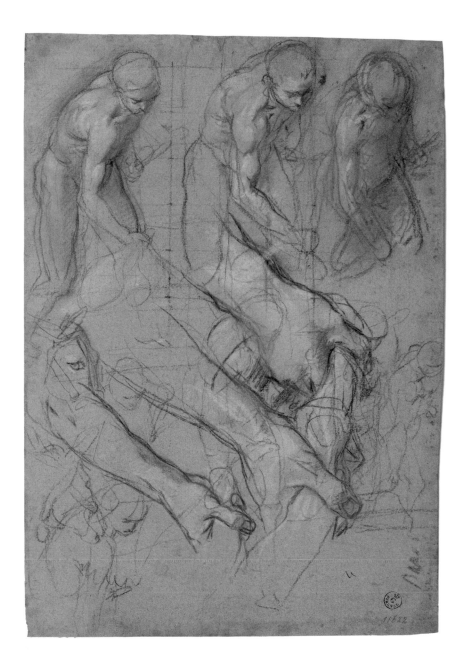

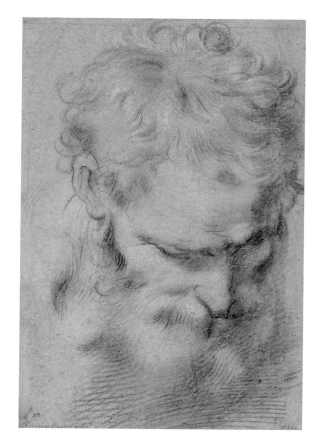

Fig. 71. Tuscan artist, copy after Barocci,
Head of Saint Joseph, after 1586. Black, red, and white chalk
with peach and ocher-yellow pastel on blue paper,
29.1 x 20.1 cm. Musée des Beaux-Arts, Lille, inv. W. 4501

LEFT: CAT. 10.9. *Studies for Saint Joseph* (recto).
Black chalk and charcoal heightened with white,
partially squared in black chalk, on blue-green paper.
[Verso: Arm and drapery studies for Saint Joseph. Black, red,
and white chalk], 15¾ x 11⅛ in. (40 x 28.3 cm). Gabinetto
Disegni e Stampe degli Uffizi, Florence, inv. 11622 F.

Albertina (cat. 10.8). Formerly attributed to Guido Reni, this sensuous, atmospheric rendering of an old man's head illustrates how much detail and naturalism Barocci's best drawings of heads achieve, without being entirely or evenly finished. Zaccharias's head and beard in particular are only roughly shaded, and even the contour of his proper right cheek and forehead was roughly sketched and revised. The greatest specificity is reserved for the eyes and nose and for the luminous, tactile, and colored treatment of the skin, exemplifying the artist's characteristic sensitivity to the play of light across surfaces.

Ten drawings for Saint Joseph are still extant, more than for any other figure in the picture, and this group is almost evenly divided between heads, hands, and full-figure studies.[42] As with the Virgin Mary and Elizabeth, Barocci's earliest, discarded ideas are recorded only in compositional studies. Probably the first of the specific studies for Joseph is a sheet in the Uffizi (cat. 10.9). The recto shows a youthful nude model, drawn three times in the final position, probably from life, with three additional renderings of the forward right arm. The verso includes a quick sketch of the same arm and a study of the sack he grasps. Two drawings in Berlin portray him in the same pose, with clothing added.[43] Characteristically, Barocci focused repeatedly on Saint Joseph's hands, particularly the right one, and his exposed right arm, which were studied in four additional drawings, one in the Uffizi and three in Berlin. Barocci drew the right arm a total of ten times, always in its final position, with no significant revisions in any of these studies. He examined the fall of light on the arm, the hand's firm grip on the white sack, the prominent forward position of the thumb, all depicted naturalistically in the painting. So much repetition cannot have been dictated solely by design explorations; it seems, rather, that Barocci was immersing himself in the forms he would later paint, assimilating the gestures into his creative repertoire.

Four drawings are connected with Joseph's head. The earliest is a quick, tiny sketch in red

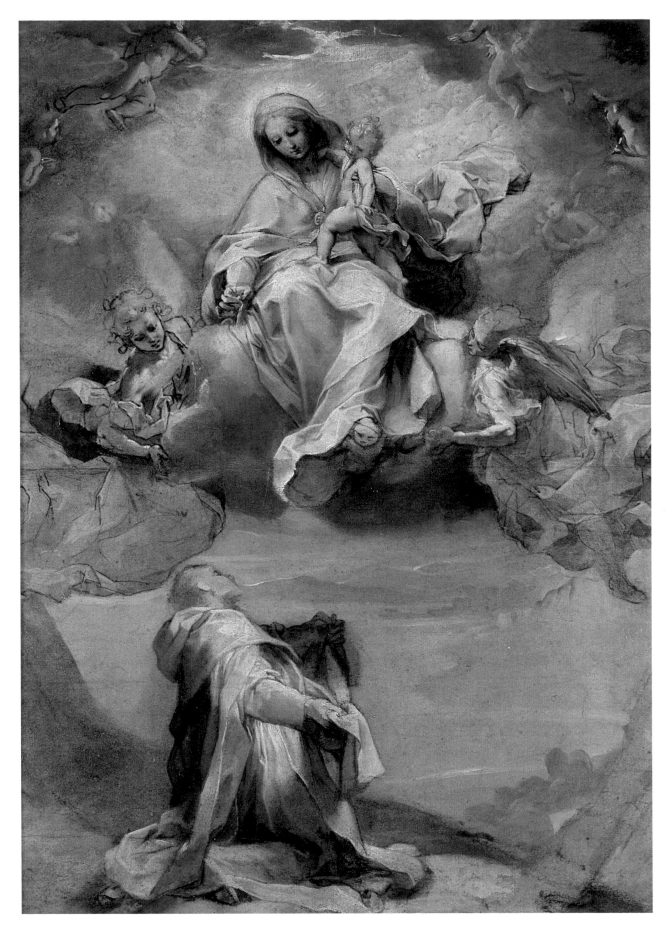

CAT. 11.7. *Cartoncino per il chiaroscuro for the Madonna of the Rosary.* Black chalk and pen and brown ink with dark brown wash, ocher and white oil, 21⁷⁄₁₆ x 15³⁄₁₆ in. (54.5 x 38.5 cm). The Ashmolean Museum of Art and Archaeology, Oxford, inv. WA1944.100

5 Anselmi 1905a, 142; Olsen 1962, 187. Pillsbury 1978, 17, n. 24, noted that the picture was delivered "probably between 1596 and 1599 when Antonio Viviani finished painting the frame," without citing a source. Camara 2002, 197, n. 106, stated the date of Viviani's commission as 1597. Anselmi 1905b, 509, who consulted the documents in the archives, cited the commission for the frame as having been given in 1598.

6 Camara 2002, 98.

7 This success was attributed to a confluence of factors. The unexpected victory took place on 7 October 1571, which happened to be the first Sunday of the month, a day on which confraternities dedicated to the rosary gathered for their monthly procession, which afforded a perfect opportunity to credit the efficacy of this form of prayer. See Camara 2002, 104–10.

8 On Alanus de Rupe, see ibid., 13–14.

9 For the reader familiar with the rosary as practiced today, it is necessary to point out that the modern form developed slowly and that, during the period under discussion, the form in which the rosary was prayed was undergoing change.

10 Quattrini 1993, 440.

11 For a reference to the Lotto painting, see n. 28. Images of the mysteries began to be incorporated in the early sixteenth century; the earliest example may have been Saturnino Gatti's altarpiece painted in 1509–11 for the Rosary Chapel in San Domenico, L'Aquila. See Camara 2002, 87.

12 Ibid., 148–49.

13 Ibid., 198–99.

14 Ibid., 198, made this observation. Camara traced Barocci's idea (p. 200) to the metaphorical wording of Pius V's papal bull, which says that Dominic "raised his eyes to heaven and to that mountain of the blessed Virgin Mary."

15 See ibid. It illustrated Andrea Gianetti de Salò's manual for rosary prayer, published in Rome in 1581. For the image, see Strauss 1982, 113, no. 76.

16 When the painting was in the church of San Rocco in the early twentieth century, it was used as a screen in front of a sculpture (although the sources do not indicate which one), causing considerable damage, for it was the custom to unveil the sculpture for particular feast days, rolling up the cover in order to expose it. See *Restauri nelle Marche* 1973, 431–33, and n. 26.

17 On the altarpiece, thought lost until its discovery by Gianni Papi in storage at the Pinacoteca di Brera, Milan, see Papi 2002. On the dating of this painting, see Mann essay, 5–6.

18 The care and attention Barocci paid to this limb is demonstrated by the fact that he drew it six times in the surviving sheets.

19 There is evidence that Barocci began with a composition similar to the British Museum drawing (cat. 11.1) when he designed one of his last altarpieces, the *Assumption of the Virgin*, which was unfinished at his death. A pen, ink, and wash drawing in the Uffizi (inv. 11486 F. recto) appears to be devoted to early concepts for this painting. The centrally placed Virgin hovers above two standing saints, one reading on the left and Saint Francis on the right. She is held aloft and brings her hands together in prayer. A second sketch shows a revised pose in which her arms have been changed to the open gesture in the oil painting (fig. 22), confirming that, in an even later altarpiece, he began with a solution similar to the one used for the Fossombrone picture.

20 Cambridge inv. PD.70-1948, Scrase 2006, 84, no. 17.

21 Based on the dated copy by Agostino Carracci (1582) and the acknowledgment that this print is not as sophisticated or technically advanced as those for *Il Perdono* and the *Annunciaton*, most scholars have dated it to around 1581. Bury 2001, 81, argued that the print served an experimental function for the artist.

22 Quattrini 1993, 441–42.

23 Ibid., 441.

24 E 2008, 2, 107.

25 See Spear, in Spear and Sohm 2010, 59, who looked at artist's fees in Rome, which gives a good idea of how Barocci's fees compared with those of other painters.

26 These observations are based on an examination of the painting by Claire Barry in April 2010.

27 Lavin 1964, 253–54; Lavin 1965.

28 Examples with Saint Catherine of Siena include a mid-sixteenth-century print by Nicolas Beatrizet (see Camara 2002, 141); Lorenzo Lotto's 1539 altarpiece (see Giovanni Carlo Federico Villa, *Lorenzo Lotto*, exh. cat., Scuderie del Quirinale, Rome [Milan, 2011], 134–35, no. 15); and Vincenzo da Pavia's 1540 altarpiece for San Domenico, Palermo (see Olsen 1965b).

29 The story is found in the thirteenth-century compilation of saints' lives, the *Golden Legend,* by Jacobus de Voragine. See Jacobus de Voragine 1993, 2, 82.

30 Pen strokes from the verso are visible on the recto, suggesting that Barocci may have worked another composition on the other side, and it is possible that the drawing relates to Saint Thomas. Because the sheet has been glued down, its verso is not visible, and thus its subject remains unknown.

31 Barocci was first asked to make that altarpiece in 1590, but the earliest evidence that work on the painting had actually begun dates to 1593; see Olsen 1962, 190. The two drapery studies on the verso of the drawing relate to Saint Anne (on the left) and the high priest (on the right). E 2008, 2, 279, no. 75, noted the sketches, incorrectly described as on the recto, as two drapery studies. See Birke and Kertész 1992, 1, 299, no. 545, illustrated.

32 Berlin inv. KdZ 20276 (4233), E 2008, 2, 116, no. 50.19.

33 Uffizi inv. 11513 F. recto, E 2008, 2, 113, no. 50.10; and Berlin inv. KdZ 20530 (4182), E 2008, 2, 115, no. 50.14.

34 The drapery studies include: Berlin inv. KdZ 20025 (4379), E 2008, 2, 116, no. 50.21; Berlin inv. KdZ 20200 (4314), E 2008, 2, 116, no. 50.22, illus-

trated; and Berlin inv. KdZ 20523 (3725), E 2008, 2, 117, no. 50.25. There are two sheets of studies for the putti in the upper portion of the *Madonna of the Rosary*: Berlin inv. KdZ 20517 (4145), E 2008, 2, 117, no. 50.29; and Urbania inv. II 164.631 recto, E 2008, 2, 116, no. 50.24. Studies for various angel limbs include: Berlin inv. KdZ 20277 (4285), E 2008, 2, 116, no. 50.19; Berlin inv. KdZ 20278 (4284), E 2008, 2, 117, no. 50.27; Berlin inv. KdZ 20279 (4366), E 2008, 2, 117, no. 50.28; Berlin inv. KdZ 20280 (4231), E 2008, 2, 116, no. 50.23, illustrated; Berlin inv. KdZ 20292 (4467), E 2008, 2, 116, no. 50.26, illustrated. The wing study is Berlin inv. KdZ 20152 (4339), E 2008, 2, 400, no. 111.21, illustrated, but not associated with a painting.

35 Berlin inv. KdZ 20528 (3751), E 2008, 2, 112–13, no. 50.7. There are two studies for the drapery of the Madonna, Berlin inv. KdZ 20183 (4316), E 2008, 2, 116, no. 50.18; and Berlin inv. KdZ 20290 (4397), E 2008, 2, 116, 50.17, which includes also two studies for her left foot.

36 An earlier stage in the development of the Madonna figure is likewise in Berlin, inv. KdZ 20498 (4183), E 2008, 2, 281, 75.4, illustrated.

37 They are: Berlin inv. KdZ 20530 (4182), E 2008, 2, 115, no. 50.14, illustrated; Uffizi inv. 11327 F. cat. 11.4; Uffizi inv. 11513 F. recto, E 2008, 2, 113, no. 50.10; Uffizi inv. 11588 F. recto, E 2008, 2, 113, no. 50.11, illustrated; Urbino inv. 1653 recto, E 2008, 2, 115, no. 50.16.

38 Uffizi inv. 11602 F. recto, E 2008, 2, 115, no. 50.13.

39 See cat. 2, for a synopsis of Lingo's discussion of this point.

Provenance: Confraternita dell'Assunta e Rosario, Senigallia; early twentieth century, moved to the church of San Rocco, Senigallia; after World War II, moved from the damaged church to the Palazzo Vescovile, Senigallia; Pinacoteca Diocesana, Senigallia

Bibliography: Bellori 1672 (1976), 180; Bellori 1672 (2000), 181; Baldinucci 1681–1728 (1974–75), 1, 337; Lanzi 1822, 2, 126; Anselmi 1905a and 1905b; Schmarsow 1909, 14, 31, 90; Schmarsow 1909 (2010), 75–78, 90; Schmarsow 1911, 11; Krommes 1912, 102, 110; Poggi 1912–13, 53; Di Pietro 1913, 95, 176; Palm 1950, 220; Olsen 1955, 69, 94, 146, 147; Lavin 1956, 436; Parker 1956, 54, no. 94; Olsen 1962, 86, 119, 186–88; Lavin 1964; Lavin 1965; Olsen 1965b; *Le dessin italien* 1973; *Restauri nelle Marche* 1973, 431–33; Emiliani 1975, nos. 192, 193, 195, 197; Pillsbury 1976, 63; Macandrew 1980, 252, no. 94; Gere, Pouncey, and Wood 1983, 39–45, no. 46; Arcangeli 1985, 103, no. 32; Emiliani 1985, vol. 2; Ekserdjian 1987, 403; Arcangeli 1988, 407–8; Black 1989, 258; Boccardo and Galassi, 1990, 32–33, no. 11; Zampetti 1990, 89; Birke and Kertész 1992–97, 1, 299; Quattrini 1993; Dunkerton, Foister, and Penny 1999, 190, 192; Turner 2000, 97–99, no. 88; Camara 2002, 196–201; Papi 2002; Nardicchi 2003, 130; Scrase 2006, no. 16; E 2008, 2, 107–17; Lingo 2008, 72–74; Lisot 2009, 189–92; Turner 2010b, 33, no. 10; Gillgren 2011, 132–34; Scrase 2011, 29–31, no. 32.

Last Supper

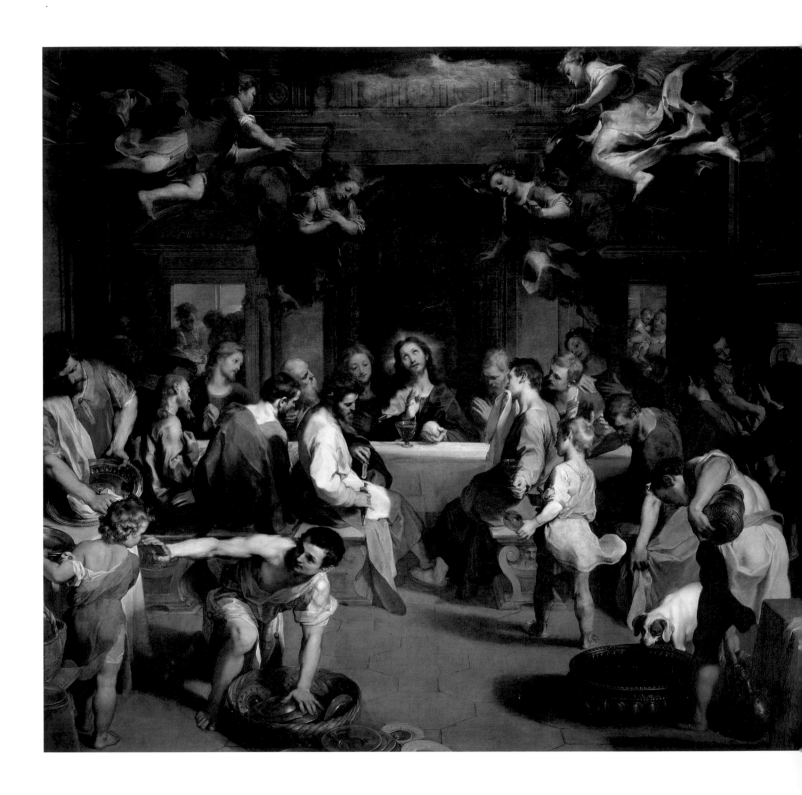

CAT. 12. *Last Supper*, 1590–99. Oil on canvas, 117¹¹/₁₆ x 126¾ in. (299 x 322 cm). Chapel of the Santissimo Sacramento, Cathedral, Urbino

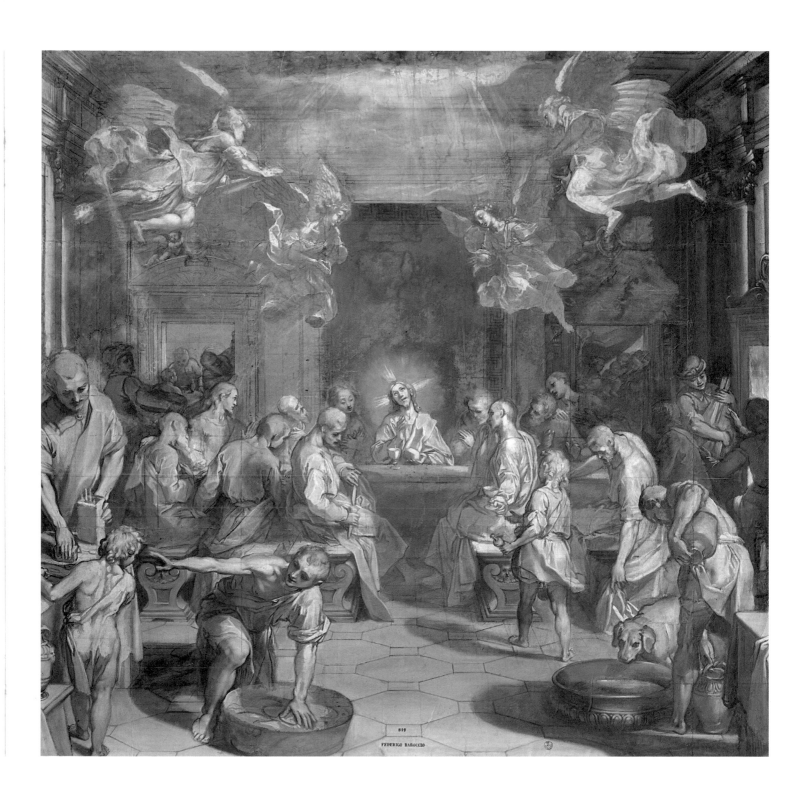

Fig. 73. *Cartoncino per il chiaroscuro for the Last Supper*. Black chalk with gray, black, ocher, and white body color, squared in black chalk, 106.5 x 109.7 cm. Inscribed (modern) in black ink lower center: "FEDERIGO BAROCCIO." Gabinetto Disegni e Stampe degli Uffizi, Florence, inv. 819 E.

Stigmatization of Saint Francis

Few subjects were of greater importance to Barocci than those concerning the devotion to Saint Francis. The saint was a subject of great currency in the late sixteenth century and one that resonated for Barocci personally. This picture, like so many in his oeuvre, reflects his years of thinking about its subject—in this case, the unique role of Saint Francis among medieval saints in his full participation in the suffering of Christ.

Choosing as his source an early-fourteenth-century account of Saint Francis called *I Fioretti* (*The Little Flowers*), rather than the more established *Life of Saint Francis* by Saint Bonaventure, Barocci offered a slightly different take on this moment of ecstatic vision and scarification. By drawing from a series of meditations published together with *I Fioretti*, he created one of the most compelling and involving images of the well-known saint. He both emphasized Francis's Christlike character—a medieval idea that enjoyed a resurgence in the late sixteenth century—and translated the textual description of the vision ("a spiritual fire") into paint. The preparatory drawings reveal how closely he adhered to the story and how he struggled to develop poses that both engaged the viewer and illustrated the disparate details of the narrative. The drawings make it clear that a decisive moment in the development of the picture was Barocci's recognition of the importance of light to the meaning of the narrative. His one other painting of the stigmatization—a version in distemper in the Pinacoteca Comunale "A Vernarecci," Fossombrone (cat. 13.1)—has been described as unrelated and much earlier. In fact, that painting, although done in preparation for a different project, was probably made shortly before the Urbino picture and reveals a key earlier stage in Barocci's thoughts about the presentation of Saint Francis's divine ordeal and the role played by the saint's companion, Brother Leo.

In a dark landscape, Saint Francis of Assisi kneels before a rocky cave, extending his arms as he addresses a heavenly apparition above. The clouds of the night sky are riven by a six-winged seraph attached to a cross and encircled in a blaze of white and yellow light. Illumination washes over the front of Saint Francis and the seated figure of Brother Leo, who raises his right arm to shield his eyes. Leo has been praying; a Bible rests on the rock in the corner, and he holds a rosary in his left hand. A bird, most likely a falcon, perches on a branch above him. A church facade with the moon reflected in its sole ocular window can be discerned between the tree and the rocky outcropping. Shepherds and sheep rest near a campfire in the intervening space. One attendant stands and gestures toward the apparition as he tries to awaken his companions.[1]

The painting was commissioned as an altarpiece for the high altar of the Capuchin church in Urbino, which was constructed in the mid-1590s and is represented in the background of the picture. The building was modeled after San Damiano in Assisi, the site of one of the early miracles in the life of Francis, when he was charged to build a following.[2] The church still stands, although considerably altered, a rectangular vertical window having replaced the original ocular one that reflects the moonlight in Barocci's painting. Duke Francesco Maria II della Rovere was the patron of the painting; his account book lists two payments for a picture for the Capuchins in February 1594 and September 1595.[3] The duke also paid for a small copy to be painted by one Morbidello in 1597; an engraving of the composition by Francesco Villamena was made that same year.[4]

The Capuchin order was still relatively young when Barocci undertook this altarpiece. At the opening of the sixteenth century, there were two main branches of the Franciscans: the Observants and the Conventuals. The Capuchin branch—an offshoot of the Observants—had its roots in the Marches and was recognized by papal bull in 1528. That Barocci should paint for the Capuchins or that the duke should support such work is hardly surprising and must be seen in the context of both Barocci's and the Della Rovere's ties to the Franciscan order. The Della Rovere, like the Montefeltro before them, supported many Franciscan churches, both in the Marches and elsewhere. Francesco Maria's father, Guidubaldo II, helped establish the Capuchins in Urbino around 1565 and assisted in the building of a church in nearby Croicchia.[5]

Barocci, too, had personal ties to the Franciscans in general as well as to the Capuchin order in particular. He produced six major paintings for Franciscan institutions and requested to be buried in the Conventual Church of San Francesco (the site of his *Il Perdono* altarpiece; see cat. 5). He created four paintings for the Capuchins. The very first one he painted, once he regained his strength after the "poisoning" episode in Rome—an ex-voto depicting the *Madonna of Saint John*, ca. 1565 (fig. 6)—was made for the Capuchins at Croicchia.[6] Giovanni Pietro Bellori related that Barocci had a small farm in Croicchia, suggesting that he may have visited the church often. The artist mentioned both the Croicchia and Urbino Capuchin churches in his will and left money so that masses could be said for his soul. However, claims first made by Harald Olsen that he became a lay member of the Capuchins are incorrect.[7] Nonetheless, his altarpiece the *Stigmatization of Saint Francis* must be seen in the context of his lifelong devotion to the saint and with the knowledge that the Capuchin order had special meaning for him.

The impressive altarpiece is marked by close adherence to the text that inspired Barocci, no doubt a suggestion from the monks themselves.[8] The subject of the stigmatization was included in Saint Francis's official biography, Saint Bonaventure's *Life of Saint Francis* of 1262, which was issued in Italian in 1477. Barocci, however, relied on a popular compilation of stories called *I Fioretti*, based on a Latin work of the fourteenth century that was likewise published in Italian in 1477, with the addition of a section of meditations on the stigmatization called *I Considerazioni*.[9] Many details in Barocci's painting are derived from the latter.

The stigmatization occurred on Mount La Verna in Tuscany, some thirty-five miles due east of Florence, where Francis spent the summer of 1224 in retreat for prayer and contemplation. He routinely experienced visions. The

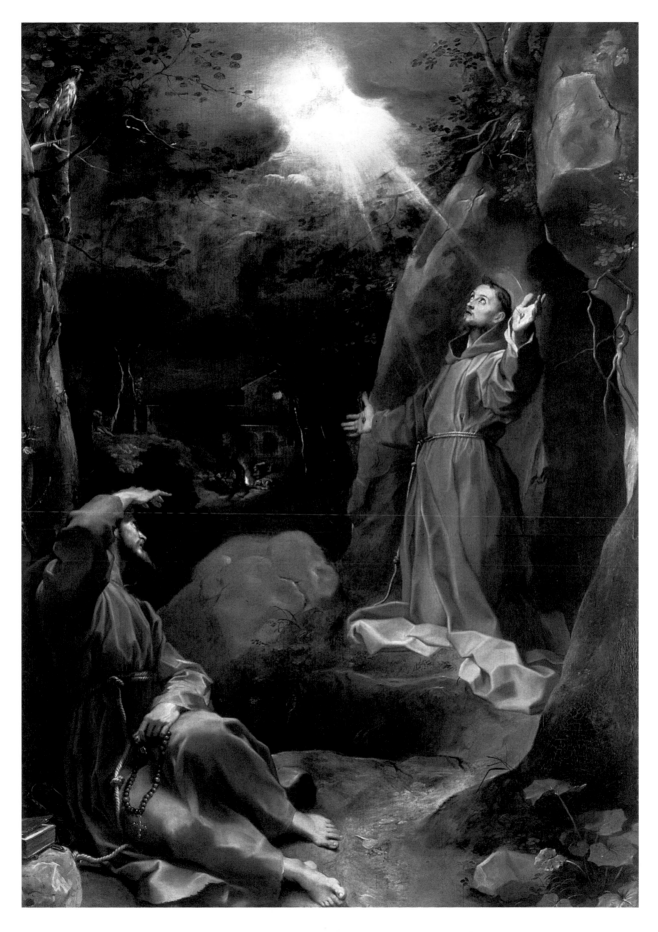

CAT. 13. *Stigmatization of Saint Francis*, 1594–95. Oil on canvas, 141¾ x 96⁷⁄₁₆ in. (360 x 245 cm).
Galleria Nazionale delle Marche, Urbino, inv. 1990 D 81

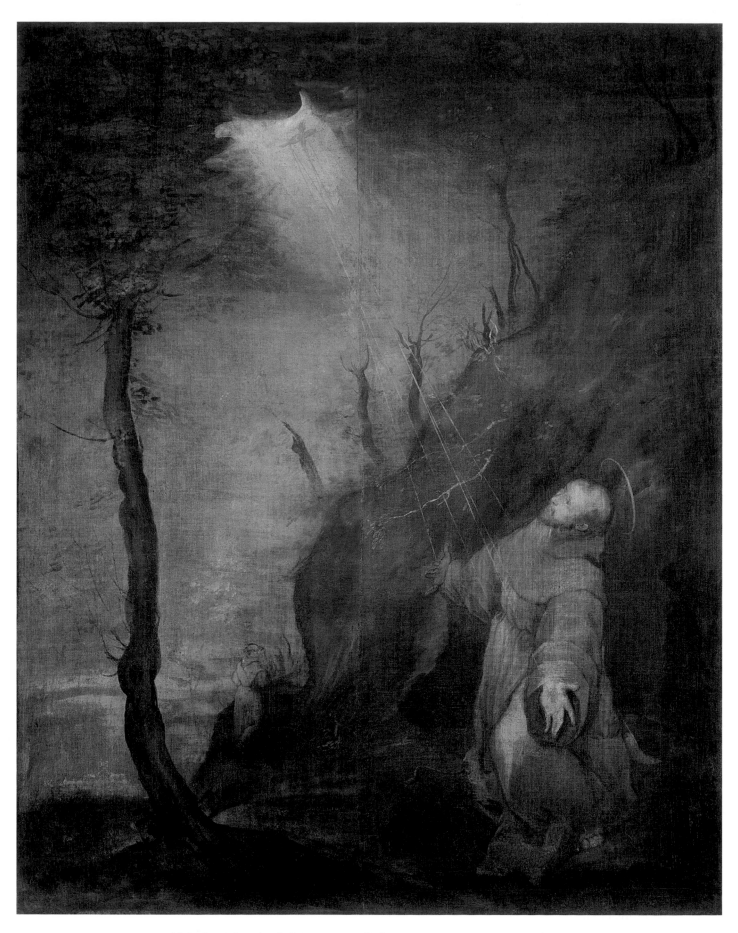

CAT. 13.1. *Saint Francis Receiving the Stigmata*, 1590s (?). Distemper on canvas, 57½ x 45¼ in. (146 x 115 cm).
Pinacoteca Comunale "A. Vernarecci," Fossombrone

The picture was probably undertaken around the same time Barocci began his Capuchin commission and offers insights into his developing ideas for interpreting this subject. Several writers, noting the technique and particularly the scant application of paint, have suggested that the Fossombrone painting was a preparatory study rather than a full-fledged painting in its own right. Most scholars have rejected, however, its possible role in the preparation of the Urbino *Stigmatization*. Lingo confirmed these doubts by noting that Francis is seen in the Conventual habit in the Fossombrone canvas, while in the Urbino version he wears the Capuchin robe with its attached hood (*cappuccio*, hence the name Capuchins).[35] The Fossombrone version, therefore, must relate to a different project.

There has been some discussion as to whether the Fossombrone picture might have been intended as a study for the clearly related etching of the *Stigmatization* (cat. 13.2).[36] There is some merit in this argument, for the etching would otherwise be the only one of Barocci's prints that is not related to a painted composition.[37] While the worn condition of the picture precludes a full understanding of its intended use, the painting appears far more monochromatic than it once was, for remnants of blue paint, perhaps azurite, are visible in the middle distance in areas that can still be read as sky.[38] There is only one example of a drawing that demonstrably prepared one of Barocci's four etchings, the pen and ink study from Budapest (cat. 9.7) that was used to prepare Barocci's *Annunciation* print; no such pen study survives for this print. However, given the very different appearance of this print when compared to the three others that Barocci produced, it is worthwhile considering whether this one was done without preparatory drawings and whether the artist treated the plate itself as a surface for exploration.[39]

The print repeats techniques Barocci used elsewhere, such as multiple bitings to create tonal variation. He first etched the design and dipped the plate in acid. Before a second biting, he covered the plate with varnish and used the etching needle to redraw parts of the plate that would become darker when dipped again. For further tone, and to provide even greater variation, he engraved parts of the figure of Saint Francis, providing a particularly rich represen-

CAT. 13.2. *Stigmatization of Saint Francis.* Etching and engraving, 9¹⁄₁₆ x 5⅞ in. (23 x 15 cm). Inscribed bottom center: "F.B.V.F." The British Museum, London, inv. V,8.182

tation. These techniques allowed Barocci to maximize the contrast between foreground and background to achieve a meaningful isolation of the saint, who experiences an inner vision of the divine. This disparity of tone also makes Brother Leo appear to be standing very deep in the background and thus removed from any participation in the event. One author described the effect as a dematerialized world contrasted with the enhanced physicality of the divinely inspired saint.[40]

Nonetheless, this etching/engraving stands apart from the artist's other printed work and demonstrates a bold attempt to give greater immediacy, even materiality, to a printed figure in terms of the sheer contrast between the pale, almost veiled background and the angled figure of the kneeling saint. Perhaps the print served as the first exploration of adapting the pose of Saint Francis from *Il Perdono* into a figure suitable for the Fossombrone composition. In that scenario, the etching almost played the role of a preparatory study, perhaps one that Barocci did not find to be entirely satisfactory. He then used distemper to create a more developed working study, in reduced format, for he

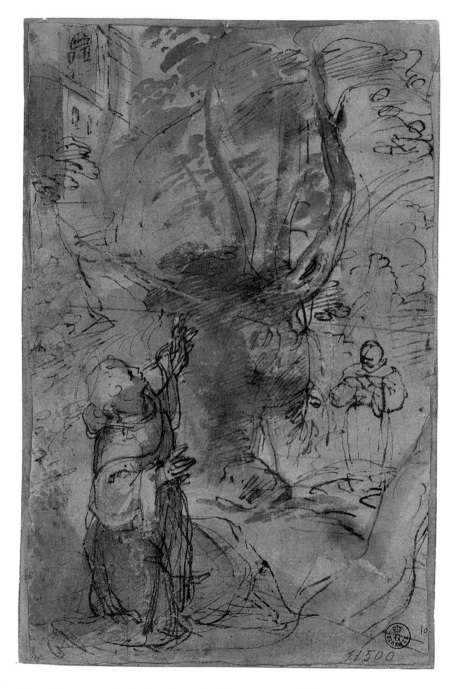

Fig. 77. *Primo pensiero for the Fossombrone Saint Francis Receiving the Stigmata.* Pen and brown ink and brown wash, partially squared in black chalk, laid down, 21.4 x 13.5 cm. Gabinetto Disegni e Stampe degli Uffizi, Florence, inv. 11500 F. recto

unusual materials. However, one advantage of working in distemper is that its fast drying time allows one to see results more quickly. Barocci may have been anxious to test a composition to which he had already devoted considerable time, although this hypothesis does not accord with his well-known slow pace of work. Therefore, without further evidence, it is difficult to ascertain his objectives in working in the relatively rare medium of distemper.

It is clear that Barocci continued to be a technical innovator at a relatively late stage in his career, in his Saint Francis print as well as in the Fossombrone painting. That work is important in that it allows us to trace the development of his thinking as he designed the Urbino altarpiece. We still have his *primo pensiero* for the Fossombrone picture (fig. 77).[44] Here, he followed the more popular disposition of the figures for the Stigmatization, with Francis placed on the left and Brother Leo on the right. In fact, a common pose for the saint showed him genuflecting, with only one knee on the ground. Based on the visible revisions he made to the legs of Saint Francis in this early compositional study, it seems that he experimented with just such a pose. No other studies survive to document his developing ideas between this drawing and the Fossombrone painting. Nonetheless, it is natural that, when designing a Stigmatization, he would initially have tried the pose from *Il Perdono.* As other writers have noted, this adaptation into the Fossombrone picture was not entirely successful. Barocci did not adjust the play of light across the saint's body to accommodate an outdoor setting.[45] However, because Barocci used a more old-fashioned (fourteenth-/early-fifteenth-century) formula with clearly defined linear rays of divine light, he may have intended the saint's torso to be unnaturalistically lit as a way of communicating the divine nature of the experience.

The Fossombrone painting seems to have been Barocci's starting point when he took up the task of designing the Capuchin altarpiece, which is demonstrated in the earliest compositional sketch for the Urbino *Stigmatization,* a fairly finished study in the British Museum (cat. 13.3).[46] Although Andrea Emiliani connected this drawing with the Fossombrone composition, it is more accurately read as a refinement that came later.[47] Because the

was still conceptualizing the final design. One element of the print that may have proven problematic is the enlarged tree behind Saint Francis. One can see the Fossombrone painting as a refinement of the print, where the artist has more successfully, and indeed beautifully, integrated the background trees into the composition.[41]

Barocci's use of distemper for the Fossombrone picture poses an additional puzzle. There are other instances where he used distemper. Bellori wrote that Barocci first painted the *Immaculate Conception* in distemper, and then, years later, repainted it in oil.[42] Furthermore, he used distemper together with oil for his largest version of the *Rest on the Return from Egypt* (fig. 52), for reasons that remain unknown.[43] His choice of distemper for this small version of the *Stigmatization,* therefore, may simply be another instance of experimenting with

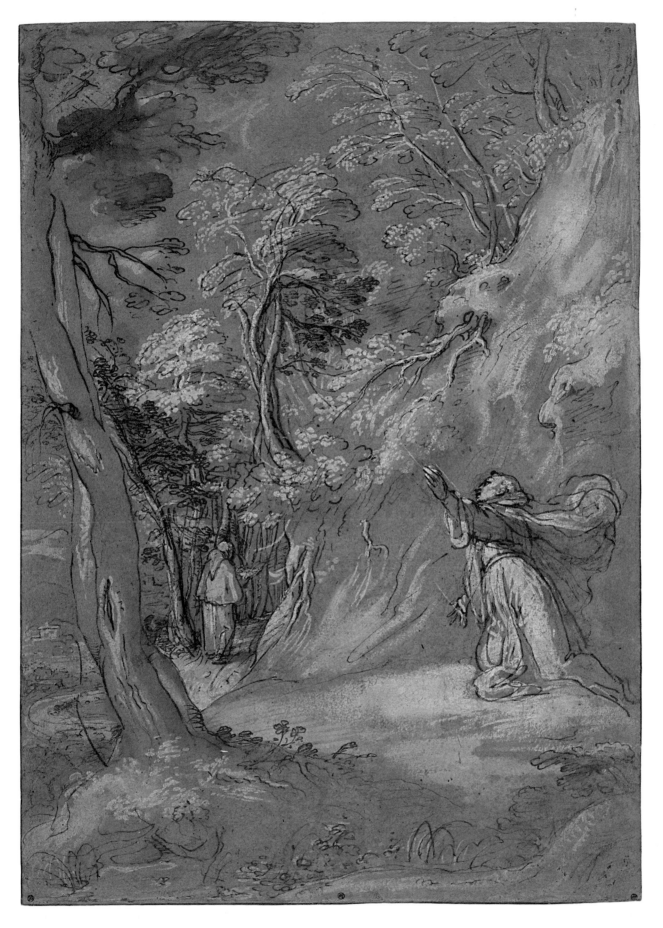

CAT. 13.3. *Saint Francis receiving the stigmata.* Pen and brown ink with brown wash and black chalk heightened with white on blue paper, 15⅜ x 10⅞ in. (39 x 27.6 cm). The British Museum, London, inv. Pp,3.203

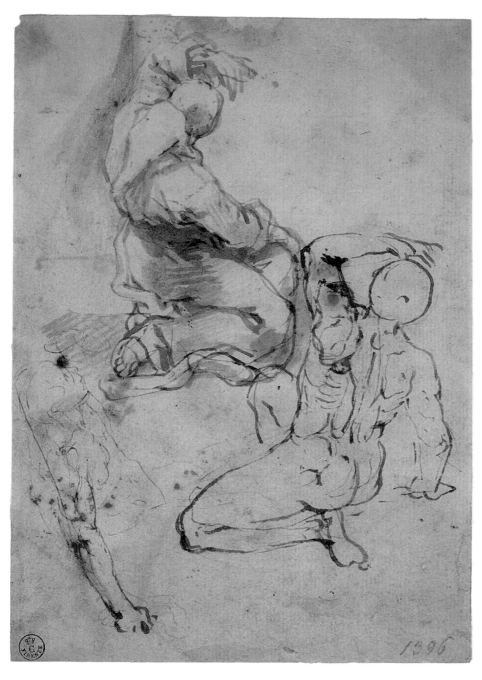

CAT. 13.4. *Studies for Brother Leo* (recto). Pen and brown ink with brown wash. [Verso: Figure studies. Black chalk], 8⅜ x 5¹⁵⁄₁₆ in. (21.2 x 15.1 cm). Gabinetto Disegni e Stampe degli Uffizi, Florence, inv. 1396 F.

menced work on the Urbino *Stigmatization,* he began with the basic format he had developed in the earlier Fossombrone picture, replacing the Conventual robes with the Capuchin hooded garment and flooding the scene with light.

Based on the next series of drawings Barocci made, one can presume that he did not find the composition in the British Museum drawing suitable. He apparently sought to incorporate Brother Leo more completely into the picture with a more dynamic presence, and he needed a more commanding figure for Saint Francis. Four pen and ink drawings survive to document Barocci's trials for Brother Leo.[49] Three of these sheets record his efforts for the reclining saint's pose; in each he drew the left arm shading the monk's eyes, while he sampled various arrangements for the bent legs and right arm. The example illustrated here (cat. 13.4) demonstrates the artist's practice of drawing the figure both nude and clothed. It shows two poses he explored, one with the arm braced against the ground to support the body and one where the arm rests across the knees. It is the latter that formed the basis for the figure he finally incorporated (in reverse) into the painting, a pose that allows the saint to hold a rosary in his left hand. As Barocci worked through the positioning of Leo's body, he may have gone back to earlier studies that he used to establish the pose of the young girl at the lower-left corner of his 1580–83 *Martyrdom of Saint Vitalis* (fig. 9). Although the general position is quite similar, there is considerably more twist and inherent energy in the figure he created for the *Stigmatization.*

What is presumably the last of the four pen studies devoted to Brother Leo—a small sheet in the Uffizi (fig. 78)—documents Barocci's decision to place the figure at the lower left, indicated by the intersection of vertical and horizontal ink lines that establish the corner. Furthermore, it is the only sketch in which the friar uses his right hand to shield his eyes, as in the finished painting.[50] The direction of Brother Leo's gaze indicates that Barocci still intended the seraph to appear at the upper-left corner as in the preparatory British Museum study (cat. 13.3), rather than in the middle of the upper register as in the finished work. Ever a master of gesture, Barocci developed a beautifully rhythmic posture for the fingers of Leo's shading hand, effectively silhouetted against the dark-

Capuchin robe appears in the London drawing and in the Urbino altarpiece, but not in the Fossombrone picture, logic suggests that the London sketch came after Fossombrone and before Urbino. The London drawing's association with the Urbino painting can be established further through the similarity of the trees at the far left of both compositions. They share the same curvilinear shape, a lower horizontal branch silhouetted against the sky, and a sec-

ond, higher branch angled upward. Barocci heightened the London sheet with white throughout the landscape to indicate the pervasive light that was so integral to the text of the *Considerazioni,* but he did not represent light in the distemper version.[48] He also introduced a more dynamic demeanor for the saint, who gestures heavenward in earnest, captured in the spirited drapery fluttering behind him. Therefore, it seems that, once Barocci com-

ened landscape for maximum effect.[51] A study in the Louvre for Leo's face allowed the artist to explore the high-intensity lighting he used on the right cheek, similar to what he had already developed for passages of the robe and body.[52]

Barocci's process for refining the figure of Saint Francis and his drapery is recorded in only six extant sheets.[53] In one of them (cat. 13.5), the second in the sequence, Barocci sketched a very generalized figure on one side of the sheet before turning it over to work further.[54] The placement of the lower legs, when compared to the British Museum study, represents a later stage of that same pose. In the exhibited sheet, Barocci worked out the leg position, the orientation of the head and body, and the arrangement of the arms. Three final sheets attest to his experiments with the drapery, determining whether the folds of cloth would reveal the legs underneath (they do not) and how the cloth that lies directly on the ground should fall. In developing the final position for the saint, Barocci may have taken inspiration from Giovanni Bellini's majestic Frick panel. Certainly the commanding and openly embracing stance of Saint Francis that Barocci ultimately painted strongly suggests that he knew Bellini's painting, especially evidenced in the tilt of the head. In the earlier compositional drawing in London, Barocci angled the saint's jaw heavenward as he took in the apparition, a position he continued in the exhibited study for Saint Francis. In the final painting, he lowered the jaw, more in conformity with Bellini's solution.[55] This is the pose we find in a related oil head study (cat. 13.7). The latest in the series of Barocci's surviving finished head studies in oil, it demonstrates all the hallmark features one expects in his head studies—the accomplished definition of the physiognomy, the linear treatment of individual strands of hair on the head and in the beard, and the use of red underpaint that gives such warmth to the skin tones, seen especially in the nose and the ear. This sensitive and beautiful drawing establishes the expression of wonderment on the saint's face. Barocci copied the head directly onto the canvas, with no revisions. Of all his extant head studies, this is perhaps the least sketchy and most refined, but it is also the only surviving one for a nocturne. Given the need to perceive the head easily against the darker background, perhaps Barocci intentionally focused more on

Fig. 78. *Study for Brother Leo*. Pen and brown ink, brown wash, and black chalk heightened with white, 19.7 x 13.5 cm. Gabinetto Disegni e Stampe degli Uffizi, Florence, inv. 11494 F. recto

the contour of the head and the realization of three-dimensional form.

Two fully developed compositional drawings have been identified for this picture. One is in the Städel Museum, Frankfurt, and a second was recently identified on the art market in Hamburg.[56] The former study, extremely close to the painting, demonstrates varying levels of quality. Although the treatment of Brother Leo is quite sensitive and beautiful, that of Saint Francis is more labored and mechanical, suggesting that this drawing may have been prepared in the workshop by the artist with the help of studio assistants. The drawing differs from the finished painting in minor ways. The study has more foliage at the upper right and a different configuration for the folds of Saint Francis's robe that touch on the ground. As the artist aged, we know from Bellori and through letters written by the duke, that his health

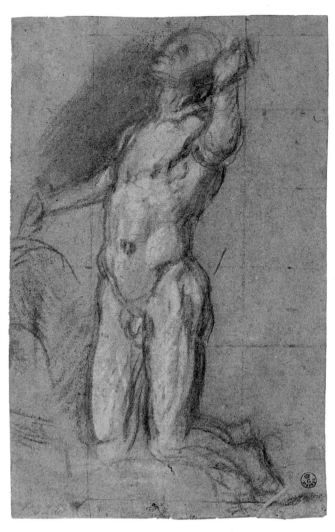

CAT. 13.5. *Study for Saint Francis* (recto). Black chalk and charcoal heightened with white, squared in black chalk, on gray paper. [Verso: Study for Saint Francis. Black chalk], 10¹³⁄₁₆ x 6¹³⁄₁₆ in. (27.4 x 17.3 cm). Gabinetto Disegni e Stampe degli Uffizi, Florence, inv. 11328 F.

CAT. 13.6. *Study for a falcon.* Brown and white chalk with ocher and rose pastel, 12³⁄₁₆ x 10¹⁄₁₆ in. (31 x 25.6 cm). Kupferstichkabinett, Staatliche Museen zu Berlin, inv. KdZ 20350

declined further, so it is likely that he increasingly relied on his assistants. A number of later paintings are generally acknowledged to be collaborative efforts undertaken with his students. The more difficult task of parsing out the drawings to individual hands within Barocci's studio has not been done, and no clear picture has yet emerged as to how his workshop may have operated. Both of these drawings may have been made as copies of the painting; the widespread popularity of Franciscan themes and the compelling composition Barocci developed may account for a growing demand among collectors. He may have assisted in some of these copies, as in the Frankfurt sheet, and given over

others to studio assistants, as is perhaps the case with the one in Hamburg. However, if the Hamburg example is a full compositional preparatory drawing produced in Barocci's studio, it is the only one fashioned completely in red chalk. This fact suggests that it may not be associated with his studio, but I could not examine the sheet, so I can make no definitive judgment.

Barocci's *Stigmatization of Saint Francis* represents one of his most dynamic compositions. Writers who have discussed the picture have invariably acknowledged its Baroque elements, which look ahead to achievements of the Seicento. In a seemingly simple composi-

tion, the artist incorporated a wide variety of details that allow the erudite viewer to meditate on the unique role of Francis as the saint chosen to relive Christ's Passion. By juxtaposing the more contorted pose of Brother Leo with the firmly planted and transported kneeling saint, Barocci provided an unforgettable re-creation of the events on Mount La Verna, which had great currency for late-sixteenth-century viewers. The simplicity of the final composition belies the several different versions the artist experimented with before settling on what seems to be an almost preordained solution that so well illustrates the personal vision of the revered saint. Undoubtedly a good

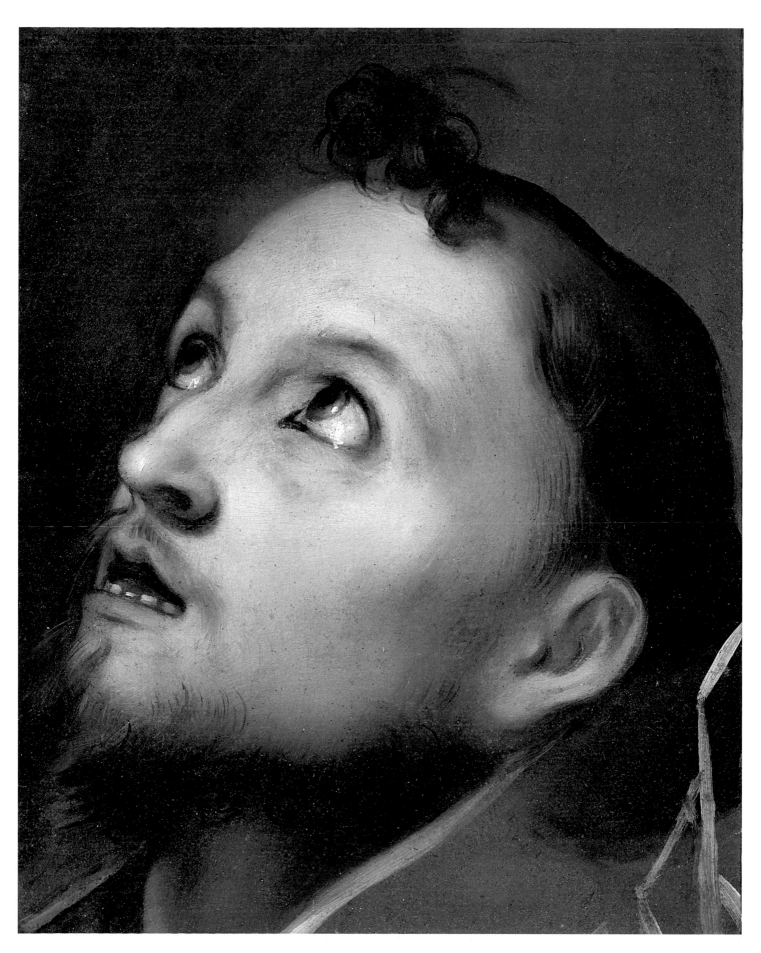

CAT. 13.7. *Head study for Saint Francis.* Oil on brown paper, 11⅝ x 8⅞ in. (29.5 x 22.5 cm). Private collection

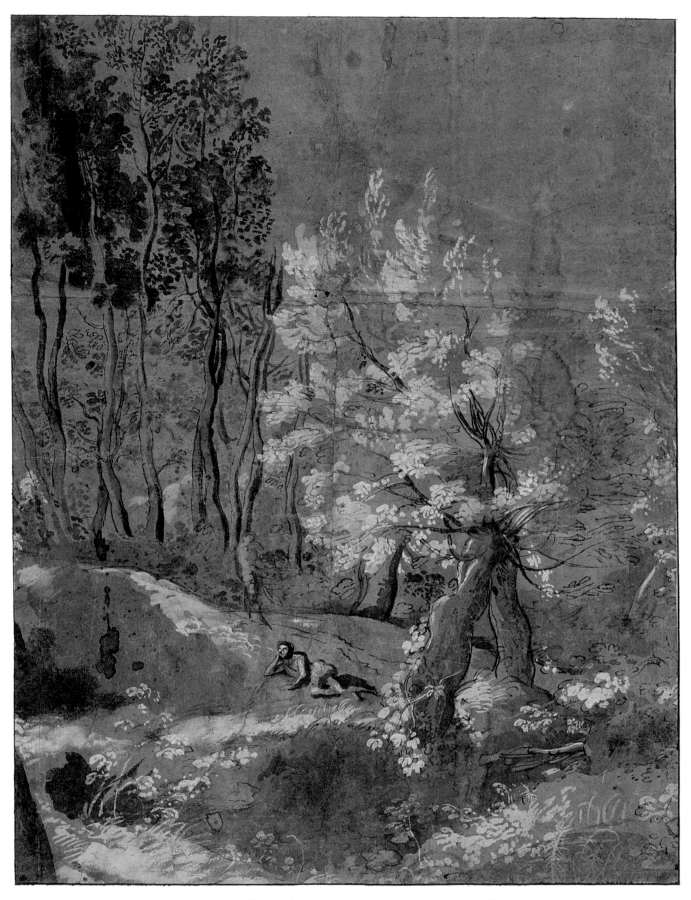

CAT. 14.4. *Landscape with reclining figure.* Brush and brown wash heightened with white on faded blue-green paper, laid down, 24⁷⁄₁₆ x 18³⁄₁₆ in. (62 x 46.2 cm). Inscribed in brown ink lower left: "Federico Baroche"; lower right: "Ecole Romaine"; on a Mariette mount lower center: "FEDERICI DE BAROCIIS / Fuit D. Crozat nunc P. J. Mariette" and "Ecole Romaine"; on back of mount: "Paysage avec figure au crayon lave de bistre rehaut de blanc." Musée du Louvre, Département des Arts Graphiques, Paris, inv. 2890

pen and ink, while the single extant landscape drawing ascribed to their compatriot Giorgione is in red chalk.[8] Polidoro da Caravaggio produced a few landscape drawings in red chalk—also finished, relatively panoramic compositions.[9] Another finished vista in red chalk (Biblioteca Oliveriana, Pesaro) is by Girolamo Genga,[10] a painter and architect from Urbino who was Barocci's relative. Genga worked extensively for the dukes, particularly Francesco Maria I della Rovere, and Barocci clearly knew his works.[11] Almost without exception, all these earlier sixteenth-century drawings were executed in a single medium—either pen and ink or red chalk. Apart from a few examples by Titian and Parmigianino, all afford relatively sweeping views of the natural world and were clearly composed as full scenes in the studio, rather than constituting specific studies from life, like those Leonardo produced.[12]

One early-sixteenth-century Italian draftsman whose landscape drawings anticipate certain features of Barocci's production is Parmigianino. Although few autonomous landscape studies by him are known, some share the specific scope and sketchy finish, if not the naturalism, of Barocci's landscape drawings. One example in particular, executed in black chalk, has undeniable affinities with some of Barocci's landscape drawings.[13] While such similarities suggest the possibility that Barocci was influenced by Parmigianino's example, we have no evidence confirming Barocci's exposure to his landscape studies.

The Italian artist whose production of landscapes on paper seems most likely to have influenced Barocci is Titian. Although only a handful of his landscape drawings are known, his designs were widely disseminated in prints.[14] The *Landscape with a Milkmaid, Saint Jerome in the Wilderness,* and *Stigmatization of Saint Francis*—all woodcuts probably made by Niccolò Boldrini about 1525–30 after Titian's designs—bring the landscape closer to the foreground than most contemporary designs and retain a sense of freedom in the line work, both features that anticipate Barocci's approach.[15] Later engravings after Titian by Cort are more finished; it may have been through Cort that Barocci was exposed to Titian's landscape designs, for in 1575 and 1577 Cort produced engravings after two of Barocci's paintings.[16]

Cort is not the only Northern European artist who may have influenced Barocci's landscape drawings. Two types of his landscape drawings seem remarkably similar to Northern examples, but it is not clear how he might have seen these works. The first examples to evince such similarities are Barocci's studies executed primarily in wash and white heightening on blue paper. The style and technique of these sheets are strikingly similar to a few drawings by the great Flemish artist Pieter Bruegel the Elder, whose landscapes were much admired during the sixteenth century. Bruegel produced numerous landscape drawings, many of them during his visit to Italy in the early 1550s. Created sometimes directly from nature and sometimes from his imagination, Bruegel's landscape drawings are remarkably detailed and naturalistic, combining his own sensitivity to the natural world with compositions and atmospheric perspectives that were influenced by the developments of Italian artists such as Leonardo and Titian. Bruegel's *Wooded landscape with a distant view toward the sea* (fig. 79)[17] is strikingly similar in medium, scale, and style to Barocci's landscape drawing in the Kunsthalle, Hamburg (fig. 80), as Martin Royalton-Kisch astutely observed.[18] The compositional similarities between Barocci's landscape drawing representing the *Stigmatization of Saint Francis* (cat. 13.3) and a drawing in the British Museum ascribed to Pieter Bruegel or his son Jan Bruegel the Elder also suggest that Barocci saw analogous examples.[19] At least for those landscapes executed primarily in pen and ink with wash and white heightening, it seems likely that Flemish drawings such as Bruegel's were influential. These landscape drawings by Barocci, in short, were inspired by art, rather than being created directly from nature.

The other type of landscape drawing produced by Barocci that may be linked to Northern practices is far more unusual for the Italian tradition: His studies of trees, executed in black chalk in combination with white heightening on colored sheets, such as the example from Urbania (cat. 14.2), have no parallels among drawings by other Italian artists; the closest analogy is provided by early-sixteenth-century Flemish and German drawings. Although these Northern examples employ pen and ink rather than chalk in combination with gouache and/or wash on colored paper, their light-on-dark pictorial effects are strikingly close to Barocci's works. The Northern landscape drawings executed in this technique, created between 1502 and 1520 by such artists as Albrecht Altdorfer and Wolf Huber, are more finished, frequently dated, and appear to have been made as independent works of art in their own right, destined for private collectors.[20] Although technically analogous to Barocci's landscape drawings, these German examples are more carefully finished, as one might expect, given their status as independent works of art. The somewhat more freely drawn Netherlandish examples, which were probably inspired by German precedents, come closer to Barocci's technique, particularly some sheets in the Errera Sketchbook in Brussels (fig. 81), which was most likely made in Antwerp during the second quarter of the sixteenth century. This bound volume of landscape and townscape compositions includes about a dozen sheets on colored grounds that set off small white blobs, applied in a manner that appears distinctly analogous to Barocci's technique. As Christopher Wood observed, the Netherlandish draftsmen used white heightening only for the leaves, in a less finished style than their German counterparts.[21] Given the sketchbook's function as a tool in the workshop, rather than a finished work designed for a collector, the freer handling in the Brussels sheets is not surprising. It is interesting, moreover, that these workshop drawings were frequently copies of compositions in existing paintings, prints, or other drawings that were retained by the workshop as a source of pictorial ideas. This approach to the use of landscape drawings—first creating the images independently, based on other works of art, and then retaining them as sources for subsequent paintings—also has pertinence for Barocci's methods, as will be discussed below.

Although there is no conclusive proof that Barocci had access to Flemish landscape drawings, the analogies between them and the two types of landscape drawings he did—relatively finished compositions principally in wash and white heightening, and tree studies in chalk and white heightening—strongly suggest that this was the case. But without further evidence, we can only speculate as to how he might have encountered such drawings. Perhaps he saw them during his early years in Rome; possibly

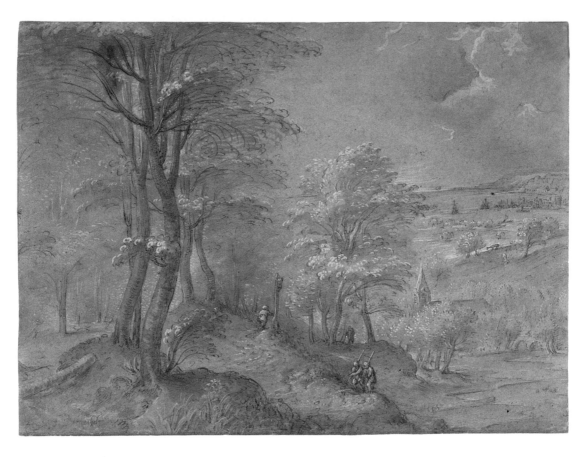

Fig. 79. Pieter Bruegel the Elder, *Wooded landscape with a distant view toward the sea,* 1554. Pen and brown ink with brown wash over black chalk, heightened with white, on blue paper, 26 x 34.4 cm. The Maida and George Abrams Collection, Harvard Art Museums/Fogg Museum, Cambridge, MA, inv. 1999.132

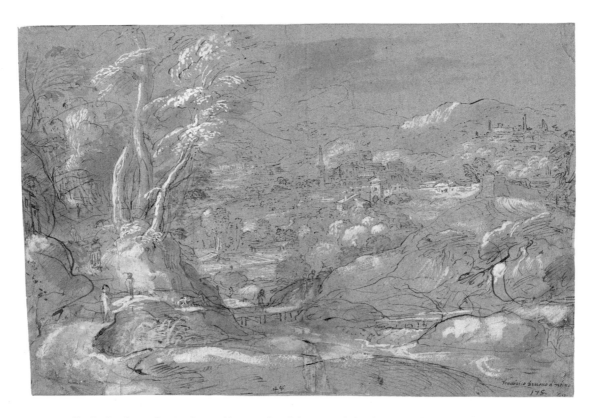

Fig. 80. *Landscape drawing.* Pen and brown ink with brown wash, heightened with white, on blue paper, 27.2 x 40.1 cm. Hamburger Kunsthalle, Hamburg, inv. 21056

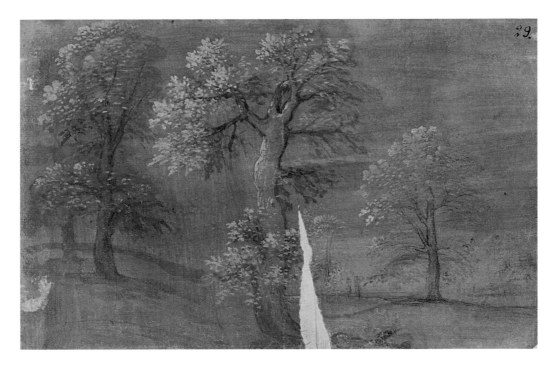

Fig. 81. Master of the Errera Sketchbook, *Drawing of trees*, ca. 1530–40. Gouache on blue paper.
Musées Royaux des Beaux-Arts de Belgique, Brussels, inv. 4630/29

his interactions with Cort provided access; or maybe he encountered drawings in Urbino. However he might have seen them, these Flemish examples undeniably provide more compelling precedents for Barocci's landscape drawings than any Italian prototypes.

The thirty-three landscape drawings by Barocci that are known today offer a conspicuous contrast to the relative uniformity of earlier Italian landscape studies, in terms of both media and subjects. The surviving examples represent only a fraction of his original production, as evidenced by the inventory of his studio after his death, which enumerated 170 landscape drawings.[22] The inventory makes clear the variety that characterized these sheets: "Landscapes colored in colored gouache, watercolors . . . other landscapes drawn in light and dark, in watercolor, with lapis, all studied from life . . . other landscape sketches studied from nature."[23]

Notwithstanding the loss of some four-fifths of Barocci's landscape drawings, much of this variety can still be appreciated today. The surviving sheets include a handful of quick sketches, executed exclusively in black chalk or in a combination of red and black chalk.[24] A very free, spirited drawing in Berlin, which is not a pure landscape but concentrates on the natural setting in a scene representing the ado-

ration of the shepherds, is principally executed in pen and ink, with wash and white heightening on blue paper.[25]

Barocci's most interesting landscape drawings, which are unprecedented in Italian art, add colored gouache, watercolor, or pastels to these traditional media. A few of these, such as two examples in the Biblioteca Oliveriana in Pesaro (see fig. 82), are quick, summary studies of a landscape, both executed in chalk, pastel, and stump.[26] These two examples, like two chalk drawings from the Rijksmuseum and Urbania,[27] were probably made outdoors, directly from nature, as suggested by their naturalistic and casual, uncomposed character and by their exclusive reliance on dry media that would have been easily transportable to the outdoors. The same may be true of a dynamic sheet in the Nationalmuseum, Stockholm, which employs the same media in a more focused but equally vivid study of a tree.[28] Although Olsen connected the Stockholm drawing with Barocci's etching the *Stigmatization of Saint Francis,* the rough finish and painterly qualities of the sheet make it unlikely to have prepared a print, and it does not correspond convincingly to the etching, in any case. As in several other cases, Barocci seems to have made the drawing independently and then

returned to this idea when he painted his *Stigmatization of Saint Francis* (cat. 13), a composition that was employed also in the small etching (cat. 13.2).

Barocci created some eight studies of trees that rely primarily on liquid media to produce startlingly vivid and naturalistic images that are new to Italian draftsmanship. Two of these extraordinary sheets are featured here; they illustrate the freshness, vitality, and striking colorism that Barocci brought to landscape drawings. The sheet from the Lugt collection (cat. 14.1) depicting two slender, foliated trees illustrates the remarkable sense of light and atmosphere that he achieved principally with a brush in such drawings. It demonstrates Barocci's versatility with the brush, using strokes ranging from short dots or blotches to long, calligraphic lines in wash and gouache to express a variety of values and textures.

A drawing from Urbania (cat. 14.2) is even more daringly economical in its portrayal of a single tree, using only black chalk, white heightening, and colored paper. This extraordinarily free but naturalistic and luminous example of Barocci's landscape draftsmanship employs only a minimal amount of heightening, in contrast to the black chalk, to evoke a sense of the illuminated foliage, set against the colored

Fig. 82. *Landscape drawing*. Black, red, and white chalk with yellow-green pastel and stump on
two joined sheets of paper, 25.6 x 38.2 cm. Biblioteca Oliveriana, Antaldi Collection, Pesaro, inv. 229

middle tone of the sheet. This drawing has been connected with the Fossombrone *Saint Francis Receiving the Stigmata* (cat. 13.1), but the connection is loose, and the artist evidently returned to an idea he had explored earlier in such drawings as this wonderful example.[29]

Perhaps Barocci's masterpiece of landscape drawing is the magnificent sheet *Riverbank with trees* in the British Museum (cat. 14.3). After making a few quick, preliminary indications in black chalk, he created the drawing entirely with a brush, using brown and black wash in combination with white, green, mauve, and yellow gouache. As with some of the drawings already discussed, Harald Olsen connected this sheet with Barocci's aforementioned etching the *Stigmatization of Saint Francis,* though this painterly sketch seems most unlikely to have been made for a print. But Barocci evidently made this drawing without a particular purpose in mind and later returned to his conception, as a point of departure, for the *Stigmatization* as well as for other works, such as the *Entombment* (cat. 8).[30]

These three examples are all spontaneous, colorful, and vividly naturalistic, despite a lim-

ited amount of detail, suggesting the possibility that they were drawn from nature. Indeed, the inventory of Barocci's studio, as noted above, indicated that all his landscape drawings were created from life, a sweeping generalization that is not entirely sustainable. We know little about exactly how sixteenth-century Italian artists used gouache and whether in fact this medium was employed outside. Although the naturalism of these examples hints at such an inception, in the absence of real evidence about Barocci's practices, we cannot be certain whether these works were created directly from nature or in the studio.

Some of Barocci's landscape drawings rely principally on the brush but are more carefully finished and were certainly not drawn from nature. A prime example is the drawing from the Louvre (cat. 14.4), an exceptionally large sheet. Such a large and finished drawing must have been intended from the outset for a discriminating collector; although the sheet's initial provenance is unknown, it made its way into Mariette's important collection at an early date. Barocci's composition in this drawing is a tour de force of chiaroscuro effects, with the

dark wash and white heightening contrasting compellingly with the middle tone of the paper. This approach, combined with the absence of any real compositional focus, seems quite analogous to some of the Flemish landscape drawings discussed above.

Because none of Barocci's landscape drawings appears to have been made as a preparatory study for a painting, there is little firm foundation for specific dates, but the range of style and technique suggests that they were made over some period of time. The most naturalistic landscape settings in his paintings range in date from the *Entombment* of 1579–82 (cat. 8) to the Prado *Crucifixion* of 1600–1604 (fig. 18), so most of his landscape drawings were probably made in that twenty-five-year period.[31]

Although constituting only a small percentage of Barocci's huge corpus of extant drawings, the surviving landscape studies provide an instructive example of how difficult it is to generalize about his practices as a draftsman. The landscapes are exceptions to two basic principles that are generally applied to Barocci's drawings: that they were invariably made from life, and that they were all made in preparation

for his paintings. The landscape drawings also illustrate Barocci's remarkable inventiveness and diversity in the media he employed for his works on paper.

Babette Bohn

NOTES

1 Barocci's removal from such classical principles of landscape suggests that his works lacked the associations with nobility and good health that Giulio Mancini appreciated in the landscapes of Annibale Carracci, Paul Bril, and others during this period. See Gage 2008.

2 See Loire 2011b, 235 and 241, who argued, e.g., that fewer than a dozen of Annibale Carracci's landscape drawings can be connected to paintings.

3 For a summary of the arguments over the chronology of these albums, see Chapman's catalogue entry on the London album, in Chapman and Faietti 2010, no. 16, esp. 127–29. Another early Italian landscape drawing is by the Florentine artist Piero di Cosimo (ca. 1462–1521). This sheet, in black chalk, is in the Uffizi (inv. 304 P.; see Bacou et al. 1973, 6, no. 2).

4 J. Paul Getty Museum, Los Angeles, inv. 2001.9, black chalk, brush and brown ink and brown wash, 40.8 x 25.8 cm; www.getty.edu/art/gettyguide/artObjectDetails?artobj=140392. Another specific landscape drawing by Fra Bartolommeo—the study of a tree in brush and brown wash—was sold by Christie's, London, 7 July 2010, lot 308. A study of a pine tree (private collection), in the unusual medium of black chalk on gray paper, was catalogued and illustrated in Bacou et al. 1973, 10, no. 5.

5 Fischer 1990, 375–77.

6 On Muziano's landscape drawings, see Marciari 2000 and Tosini 2008.

7 Marciari 2000, 193–94 and 310–11, suggested that Muziano's pen style in his early landscape drawings was influenced by Domenico Campagnola, who was the leading artist in Padua when Muziano arrived there in 1544 (25–27).

8 Giorgione's drawing is in a private collection. According to Châtelet 1984, Domenico Campagnola's landscape drawings are all in pen and ink.

9 Two examples, in the Hessisches Landesmuseum, Darmstadt (inv. AE 1267), and the British Museum (inv. 1905,1110.48), were catalogued and illustrated in Bacou et al. 1973, 70, nos. 44–45.

10 Biblioteca Oliveriana, Pesaro, inv. 726; illustrated in Forlani Tempesti and Calegari 2001, pl. XL.

11 On Genga's drawings, see Pouncey and Gere 1962, 159–60. Two landscape studies are also known by the Florentine Francesco Salviati, one in red chalk (Louvre inv. 11042) and the other in pen, ink, and wash heightened with white on blue paper (Scottish National Gallery, Edinburgh, inv. D 1026). See Monbeig-Goguel 1998, nos. 26 and 126.

12 I have not discussed landscape drawings by Annibale Carracci here, for it seems doubtful that Barocci would have known them. Annibale proba-

bly began producing landscape drawings during the 1580s, and he continued until the end of his career. While most of his landscape drawings are full scenes, often panoramic, in pen and ink, a few examples study more specific motifs. Annibale and his relatives Ludovico and Agostino Carracci were aware of Barocci's prints, at least, but there is no evidence that Barocci saw Carracci drawings. Although most were produced earlier in Bologna, a few of Annibale's late landscape drawings were made in Rome (long after Barocci visited that city). These late drawings in pen and ink are in any case stylistically so distant from Barocci's landscape studies that they have no pertinence for the latter's production. See also Loire 2011b, 241, who remarked that it was impossible to be certain whether Annibale's landscape drawings were made outdoors or in the studio.

13 On this drawing, in a private collection, see the entry by Carmen Bambach, in Bambach et al. 2000, no. 53. She noted the existence of eight autonomous landscape drawings by Parmigianino, few of which are firmly connected to finished works. Mary Vaccaro questioned the attribution of this drawing to Parmigianino (private communication).

14 The earliest examples are a small group of woodcuts datable to ca. 1525–30; beginning in 1565, Cornelis Cort made numerous reproductive engravings after Titian.

15 On Titian's landscape prints and drawings, see Rosand and Muraro 1976, esp. 140–53.

16 See, e.g., cat. 7.7. On Cort, see J. C. J. Bierens de Haan, *L'Oeuvre gravé de Cornelis Cort, graveur hollandais, 1533–1578* (The Hague, 1948).

17 Signed and dated at lower left: "1554 brueghel." See the catalogue entry on this drawing by Nadine M. Orenstein, in Orenstein 2001, 106–8, no. 14.

18 Pillsbury and Richards 1978, 38, no. 10; E 2008, 1, no. 16.6.

19 This relationship was also observed by Royalton-Kisch, whose excellent essay on Bruegel's drawings (2001) provides the basis for my discussion of the relationship between Barocci and Bruegel. Royalton-Kisch suggested that the sixty-one drawings by Bruegel known today constitute only a tiny part of his original output, and he argued that Bruegel may originally have produced thousands of drawings, many of them landscapes. I am indebted to Jeffrey Chipps Smith, who drew my attention to this essay.

20 See the excellent discussion by Wood 1998, 107–9. See also Winzinger 1979, esp. nos. 45, 62, and 63, all in Budapest.

21 Wood 1998.

22 Calzini 1913b, 80–82.

23 Ibid.

24 Rijksmuseum, Amsterdam, inv. RP-T-1981-29 verso; Biblioteca e Museo Civico, Urbania, inv. II 143.463 recto, and inv. II 205.502 verso. The latter was catalogued by E 2008, 2, 406, no. 114.1.

25 Berlin inv. KdZ 20291 (4131). Emiliani (2008, 1, 158–59, no. 18.9) connected the Berlin sheet with some early drawings of this subject, all related to a painting that is no longer traceable.

26 Inv. 229 (fig. 82) is previously unpublished, but inv. 239 (recto and verso) was published and illustrated by Forlani Tempesti and Calegari 2001, no. 33; and by E 2008, 2, 382, nos. 101–2. Both drawings were created on two joined pieces of paper.

27 The drawing in the Rijksmuseum is inv. RP-T-1981-29 verso, in black chalk; the sheet from Urbania is inv. II 150.446 recto and verso, in black chalk with some ocher-brown pastel, catalogued and illustrated in Cellini et al. 1994, 86–87, no. 19.

28 Nationalmuseum inv. NM 410/1863, in black with some red chalk and yellow pastel, 40.4 x 26.4 cm. The simpler verso, inv. NM 411/1863, is in black chalk only. See Bjurström and Magnusson 1998, no. 423. Two similar drawings by Barocci are in the Uffizi (inv. 418 P.) and the Cleveland Museum of Art (inv. 1973.171), both catalogued and illustrated in E 2008, 1, 286–87, nos. 35.2–35.3.

29 Five other tree studies by Barocci, executed principally in liquid media are: Uffizi inv. 11364 F. verso; Albertina inv. 567, E 2008, 1, 289, no. 35.5, and 2, 406, no. 114.3; Rouen inv. 975.4.614 (known to me only from a photograph); Louvre inv. 2916, E 2008, 2, 407, no. 114.9; and Louvre inv. 2889, E 2008, 2, 407, no. 114.7.

30 Gere, Pouncey, and Wood 1983 also argued against the likelihood that this drawing was made to prepare a specific work. A drawing in the Uffizi (inv. 418 P., in brush and brown wash, with a greenish wash that has darkened almost to black, heightened with white, over some charcoal, 42.3 x 27.7 cm, E 2008, 1, 286, no. 35.2) has some similarities to the London drawing, but here the colored media appear to be ink washes rather than gouache, and much of the original color has been lost. A third drawing with a similar composition but less color is in the Cleveland Museum of Art (inv. 1973.171, in black chalk with brown wash heightened with white, 19.8 x 13.2 cm, E 2008, 2, 287, no. 35.3).

31 Pillsbury, however (in Pillsbury and Richards 1978, 38, no. 10), argued that Barocci's drawing *Landscape* in Hamburg (fig. 80) was done early, perhaps while he was on his way to or from Rome in the mid-1550s or early 1560s. On this drawing, see the discussion above.

Bibliography: Schmarsow 1911, 13, 21; Krommes 1912, 105; Olsen 1962, 50–51; Olsen 1965a, 26–32; Byam Shaw 1969, 88; Chiarini 1973, 15; Bacou et al. 1973, 205, no. 144; Pillsbury and Richards 1978, 56–57, no. 32; Byam Shaw 1983, 1, 106–14; Gere, Pouncey, and Wood 1983, 43–44, no. 51; Cellini et al. 1994, 78–79, no. 15; Royalton-Kisch 1999, 41 and 59, n. 103; Turner 2000, 65; Scrase 2006, 124–25, no. 37; E 2008, 1, 288–89, no. 35.4, 290, no. 35.6, and 2, 406–7, no. 114.6; Prosperi Valenti Rodinò 2009, 74.

Nativity

Barocci's *Nativity*, painted in 1597 for Duke Francesco Maria II della Rovere and given by him to the queen of Spain in 1605, provides a remarkable synthesis of iconographic tradition and innovation. The painting amalgamates several different types of representations, combining a conventional Nativity scene with elements of the Adoration of the Child by the shepherds and by the Virgin. Beginning with features derived from Correggio and other artists, Barocci experimented with composition and iconography by creating a religious scene that combines the ordinary with the miraculous, a formula well suited to the orthodox Catholicism of both his original patron and the picture's subsequent recipient. To arrive at this innovative resolution, Barocci experimented with different compositional approaches in his preparatory drawings, exploring varied ideas for the key figure of the Virgin Mary. His final solution resulted in a quiet but fervently devotional picture that links the birth of the Savior to the miraculous as well as the ordinary, rendering its Christian narrative both accessible and orthodox.

Barocci's painting depicts a nocturnal scene set in a stable, with the Virgin and Child portrayed in the right foreground, the figures closest to the viewer. The principal source of illumination is the child, who glows with miraculous, divine light, illuminating both his mother, who kneels in adoration, and the ox and ass cut off by the picture frame at right. In front of Mary is a circular object, largely concealed by the shadows which, according to Peter Gillgren, is decorated with the signs of the zodiac, suggesting the cosmological importance of the event.[1] Behind Mary to the left, Saint Joseph opens the stable door to admit a sheep and two shepherds, who peer toward the child, to whom Joseph points. Saint Joseph, with his extended left arm, provides a crucial compositional link between the humble shepherds in the background and the holy figures in the foreground, also creating a strong sense of recession into depth, despite the pervasive darkness of the scene.

The early history of the picture is well documented. Bellori noted that Barocci painted the *Nativity* for Duke Francesco Maria II della Rovere, who "gave the picture to the queen of Spain for her chapel, together with another picture of Christ expiring on the Cross."[2] Presumably because the picture was in Spain and hence inaccessible to Bellori, he did not comment further on it. The work is also documented in the duke's record of expenses, where a payment to Barocci was entered on 19 August 1597. The gift of the painting to the Spanish queen is documented in the duke's correspondence with Bernardo Maschi during 1604–5. On 4 September 1604, Maschi wrote from Valladolid requesting a devotional painting by Barocci for the queen's oratory. The duke replied on 9 October, noting that Barocci was busy on a project for the pope, but suggesting that he already had a painting in hand, representing the *Nativity,* that should work. A letter dated 2 March 1605 indicates that the painting had not yet been sent, but on 17 July, the duke wrote to Maschi from Urbino, acknowledging his receipt of the news that the painting had arrived in good condition and that the queen liked it.[3]

The recipient of Barocci's *Nativity* was the young Margaret of Austria (1584–1611), who in 1599 married the Spanish king Philip III, a key ally of Francesco Maria. Margaret, Philip's second cousin and a member of the Austrian branch of the Hapsburg family, was a well-educated and devout woman who was thoroughly conversant with Tridentine Catholicism and employed a Jesuit confessor.[4] The duke's gift for the young queen was a good choice. The religiously conservative wife of a religiously conservative monarch, Queen Margaret constituted a perfect audience for a devotional painting that adhered closely to the strictures of the Council of Trent (1545–63) on religious art in terms of its narrative clarity, fidelity to key texts, devotional fervor, and strong sense of the miraculous.

The story of Christ's birth and the visit of the shepherds to the Holy Family are described in Luke's Gospel (2:1–20) but ignored by the three other Gospel writers. These events were further elaborated in the Apocrypha, in the thirteenth-century *Golden Legend* by Jacobus de Voragine, and by other Christian writers.

Luke's account specified little beyond the details that the Christ Child was born in Bethlehem, wrapped in bands of cloth, and laid in a manger. The *Golden Legend* introduced the ox and ass who accompanied the Holy Family and knelt to worship Christ when they miraculously recognized him.

Beginning in the fourteenth century, representations of the Nativity were transformed by Western artists into scenes of adoration. In these the Virgin is depicted, after a painless birth, kneeling with clasped hands before a naked and luminous child. This emphasis on the kneeling Virgin in adoration may have been inspired by the writings of Saint Bridget of Sweden (ca. 1303–1373), who had a vision of Christ's birth that corresponded exactly with the new iconography, centering on a kneeling Virgin with clasped hands.[5] Some writers have suggested that Mary's kneeling posture may also have been meant to express both her freedom from pain in childbirth and her adoption of a posture that was believed to facilitate childbirth.[6] Well before the Council of Trent confirmed that she had given birth without pain, many depictions portrayed the Virgin kneeling before a nude and humble Christ Child, sometimes accompanied in her posture of adoration by Saint Joseph (see, e.g., a painting by Fra Bartolommeo, Galleria Borghese, Rome, ca. 1495–1500) and sometimes by the shepherds, angels, and even the ox and ass (as in paintings by Pinturicchio, Santa Maria del Popolo, Rome, about 1488–90; and one by Perugino, Galleria Nazionale dell'Umbria, Perugia, 1517).

The Adoration of the Shepherds emerged in Western art much later; the earliest depictions of this subject, which were based on Luke's account (2:15–20), appeared during the fifteenth century. The subject became much more frequently represented after the Council of Trent, and during this period, painters often synthesized the Nativity with the Adoration of the shepherds. This combination of two biblical subjects is theologically significant, for it fused the depiction of Christ's birth with the first recognition of the Savior by men. The new synthesis was also emotionally innovative,

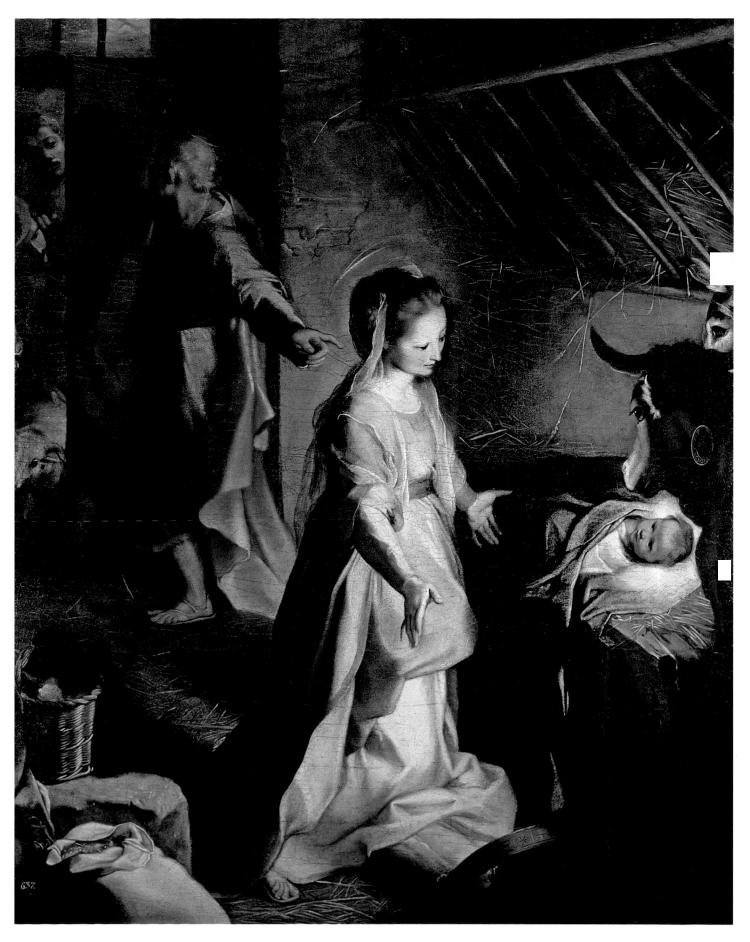

CAT. 15. *Nativity*, 1597. Oil on canvas, 52¾ x 41⁵⁄₁₆ in. (134 x 105 cm). Museo Nacional del Prado, Madrid, inv. P00018

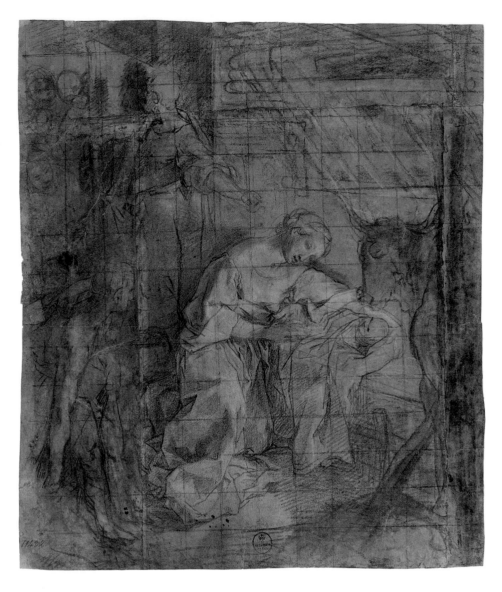

Fig. 83. *Compositional study for a Nativity (Nativity B)*, ca. 1597. Black and white chalk, squared in black chalk, on four joined pieces of paper, 51.7 x 44.1 cm. Gabinetto Disegni e Stampe degli Uffizi, Florence, inv. 11432 F.

Savior; and the Virgin's adoration of her divine child. Thus the viewer-worshiper witnesses humanity in two stages of spiritual awareness, one just before and the other immediately after awakening to Christian salvation. These two groups are linked by the dynamic Saint Joseph, whose extended left arm connects the ordinary with the extraordinary by relating the shepherds to the Christ Child. This connection of humanity to divinity seems to emphasize the central paradox of Christ's nature. As doctrinally established in 451, he is both fully human and fully divine.

The surviving drawings indicate that Barocci designed three different *Nativity* compositions. In one of these conceptions, he adhered more closely to Correggio's example, depicting the Virgin kneeling affectionately over the manger containing her child, with one of the shepherds in the foreground joining her in proximity to Christ. In the Prado picture, the artist rejected this more traditional approach, choosing instead to isolate the sanctified figures of the Virgin and Child from their humble visitors and emphasizing the Virgin's devotional response to Christ rather than her maternal reaction. This approach accentuates Mary's special status and purity, her freedom from pain in childbirth, and also her exemption from Original Sin. She alone is bathed in the divine light radiating from the child, and only she is graced with one of Barocci's rare haloes, an attribute that he more often reserves solely for Christ.[9] Although Barocci's picture was not designed for the Spanish court, his unusual emphasis on Mary's special status in his *Nativity* would have been appreciated by its conservative audience in a court that had long supported the controversial doctrine of Mary's Immaculate Conception—the notion that she was conceived from the very beginning without the stain of Original Sin.[10]

Barocci produced forty-two drawings for Nativity scenes, but these appear to relate to three separate compositions and were probably made for three different paintings.[11] One of the two other pictures was probably intended for Simonetto Anastagi, who also commissioned a Rest on the Return from Egypt from the artist.[12] The smallest group (here termed Nativity A)—six drawings that were all published by Emiliani—prepared a picture formerly in the Rasini collection in Milan that may be the work

eschewing the sadness of the abandoned Holy Family that was expressed in a conventional Nativity.[7]

Many sixteenth-century depictions portrayed a nocturnal scene, an approach popularized though not invented by Correggio in his painting of 1530. Correggio's *Notte*, as it was commonly called, emphasized the divine light emanating from the child, contrasting it with the deep darkness that surrounds the figures. Correggio's combination of the Nativity with the Adoration of the Shepherds within a nocturnal setting, with the Virgin kneeling beside the Christ Child but leaning forward to embrace him rather than kneeling in adoration, pioneered a new synthesis of maternal devo-

tion with the miraculous and provided a model for many subsequent Cinquecento examples.[8]

Barocci's iconography incorporated some aspects of these earlier representations but also struck new ground. He adopted the nocturnal setting, the illumination of the scene by the glowing newborn, the kneeling Virgin, and the introduction of the shepherds. But unlike the earlier examples noted above, Barocci depicted the prelude to the shepherds' adoration, as they are just arriving at the stable housing the Holy Family. Instead of portraying a group unified in adoration, Barocci's picture is effectively divided into two narratives: the arrival of the shepherds, who are just entering the stable door and will shortly recognize their

Fig. 84. *Studies for the Virgin Mary in the Nativity,* ca. 1597. Black chalk and charcoal with pen and brown ink on blue paper, 27.7 x 39.4 cm. Gabinetto Disegni e Stampe degli Uffizi, Florence, inv. 11634 F. verso

described in the inventory of Barocci's studio as a small, unfinished picture.[13] Nativity A seems to have been designed independently of the two other *Nativities* and shares only a few features with them, such as the nocturnal setting and the position of the ox at the right of the composition.

The two other compositions are more closely related. One group of eight drawings documents the design of a composition that is here termed Nativity B. A large and finished drawing in the Uffizi from this group (fig. 83) suggests that the design of Nativity B was fully realized by the artist, probably resulting in a painting that is no longer traceable. This version, like the Prado *Nativity,* portrays the Virgin, Child, and ox close together in the right foreground, with Joseph in the middle ground, linking them to the arriving shepherds in the left background. But unlike the Prado picture, Nativity B shows the Virgin kneeling and leaning over her child, a solution, probably inspired by Correggio's *Notte,* that was more common during the Cinquecento than Barocci's resolution in the Prado canvas. Moreover, Nativity B

also includes a kneeling shepherd in the left foreground, near the Virgin, in a pose that is identical, in reverse, to that of the kneeling shepherd in Barocci's *Presentation of the Virgin in the Temple* (1593–1603; fig. 15). This kneeling shepherd was studied specifically in a figure drawing in the Uffizi and appears also in the finished compositional drawing, noted above (fig. 83).[14] All six of the other drawings for Nativity B examine the kneeling Virgin.[15] Although this Nativity features the arrival of the shepherds, as retained in the Prado picture (with the addition of another shepherd in the left foreground, who has already arrived), Barocci's innovative portrayal of the Virgin in the Prado canvas was not introduced here. This intermediate level of innovation may indicate that Nativity B preceded the series of drawings for the Prado picture.

A two-sided drawing in the Uffizi provides the only link between these two compositions.[16] On the verso of this sheet (fig. 84), at lower right, Barocci first drew the Virgin in her kneeling position, as conceived in Nativity B. At the left, he drew her again, now nude and

kneeling in a more upright position and with her right arm down by her side and her left raised to her chest. This second solution is close to the pose in the Prado *Nativity,* apart from the position of the left arm. Barocci explored yet another approach to the kneeling figure in a pen and ink sketch superimposed over the first rendering, in which both arms seem to be raised to her chest in prayer. On the recto of this sheet, Barocci produced four studies of the Virgin's left hand, as realized in Nativity B, and one study of the Virgin's right hand, extended toward the child, also portrayed in this earlier group. Thus, although the recto relates only to the earlier sequence, the verso shows Barocci experimenting, perhaps for the first time, with another solution for the Virgin, which ultimately led to his conception of this figure as realized in the Prado *Nativity.*

The artist's progression for the Prado picture is not entirely clear; some critical drawings in his design sequence have probably been lost. A small, early compositional sketch in the Uffizi shows that he may initially have considered reversing the positions of the Virgin and Saint

Fig. 85. Workshop of Barocci, *Studies related to Saint Joseph and the Christ Child*, ca. 1597. Black and white chalk with stump, 28.3 x 40.1 cm. Veneranda Biblioteca Ambrosiana, Milan, inv. F. 290 inf. n. 5

Joseph, with the latter in the right foreground and the Virgin positioned in the center, with her extended arms linking foreground to background.[17] The decision to transfer the more dynamic role and central position to Joseph seems significant and may reflect the growing popularity and importance of his cult during this period. A sheet with two figure studies for Saint Joseph, also in the Uffizi, examines this arrangement more closely, but the absence of other drawings that explore this solution suggests that it was quickly abandoned.[18] Six full-figure studies for Mary all portray her in more or less her final position, but three drawings that depict the full figure of Saint Joseph are more problematic. Although two of these represent the male saint in his final pose, the handling of all three sheets is troubling, with uncharacteristically regular hatching, awkward proportions, and thick, shapeless extremities, all of which probably preclude Barocci's authorship. The most elaborate of these three drawings, in the Biblioteca Ambrosiana (fig. 85), portrays Joseph in his final pose at left and the child, also in his final position, at right. Either this drawing was made as a partial copy after the picture, or it was executed by a member of the workshop when the design was well advanced.[19] At least one other drawing, a rela-

tively finished composition in the Louvre, confirms that there were other workshop drawings made from Barocci's *Nativity* designs.[20] While our information about the workings of Barocci's studio is relatively limited, sheets like this one and the Saint Joseph studies noted above suggest that Barocci's assistants made drawings related to the master's paintings, and that these drawings have sometimes been confused with his own works.

The autograph studies for the Prado *Nativity* demonstrate a particular concern with the Virgin Mary, whose pose, as noted above, constituted a revival of an older iconographic type—the Virgin in adoration. Six full-figure studies represent Mary close to her final kneeling pose, with arms slightly outstretched. The first two of these were evidently drawn from a youthful male model[21]; one provides a quick sketch of the pose with the model clothed[22]; and three sheets study the fully draped Virgin, with careful attention to pose and draperies. One example illustrated here is a drawing that portrays the Virgin almost in her final position, but in a somewhat lower, kneeling posture (cat. 15.1). In this sheet, Barocci drew Mary's nude right leg in black chalk, then sketched the drapery over the leg in pen, ink, and wash. As always, his drawing

is sensitive to the play of light, and the cast shadows on her head, neck, right arm, and back are also indicated. Mary's abundant draperies, which are so prominent in the painting, were the principal subject of no less than five drawings. The three most beautiful examples are all in the Biblioteca Ambrosiana, and two of these are featured here. One (cat. 15.3) retains the more bent knee of the Uffizi drawing and includes a more elaborate arrangement of the draperies, with a large cluster of beautifully modeled folds at the rear.[23] A third Ambrosiana drawing simplifies this arrangement, substituting a vertical drapery arrangement for the cluster.[24] Both these sheets include only a perfunctory rendering of the figure, focusing instead on a careful rendering of the complex draperies.

In the second breathtaking example (cat. 15.2), Barocci closely examined the volumetric chiaroscuro of this drapery arrangement. To achieve as broad a range of tone as possible, he worked in black and white chalk, using stump to blend it and create a gray middle tone. This study is not merely a formal exercise; it also pursues a feature that is central to the iconography: the divine light that emanates from Christ and illuminates his mother. This passage creates a kind of miraculous paradox: it is a divine source that imparts palpability and weight to material form. This relationship between naturalism and the miraculous, this employment of convincing passages from the real world to express the presence of the divine, is at the heart of Barocci's artistry.

In addition to the six full-figure drawings and three drapery studies for Mary, four sheets focus specifically on her arms and especially her hands.[25] As always in Barocci's paintings, gestures constitute crucial signifiers of narrative content, and in the *Nativity,* the Virgin's hands express her awareness of the miracle of Christ's birth, her reverence toward her son, and the grace she shares with him.

There are also four drawings with studies for Joseph's arms and hands that provide the key connection between the two portions of the narrative. The conception for Saint Joseph is the one portion of the Prado *Nativity* that appears to have been taken largely unaltered from Nativity B, so the drawings connected to him are related to both compositions. As noted above, some of the full-figure studies for Saint Joseph

seem to have been executed by a member of the workshop. But one splendid autograph study for Joseph's head, in *profil perdu* (cat. 15.4), confirms Barocci's personal involvement with the design of this figure. In this working drawing, a pentimento in the cheek and forehead adjusts the head so that Joseph's gaze is directed more deeply into the pictorial space. In the painting, the passage Barocci designed here—the gleaming back of an old man's head that shines out in the darkness—has considerable visual prominence. In Barocci's daring nocturnal interpretation of the Nativity, Joseph's face is not visible; he functions not as an emotional participant in the narrative, but as a marker in the middle ground, providing a spatial transition between the arriving shepherds and the brilliantly illuminated Virgin and Child. In iconographic terms, this illumination symbolizes the movement of humanity from darkness into the light of Christianity.

Only a couple of drawings focusing on the Christ Child and the shepherds have survived. A sketch in the Uffizi records the artist's preparation for the shepherds, who are largely obscured by the darkness.[26] One marvelous study for the head of the infant (cat. 15.5), in chalk and pastel, corresponds precisely to the Christ Child in both the Rasini and Prado *Nativities*. Nicholas Turner suggested that this full-scale drawing may have been torn out from the cartoon for the Prado picture,[27] although this seems improbable, for there is no evidence that the sheet was incised for transfer to the painting. This well-preserved study illustrates the remarkable sense of vitality the artist achieved in such drawings, with a balanced but vigorous combination of red and black lines to describe forms.

Barocci's nocturnal *Nativity* exemplifies his iconographic originality and his skills in combining believable, quotidian reality with a forceful sense of the miraculous. The fact that the painting was originally made for the duke of Urbino, his most sensitive and constant patron, notwithstanding its subsequent transportation to the Spanish queen's chapel, suggests that this synthesis of the ordinary with the divine was close to the hearts of both patron and artist. The aging Barocci may well have been concerned during this period with his own mortality: he wrote his will only two years later. Turning to thoughts of death and the prospects for his own

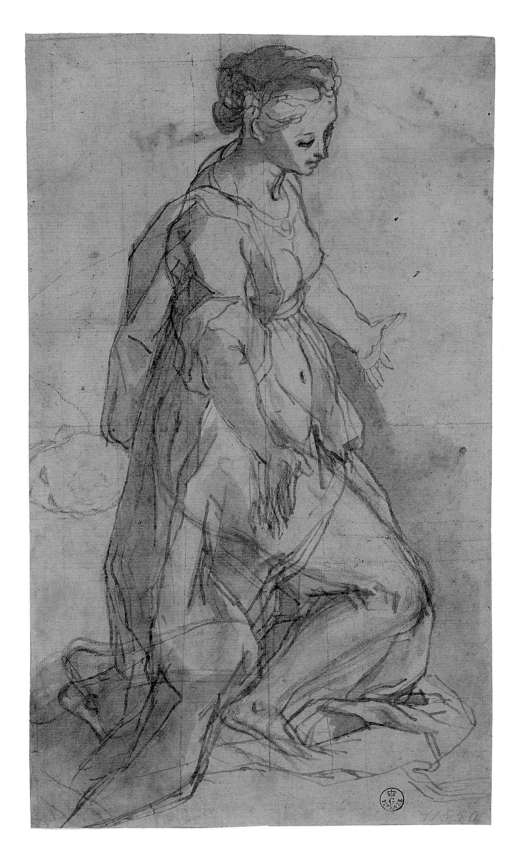

CAT. 15.1. *Study for the Virgin Mary* (recto). Pen and black ink with gray wash over black chalk, squared with black chalk. [Verso: Illegible sketch, possibly architecture. Red chalk, squared in black chalk], 10⅞ x 6⅜ in. (27.6 x 16.2 cm). Gabinetto Disegni e Stampe degli Uffizi, Florence, inv. 11550 F.

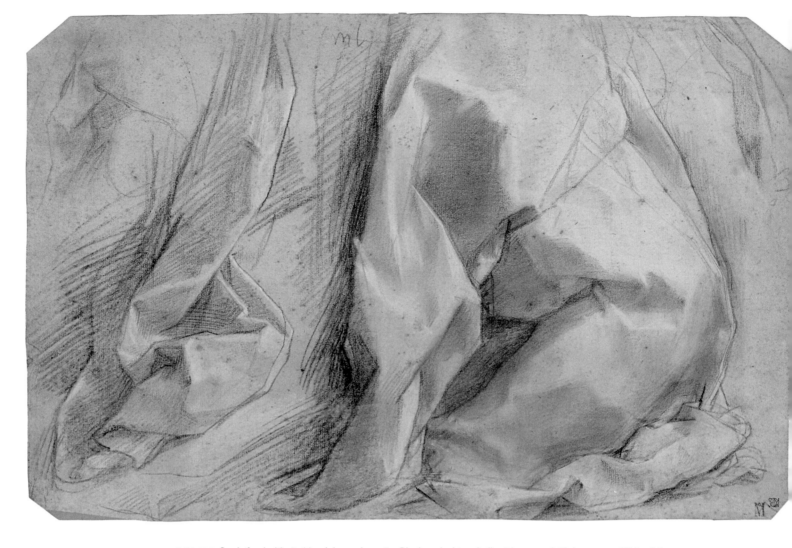

CAT. 15.2. *Study for the Virgin Mary's lower draperies.* Black and white chalk with stump, laid down, 11 x 16⅝ in. (28 x 42.2 cm). Veneranda Biblioteca Ambrosiana, Milan, inv. F. 290 inf. n. 2

salvation, the artist created a dramatic interpretation of the traditional subject that movingly expresses the first access of common people to their Savior.

Babette Bohn

NOTES
1 Gillgren 2011, 144.
2 Bellori 1672 (1976), 204; Bellori 1672 (2000), 189. The second picture noted by Bellori is also in the Prado (fig. 18).
3 This correspondence was published by Gronau 1936, 172–76.
4 On Queen Margaret, see Sánchez 1998, 2–74, and Schroth and Baer 2008, 27, 197, and 203.
5 Réau 1955–59, 2.2, 225.
6 Ibid., 218–25.
7 Mâle 1951, 240–43.

8 As may be seen in works by both Taddeo and Federico Zuccaro, Cherubino Alberti, Giorgio Vasari, Annibale Carracci, and both Jacopo and Francesco Bassano. Correggio's *Notte* is in the Gemäldegalerie, Dresden.
9 After his early *Deposition* (cat. 3), which provides haloes for most of the saints, Barocci usually supplied only a crucifix nimbus for Christ. Exceptions to this include the haloes for the Virgin in the Vatican *Annunciation* (cat. 9) and in the Senigallia *Madonna of the Rosary* (cat. 11, which also features a halo for Saint Dominic), and one for Saint Francis in the *Stigmatization* (cat. 13).
10 For a fuller discussion of this issue and its importance to Mary's Immaculate Conception, see cat. 6.
11 Pillsbury (in Pillsbury and Richards 1978, 85, no. 63) argued that all these drawings were related to the Prado picture, and he identified four different stages of conception, separating the *primo pen-*

siero recorded in Uffizi inv. 11485 F. as the first of these four stages. E 2008 listed thirty-nine preparatory studies for the Prado picture and Nativity B (actually forty, for both the recto and verso of a sheet in Cambridge are listed under one entry), in addition to six studies for the Rasini picture, but I reject the attributions of his nos. 63.28, 63.34, 63.37 and probably 63.35–63.36. I am also not convinced that three of the drawings he listed are connected to these pictures (nos. 63.21 and 63.38–63.39). Two drawings that are preparatory studies for the picture (Uffizi inv. 11598 F. verso and Berlin inv. KdZ 20516 [4438]) were not listed by Emiliani.
12 Anastagi's letters indicate that he asked Barocci for a never-executed Nativity, probably during the 1580s or 1590s. See Giovanna Sapori 1983, 80, and cat. 4, n. 8.
13 E 2008, 2, 202–5, nos. 63.40–63.47, illustrated; Calzini 1913b, 77. The precise description of the painting in the inventory reads, "Una Natività di N.

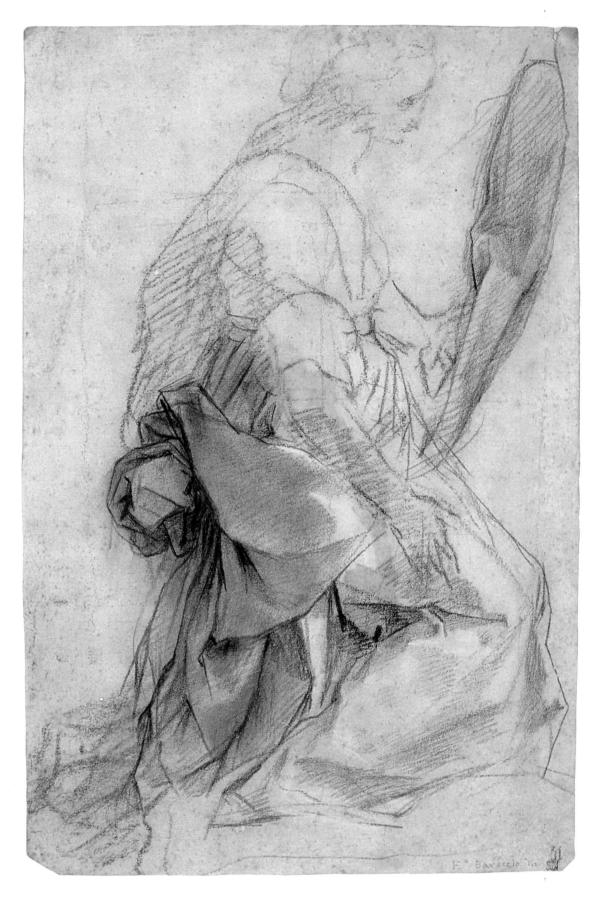

CAT. 15.3. *Study for the Virgin Mary's draperies.* Black chalk with stump and some light squaring in black chalk,
laid down, 16¹³⁄₁₆ x 10⅞ in. (42.7 x 27.7 cm). Inscribed in pencil on recto lower right: "F.º Baroccio dis";
in brown ink on verso: "Federio Baroccio." Veneranda Biblioteca Ambrosiana, Milan, inv. F. 290 inf. n. 4

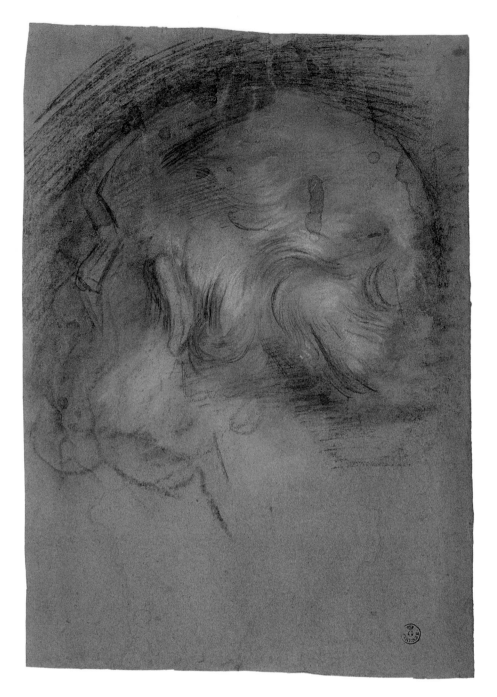

CAT. 15.4. *Study for the head of Saint Joseph.* Black, red, and white chalk with charcoal and peach and pink pastel on blue paper, 16 x 11⅛ in. (40.6 x 28.3 cm). Gabinetto Disegni e Stampe degli Uffizi, Florence, inv. 11276 F.

Signore, quadretto da Camera, alto tre piedi e mezzo abbozzato." Pillsbury also discussed this picture (in Pillsbury and Richards 1978, 85, no. 63), which he described as an unfinished canvas that is the same size as "the finished work" (the Prado picture?). Judith Mann, who has seen this painting (I have not), believes that it was executed by a member of Barocci's workshop, rather than by the master.

14 The figure study is Uffizi inv. 11288 F., in black chalk and charcoal heightened with white, squared with black chalk, 27.5 x 17.8 cm, E 2008, 2, 198, no. 63.23, illustrated. The composition is Uffizi inv. 11432 F. (here fig. 83), E 2008, 2, 199, no. 63.30.

15 These drawings include: Fitzwilliam Museum inv. 1977 recto and verso, E 2008, 2, 193, no. 63.7, illustrated, and Scrase 2011, 27–28, illustrated; Berlin inv. KdZ 20325 (3757), E 2008, 2, 199, no. 63.32, illustrated; Detroit Institute of Arts inv. 34.139, E 2008, 2, 192, no. 63.6, illustrated; Uffizi inv. 11372 F., E 2008, 2, 190–91, no. 63.3, illustrated; and Uffizi inv. 11380 F., E 2008, 2, 194, no. 63.8. The last two drawings, in my opinion, are questionable attributions to Barocci and were probably executed by a member of his workshop, in light of the somewhat awkward proportions and blocklike rendering of the head, hands, and arms.

16 Inv. 11634 F., the recto in black and white chalk and charcoal and stump on blue paper (the verso is fig. 84 here), E 2008, 2, 197, no. 63.21, and 199, no. 63.31.

17 Uffizi inv. 11485 F. recto, in pen and brown ink with brownish gray wash over some black chalk, 19.3 x 19.5 cm, E 2008, 2, 199, no. 63.29. E 2008 (2, 201, no. 63.39, illustrated) also listed the verso of this sheet as a preparatory study for the *Nativity,* but it does not appear to be connected to this composition.

18 Uffizi inv. 11607 F., in black and white chalk on brown paper, 27.9 x 41.3 cm, E 2008, 2, 196–97, no. 63.16, illustrated.

19 Fig. 85, inscribed in pencil on the recto, lower left: "S. Giuseppe" and lower right: "Fed Baroccio;" inscribed on the verso in brown ink in the same hand: "Federico Baroccio," E 2008, 2, 197, no. 63.17, illustrated. The two other drawings are both in the Uffizi. The first, which portrays Saint Joseph in a somewhat different pose, is inv. 11386 F., in black and some white chalk on brown paper, 26.9 x 15.3 cm, E 2008, 2, 197, no. 23.19, illustrated. The second, portraying Joseph in his final position, is inv. 11384 F., in black chalk, 26.8 x 15.8 cm, E 2008, 2, 197, no. 63.18, illustrated.

20 Louvre inv. 2843, in pen and brown ink over black chalk with brown wash heightened with white, and squared in black chalk, 34.5 x 31.5 cm. This sheet was not published by Emiliani, and Olsen (1962, 289) rightly listed it as a work of Barocci's studio, a suggestion that is confirmed by both style and iconography. The drawing portrays a Nativity with some features shared by the Prado and Nativity B compositions, such as the ox at far right, the shepherds entering at upper left, and the figure of Saint Joseph in more or less his final pose. But the shepherds and Saint Joseph seem disproportionately small, and there are many aspects of the composition that do not appear in any other drawings: the Virgin's pose in three-quarter view, kneeling with hands clasped in prayer; the nude and uncovered child; and the prominently placed saddle in the left foreground. Significantly, the miraculous lighting that is a central feature for the iconography of both the Prado picture and Nativity B is nowhere in evidence here, and the lighting seems evenly distributed throughout the composition. It is difficult to see how or where this drawing would have fit into the artist's design process.

21 Uffizi inv. 11598 F. verso, in charcoal and white chalk, 18.8 x 24 cm, not listed in E 2008; and Uffizi inv. 11315 F., in black chalk and charcoal heightened with white, partially squared in black chalk, 34.2 x 21.6 cm, E 2008, 2, 190, no. 63.1, illustrated.

22 Uffizi inv. 11636 F. verso, in charcoal, 39.3 x 25.6 cm, E 2008, 2, 190, no. 63.2, illustrated.

23 E 2008, 2, 194, no. 63.9, illustrated.

24 Ambrosiana inv. F. 290 inf. n. 3, in black and white chalk with stump, inscribed on the verso in brown ink: "Federico Baroccio," 43.2 x 28.8 cm, E 2008, 2, 191, no. 63.5, illustrated.

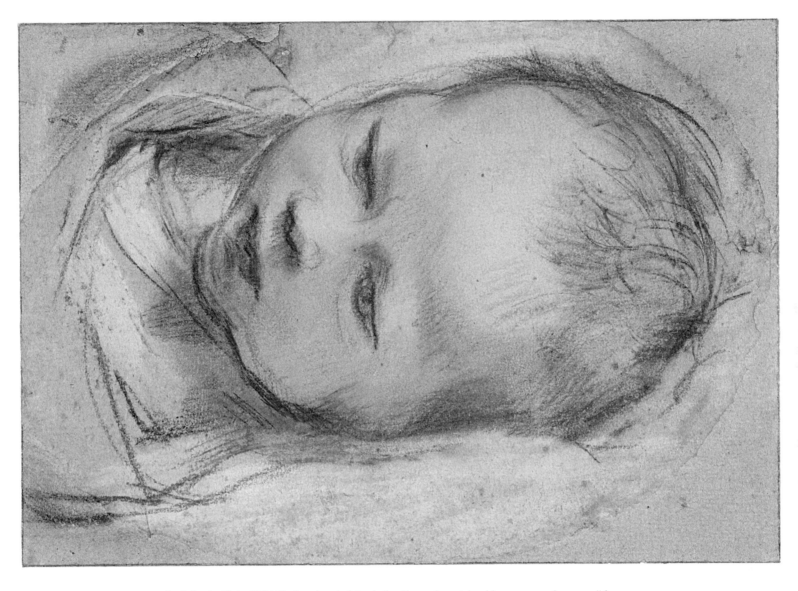

CAT. 15.5. *Study for the Christ Child.* Black, red, and white chalk with peach pastel on blue paper, made up on all four corners, laid down, 6⅝₁₆ x 8¹¹⁄₁₆ in. (16 x 22.1 cm). The Royal Collection, Windsor Castle, inv. 5223

25 Three of these studies are in Berlin: inv. KdZ 20316 (4358) recto and verso, E 2008, 2, 196, no. 63.13 and 2, 198, 63.27, illustrated; and inv. KdZ 20159 (4248), E 2008, 2, 195, no. 63.12, illustrated. The fourth drawing is Uffizi inv. 11636 F. recto, E 2008, 2, 196, no. 63.14, illustrated.

26 Uffizi inv. 11351 F., in black and white chalk on gray paper, 27.1 x 19.4 cm, E 2008, 2, 199, no. 63.33, illustrated.

27 Turner 2000, 120.

Provenance: Duke Francesco Maria II della Rovere; in 1605, given by the duke to the Spanish queen Margaret of Austria; 1779, Casita del Principe, El Escorial; 1814, Palacio Nuevo; Museo Nacional del Prado, Madrid

Bibliography: Bellori 1672 (1976), 204; Bellori 1672 (2000), 189; Schmarsow 1909, 10; Schmarsow 1909 (2010), 49–50; Schmarsow 1910, 9, 19; Schmarsow 1911, 5; Krommes 1912, 92; Di Pietro 1913, 112–30; Gronau 1936, 172–76; Popham and Wilde 1949, 189, no. 89; Olsen 1962, 196–98, no. 51; Pérez Sánchez 1965, 229; Prado 1970, 50–51, no. 9; Bertelà 1975, 83–84, no. 92; Emiliani 1975, nos. 226–31; Pillsbury 1976, 60; Bora 1978; Pillsbury and Richards 1978, 85–86, no. 63; Emiliani 1985, 2, 318–29; Zampetti 1990, 122–23; Fontana 1997b, 19; Turner 2000, 118–21; Ambrosini Massari and Cellini 2005, 33, 38, 41, 42; Scrase 2006, 190–94, nos. 69–70; E 2008, 2, 188–205, no. 63; Lingo 2008, 162, 169; Marciari and Verstegen 2008b, 301, 311; Rosci 2009; Sangalli 2009; Gillgren 2011, 144, and 259, no. 34.

Aeneas Fleeing Troy

Barocci's painting of *Aeneas Fleeing Troy* is unusual for the artist in several respects. It was his only secular narrative painting and one of the few that he copied in a full-scale, autograph replica for a key patron. Moreover, the group of extant preparatory studies for the picture is as striking for what is absent as for what is included. In contrast to the *Visitation* that immediately preceded the first *Aeneas*, there are no surviving head studies in oil for any of the four principal figures here. The preparatory studies suggest a singular concentration on pose and gesture. In addition, drawings that prepared the classical setting provide insights into the artist's approach to architecture, and the surviving cartoon and *cartoncino* illustrate some key differences in his employment of these two types of preparatory instruments.

The painting depicts a scene from Virgil's *Aeneid* (2.634–795): the dramatic flight of Aeneas and his family from Troy after the city's invasion by the Greeks. Four brilliantly colored figures stand out against the almost monochromatic background of classical architecture in flames. Aeneas, sumptuously attired in silver and gold armor with a green tunic and sandals, strides forward determinedly over ruined architectural fragments. He carries his aged father, Anchises, whose golden and pink garments contrast with those of his son. Aeneas's young son Ascanius (also called Iulus) climbs up beside his father, while Aeneas's wife, Creusa, a vision of billowing hair and red, gold, white, and blue draperies, attempts to keep up with the male members of her family. Her physical separation from the men in Barocci's painting hints at her doom: she will not escape Troy alive.

Barocci's first, lost version of *Aeneas Fleeing Troy* was painted in 1586–89 for Holy Roman Emperor Rudolf II in Prague (r. 1576–1612). Commissioned as a gift for the emperor by Duke Francesco Maria II, the picture earned Barocci a handsome four hundred *scudi,* paid in four installments during 1587–88. Barocci delivered the painting to the duke in January 1589.[1] It was sent to Prague on 15 March and arrived there on 3 July, but the emperor evidently never acknowledged its arrival or thanked the duke.[2]

The picture was listed in the Prague inventory of 1621. Taken from Rudolf's collection by Prince Karl Gustav after the sack of Prague by Swedish troops in 1648, the painting was incorporated into Queen Christina of Sweden's collection.[3] It was later moved to the Palazzo Odescalchi at Bracciano, where it was already described as being in poor condition.[4] In 1721 it was owned by the Galérie Orléans in Paris, and in 1800 it was sold in London for fourteen guineas, the low price presumably reflecting its bad condition. Lamentably, this important work, which was described with great admiration by both Giovanni Pietro Bellori and Filippo Baldinucci, has now disappeared.

The Borghese version is a replica painted by Barocci in 1598, a decade after the original, for Monsignor Giuliano della Rovere (see cat. 21) and perhaps presented by him to Cardinal Scipione Borghese, for it is documented in the Borghese collection in 1613.[5] It is signed and dated 1598, making it the eighth or ninth of Barocci's ten signed paintings.[6]

This production of a replica raises interesting questions about Barocci's retention of his drawings, his methods for reproducing his compositions, and the expectations of his patrons in terms of how much originality they demanded in his works. Given Barocci's increasing tardiness in producing his commissions, perhaps patrons such as Giuliano della Rovere, who knew his habits, were willing to compromise to encourage a prompter fulfillment of commitments. In any case, it seems clear that the preliminary drawings for *Aeneas* were made in 1586–88 for the first version, and were reused for the second picture, as several writers have suggested. This reuse of the drawings for a second version may account for the probable destruction of many of Barocci's preparatory drawings, given his frequent reliance on incision for transfer.

Although both Baldinucci and Bellori claimed that Emperor Rudolf II was so pleased with the *Aeneas* that he invited Barocci to move to his court,[7] there is no evidence that Barocci's sole foray into mythological narrative pleased its recipient. A great art collector with distinctive tastes that tended to the secular and even the erotic, Rudolf may have found Barocci's portrayal too staid compared to the lascivious works produced for him by Bartholomäus Spranger and other favorites of the Prague court.[8]

Barocci's protagonist, Aeneas, son of Venus, fought the Greek army at King Priam's palace at the end of the Trojan War. After the king was killed, Venus encouraged her son to flee the city. Aeneas returned home, asked his father to hold the household gods,[9] and carried the aged man on his back. Taking his young son Ascanius by the hand, Aeneas instructed his wife to follow. Later, in the confusion, Creusa was lost, separated from her family, and killed, but Barocci portrayed the story before this event transpired, depicting only her distress and agitation as they attempt to escape the doomed city. After the events depicted here, Aeneas traveled to the Italian peninsula, where his descendants founded Rome.

Barocci's subject, the destruction of Troy, has been connected with the Sack of Rome (1527), a plausible association with Aeneas, ancestor of Rome's legendary founders, but the subject was probably intended also as a complimentary metaphorical allusion to Rudolf's court in Prague.[10] The tragic destruction of Troy's sophisticated civilization, portrayed poignantly by Barocci in his precise descriptions of classical architecture surrounded by flames and by the fragments of already annihilated artifacts in the foreground, testified to both the greatness and the ephemeral character of such human accomplishments.

In Barocci's painting, the four colorful figures inhabit a setting defined by classical architecture and by the light and smoke from the fires that stream dramatically into the scene. Both Aeneas and his young son stand, somewhat precariously, on broken stones and architectural fragments. As Ascanius climbs up onto a stone, he clasps his father's thigh and presses one hand to his head in distress.[11] Aeneas looks down at Ascanius, while gripping his father firmly with both hands, his right forearm swelling with muscular effort. The body of Anchises curves closely around that of Aeneas, his two

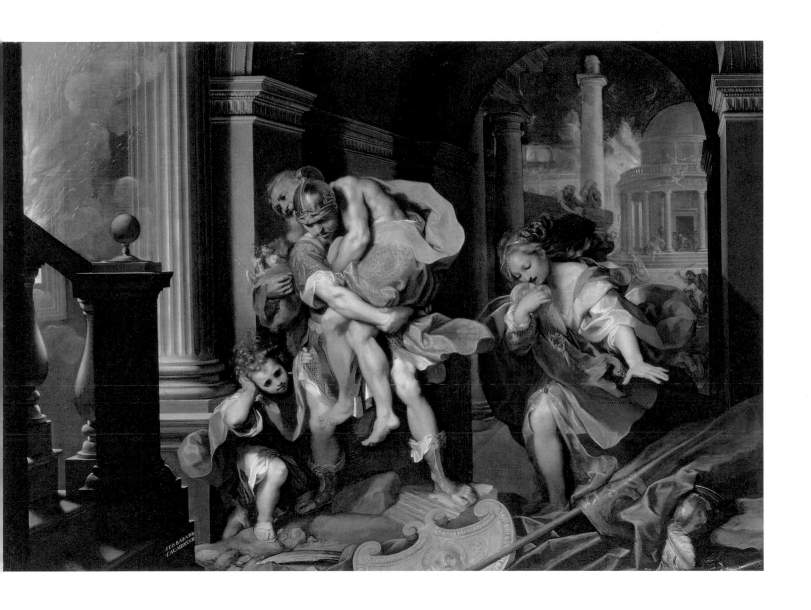

CAT. 16. *Aeneas Fleeing Troy*, 1598. Oil on canvas, 70½ x 99⅝ in. (179 x 253 cm).
Signed lower right: "FED. BAR. VRB. / FAC. MDXCVIII." Galleria Borghese, Rome, inv. 68

legs dangling between those of his son, his head visible behind that of Aeneas, and his right arm gripping the two golden statuettes of Poseidon and Athena, whose color is balanced by the golden draperies of the old man's robes. These three figures form a tightly cohesive pyramidal grouping, whereas Creusa is distinctly separated from them, proleptically suggesting her imminent, fatal separation from her family.

Creusa occupies almost as much space as the three other figures combined. With her long hair and abundant red and golden draperies flowing about her, she looks down and extends her left arm, presumably to maintain her balance amid the rubble. The form of her body is largely concealed beneath these fulsome draperies, which expand to fill the width of the archway in which she stands. The composition is coloristically balanced, with the red mantles of Creusa and Ascanius flanking the softer colors of the two adult men's clothing. Creusa's mantle transitions from red to a softer rose, contrasting with her gold and white brocade dress and the black cameo pinned to her skirt above her knee. She also wears a translucent veil and white ribbons in her golden hair. Her gaze is lowered, and although her mouth is open, it is her dynamic draperies and hair, as well as her affective gestures and forward stride, that express emotion.

These colorful, strongly illuminated figures occupy a foreground space that is clearly defined by architecture. In the background is a building reminiscent of Donato Bramante's Tempietto in Rome, amid other classical constructions, flames, and spectral fighting figures. This almost monochromatic space, together with the darkened stair rail in the left foreground, sets off the figures to dramatic effect.

Barocci's conception was influenced by two works he had seen, years earlier, in Rome. First, Bramante's round Tempietto was the model for the principal building in the background, and second, Raphael's famous fresco of the *Fire in the Borgo* (Vatican Palace, 1514) provided a point of departure for Barocci's conception of the two adult men and the classical buildings on fire in the background.

Another possible influence was Girolamo Genga's fresco of *Aeneas Fleeing Troy* in the Palazzo Petrucci, Siena, painted around 1509. Now detached and in the Pinacoteca Nazionale, Siena, this painting by Barocci's relative anticipates several aspects of his own interpretation. Like Barocci, Genga portrayed a tight-knit group of Aeneas, Anchises, and Ascanius, and he too included Creusa, who is often absent from pictorial depictions of the narrative. Two prints from the early sixteenth century that Barocci may well have known do not include Creusa: a chiaroscuro woodcut of 1518 by Ugo da Carpi after Raphael; and an anonymous engraving after Giulio Romano.[12]

Twenty-three preparatory drawings are connected with Barocci's two paintings of *Aeneas Fleeing Troy*. Although his early compositional explorations for this painting are no longer known, the extant works include a beautiful *cartoncino per il chiaroscuro* and one of his most complete full-scale cartoons. The largest single category of surviving drawings, however, is composed of the studies examining anatomical particulars: seven sketches of arms, hands, legs, or feet, and five heads. This focused preparation resulted in figures whose expressive power derives largely from pose and gesture, conveying a range of emotion in the four who provide a diverse group in terms of age and gender: an old man, a mature man, a male child, and an adult woman. Barocci's careful attention to anatomical particulars enabled him to differentiate effectively between the physical attributes of these four types.

Our knowledge of Barocci's preparatory drawings for *Aeneas Fleeing Troy* has grown considerably over the past half-century. When Harald Olsen published his monograph on Barocci in 1962, he listed only sixteen drawings, one of which can no longer be accepted as autograph.[13] By the time Andrea Emiliani published his monograph in 2008, this group had grown to twenty-one, although for three of these drawings, either the connection to the painting or the attribution to Barocci cannot be sustained,[14] effectively bringing the group down to eighteen sheets. The expansion of this corpus to twenty-three drawings here includes the following additions: two head studies for Creusa that were reused designs from the *Deposition* (cats. 3.7 and 3.8), two architectural studies, and a study for the head of Ascanius.[15]

One challenge for any artist depicting Aeneas and his family fleeing Troy is the necessity of portraying Aeneas carrying his father, a grown man. Gianlorenzo Bernini undertook this same challenge almost a quarter-century later in sculpture, also for Cardinal Borghese, and it is a barometer of Barocci's success that his graceful solution influenced the gifted young sculptor. Barocci's compact arrangement of the two figures was devised in two drawings. The initial sketches for Aeneas and Anchises must be lost, for the two existing ones both essentially conform to the final arrangement, although with differing degrees of detail. The earliest and most sketchy, in the Uffizi, provides a summary study of both figures, nude but in their final positions, with minimal anatomical detail.[16] This sketch essentially establishes the poses of both figures. The second drawing, in Berlin (cat. 16.1), also provides only a summary treatment of anatomy, focusing instead on the drapery arrangement, particularly for Anchises. In this sheet, Barocci employed black and white chalk to model forms volumetrically in light and shadow. The drapery is a key component of Barocci's composition, for it completes the graceful oval formed by Aeneas's right arm and Anchises's back and head. In the painting, the cohesion and stability of the two figures' grouping are achieved by the creation of this oval above the vertical elements of the four legs.

The complex positioning of Anchises's and Aeneas's arms and legs was examined in four drawings. Aeneas's right arm, which plays a pivotal role in supporting his father's body, was studied in a sheet in an American private collection.[17] A drawing in Berlin depicts the two dangling legs of Anchises, which poignantly express his helplessness.[18] Barocci then examined both feet, the right leg in reverse, and Anchises's right hand in another sheet of studies.[19] Yet another small sketch revisits his right hand, tightly gripping the two golden statuettes of Athena and Poseidon.[20]

One of Barocci's most beautiful preparatory drawings for *Aeneas Fleeing Troy* is his spectacular study for the head of Anchises at Windsor Castle (cat. 16.2). The drawing is one of his best-preserved and most expressive heads in pastel and chalk. The old man's concentration, conveyed through his knitted brows, focused gaze, and tightly drawn lips, provides a key element of the dramatic tension in the painting. This full-scale drawing may have been used as an auxiliary cartoon for the head in the painting, for there is some evidence of incision along the forehead, right eye, ear, and beard.

The use of incision, scattered throughout the sheet but not completely outlining every particular, may have been kept to a minimum to preserve the drawing for future use. There appears to be just enough incision to mark the location on the painted surface.[21] Barocci's wish to preserve the Windsor sheet was doubtless motivated by his intention to reuse the handsome template he had created: Anchises's head served, in reverse, as the model for his painting *Saint Jerome in Penitence* (Galleria Borghese, Rome).[22] Because the latter was engraved by Francesco Villamena in 1600, the painting must be roughly contemporary with the *Aeneas,* although of course the Windsor drawing, like the other studies for the picture, was presumably created in 1586–89, for the first version of the work. Many years later, Barocci used the head again, as the model for the bishop saint at the left in the *Lamentation* painting left unfinished at his death in 1612 (fig. 21).

Barocci's emotional and dynamic Creusa is one of his most successful female figures. As with Aeneas and Anchises, his earliest deliberations for Creusa seem to be lost; all seven known drawings for the figure essentially correspond to her final position. The earliest is probably a drawing in the Uffizi, which studies the full figure in the nude.[23] It seems unlikely that this drawing was based on a living model, male or female: her neck is overlong; her shoulders are disproportionately narrow; and her breasts are treated in a summary, formulaic fashion. The next study for Creusa combines an examination of the full figure with a closer rendering of both hands. This drawing (cat. 16.3 recto) provides another summary treatment of the full body, with little interior definition or anatomical detail. The two studies of her expressive left hand, with its splayed fingers, and the single study of the right hand, which rather incongruously plays with her hair in the painting, show that these two extremities had been designed in essentially their final form by this juncture. Nevertheless, the indefatigable Barocci revisited the limbs in two further drawings: a cursory sketch of Creusa's left arm[24]; and a detailed study of both the left and right hands and forearms (cat. 16.4). This handsome and colorful drawing features two renderings of the right hand, which in the more finished version includes what must have been intended as Creusa's wedding ring, a detail that was elimi-

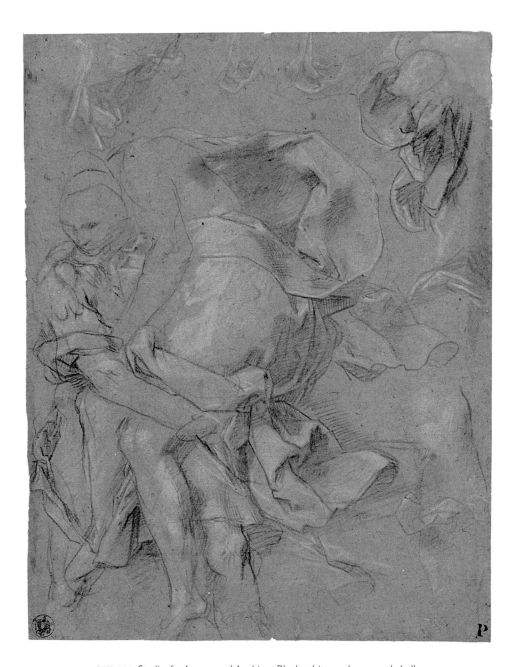

CAT. 16.1. *Studies for Aeneas and Anchises.* Black, white, and some red chalk on gray (faded blue) paper, 10¹¹⁄₁₆ x 8¹⁄₁₆ in. (27.2 x 20.5 cm). Kupferstichkabinett, Staatliche Museen zu Berlin, inv. KdZ 20294 (4417)

nated in the painting. Barocci also studied, more cursorily, the sleeve and right wrist, and then drew his most detailed surviving study of the left forearm and hand. A hand with splayed fingers was a favorite motif of the artist's. It was employed, with variations, also in the Perugia *Deposition* (cat. 3), the Vatican *Annunciation* (cat. 9), the *Martyrdom of Saint Vitalis* (fig. 9), three figures in the late *Assumption* (fig. 22), the *Institution of the Eucharist* (cat. 18), the *Last*

Supper (cat. 12), and the late *Beata Michelina* (Vatican Museum).

Three further drawings are associated with Creusa. The first, in Berlin, is the only extant study of the full figure with drapery.[25] Creusa's complex draperies must surely have been explored in other drawings, which have not survived. Despite its abraded condition, the Berlin drawing shows Barocci's concern with the play of light over Creusa's clothing but does

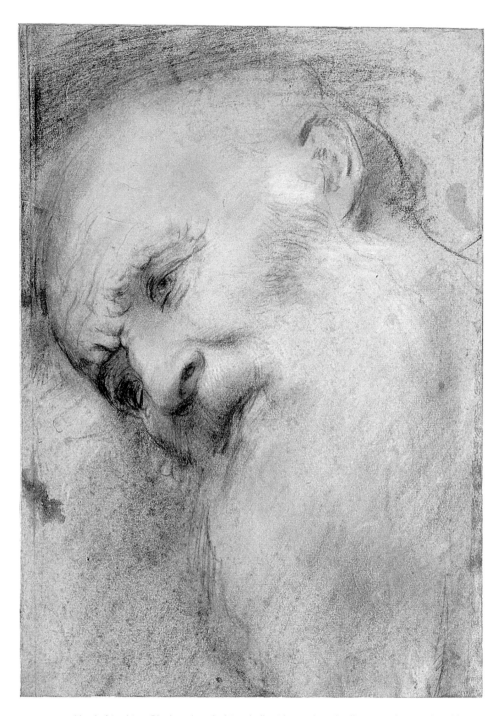

CAT. 16.2. *Head of Anchises*. Black, red, and white chalk with peach and yellow pastel, incised, on blue paper, laid down, 14⅞ x 10³⁄₁₆ in. (37.8 x 25.9 cm). The Royal Collection, Windsor Castle, inv. 5233

not depict all the abundant, fluttering draperies that in the painting almost entirely conceal the form of her body. Apart from the revealed areas of shoulder, hands, and right leg, the body is completely obscured beneath the plentiful draperies. The two final drawings Barocci used for Creusa were first made for another painting, twenty years earlier. His magnificent head study in Besançon, created for one of the Marys in the *Deposition* (cat. 3.7), provided the basis

for Creusa, to whom he gave a completely different coiffure. While the Besançon drawing is not incised for transfer, Barocci incised the cartoon fragment for this head in the Albertina (cat. 3.8), which he employed again for Creusa. This skilled reuse of his figures, each time with distinctive and creative differences, was a hallmark of his procedure.

Only two autograph sheets can be definitely connected today with Ascanius.[26]

Barocci made one drawing that studies the boy's left leg and left arm, portraying both limbs in essentially their final positions.[27] The second, more finished drawing for Ascanius is the head study now in the Getty Museum, a vividly colored sheet in black, red, and white chalk with peach pastel and some incision on blue paper.[28] A drawing in Princeton related to Ascanius has been ascribed to Barocci, but it seems more likely to be by a member of his

workshop.[29] The artist must have made other preparatory studies for Ascanius, but apart from his unclothed forearm, right leg, and face, the abundant draperies of his clothing effectively conceal the form of his body.

An anomalous category of preparatory drawings for *Aeneas Fleeing Troy* consists of the four studies for the classical architecture in the background. A rough sketch in the Uffizi, on the verso of a study for Creusa, was done freehand in black chalk, without the benefit of a straightedge.[30] This sheet records Barocci's first foray into designing the background space; most elements were subsequently revised. A second, previously unpublished sketch in the Biblioteca Ambrosiana (fig. 86) is further advanced in the artist's creative deliberations.[31] Here he portrayed some of the buildings in the painting, most notably the circular, domed edifice, as well as the clouds of smoke that rise from the burning city. The round building was further explored in a densely squared, nearly illegible sketch now in Urbania,[32] but the detailed description of this building was fully realized in a finished study in the Uffizi.[33] This large and detailed drawing was created meticulously with a straightedge, and the proportions of the building were carefully designed to adhere to precise mathematical formulae, with columns whose height is exactly half the measurement of the entablature's width.

Although Bellori reported that Barocci studied architecture under Bartolomeo Genga and was learned in architecture and perspective, few paintings testify to these skills. Barocci's admiration for the famous Tempietto of his compatriot Bramante is expressed both here and in his late *Madonna Albani*. Stuart Lingo observed that there are differences between Bramante's building and Barocci's realizations of it and suggested that the painter probably used as a model Sebastiano Serlio's woodcut of the building in the *Terzo Libro* of his *Architettura* (Venice, 1540). This hypothesis is plausible, both because Barocci had not visited Rome for many years when he painted the *Aeneas,* and also because he appears to have based the adjacent Column of Trajan on the same source. Lingo further proposed that Barocci transformed the Tempietto to make it more appropriate for a scene from ancient history by using the Doric order, which is linked to an earlier historical period.[34]

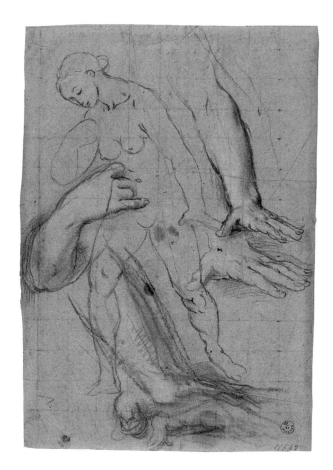

CAT. 16.3. *Study for Creusa* (recto). Black and white chalk with charcoal and stump, incised, squared in black chalk, on blue paper. [Verso: Studies for Aeneas and Anchises. Black and white chalk], 14⅞ × 10³⁄₁₆ in. (37.8 × 25.8 cm). Gabinetto Disegni e Stampe degli Uffizi, Florence, inv. 11642 F.

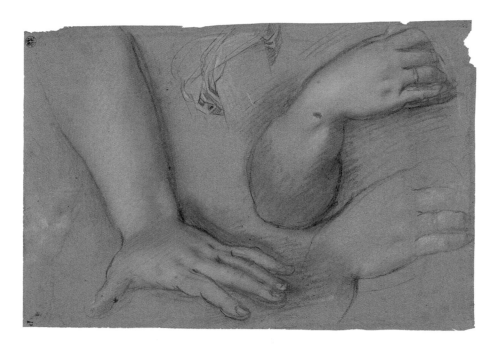

CAT. 16.4. *Two studies of Creusa's right hand and one study for her left hand and forearm.* Black, red, and white chalk with pink pastel on blue paper, 10⅝ × 16⅛ in. (27 × 41 cm). Kupferstichkabinett, Staatliche Museen zu Berlin, inv. KdZ 20274 (4224)

Fig. 86. *Architectural sketches for Aeneas Fleeing Troy*. Pen and brown ink over black chalk, with some incision, 13.1 x 19.2 cm. Veneranda Biblioteca Ambrosiana, Milan, inv. F. 281 inf. n. 29 bis verso

Lingo's compelling suggestions imply that Barocci used architecture with learned sophistication for iconographic purposes. But why did he produce such a large, finished drawing of this building? The only other sheet in his oeuvre that is comparable in any way is the *cartoncino per il chiaroscuro* for *Il Perdono* from the Hermitage (cat. 5.7). But that drawing, unlike the Uffizi sheet, is a design for the full composition and performed a designated role in Barocci's creative process. The Tempietto study is anomalous and thus difficult to explain. Perhaps he intended to sell the sheet to a collector with an interest in Bramante's architecture, but existing evidence does not confirm this hypothesis.

As noted above, both a full-scale cartoon and a *cartoncino per il chiaroscuro* for *Aeneas Fleeing Troy* have survived. The cartoon (fig. 87) includes little of the background (as is true of most of Barocci's surviving cartoons) but provides a full template for the four principal figures. Although their poses correspond closely to those in the Borghese picture, the background architecture is quite different, and, as several authors have suggested, it probably corresponds to the first, lost version of the picture. The cartoon demonstrates an understandable emphasis on contour, although the figures are also modeled and shaded effectively to cre-

ate a sense of three-dimensionality. Many contours were incised for transfer to the painting, particularly the external outlines of the figures, but incision is not evident in all the details of the draperies.

As is typical for Barocci, his *cartoncino per il chiaroscuro* (cat. 16.5) provides a far more detailed rendering of the composition than that depicted in the larger cartoon. This luminous *cartoncino* was only recently recognized as Barocci's autograph drawing.[35] First listed in an early inventory at Windsor Castle as a copy after Barocci,[36] the drawing was subsequently ascribed to Agostino Carracci, who in 1595 made a reproductive engraving after Barocci's first composition (cat. 16.6), three years before the Borghese version of the *Aeneas* painting was completed. Agostino's print was dedicated to Cardinal Odoardo Farnese, who probably commissioned it, and who may have convinced Barocci to supply a model.[37] Carlo Cesare Malvasia, Agostino's seventeenth-century Bolognese biographer, reported that this work was made expressly to please Barocci, to whom Carracci sent two impressions. But Barocci disliked the print, according to the patriotic Bolognese Malvasia's biased account, because it had surpassed the original painting.[38] Whatever Barocci's reasons for disliking Carracci's engraving, it otherwise enjoyed tremendous critical

success. Both Pierre-Jean Mariette and Adam von Bartsch praised it as one of Agostino's most famous engravings.[39] The numerous surviving impressions and high praise in the literature testify to the print's widespread popularity and success. Agostino's engraving is larger than Barocci's *cartoncino*, which may well have served as the model for the print. Because the first painting was in Prague, and the second painting had not yet been produced in 1595, Agostino must have worked from a drawing, and the *cartoncino* is the most likely candidate. In this instance, it seems that Barocci found yet another purpose for his *cartoncino per il chiaroscuro*: providing a model for a reproductive print.

The Windsor *cartoncino* is among Barocci's most lavishly finished and detailed instruments of design. It does full justice to the raging fires consuming the city, closely attending to the rich range of light and shadow created by the flames. The figures are fully portrayed in every detail, with billowing draperies, articulated musculature, and elaborate clothing. It seems likely that Barocci intended from the outset to use this *cartoncino* as a model for future replication, employing it for both his painted replica for Borghese and for Agostino's print. The beauty of the sheet made it an attractive collectible for prominent early connoisseurs; the trace of gilding on the outer edge may point to its

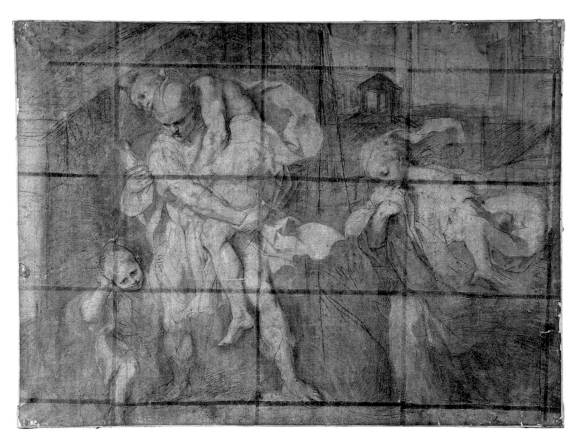

Fig. 87. *Cartoon.* Charcoal and white chalk, incised, on twenty-five sheets, joined together,
58¼ x 74³⁄₁₆ in. (148 x 190 cm). Musée du Louvre, Département des Arts Graphiques, Paris, inv. 35774

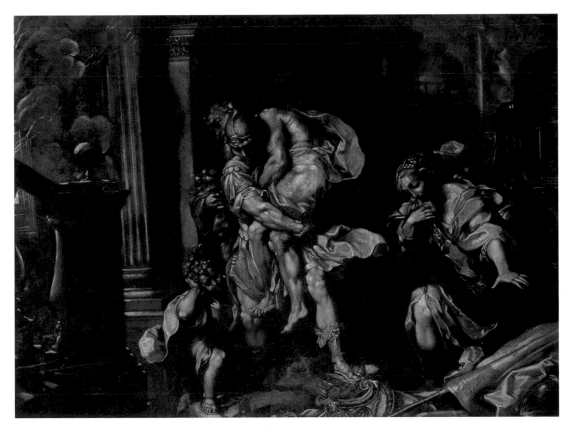

CAT. 16.5. *Cartoncino per il chiaroscuro.* Pen and brown ink over black chalk, with brown oil paint heightened with white,
13⁷⁄₁₆ x 17¹⁵⁄₁₆ in. (34.2 x 45.5 cm). The Royal Collection, Windsor Castle, inv. 2343

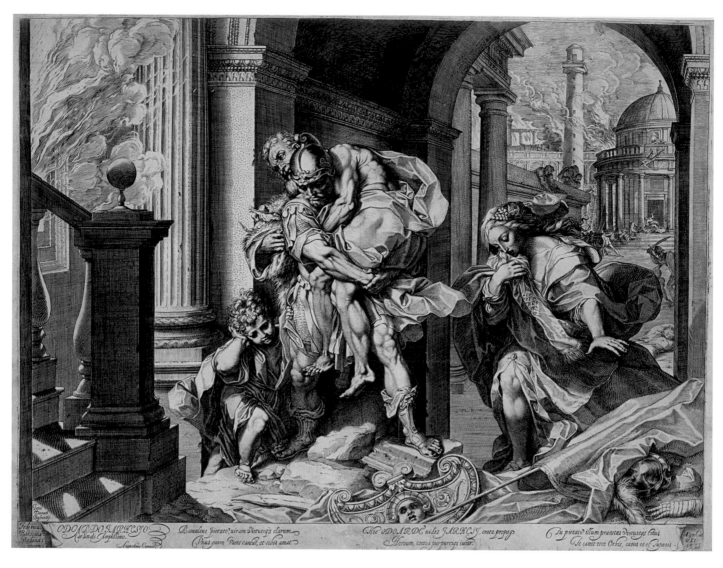

CAT. 16.6. Agostino Carracci after Barocci, *Aeneas Fleeing Troy*, 1595. Engraving, 15⅞ x 20¹¹⁄₁₆ in. (40.4 x 52.6 cm).
Inscribed lower left, above margin: "Typis Donati Rasecottij"; in margin lower left: "Federicus / Barocius / Urbinas / inven:";
four two-line inscriptions in lower margin: "ODOARDO FARNESIO / Cardinali Amplissimo. / Augustinus Carracci.⁵ . . . Te danit ecce Orbis,
carus et superis"; in margin lower right: "Aᵘgo. Car. / Fe / 1595." The British Museum, London, inv. V,8.186

ownership by the great early collector Everhard Jabach, and it may be the *cartoncino* listed in the sale of Pierre Crozat's famous collection as well.⁴⁰

Aeneas Fleeing Troy is anomalous in Barocci's production for its secular narrative subject and unusual for its repetition in a second autograph replica. Also exceptional is the group of four architectural studies for this picture, which were no doubt inspired by the setting of the story in ancient Troy. A more characteristic feature of the preparatory drawings for the work is the heavy concentration on preparing hands and feet, a preoccupation that may be found throughout the artist's career. Also typical is his reuse of templates in other pictures. Just as the head of Creusa repeated a head from his earlier *Deposition,* so that of Anchises, conceived for the *Aeneas* picture, was recycled as the model for a Saint Jerome and for a bishop saint in two later paintings. Barocci's inventiveness, combined with his skill in repetition, is a signature feature of his mature artistry.

Babette Bohn

NOTES

1 Emperor Rudolf communicated his desire for a painting by Barocci through his ambassadors, who approached Girolamo Nucci, the duke's representative in Venice. A letter of 29 September 1586, from the duke to Grazioso Graziosi, his minister in Rome, acknowledged this request, specifying the emperor's preference for a secular subject. A second letter from the duke to Graziosi (14 December 1589) noted that the painting was sent to the emperor "many months ago" (Gronau 1936, 163–64). The payments to Barocci are documented in the duke's "Note di spese" beginning on 25 March 1587 (Sangiorgi 1989, c. 708–9).

2 The duke's note to this effect was published by Gronau 1936, 28, 164.

3 Campori 1870, 346.

4 Richardson 1728, 282–83.

5 Bellori 1672 (1976), 202–3; Scannelli 1657 (1989), 196–97; Baldinucci 1681–1728 (1974–75), 3, 401; E 2008, 2, 58–70, no. 46.

6 Barocci's other signed paintings are: the *Madonna del Popolo*, signed and dated 1579; the *Entombment*, signed and dated 1582; the *Martyrdom of Saint Vitalis*, signed and dated 1583; the *Calling of Saint Andrew*, signed and dated 1586; *Christ Appearing to Mary Magdalen*, signed and dated 1590; the *Circumcision*, signed and dated 1590; the Genoa *Crucifixion*, signed and dated 1596; the Borghese *Saint Jerome*, signed but undated; and the *Portrait of a Nobleman*, private collection, London, signed and dated 1602.

7 Baldinucci 1681–1728 (1974–75), 3, 401; Bellori 1672 (1976), 202–3.

8 On Emperor Rudolf II's art patronage, see Kaufmann 1988.

9 Gillgren 2011, 164, suggested that the Tempietto in the background refers to the Roman Temple of Vesta, likewise a circular building (thereby making an allusion to the Sack of Rome), and that it was the place from which Aeneas saved the holy images his father carries. However, this contradicts Virgil's account that Anchises took their own household gods.

10 E 2008, 2, 60.

11 Gillgren 2011, 164–65, suggested that the boy's left leg is stuck in the rubble, but it seems to me that he is simply in the process of climbing up. Gillgren's rather farfetched reading of the iconography as referencing Saint Peter is not convincing, nor can I concur with his reading of Barocci's Aeneas as hesitant and "at a loss" (167).

12 On Genga's fresco *Aeneas Fleeing Troy*, see Torriti, 1978, 50–52, no. 334, illustrated. A list of painted, printed, and sculpted examples of this subject was given by Marcello Fagiolo et al., *Virgilio nell'arte e nella cultura europea*, exh. cat., Biblioteca Nazionale Centrale (Rome, 1981), 203–4, which illustrates the engraving, 210, fig. 8. Ugo da Carpi's print was catalogued and illustrated in Manuela Rossi, ed., *Ugo da Carpi, l'opera incise: Xilografie e chiaroscuro da Tiziano, Raffaello e Parmigianino*, exh. cat., Palazzo dei Pio, Carpi (n.p., 2009), 130–31, no. 20. Ludovico Carracci's fresco of the subject (Palazzo Fava, Bologna) does include Creusa, but it is datable to ca. 1593 and was in any case probably not known to Barocci. On the Carraccis' Aeneas frescoes, see Alessandro Brogi, *Ludovico Carracci (1555–1619)* (Bologna, 2002), 1, 162–65, no. 51, and 2, pls. 118–30. One other example of the subject from the Marches that includes Creusa is a majolica dish produced in Casteldurante during the mid-sixteenth century and now in the Victoria and Albert Museum, London, inv. C.2081-1910, illustrated on the museum's web site.

13 The attribution to Barocci of a compositional drawing in the Cleveland Museum of Art, inv. 1960.26 (by Olsen 1962, 77–78; Pillsbury and Richards 1978, 77–78, no. 54; and E 2008, 2, 63–64, no. 46.4, illustrated) is not accepted here, though I have seen only photographs of this work.

14 The sheets published by Emiliani that are not accepted as autograph works here are the Cleveland drawing (see n. 13) and a drawing in the Princeton Art Museum (inv. 47-119), a study after Ascanius that Emiliani termed a retouched original. For a discussion of earlier opinions on the attribution of the Princeton drawing, see E 2008, 2, 70, no. 46.21. Emiliani (2008, 2, 65, no. 46.7, illustrated) also published a drawing formerly in the. J. Q. van Regteren Altena collection, Amsterdam, as a study for Creusa in reverse, but the pose is too far from that of the painted figure to sustain this connection. The drawing, now in the Rijksmuseum (fig. 31), actually prepared the mother and child at the right in the *Madonna del Popolo*. There are studies on both the recto and verso for these two figures.

15 Architectural studies: Uffizi inv. Arch. 135A, illustrated in Lingo 2008, 179, fig. 151, and Biblioteca Ambrosiana inv. F. 281 inf. n. 29 bis verso (fig. 86); head of Ascanius: Getty Museum inv. 94.GB.35. Another drawing previously called an autograph study for the painting but not in Emiliani's monograph is a study for Aeneas and Anchises (Musée des Beaux-Arts, Lille, inv. W. 4458; formerly in the collections of Alessandro Maggiori and then Duke Roberto Ferretti; sold Christie's, London, 2 July 1996, lot 5; published in *Italian Drawings from the Collection of Duke Roberto Ferretti*, exh. cat., Art Gallery of Ontario [Toronto, 1985]). Although the figures in the drawing are close to those in the painting, and the technique—black chalk with incision—is characteristic of Barocci, certain anatomical weaknesses and the uncharacteristic interior modeling suggest that the drawing is not by the master but by a member of his studio.

16 Inv. 11642 F. verso, E 2008, 2, 66, no. 46.13, illustrated.

17 Formerly Christie's, New York, 22 January 2004, lot 20; see E 2008, 2, 70, no. 46.22.

18 Inv. KdZ 20262 (4268), E 2008, 2, 69, no. 46.18.

19 Uffizi inv. 11666 F., E 2008, 2, 69, no. 46.17, illustrated. A two-sided drawing of feet in the Uffizi (inv. 11656 F.) may be a study for either Aeneas's feet or for those of Christ in *Christ Appearing to Mary Magdalen* (fig. 12).

20 Uffizi inv. 11650 F., E 2008, 2, 67–69, no. 46.16, illustrated.

21 See my essay, 41, for further discussion of this phenomenon.

22 On the *Saint Jerome*, see E 2008, 2, 168–71, no. 58, illustrated.

23 Inv. 11296 F. recto, E 2008, 2, 65, no. 46.9, illustrated.

24 This sheet, now in a private collection, also includes a study of Aeneas's right arm and is noted above, in the discussion of Aeneas.

25 Inv. KdZ 4588 (49-1912), E 2008, 2, 66, no. 46.10.

26 A third drawing (Berlin inv. KdZ 20353 [4421]) may have been an early idea for Ascanius, but it seems more likely to have been made to prepare the figure of Judas in the *Institution of the Eucharist* (cat. 18).

27 Berlin inv. KdZ 20293 (4240), E 2008, 2, 66, no. 46.11.

28 Inv. 94.GB.35. Although not included in Emiliani's monograph, this drawing was published by Turner, Hendrix, and Plazzotta 1988, 7–9, no. 3.

29 Inv. 47-119, E 2008, 2, 70, no. 46.21, illustrated and catalogued as autograph. The attribution was also rejected by Turner, Hendrix, and Plazzotta 1988.

30 Inv. 11296 F. verso, E 2008, 2, 64, no. 46.5, illustrated.

31 On the recto is a cityscape in the same media.

32 Inv. II 137.464 verso, E 2008, 2, 69, no. 46.20.

33 Not in E 2008; published by Shearman 1976, 51, and Lingo 2008, 179, fig. 151.

34 Lingo 2008, 177–86.

35 Boesten-Stengel 2001; Scrase 2006, 168–71, no. 59.

36 Wittkower 1952, 113, no. 99.

37 On Agostino's print, see Bohn 1995, 284–88, no. 192.

38 Malvasia 1678 (1841), 1, 76, and 293.

39 Bartsch 1803–21, vol. 18, 99, no. 110; Mariette 1851–53, 69.

40 See Scrase 2006, 168–69, no. 59.

Provenance: Painted for Monsignor Giuliano della Rovere; probably a gift from him to Cardinal Scipione Borghese; in 1613, documented in the Borghese collection, Rome; Galleria Borghese, Rome

Bibliography: Scannelli 1657 (1989), 196–97; Bellori 1672 (1976), 202–3; Bellori 1672 (2000), 188; Malvasia 1678 (1841), 401; Baldinucci 1681–1728 (1974–75), 3, 401; Richardson 1728, 282; Schmarsow 1909, 18; Schmarsow 1909 (2010), 118–22; Krommes 1912, 80–81; Calzini 1913b, 80; Di Pietro 1913, 70–77; Schmarsow 1914, 14; Gronau 1936, 163–64, 197; Popham and Wilde 1949, 190, no. 98; Wittkower 1952, no. 99; Richards 1961; Olsen 1962, no. 39; Bacou 1974, 13, no. 14; Bertelà 1975, 61, no. 56; Emiliani 1975, 150–53, nos. 163–66; Pillsbury 1976, 57–58 and 63; Pillsbury and Richards 1978, 77–78, nos. 54–55, and 108–9, no. 79; DeGrazia Bohlin 1979, 326–28, no. 203a; Emiliani 1985, 2, 230–37; Bohn 1995, 284–88; Fontana 1997b, 47, n. 107; Turner 2000, 108–11; Boesten-Stengel 2001; Bohn 2004, 284–88; Scrase 2006, 168–71, no. 59; E 2008, 2, 58–70, no. 46; Lingo 2008, 177–86; Marciari and Verstegen 2008, 311, n. 69; Loisel, Tosini, and Cerboni Baiardi 2009, nos. 72–74; Gillgren 2011, 162–68, and 253–54, no. 24.

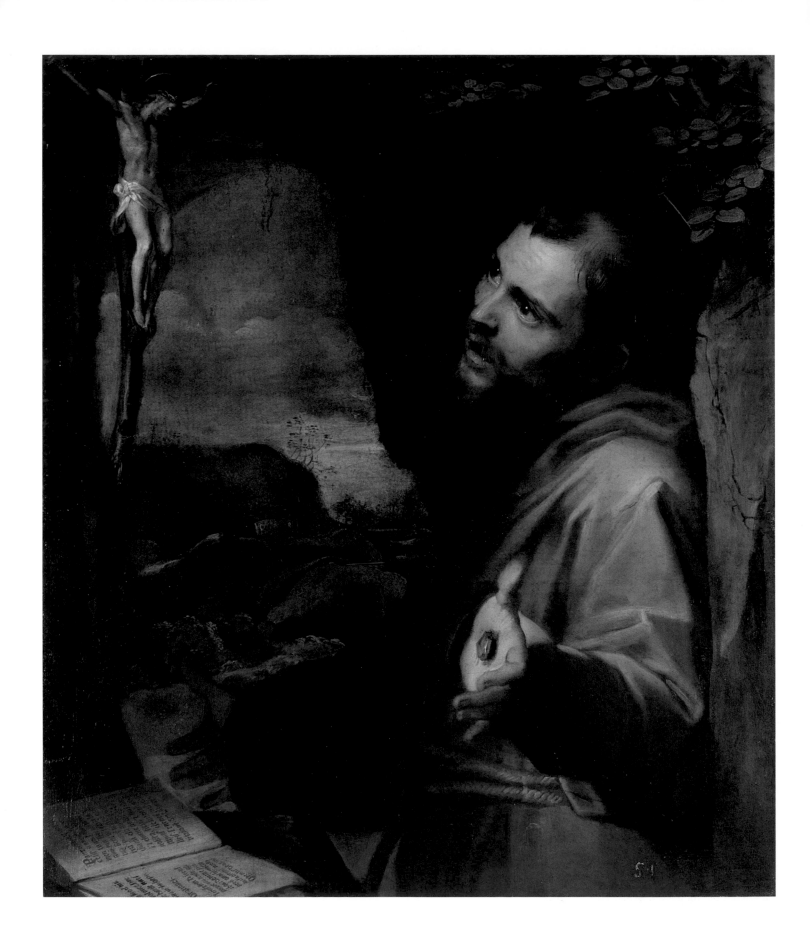

CAT. 17. *Saint Francis in Prayer*, ca. 1604–6. Oil on canvas, unlined, 35⅜ x 30⅞ in. (89.9 x 78.4 cm) (with added strips, 35⅞ x 31⅜ in. [91.1 x 79.7 cm]).
The Metropolitan Museum of Art, Purchase, Lila Acheson Wallace Gift and 2002 Benefit Fund, 2003, inv. 2003.281

Saint Francis in Prayer

The latest addition to Barocci's oeuvre, this picture received no mention in Bellori's biography. It was untraced until the Metropolitan Museum of Art bought it in 2003. It represents a type of image that was ubiquitous in the sixteenth and seventeenth centuries: the half-length, close-up view of a saint in the throes of penance or prayer, intended to evoke personal meditation. As he did in almost every instance, Barocci took a type—Saint Francis in private prayer—and created a completely new and original interpretation of a simple theme. Painted during the last decade of the artist's life, this small picture had obvious resonance for Barocci himself, for his lifelong dedication to Saint Francis and various Franciscan establishments in and around Urbino is well known (see cat. 13).

Barocci has depicted Francis in reclusive prayer, as described in several sources on the saint's life. In order to underscore a popular understanding of Saint Francis as a type of "new Christ," the artist has incorporated a direct reference to a section of the *Revelations of Saint Bridget,* a text that focused on the Virgin's account of the wounds and suffering of Jesus. In doing so, Barocci created a direct appeal for meditation on the physicality of Christ's suffering, evoking Saint Francis as the reenactment of this aspect of Christ's sacrifice. Only one extant drawing was made specifically for this picture— a head study from the Ashmolean Museum, Oxford (cat. 17.1). There are, however, two other related drawings for the pose of Saint Francis that were first developed in relation to Barocci's late altarpiece of *Christ Taking Leave of His Mother* (ca. 1604–12; fig. 20).[1] The half-length figure seen here was based on Barocci's designs for that altarpiece, and the drawings demonstrate the adjustments he made to adapt the figure for personal devotion.

The painting shows Saint Francis posed against the rough-hewn rock of a cave wall. He faces left and inclines his head toward his left shoulder, extending both arms. His left arm appears nearly to break out of the confines of the canvas; a nail with a large head, surrounded by blood, penetrates his left palm. A prayer book lies open before him; on the right page,

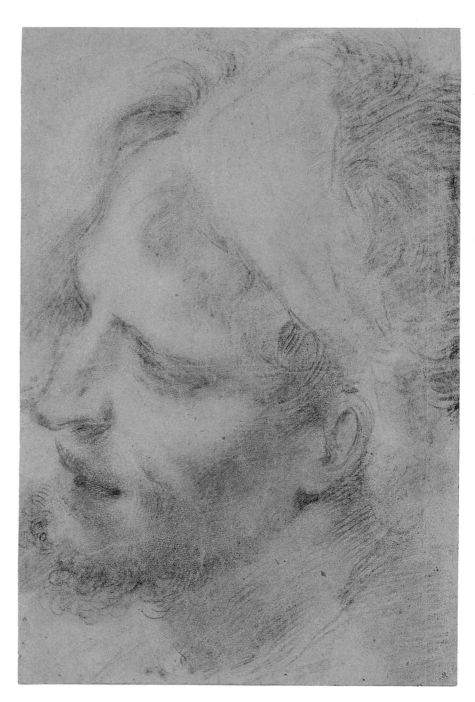

CAT. 17.1. *Study for the head of Saint Francis.* Black and red chalk with peach and yellow pastel on blue paper, laid down, 14⅞ x 10 in. (37.8 x 25.4 cm). The Ashmolean Museum of Art and Archaeology, Oxford, Purchased 1937, inv. WA1937.297

recorded in red letters, is the Lord's Prayer. The left page appears likewise to contain a prayer, but the text, although legible, has not been identified. A crucifix stands above the book, a crude stick on which hangs the diminutive body of Christ. Without a chest wound, the figure must be intended to recall a point in time after the Crucifixion yet before a soldier pierced his side to test whether he was dead (as recounted in John 19:32–34). Christ's head leans toward his left, creating a diagonal counter to that of Saint Francis. A distant landscape is visible through the arched cave opening. The sky has darkened; lingering streaks of evening light appear near the horizon. The landscape is hilly, with a single church nestled among its rocky contours.

Images of the half-length Saint Francis became especially popular in the late sixteenth century, part of a new interest in penitential saints as models for meditation. Perhaps first developed by the Brescian painter Girolamo Muziano for a series of prints that were issued in the 1570s, they were produced in most major artistic centers of Italy by such artists as Ludovico Cigoli (Florence), the Carracci (Bologna), and El Greco, reflecting their popularity in the Veneto.[2] Although some of these pictures represent Francis experiencing a vision or receiving the stigmata, the depiction of the saint in prayer usually shows him half-length and includes a dark cave setting and a crucifix. Skulls and prayer books sometimes appear but are not necessarily required. Two elements distinguish Barocci's representation: the assertive position of the saint's left hand, which extends toward the viewer to display the protruding nail head; and the position of Christ's legs, with the left foot on top of the right. These components make the image particularly effective in inspiring prayer related to Francis's role as a typological parallel to Christ, called in Latin *Franciscus alter Christus* (Francis as a second Christ). This medieval belief in Francis as a Christlike figure had a resurgence after 1590, when an earlier treatise on Francis as the new Christ was reissued.[3] It has already been discussed in relationship to Barocci's narrative image of the *Stigmatization of Saint Francis* (cat. 13), and it is equally important here in this smaller devotional picture, in which Francis's wounds are so vividly evoked. No other image so forcefully presents Francis's bloody

palm, suggesting the physical sensation of the metal nail that has been pushed through the flesh. Certainly Barocci was inspired to depict the protruding nail head by the source that he must have consulted for both his earlier *Stigmatization* altarpiece and this devotional picture—the fourteenth-century *I Fioretti* (*Little Flowers of Saint Francis*).[4] In that account, Saint Francis's reception of the wounds of Christ is described specifically in terms of nails that penetrated the flesh of his palms so that their points protruded through the backs of his hands. Such emphasis on physical suffering is characteristic of late-sixteenth-century faith, where the devout Christian was expected to imagine the tactile quality of Christ's torment. Contemporary theologians, most notably Saint Ignatius Loyola, exhorted their readers to try to imagine, through physical sensation, this aspect of Christ's ordeal. Barocci demonstrated a sensibility far more akin to the drama and immediacy of Baroque painters such as Caravaggio and Rubens in his bold evocation of the physical and his clear challenge to the implied separation between viewer and viewed.

Barocci added a further gloss on Christ's suffering by alluding to another popular meditational guide. As noted above, Christ on the cross with his left foot over his right is extremely rare in images of the Crucifixion or in images of Francis adoring the cross, although Barocci experimented with the pose earlier in his career. As he developed his *Crucifixion* altarpiece in the late 1560s (cat. 2), he included this very pose in a preliminary compositional study (fig. 45), but he abandoned it in the finished painting. This idea was first suggested to him by one of Michelangelo's late Crucifixion drawings, which Barocci must have seen when he was in Rome during the 1550s or 1560s.[5] The pose can be traced to the fourteenth-century mystic Saint Bridget, whose *Revelations* were first issued in 1492 and published in Italian in 1556.[6] Bridget experienced a number of visions. During one, the Virgin appeared to her and described in painstaking detail the terrible torments inflicted on Christ, part of an extended narrative on his life leading up to the Crucifixion. The account emphasized with vivid vocabulary filled with references to sensate experience the painful wounds and profuse bleeding Jesus experienced. A short passage demonstrates the power and physicality of the

imagery: "Then they crucified his right foot with the left foot on top of it using two nails so that all his sinews and veins became overstrained and burst. After that they put the crown of thorns on his head and it cut so deeply into my Son's venerable head that the blood filled his eyes as it flowed, blocked up his ears and stained his beard as it ran down."[7]

The painting eschews the blood imagery so evocatively described in Bridget's passage; in fact, Barocci almost always avoided blood and gore in his representations of the crucified Christ. When the totality of Barocci's oeuvre is reviewed, it is clear that he made careful selections when representing any subject. Therefore, his choice of Christ's pose must be taken as meaningful intention and not mere serendipity.[8] By alluding to Bridget's writings, Barocci framed the very physical presence of Saint Francis's wounds with the recollection of the horror of Christ's torture (on the part of both Saint Francis and the contemporary viewer).

Christ is shown with only one nail through both feet, following tradition rather than the text.[9] The number of nails used to crucify Jesus was the topic of considerable debate during the period, with some theologians arguing for four nails and others for three.[10] There was no official rule, but in Italy artists generally favored three nails. Barocci's choice may have been dictated, in part, by the complexity of painting a nail in each foot and his recognition that the placement of the left foot on top was adequate reference to Saint Bridget's description.

Barocci made reference to a text that a devout viewer would undoubtedly have known. Keith Christiansen suggested that this painting may have been intended as a gift to a cleric, perhaps someone involved with planning Barocci's own burial.[11] It is difficult to know its precise purpose, but Christiansen's argument for a late date seems to be generally correct. It was most likely executed at the same time that Barocci developed the *Christ Taking Leave of His Mother*, ca. 1604–12 (fig. 20), in Chantilly, as Christiansen also noted.[12] The Chantilly altarpiece portrays a rarely represented episode in Christ's life, derived from the thirteenth-century account in the *Meditations on the Life of Christ*, attributed to the writer known as the Pseudo-Bonaventure. It tells of a visit Jesus made to Mary before his Crucifixion to warn her of his impending death.[13] Barocci's unfinished altar-

piece depicts Christ standing in the center of the composition, raising his right hand to bless his seated mother, who is assisted by Saint John the Evangelist. Mary Magdalen stoops at the lower right, presumably preparing to anoint Christ or to kiss his feet. Behind her kneels Saint Francis, evidence that the altarpiece was intended for a Franciscan church.[14] Because this painting was left unfinished at Barocci's death, it has rightly been considered a product of his last years.[15] Although most scholars consider the picture an autograph work, it was most likely designed by Barocci and executed by him with workshop assistance.[16] The rote application of paint and harder contours for the figures suggest the intervention of a hand or hands other than Barocci's.

The close relationship of the saint in the *Saint Francis in Prayer* to the same figure in the Chantilly altarpiece suggests the pictures are close in date. Christiansen dated the *Saint Francis in Prayer* to between 1600 and 1604, but Emiliani placed the painting in the 1570s, based on its naturalism as well as affinities with the figure of Saint Francis found in Barocci's early altarpiece in the Pinacoteca di Brera, Milan (fig. 5).[17] A later date, however, seems more plausible. The elegiac mood of the *Saint Francis in Prayer,* its nearly monochromatic palette, and a sensibility of intense inner spirituality similar to Barocci's monumental *Christ Expiring on the Cross,* 1600–1604 (fig. 18), argue for dating it to the last decade of Barocci's life, when he worked on the Chantilly altarpiece. Christiansen, maintaining that the New York painting predates the Chantilly canvas, based his argument on the relationship between the pose of Christ in the Chantilly painting and the same figure in yet another work, the *Institution of the Eucharist,* executed for Pope Clement VIII, 1603–9 (cat. 18). Christiansen suggested that the Christ in the *Institution of the Eucharist* is based on the figure in *Christ Taking Leave of His Mother.* A letter dated 1604 instructs Barocci to revise Christ's hand gesture in the *Institution of the Eucharist;* Christiansen therefore argued that the Chantilly picture must have been developed prior to that date if it served as the model for the Jesus in the *Institution.*[18] Because he found the Chantilly picture to be largely by studio assistants, whereas the *Saint Francis in Prayer* is entirely autograph, he believed that the Metropolitan picture came before the 1604

date of the altarpiece, based on the hypothesis that as the artist aged, he turned more work over to his workshop.[19]

However, the relationship between the figure of Saint Francis in the Chantilly altarpiece and the *Saint Francis in Prayer* is not so straightforward, and the evidence of the two extant drawings suggests that Barocci may have worked on the two paintings simultaneously. After first establishing Francis's pose in the Chantilly painting, he adapted it for the smaller devotional image. Because the saint's role in the Chantilly picture was probably to acknowledge the Franciscan affiliation of the church in which the painting was to hang, Barocci's task was to define a pose for this secondary figure that allowed him graceful entry into the composition.[20] As an observer and a believer, Francis extends his arms, no doubt in part to remind viewers of his stigmatization, signaling his particular role as a sufferer who shared Christ's wounds. A sheet in the Martin-von-Wagner-Museum, Würzburg (fig. 88), presents Barocci's earliest surviving sketches for this figure.[21] The study shows how Barocci defined the overall pose at the right, with light falling on the left shoulder. He then reexamined the hand several times on the left half of the sheet, where the primary drawing shows the fingers slightly separated and the hand opened out more toward the viewer. He also used white chalk to indicate the luminosity of the palm, an idea he carried into the altarpiece, albeit with a different hand position.

A second sketch, now in the Biblioteca Oliveriana, Pesaro (fig. 89), records alterations in the saint's pose.[22] Barocci turned the figure slightly clockwise, causing the left hand to move to the left. Furthermore, he opened out the palm of the saint's left hand and rotated the wrist, moving toward the final position, which was used in the Chantilly altarpiece. He also tilted the head farther back. Although Barocci created the Würzburg drawing for the Chantilly altarpiece, it is less apparent whether he made the Pesaro drawing before or after he finalized the position in the altarpiece. However, a number of characteristics suggest the drawing was made to adapt the figure for use in the devotional picture. The angle of the head and the open-mouth expression in the Pesaro sheet come closer to the depiction of the saint in the Metropolitan picture than to the head

position in the altarpiece. Furthermore, the position of the left palm, opened to show the nail, seems far more important for the devotional picture than for the altarpiece, where there is no nail. Given the unfinished status of the Chantilly painting, it seems more likely that Barocci used the Pesaro sheet to refine the pose as he adapted it for the devotional picture. After he completed the latter work, he returned to the altarpiece and revised the position of Saint Francis's hand accordingly.[23] Costume details are identical in both drawings, showing the hook with which the rosary beads could be affixed to the saint's rope belt. Barocci initially transferred this detail to the small *Saint Francis* but then apparently decided against its inclusion and painted over it.[24]

Further evidence for understanding the Pesaro drawing as a transitional sheet between the larger altarpiece and the smaller private picture is the extant head study for Saint Francis (cat. 17.1), a new discovery that echoes the expression of the head shown in the Pesaro sheet.[25] In adapting the figure of Saint Francis, Barocci changed the expression from the observing figure in the altarpiece to the visionary ecstatic that he used in the smaller devotional painting. To this end, he used a live model (perhaps a shop assistant with a rag around his scalp), who was asked to angle his head in the appropriate direction and open his mouth in an expression of devotion.[26] Barocci used red chalk to reinforce those sections of the face that receive the fullest light. The study was not the final position for Saint Francis's head: when he painted the Metropolitan picture, Barocci rotated the head so that the face was shown more fully to the viewer, revealing more of the right eye and cheek. His objective was to position the saint so that the intensity of his prayer could be better appreciated. He also rotated the left hand to make the palm entirely visible in order to maximize the impact of the puncturing nail. Such a working procedure is in keeping with what we see in many of Barocci's paintings, where corrections and adjustments continue through the final application of paint. These late changes are especially apparent on the surface of the *Saint Francis in Prayer,* where Christiansen noted changes throughout the picture.[27]

Taking into account the evidence of the drawings, it seems logical to place the *Saint*

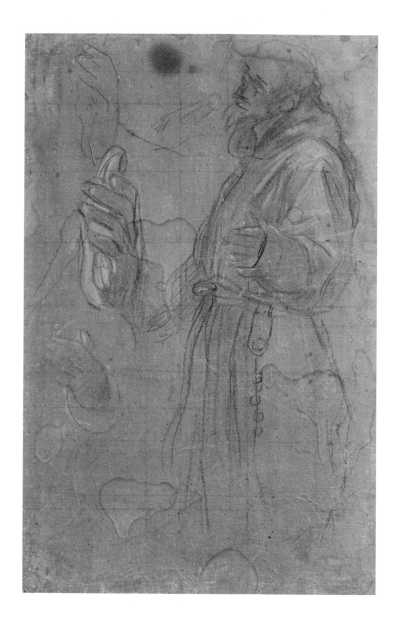

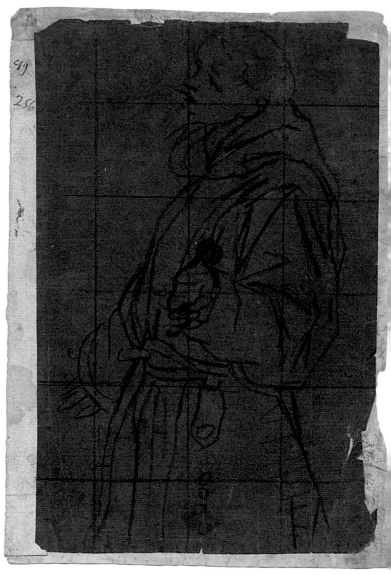

Left: Fig. 88. *Study for Saint Francis*. Black and white chalk, squared in black chalk, on brown paper, 40 x 25.7 cm. Martin-von-Wagner-Museum der Universität Würzburg, inv. HZ 7177

Right: Fig. 89. *Study for Saint Francis*. Black and white chalk squared in black chalk on brown paper, 27.9 x 17.9 cm. Biblioteca Oliveriana, Antaldi Collection, Pesaro, inv. 431

Francis in Prayer slightly later than the 1604 date Christiansen assigned to the design of the Chantilly altarpiece. A date of 1604–6 seems more plausible, although the relationship between the two pictures was fluid and not strictly sequential.

Bellori recorded two instances of similar half-figure devotional pictures that Barocci painted: "For Count Francesco Maria Mamiani Barocci painted two half figures of *Saint Catherine* and *Saint Sebastian,* depicting the latter turned toward the heavenly splendor with arrows in one hand while his other hand is pressed against his chest."[28] Bellori gave no indication as to when Barocci may have painted these pictures; indeed, it is more than likely that he created such images throughout his career. As private devotional works, however, they are less likely to have been recorded in subsequent centuries. One suggestive piece of evidence indicating that Barocci designed such paintings early in his career is contained on the verso of a preparatory drawing for the Bonarelli *Crucifixion* (cat. 2.3 verso). It depicts the upper half of a nude figure facing left, with the head angled toward the right, holding a covered jar. It appears to be a male figure studied from life that was then converted to a female with the addition of longer hair, more feminine facial features, and a breast. The iconography is that of Mary Magdalen, a most popular devotional subject at the time. She was understood to have been a prostitute who renounced sin to follow Christ, making her an ideal example of the power of penance.[29] The sketch may have been part of a series of studies in which Barocci prepared a half-length picture of the penitent Magdalen. All of this suggests that this small *Saint Francis in Prayer*, designed to elicit meditation on the saint's wounds, represents an aspect of Barocci's work that is not yet properly represented among his known oeuvre. If *Saint Francis in Prayer* is any indication, Barocci approached these devotional pictures of individual saints with the same originality of thought and experimentation that he used in his larger altarpieces and devotional narratives, constantly seeking new and innovative ways to engage his viewers.

Judith W. Mann

NOTES
1 E 2008, 2, 342–49, no. 85.
2 See Mina Gregori, "Caravaggio Today," in Salerno, Spear, and Gregori 1985, 294, nos. 82 and 83, for a discussion of the theme as depicted by Caravaggio.
3 The treatise was Bartholomew of Pisa's *Liber aureus: Inscriptus Liber conformitatum vitae beati ac seraphici patris Francisci ad vitam Jesu Christi* (Bologna, 1590), originally issued in 1399. See Askew 1969, 289, who also cited Mâle 1932, 175. On Saint Francis as Christ, see cat. 13.
4 Christiansen 2005a, 726–27, made this association. Okey 1910 (1963), 114–15.
5 On Barocci and Michelangelo, see cat. 2, 81, and Lingo 2008, 26–27.
6 On Michelangelo's use of this motif inspired by Saint Bridget, see cat. 2, n. 30. On Saint Bridget and Barocci, see Lisot 2009, 100–101, 115–16, 147–48, who has made very different associations in Barocci's work. On the history of editions of the text, see Harris 1990, 3–4.
7 *The Revelations of St. Birgitta of Sweden* 2008, 1, 68, Book 1:23.
8 Although the isolation of a single detail to evoke Bridget's writings may seem farfetched, it corresponds to the impact of her description of Christ's birth, acknowledged to have had a profound influence on the representation of the Nativity (Schiller 1971, 1, 78–79). While Bridget's description is full of rich visual details, only one or two of them entered into Nativity iconography. Barocci used the same position of Christ's feet in the Genoa *Crucifixion*, painted between 1593 and 1596, also related to Bridget's writings. See Mann essay, 21–22, for a fuller discussion of this important picture.
9 Mâle 1932, 170–73, noted that in the sixteenth and seventeenth centuries, artists seemed split on this, as were contemporary theologians—Bellarmine and Cardinal Tolet argued for four nails, while Tostat and the Jesuits were in favor of the more traditional three nails.
10 Schiller 1971, 2, 230, suggested that it was really a matter of the individual artist's preference and not necessarily any formal or dogmatic guideline.
11 Christiansen 2005a, 728.
12 Ibid., 723–24.
13 See Isa Ragusa and Rosalie B. Green, eds., *Meditations on the Life of Christ* (Princeton, 1961), 308–9, LXXII.
14 Described in the inventory of Barocci's studio as "a kneeling Saint Francis praying." Calzini 1913b, 75.
15 Because it was in Barocci's studio, unfinished, at the time of his death, the painting has traditionally been dated to the last decade of his life. There are no documents to provide any relevant dates, and the early biographers did not mention the picture.
16 Christiansen 2005a, 728, argued for the heavy use of workshop assistants. E 2008, 2, 342, no. 85, recognized the different quality of the tonality but did not identify studio assistance. Turner 2000, 133, also recognized that the forms are "a little hard" but did not suggest the intervention of other hands.

17 E 2008, 1, 222–24, no. 25.
18 For the details of this letter from Malatesta Malatesti, Duke Francesco Maria's agent in Rome, to the duke, recording the pope's response to the large drawing Barocci had submitted for review, see cat. 18. For the text of the letter, see Gronau 1936, 183.
19 Christiansen 2005a, 728; E 2008, 1, 222, no. 25, placed it in the 1580s and related it to a new naturalism in Barocci's work, exemplified in pictures such as the Senigallia *Entombment*.
20 E 2008, 2, 342; Olsen 1962, 215–16, no. 70.
21 Martin-von-Wagner-Museum, Würzburg, inv. 7177. Christiansen 2005a, 726. The drawings are not published in E 2008.
22 Antaldi Collection, Biblioteca Oliveriana, Pesaro, inv. 431. Forlani Tempesti and Calegari 2001, xl, xlvii. This drawing was not examined firsthand, for it could not be located when Babette Bohn visited the collection in March 2010. Christiansen 2005a, 726, did not place the drawings in a sequence.
23 Although I have visited Chantilly to see this picture, which hangs high on a wall in the gallery, I was not able to examine it up close. However, seen from below, the left hand of Francis appears to have been overpainted and handled in a very cursory way, lacking much modulation in tone.
24 Christiansen 2005a, 726.
25 Bohn was the first to relate this drawing to the Metropolitan Museum's painting. Olsen 1962, 289, listed the sheet as "Not by B."
26 It should be noted that although he was unaware of the existence of this head study, Christiansen 2005a, 726, posited a living model for this picture, suggesting the artist had employed a friar in this role.
27 Ibid., 726–27.
28 Bellori 1672 (1976), 204; Bellori 1672 (2000), 189. Pillsbury, in Pillsbury and Richards 1978, 204, suggested that the Saint Sebastian may relate to a drawing of Saint Sebastian in the Kupferstichkabinett, Berlin (inv. KdZ 15228 [4195]); and the Saint Catherine may be related to a painting in the Galleria Borghese, Rome, attributed to a follower of Barocci, as proposed by Olsen 1962, fig. 120b.
29 See cat. 12 for a discussion of penance and its importance in post-Tridentine theology and practice.

Provenance: Barocci's heirs until 1658, when sold; Carpegna collection; 1803, to the collection of Ferdinand IV, Naples; until 1858, Santangelo collection; Arthur Costantini, London; from early 1980s, Mario Tazzoli; 2003, The Metropolitan Museum of Art, New York

Bibliography: Celano 1858, 3, 690; Parker 1956, 55, no. 97; Olsen 1962, 289; MacAndrew 1980, 253, appendix 2, no. 97; Christiansen 2005a; E 2008, 1, 222–24, no. 22; Gillgren 2011, 216–18.

Institution of the Eucharist

The altarpiece of Christ administering the Eucharist to his apostles represents the culmination of more than a decade of Barocci's thinking about the biblical account of the Last Supper and its associated references to the celebration of the Mass. Although the artist created the painting between 1603 and 1609, it must be seen in direct relationship to his work on the Urbino *Last Supper* of the previous decade (cat. 12). As he had done in the *Last Supper*, Barocci emphasized the importance of proper preparation for taking Communion, not just through narrative detail as he had in the Urbino picture, but by devising a restricted vocabulary of metaphor and ritual. This painting—Barocci's only papal commission—marks a unique situation in his career. Documents indicate that he prepared two compositional studies that were presented simultaneously for his patron's review. Both studies still survive (although in different states of finish), offering a rare opportunity to evaluate how the artist responded to his patron's demands. Thirty additional preparatory studies document Barocci's refinement of the poses for the apostles and servants, as well as the changes that he made in lighting the scene.

The altarpiece is structured around Christ, the largest figure in the composition, aligned along the central vertical axis. He stands in a darkened interior illuminated by four candles to indicate a nocturnal event. A young man stands at the left, in shadowed silhouette, holding a large lit torch; servants in the background on the right use two candles, one on the table being cleared (to the right of Jesus), the other held before the credenza where unused plates are displayed. Finally, a small candle rests at the very bottom of the composition; in situ, it is not visible, for it is covered by part of the altar. Rays of light form an aura around Christ's head and offer increased illumination for two nude angels hovering above. On the foreground steps, two servants accompanied by a dog carry away the leftovers from the recently completed meal. Other attendants return wine receptacles to their places on the deep background wall or clear away smaller plates from the table to the

right of Jesus. All twelve disciples are included in the scene, seven to the left of Jesus, the remaining five on the right. In his selection of an angled interior space that veers off to the right, Barocci adapted a format that was very popular in Venice, perhaps first introduced by Titian, who, in his *Last Supper* for the Della Rovere in Urbino, was the first to use an obliquely positioned table.[1]

Pope Clement VIII Aldobrandini commissioned the painting for the chapel in the church of Santa Maria sopra Minerva in Rome in which his parents were interred. Having assumed patronage of the space around 1570, Clement set about seeing that it was elaborately embellished with marble pavement, richly appointed walls, and tomb sculptures by some of Rome's leading artists. Clement's decision to order a painting from Barocci was prompted in part by the two previous altarpieces the artist had provided for one of the most important of all Roman churches, the Chiesa Nuova. The *Visitation* had been unveiled there in 1584 (see cat. 10) and the *Presentation of the Virgin in the Temple* (fig. 15) in April 1603, four months before the first letter declaring the pope's intent to employ Barocci for his family chapel.[2] The pope's choice may also have been motivated by Duke Francesco Maria II della Rovere, who presented Clement with a holy-water receptacle when the pontiff visited Pesaro en route to Ferrara in 1598.[3] Bellori explained that the duke commissioned Barocci to paint an image of the Christ Child, in gold, to adorn the water holder, making it a more appealing gift and a reminder of the artist's talents. The pope was apparently so pleased that he removed the image from the vase and put it in his breviary "in order to see it every day at the times of the Holy Office."[4]

All negotiations for the Aldobrandini altarpiece, beginning in August 1603, were handled through Duke Francesco Maria II and his ambassador in Rome, initially Giacomo Sorbolongo, who was in direct contact with the pope.[5] Much of their correspondence still survives; it indicates that Clement was aware of the time limitations for Barocci's work (primarily his slow progress due to his illness), a fact that

the duke made clear from the start.[6] The artist was also reminded that the altarpiece would need to be narrow and vertical, an unusual format for a Last Supper. Clement even suggested, in hopes of making the project simpler and no doubt based on his awareness of Barocci's notorious tardiness, that he would be willing to accept an image of his patron saints (Saint Clement and Saint Hippolytus) together with a figure of Christ or the Virgin. Barocci chose to stick with the Last Supper.[7] The dimensions, a plan, and a drawing of the chapel facade were provided for the artist, and it seems that designs were made at this point.[8] Clement died in 1605. Subsequent negotiations were handled by his nephew Cardinal Pietro Aldobrandini, who was informed in a letter of 24 July 1608 from Duke Francesco Maria that the finished painting was ready; in 1609 it was sent to the pope's sister, Olimpia Aldobrandini, in Rome, per Pietro Aldobrandini's instructions, proof that it was surely completed by that date. It was installed on the altar when the chapel was consecrated on 9 March 1611.

In undertaking the altarpiece, Barocci eschewed the narrative-based representation he had employed for the Urbino *Last Supper* and selected instead a simplified format that emphasizes ritual. He chose to elevate his setting with three foreground steps, making the composition more vertical and also creating a transitional introductory space, which his early sketches indicate he intended to use for an ancillary scene. Barocci had employed stepped settings in his *Visitation* (cat. 10) and *Presentation in the Temple* (fig. 15) altarpieces, so it is not surprising to see him repeat this successful solution to the vertical format. The elevated Last Supper/Institution of the Eucharist seems to have been popular in Venice, as evidenced in a number of examples by Tintoretto, and it is this precedent that is relevant here.

An initial sketch (*primo pensiero*) still exists showing how Barocci responded to some earlier examples of the scene (fig. 90). This diminutive study includes a number of the key elements that distinguish the finished altarpiece—a centrally placed Jesus, angled space,

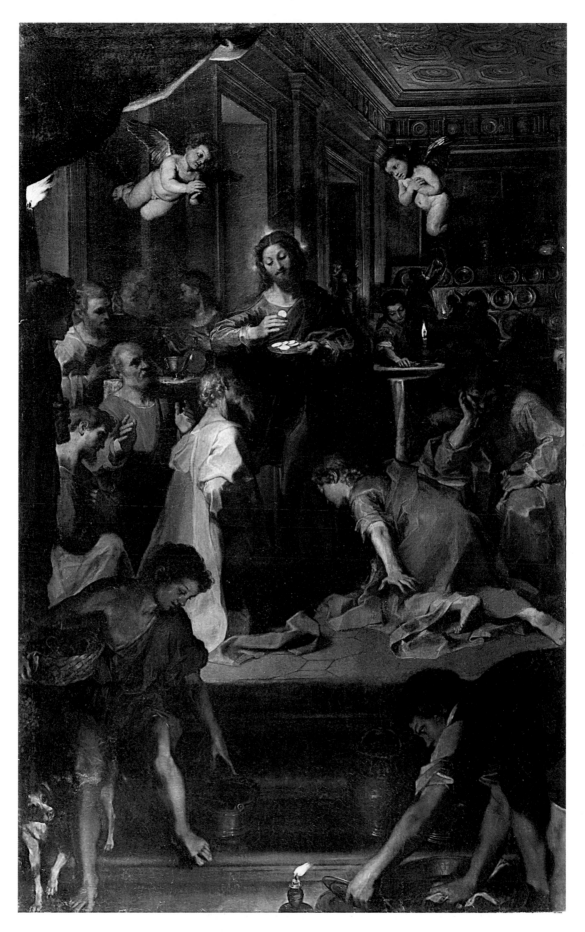

CAT. 18. *Institution of the Eucharist*, 1603–9. Oil on canvas, 114³⁄₁₆ x 69¹¹⁄₁₆ in. (290 x 177 cm).
Aldobrandini Chapel, Santa Maria sopra Minerva, Rome

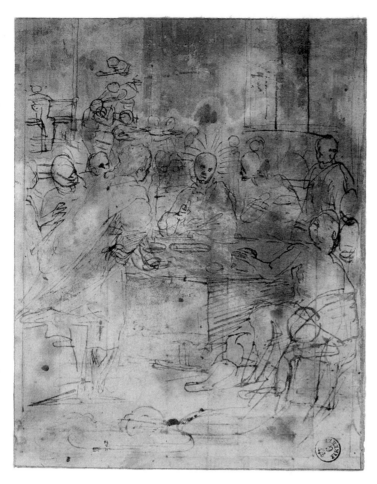

Fig. 90. *Primo pensiero for the Institution of the Eucharist.* Pen and brown ink with brown wash, 15 x 11.6 cm. Gabinetto Disegni e Stampe degli Uffizi, Florence, inv. 1735 E.

the prominent inclusion of Judas (a plausible although not certain identification for the standing figure at left), and background servants tending to the replacement of dishware. Barocci most likely knew Titian's *Last Supper* of 1542, on display beside the main altar of the meeting house for the Confraternita del Corpus Domini in Urbino.[9] However, he also borrowed elements from *Last Supper*s by Tintoretto in Venice, such as the servants in an elevated rear storage room from the latter's San Rocco painting. Another Tintoretto motif is the reclining figure on the floor near the table at the right, related to a similarly posed pauper in his *Last Supper* for the church of San Polo, dated 1574–75, as well as the foreground beggar in his version done for Santa Margherita around 1576.[10] Barocci built the small sketch around a centrally placed seated Christ and then introduced varied positions for the other figures as he sought to avoid the standard format with the apostles around an elongated table. Primarily,

this sketch suggests an artist working to make a horizontal subject fit a vertical format. He undoubtedly realized its main compositional drawback—the empty foreground area—which may explain his experimentation with the reclining beggars as well as his subsequent decision to use the elevated stage set.

In 1603 Barocci presented two early compositional sketches to Clement VIII. A letter dated November 1603 to Francesco Maria from his ambassador Malatesta Malatesti (Sorbolongo's successor) reports that the pope had assessed two drawings and, "in looking first at one and then the other," decided which one he preferred.[11] The two sheets survive: an unfinished, large study at Chatsworth (cat. 18.1) and a slightly larger and more finished sheet in the Fitzwilliam Museum, Cambridge (cat. 18.2). Although the Chatsworth drawing retains much of its original appearance, Barocci revised the one in the Fitzwilliam in response to the pope's concerns. As some scholars have con-

cluded, these drawings are two distinct steps in Barocci's design process, for the Fitzwilliam study was corrected and resubmitted later.[12] Clement had two main criticisms of the earlier version of the Cambridge drawing: he wanted no more than one window, and he asked that the hand of Christ be elevated and more clearly differentiated from his body. The letters provide no explanation as to why the Chatsworth sheet was not chosen, but Bellori wrote that "the pope said it would not please him to see an image over an altar in which the Devil appears in such close proximity to Jesus Christ."[13]

Barocci responded to Clement's comments by revising the presentation study into the more finished Cambridge drawing that exists today. He addressed only one of the pope's written criticisms by placing a protruding drape on the left side of the sheet to block most of the near window. He covered areas of the original drawing with oil paint, most evident in the group of apostles to the left of Christ as well as in the lower-right corner, where three figures were drawn. He did not change the placement of Christ's hand; it repeats the identical position seen in the Chatsworth drawing, and Christ's figure does not display any of the type of revisions (white oil paint or thickly applied wash) used elsewhere on the sheet. Malatesti noted this failure in a 1604 letter in which he itemized the shortcomings the pope found in Barocci's resubmission of the Cambridge drawing. Malatesti pointed out that one of Clement's objections had been raised before (Christ's hand) and one was a new correction, for the pope now desired a night scene.[14] No mention of the window suggests that Barocci's solution was acceptable, although there are technically still two windows.

It is tempting to suggest that Clement, in asking for a nocturne, was expressing an aesthetic preference. He may have been familiar with the popular naturalist style incorporating darkened spaces and dramatic lighting that Caravaggio had recently introduced, most notably in the Contarelli Chapel in San Luigi dei Francesi as well as at Santa Maria del Popolo. However, it is more likely that the pontiff was responding to the strictures of the Council of Trent, which recommended close adherence to biblical text. Three of the four Gospel writers specified that the Last Supper took place after sundown.[15] According to Jewish observance,

this was the appropriate time of day for a Passover meal. Barocci had previously created successful nocturnal paintings, as his Prado *Nativity* (cat. 15) and his *Stigmatization* (cat. 13) demonstrate. It is difficult to say whether Clement knew those paintings firsthand, but he may have heard about them through the duke's ambassador.

In comparing the two drawings, it is possible to make some observations as to Barocci's intentions. The drawings share a number of key elements in the upper register. Barocci used identical figures for Jesus and the group of apostles on the right side of each.[16] In both cases, the key pen strokes defining Christ's contours and drapery lines appear mechanical, suggesting the form had already been developed in earlier sketches, although none survives to support this theory. While the background is not as complete on the Chatsworth sheet, the presence of perspective lines immediately to the right of Christ's left hand indicates that Barocci was planning the same recessed space that he included in the Cambridge study. Putti, nearly identical to those in that drawing, can be discerned on the same part of the Chatsworth sheet.

In the Chatsworth study, Barocci presented Christ dispensing the host to a kneeling Judas and a genuflecting Saint John the Evangelist. Remarkable in this rendering is the striding Satan, tail clearly visible, who speaks to Judas. Visible pentimenti in the sheet indicate that Barocci had initially placed the devil's head a bit lower, squarely between Judas and Christ, and then changed to a slightly more vertical posture. Although it was not unheard of to include Judas in scenes of the Institution of the Eucharist—and there are several examples of him placing the host in his pocket (as he does here)—the figure of the devil is rare and is never placed so close to the dispensing of the Eucharistic bread.[17] This lacuna is perhaps surprising, for the Gospel of John states that, after Christ gave Judas bread dipped in the wine, "Satan entered him." This, then, is a direct illustration of scripture, presumably a result of Barocci's careful adherence to Gospel texts, which we also see in other works.[18] However, he must have realized that the unusual portrayal risked disapproval, and he therefore prepared an alternative design with a more conventional iconography.[19]

That may also explain another anomaly in the Chatsworth drawing: the seminude reclining woman at the lower left. Although Barocci prepared a number of his figures by first creating nude studies, and although some of the nude drawings depict females, there are no nudes in any of his finished paintings.[20] Barocci probably adopted the motif from examples of Charity found in Venetian *Last Supper*s, based on passages in both Luke's and John's accounts of the meal where Christ explained the importance of humility.[21] That idea, in turn, was linked to performing charitable acts, as Christ himself had done by washing the feet of his disciples. Barocci's intent becomes very clear when we look at the contemporary *Last Supper* painted between 1592 and 1594 by Tintoretto's workshop for the cathedral in Lucca, where a very similar personification occupies the lower-right corner.[22] There is no evidence that Barocci ever saw this canvas firsthand, but the Lucca painting was developed with the same understanding of the role of charity as it related to Gospel teachings. A figure of Charity also alludes to an issue of topical importance in the sixteenth century: the role of faith versus charitable and good works as a means of obtaining grace.[23]

Barocci identified Charity by using her most common attributes: two small children. He took her role beyond mere symbol: She and her children are the recipients of a charitable act, for the bending servant selects food from the platter to place in the child's dish. The young man also holds a jug in his left hand, thus alluding to both the bread and the wine of the Eucharistic meal. Stuart Lingo, arguing that the woman was designed to be alluring as a means of inspiring viewer interest, noted that in selecting this particular figure, Barocci failed to recognize the decorum required for a papal chapel, or at least he misjudged the current artistic trends in Rome because he had been living and working in far-away Urbino since the mid-1560s.[24]

Barocci's purpose in including Charity was part of the painting's theme—the sin of taking the Sacrament unworthily.[25] Barocci had explored this subject during the previous decade in his Urbino *Last Supper*. The details of that argument have been outlined in the discussion of that painting (see cat. 12), so only a cursory version need be expounded here. The focus on Christ's final meal with his disciples, and its ritual reenactment in the Mass, was a

subject of enormous concern at the Council of Trent (1545–63). Of particular importance was how the faithful best prepared to participate in the Eucharist, and one of the decrees the council issued in 1551 addressed the matter directly by stating that the act of confession, or penance, was required. By the late sixteenth century, particularly in the Veneto, the means for communicating this idea in a visual format was most typically an image of Christ, humbling himself by performing the ritual act of cleansing (washing his apostles' feet) prior to sharing the first Eucharistic meal with them. Such a deliberate act of humble service or charity could be alluded to also through the allegorical figure of Charity. By aligning her with the kneeling Judas, who starts to take the Sacrament, Barocci reminded the viewer that Judas is unworthy; the presence of the devil emphasizes how unworthy Christ's betrayer is. In his alternative compositional drawing in Cambridge, Barocci developed this meaning in a slightly different way. He maintained the two-part format while introducing substantive changes. Judas continues to kneel before Christ on the left, offset by John the Evangelist on the right. Now, however, the foreground is populated by a different servant, shown on the left carrying a large basket under his right arm while he reaches for a small kettle with his left. A double-sided sheet from the Getty Museum (cat. 18.3) demonstrates that Barocci considered this figure from both sides, exploring a possible lower-right location.[26]

Opposite the servant is a kneeling man, shown in a costume closely associated with Roman rulers or soldiers and whose fitted leggings sport a scalloped edge visible at his calf.[27] A secondary player, in shadow, kneels behind him and speaks to a small child while gesturing toward Judas. The child also kneels and clasps his hands in prayer. The man in shadow may be intended to represent a priest, perhaps shown instructing the boy, although the edicts of the Council of Trent made it very clear that children did not need to take Communion for salvation.[28] The kneeling observer responds to the scene before him as he holds out his left arm, palm open toward Christ in a pose connoting revelation. In terms of the Last Supper, one might posit that the miracle most germane to the subject would be the doctrine of Transubstantiation, the idea that during the

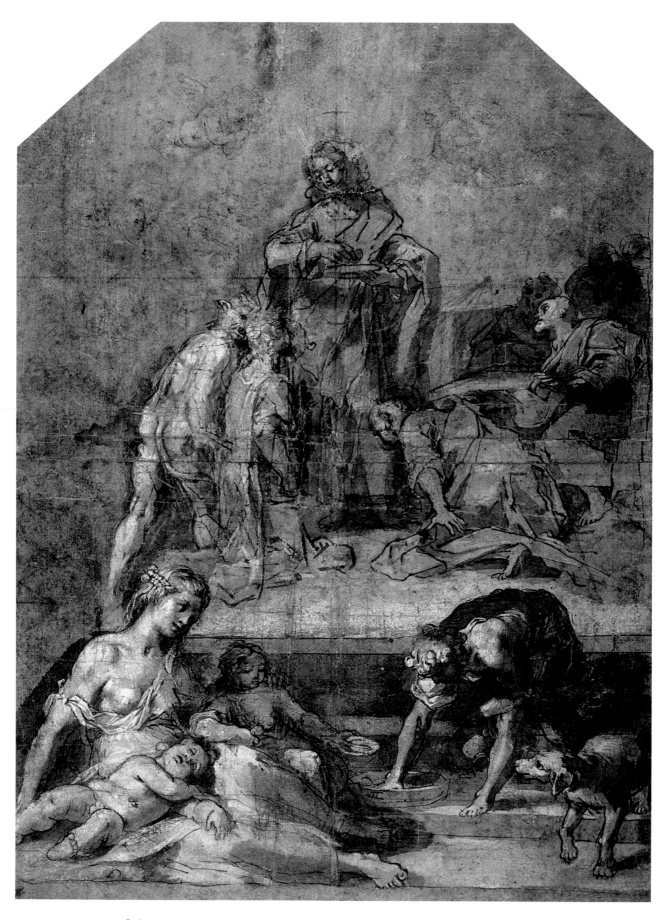

CAT. 18.1. *Preliminary compositional study.* Black chalk, pen, and brown ink with brown wash heightened with white, partially squared (faint) in black chalk on paper washed brown, laid down on old mount, 18⅞ x 13½ in. (48 x 34.3 cm). The Trustees of the Chatsworth Settlement, Chatsworth House, Derbyshire, inv. 361

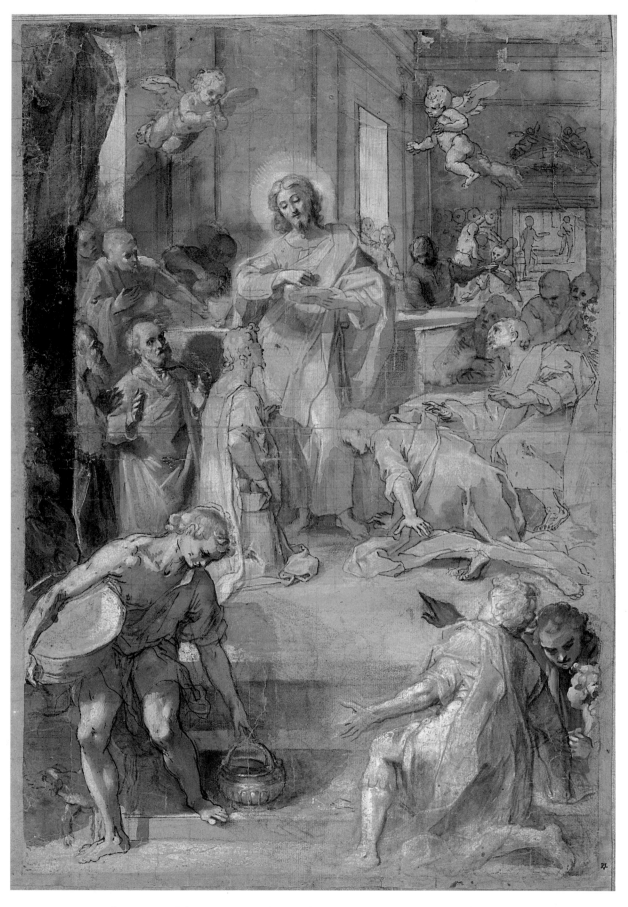

CAT. 18.2. *Cartoncino per il chiaroscuro*. Pen and brown ink and brown wash over black chalk heightened with white, with gray and black oil paint, faintly squared in black chalk, 20¼ x 14 in. (51.5 x 35.5 cm). Lent by the Syndics of The Fitzwilliam Museum, Cambridge, Acquired with contributions from the National Art Collections Fund, supported by the National Lottery through the Heritage Lottery Fund, 2002, inv. PD.1-2002

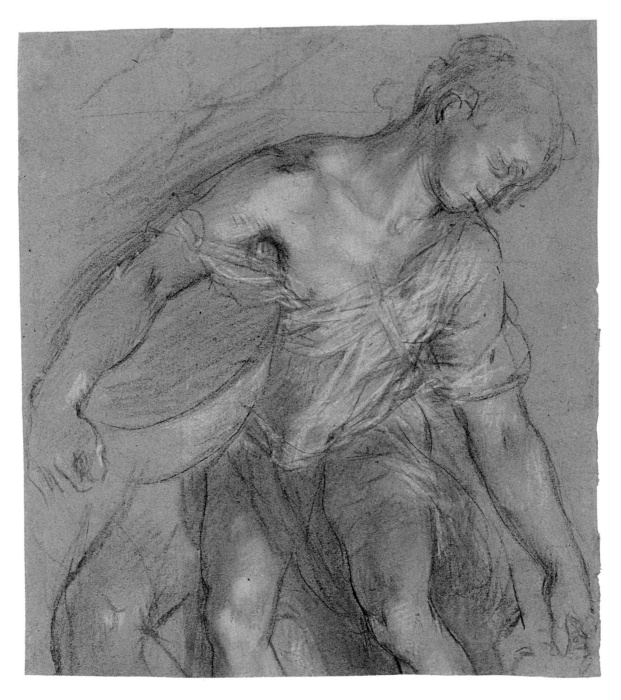

CAT. 18.3 RECTO. *Study for servant on the lower left.* Black, white, and beige chalk on blue paper, 11⅞ x 10¹¹⁄₁₆ in. (30.1 x 27.2 cm). J. Paul Getty Museum, Los Angeles, inv. 83.GB.279

Mass, the bread and wine actually transform into Christ's flesh and blood, a subject of particular importance in the sixteenth century because it was rejected by Protestant reformers. Judas, however, would play no role within the depiction of that miracle, making it unlikely that Barocci intended to address that particular issue. It must be assumed, therefore, that the right-hand observers are there to encourage meditation on the significance of Judas's accep-tance of Eucharistic bread, and that the artist was simply seeking a more acceptable (and visually understandable) way to emphasize the ineligibility of Judas to participate in the Mass.[29]

Barocci's genuflecting Saint John on the Chatsworth sheet connotes humility and calls to mind Jesus's act of washing the apostles' feet, emphasizing the cleansing sacrament of penance necessary for Communion. Without humility and therefore without penance, Judas participates in the Mass, while John, demon-strating the requisite humility, serves as a coun-terpoint. A beautiful study for Saint John's left arm (cat. 18.4) documents the close attention Barocci paid to John's hand, not only indicating through red chalk the reflection of the saint's red drapery, but also studying its illumination contrasted with the shadowed hand of an apos-tle seen on the right side of both the Cambridge and Chatsworth studies.

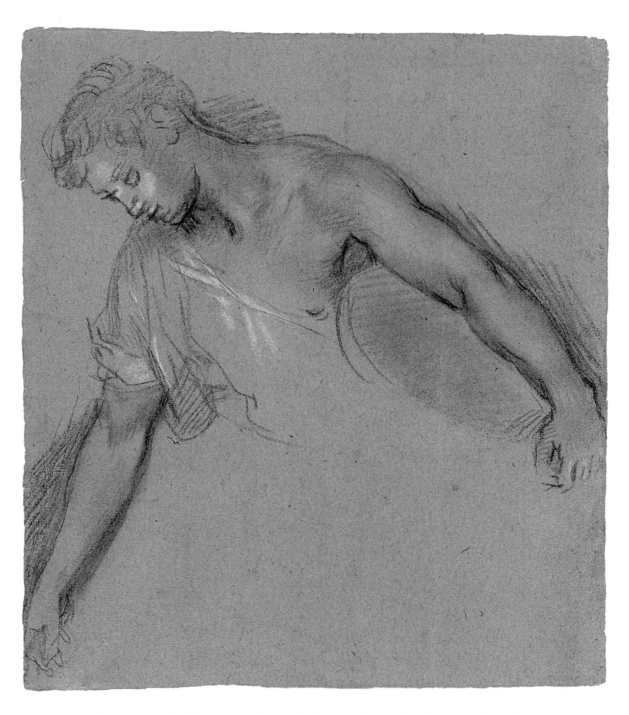

CAT. 18.3 VERSO. *Study for servant on the lower left.* Black and white chalk on blue paper, 11⅞ x 10¹¹⁄₁₆ in. (30.1 x 27.2 cm). J. Paul Getty Museum, Los Angeles, inv. 83.GB.279

The finished altarpiece displays several changes made after the revised Cambridge study was submitted to the pope. The foreground servants, for example, represent a compromise between the two early drawings, for Barocci kept the servant from the left of the Cambridge study and paired him with a variation of the servant on the right of the Chatsworth drawing. The Getty sheet (cat. 18.3) records earlier ideas for the young attendant, where the artist experimented with a more acute angle for the right knee and included a favorite drapery motif—a band of white linen with a button in the middle that falls over the shoulder.[30]

Except for John (and perhaps Peter, the gray-haired man with opened hands on the left), none of the apostles can be specifically identified, save for the brooding Judas.[31] This reflects Barocci's emphasis on the sacramental ritual in the *Institution* rather than the more narrative interpretation of the *Last Supper*. No longer a key player, Judas does not partake of the Mass and is shown sitting in a contemplative pose to the right of Christ, holding his moneybag. The painter adapted the figure from Raphael's Heraclitus in his Vatican fresco the *School of Athens,* traditionally identified as bearing the features of Michelangelo.[32] No evidence allows a definitive explanation of this change from the Cambridge study. The

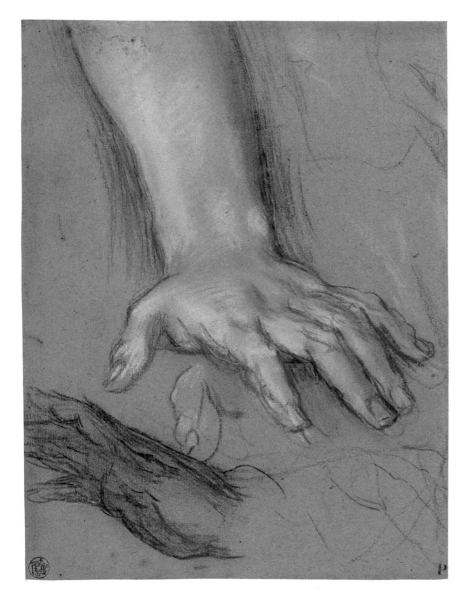

CAT. 18.4. *Study for hand of Saint John the Evangelist and another apostle's hand.* Black and white chalk and red and pink pastel on faded blue paper, 10¹¹⁄₁₆ x 8¹⁄₁₆ in. (27.1 x 20.4 cm). Kupferstichkabinett, Staatliche Museen zu Berlin, inv. KdZ 20319 (4458)

the hands of the apostle at the far left of the Cambridge study, a gesture not used in the finished altarpiece.

A number of specific changes were required to meet the pope's demand for nocturnal illumination. Most of the thirty-two extant drawings include white heightening, sometimes applied sparingly, that conforms to the light in the finished version of the painting.[34] However, some of them must predate the change, for they appear to have been produced for the Cambridge drawing. For example, the Getty study (cat. 18.3) for the left-hand servant must have been made before the Cambridge sheet, for it records an alternative position for the boy's right leg beside the solution that appears in both the Cambridge study and the final picture. Yet, the play of light differs from the preparatory drawing and is closer to that of the final painting, indicating that Barocci explored the ramifications of the nighttime setting on some of the figures within his composition by adding white heightening to earlier drawings. The adoption of a night scene also required the additional servant who holds an elongated torch at the far left. A chalk study, now in Berlin (cat. 18.6), includes a profile study of this servant, darkened as he is in the final painting, with only one small highlight on his left thumb, which grips the bottom of the torch. Another sheet with two studies for background servants flanking the lower torso of a flying putto appears also to have been made to study lighting (cat. 18.7). The scale discrepancies between the putto and the serving figures indicates that the sheet probably played no compositional role; rather, it shows how the artist juxtaposed disparate forms as he experimented with the reflected nighttime illumination.

The change to a night scene affected Barocci's palette as well. His choice of hues still demonstrates his considerable gifts as a colorist, particularly the riveting cobalt blue of Christ's garment offset against rich yellow and an array of choice reds. He painted the apostles on the left in garments of pink and moss green, but overall he relied more on dark and light patterning than the compelling juxtapositions of a larger number of individual colors. Given the overall darker tonality, the yellow of the kneeling figure on the left draws the viewer's eye into the painting, allowing us to focus on the single act of Communion by this unidentified apostle.

pope may have suggested that Judas not participate in the Mass. The drawings demonstrate, however, that Barocci developed the idea for Judas prior to amending the painting into an evening scene. Three sketches document the development of Judas. In the earliest (cat. 18.5), where Barocci drew studies for servants as well as hands in prayer, he sketched in Judas's basic pose, perhaps drawn from the living model of an assistant, for the clothing reflects contemporary dress and was changed in later studies to the generic loose drapery worn by all of the apostles.[33] On the lower right, Barocci drew a study for the left foot of the foreground servant on the left. In the Cambridge sheet, where the

light sources are primarily natural, part of that ankle and foot are in shadow, the way they appear in this drawing. When Barocci changed to nocturnal illumination, this same foot received full light from the candle at the very bottom. Assuming that the sketches on this sheet were all done at the same time, it seems that the artist may already have decided to change the figure of Judas before he responded to the request to shift the time of day. This sheet of sketches demonstrates other alterations Barocci made as he developed the composition from the Cambridge study into the final painting. A sketch for praying hands in the upper part of the sheet is similar but not identical to

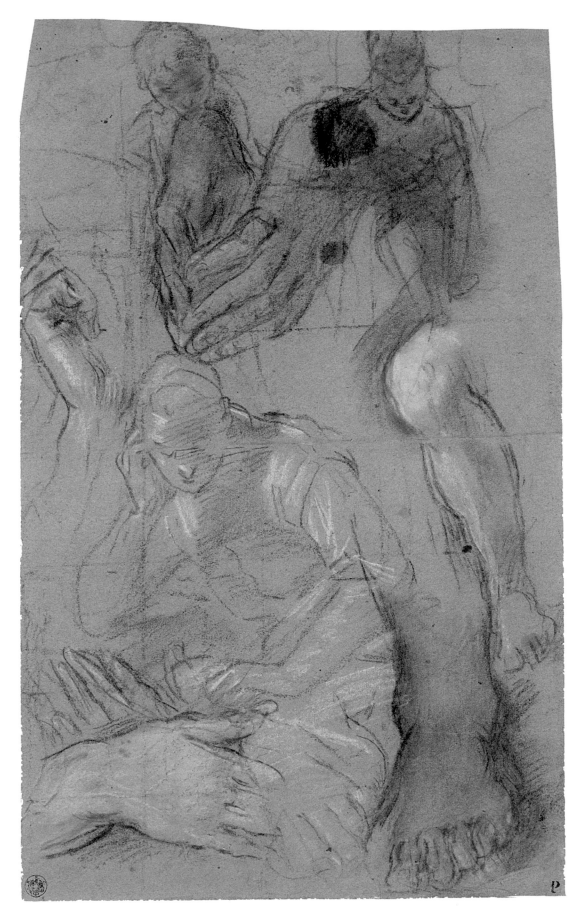

CAT. 18.5. *Studies for servants and Judas; studies for legs and hands.* Black and white chalk with stump, partially squared in black chalk, on blue paper, 16 x 9¾ in. (40.7 x 24.8 cm). Kupferstichkabinett, Staatliche Museen zu Berlin, inv. KdZ 20331 (4208)

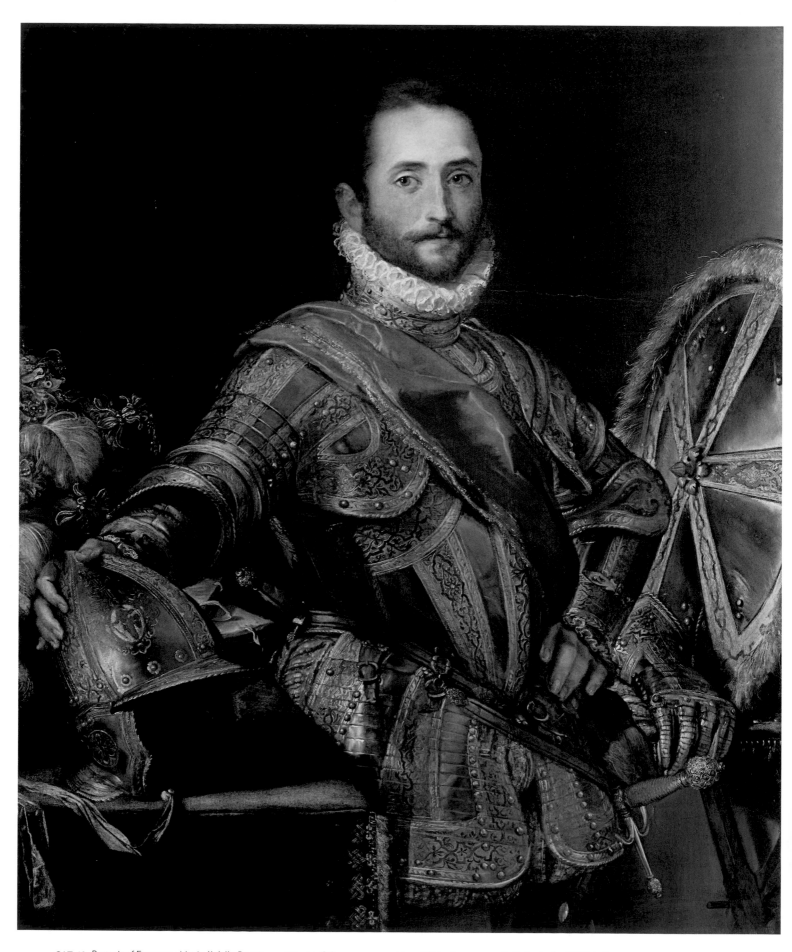

CAT. 19. *Portrait of Francesco Maria II della Rovere*, ca. 1571–72. Oil on canvas, 44½ x 36⅝ in. (113 x 93 cm). Galleria degli Uffizi, Florence, inv. 1890 n. 1438

Portraits

Previous authors have tended to downplay Barocci's role as a portraitist, emphasizing instead the accomplished narrative pictures that secured his fame. Yet, he produced a small but impressive group of portraits, five of which are featured here. Barocci provided his sitters with creative and compelling likenesses in spite of the limited range of available options. Through the careful location of his subjects within the pictorial space, attention to hand placement, and to the arrangement of subordinate objects, Barocci achieved novel inventions within the genre. In contrast to the situation with his narrative paintings, very few drawings related to his portraits have survived. There is no single study of an individual face that can be conclusively linked to a specific portrait. Nonetheless, the portraits offered here encompass an interesting array of preparatory studies that illuminate steps in Barocci's thinking as he worked out the compositions. His early exposure to Titian's models in the ducal collection must have laid the basis for his own representations of his sitters as well as his keen understanding of the traditions of sixteenth-century portraiture.

Aristocratic portraiture came into its own in the sixteenth century. Early Renaissance portraits present powerful individuals in static poses with simple backgrounds and limited space. During the sixteenth century, painters began to experiment with bolder positions, more extensive settings, and expressions and poses that reflect the inner lives of their subjects. Titian developed some of the most lasting formats, particularly the full-length standing male, portrayed in impressive interiors and accompanied by objects that attest to temporal power and material wealth. Sumptuous fabric, deftly applied paint, and resonant color were the tools used to enhance these likenesses. Barocci was heir to many of these devices, although no full-length portrait by his hand has survived.[1]

By far the most dazzling of Barocci's portraits is the depiction of his patron and long-time friend Francesco Maria II della Rovere (1549–1631; cat. 19). He stands in a finely tooled suit of armor beside a velvet-clad table, embracing with

CAT. 20. *Portrait of Francesco Maria II della Rovere*, after 1572. Oil on canvas, 43⅜ x 35⅝ in. (110.2 x 90.5 cm). Collection of the Duke of Northumberland, Alnwick Castle, inv. 03337

his right hand the elaborately plumed helmet on the table, while a gauntlet and shield are displayed at the right. Barocci spared no opportunity to demonstrate his sure handling of paint, evoking the polished surface of the metal and its myriad reflections with unrivaled facility. The red sash diagonally across Francesco's chest adds to our understanding of the sitter as a self-assured young man and attests to Barocci's consummate skill as a colorist and painter of fabric.

Traditionally, this portrait has been dated 1571–72, based on the description in the ducal inventories stating that it depicts the young Della Rovere "when he returned from the armada."[2] Undoubtedly, it commemorates Francesco Maria's service in the war against the Turks, particularly his courageous performance during the naval battle of Lepanto in 1571.[3] The young man, in his splendid armor, stands amid a display of the trappings of victory, making the

painting an effective evocation of a skilled soldier. In fact, Francesco Maria wears infantry armor designed for foot rather than mounted combat, appropriate for service on board a ship. Other elements identifying this as infantry armor are its half-length form, the open-faced helmet, and the round shield.[4] Lionello Boccia and E. T. Coelho identified the duke's costume as a typical example of Italian-made armor of around 1575. On this basis, they proposed a slightly later dating, suggesting that the portrait was made to commemorate Francesco Maria II taking over the duchy on the death of his father, Guidubaldo, in 1574.[5] However, when the portrait is compared to Titian's portrayal of Francesco's grandfather and namesake, Francesco Maria I (Galleria degli Uffizi, Florence)—Barocci's likely model—the young man is not endowed with all the trappings of rule.[6] Titian portrayed the dour and determined Francesco Maria I ostentatiously grasping a baton, a reference to his office of duke. Barocci portrayed the grandson with the same assured pose and confident gaze, but the absence of the baton may have been intended to indicate that the younger man had not yet become duke.

Barocci's subtle manipulation of standard elements denoting the confident soldier makes this portrait among the finest of its type. Andrea Emiliani and others suggested that the placement of the right hand on the helmet, an unusual but by no means unprecedented gesture, resulted from a request by Francesco Maria himself to emulate Titian's 1551 portrait of the Spanish king Philip II.[7] Francesco Maria had spent more than two years at the Spanish court between 1565 and 1568, and he maintained lifelong ties to Madrid, evidenced by his generous bestowals of several Barocci paintings upon members of that court.[8] Barocci may well have placed the hand on the helmet in response to the future duke's request, but he adjusted the angle of the arm for maximum effect. In Titian's portrait, as in others that employ the motif, the sitter's arm reaches to the side or even behind. Placing his subject slightly beside and behind the table, Barocci allowed the arm to come forward in a dynamic pose, enhancing the vitality of Francesco Maria's steady gaze. Even without the baton of rule, he thrusts his arm forward in an aggressive affirmation of self-assurance and spatial immediacy.

Barocci followed tradition in the array of accouterments of battle and power with which he surrounded his sitter. However, he made Francesco Maria the tallest element in the composition, unlike the two paintings he used as models, where architectural elements or battle standards are seen above the sitter's head. In fact, Barocci framed his sitter more closely within the picture space to create a monumental figure of impressive stature. Furthermore, Francesco Maria stands akimbo, a pose made famous by Joaneath Spicer, who wrote that the confidently bent left elbow with the hand placed on the hip is among the most efficacious conveyers of male entitlement.[9] Interestingly, the sole surviving (although minor) drawing for Francesco's portrait includes a study for this very gesture where Barocci refined the grouping of the fingers and the exact angle of Francesco Maria's stance.[10]

Given the importance of the sitter and the quality of the Uffizi portrait, it is hardly surprising that an autograph replica was made, a common practice during the Renaissance. No documents identify the specific purpose for this portrait, but the mere fact that the Della Rovere spent time in Urbino and, increasingly, in Pesaro and Casteldurante, could explain the need for a duplicate image. There was demand both for images of the duke and for portraits by Barocci's hand. He was commissioned in 1583, for example, to paint a now-lost portrait of Francesco Maria II for Grand Duke Francesco I of Tuscany.[11] The present example (cat. 20), from Alnwick Castle, Northumberland, demonstrates the difference between an initial version and a replica. There are several cases of two or more iterations of the same composition among Barocci's narrative pictures, but this is the sole surviving instance among his portraits.[12] The Alnwick canvas is slightly smaller than the original version but otherwise duplicates every detail. The paint application in the Alnwick portrait is more tightly controlled and deliberate. The reflections in the shield on the right are smaller and less complex, and the duplicate offers a less coherent definition of spatial recession along the tabletop by the helmet than is found in the original.

Two studies for heads that have been identified as representing Francesco Maria II are included here as comparisons for the painted portrait. Both drawings demonstrate Barocci's sensitive attunement to his sitter, particularly the sheet from the Lugt collection (cat. 19.1), which represents the duke in middle age, presumably from the 1580s or 1590s, when he was in his thirties or forties and when he and Barocci may have had more contact.[13] Fine, controlled strokes define the facial features, particularly the red outlines of the upper lids and the inside corners of the eyes. The irises are depicted with great sensitivity, and the thinning hair on top of the head suggests a slightly vulnerable person. The broader and freer strokes, applied more quickly, give a much sketchier description of the clothing. Although this sketch has not been associated with a known painting, Edmund Pillsbury suggested that it may have been made in preparation for the above-mentioned 1583 portrait of Francesco Maria, commissioned for the grand duke of Tuscany.[14]

A beautiful head study from the Uffizi (cat. 19.2) bears a strong resemblance to the Lugt drawing, but its identification as a representation of the duke is problematic. Because of the hat and the facial similarity, this drawing has also been deemed a preparatory study for Barocci's portrait of Antonio Fazzini in the Goethe House, Weimar (fig. 91), to which it bears a strong resemblance. This association has led some authors to identify the Goethe House portrait as depicting Francesco Maria.[15] However, as Fert Sangiorgi pointed out, an eighteenth-century description of the *Portrait of Antonio Fazzini,* when it was still in the Fazzini family collection, seems to match the Weimar picture: " . . . a curious costume with which he is painted, being a heavy cloak, a large collar of lace, and a thin belt with a large sword, and a cap on his head of the type worn in Syria."[16] The physiognomy in the portrait resembles that of both exhibited drawings, and yet it can also be likened to the features of the young Francesco Maria II. The red-chalk shading in the Uffizi sketch indicating areas of the face that will receive a warmer light corresponds to the coloration of the Weimar portrait, lending support to the theory that the drawing represents Fazzini. The confusion stems in part from Barocci's somewhat generic faces, which bear few very distinctive features, and his inclusion of nearly identical facial hair on all his male sitters. Therefore, the identity of the sitter for both the Lugt and Uffizi drawings remains something of a conundrum.

The Uffizi sketch (cat. 19.2) was made more quickly than the Lugt drawing. Barocci

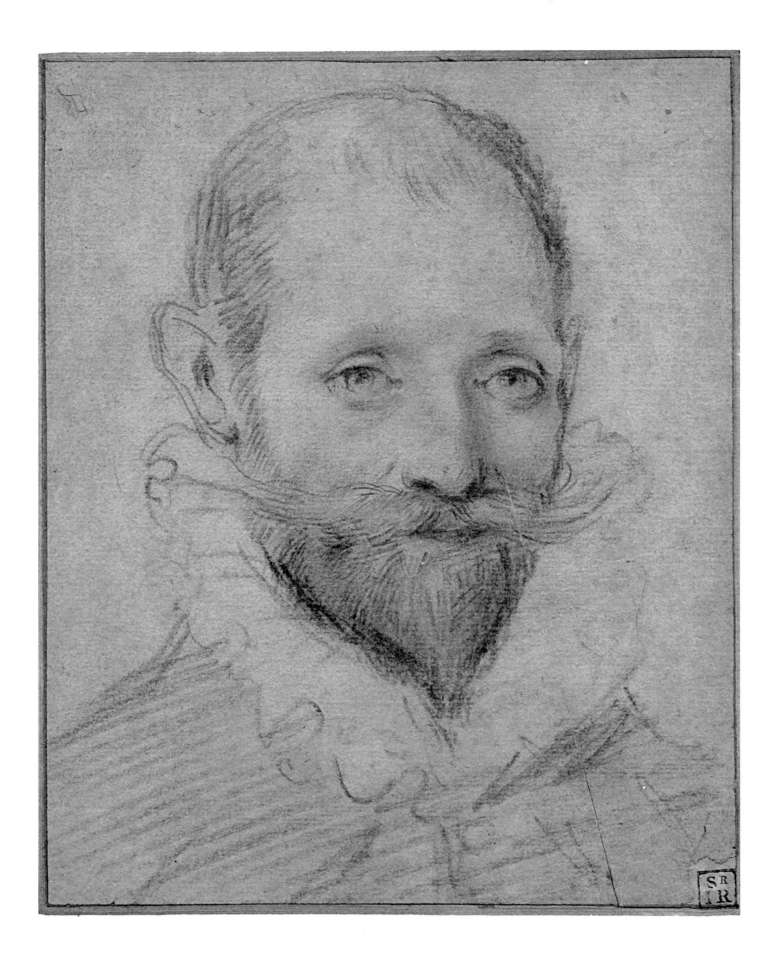

CAT. 19.1. *Francesco Maria II della Rovere in middle age.* Black, red, and white chalk with ocher pastel,
7⅜ x 6¹⁄₁₆ in. (18.8 x 15.4 cm). Fondation Custodia, Collection Frits Lugt, Paris, inv. 5061

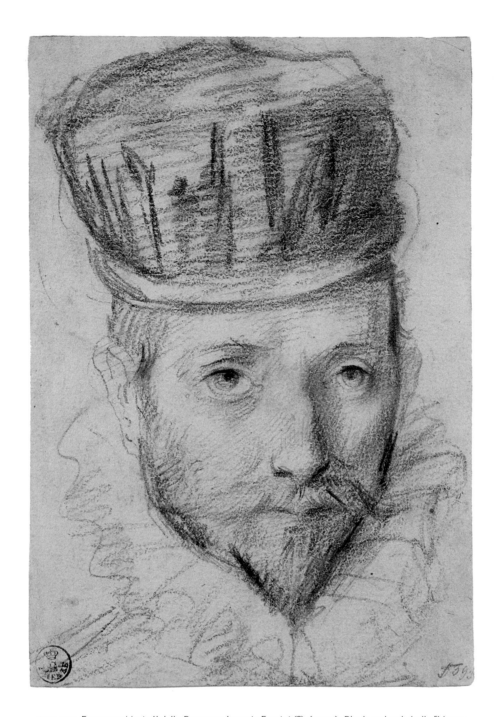

CAT. 19.2. *Francesco Maria II della Rovere or Antonio Fazzini* (?) (recto). Black and red chalk. [Verso: Study for sword hilt (?). Black chalk], 5⅞ x 4¹⁄₁₆ in. (14.9 x 10.3 cm). Gabinetto Disegni e Stampe degli Uffizi, Florence, inv. 1393 F.

started with red chalk and then worked it over with black. This is contrary to the way he used red chalk in many of his studies, where the later addition of red over black served to help establish areas of warmer coloration and greater illumination. Given the seemingly close relationship he had with the duke, it is very likely that he made several sketches of his patron, and in spite of the confusion discussed above, this sheet should probably be counted among

them. Perhaps the possibility should even be considered that this drawing was not a preparatory sketch at all, but merely the recording of the countenance of someone who played an important role in Barocci's life.

The second Della Rovere portrait in the exhibition (cat. 21) shows Giuliano della Rovere, illegitimate son of Francesco Maria's uncle Giulio della Rovere, and thus the duke's cousin. Most scholars have dated the picture to the

mid-1590s, a dating followed here, for it seems to reflect accurately the sitter's age then, in his thirties. Giuliano was born in 1560 and died in 1621. He was prior of Corinaldo, abbot of San Lorenzo in Campo, and resided in Fossombrone, near Urbino. Bellori stated that Giuliano commissioned two important works from Barocci, *Christ Appearing to Mary Magdalen* of 1590 (fig. 12), and a second version of *Aeneas Fleeing Troy* (cat. 16).

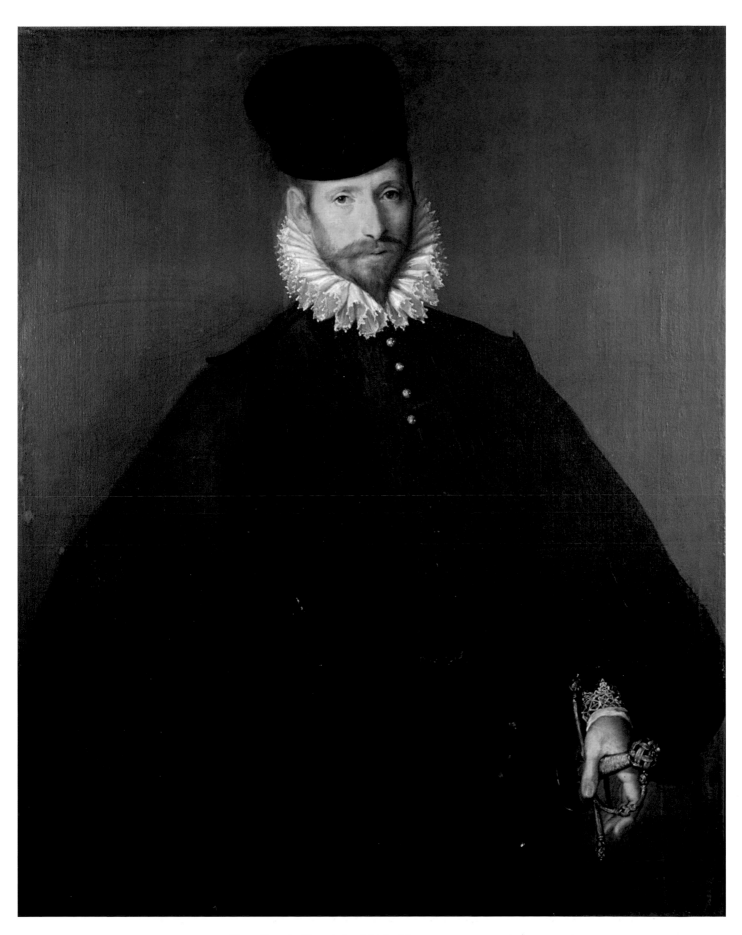

Fig. 91. *Portrait of Antonio Fazzini,* 1583. Oil on canvas, 123 x 99 cm.
Goethehaus, Weimar

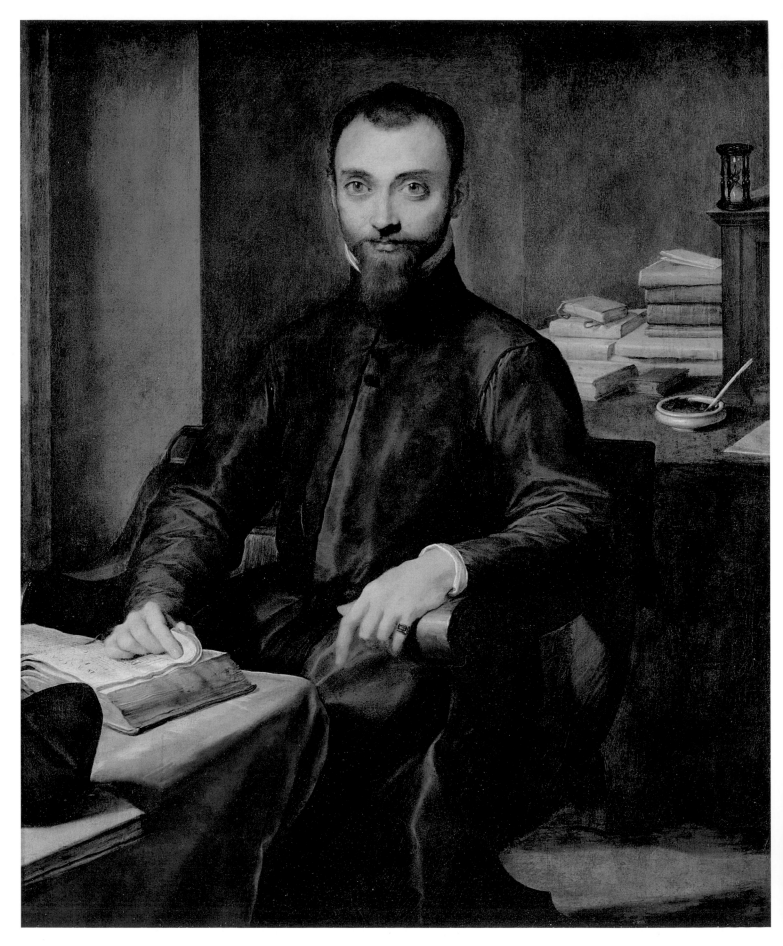

CAT. 21. *Portrait of Monsignor Giuliano della Rovere*, ca. 1595. Oil on canvas, 46¹⁄₁₆ x 38⅜ in. (117 x 97.5 cm). Gemäldegalerie, Kunsthistorisches Museum, Vienna, inv. 162

Barocci's portrait depicts a cleric, posed along a diagonal that recedes back toward the right. Giuliano sits with his left hand on the armrest while his right hand grasps several pages of the book that lies on the velvet-covered table in front of him. The only legible letters in the text spell out "in Ascens . . . " His hat rests in the lower-left corner, reinforcing the strong diagonal of the composition. At the right edge of the painting, one glimpses the depths of the small chamber. Several books are stacked in two piles on a background table. A single volume lies before them, and a small red-bound book, perhaps a prayer book, is located to its right. An hourglass stands above, and an inkpot and pen sit on the near edge of the table with a sheet of paper alongside. Giuliano is thus shown to be a writer as well as a reader.

This portrait has none of the trappings of power or grandeur that Barocci expressed so effectively in portraying Francesco Maria, yet it is in some ways a more complex creation. It follows the well-known type of the seated cleric, perhaps shown in its most successful form in Raphael's iconic image *Leo X and His Nephews* of 1519.[17] As John Pope-Hennessy noted some time ago, by angling the direction in which the sitters are posed, Raphael expanded the available space beyond merely the painting's width for the placement of his three subjects.[18] This was an appropriate model for Barocci, who often investigated ways to imply greater space. Raphael, who was painting three separate portraits on one canvas, did not encourage an exploration of the deeper recesses of the work's implied space, whereas Barocci provided a detailed still life to draw the viewer's eye back into the room. He emphasized his subject as an intellect by calling attention to the books in the background and by showing the sitter poised in perusal of an open volume.

Few if any other contemporary portraits use the available dimensions of the sitter's space so effectively. Other artists had depicted deep interiors or offered glimpses into contiguous rooms, but few had expanded the space so deeply and at so acute an angle. Barocci placed the monsignor along the central axis of the composition, both laterally and in terms of depth. He cut off the hat in the left foreground to emphasize the continuation of the desk into the viewer's realm. Even Giuliano's left hand, with its extended index finger, reinforces this diagonal. The window at left casts light onto the floor behind his chair, further reinforcing the sense of an open and inhabitable interior.

Four drawings can be associated with the portrait, two of them featured here (cats. 21.1 and 21.2). It is unclear how many or what type of studies preceded these two sheets, but the drawing with the figure facing right (cat. 21.1) is most likely the earlier of the two. Barocci's task was to design a seated figure holding or reading a book, perhaps a stipulation requested by Giuliano. The artist's first idea was a figure facing right with the right hand holding the armrest and the left hand grasping a book. He began by quickly sketching a seated figure, just right of center, and then explored how the figure's left hand would hold a book. Interestingly, perhaps the earliest hand study represented, in the upper right, displays a position very close to one Barocci used in his earliest known portrait, *Antonio Galli*, 1552–53? (fig. 2). Although Galli is shown standing, Barocci portrayed him marking the page of a prayer book with his left hand, and it is this pose he repeated in cat. 21.1. He then tried an alternative position, where the left hand grasped an open book, shown at the lower right. He worked up the resting right hand of the sitter in the more detailed study in the lower center of the sheet. Pentimenti reveal that he shifted the position of the hand from resting horizontally on the arm of the chair (as shown in the quick sketch) to slightly turned and extending over the side of the arm. Another drawing, in the Biblioteca e Museo Civico in Urbania, most likely a study for this portrait and perhaps this hand, shows a left hand grasping a closed book by its front edge. The artist not only worked on the position and modeling of the hand and fingers, but he also captured light passing through the space between the book and the wrist.[19]

By the time Barocci began this second sheet of studies (cat. 21.2), he had abandoned the idea of a figure facing right and devoted his efforts to trying out other poses. On the lower right, he sketched one nearly frontal position, with a raised right hand that rests on a book, while the left hand relaxes in the sitter's lap. He did not explore that idea much further; the other three figure sketches all position the sitter facing left to some degree.

Much of the paper surface is devoted to the search for suitable hand positions. Barocci tried out several variations for the right hand grasping a book, including a position with the hand aligned along the book's spine (top center). The two large hands indicate one solution in which both hands rested on the arms of the chair, the left hand in a relaxed pose and the right grasping the cover of a book. There must have been additional hand studies, for none on this sheet matches the final painting.

The final position for Giuliano's right hand may be based on an earlier figure study that Barocci made using workshop assistants as models. A drawing in the Lugt collection in Paris that has never been linked to any of Barocci's paintings contains two kneeling figures, each holding an open book on his left knee. One of them leafs through the book with his right hand, grasping the curled pages in a pose identical to that in Giuliano's portrait.[20] It is unclear whether this drawing was made specifically for the portrait in question, or whether Barocci had made it earlier and simply consulted it as he designed the portrait. No sketches document his designs for Giuliano's left hand, one of the most sensitive features of the portrait. In perfect vertical alignment with Giuliano's face and enforcing the organizational diagonal of the painting, the left hand was very likely a feature to which Barocci devoted considerable study.

No example better demonstrates the importance of hand placement to the effectiveness of a likeness than the signed and dated *Portrait of Count Federico Bonaventura* (1555–1602; cat. 22). The portrait derives part of its strength from the uncompromising force of the sitter's gaze and its brilliant demonstration of Barocci's ability to paint black designs on black clothing. He adeptly exploited the contrast of light skin against dark fabric—an element that Titian and Tintoretto had used to good effect—to render an image of particular pictorial power. However, it is the sensitive portrayal and inspired placement of the hands that establish this portrait as a masterpiece.

Because the painting has been in England since the nineteenth century, the sitter was initially identified as the earl of Pembroke. Harald Olsen first suggested that it might be Marchese Ippolito della Rovere.[21] Bellori's biography gives evidence that the marchese sat for Barocci. A 1652 inventory of the ducal palace in Urbino lists a painting of similar dimensions depicting

CAT. 21.1. *Studies for Portrait of Monsignor Giuliano della Rovere.* Black, white, and red chalk with pink pastel, 11 x 15¹⁵⁄₁₆ in. (27.9 x 40.5 cm). Kupferstichkabinett, Staatliche Museen zu Berlin, inv. KdZ 20446 (4373)

"Marche Ipolito della Rovere. Del Baroccio."[22] This identification has generally been followed by most Italian authors, in spite of Sangiorgi's 1991 article demonstrating the more likely association of the portrait with Federico Bonaventura.[23] Bonaventura (1555–1602) was a beloved friend of Francesco Maria and a patron of Barocci (he contributed three hundred *scudi* for the *Presentation of the Virgin* [fig. 15] that the artist painted for the Chiesa Nuova). A portrait of him by Barocci's hand hung in the Bonaventura home until the early eighteenth century.[24] That portrait then passed to the Antaldi family through marriage, and a description of the Antaldi picture from an eighteenth-century Urbino guidebook fits the London picture well: "Superb portrait of a man dressed in black with

a collar in the Spanish fashion, half figure by Barocci."[25] Furthermore, as Dante Bernini pointed out before the association with Bonaventura was proposed, Francesco Maria exiled Ippolito della Rovere in 1602, and it is unlikely that Barocci would have portrayed an enemy of the duke, particularly in the very year he was exiled.[26]

Only two drawings have been associated with the painting, a study for the full figure and a sheet devoted to refining the hands.[27] The figure study (cat. 22.1) was done very quickly, and it seems that Barocci's primary intention was to establish the pose and determine the disposition of the hands and drapery. He chose a slightly angled position, with the count's right shoulder lowered and presented slightly for-

ward toward the viewer. With masterful assurance, he defined the right arm with bold strokes of black chalk and white heightening to suggest its three-dimensional form. He successfully exploited the simple means at his disposal. Through variations in thickness and pressure, he used the black and white media to superb effect to define an assertive, standing figure. He included neither the sword nor the chair, and although Pillsbury identified the hatched lines at the upper corners as a drape to add grandeur, those lines are more likely related to unidentifiable drapery studies that populate many of the artist's sheets.

The second very handsome drawing (cat. 22.2) shows Barocci's refinements to Bonaventura's hands, executed well along in the design

CAT. 21.2. *Studies for Portrait of Monsignor Giuliano della Rovere.* Black, white, and red chalk and charcoal, partially squared in black chalk, laid down, 10¹³⁄₁₆ x 15⁹⁄₁₆ in. (27.5 x 39.6 cm). Gabinetto Disegni e Stampe degli Uffizi, Florence, inv. 11649 F.

process. There were probably earlier hand studies, for by the time the artist began his explorations on this sheet, he had already arrived at the essential position for the left hand. Although he refined it later, the extended little finger brilliantly captures the sitter's social status and self-importance. Barocci devoted three sketches to fine-tuning the position for the right hand resting on the chair arm. Seeking a position where the hand firmly grips the wood, he directed his efforts at establishing the foreshortening and developing the curved contour to the left of the thumb. He began this series at the upper right, where the edge of the hand ending in the index finger is almost completely straight; he revised the contour at the lower left and added finish to the final pose through colored

chalk and pastel. As he often did in his chalk studies, he applied red chalk strategically to define areas of warm shadow—between the fingers and along the knuckles and joints of the right hand.

One last portrait by Barocci to be considered here is his *Self-Portrait,* which scholars have surmised was painted between 1595 and 1600, based on the painter's presumed age (cat. 23). The image was apparently popular, having inspired at least two copies, but neither appears to be autograph. The superior version is the one in the Residenzgalerie in Salzburg.[28] Writers have generally found this portrait to be an illustration of the personality of the artist described by Bellori—melancholic, a chronic insomniac, and living with the legacy of pain

caused by his supposed poisoning in the 1560s. There is no doubt that Barocci suffered considerable discomfort for most of his life (graphically detailed in Bellori's account).[29] Bellori also indicated that the artist was forced to be somewhat of a loner, noting that when he was able to work, he reluctantly removed himself from his pupils in order to fulfill his commissions.

However, his suffering did not dominate his life. Although he was shy, he invited the "leading and most virtuous members of the city" to his house for discussions that lasted into the early morning.[30] Therefore, the record he left of his own appearance late in his life should not be seen only in terms of his physical trials, or even his possible psychological woes.

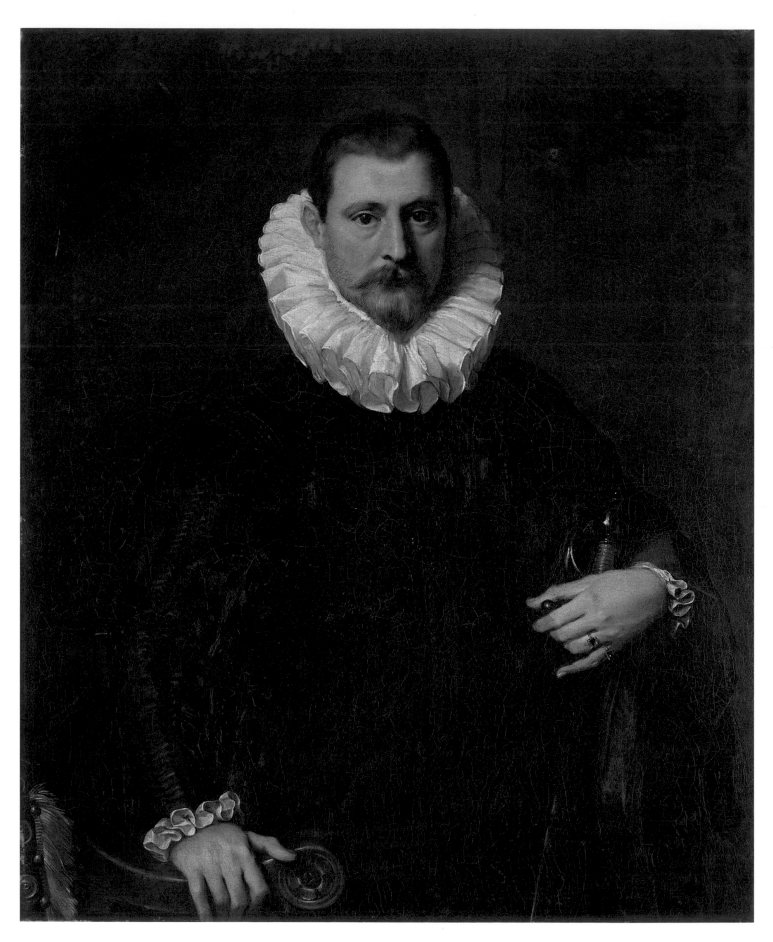

CAT. 22. *Portrait of Count Federico Bonaventura*, 1602. Oil on canvas, 46⁷⁄₁₆ x 37³⁄₈ in. (118 x 95 cm). Signed and dated, lower-left corner: "FED. BAR. VRB. / AD MDCII." Embassy of Italy, London

CAT. 22.1. *Figure study for Portrait of Count Federico Bonaventura.* Black chalk and charcoal heightened with white on gray-green paper, 14¹⁄₁₆ x 10⅝ in. (35.7 x 27 cm). Martin-von-Wagner-Museum der Universität Würzburg, inv. HZ 7185

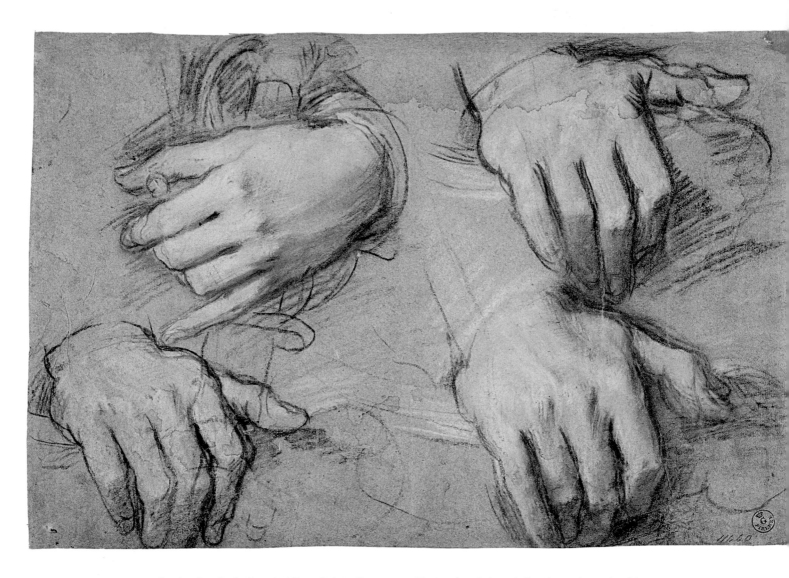

CAT. 22.2. *Four hand studies for Portrait of Count Federico Bonaventura.* Black, red, and white chalk with peach pastel on blue paper, 11¼ x 16⅝ in. (28.6 x 42.2 cm). Gabinetto Disegni e Stampe degli Uffizi, Florence, inv. 11440 F.

Rather, one can find in this remarkably sensitive and inviting visage the eyes of a keen observer, who from his Urbino workshop, isolated from the ducal court in Pesaro or Casteldurante, enjoyed the pleasures of the local countryside, which he recorded from his window or on walks through the nearby fields and woods. His steadfast gaze and the upward angle of the left brow convey his intelligence and honesty as he inventories the effects of aging and lifelong infirmity upon his face. When Barocci completed this image, he was still producing paintings and drawings of remarkable facility and originality. He employed the same high standards when he recorded his own appearance, even if the costume is only quickly roughed in. It is tempting to see in his subtle immersion of the left side of his face in shadow a suggestion of his fear of illness and personal demons; but it is also testament to his careful and controlled handling of light, which is always a hallmark of both his painted and his sketched compositions. Here, it allows his face to penetrate the shadow just enough to create a palpable and believable presence.

No certain drawings exist for this painting. Done in oil on paper, it is not dissimilar to the heads Barocci prepared for some of his greatest narrative paintings. It retains the immediacy and sense of purpose that such a "drawing" conveys. One very damaged sheet in the Martin-von-Wagner-Museum in Würzburg has been proposed as a preparatory study, but its crude definition of form and lack of any sensitivity indicate that it is a copy done after the picture.[31]

Judith W. Mann

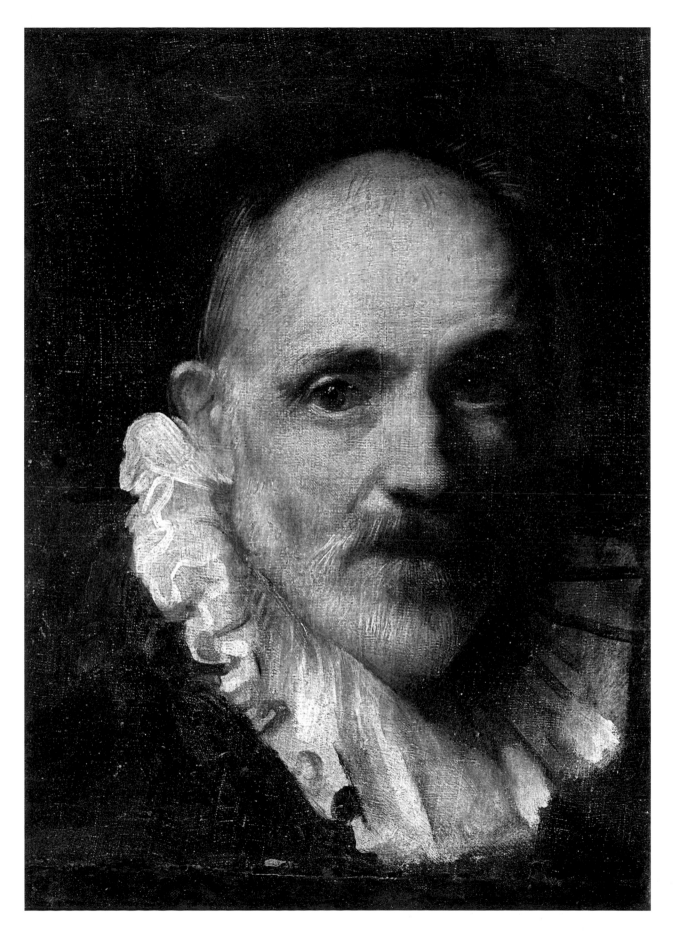

CAT. 23. *Self-Portrait*, ca. 1595–1600. Oil on paper mounted on canvas, 16⅝ x 13 in. (42.2 x 33 cm). Galleria degli Uffizi, Florence, inv. 1890 n. 1848

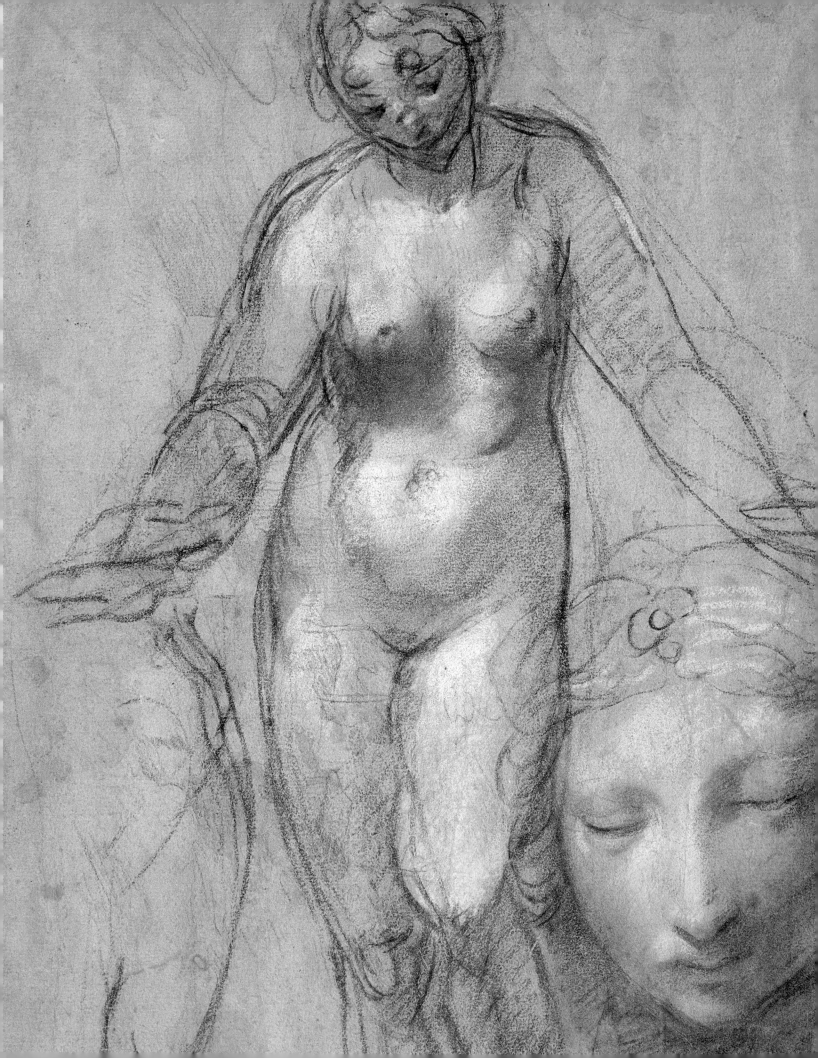

Line, Shadow, and Color in Barocci's Drawings

MARZIA FAIETTI

At the conclusion of the section "Excellency and Necessity of Drawing" in his *L'Idea de' pittori, scultori, et architetti* (Turin, 1607), Federico Zuccaro synthesized the characteristics and quality of drawing, defining it as "the form of all forms, the light of the intellect and the life of all operations." He went on to say that the appearance of drawing is that of a "simple linearity" accomplished by using the pen or the *tocalapis* (chalk holder).[1]

In the practice of drawing, Zuccaro was not as radical as he claimed to be in his treatise. He used, in fact, diverse techniques, at times favoring polychromy. Nevertheless, in some of his sheets, such as the *Study of two demons armed with spears,* a preparatory sketch for the northwest side of the dome of Santa Maria del Fiore in Florence,[2] the chromatically different parts result in areas that are distinct and separated, while the contour line of the bodies and forms constitutes an effective demarcation of borders. It is a liminal line, therefore, that "like a dead thing, is not the science of drawing or of painting, but the operation of it," as Zuccaro affirmed in "What Is Outline Drawing?"[3]

By the time that Zuccaro was composing his *Idea,* his and Barocci's professional paths had long since diverged. The two young artists, both from the Marches, had collaborated in Rome in the early 1560s; despite going their separate ways, they were still bonded with "a knot of true and indissoluble love."[4]

Barocci was apparently isolated from the greater artistic circles. Yet his work reached sovereigns and other powerful men of Europe, thanks to the policy of the dukes of Urbino of dispatching diplomatic gifts. In his native Urbino, Barocci had devised strategies and drawing methods that were radically different from both Zuccaro's metaphysical vision of drawing and the empirical method, which Zuccaro criticized in the *Idea* for its lack of rigor.

The starting point of my essay derives from an observation formulated in 1976 by John Shearman, who shrewdly perceived in Barocci's works "the indivisibility of the drawing process from that of painting." Such indivisibility, in my opinion, does not concern just the operative process of drawing and painting, but more deeply elaborates the conceptual structure as well as the ontology of drawing.

Although Barocci, unlike Zuccaro, did not leave any written work, his vast corpus of drawings enlightens us about his techni-cal and stylistic achievements. It is precisely those achievements, focused on his interests in light and color effects, that prompt me to further investigate Barocci's role in the development of the graphic art of his period. I also reexamine some aspects of the drawing theory that Barocci's colleagues Alessandro Allori and Giorgio Vasari elaborated in the 1560s, Allori likely reflecting the opinions of his teacher, Agnolo Bronzino. Partly because of space, this study is limited to one decade, from Barocci's stay in Rome (1561–63) to his completion of the Perugia *Deposition* (1569).

Barocci had in fact just left Rome for good to return to his native Urbino when, between about 1560 and 1570, Allori wrote several drafts of "Dialogue on the Art of Figure Drawing." The text, nominally a manual on beautiful drawing for noble amateurs, is at the same time testimony to the interest in anatomical practice that Allori had exercised since his youth.[5] The first version, written around 1560, is titled, "The First Book of Discourses of the Rules of Drawing by Alessandro Allori with M. Agnolo Bronzino." It translates theoretical and stylistic problems into formal praxis. It is sufficient to consider just one of the first responses that Bronzino supposedly gave to Allori in order to understand how Bronzino's artistic activity sprang from a knowledge of Renaissance principles of drawing theory and from his willingness to apply these principles harmoniously in a working process that in his most finished studies foreshadows the desired point of arrival.

> Every time an artist through the strength of shadow or light wishes to achieve the effects of sculptural relief with whatever color, his work becomes painting and not drawing, for drawing is nothing more than a line as subtle as one can achieve. However, I would not wish the reader to believe that with my reasoning I was trying to persuade both painters and sculptors or other artists to avoid giving shadow and relief to their drawings in every manner that is used in drawing. If that happened, I would go against the very practice I myself employ every time I need to make drawings. But this I wrote more to satisfy your question a bit, and in fact I do hope for the drawings to be studied and finished as much as possible so that the works can be facilitated in their making. And leaving aside for now the dispute of this topic, I resolve to consider the many difficulties that an artist will encounter before making the actual drawing.[6]

Opposite: *Studies for the Virgin Mary* (detail), cat. 6.5

Bronzino was aware of the discrepancy between the theoretical definition of drawing exclusively focused on line and the level of compromise achieved in the functional drawing, where shadow and relief are necessary. As an example of such an inevitable contradiction, he in fact indicated his own experience.

The recent monographic exhibition on Bronzino at the Metropolitan Museum of Art has reaffirmed the importance of drawing for the artist, together with his brilliant use of a varied range of techniques and typologies. His drawings should therefore not be categorized exclusively as simple *lineamentum* (line); on the contrary, one should remark that in Bronzino the paucity of studies with pen and ink is due, at least in part, to his apprenticeship with Jacopo da Pontormo.[7]

A few years later, Giorgio Vasari—in his *Introduction . . . to the Three Arts of Design, Architecture, Paintings and Sculpture . . .* (in Book 1 of the *Lives* [Giuntina edn. of 1568])—gave chapter 15 the heading, "What Design is, and how good Pictures are made and known, and concerning the invention of Compositions,"[8] expanding the section from the 1550 edition, where it was called "How good Pictures are made and known, and concerning the invention of Compositions."[9] The first addition, inserted at the very beginning, is rather important, for it contains the famous affirmation of drawing as the father of the three arts:[10]

Seeing that Design, the parent of our three arts, Architecture, Sculpture, and Painting, having its origin in the intellect, draws out from many single things a general judgement, it is like a form or idea of all the objects in nature, most marvelous in what it compasses, for not only in the bodies of men and of animals but also in plants, in buildings, in sculpture and in painting, design is cognizant of the proportions of the whole to the parts and of the parts to each other and to the whole. Seeing too that from this knowledge there arises a certain conception and judgement, so that there is formed in the mind that something which afterwards, when expressed by the hands, is called design, we may conclude that design is not other than a visible expression and declaration of our inner conception and of that which others have imagined and given form to in their idea.[11]

Probably a few days after 18 October 1564, Lieutenant Vincenzio Borghini, in a speech presented at the Accademia del Disegno in Florence, accepted the concept of "drawing as a father who always kept his three daughters, like the three Graces, united and in perfect agreement."[12] However, he mentioned only painting and sculpture, the two minefields in which those disputes that so displeased him took place among the arts.

Vasari, by contrast, explicitly noted architecture, which thus acquired full right to the role of the third Grace[13] and overcame its subordinate position with respect to painting, as it was described,

for example, in the *Dialogue of Painting* by Ludovico Dolce (1557), as well as in the earlier *Dialogue* of Paolo Pino (1548).[14] Moreover, Vasari created a theoretical framework for the concept he had already expressed in 1546 in a letter to Benedetto Varchi, where drawing is defined as the "mother" of the three arts.[15]

The introduction of architecture, now in the guise of the third daughter of drawing, "father of the arts," appropriates the technique of line drawing specifically for architecture, although the practice of drawing lines remained a fundamental operation for both painting and sculpture.

The masters who practice these arts have named or distinguished the various kinds of design according to the description of the drawing which they make. Those which are touched lightly and just indicated with the pen or other instrument are called sketches, as shall be explained in another place. Those, again, that have the first lines encircling an object are called profiles or outlines. All these, whether we call them profiles or otherwise, are as useful to architecture and sculpture as to painting. Their chief use indeed is in Architecture, because its designs are composed only of lines, which so far as the architect is concerned, are nothing else than the beginning and the end of his art, for all the rest, which is carried out with the aid of models of wood formed from the said lines, is merely the work of carvers and masons. In Sculpture, drawing is of service in the case of all the profiles, because in going round from view to view the sculptor uses it when he wishes to delineate the forms which please him best, or which he intends to bring out in every dimension, whether in wax, or clay, or marble, or wood, or other material. In Painting, the lines are of service in many ways, but especially in outlining every figure, because when they are well drawn, and made correct and in proportion, the shadows and lights that are then added give the strongest relief to the lines of the figure and the result is all excellence and perfection. Hence it happens, that whoever understands and manages these lines well, will, with the help of practice and judgement, excel in each one of these arts.[16]

In the above excerpt, one can also observe the possibility of an effective reconciliation between intellect, concept, hand, and experience under the aegis of drawing. If drawing is nothing other than "a visible expression and declaration of our inner conception,"[17] one expresses it with the hands, needing practice and exercise. The close collaboration between the intellect, which "puts forth refined and judicious conceptions," and "the hand which has practiced design for many years . . . exhibits the perfection and excellence of the arts as well as the knowledge of the artist."[18] In this way, the distinction between action and thought is overcome by the creative act and the working praxis of the artist.

Some final clarification, more from the mouth of the artist

than the theoretician, is found in chapter 16, titled, "Of Sketches, Drawings, Cartoons, and Schemes of Perspective; how they are made, and to what use they are put by the Painters," based on the example of Cennino Cennini but with more extensive description of artistic procedure.[19] I select here an excerpt useful for its definition of the typologies of drawing and its techniques:

> Sketches, of which mention has been made above, are in artists' language a sort of first drawing made to find out the manner of the pose, and the first composition of the work. They are made in the form of a blotch, and are put down by us only as a rough draft of the whole. Out of the artist's impetuous mood they are hastily thrown off, with pen or other drawing instrument or with charcoal, only to test the spirit of that which occurs to him, and for this reason we call them sketches. From these come afterwards the drawings executed in a more finished manner, in the doing of which the artist tries with all possible diligence to copy from the life, if he does not feel himself strong enough to be able to produce them from his own knowledge. Later on, having measured them with the compasses or by the eye, he enlarges from the small to a larger size according to the work in hand. Drawings are made in various materials, that is, either with red chalk, which is a stone coming from the mountains of Germany, soft enough to be easily sawn and reduced to a fine point suitable for marking on leaves of paper in any way you wish; or with black chalk that comes from the hills of France, which is of the same nature as the red. Other drawings in light and shade are executed on tinted paper which gives a middle shade; the pen marks the outlines, that is, the contour or profile, and afterwards half-tone or shadow is given with ink mixed with a little water which produces a delicate tint: further, with a fine brush dipped in white lead mixed with gum, the highlights are added. This method is very pictorial, and best shows the scheme of colouring. Many work with the pen alone, leaving the paper for the lights, which is difficult but in effect most masterly.[20]

Vasari then referred to many other ways of drawing that are not specified, but that belong equally to the act of drawing: "Innumerable other methods are practiced in drawing, of which it is not needful to make mention, because all represent the same thing, that is drawing." This particular observation, in fact, leaves open many paths for graphic experimentation, showing themselves to be, in my opinion, very important for understanding the mental freedom that governed Barocci's choices.

Around the time Barocci returned to Urbino after his second visit to Rome, the theoretical definition of drawing and the illustration of its techniques of execution must have circulated among the practitioners of his profession. Research on the artistic personality of Barocci has long privileged the perusal of documents

and sources from the late sixteenth and seventeenth centuries.[21] If one turns more specifically to the drawings, however, scholars have frequently singled out Bellori's biography of Barocci (1672) as a source of primary interest. It becomes a sort of *vade mecum* or manual that helps make it possible to penetrate the intricacy of Barocci's graphic production, distinguishing its objectives, its phases, and its different types of drawings.[22]

Bellori's text is undoubtedly as relevant as it is impossible to disregard. But to conduct a useful study, it is best to consider the biography in its historical context and proceed with a scrupulous philological examination. It is also important to examine other sources that precede the biography, such as the three mentioned at the beginning of this essay. Bellori should not monopolize our attention to the exclusion of other sources from the period when Barocci was first defining his drawing strategy (Allori and Vasari) or those written by his colleagues (Zuccaro).

After exhibitions in Bologna and Florence in 1975 created new interest in Barocci's work,[23] Bellori's biography became the object of differing critical reflections. Most important was the review by Shearman, whose conclusions on Barocci's graphic activity were expressed with necessary caution, awaiting a more thorough investigation of the visual sources.[24] By singling out two preparatory studies in oil (*bozzetti*), Shearman had some specific and well-founded reservations regarding the authority of Bellori's text, which previously had been understood as a faithful record of Barocci's drawing process. Shearman's review directed drawing specialists toward a rereading of the biography with greater awareness of the ideological filter that motivated its seventeenth-century author.

Edmund Pillsbury provided the first significant revisions to the *modus operandi* that Bellori had described analytically.[25] According to Pillsbury, Bellori tried too hard "to demonstrate similarities of approach and method between Barocci and certain artists of the High Renaissance rather than [seeing] his art as an individual response to particular problems of representation and interpretation."[26] Furthermore, discoveries of new drawings documenting the beginning of Barocci's activity—such as the sheet of the Infant Jesus in the Art Institute of Chicago made for the *Madonna of Saint John* (fig. 6)—led Suzanne Folds McCullagh to make observations that go beyond those of both Bellori and Pillsbury.[27]

A main point in Bellori's biography is his emphasis on Barocci's drawing exercises from nature. The surviving materials do not contradict the assumption that Barocci drew from life (his celebrated *arie di teste* [facial expressiveness] being particularly suggestive in this regard), but close examination even of his figure drawings corroborates instead a clear and harmonious alternation between studies done from nature and studies done from the imagination (*studi da sè*).

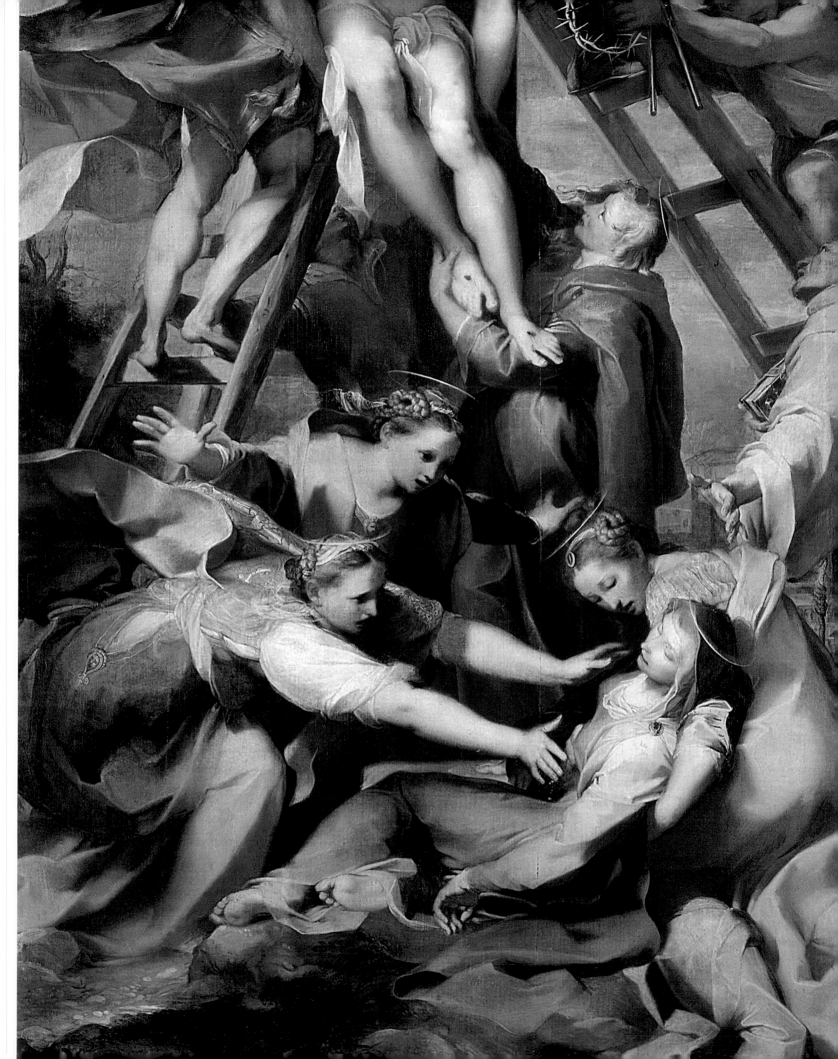

Perfecting the Light
Barocci's Red Outlining Technique

CLAIRE BARRY

Introduction

Barocci was a devout perfectionist who would spend years creating a single altarpiece, and his meticulous working methods produced an exquisite painting technique. The extensive time he invested in studying almost every detail of a painting left little to chance, as evidenced by his vast corpus of preparatory drawings, but yielded only a relatively small number of finished works in oil.[1] These paintings, however, rank among the most coveted and influential works created in Italy during the late sixteenth century. Barocci was esteemed as a "painter's painter," and aspects of his innovative techniques were adopted by the following generation of artists from both Italy and the north, altering the future course of painting.[2]

Barocci's deft handling of color and crisp impasto are defining characteristics of his virtuosity in portraying the effects of light. This essay explores both these aspects of his painting method, which have previously received little notice, particularly the outlining of figures in red, a color appropriately suited to the rendering of human skin.[3] The artist discovered the expressive potential of applying vivid red outlines as a means to highlight form and perfect the fall of light on anatomical details. The precision of these colored outlines is integrally related to his work as a master draftsman. As Stendahl wrote, Barocci applied paint as if sketching a pastel.[4] He invested tireless effort in understanding the properties of light during the course of executing an enormous number of preparatory works—including drawings, oil studies, and pastels—that enabled him to infuse his paintings with such refined naturalism. Barocci's preoccupation with the illumination of the figure was reflected in the subtle distinctions he made in rendering different parts of the anatomy in light or shadow, including the smallest details, even fingernails.

Barocci referred to painting as music, and perhaps the use of red outlines provided a way of harmonizing the color of his skin tones with an enveloping light. Together with his use of impasto to apply flickering highlights on material surfaces such as fabrics or metal (another sometimes overlooked aspect of his technique), these refined contours were central to his strategy for creating a magical atmosphere of light in his paintings.

His practice of painting elegant outlines, whose color shifted from different shades of red to black and back again, helped Barocci capture the intermittent play of light along the contours of his figures. Close examination of his paint surfaces reveals the technical refinement of these changeable outlines. This outlining technique, which he used in his monumental altarpieces, portraits, and small devotional paintings alike, also helped him to position different anatomical details in space. Areas outlined in red appear to advance, while those surrounded in black recede. In his *Portrait of Francesco Maria II della Rovere,* ca. 1571–72 (cat. 19), for example, he selectively outlined the ring-finger nail of the right hand in red. Finding the terminology to describe these meticulously painted contours is difficult. They are an integral part of Barocci's final paint surface, yet they fuse easily with the rouge tonality of the skin tones.

The use of changing, colored outlines should also be considered within the context of Barocci's experimentation with color to achieve greater naturalism in the rendering of human skin. He was one of the most important of all Renaissance colorists, and his novel treatment of skin tones with translucent blue and green shadows was one of the great coloristic innovations of the sixteenth century.[5] Rubens famously adopted this technique in painting skin tones, especially visible in his nudes.[6] Georges de La Tour also added blue pigment (azurite) to shade his skin tones, employing one of Barocci's practices, and he sometimes delineated the contours of his figures using very precise red lake pigment[7] outlines (fig. 94).[8] Contrary to Barocci's selective red outlining on the final paint surface, however, La Tour intended his preparatory red lake drawing to be largely concealed beneath the paint layer. Examples of Nicolas Poussin's emulation of Barocci's technique can be seen in the reflected light of the skin tones of the foreground figures in *Adoration of the Golden Calf,* 1633–34 (National Gallery, London), or the selective red outlining of skin tones in the putto in *Cephalus and Aurora,* 1630 (National Gallery, London).[9]

Our understanding of Barocci's oil-painting technique, however, has traditionally been hampered by several factors. The inaccessibility of many altarpieces, particularly those preserved in situ

Opposite: *Deposition* (detail), fig. 47

in remote Italian towns, has prevented direct examination of the paintings. Apart from those works that have found their way into a handful of (mostly European) museums,[10] many of Barocci's most celebrated large altarpieces, such as *Il Perdono*, 1571–76 (cat. 5), remain in their original locations in dim church interiors, where they are hung above eye level, behind an altar. Other physical impediments, such as the locked gate in the side chapel where Barocci's *Institution of the Eucharist*, 1603–9 (cat. 18), hangs, present significant obstacles to the close examination of surface details.

Moreover, layers of discolored, opaque varnish and overpaint on works in need of restoration have hindered an accurate assessment of the painter's intentions, particularly with regard to his consummate handling of color and subtle details in oil. Fortunately, the cleaning and restoration of a number of his most important paintings in recent decades have enabled a much greater knowledge of the artist's achievements, particularly in his best-preserved works, such as the *Madonna del Popolo,* 1575–79 (fig. 8).[11] The publication of technical studies has been part of a growing trend to examine Barocci's creative process within the context of individual works such as the *Deposition* (cat. 3).[12] The exhibition catalogue produced after its recent restoration represented a significant milestone in advancing our understanding of Barocci's painting materials and techniques. Yet, despite such publications, a pressing need remains for a more comprehensive and collective overview of his painting method.

Rather than attempting a complete technical study of Barocci's painted oeuvre, this essay will highlight aspects of his technique worthy of close consideration and suggest areas for future study. The findings here are based on observations from a number of paintings that were examined firsthand with magnification, both in situ and in museum galleries, and on information provided by their owners in conservation reports.[13] Monographic exhibitions such as the one that occasioned this book provide a rare opportunity to evaluate Barocci's paint surfaces by assembling works not normally seen together. It is hoped that this essay will stimulate a greater appreciation of Barocci's painting technique by supplementing the direct experience of the works of art themselves with observations aimed at illuminating the innovation and refinement of his handling.

Barocci's red outlining method is considered within the context of both earlier and contemporary preparatory drawing, underdrawing, and painting practices in Italy. The method is analyzed also in relation to the artist's own preparatory drawing practice, especially his inventiveness in translating the fragile effects of pastel studies into the more permanent hues of oil painting.[14] Finally, Barocci's painted contours are discussed among other observations about the condition and painting techniques of some of his most important works.

Red in Graphic Designs, Underdrawing, and Painted Contours in Fifteenth- and Sixteenth-Century Italian Painting

There were some precedents in Italian art for the use of both red underdrawing and painted contours applied to the final surface. However, Barocci's technique of red outlining, which falls into the latter category, appears uniquely intended to impart a glowing light to skin tones. Reviewing Italian underdrawing practices sheds light on the role red media have historically played in this important preparatory step. So far, no use of red media has been found in Barocci's underdrawing. However, this preliminary phase of his painting process requires further investigation, for we are just beginning to document it.

Recent examination of Barocci's *Deposition* (cat. 3) with infrared reflectography revealed his use of black media for the preparatory underdrawing, and exposed his subtle shifts in the positioning of figures.[15] Black underdrawing can normally be readily detected with infrared reflectography, the traditional tool for examining underdrawing. The infrared camera detects the contrast between the infrared-absorbing dark (carbon-based) media and the white reflective ground, reacting so strongly to this contrast that the overlying paint layers are visually negated.[16]

When working in fresco rather than oil, however, Barocci may have used a sinopia, a red pigment made from iron oxide, which Cemino Cennini praised for being good for painting on walls in fresco or secco.[17] Barocci was a skilled practitioner of fresco painting technique, having executed murals for the Casino of Pius IV in Rome, including the *Holy Family with Elizabeth, Zaccharias, and Saint John the Baptist* (fig. 4), when he helped with the decoration of the rooms in the casino in the 1560s. His fresco has been called "the pièce de résistance of Barocci's early career."[18] When sinopia was used in fresco painting, it was applied to the *arriccio* (preliminary layer of plaster), later becoming concealed during the course of painting. Unpublished technical analysis of Barocci's frescoes confirms that he used *calco* (incisions) for transferring designs (see Bohn essay, 62). But whether or not Barocci ever used sinopia, he would have been familiar with this traditional practice in earlier Italian fresco painting.[19]

Raphael, one of the towering giants of the Italian Renaissance, also hailed from Barocci's hometown of Urbino, and his work had a profound impact on the younger artist. Barocci intensely admired both Michelangelo's and Raphael's Vatican frescoes, which he saw during his first sojourn in Rome. Several years later, he borrowed the figure types and design ideas from Raphael's *Disputa,* ca. 1509–10, with its two-storey division of space, for his own celebrated altarpiece *Il Perdono* (cat. 5).[20] Raphael sometimes employed red media in the underdrawings of his paintings, but although as a young artist Barroci copied Raphael's work, it

is debatable whether he was ever aware of Raphael's underdrawing practices.[21]

Raphael used various means to transfer his preparatory graphic designs to the white gesso grounds of his paintings, including transferring cartoons by tracing, incising, or pricking them as part of the *spolvero* technique.[22] In spite of his detailed preparation, however, he continued to refine his compositions throughout the creative process. He sometimes applied freehand sketches directly on the gesso ground, apparently even by drawing with a pen and ink, confirming that his underdrawings evolved in an organic way to suit his needs.

Raphael executed his underdrawings in a variety of black media, including metalpoint, charcoal, and pen and ink.[23] Although paint layers and underdrawing executed in red media are typically transparent when examined under infrared light, advanced infrared cameras with more sensitive detectors have recently made it possible to see previously unknown red underdrawing in Raphael's paintings.[24] His use of very light preparatory drawings in red pencil, combined with black underdrawing in ink and charcoal, was recently discovered during the examination of several of his paintings using scanning infrared reflectography.[25] Seen within the context of his entire graphic oeuvre, this is perhaps not surprising, for red chalk, or studies in red media, also appear in Raphael's immense corpus of drawings, such as the preparatory sheet for the *Madonna of Alba* (Musée des Beaux Arts, Lille). Michelangelo and other artists of the late Quattrocento likewise made use of red-chalk preparatory drawings.[26]

Correggio, another artist who profoundly influenced Barocci, used red chalk extensively for his preparatory drawings, and he allegedly adopted the innovative technique of drawing with pastels. As Bellori recounted, early in Barocci's career a young artist visiting Urbino introduced him to some of Correggio's pastels, inspiring Barocci to adopt the new medium in his own preparatory studies.[27] None of Correggio's pastels is known today, however, and scholars debate whether he ever made them (see Bohn essay, 40 and 42).[28] The use of red chalk for drawing continued to grow in popularity in Italy, and by the end of the sixteenth century, colored chalks and combinations of red, black, and sometimes white "chalks" gained in favor, as did other color chalks, partly due to Barocci's example.[29]

Barocci's exposure to some of Titian's greatest masterpieces, such as the *Venus of Urbino* in the collection of the duke of Urbino (now in the Uffizi, Florence), informed his artistic development from the earliest stages of his career in Urbino (see Mann essay, 2). However, from what we know of Titian's preparatory drawing practice, it differed significantly from Barocci's. Titian's surviving workshop drawings are few in number, for most were lost when his studio was vandalized after his death.[30] Although his extant drawings range from a preliminary sketch, or *abozzo,* to a finished

Fig. 94. Georges de La Tour, *The Cheat with the Ace of Clubs,* 1630–34. Oil on canvas. Kimbell Art Museum, Fort Worth, inv. AP 1981.06. Detail of pentimento in courtesan's index finger

Fig. 95. Fra Angelico, *The Virgin of Humility,* ca. 1433–35. Tempera on panel, Museo Thyssen-Bornemisza, Madrid, on deposit with the Museu Nacional d'Art de Catalunya (MNAC), inv. 7 (1986.10). Detail of the lute-playing angel's right hand, delineated entirely in red

Fig. 96. *Deposition,* 1568–69 (cat. 3), Cathedral, Perugia. Detail of hand of a woman

compositional model—and include sketches of single figures, legs, and feet—they lack color and are limited to a single medium. By contrast, Barocci's surviving preparatory drawings include a vastly greater number of studies, executed in a wider variety of media.[31] Whatever influence Titian's technique may have exerted on Barocci, however, no red underdrawing has been identified in the Venetian's paintings. Examination of Titian's paintings with infrared reflectography has revealed his use of black underdrawing, probably applied in a liquid medium by brush.[32]

Tintoretto, on the other hand, sometimes applied a type of preparatory underdrawing on his canvases using red lake, a pigment widely associated with the Venetian practice of oil glazing. In addition to using this transparent color in his paint layers, Tintoretto also applied thin, streaky preparatory lines in red lake that were later concealed beneath the final paint surface.[33] His use of red preparatory lines reflects the general flexibility of his underdrawing techniques; he typically altered the color of the preparatory sketch (whether black, red, or white), depending on the particular ground color he selected for his canvases.[34]

In addition to evidence of red-based underdrawing in sixteenth-century oil painting in Italy, the use of painted red outlines was not uncommon in egg tempera panels from the Quattrocento and even earlier.[35] Unlike preparatory underdrawing, these painted red outlines formed an integral part of the final paint surface as artists such as Fra Angelico sought to find a more natural means of rendering skin tones. For example, he delineated the hands and fingers of the lute-playing angel in the *Madonna of Humility,* ca. 1433–35, entirely in red with his characteristic delicacy and refinement (fig. 95).[36] Painted with the fast-drying medium of egg tempera, which allows little flexibility, Fra Angelico's red outlines were homogeneous in color. By contrast, the slower-drying medium of oil gave Barocci greater working time and flexibility, enabling him to alter the color of his outlines at will in response to the differential fall of light on his figures.

Selective Highlighting of Skin Tones in Sixteenth-Century Italian Art

Glazing—the technique of applying thin, transparent layers over opaque layers to add depth and transparency—is characteristic of the expressive capabilities of the oil-painting medium. Correggio and Titian, two masters of hue in their handling of oil, modulated the highlighting of skin tones through the selective application of red-lake oil glazes. Barocci's innovation was to further emphasize areas of highlighting in skin tones by "drawing" with painted red outlines, in addition to applying oil glazes in a manner that intensified the light. In *Venus and Cupid Discovered by a Satyr,* 1534, Correggio created subtle variations along the contours of his figures—between a soft red highlighting and muted gray shading of the skin tones.[37] Contrary to the linear precision of Barocci's highlighting of contours, however, Correggio's treatment of edges is softer and more blurred, contributing to the sfumato that is central to his style. He applied red glazes to enhance the illumination of protruding anatomical details that catch the light, such as Cupid's heel and toes or Venus's feet, an aspect of his technique that Barocci must have noticed and absorbed.

Titian's brilliant example in the application and use of glazes to achieve luminous skin tones in works such as the *Venus of Urbino* and other paintings of the nude must also have inspired Barocci's artistic development. Titian's highlighting of skin-tone details such as fingertips, knees, or feet with rosy tints through the application of red-lake glazes established a model for Barocci's handling of the figure. The edges of Titian's figures, however, which were more often modulated through glazing alone, were much softer and less distinct than Barocci's carefully delineated contours.[38] The depth and transparency of Titian's glazes led to a treatment of the figure with greater contrasts between lights and shadows, while Barocci's figures were generally keyed to the light range of the palette.[39]

The above examples illuminate some of the diversity and flexibility of preparatory drawing, outlining, and glazing techniques in sixteenth-century Italy. The extent to which these practices may have informed Barocci's use of colored outlines, however, must be considered also in light of his own elaborate drawing process in preparation for painting, in particular his pioneering use of pastels (see cats. 3.7, 3.11). His practice of making colored oil sketches for the heads of some altarpieces, in addition to his preparatory drawings, undoubtedly influenced his painting method. The pastel studies, which allowed him to draw directly with color, may have found their later expression in his red linear highlighting technique when working in oil.

Barocci's Preparatory Drawing Techniques and Use of Pastels

Barocci's vast drawing corpus has yielded unparalleled insights into his creative process, revealing his special concerns while preparing painted compositions. Most of these drawings reveal that from the beginning of his preparatory process Barocci considered the direction and character of light required in the final painting.[40] He created many drawings of draperies and life studies of figures, including detailed studies of heads and hands.[41] The numerous studies for the Virgin's pointing right hand, some in red chalk, for the *Madonna del Gatto,* ca. 1575–76 (cat. 7), demonstrate his preoccupation with the lighting of a key narrative detail in the painting.[42] Like many early studies, it reveals that Barocci was thinking

about lighting at a very early stage of the creative process, even though this aspect of his design was sometimes subject to change in the final painting.[43]

The pastel studies represent one of Barocci's most lasting and original contributions as a draftsman. Colored pastel studies allowed him to focus on the precise effects he wished to achieve in the final work. The artist consulted them during the course of painting,[44] when he transformed the red-chalk outlines used for the eyelids, ridge of nose, ears, and other critical facial features into oils (e.g., compare cat 8.8 with cat 8.9). The significance of Barocci's work in pastels cannot be overstated; both the palette and the sfumato modeling of his paintings in oil seem intended to re-create the colors of chalks.[45]

Notes on Paintings: Condition, Materials, Techniques

CONDITION

Barocci's bright palette of pastel colors reemerged following the removal of layers of discolored varnish from the *Deposition* (cat. 3), his early masterpiece, confirming his preference for mid-range colors rather than full saturation.[46] The innovative coloring of *Il Perdono* (cat. 5), arguably one of Barocci's greatest works, was also revealed during recent cleaning and restoration.[47] He used primary colors in the upper tier of *Il Perdono* to distinguish it from the muted lighting of the church interior below. The heightened intensity of the heavenly aura was created by contrasting Christ's billowing red mantle against a bright yellow sky, while the *cangiante* blue and crimson draperies of Saint Nicholas and the Virgin Mary mirror Christ's spiritual light. Barocci's abiding interest in reflected light was uncovered by the cleaning of the *Madonna del Popolo*, which has been praised as "a painting of optical sophistication with almost magical illusionistic effects."[48] The vivid, rosy skin tones of the baby that reflect his mother's bright red mantle in the lower left are a tour de force, testimony to the artist's fascination with luminous skin tones.

Evidence of Barocci's technical mastery in the handling of color to suggest reflected light on materials and still-life objects as well as skin tones emerged after cleaning his secular composition *Aeneas Fleeing Troy*, 1598 (cat. 16). Here he portrayed the reflected light of the burning fires by a variety of means, ranging from the application of pink highlights on the fluted column at left, to the pink/lavender *cangiante* lining of Anchises's damask drapery and the pink tints of the child's face. As Charles Dempsey observed, Barocci's colors were conceived optically, and their effect was naturalistic.[49]

The removal of layers of discolored varnish from the *Entombment*, 1579–82 (cat. 8), has revealed Barocci's palette of Venetian pigments such as orpiment, red lake, and lapis lazuli for the richly colored draperies. The expensive pigments underscored the importance of this commission for the main altarpiece of the Chiesa della Croce in Senigallia. Some irreversible darkening has occurred, however, in the copper-resinate green glazes of the foliage, and some loss of hue may have occurred in the sky due to the presence of an unstable blue pigment such as smalt. Other changes to the composition resulted from Barocci's own intervention when he restored the painting after it had suffered significant damage by copyists making direct tracings of different parts of the composition. However, understanding the full extent of his repainting, which was carried out late in his career, requires further examination.

PAINTING SUPPORTS

Barocci painted the vast majority of his monumental altarpieces on high-quality herringbone-weave canvases, prepared with a gray imprimatura (thin toning layer applied to the ground), with the exception of the *Madonna del Popolo* (fig. 8), which is unique among his altarpieces for its use of a wooden support consisting of a series of horizontal planks joined together. Herringbone-weave canvas was regularly used by Venetian artists. While Tintoretto and Veronese emphasized the distinctive texture of the herringbone pattern by allowing it to remain visible on their paint surfaces, Barocci often opted for a smoother paint surface that masked the canvas texture.[50] In the *Madonna del Gatto*, ca. 1575–76 (cat. 7), for example, the texture of the canvas is completely concealed beneath the porcelain-smooth paint surface. Perhaps the pattern and scale of the weave would have detracted from the delicate painterly effects the artist sought in the surfaces of his altarpieces.

In an exceptional case for Barocci, the artist layered paper over the painted canvas for *Il Perdono*. Possibly dissatisfied with his painting of Saint Francis's upturned head, he glued an image of the saint, painted on a roughly cut, rectangular piece of paper, directly onto the canvas support. While there could be many reasons why Barocci added a repainted head on paper to the canvas for the central figure of this important altarpiece, there were precedents. Earlier Northern painters attached portraits to panels, painted on supports such as canvas, parchment, or tin foil.[51]

PAINT LAYERS
Outlining

The *Deposition*, 1568–69 (cat. 3), is Barocci's first significant altarpiece. His scrupulous planning of the complex, multifigure composition with numerous studies from life became his standard working method.[52] His attention to lighting united all of his preparatory studies for the *Deposition*, including several individual chalk studies of the standing figure on the ladder, the delicate

———, and Carter E. Foster, eds. 2000. *Master Drawings from the Cleveland Museum of Art.* New York.

DeGrazia Bohlin, Diane. 1979. *Prints and Related Drawings by the Carracci Family.* Exh. cat. National Gallery of Art. Washington, D.C.

Dempsey, Charles. 1987. "Federico Barocci and the Discovery of Pastel." In *Color and Technique in Renaissance Painting: Italy and the North,* ed. Marcia B. Hall, 55–65. Locust Valley, NY.

———. 2010. "Stuart Lingo, Federico Barocci: Allure and Devotion in Late Renaissance Painting." *Art Bulletin* 92.3:251–56.

Dennistoun, James. 1909. *Memoirs of the Dukes of Urbino,* ed. Edward Hutton. 3 vols. London.

Denny, Don. 1977. *The Annunciation from the Right from Early Christian Times to the Sixteenth Century.* New York.

Le Dessin italien dans les collections hollandaises. 1962. Exh. cat. Institut Néerlandais. Paris.

Le Dessin italien sous le Contre-Réforme. 1973. Review of exh. Musée du Louvre. *Le petit Journal, des grandes Expositions,* July/September. Paris.

Di Giampaolo, Mario. 2008. "Federico Barocci: Sulla 'Visitazione' alla Chiesa Nuova." *Prospettiva* 129 (January): 93–96.

———, and Giulio Angelucci, eds. 1995. *Disegni Marchigiani dal Cinquecento al Settecento.* Florence.

Dolci, Michelangelo. 1775 (1933). "Notizie delle pitture che si trovano nelle chiese e nei palazzi d'Urbino." *Rassegna Marchigiana* 11.8–9:281–367.

Doni, Antonio Francesco. 1549 (1970). *Disegno,* ed. Mario Pepe. Milan.

Dubois, Hélène, and Arie Wallert. 2003. "Titian's Painting Technique in *Jacopo Pesaro Being Presented by Pope Alexander VI to Saint Peter.*" *Restoration* 3.1:22–37.

Dunkerton, Jill. 2007. "Tintoretto's Underdrawing for Saint George and the Dragon." *National Gallery Technical Bulletin* 28:6–35.

———, and Nicholas Penny. 1993. "The Infrared Examination of Raphael's *Garvagh Madonna.*" *National Gallery Technical Bulletin* 14:6–21.

———, Susan Foister, and Nicholas Penny. 1999. *Dürer to Veronese: Sixteenth-Century Paintings in the National Gallery.* New Haven.

———, and Marika Spring. 2003. "The Technique and Materials of Titian's Early Paintings in the National Gallery, London." *Restoration* 3.1:9–21.

Duston, Allen, and Arnold Nesselrath. 1998. *Angels from the Vatican: The Invisible Made Visible.* Alexandria, VA.

Dvořák, Max. 1927–28. *Geschichte der Italienischen Kunst.* 2 vols. Munich.

Eiche, Sabine. 1982. "Federico Zuccari and Federico Barocci at Loreto and Urbino." *Mitteilungen des Kunsthistorischen Institutes in Florenz* 26:398–400.

———. 1984. "Francesco Maria II della Rovere as a Patron of Architecture and His Villa at Monte Berticchio." *Mitteilungen des Kunsthistorischen Institutes in Florenz* 28:78–79.

———. 1991. "Fossombrone. Part 1: Unknown Drawings and Documents for the "Corte" of Leonora Gonzaga, Duchess of Urbino, and Her Son, Giulio della Rovere." *Studi di Storia dell'arte* 2:103–28.

Ekserdjian, David. 1987. "Review of Federico Barocci." *Burlington Magazine* 129:402–3.

———. 1997. *Correggio.* New Haven.

———. 2007. *Alle origine della natura morta.* Milan.

Emiliani, Andrea, ed. 1975. *Mostra di Federico Barocci.* Exh. cat. Museo Civico. Bologna.

———. 1985. *Federico Barocci (Urbino 1535–1612).* 2 vols. Bologna.

———. 1992. "*La Sepoltura di Cristo* di Federico Barocci in Santa Croce di Senigallia: Un inedito 'bozzetto per i colori' e altri contributi alla conoscenza dell'artista." *Artibus et Historiae* 13.25:9–46.

———. 1994. "Aggiunte al catalogo di Federico Barocci: Tre 'abbozzi per il colore.'" *Hommage à Michel Laclotte: Études sur la peinture du Moyen Age de la Renaissance,* ed. François Avril et al., 456–66. Milan.

———. 1998. *La provincia di Pesaro e Urbino tra arte e paesaggio.* Milan.

———. 2005. "Federico Barocci, tecnica e sentimento. Storie di allievi, copisti, ammiratori." In Ambrosini Massari and Cellini 2005, 9–18.

———. 2008. *Federico Barocci (Urbino 1535–1612).* 2 vols. Ancona. (E 2008 throughout)

———, and Marina Cellini. 1997. *Giovanni Francesco Guerrieri da Fossombrone.* Fano.

Fagiolo, Marcello, et al. 1981. *Virgilio nell'arte e nella cultura europea.* Exh cat. Biblioteca Nazionale Centrale. Rome.

Faietti, Marzia. 2009. "Antinomie e armonie nei disegni di Barocci." In Giannotti and Pizzorusso 2009, 76–81.

———. 2010. "The Critical Fortunes of Bronzino's Drawings from Vasari to Berenson." In Bambach, Cox-Rearick, and Goldner 2010, 10–19.

———. 2011. "Il disegno, padre delle arti, i disegni degli artisti, il disegno delle 'Vite': Intersecazioni semantiche in Vasari scrittore." In *Figure Memorie Spazio: La grafica del Quattrocento: Appunti di teoria conoscenza e gusto,* ed. Marzia Faietti, Alessandra Griffo, and Giorgio Marini, 12–37. Florence.

———, and Daniela Scaglietti Kelescian. 1995. *Amico Aspertini.* Modena.

———, Lorenza Melli, and Alessandro Nova, eds. 2008. *Le tecniche del disegno rinascimentale: Dai materiali allo stile. Mitteilungen des Kunsthistorischen Institutes in Florenz* 52.2–3.

Falomir Faus, Miguel, ed. 2003. *Tiziano.* Exh. cat. Museo del Prado. Madrid.

———. 2007. *Tintoretto.* Exh. cat. Museo del Prado. Madrid.

Farago, Claire, ed. 2009. *Re-Reading Leonardo: The "Treatise on Painting" across Europe, 1550–1900.* Farnham.

Faries, Molly, and Ron Spronk, eds. 2003. *Recent Development in the Technical Examination of Early Netherlandish Painting: Methodology, Limitations and Perspectives.* Turnhout, Belgium.

Fenley, Laura. 2007. Confraternal mercy and Federico Barocci's "Madonna del Popolo": An iconographic study. MA thesis, Texas Christian Univ., Forth Worth.

Ferrara, Daniela. 1995. "Artisti e committenze alla Chiesa Nuova." In Strinati, Melasecchi, et al. 1995, 108–29.

Ferrari, Oreste. 1974. *The Italian Embassy in London and Its Works of Art,* trans. Jane Carroll. London.

———. 1988. *The Italian Embassy in London and Its Works of Art.* Rome.

———. 1990. *Bozzetti italiani dal Manierismo al Barocco.* Naples.

Ferri, Pasquale Nerino. 1881. *Catalogo delle stampe esposte al pubblico nella R. Galleria degli Uffizi.* Florence.

———. 1890. *Catalogo riassuntivo della raccolta di disegni antichi e moderni posseduta dalla R. Galleria degli Uffizi di Firenze.* Rome.

———. 1910. "Un disegno del Baroccio negli Uffizi già attribuito al Rembrandt." *Rivista d'arte* 7.1–2:29.

———. 1913. *Mostra dei cartoni e disegni di Federigo Baroccio.* Bergamo.

Fifty Master Drawings in the National Gallery of Scotland. 1961. Edinburgh.

Fini, Sante. 2011. *Piobbico: Antica contea Brancaleoni. Storia—arte—natura.* 2nd edn. Piobbico.

Fiorani, Francesca. 2009. "The Shadows of Leonardo's *Annunciation* and Their Lost Legacy." In *Imitation, Representation, and Printing in the Italian Renaissance,* ed. Roy Eriksen and Magne Malmanger, 119–56. Pisa.

Fischer, Chris. 1990. *Fra Bartolommeo: Master Draughtsman of the High Renaissance.* Exh. cat. Museum Boijmans Van Beuningen. Rotterdam.

———. 2001. *Central Italian Drawings: Schools of Florence, Siena, the Marches and Umbria.* Statens Museum for Kunst. Copenhagen.

Fontana, Jeffrey. 1997a. "Evidence for an Early Florentine Trip by Federico Barocci." *Burlington Magazine* 139:471–75.

———. 1997b. Federico Barocci: Imitation and the formation of artistic identity. PhD diss., Brown Univ.

———. 2007. "Duke Guidobaldo II della Rovere, Federico Barocci, and the Taste for Titian at the Court of Urbino." In Verstegen 2007a, 161–78.

Forlani Tempesti, Anna. 1975. "Una scheda per il Barocci." *Prospettiva* 3:48–50.

———. 1987. *The Robert Lehman Collection. 5. Italian Fifteenth- to Seventeenth-Century Drawings.* The Metropolitan Museum of Art. New York.

———. 1995. "Attorno al Barocci." In Di Giampaolo and Angelucci 1995, 57–67.

———. 1996. "Barocci infinito." In *Hommage au Dessin—Mélanges offerts à Roseline Bacou,* ed. Maria Teresa Caracciolo, 58–71. Rimini.

———, and Annamaria Petrioli Tofani. 1972. *I grandi disegni italiani degli Uffizi a Firenze.* Milan.

———, and Annamaria Petrioli Tofani, eds. 1976. *Omaggio a Leopoldo de' Medici.* Vol. 1. Florence.

———, and Grazia Calegari. 2001. *Da Raffaello a Rossini: La collezione Antaldi: I disegni ritrovati.* Exh. cat. Palazzo Antaldi, Pesaro. Regione Marche, Centro beni culturali.

Foucart-Walter, Elisabeth, and Pierre Rosenberg. 1987. *Le Chat et la palette.* Paris.

Francia, Vincenzo, ed. 2004. *Splendore di bellezza: L'iconografia dell'Immacolata Concezione nella pittura rinascimentale italiana.* Rome.

Freedberg, Sydney. 1971. *Painting in Italy 1500–1600.* Pelican History of Art. New Haven.

Frerichs, L. C. J. 1981. *Italiaanse tekeningen. 2. De 15de en 16de eeuw.* Exh. cat. Rijksprentenkabinet, Rijksmuseum. Amsterdam.

Friedländer, Walter. 1908. "Federico Barocci." In *Allgemeines Lexikon der bildenden Künstler,* ed. Ulrich Thieme and Felix Becker, 511–13. Leipzig.

Friedmann, Herbert. 1946. *The Symbolic Goldfinch: Its History and Significance in European Devotional Art.* New York.

Frizzoni, Gustavo. 1907. "Le novità della Pinacoteca Ambrosiana." *Bollettino d'arte* 1:15f.

Frosinini, Cecilia, Letizia Montalbano, and Michela Piccolo, eds. 2008. *Leonardo e Raffaello, per esempio: Disegni e studi d'artista.* Exh. cat. Palazzo Medici Riccardi. Florence.

Gage, Frances. 2008. "Exercise for Mind and Body: Giulio Mancini, Collecting, and the Beholding of Landscape Painting in the Seventeenth Century." *Renaissance Quarterly* 61:1167–1207.

Galizzi Kroegel, Alessandra. 2004. "A Misunderstood Iconography: Girolamo Genga's Altarpiece for S. Agostino in Cesena." In *Drawing Relationships in Northern Italian Renaissance Art: Patronage and Theories of Invention,* ed. Giancarla Periti, 75–100. Burlington, VT.

Galleria degli Uffizi. 1979. *Gli Uffizi: Catalogo generale.* Florence.

Gamba, Carlo. 1927. "Federico Baroccio." In *Il ritratto italiano dal Caravaggio al Tiepolo,* ed. Ciro Caversazzi et al., 21–22, pls. VIII–IX. Bergamo.

Garrido, Carmen. 2000. "Tintoretto's *The Washing of the Feet:* Creating an Original." In *Una obra maestra restaurada: El lavatorio de Jacopo Tintoretto,* ed. Miguel Falomir Faus, 85–100. Exh. cat. Museo del Prado. Madrid.

Gaye, Johann Wilhelm. 1840. *Carteggio inedito d'artisti dei secoli XIV, XV, XVI.* Vol. 3. Florence.

Geiger, Benno. 1948. *Handzeichnungen alter Meister.* Zurich.

Gere, John Arthur, Philip Pouncey, and Rosalind Wood. 1983. *Italian Drawings in the Department of Prints and Drawings in the British Museum: Artists Working in Rome c. 1550 to c. 1640.* London.

Gherardi, Pompeo. 1875. *Guida di Urbino.* Urbino.

Giannotti, Alessandra. 1999. "Genesi e fortuna di un 'exemplum caritatis': La Madonna del Popolo di Federico Barocci." In *L'Onestà dell'invenzione: Pittura della Riforma Cattolica agli Uffizi,* ed. Antonio Natali, 25–42. Milan.

———. 2009. "Con gli occhi di Bellori." In Giannotti and Pizzorusso 2009, 24–35.

———, and Claudio Pizzorusso, eds. 2009. *Federico Barocci 1535–1612: L'Incanto del colore: Una lezione per due secoli.* Milan.

Gianuizzi, Pietro. 1892. "I tesori d'arte della Santa Casa di Loreto rapiti nel 1797." *Nuova Rivista Misena* 5.6:83–87.

Gillgren, Peter. 2010. "The Lure of Aesthetic Criticism." *Konsthistorisk tidskrift* 79.4:228–31.

———. 2011. *Siting Federico Barocci and the Renaissance Aesthetic.* Surrey.

Giovannoni, Simona Lecchini. 1991. *Alessandro Allori.* Turin.

Goffen, Rona. 1997. *Titian's Women.* New Haven.

Goldman, Jean. 1988. "An Unpublished Drawing by Federico Barocci for 'The Entombment.'" *Master Drawings* 26.3:249–52, 299.

Goldner, George R., Lee Hendrix, and Gloria Williams. 1988. *European Drawings.* Vol. 1. *Catalogue of the Collections.* The J. Paul Getty Museum. Malibu, CA.

Gould, Cecil. 1975. *The Sixteenth-Century Italian Schools.* Rev. edn. National Gallery Catalogue. London.

Grayson, Cecil, ed. 1980. *De pictura, di Leon Battista Alberti.* Bari.

Grigorjeva, Irina. 1970. *Kiállítás a Leningrádi Ermitázs legszebb rajzaiból.* Museum of Fine Arts. Budapest.

Griswold, William M., and Linda Wolk-Simon. 1994. *Sixteenth-Century Italian Drawings in New York Collections.* Exh. cat. The Metropolitan Museum of Art. New York.

Grohmann, Alberto. 1981. *Perugia: La città nella storia d'Italia.* Rome.

Gronau, Giorgio. 1936. *Documenti artistici urbinati: Con una tavola fuori testo.* Florence.

Gualandi, Michelangelo. 1844. *Nuova raccolta di lettere sulla pittura, scultura ed architettura scritte da' più celebri personaggi dei secoli XV. a XIX.* Vol. 1. Bologna.

Gualazzi, Enzo. 1975. "Federico Barocci, ultima occasione." *Arti* 25.8–9:37–42.

Haboldt. 1990. *Tableaux anciens des écoles du nord, françaises et italiennes: 1990–1991.* Exh. cat. Haboldt Gallery. Paris and New York.

———. 1995. *Fifty Paintings by Old Masters.* New York.

Halasa, Grazyna. 1993. "Studies of the Heads of Federico Barocci in the National Museum of Poznan." *Studia Muzealne* 17.

Hall, James. 1974. *Dictionary of Subjects and Symbols in Art.* London.

Hall, Marcia B. 1992. *Color and Meaning: Practice and Theory in Renaissance Painting.* Cambridge, UK.

———. 2011. *The Sacred Image in the Age of Art.* New Haven.

Hamburgh, Harvey E. 1981. "The Problem of Lo Spasimo of the Virgin in Cinquecento Paintings of the Descent from the Cross." *The Sixteenth Century Journal* 12.4:45–75.

Härb, Florian. 2005. "'Dal vivo' or 'da se': Nature versus Art in Vasari's Figure Drawings." *Master Drawings* 43:326–38.

Harris, Marguerite Tjader, trans. 1990. *Saint Bridget of Sweden: Life and Selected Revelations.* New York.

Hasselt, Carlos C. van. 1960. *Fifteenth and Sixteenth Century Drawings.* Exh. cat. The Fitzwilliam Museum. Cambridge, UK.

Heise, Helga, and Margit Ziesche, eds. 1986. *Friederich Wilhelm von Erdmannsdorff, 1736–1800. Sammlung der Zeichnungen.* Staatliche Galerie Dessau, Schloss Georgium, Graphische Sammlung. [Dessau].

Held, Julius Samuel. 1963. "The Early Appreciation of Drawings." In *Latin American Art, and the Baroque Period in Europe. Studies in Western Art.* Acts of the Twentieth International Congress of the History of Art, 3, 72–95. Princeton.

Henninges, Hieronymus. 1598. *Theatrum genealogicum ostentans omnes omnium aetatum familias.* 4 vols. Magdeburg.

Hirst, Michael. 1967. "Daniele da Volterra and the Orsini Chapel. 1. The Chronology and the Altar-Piece." *Burlington Magazine* 109:498–509.

Hollstein, F. W. H. 1993. *The New Hollstein: Dutch and Flemish Etchings, Engravings, and Woodcuts, 1450–1700.* Amsterdam.

Holmes, Charles. 1923. *Old Masters and Modern Art: The National Gallery Italian Schools.* London.

Hope, Charles. 1990. "Altarpieces and the Requirements of Patrons." In *Christianity and the Renaissance: Image and Religious Imagination in the Quattrocento,* ed. Timothy Verdon and John Henderson, 535–71. Syracuse.

Hubala, Erich. 1975. *Federico Barocci, Handzeichnungen.* Exh. cat. Martin-von-Wagner-Museum. Würzburg.

Huber, Raphael M. 1938. *The Portiuncula Indulgence from Honorius III to Pius XI. Franciscan Studies* 19. New York.

Hurt, Jethro. 1975–76. Review of *The Grimani Breviary, Reproduced from the Illuminated Manuscript Belonging to the Biblioteca Marciana, Venice,* by Giorgio E. Ferrari. *Art Journal* 35.2:182–86.

Incisa della Rocchetta, Giovanni, and Nello Vian, with P. Carlo Gasbarri. 1957–63. *Il primo processo per San Filippo Neri.* 4 vols. Vatican City.

Israëls, Machtelt. 2007. "Absence and Resemblance: Early Images of Bernardino da Siena and the Issue of Portraiture (with a New Proposal for Sassetta)." *I Tatti Studies: Essays in the Renaissance* 11:77–114.

———, ed. 2009. *Sassetta: The Borgo San Sepolcro Altarpiece.* 2 vols. Leiden.

Italienische Barockzeichnungen. 1952. Heinrich Brauer. Exh. cat. Schloss Celle. [Celle.]

J. Paul Getty Museum. 1997. *Masterpieces of the J. Paul Getty Museum: Drawings.* Los Angeles.

Jackson, Radway. 1981. *The Concise Dictionary of Artists' Signatures: Including Monograms and Symbols.* New York.

Jacobsen, Emil. 1908. "Uno studio di Rembrandt negli Uffizi di Firenze." *L'Arte* 11:451–52.

Jacobus de Voragine. 1993. *The Golden Legend: Readings on the Saints,* trans. William Granger Ryan. 2 vols. Princeton.

Jaffé, Michael. 1994. *The Devonshire Collection of Italian Drawings.* Vol. 2. *Roman and Neapolitan Schools.* London.

James, Carlo. 2010. *Visual Identification and Analysis of Old Master Drawing Techniques.* Florence.

Jameson, Anna. 1864. *Legends of the Madonna as Represented in the Fine Arts.* 3rd edn. London.

Joannides, Paul. 1983. *The Draftsman Raphael.* Berkeley, CA.

Kai, Noriyuki. 1994. "Federico Barocci, i Cappuccini, la *Madonna del Popolo.*" *Artista* 6:92–103.

Katalan, Jak. 1997. "Federico Barocci (1535–1612) et la Majolique." *La Revue du Louvre et des Musées de France* 1:48–53.

Kaufmann, Thomas DaCosta. 1988. *The School of Prague: Painting at the Court of Rudolf II.* Chicago.

Keith, Larry, Minna Moore Ede, and Carol Plazzotta. 2004. "Polidoro da Caravaggio's *Way to Calvary:* Technique, Style and Function." *National Gallery Technical Bulletin* 25:36–47.

Kiefer, Lisa. 2001. The iconography of the Visitation in Italian Renaissance art. PhD diss., Case Western Reserve Univ.

Kieser, Emil. [1931.] *Zeichnungen aus dem Kupferstichkabinett des Martin-von-Wagnermuseums der Universität Würzburg.* Frankfurt.

Klauner, Friderike. 1973. *Kunsthistorisches Museum, Wien. Verzeichnis der Gemälde.* Vienna.

Klessmann, Rüdiger, and Reinhold Wex, eds. 1984. *Beiträge zur Geschichte der Ölskizze vom 16. bis zum 18. Jahrhundert.* Hanover.

Köller, Manfred. 1982. "Die Technische Entwicklung und Künstlerische Funktion der Unterzeichnung in der Europäischen Malerei vom 16. bis 17. Jahrhundert." In *Le Dessin sous-jacent dans la peinture,* Colloque IV, 29–31 October 1981, 173–90. Louvain-la-Neuve.

Krommes, Rudolf Heinrich. 1911. *Studien zu Federigo Barocci: Inaugural-Dissertation.* Leipzig.

———. 1912. *Studien zu Federigo Barocci.* Leipzig.

Landau, David, and Peter Parshall. 1994. *The Renaissance Print 1470–1550.* New Haven.

Landseer, John. 1834. *A Descriptive, Explanatory and Critical Catalogue of Fifty of the Earliest Pictures Contained in the National Gallery of Great Britain.* London.

Lanzi, Luigi. 1809. *Storia pittorica della Italia: Dal risorgimento delle belle arti fin presso al fine del XVIII secolo.* Bassano.

———. 1815. *Storia pittorica dell'Italia.* Vol. 2. Pisa.

———. 1822. *Storia pittorica della Italia: Dal risorgimento delle belle arti fin presso al fine del XVIII secolo.* Vol. 2. Florence.

Lauder, Anne Varick. 2009. *Musée du Louvre, Départment des arts graphiques: Inventaire général des dessins italiens.* Vol. 8. *Battista Franco.* Paris.

Lavin, Marilyn Aronberg. 1954–55. "A Late Work by Barocci." *Metropolitan Museum of Art Bulletin* 13:266–71.

———. 1955. "Giovanni Battista: A Study in Renaissance Religious Symbolism." *Art Bulletin* 37:85–101.

———. 1956. "Colour Study in Barocci's Drawings." *Burlington Magazine* 48:434–49.

———. 1964. Review of *Federico Barocci* by Harald Olsen. *Art Bulletin* 46 (June): 251–54.

———. 1965. Letter to the Editor. *Art Bulletin* 47.4:541–42.

———. 1990. *The Place of Narrative: Mural Decoration in Italian Churches, 431–1600.* Chicago.

———. 2006. "Images of a Miracle: Federico Barocci and the Porziuncola Indulgence." *Artibus et Historiae* 54:9–50.

Lazzari, Andrea. 1800. *Memorie di alcuni celebri pittori d'Urbino.* Urbino.

———. 1801. *Delle chiese d'Urbino e delle pitture in esse esistenti.* Urbino.

Lazzarini, Lorenzo. 1973. "Federico Barocci, Transporto di Cristo al sepolcro: Esame tecnico scientifico di alcuni sezione di colore." In *Restauri nelle Marche,* 422–28. Urbino.

Lechi, Fausto. 1968. *I quadri delle collezioni Lechi in Brescia: Storia e documenti.* Florence.

Leonardo da Vinci. 1956. *Treatise on Painting* [*Codex Urbinas Latinus 1270*], trans. and annotated A. Philip McMahon, intro. Ludwig H. Heydenreich. 2 vols. Princeton.

———. 1995. *Libro di Pittura: Codice Urbinate lat. 1270 nella Biblioteca Apostolica Vaticana,* ed. Carlo Pedretti. Florence.

Leone, Giorgio. 2011. "Istuzione dell'Eucarestia o Communione degli Apostoli." In Morello 2011, 198–99, no. 36.

Levi, Donata. 2009. "Federico Barocci e le requisizioni napoleoniche." In Giannotti and Pizzorusso 2009, 250–61.

Levi D'Ancona, Mirella. 1957. *The Iconography of the Immaculate Conception in the Middle Ages and Early Renaissance.* New York.

Libro delle Notizie del Convento di S. Francesco. Unpublished MS, Archivio di San Francesco, Urbino, Italy.

Lightbown, Ronald. 2004. *Carlo Crivelli.* New Haven.

Ligi, Bramante. 1956. *Le chiese monumentali in Urbino.* Urbino.

———. 1972. *Il convento e la Chiesa dei Minori Conventuali e la Libera Università degli studi di Urbino.* Urbania.

Lilio, Andrea, Giovanna Bonasegale Pittei, and Luciano Arcangeli. 1985. *Andrea Lilli nella pittura delle Marche tra Cinquecento e Seicento.* Exh. cat. Pinacoteca Civica Francesco Podesti, Ancona. Rome.

Lingo, Stuart Patrick. 1998. The Capuchins and the art of history: Retrospection and reform in the arts in late Renaissance Italy. PhD diss., Harvard Univ.

———. 2001. "Retrospection and the Genesis of Federico Barocci's *Immaculate Conception.*" In *Coming About: A Festschrift for John Shearman,* ed. Lars Jones and Louisa Matthew, 215–21. Cambridge, MA.

———. 2007. "Francesco Maria della Rovere and Federico Barocci: Some Notes on Distinctive Strategies in Patronage and the Position of the Artist at Court." In Verstegen 2007a, 179–99.

———. 2008. *Federico Barocci: Allure and Devotion in Late Renaissance Painting.* New Haven.

Linnenkamp, Rolf. 1961. "Zwei unbekannte Selbstbildnisse von Federigo Barocci." *Pantheon* 19:46–50.

Lipparini, Giuseppe. 1913. "I 'Barocci' Urbinati." In *Studi e notizie su Federico Barocci,* 58–62. Florence.

Lisimberti, Paola, and Antonio Todisco. 2000. *Il bel San Francesco e l'Arciconfraternita dell'Immacolata Concezione di Ostuni.* Fasano (Brindisi).

Lisot, Elizabeth Jane Alker. 2009. Passion, penance, and mystical union: Early modern Catholic polemics in the religious paintings of Federico Barocci. PhD diss., Univ. of Texas at Dallas.

Lloyd, Christopher, Mary Anne Stevens, and Nicholas Turner. 1987. Exh. cat. *Master Drawings: The Woodner Collection.* Royal Academy of Arts, London.

Loire, Stéphane. 2011a. "Le paysage à Rome: Annibal Carrache et ses suiveurs." In Cappelletti et al. 2011, 15–27.

———. 2011b. "Annibal Carrache." In Cappelletti et al. 2011, 235–41.

Loisel, Catherine. 2008. "L'Exemple de Bassano et Barocci et le premier pastel d'Annibale Carracci." In Faietti, Melli, and Nova 2008, 205–13.

———, Patrizia Tosini, and Anna Cerboni Baiardi. 2009. In Giannotti and Pizzorusso 2009. Cats. 31, 41, 44, 56, 58, 61, 65, 72–74, 78, 100, 122.

Lomazzo, Giovanni Paolo. 1584 (1974). *Idea del tempio della pittura*, ed. Robert Klein. Florence.

———. 1590. *Idea del tempio della pittura*. Milan.

MacAndrew, Hugh. 1980. *Catalogue of the Collection of Drawings in the Ashmolean Museum. Vol. 3. Italian Schools: Supplement*. Oxford.

McCullagh, Suzanne Folds. 1991. "Serendipity in a Solander Box: A Recently Discovered Pastel and Chalk Drawing by Federico Barocci." *The Art Institute of Chicago Museum Studies* 17:53–65 and 93–94.

———. 2000. "Early Portraits, Portrayals and Pastels in the Art of Federico Barocci." In *Festschrift für Konrad Oberhuber*, ed. Achim Gnann, Heinz Widauer, Katja Gnann, and Brigitte Willinger, 166–74. Milan.

———, and Laura M. Giles. 1997. *Italian Drawings before 1600 in the Art Institute of Chicago: A Catalogue of the Collection*. Chicago.

McGrath, Thomas. 1994. "Disegno," "colore" and the "disegno colorito": The use and significance of color in Italian Renaissance drawings. 3 vols. PhD diss., Harvard Univ.

———. 1997. "Color in Italian Renaissance Drawings: Reconciling Theory and Practice in Central Italy and Venice." *Apollo* 146:22–30.

———. 1998. "Federico Barocci and the History of *pastelli* in Central Italy." *Apollo* 148:3–9.

———. 2000. "Color and the Exchange of Ideas between Patron and Artist in Renaissance Italy." *Art Bulletin* 82.2:298–308.

Madsen, S. Tschudi. 1959. "Federico Barocci's *Noli me tangere* and Two Cartoons." *Burlington Magazine* 101:273–77.

Mahon, Denis, Massimo Pulini, and Vittorio Sgarbi. 2003. *Guercino: Poesia e sentimento nella pittura del '600*. Exh. cat. Palazzo Reale, Milan. Novara.

Mâle, Émile. 1932. *L'Art religieux après le Concile de Trente: Étude sur l'iconographie de la fin du XVI^e siècle, du XVII^e, du XVIII^e siècle—Italie, France, Espagne, Flandres*. Paris.

———. 1951. *L'Art religieux de la fin du XVI^e siècle, du XVII^e siècle, et du XVIII^e siècle: Étude sur l'iconographie après le Concile de Trente: Italie, France, Espagne, Flandres*. Paris.

Malvasia, Carlo Cesare. 1678 (1841). *Felsina pittrice: Vite de' pittore bolognesi*. Vol. 1. Bologna.

Mancini, Francesco Federico. 2009. "Il maestro e la scuola: Barocci e il baroccismo in Umbria." In Giannotti and Pizzorusso 2009, 138–45.

———. 2010. *Federico Barocci e la pittura della maniera in Umbria*. Milan.

Marciari, John. 2000. Girolamo Muziano and art in Rome, circa 1550–1600. PhD diss., Yale Univ.

———. 2002. "Girolamo Muziano and the Dialogue of Drawings in Cinquecento Rome." *Master Drawings* 40.2:113–24.

———, and Ian Verstegen. 2008. " 'Grande quanto l'opera': Size and Scale in Barocci's Drawings." *Master Drawings* 46.3:291–321.

Mariette, Pierre-Jean. 1851–53. *Abecedario de P.-J. Mariette: Et autres notes inédites de cet amateur sur les arts et les artistes*. Paris.

Marinelli, Olga. 1965. *Le confraternite di Perugia dalle origini al sec. Vol. XIX*. Perugia.

Martin, Gregory. 1968. "Rubens's 'Dissegno Colorito' for Bishop Maes Reconsidered." *Burlington Magazine* 110:434–37.

Martín, Pedro García, Giovanna Motta, and Giordano Altarozzi. 2005. *Imagines paradisi: Storia della percezione del paesaggio nell'Europa moderna*. Rome.

Mayberry, Nancy. 1991. "The Controversy over the Immaculate Conception in Medieval and Renaissance Art, Literature, and Society." *Journal of Medieval and Renaissance Studies* 21.2:207–24.

Mazzanti, Marinella Bonvini. 2002. "Aspetti della politica interna ed esterna di Francesco Maria II della Rovere." In Cleri et al. 2002, 77–91.

Mazzei, Mimma. 2002–3. La soppressione del Convento di San Francesco in Urbino (1866): Analisi storico-giuridica. Jurisprudence thesis, Univ. degli studi di Urbino "Carlo Bo."

Mazzini, Franco. 2000. *Urbino: I mattoni e le pietre*. Urbino.

Meijer, Bert W., ed. 1995a. *Italian Drawings from the Rijksmuseum, Amsterdam*. Exh. cat. Rijksmuseum, Amsterdam. Florence.

———, ed. 1995b. *Maestri dell'invenzione: Disegni italiani del Rijksmuseum, Amsterdam*. Exh. cat. Istituto universitario olandese di storia dell'arte. Florence.

Meiss, Millard. 1964. *Bellini's St. Francis in the Frick Collection*. Princeton.

———. 1970. *The Great Age of Fresco: Discoveries, Recoveries and Survivals*. New York.

Mellini, Gian Lorenzo. 2000. "Barocci, Lanfranco e l'ermeneutica." *Labyrinthos* 19.37–38:215–79.

Merrifield, Mary. 1966. *The Art of Fresco Painting*, intro. A. C. Sewter. London.

Michel, André. 1886–1902, "Barocci (Federigo)." In *La Grande Encyclopédie* 5, 442–43. Paris.

Milano, Carlo, ed. 2003. *The Italian Embassy in London*. London.

Minardi, Mauro. 2008. *Lorenzo e Jacopo Salimbeni: Vicende e protagonisti della pittura tardo gotica nelle Marche e in Umbria*. Florence.

Monbeig-Goguel, Catherine. 1967. "Federico Barocci." In Musée du Louvre 1967, 48–49, cats. 10–12.

———, ed. 1998. *Francesco Salviati (1510–1563), o La bella maniera*. Exh. cat. Villa Medici, Rome. Paris.

Monelli, Nanni, and Giuseppe Santarelli. 1999. *La basilica di Loreto e la sua reliquia*. Loreto.

Montalbano, Letizia, and Nadia Bastogi. 2008. "Federico Barocci: *Putto sulle nubi*." In Frosinini, Montalbano, and Piccolo 2008, 118–22.

Montevecchi, Benedetta. 2001. "Federico Barocci: *Riposo nella fuga in Egitto*." In *Opere Restaurate, 1999–2000*, ed. Paolo Dal Poggetto, 42–45. Urbino.

Moranti, Luigi. 1990. *La Confraternita del Corpus Domini di Urbino*. Bologna.

Morelli, Giovanni Francesco. 1683. *Brevi notizie delle pitture e sculture che adornano l'augusta città di Perugia*. Perugia.

Morello, Giovanni, ed. 2011. *Alla Mensa del Signore, Capolavori dell'arte europea da Raffaello a Tiepolo*. Turin and Rome.

———, Vincenzo Francia, and Roberto Fusco, eds. 2005. *Una donna vestita di sole: L'Immacolata Concezione nelle opere dei grandi maestri*. Milan.

Moretti, Massimo. 2009. "Visitazione." In Giannotti and Pizzorusso 2009, 282, no. 15.

———, and Alessandro Zuccari. 2009. "Barocci e Roma: Tre dipinti e una scuola da Gregorio XIII a Clemente VIII." In Giannotti and Pizzorusso 2009, 146–55.

Mormando, Franco. 1999. *The Preacher's Demons: Bernardino of Siena and the Social Underworld of Early Renaissance Italy*. Chicago.

Muller, Jeffrey M. 1975. "Oil-Sketches in Rubens's Collection." *Burlington Magazine* 117:371–77.

Muller, Norman E., Betsy J. Rosasco, and James H. Marrow, eds. 1998. *Herri met de Bles: Studies and Explorations of the World Landscape Tradition*. Princeton.

Musée du Louvre. 1967. *Le Cabinet d'un grand amateur, P.-J. Mariette, 1694–1774: Dessins du XV^e siècle au XVIII^e siècle*. Paris.

Nagel, Alexander. 2005. "Experiments in Art and Reform in Italy in the Early Sixteenth Century." In *The Pontificate of Clement VII: History, Politics and Culture*, ed. Kenneth Gouwens and Sheryl E. Reiss, 385–409. Hampshire.

Nagler, Georg K. 1860. *Die Monogrammisten und diejenigen bekannten und unbekannten Künstler aller Schulen*. Munich.

Nardicchi, Stefania. 2003. "Iconografia della Madonna del Rosario." In *Storia e fortuna del Rosario nella diocesi di Spoleto*, ed. Stefania Nardicchi, 127–31. Exh. cat. Museo diocesano e Basilica di S. Eufemia. Spoleto.

Natali, Antonio. 2003. *Federico Barocci: Il miracolo della Madonna della gatta*. Milan.

———, and Federica Chezzi. 2008. "Federico Barocci, *Autoritratto*." In *100 autoritratti dalle collezione degli Uffizi; 100 Self-portraits from the Uffizi Collection*, 29, no. 12. Florence.

Negroni, Franco. 1993. *Il duomo di Urbino*. Urbino.

Nicolson, Benedict. 1975. *Georges de la Tour*. Milan.

Nova, Alessandro. 1992. "Salviati, Vasari, and the Reuse of Drawings in Their Working Practice." *Master Drawings* 30.1:83–108.

———. 2008. "Pietre naturali, matite colorate, pastelli e il problema del ritratto." In Faietti, Melli, and Nova 2008, 158–75.

Oberhuber, Konrad. 1999. *Raphael: The Paintings*. Milan.

Okey, Thomas, trans. and intro. 1910 (1963). *The Little Flowers of St. Francis: The Mirror of Perfection: St. Bonaventure's Life of St. Francis*. Everyman's Library. New York.

Old Master Drawings from Chatsworth. 1962. Exh. cat. Smithsonian Institution. Washington, D.C.

Olsen, Harald. 1955. *Federico Barocci: A Critical Study in Italian Cinquecento Painting.* Stockholm.

———. 1962. *Federico Barocci.* 2nd edn. Copenhagen.

———. 1965a. "Some Drawings by Federico Barocci: 1. Drawings in East-Berlin; 2. Studies of Landscape." *Artes: Periodical of the Fine Arts* 1:17–32.

———. 1965b. Letter to the Editor. *Art Bulletin* 47.4:541.

———. 1966. "En tegning af Federico Barocci i Louvre." *Artes: Internationalt Kunsttidsskrift* 2:70–72.

———. 1969. "Eine Kompositionsskizze von Federico Barocci." *Jahrbuch der Staatlichen Kunstsammlungen in Baden-Württemberg* 7:49–54.

———. 2002. "Relazioni tra Francesco Maria II Della Rovere e Federico Barocci." In Cleri et al. 2002, 2, 195–204.

Oradei, Alessandra. 2002. "La 'Libreria Impressa.'" In Cleri et al. 2002, 3, 115–28.

Orbaan, J. A. F. 1920. *Documenti sul barocco in Roma.* 2 vols. Rome.

Orenstein, Nadine M., ed. 2001. *Pieter Bruegel the Elder: Drawings and Prints.* Exh. cat. The Metropolitan Museum of Art. New York.

Orsini, Baldassare. 1784. *Guida al forestiere per l'augusta città di Perugia.* Perugia.

Ortenzi, Francesco. 2009. "Annunciazione" and "Madonna del Gatto." In Giannotti and Pizzorusso 2009, 285–86, cat. 18, and 386–87, cat. 112.

Osborne, June. 2003. *Urbino: The Story of a Renaissance City.* Chicago.

Ottley, William Young. 1832. *A Descriptive Catalogue of the Pictures in the National Gallery.* London.

Pacetti, Dionisio. 1940. *La predicazione di S. Bernardino da Siena a Perugia e ad Assisi nel 1425.* Assisi.

Pallucchini, Rodolfo, and Paola Rossi. 1982. *Tintoretto: Le opere sacre e profane.* 2 vols. [Venice.]

Palm, Erwin Walter. 1950. "A Vault with Cosmo-theological Representations at the 'Imperial Monastery' of the Dominicans on the Island of Hispaniola." *Art Bulletin* 32.3:219–35.

Panofsky, Erwin. 1930 (1962). "La prima pagina del 'Libro' di Giorgio Vasari" (1930). In Erwin Panofsky, *Il significato nelle arti visive,* 169–215. Turin.

Paolini, Maria Maddalena. 2003. "Federico Barocci, *Stimmate di S. Francesco.*" In Cleri and Giardini 2003, 200–201, no. 27.

Papi, Gianni. 2002. "Una pala d'altare di Federico Barocci nei depositi della Pinacoteca di Brera." *Arte cristiana* 90 (March–April): 105–14.

Paraventi, Marta. 2002. "Ai confini del Ducato: Castelleone di Suasa, l'ultima dimora di Livia Della Rovere e altre ricerche." In Cleri et al. 2002, 123–28.

Parisciani, Gustavo. 1984. *La riforma tridentina e i frati minori conventuali.* Rome.

Parker, Karl Theodore. 1956. *Catalogue of the Collection of Drawings in the Ashmolean Museum.* Vol. 2. *Italian Schools.* Oxford.

Parkhurst, Charles. 1987. "Leon Battista Alberti's Place in the History of Color Theories." In *Color and Technique in Renaissance Painting: Italy and the North,* ed. Marcia B. Hall. Locust Valley, NY.

Parma, Rita. 1995. "Disegni di Battista Franco per Opere Marchigiane." In Di Giampaolo and Angelucci 1995, 31–44.

Pauwels, P. Pietro. 1904. *I Francescani e la Immacolata Concezione.* Rome.

Pelli Bencivenni, Giuseppe. 1784. "Inventario generale della R. Galleria di Firenze compilato nel 1784, essendo direttore della medesima Giuseppe Bencivenni già Pelli." Unpublished manuscript, vol. 102. Gabinetto Disegni e Stampe degli Uffizi, Florence.

Penny, Nicholas. 1986. "The Raphael of the Counter-Reformation." Review of *Federico Barocci,* by Andrea Emiliani. *Times Literary Supplement,* 26 September, 1059–60.

———. 2008. *The Sixteenth-Century Italian Paintings.* Vol. 2. *Venice, 1540–1600.* National Gallery. London.

Pérez Sánchez, Alfonso E. 1965. *Pintura italiana del siglo XVII en España.* Madrid.

Perini, Claudia. 2009. "La Chiesa della Croce." In Quaglia 2009, 45–70.

Perini, Giovanna. 2005. "Appunti sulla fortuna critica di Federico Barocci tra Cinque e Settecento." In Ambrosini Massari and Cellini 2005, 394–405.

Petrioli Tofani, Annamaria. 1964. "La *Resurrezione* del Genga in S. Caterina a Strada Giulia." *Paragone* 15.177:48–58.

———. 1969. "Per Girolamo Genga." *Paragone* 20:18–36, no. 229, and 39–56, no. 231.

———. 1972. *I Grandi disegni italiani degli Uffizi di Firenze.* Milan.

———, ed. 1986–87. *Inventario: Disegni esposti.* 2 vols. Gabinetto Disegni e Stampe degli Uffizi. Florence.

———. 2008. *Michelangelo, Vasari, and Their Contemporaries: Drawings from the Uffizi.* Exh. cat. The Morgan Library and Museum. New York.

Phillips, John Goldsmith. 1937. "A Crucifixion Group after Michelangelo." *The Metropolitan Museum of Art Bulletin* 32.9:210–14.

di Pietro, Filippo. 1909. "Un disegno del Barocci all'Albertina già attribuito al Domenichino." *Rivista d'arte* 6.5:297–301.

———. 1913. *Disegni sconosciuti e disegni finora non identificati di Federico Barocci negli Uffizi.* Florence.

Pillsbury, Edmund P. 1973. Jacopo Zucchi: his life and works. PhD diss. Univ. of London.

———. 1976. Review of *Barocci at Bologna and Florence. Master Drawings* 14.1:56–64.

———. 1978. "The Oil Studies of Federico Barocci." *Apollo* 108 (September), 170–73.

———. 1987. Review of *Federico Barocci: Urbino 1535–1612,* by Andrea Emiliani. *Master Drawings* 25:285–87.

———. 2000. "Barocci, Federico." *Grove Art Online. Oxford Art Online.* http://www.oxfordartonline.com/subscriber/article/grove/art/T006432 (March 31).

———, and Louise S. Richards, eds. 1978. *The Graphic Art of Federico Barocci: Selected Drawings and Prints.* Exh. cat. Cleveland Museum of Art. New Haven.

Pilon, Valerio. 1975. "1975: Resurrezione di Federico Barocci. IX Biennale d'arte antica bolognese." *Arte cristiana* 63.10:255–68.

Piperno, Franco. 2002. "Cultura e usi della musica alla corte di Guidubaldo II Della Rovere." In Cleri et al. 2002, 25–36.

Pirovano, Carlo, Giulio Briganti, et al. 1988. *La pittura in Italia: Il Cinquecento.* Milan.

Pizzorusso, Claudio. 2009. "Federico Barocci e il paradosso dell' 'ottimo scultore.'" In Giannotti and Pizzorusso 2009, 54–65.

Plazzotta, Carol. 2004. "The Crucified Christ with the Virgin Mary, Saints and Angels." In Chapman, Henry, and Plazzotta 2004, 120–24, no. 27.

———. 2007. Entries on Domenico Beccafumi. In *Renaissance Siena: Art for a City,* ed. Luke Syson et al., 334–37, nos. 108–9. Exh. cat. National Gallery. London.

Plesters, Joyce. 1979. "Tintoretto's Paintings in the National Gallery. 1. Condition, History of Restoration and Recent Treatment." *National Gallery Technical Bulletin* 3:3–24.

———. 1980. "Tintoretto's Paintings in the National Gallery. 2. Materials and Techniques." *National Gallery Technical Bulletin* 4:32–48.

———. 1984. "Tintoretto's Paintings in the National Gallery. 3. Technical Examination of the Four Remaining Works Attributed to or Associated with Tintoretto." *National Gallery Technical Bulletin* 8:24–35.

———, and Lorenzo Lazzarini. 1972. "Preliminary Observations on the Technique and Materials of Tintoretto." In *Conservation of Paintings and the Graphic Arts: IIC Preprints of Contributions to the Lisbon Congress,* 153–80.

Poggi, Giovanni. 1912–13. "Federico Barocci nel terzo centenario della morte." *Il Marzocco* (Florence) 17.39:52.

Polecritti, Cynthia L. 2000. *Preaching Peace in Renaissance Italy.* Washington, D.C.

Polverari, Michele. 1990. *Tiziano: La crocefissione di Ancona.* Ancona.

Ponnelle, Luigi, and Luigi Bordet. 1986. *San Filippo Neri e la Società Romana del suo tempo (1515–1595).* Florence.

Poole, Paul Falconer. 1884. *Exhibition of Works by the Old Masters, and by Deceased Masters of the British School: Including a Special Selection from the Works of Paul Falconer Poole, R.A.* Royal Academy of Arts. London.

Pope-Hennessy, John. 1970. *Raphael.* New York.

Popham, Arthur E., and Johannes Wilde. 1949. *The Italian Drawings of the XV and XVI Centuries in the Collection of His Majesty the King at Windsor Castle.* London.

Pouncey, Philip, and J. A. Gere. 1962. *Italian Drawings in the Department of Prints and Drawings in the British Museum: Raphael and His Circle.* 2 vols. London.

Prado, Museo del. 1970. *Pintura italiana del siglo XVII: Exposición conmemorativa del ciento cincuenta aniversario de la fundación del Museo del Prado.* Exh. cat. Madrid.

Prete, Serafino. 1948. "Il quarto centenario del Concilio di Trento (1545–1547): Il contributo delle Chiese marchigiane." In *Studia Picena* 18–19:1–9.

Prosperi Valenti Rodinò, Simonetta. 2009. "Studio e metodo: Fortuna del disegno di Federico Barocci." In Giannotti and Pizzorusso 2009, 66–75.

———, and Claudio M. Strinati, eds. 1982. *L'immagine di San Francesco nella Controriforma.* Exh. cat. Calcografia. Rome.

Prytz, Daniel. 2011."Two Unpublished Oil Studies by Federico Barocci in the Nationalmuseum, Stockholm." *Burlington Magazine* 153:653–56.

Py, Bernadette, and Françoise Viatte. 2001. *Everhard Jabach, collectionneur (1618–1695): Les dessins de l'inventaire de 1695.* Paris.

Quaglia, Gianluca, ed. 2009a. *La Chiesa della Croce e la sua Confraternita.* Senigallia.

———. 2009b. *Inventario e documenti salient dell'Archivio della Confraternita del SS.mo Sacramento e Croce di Senigallia.* Ostra Vetere.

Quattrini, Cristina. 1993. "Un'ipotesi iconografica per la 'Madonna del Rosario' di Federico Barocci." In *Studi per Pietro Zampetti,* ed. Ranieri Varese, 440–43. Ancona.

Ratti, Achille. 1907. *Guida sommaria per il visitatore della Biblioteca Ambrosiana e delle collezioni annesse.* Milan.

Réau, Louis. 1955–59. *Iconographie de l'art chrétien.* 6 vols. Paris.

Renaissance Siena: Art for a City. See Syson et al. 2007.

Renzetti, Luigi, et al. 1913. *Studi e notizie su Federico Barocci.* La Brigata urbinate degli Amici dei monumenti. Florence.

Restauri nelle Marche. 1973. Soprintendenza ai monumenti delle Marche. Ancona.

The Revelations of St. Birgitta of Sweden. 2008. Trans. Denis Searby, intro. and notes Bridget Morris. 2 vols. New York.

Reynolds, Joshua. 1798. *The Works of Sir Joshua Reynolds, Knight,* ed. Edward Malone. 3 vols. London.

Richards, Louise. 1961. "Federico Barocci: A Study for Aeneas's Flight from Troy." *Bulletin of the Cleveland Museum of Art* 48:63–65.

Richardson, Jonathan. 1728. *Description de divers fameux tableaux, dessins, statues etc. en Italie.* Amsterdam.

Ricotti, Egidio. 1954. *Il convento e la chiesa di S. Francesco di Assisi in Urbino.* Padua.

Riedl, Peter Anselm. 1976. *Disegni dei Barocceschi Senesi (Francesco Vanni e Ventura Salimbeni).* Florence.

Roncetti, Mario. 1992. "Il duomo di Perugia: Un approccio bibliografico." In *Una città e la sua cattedrale: Il duomo di Perugia,* ed. Maria Luisa Cianini Pierotti, 1–47. Perugia.

Rosand, David. 1982. *Painting in Cinquecento Venice: Titian, Veronese, Tintoretto.* New Haven.

———, and Michelangelo Muraro. 1976. *Titian and the Venetian Woodcut.* Exh. cat. National Gallery of Art. Washington, D.C.

Rosci, Marco. 2009. "La fascinazione cromoluministica di Barocci in Lombardia." In Giannotti and Pizzorusso 2009, 166–71.

Rosenberg, Pierre. 1981. "Un Carton de Baroche et un dessin d'Annibal Carrache inédits." In *Per A. E. Popham,* 131–35. Parma.

———. 2009. "Barocci e la pittura francese del Settecento: Un rendez-vous mancato." In Giannotti and Pizzorusso 2009, 226–35.

Roy, Ashok, and Marika Spring, eds. 2004. *Raphael's Painting Technique: Working Practices before Rome.* London.

Royalton-Kisch, Martin. 1999. *The Light of Nature: Landscape Drawings and Watercolours by Van Dyck and His Contemporaries.* Exh. cat. The British Museum. London.

———. 2001. "Pieter Bruegel as a Draftsman: The Changing Image." In Orenstein 2001, 13–40.

Rubin, Patricia. 1994. "Commission and Design in Central Italian Altarpieces c. 1450–1550." In *Italian Altarpieces 1250–1550: Function and Design,* ed. Eve Borsook and Fiorella Superbi Gioffredi, 201–30. Oxford.

Ruhwinkel, Stephanie. 2010. *Die Zeichnungen Federico Baroccis im Martin-von-Wagner-Museum Würzburg.* Weimar.

Russell, Francis. 2000. "A Drawing by Barocci and Two Issues of Context." In *Studi di storia dell'arte in onore di Denis Mahon,* ed. Maria Grazia Bernardini, Silvia Danesi Squarzino, and Claudio Strinati, 17–18. Milan.

Rustici, Alfonso. 1923. "Federico Zuccari." *Rassegna marchigiana* 1.11 (August), 405–29.

———. 1924. "Gli affreschi di Federico Zuccari a Loreto." *Rassegna marchigiana* 2.4 (January), 133–44.

Salerno, Luigi, Richard E. Spear, and Mina Gregori, eds. 1985. *The Age of Caravaggio.* Exh. cat. The Metropolitan Museum of Art, New York. Milan.

Sánchez, Magdalena S. 1998. *The Empress, the Queen, and the Nun: Women and Power at the Court of Philip III of Spain.* Baltimore.

Sangalli, Maurizio. 2009. "Federico Barocci o delle controriforme: Tra Filippo Neri, i cappuccini, Federico Borromeo. Roma Urbino Milano." In Giannotti and Pizzorusso 2009, 156–65.

Sangiorgi, Fert. 1976. *Documenti urbinati: Inventari del palazzo ducale (1582–1631).* Urbino.

———. 1982. *Committenze milanesi a Federico Barocci e alla sua scuola nel carteggio Vincenzi della Biblioteca universitaria di Urbino, presentazione di Andrea Emiliani.* Urbino.

———, ed. 1989. *Diario di Francesco Maria II della Rovere.* Urbino.

———. 1991. "Precisazioni su due ritratti di Federico Barocci." *Notizie da Palazzo Albani* 20:165–70.

Sani, Bernardina. 2009. "Tra disegno e pittura: Il pastello come tecnica sperimentale da Federico Barocci a Rosalba Carriera." In Giannotti and Pizzorusso 2009, 236–41.

Sansovino, Francesco. 1582. *Della origine et de' fatti delle famiglie illustri d'Italia.* 4 vols. Venice.

Santi, Francesco. 1972. "Un'opera perduta di Vincenzo Danti." *Bollettino d'arte* 57.2:112–14.

Sapori, Armando. 1983. *Il mercante italiano nel medioevo.* Milan.

Sapori, Giovanna. 1983. "Rapporto preliminare su Simonetto Anastagi." In *Artisti e committenti nel '500,* 77–85. Rome.

Scannelli, Francesco. 1657 (1989). *Il microcosmo della pittura.* Bologna.

Scaramuccia, Luigi Pellegrini. 1934. *Le finezze de' pennelli italiani ammirate e studiate de Girupeno sotto la scorta e disciplina del genio di Raffaello d'Urbino.* Milan.

Scatassa, Ercole. 1900. "Il Crocifisso dipinto dal Barocci per la Compagnia della Morte di Urbino." In *Rassegna bibliografica dell'arte italiana* 3:78–80.

———. 1901. "Documenti: Federico Barocci. " In *Rassegna bibliografica dell'arte italiana* 4:129–32.

Schapelhouman, Marijn. 1995. "Aegidius Sadeler d'après Federico Barocci, *La Déposition*." In *Fiamminghi a Roma, 1508–1608: Artistes des Pays-Bas et de la Principauté de Liège à Rome à la Renaissance,* ed. Anne-Claire de Liedekerke, 313–14, cat. 176. Exh. cat. Palais des Beaux-Arts. [Brussels.]

Schiferl, Ellen. 1989. "Corporate Identity and Equality: Confraternity Members in Italian Paintings, c. 1340–1510." *Source* 8.2:12–18.

Schiller, Gertrud. 1971. *Iconography of Christian Art.* 2 vols. Greenwich, CT.

Schmarsow, August. 1909. *Federigo Baroccis Zeichnungen: Eine kritische Studie von August Schmarsow.* Vol. 1. *Die Zeichnungen in der Sammlung der Uffizien zu Florenz. Abhandlungen der Philologisch-Historischen Klasse der königl. Sächsischen Gesellschaft der Wissenschaften* 26.5. Leipzig.

———. 1909 (2010). *Federico Barocci: Un capostipite della pittura barocca,* ed. Luigi Bravi, trans. Ludovica Pampaloni. Urbino.

———. 1910. *Federigo Baroccis Zeichnungen: Eine Kritische Studie von August Schmarsow*. Vol. 2. *Die Zeichnungen in den übrigen Sammlungen Italiens. Abhandlungen der Philologisch-Historischen Klasse der königl. Sächsischen Gesellschaft der Wissenschaften* 28.3. Leipzig.

———. 1911. *Federigo Baroccis Zeichnungen: Eine Kritische Studie von August Schmarsow*. Vol. 3. *Die Zeichnungen in den Sammlungen ausserhalb Italiens. A. Westliche Hälfte Europas. Abhandlungen der Philologisch-Historischen Klasse der königl. Sächsischen Gesellschaft der Wissenschaften* 29.2. Leipzig.

———. 1914. *Federigo Baroccis Zeichnungen: Eine Kritische Studie von August Schmarsow*. Vol. 3. *Die Zeichnungen in den Sammlungen ausserhalb Italiens. B. Östliche Hälfte Europas. Abhandlungen der Philologisch-Historischen Klasse der königl. Sächsischen Gesellschaft der Wissenschaften* 30.1. Leipzig.

Schroeder, Rev. H. J., trans. and intro. 1978. *The Canons and Decrees of the Council of Trent*. Rockford, IL.

Schroth, Sarah, and Ronni Baer. 2008. *El Greco to Velázquez: Art during the Reign of Philip III*. Exh. cat. Museum of Fine Arts. Boston.

Schulz, J. 1962. "Pintoricchio and the Revival of Antiquity." *Journal of the Warburg and Courtauld Institutes* 25.122:35–55.

Schwartz, Sheila. 1975. The Iconography of the Rest on the Flight into Egypt. PhD diss., New York Univ.

Scolaro, Michela. 2005. " 'Accordando . . . questa musica.' L'arte del disegno per Federico Barocci." In Ambrosini Massari and Cellini 2005, 50–59.

Scrase, David. 1992. *Recent Discoveries at the Fitzwilliam Museum, Cambridge*. Perugia.

———, ed. 2006. *A Touch of the Divine: Drawings by Federico Barocci in British Collections*. Exh. cat. The Fitzwilliam Museum. Cambridge, UK.

———. 2011. *Italian Drawings at the Fitzwilliam Museum, Cambridge, together with Spanish Drawings*. Cambridge, UK.

Semenza, Giulia. 2009. "Sepoltura di Cristo." In Giannotti and Pizzorusso 2009, 273–74, cat. 8.

Sensi, Mario. 2002a. *Santuari nel territorio della Provincia di Perugia*. Ponte San Giovanni, Perugia.

———. 2002b. *Il Perdono di Assisi*. Assisi.

Serra, Luigi. 1930. *Il palazzo ducale e la Galleria Nazionale di Urbino*. Rome.

———. 1931. "Federico Brandani e le sculture della Santa Casa di Loreto." *Il Vasari* 3.2–3:3–9.

———. 1932. *Catalogo delle cose d'arte e di antichità d'Italia*. Rome.

Shearman, John. 1976. "Barocci at Bologna and Florence." *Burlington Magazine* 118:2 and 49–55.

Shelley, Marjorie. 2011. "Painting in the Dry Manner: The Flourishing of Pastel in 18th-Century Europe." *Metropolitan Museum of Art Bulletin*, 68.2:4–56.

Siena, Lodovico. 1746 (1977). *Storia della città di Sinigaglia*. Bologna.

Sievers, Ann H. 2000. "Head of a Young Woman, Study for the Painting Madonna del Gatto." In Ann H. Sievers, Linda D. Muehlig, and Nancy Rich, *Master Drawings from the Smith College Museum of Art*, 45–48, cat. 7. New York.

Simonetti, Carlo Maria. 2005. *La vita delle "Vite" vasariane: Profilo storico di due edizioni*. Florence.

Sirén, Osvold. 1902. *Dessins et tableaux de la Renaissance italienne dans les collections de Suède*. Stockholm.

Smith College Museum of Art. 1986. *A Guide to the Collections of the Smith College Museum of Art*. Northampton, MA.

Smith, Denis Mack. 2005. *Federigo da Montefeltro*. Urbino.

Smith, Graham. 1970. "A Drawing for the Interior Decoration of the Casino of Pius IV." *Burlington Magazine* 112:108–11.

———. 1974. "The Stucco Decoration of the Casino of Pius IV." *Zeitschrift für Kunstgeschichte* 37.2:116–56.

———. 1978. "Federico Barocci at Cleveland and New Haven." *Burlington Magazine* 120:330, 332–33.

Smith, Katherine Allen. 2006. "Bodies of Unsurpassed Beauty: Living Images of the Virgin in the High Middle Ages." *Viator* 37:167–87.

Smith, Thomas. 1860. *Recollections of the British Institution for Promoting the Fine Arts in the United Kingdom*. London.

Spear, Richard. 2003. "Scrambling for Scudi: Notes on Painters' Earnings in Early Baroque Rome." *The Art Bulletin* 85.2:310–20.

———, and Philip L. Sohm. 2010. *Painting for Profit: The Economic Lives of Seventeenth-Century Italian Painters*. New Haven.

Spike, John T. 1994. "Barocci in Urbania." In Cellini 1994, 39–97.

Spinosa, Nicolà, ed. 1994–95. *Museo e Gallerie Nazionali di Capodimonte: La collezione Farnese*. 2 vols. Naples.

Stix, Alfred, and Lili Fröhlich-Bum. 1932. *Beschreibender Katalog der Handzeichnungen in der Graphischen Sammlung Albertina*. Vol. 3. *Die Zeichnungen der Toskanischen, Umbrischen und Römischen Schulen*. Vienna.

Stratis, Harriet K., and Britt Salvesen. 2002. *The Broad Spectrum: Studies in the Materials, Techniques, and Conservation of Color and Paper*. London.

Stratton-Pruitt, Suzanne L. 2002. *Bartolomé Esteban Murillo (1617–1682): Paintings from American Collections*. New York.

Strauss, Walter L., ed. 1982. *The Illustrated Bartsch*. 34. *Italian Artists of the Sixteenth Century*, ed. Sebastian Buffa. New York.

Straussman-Pflanzer, Eve. 2009. "An Exploration of the Female Life Model in Early Modern Italy." Unpublished paper, College Art Association Annual Meeting.

Strinati, Claudio, Olga Melasecchi, et al. 1995. *La regola e la fama: San Filippo Neri e l'arte*. Exh. cat. Palazzo di Venezia, Rome. Milan.

Strong, S. Arthur. 1902. *Reproductions of Drawings by Old Masters in the Collection of the Duke of Devonshire at Chatsworth*. London.

Studi e notizie su Federico Barocci. 1913. Florence.

Sweeny, Barbara. 1966. *John G. Johnson Collection, Philadelphia: Catalogue of Italian Paintings*. Philadelphia.

Syson, Luke, et al. 2007. *Renaissance Siena: Art for a City*. Exh. cat. National Gallery. London.

———, and Dillian Gordon. 2001. *Pisanello: Painter to the Renaissance Court*. Exh. cat. National Gallery. London.

Tarducci, Antonio. 1897 (2003). *Piobbico e i Brancaleoni*. Cagli.

Tarnow, U. 2005. Artefice Cristiano: Studien zur religiösen Malerei Federico Baroccis. Phil. diss. Technische Universität, Berlin.

Thiem, Christel. 1977. *Italienische Zeichnungen, 1500–1800. Bestandskatalog der Graphischen Sammlung der Staatsgalerie Stuttgart*. Stuttgart.

———. 2008. "Barocci-Studien: Elf in einer Privatsammlung entdeckte Pastell- und Kreidezeichnungen von Federico Barocci." *Jahrbuch der Berliner Museen*, n.s., 50:35–52.

Thomas-Maurin, Frédérique. 2003. "Federico Barocci, Tête de femme: Étude pour la *Déposition*." In *Les Dessins du Musée des Beaux-Arts et d'archéologie de Besançon*, 34. Exh. cat. Paris.

Timm, Werner. 1962. *Zeichnungen alter Meister*. Kupferstichkabinett, Staatliche Museen zu Berlin. Berlin.

Titi, Filippo. 1763. *Descrizione delle pitture, sculture e architetture esposte al pubblico in Roma: Opera cominciata dall'abate Filippo Titi, con l'aggiunta di quanto è stato fatto di nuovo fino all'anno presente*. Rome.

de Tolnay, Charles. 1943. *History and Technique of Old Master Drawings*. New York.

Torriti, Pietro. 1978. *La Pinacoteca Nazionale di Siena: I dipinti dal XV al XVIII secolo*. Genoa.

———, and Franca Bizzotto Abdalla, eds. 1973. *Restauri nelle Marche: Testimonianze, acquisti e recuperi*, 413–36, nos. 102–7; and 682–85, no. 168. Exh. cat. Palazzo Ducale, Urbino. [N.p.]

Tosini, Patricia. 2008. *Girolamo Muziano 1532–1592: Dalla maniera alla natura*. Rome.

Trkulja, Silvia Meloni. 1975. "Leopoldo de' Medici collezionista." *Paragone* 26.307:15–38.

Turner, Nicholas. 1999. *Roman Baroque Drawings, c. 1620–c. 1700*. London.

———. 2000. *Federico Barocci*. Paris.

———. 2010a. *Guido Reni: Santa Caterina da Siena: Dipinti inediti del barocco italiano da collezioni private*. Exh. cat. Palazzo Chigi. Ariccia.

———. 2010b. "Study for the 'Madonna of the Rosary.'" In *Gray Collection: Seven Centuries of Art*, ed. Suzanne Folds McCullagh. Exh. cat. Art Institute of Chicago. New Haven.

———, Lee Hendrix, and Carol Plazzotta. 1988. *European Drawings: Catalogue of the Collections.* Vol. 3. The J. Paul Getty Museum. Los Angeles.

———, and Jean Goldman. 2009. *Drawn to Italian Drawings: The Goldman Collection.* New Haven.

Valazzi, Maria Rosaria. 2009. "Barocci e la sua terra." In Giannotti and Pizzorusso 2009, 36–45.

Valentiner, Wilhelm Reinhold. 1945. "The Last Prince of Urbino." *Gazette des beaux-arts* 27:32.

Van der Sman, Gert. 2000. "Battista Franco: Studi di figura per dipinti e incisioni." *Prospettiva* 97:63–72.

Van Regteren Altena, Johan Quirijn, and Raimond van Marle. 1934. *Italiaansche Kunst in Nederlandsch bezit.* Exh. cat. Stedelijk Museum. Amsterdam.

Van Schaack, Eric. 1962. *Master Drawings in Private Collections.* New York.

Vasari, Giorgio. 1568 (1907). *Vasari on Technique; Being the Introduction to the Three Arts of Design, Architecture, Sculpture and Painting, Prefixed to the Lives of the Most Excellent Painters, Sculptors and Architects,* ed. G. Baldwin Brown, trans. Louisa S. Maclehose. London.

———. 1960. *On Technique,* ed. G. Baldwin Brown, trans. Louisa S. Maclehose. New York.

———. 1966–87. *Le vite de' più eccellenti pittori, scultori e architettori nelle redazioni del 1550 e 1568,* ed. Rosanna Bettarini and Paola Barocchi. Florence.

———. 1987. *Lives of the Artists,* trans. George Bull. 2 vols. Rev. edn. London.

Vastano, Agnese. 2004. "Ritratto del marchese Ippolito Della Rovere." In Dal Poggetto 2004a, 339–41, cat. VIII.5.

———. 2009. "Perdono di Assisi" and "Ultima Cena." In Giannotti and Pizzorusso 2009, 268–69, cat. 2, and 276–77, cat. 10.

———. 2011. "Ultima Cena o Istitudione dell'Eucarestia." In Morello 2011, 175, no. 5.

Vecchioni, Emilio. 1926–27. "La Chiesa della Croce e Sagramento in Senigallia e la 'Deposizione' di Federico Barocci." *Rassegna marchigiana* 5:497–503.

Veliz, Zahira. 1986. *Artists' Techniques in Golden Age Spain.* Cambridge, UK.

Velli, Silvia Tomasi. 1997. "Federico Barocci, Clemento VIII e la 'communione di Giuda.'" *Prospettiva* 87–88:157–67.

Venturi, Adolfo. 1925. *Storia dell'arte italiana.* Vol. 9. Milan.

———. 1934. *Storia dell'arte italiana.* Vol. 9, part 7. *La pittura del Cinquecento.* Milan.

Venturoli, Alberto. 1998. *San Filippo Neri: Vita, contesto storico e dimensione mariana.* Casale Monferrato.

Verstegen, Ian. 2002. Federico Barocci: The art of painting and the rhetoric of persuasion. PhD diss., Temple Univ.

———. 2003a. "Federico Barocci, Federico Borromeo, and the Oratorian Orbit." *Renaissance Quarterly* 56:56–87.

———. 2003b. "Three Cartoon Fragments for Barocci's *Madonna di San Simone.*" *Master Drawings* 41.4:378–83.

———, ed. 2007a. *Patronage and Dynasty: The Rise of the Della Rovere in Renaissance Italy.* Kirksville, MO.

———. 2007b. "Barocci, Cartoons, and the Workshop: A Mechanical Means for Satisfying Demand." *Notizie da Palazzo Albani* 36:101–23.

———. 2007c. "Reform and Renewed Ambition: Cardinal Giulio Feltrio della Rovere." In Verstegen 2007a, 89–110.

———. 2007d. "Francesco Maria and the Duchy of Urbino, between Rome and Venice." In Verstegen 2007a, 141–60.

Vertova, Luisa. 1989. "Un disegno compito del Baroccio per la Madonna della Culla di Casa Albani." *Antichità viva* 28:26–34.

Virgil. 1916. *Aeneid,* trans. H. Rushton Fairclough. Loeb Classical Library. London.

Voss, Hermann. 1920. *Die Malerei der Spätrenaissance in Rom und Florenz.* Vol. 2. Berlin.

Wallert, Arie, and Carlo van Oosterhout. 1998. *From Tempera to Oil Paint: Changes in Venetian Painting, 1460–1560.* Amsterdam.

Walters, Gary R. 1978. *Federico Barocci: Anima naturaliter.* New York.

Warnke, Martin. 1985. *The Court Artist: On the Ancestry of the Modern Artist.* Cambridge, UK.

Weil-Garris, Kathleen. 1977. *The Santa Casa di Loreto: Problems in Cinquecento Sculpture.* 2 vols. New York.

Weissman, Ronald F. E. 1982. *Ritual Brotherhood in Renaissance Florence.* New York.

Welch, Evelyn. 2004. "Painting as Performance in the Italian Renaissance Court." In *Artists at Court: Image-Making and Identity 1300–1550,* ed. Stephen J. Campbell, 19–32. Chicago.

Westergård, Ira. 2007. *Approaching Sacred Pregnancy: The Cult of the Visitation and Narrative Altarpieces in Late Fifteenth-Century Florence.* Helsinki.

Wickhoff, Franz. 1891. *Die Italienischen Handziechnungen der Albertina.* Vienna.

Wilson, Carolyn C. 2001. *St. Joseph in Italian Renaissance Society and Art: New Directions and Interpretations.* Philadelphia.

Winzinger, Franz. 1979. *Wolf Huber: Das Gesamtwerk.* Munich.

Wittkower, Rudolf. 1952. *The Drawings of the Carracci in the Collection of Her Majesty the Queen at Windsor Castle.* London.

———. 1967. "Introduction." In *Masters of the Loaded Brush: Oil Sketches from Rubens to Tiepolo,* 15–25. Exh. cat. Organized by the Department of Art History and Archaeology, Columbia University, and held at M. Knoedler and Co. [New York.]

Wood, Christopher S. 1998. "The Errera Sketchbook and the Landscape Drawing on Grounded Paper." In *Herri met de Bles: Studies and Explorations of the World Landscape Tradition,* ed. Norman E. Muller, Betsy J. Rosasco, and James H. Marrow, 101–16. Princeton.

Zampetti, Pietro. 1953. *Antichi dipinti restaurati.* Urbino.

———. 1975. "Le Mostre: La Mostra del Barocci a Bologna." *Notizie da Palazzo Albani* 4.2:78–83.

———. 1990. *Pittura nelle Marche.* Vol. 3. Florence.

Zonghi, Aurelio. 1884. *Gesù Cristo portato al sepolcre: Quadro in tela di Federico Barocci nella Chiesa della Croce e Sagramento in Senigallia.* Fano.

Zuccari, Alessandro. 1995. "Cesare Baronio, le immagini, gli artisti," and "Parte centrale del cartone per la Visitazione della Chiesa Nuova." In Strinati, Melasecchi, et al. 1995, 80–97 and 525–26.

Zuccaro, Federico. 1607 (1973). *Idea de' pittori, scultori et architetti.* In Barocchi 1971–77, 2, 2062–2118.

Zuffi, Stefano. 2007. *The Cat in Art.* New York.

Index

Photo Credits